JAPAN

ART AND CIVILIZATION

LOUIS FRÉDÉRIC

JAPAN

ART AND CIVILIZATION

HARRY N. ABRAMS, INC. *Publishers* NEW YORK

A NOTE ON THE ENDPAPERS

Each Buddhist monastery and Shintō shrine has its own unique symbol or seal. Thought to be endowed with talismanic powers, these seals are sold as amulets at the temples and shrines. Known as Ofuda, *these talismans are piously collected by the faithful. Reproduced on the front endpapers are* Ofuda *from various Buddhist temples; those on the back endpapers are from Shintō shrines.*

On the front endpapers

A. SHIN YAKUSHI-JI, NARA.
B. KŌFUKU-JI, NARA.
C. BYŌDŌ-IN, UJI.
D. OKADERA, NARA.
E. MYŌSHIN-JI, TAIZŌ-IN, KYOTO.
F. HŌRYŪ-JI, NARA.
G. ASUKA DERA, NARA.
H. AKISHINO DERA, NARA.
I. KŌFUKU-JI, NARA.
J. HŌRIN-JI, NARA.
K. JŌRURI-JI, NARA.
L. NINNA-JI, NARA.
M. CHŪGŪ-JI, NARA.
N. HOKKI-JI, NARA.
O. MAMPUKU-JI, KYOTO.

On the back endpapers

A. GOKŌNOMIYA JINJA, KYOTO.
B. KASHIMA JINGŪ, KASHIMA.
C. & J. FUSHIMI INARI TAISHA, KYOTO.
D. DANZAN JINJA, NARA.
E. ISONO KAMI JINJA, TENRI.
F. KAMEIDŌ TENMANGŪ, TOKYO.
G. YASAKA JINJA, KYOTO.
H. HEIAN JINGŪ, KYOTO.
I. ASAKUSA JINJA, TOKYO.
K. KITANO TEMMANGŪ, KYOTO.
L. SHIMOGAMO JINJA, KYOTO.

Standard Book Number: 8109-0209-5
Library of Congress Catalogue Card Number: 77-125780
Copyright 1969 in France by Arts et Métiers Graphiques, Paris
All rights reserved. No part of the contents
of this book may be reproduced without the
written permission of the publishers
Harry N. Abrams, Incorporated, New York
Printed and bound in the Netherlands

CONTENTS

INTRODUCTION

JAPAN WAS one of the last nations of Asia to become known to the peoples of the West. In fact, what little we do know about Japan prior to the time when Emperor Meiji opened it to foreigners is contained in the reports of a few missionaries and navigators who were acquainted with it. Even the Chinese do not appear to have had a more extensive knowledge of Japan in ancient times, although Chinese literature and art had had a profound and lasting influence on the Islands of the Rising Sun. Despite the fact that the geography of Japan was well known, its ancient history and prehistory were still obscure until after World War II. The sacred character of the imperial ruling family prevented excavations in the royal tombs, which would have clarified certain mysteries that still enveloped the historical origins of Japan. In addition, Shintō, the official cult and religion, prohibited investigation of the accepted mythology and proclaimed the emperor to be the direct descendant of the sun goddess Amaterasu. Few Japanese books had been translated, and even now not many are available, despite the enormous amount of literary and historical writing produced by Japanese authors. The language itself is complicated, and Japan's ancient literature is difficult to decipher.

Since 1945, however, most of the official interdicts have been lifted, thereby increasing the Western world's knowledge of Japan. Japanese archaeologists have begun to undertake ambitious excavations, and historians have been able to undertake numerous research projects; the results of these probings, when published, will have to be translated into a European language, so that their discoveries will be available to Western scholars. Expert translators are rare, and even a working knowledge of the Japanese language requires years of study. It is possible, however, to offer a glimpse of Japan not only in her modern state but in the various stages of her geological, historical, and artistic development.

Japanese civilization, essentially complex, has become even more difficult to understand because with its present contacts with the West it changes from year to year. Between 1945 and 1965 the country progressed from a "military medievalism to the modern era"; in its demilitarized modernity it has become an equal to the other major world powers. In certain spheres of industry and the arts the Japanese capacity for assimilation has also enabled them to absorb numerous foreign cultures in record time and to adapt them so successfully that they have become typically Japanese. In our own era Japan has made remarkable strides in industry that point to a future of extraordinary affluence in all fields once it has assimilated the West, whose influence is still somewhat stifling.

Another characteristic of Japanese civilization, found in all the stages of its evolution, is its almost total inability to make deliberate selections among all the offerings the outside world

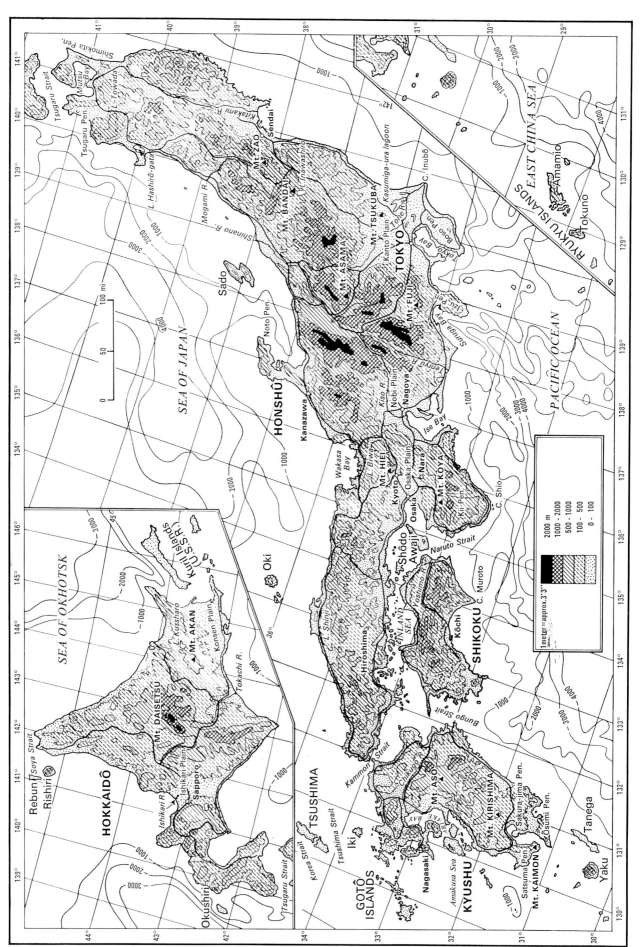

I. TOPOGRAPHY OF JAPAN. GENERAL MAP

bestows on it. This lack of a discriminatory sense can be discovered in the religious, artistic, literary, commercial, and political fields. In Japanese civilization there are many contrary elements which, instead of opposing, reciprocally complete one another. That is why Japan is a subject to be approached with prudence. Those who know it well, having lived there for a long time, do not venture to offer a judgment or even to proffer a simple opinion regarding it. On first sight Japan could be described as a "package civilization": a country that resembles a beautifully wrapped box which, once opened, releases a Chinese demon. This is, however, only partly true, since social restraints, which have weighed on the life of the Japanese throughout their entire history, have obliged them to display only one aspect of their civilization: that which is socially acceptable and sanctified by custom. The demon that springs out of the box is the symbol of the considerable influence which China has exercised on Japan and which often breaks through the purely Japanese facade. Yet Japanese power and character already existed before Chinese influence made itself felt, and this Japanese spirit still persists, regardless of foreign influences.

This underlying Japanese spirit cannot be easily identified, however. It is revealed only by an attentive examination of the evolution of Japanese civilization from a geographical, historical, religious, and artistic point of view. Otherwise, Japanese civilization, so diverse in its multiple aspects, so permeated with foreign influences and yet so constantly and profoundly original, can be baffling to the Western spirit.

It has often been said that Japan is a country without a philosophy. That is true in the sense that it has never developed a coherent philosophical system analogous to those that Western, Indian, and Chinese thinkers have created throughout the centuries. Yet there is a Japanese philosophy—not vain spiritual speculation, but essentially the normal consequence of the practical acts of daily social life on the one hand and the result of the silent confrontation of man with nature on the other. This Japanese philosophy is composed of apparently antagonistic elements, such as the beliefs of the people and the doctrines of the state, the necessity of accepting an extremely difficult life struggle along with the restraints imposed by the Japanese on themselves in order to reconcile group interests with individualistic tendencies. In fact, contrary to appearances, the Japanese are individualistic.

The fact that they inhabit islands with limited resources has forced these born individualists to live in a crowded environment that would be difficult to imagine even in Europe. In a country barely two-thirds the size of France there is a population of 90 million with an average density, therefore, of about 540 people per square mile of arable ground: the highest density in the world. In fact, as a mountainous and volcanic country, more than 80 percent of Japan consists of almost uninhabitable rocky regions or forests. Because of this crowding, Japanese philosophy stresses the necessity of a certain harmony among human beings who are individualistic and have in common only the conditions under which they live.

As a result, the entire evolution of Japan was and is conditioned by continual tension created by disparities of temperament and education of individuals obliged to live together in a restricted space and in relative isolation. The tensions of the individuals, moreover, have found alleviation only in religion or in periodic civil wars. This tension also accounts for the apparent paradox of the refined courtesy and the often brutal behavior of the Japanese. It is a tension that has been aggravated by the conflict between the duty to follow tradition and the attraction of novelty.

This perpetual tension has made the Japanese one of the most nervous peoples in the world. It is a nervousness that is carefully concealed, that has been expressed in the past only by recourse to arms, and that is now finding an outlet in sports in which these apparently lethargic people excel because of their marvelously rapid reflexes. In fact, these seemingly cold men are extraordinarily emotional and hypersensitive. A Japanese warrior, trained for merciless battle, will compose poetry of a subtle delicacy. He will respond with deep appreciation to a vase of spring flowers, a cup of tea, a rare perfume, will handle with awe a beautiful piece of porcelain.

When studying Japanese civilization and its development—and there can be no better way

than to examine the evolution of its thought, culture, and art—one must bear in mind several important factors:

1. The capacity of the Japanese to absorb and adapt foreign influences.
2. The incapacity of the Japanese to discriminate among these influences.
3. The overpopulation of Japan's relatively limited habitable land.
4. The continual conflict between social necessities and individualistic tendencies.
5. The exceptional emotionalism of the Japanese character.
6. The excessive nervousness of the Japanese.

Other factors must also be taken into consideration, because they justify the preceding:

1. The unstable geological character of the islands, which is the cause of frequent natural catastrophes.

2. The great variety of climate and ways of life—the Japanese islands extend over three climatic zones.

3. The different ethnic origins of the individuals making up the Japanese people as a whole.

4. An exceptionally pronounced division of classes in Japanese society imposed by political necessities.

5. The patriarchal social organization, which was superimposed on an agrarian society that from prehistoric times had been inveterately matriarchal.

6. The difficult medium in which Japanese thought has been transcribed: Chinese script.

These multiple factors, far from separately influencing the development of Japanese civilization, have combined in different epochs and diverse regions to modify the normal evolution of Japanese society.

This, in other words, is an extremely mobile civilization that has been the subject of numerous involutions and of continuous struggles, which unceasingly destroyed in order to build again in a better form. It is also a unique civilization in the sense that, prior to the nineteenth century, it had merely received without ever giving anything; it was a work of perfect assimilation, which succeeded in creating a society of a special type that was strongly egocentric and conditioned by the need to survive against the powers of nature and man by means of the deification of both. Despite outside influences the inhabitants of the Japanese islands have always preserved their own way of life and a culture that is different from that of other countries—even those as close as China and Korea. Except for a relatively brief period of its history, Japan was always wide open to other currents of civilization, but it always adopted the most diverse elements and was able to make them coexist in complete harmony.

All this may appear contradictory, and yet it can be explained. "Mysterious Japan" exists only in the imagination of novelists enamored of the exotic or in the superficial conclusions of hurried tourists. The Japanese are a people whose reactions are conditioned by the multiple factors that we have enumerated; they are logical and profoundly human and they embody all the fine qualities and all the defects in the nature of man.

We should like, therefore, to invite our readers to examine all these elements so as to be able to judge the facts more clearly. In order to present these facts, we have deliberately chosen a method that is different from the one employed in our previous books: *The Art of India: Temples and Sculpture* (Abrams, 1959) and *The Art of Southeast Asia: Temples and Sculpture* (Abrams, 1965). Those two volumes dealt with civilizations which, although not completely vanished, were very different from those that are evolving in those areas at present; in other words, they were basically civilizations of the past. In Japan the past is always present, and the people have remained exactly the same since the beginning of its history. One is not able, therefore, to detach the Japanese people from their creations or adaptations or to understand Japanese art without being acquainted with the thought and way of life of those who developed it and still live it.

We have felt obliged, as a result, to present Japanese civilization in its particular essentials, and at the same time as a whole, from its prehistoric period up to the beginning of the Meiji era when Japan accepted Western influence on a large scale, but we have omitted this last period.

A large part of this work, therefore, will be devoted to the evolution of art in such a way as to afford a better comprehension of the Japanese mentality. It is always an error to try to disassociate the art from the life of a people in whom it was born, and it is impossible to make such a division with the art of Japan. Above all, Japanese art reflects the fluctuations of the nation's political, religious, and social evolution.

The choice of photographs presented here will be the subject of debate. We have attempted to show, rather than the pure beauty of the works, the diversity of inspiration and workmanship that is so characteristic of Japan. It would have been advantageous to be able to present everything, but obviously this was impossible. We have tried to illustrate the evolution of the spirit of the Japanese as a whole. Several of the most famous works are missing; others, less well known, appear here. We hope, however, that the reader will be able, through these illustrations, to understand better the reasons behind the evolution of Japanese civilization from prehistory up to the dawn of modern times. As far as the chronology of our plan is concerned, we have judged it wise to follow the large subdivisions that are generally accepted for the classification of the works of art: subdivisions that correspond, with variations of very few years, to the great historical epochs of Japan.

Following a first chapter dealing with Japan as a geographical entity, we have devoted a second chapter to its prehistory and to the formation of the Japanese people: an indispensable preliminary study to an understanding of the following chapters. These chapters—with the exception of the introduction of Buddhism about A.D. 552, an event that was a turning point in the evolution of Japanese civilization as well as of its art—follow step by step the customary chronological divisions and present events that had both historical importance and significance in the spiritual and artistic evolution of the country. The decision not to deal with the Meiji epoch (1868–1912) or the more recent period, from 1912 to 1945, arose partly from the preliminary outline of this work, which did not include such material, and partly from the fact that the impact of Western civilization temporarily halted the evolution of Japanese culture while the country paused to assimilate Western ideas. Art itself in these periods was subjected to too many influences to make inclusion of them in the plan for this volume possible. We preferred, therefore, to limit ourselves to those periods characterized by the development and flowering of a typically Japanese civilization.

A civilization does not consist solely of history, art, and literature; it also includes customs, tales, myths, and all the useful objects that owe their existence to the talents of the people. A civilization is a cultural and technical accumulation of a country's characteristic thoughts and actions determined by and evolving in time, and entire libraries would be needed to describe even a single component completely. Our study of Japanese civilization is, therefore, as brief as the subject is vast, and is all the more imperfect since the author, being European, has not inherited Japanese traditions and can only attempt to see them from the exterior, even though one must live with them for a long period in order to understand and appreciate them fully and, even more important, to feel them.

We have been unable to avoid the use of many Japanese words, since for the most part they are untranslatable. Proper names of people have been written in the Japanese fashion —in other words, the surname precedes the given name. The years, for reasons of facility, are given according to the Gregorian calendar. We have employed for the transcription

2. GEOGRAPHICAL POSITION OF JAPAN AS COMPARED WITH EUROPE

13

of Japanese words the Hepburn system of transliteration. According to this very simple system the vowels are pronounced as in French or Italian with the exception of the *u*, which has the sound of *ou* (as in "soup"); the *ch* is pronounced *tch*, and the *g* is always hard. In addition the *e* is pronounced as in "led." The long vowels are indicated by a small straight line above them.

The list of people, among them Japanese friends, who have helped me with advice, information, and suggestions is really too long to include here, although I am deeply grateful to them. I should not like to pass over in silence, however, the names of MM. Marcel Giuglaris, Jean-Pierre Hauchecorne, René de Berval, of Dr. S. Horie, who aided me in my research on the island of Rebun to the north of Hokkaido, or of M. J. o'Meara, publisher of the French edition, without whom this book could not have been completed.

Finally, I must express my deep gratitude to my wife, Hiroko, who, with her perfect knowledge of both Japanese and French, has been of incomparable help in the translation of numerous texts. Without her invaluable assistance it is quite probable that this book would have been written with enormous difficulty, if it could have been written at all.

<div align="right">

Louis Frédéric

</div>

I. JAPAN OF THE SEA

Myth Concerning the Creation of Japan

IF THE BIRTH of humanity has always been a subject of inquiry for men, that of the earth on which they live has been no less a source of supposition and legend; and if people on the mainland have been interested in investigations of the origin of the world, islanders in general, living in a limited universe, have been intensely intrigued by the birth of their islands. Primitive Japanese folklore seems to ignore the external world; it is interested only in the islands of its own archipelago. Our knowledge of the thinking of the first Japanese and their cosmogony has come to us only through relatively late compilations—which date from the beginning of the eighth century and were permeated with Chinese thought and concepts—contained in the *Kojiki* and the *Nihon-shoki* (or *Nihongi*). These works do not speak of a beginning, but merely of the existence of two primordial beings, Izanagi and Izanami, from whose union Japanese cosmogony was derived. These two were the last of a long line of divinities whose functions have always remained rather vague. As the legend goes:

"Izanagi and Izanami, hanging onto the floating bridge of the skies and taking counsel between themselves, asked, 'Is there no land below us?' They then plunged the glittering lance of the sky into the shadows and gropingly found the ocean. The salt water, falling in drops from the point of the lance, coagulated and formed an island, which was called Onokoro-shima and on which they raised the column of the center of the Earth...."

The legend then relates how Izanagi and Izanami walked in opposite directions around the column and met twice. On the first occasion it was the woman who seduced the man; the second time it was the man who took the initiative. The balance between the sexes was thus established, they recognized their different natures as male and female, and they joined, thus becoming the primordial couple. From this union were born the islands of Japan. The archipelago thus created was called "the country of eight great islands." The other smaller islands were formed by the foam of the ocean.

This legend is rather reminiscent of an old Indian myth in which one finds Shiva and Vishnu searching in diverse fashions for the origins of a column, which is finally revealed as the phallus of the world, symbolizing the omnipotence of Shiva. The Japanese legend could have been born only at a late date in an epoch in which the cultivation of grain had already been developed: "the country of Yamato was rich at the time of the autumn harvest." One could perhaps compare the two primordial creative divinities with those of the mountain and the sea whose intimate union is so characteristic of the Japanese islands. At any rate, the majority of the original myths of the tribes composing the prehistoric population of Japan have been lost and vestigially exist today only in Japanese rites, customs, and names. One can only believe, therefore, that this idea

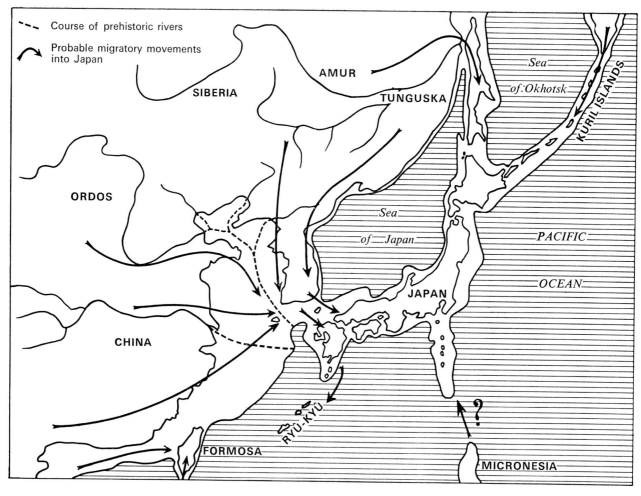

3. PRESUMED GEOGRAPHICAL FORMATION OF JAPAN IN THE PALEOLITHIC ERA.
PREHISTORIC RIVERS. PROBABLE MIGRATORY MOVEMENTS INTO JAPAN

of the creation of Japan was imported at a very late date and perhaps by the clan which, toward the end of the third century, subjugated its neighbors and established itself in the Yamato area.

The creative union of Izanagi and Izanami is symbolized not far from the sacred forest of Ise by the two rocky crags of Futami-ga-ura linked together by a large straw rope, which is replaced each year at the beginning of January in the course of a religious ceremony.

The Formation of the Japanese Islands

The approximately four hundred islands of the Japanese archipelago cover an area of 146,690 square miles. Only four of these islands are important, however: in the north, Hokkaido; in the center, Honshu; to the south and southeast, Kyushu and Shikoku. The relative area of each of the four is: 30,000, 87,000, 16,240, and 7,246 square miles.

The islands are part of a group which, in addition to the Japanese archipelago proper, includes the northern island of Sakhalin (Karafuto) to make up the Honshu chain; the Kuril Islands form the Chishima Retto chain; and the Ryukyu Islands and Formosa compose the Ryukyu chain, which, if extended south into the Pacific Ocean to include the Mariana Islands, then becomes known as the Shichito Mariana chain. These insular chains create between themselves and the continent of Asia two internal seas: the Yellow Sea in the south, the Sea of Japan

in the north. The islands are part of the volcanic mountain chain which encircles the Pacific Ocean and includes the Cordilleras of the Andes in South America. The region circumscribed by these mountains is geologically unstable and in a continuous state of transformation due to its numerous active volcanoes (it is sometimes called "the ring of fire").

The mountain chain that makes up modern Japan rose from the ocean bed toward the end of the Paleozoic era and was gradually subjected to important modifications by the movement of the earth's crust. The group of islands was attached to the continent until the middle of the Tertiary era, an epoch in which a tectonic movement, accompanied by numerous eruptions, submerged a large part of the area. Toward the end of the Tertiary era, however, a slow reaction brought to the surface a certain area of the group, which formed the actual chain of Japanese islands. Yet they were still attached to the continent, and between the continent and the summits there was an immense lake. During the entire Quaternary era, when the mountains assumed their present aspect, a progressive subsidence of the lowlands must have transformed the inner lake into a sea and isolated the mountain chains. Thus the islands were born.

During the Quaternary era the mountains were also subjected to the glacial action which, extended to its maximum, covered all of Siberia. The isostatic movements, together with erosion, contributed to the formation of the present aspect of the coast. Due to the partial sinking of the land, the sea penetrated the valleys and created numerous small islands and promontories, which give to the Japanese isles their torn and slashed appearance.

Traces of Japan's violent geological past are also to be found on its land surface: the intense volcanic eruptions of the Tertiary era covered a large part of the thick calcareous sediment deposited by the sea, and the upheavals brought to the surface the Precambrian, Paleozoic, Mesozoic, and Triassic terrain (Cretaceous on the islands of Shikoku and Hokkaido). The largest part of the surface soil of the Japanese islands, however, was created by eruptions in the Paleozoic era, whereas the plains and plateaus were formed by calcareous banks of the Tertiary era on which alluvial soil and coral accumulations were deposited in more recent epochs. Because of the fact, moreover, that the Japanese mountains (whether alpine or volcanic) are of relatively recent geological formation and have high summits and steep slopes, the rivers, although numerous, are of little importance and have only a seasonal torrential flow accompanied by exceptional erosive action. The mountains are thus linked directly to the sea by way of the rivers and the coastal plains, and this powerful geographical contrast has contributed in large part to the formation of the Japanese people's spirit.

Japanese Territory Throughout History

It seems that the territory that was to become modern Japan was limited at the beginning of history to the coastal areas of the islands of Kyushu, Honshu, and Shikoku that bordered on the Inland Sea. In the seventh century the government of Nara, as a result of its conflicts with the unorganized primitive tribes, extended the empire by occupying the largest part of the islands of Kyushu and Honshu together with the entire island of Shikoku. It was only toward the end of the twelfth century, however, that Honshu was completely conquered, and it was still later, in the sixteenth century, that the east and west coasts of Hokkaido were explored, and only toward the end of the eighteenth century that the island was completely subdued.

Although the Ryukyu Islands were populated from the beginning by tribes related to the Japanese, they were not annexed to the empire until 1609. In fact, the conquest of Japan by the Japanese extends over the major part of the history of the country. In the eighteenth century and at the beginning of the nineteenth two bold explorers, Mogami Tokunai (1755–1836) and Mamiya Rinzō (1776–1845), discovered the island of Sakhalin (Karafuto), which is separated from Hokkaido only by the Soya Strait; in 1875 the administration of this island was divided

with Russia as a result of a treaty which recognized Japanese sovereignty of the Kuril Islands (Chishima Retto).

The oldest-known maps of Japan are those attributed to the monk Gyōgi (668–749)—although the originals have disappeared—and the surveyor's plans for the temple of Tōdai-ji at Nara, which date from the eighth century. Gyōgi's map was used by European geographers up to the eighteenth century. The Florentine map of 1685, which indicated the Roman Catholic dioceses of Japan, was much less precise, since it was drawn not by geographers but on the basis of missionaries' reports. The maps of the nineteenth century became precise only after the opening of Japan to foreigners at the beginning of the Meiji era; practically speaking, except for Gyōgi's, no complete map of Japan existed prior to that date.

As far as the origin of the present name of Japan is concerned, one must go back to Marco Polo, who called the country Cipangu, or the nation of the Cipan. Cipan was an approximate Chinese pronunciation of two significant characters, "sun" and "origin," and the inhabitants of the Japanese islands indicated their country with the name given to it from the beginning: Nihon. As a matter of fact, this is the easternmost nation of Asia—in other words, near the rising sun. The Japanese, however, do not always agree on the pronunciation of these two Chinese characters. Some prefer "Nippon," others "Nihon." Japan, moreover, has many other names that have been used from time to time to indicate its territory in the various ancient chronicles and in its poetry. It has often been called, for example, the "country of Yamato" from the name of the first kingdom set up in the country in the Nara region.

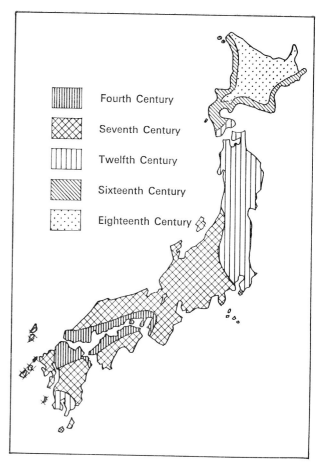

Fourth Century

Seventh Century

Twelfth Century

Sixteenth Century

Eighteenth Century

4. HISTORICAL JAPAN

Physical Japan

PHYSICAL GEOGRAPHY

The Japanese islands form a continuous mountain chain of islands, and the principal ones create an arc extending from the northeast to the southwest. They are situated approximately between 30° and 46° latitude and between 146° and 128° longitude. The northernmost island of the archipelago, Hokkaido, is essentially two chains of mountains of which the most important peak, Mount Ishikari, rises to more than 6,000 feet. The highest summits of the Hidaka chain run toward the south and are separated from those of the central chain by a low valley. The central chain is a direct continuation of the mountains of northern Honshu from which Hokkaido is separated only by the Tsugaru Strait.

The largest of the islands, Honshu, can be divided into two distinct regions. The northeast, known as Tōhoku, consists of parallel chains of mountains which extend from north to south and are known as the Japanese Alps. Southwest Honshu has chains of mountains of lesser height which lie in a general west-east direction.

The principal mountain chains of Kyushu extend from north to south and include Mount Kyushu and Mount Hyūga, but there is also the small Tsukushi chain running from east to west.

The northern part of Kyushu is separated from Korea by the double straits—the Korea Strait and the Tsushima Strait—which are less than one hundred miles wide and are dotted with numerous small islands, of which the most important are Tsushima and Ikishima.

The island of Honshu contains only a few of the large plains: Sendai, Tokyo (Kantō), Nagoya (Nōbi), Osaka. The rivers of these plains are of relatively little importance and are extremely seasonal in character. The longest of them—Shinanogawa—is only about two hundred and fifty miles in length. Their irregular flow and their sharp declivity exclude any form of navigation. The Japanese islands, on the other hand, contain numerous mountain lakes with extraordinarily clear water. The largest of these, Lake Biwa, is situated to the north of Kyoto and lies in a north-south direction.

The coasts are deeply indented, and the inlets form strongly protected harbors. The most sheltered bays are those of Tokyo, Osaka, and Ise in Honshu, and Ariake, Nagasaki, and Kagoshima in Kyushu.

The peninsulas are numerous and are generally rocky with sharply descending cliffs.

The Pacific Ocean (*Taiheiyō*) washes the south and east coasts of Japan; the East China Sea extends to the west and south shores of Kyushu; the Sea of Japan separates the north and west coasts of the Japanese islands from Manchuria and Siberia, and the northern shore of Hokkaido extends into the Sea of Okhotsk. This lengthened and mountainous contour, which is extensively cut by deep transversal valleys, explains the slow conquest of the islands and the difficulty of communication between the different parts of the country; the inhabited centers, in fact, are to be found only in the valleys, which are often barely accessible, and on the coastal plains. These geographical factors also account for certain aspects of the Japanese character.

CLIMATE

The lengthy extension of the Japanese islands over sixteen degrees of latitude, their parallel position to the Siberian coast, and the existence of ocean currents along all the coasts are factors which contribute to Japan's strongly differentiated climates from north to south. Generally speaking, Japan is situated in the North Temperate Zone, but the four seasons are more or less modified or varied from region to region. In other words, the overall seasonal tendencies are locally altered by the influence of winds, altitude, and the direction in which the valleys lie. The Ryukyu Islands, situated far to the south, have a definitely subtropical climate.

One can, therefore, attribute three climatic zones to Japan: Subarctic, Temperate, and Subtropical.

THE SEA AND OCEAN CURRENTS

Japan is surrounded by numerous ocean currents which wash its coasts. There are two principal streams. The Oyashio, which descends from the north, is cold but of relatively weak intensity. The Kuroshio, which ascends from the equator, is warm and very important to the life of Japan. These two currents collide and mix in the Sea of Japan and to the east of Honshu in the Pacific, thus creating alternating hot and cold zones that are highly favorable to the development of marine life, because each species can choose the water and currents according to its preferences.

It is for this reason, furthermore, that the Japanese coasts have always been extremely good fishing areas. In addition, it was the existence of these important warm ocean currents rising near the Philippine Islands and extending north along the Ryukyu Archipelago that facilitated in prehistoric times the navigation of peoples who arrived on the southern coast of Japan and introduced there the cultivation of rice.

The Pacific is relatively calm except during the typhoon season, when navigation becomes dangerous. The Japanese islands, being merely the emerged summits of an enormous chain of

mountains, are surrounded along the Pacific littoral by submarine valleys which are among the deepest in the world; and in the Sea of Japan the sea floor reaches a depth of almost twelve thousand feet. This fact, together with the insularity of each single part of Japan, has at all times had a profound influence on Japanese life, which depends extensively on the sea.

POPULATION AND ITS DISTRIBUTION

As has been noted, the Japanese islands have always been relatively overpopulated, in view of the limited area of arable land available. With the mountainous character and the numerous climatic differences of the country, the population can easily be classified in three distinct groups: the farmers, the fishermen, and the inhabitants of the towns and cities. In some cases, when the fishermen live in the coastal cities and seasonally fish in deep seas, they may be considered townsmen. Generally speaking, however, they are scattered in little villages along the seacoast or on the shores of rivers and engage in the type of fishing available on the spot.

One can distinguish four different types of arable land and, as a result, four types of inhabitants devoted to farming. These categories arose in four distinct periods of the economic development of the country:

Jōri. The most ancient. One still finds this type of land allotment, which was based on a Chinese model and dates from the seventh century, in most of the alluvial valleys known in the country at the time of its introduction: principally in the Kinki area around Nara, Osaka, and Lake Biwa, as well as in the northern parts of Kyushu and Shikoku. According to this system, the land is geometrically divided into equal sections with a surface area of approximately one *chō* (two and one-half acres), and the farmhouses are grouped in a spacious fashion in the center of a number of plots. A *jōri* is a village made up of several of these hamlets with each hamlet containing from thirty to fifty houses, its own rice fields, irrigation canals, and paths laid out in a geometric pattern. The system is very similar to that adopted by the Roman centurions.

Gōshi. This type of land allotment resembles that which was common in feudal France. The houses of the peasants are grouped around the residence of the landlord or the monastery. The land belonged to the lords of the manor or to the religious orders, and the peasants were bound to the soil as serfs. This system of cultivation and ownership of the land was introduced in the Kamakura period, when the northern part of Honshu and the southern parts of Kyushu and Shikoku were conquered and the primitive Ainu peoples were subjected to military domination.

Shinden. Certain of the great landlords, in need of increased revenues, decided to bring into cultivation land that had hitherto been left fallow: marshes, forests, plateaus, and even sections of the coastal plain reserved previously for the farmers and the townsfolk. The peasants who were brought in to settle these lands received equal portions of arable soil and identical housing. The inhabitants were settled gradually in the new areas as the work of clearing or drainage or conquest progressed. The allotment pattern, therefore, took on a lengthened appearance following the contour of the terrain, and the houses were built on parallel lines.

Tonden. This is the most recent type and was introduced on the island of Hokkaido in 1875 by the pioneers under the protection of the army after the military conquest. The allotment of the land followed the American pattern—it was carried out with the help of American engineers—without taking into account the characteristics or the contour of the land. The new towns were built along rectilinear roads, with the result that the landscape of Hokkaido is most monotonous and unattractive.

The towns grew up on the coasts in well-protected ports or in the countryside where the main roads met or at points that could be easily defended. The villages were protected from the winds by numerous trees planted between the houses. The houses were usually small, separate one-story buildings with low-hanging roofs. In the regions where the land is intensively cultivated and along the shores of Hokkaido, the houses are protected from the winds by wooden palisades, trees, or even stone walls. The thatching, with which most of the farmhouses were traditionally roofed, is now rare; tiles or sheet metal are more widely used.

Beginning in the seventh century some cities—Nara, Kyoto—were laid out according to the Chinese geometric system. Later, other cities grew up around the temples or marketplaces in the shape of irregular stars with the points extending along the roads leading to the centers. From about the sixteenth century onward some towns sprang up around the castles or residences of the landlords; they were laid out in a geometric fashion at the base of the castle, if it was in the mountains *(yamajiro)*, and in a circular pattern if the castle was on the coastal plain *(hirajō)* like the city of Tokyo. In these cases the streets leading to the center were narrow and tortuous in order to defend the citadel better.

At certain points on the large roads—Tōkaidō, Nakasendō—that linked the more important centers, towns were built around the inns and the shogunal or imperial relay points. The fifty-three stages of the Tōkaidō Road have become famous through the magnificent woodblock prints of Hiroshige.

With the extraordinarily rapid development of the country since the beginning of this century (Tokyo 10 million inhabitants, Osaka 3.5 million, Nagoya 2 million) some of the cities have joined one another in immense urban concentrations (Tokyo-Yokohama-Yokosuka more than 13 million inhabitants, Osaka-Kobe more than 7 million). As a result there has been a notable depopulation of the countryside. In 1966 it was calculated that 45 million people (the population of France) lived on only 1 percent of the land surface of Japan in urban agglomerations. The attractions of city life, the industrialization of the nation, and the excessive concentration in the plains have all been factors responsible for this phenomenon. The entire physiognomy of the country has been changed, and the transformation continues on an ever-increasing scale. The whole of Japan, beginning with the extremely powerful stimulus given to industrialization in the Meiji era, has been almost completely transmuted in less than a century, and this development has created serious population and economic problems, due to the limited agricultural, mineral, and maritime resources of the country.

RESOURCES AND INDUSTRIES

Agriculture. Only 16 percent of the land surface of the country is arable, to which can be added another 4 percent of mere pasturage. The agrarian population is made up of approximately 6 million families; each single family possesses only a very small part of the land available and, although all the arable soil is cultivated, 65 percent of the peasant families possess not more than two and one-half acres each (with the exception of the island of Hokkaido where for climatic reasons the population is still only about 5 million people) and another 9 percent have less than five acres. The results are, first of all, a great diversity of products and, second, extreme poverty among the peasants. In fact, only 2 million peasant families live exclusively on their incomes from agriculture, while members of the other 4 million families are obliged to find subsidiary employment as tradesmen or artisans in order to survive. This is also one of the reasons for the progressive depopulation of the countryside and the constant growth of the urban agglomerations.

Japan's principal agricultural products are various types of grain. Rice makes up about 40 percent of the total, and more than sixteen tons per acre are produced on an average—an enormous figure when compared to less than six tons per acre in India or ten tons per acre in China. Other grains cultivated are wheat, rye, oats, barley, and millet. Other common crops are peas, soybeans, potatoes, sweet potatoes, sugar beets, and tobacco. There are also extensive market gardens and fruit orchards in which are found numerous mulberry trees needed for the breeding of silkworms. The cultivation of tea occupies about 6 percent of the arable land. There are winter crops, summer crops, and those indigenous solely to the plateaus, which are cut into terraces in order to guarantee systematic irrigation, giving a peculiar appearance to the countryside.

The breeding and raising of cattle is limited. For one thing, there is a shortage of pasture land, and, for another, the Japanese eat very little meat. The cultivation of the land is carried out for the most part by hand, and little use is made of work animals. Agriculture, however, is now be-

coming increasingly mechanized. On the island of Hokkaido the breeding of cattle and horses is being intensified from year to year. The number of sheep, which are raised for wool alone, does not reach one million. In the historical past agriculture was less diversified, the cities less extensive, and the farm population relatively greater. The situation of the farmers was then more or less comparable to that at the beginning of the Meiji era: small land holdings, high rents, heavy taxes imposed by the feudal or monastic landlords. The Japanese peasant was forced to work intensively in order not to die of starvation.

Fishing. In the beginning fishing was confined to the coastal areas, but it was extended gradually toward the high seas and was intensified with the increasing use of motorized craft. Not only do fish and seaweed supply proteins, which are lacking in the normal Japanese diet, but they are also an important source of export products. Coastal fishing is essentially in the hands of small family units, but prior to World War II it supplied 80 percent of the total production of the country, and in prehistoric times all of it. This coastal activity is now declining in favor of deep-sea fishing—tuna, bonito, salmon, crab—which, however, has given rise to sharp disputes regarding international fishing rights. Japan competes directly in this regard with other countries, particularly Soviet Russia.

Whaling is carried on widely in both the waters of Antarctica and the North Pacific by extremely modern fleets of factory ships and whaleboats. Pearl fishing is a well-known Japanese activity in the South Seas, and the cultivated oyster beds along the coast of the Izu peninsula of Honshu have become world famous.

Mineral and other resources. Although the number of minerals to be found in the subsoil of Japan is large, the available quantity of each is extremely limited and quite insufficient for the national needs. (There was enough iron, however, during the Middle Ages for the artisans and armorers.) With the development of its industries, Japan was obliged to begin importing almost all of its necessary raw materials. Copper was to be found in Japan in sufficient quantities to permit the bronzeworkers of the Middle Ages to produce such gigantic works as the Buddhas of Nara and Kamakura.

Today, however, although the nation is the seventh largest producer of raw copper in the world with an annual production of 88,000 tons, it is obliged to import additional amounts of this metal for its own needs. The iron resources, which were once extensive in the form of ferrous sand, have now been practically exhausted, and the country is forced to import almost all the ore for its steel industry. The existing coal mines supply a very inferior product, which can be used in large boiler furnaces only with great difficulty. The mines are widely scattered throughout the country and are generally at great distances from the industries they serve. The petroleum and natural gas available are quite insufficient for the demands. Only sulfur and its by-products are to be found in such abundance that they can even be exported.

The electric power consumed in Japan is derived from hydroelectric resources (40 percent), imported petroleum (30 percent), and locally extracted or imported coal (30 percent). The coal-consuming power stations are being rapidly replaced, however, by hydroelectric installations. The power developed by these installations was more than 7.5 million kw (1964) as compared to the 3.6 million kw of the thermoelectric plants. Beginning in the Meiji era, Japan, which had had an almost static economy because of its limited natural resources, developed an economy based on industries which converted imported raw materials (more than 50 percent of all imports). The export of manufactured products became necessary in order to match the Japanese commercial balance of payments. In fact, the nation exports approximately 20 percent of its industrial production, which accounts for 90 percent of its exports; however, in order to support its population, which has doubled in the past fifty years, it must import rice, wheat, and other cereal grains in proportion to its needs.

NATURAL DISASTERS

The geological characteristics of its land as well as its geographical position have made of Japan

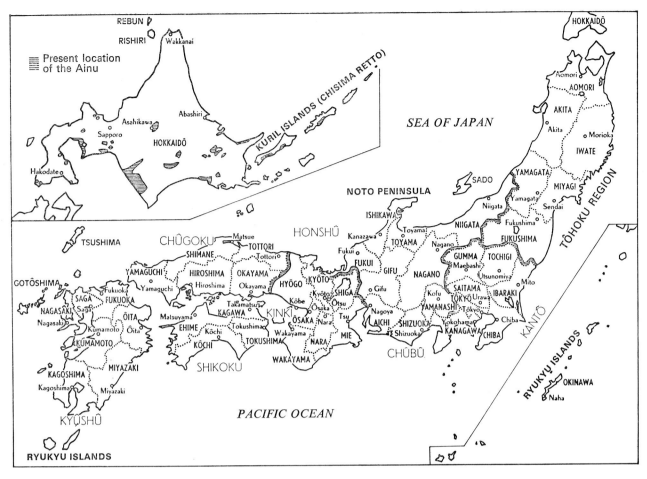

5. PROVINCES, LARGE CITIES, PRESENT LOCATION OF THE AINU TRIBES, AND NATURAL REGIONS

a country subject to immense natural disasters: earthquakes, volcanic eruptions, tidal waves, and typhoons.

Earthquakes. They are extremely frequent, and the seismographs have registered more than five thousand per year powerful enough to be felt by a man. There are many others which are imperceptible to human beings. The seismographic shocks on the Japanese scale of intensity—ranging from 1 to 7—rarely reach the level of 4 or 5, when they become dangerous to the security of the inhabitants. Yet one can calculate that on an average there is a disastrous earthquake once every ten years.

Tidal waves. They are caused by submarine earthquakes with epicenters along the south and east coasts of Japan, and they can be much more destructive than the earthquakes themselves. Waves at the mouths of Japanese bays may reach a height of almost sixty feet.

Volcanic eruptions. They are quite frequent and are very dangerous, not so much in themselves as in their consequences: rivers of mud, torrents of lava, steam geysers, clouds of cinders, avalanches. Although the eruptions, which to a certain extent can be scientifically predicted, cause only a limited loss of life, they are often responsible for considerable damage to the forests and to agriculture in general.

Typhoons. The most threatening natural phenomenon to crops, they generally arrive at harvest time. From fifteen to thirty typhoons attack Japan each year during August, September, and October, and they can cause serious floods. The winds that accompany them destroy houses and communications systems.

Japan has also suffered years of drought and intense cold, which have had a profound effect on agriculture and, in turn, on the general economy.

All these natural disasters, which regularly threaten the life of Japan, have affected the ways

of life and thought of the inhabitants throughout history. Caught between the mountains and the sea, the Japanese are compelled to submit to these two forces which they are incapable of mastering.

More than any other natural element, the numerous volcanoes, whether active or extinct, have been the basis of legends. Since A.D. 684 Mount Asama has erupted two hundred and sixty-six times, Mount Fuji fifteen, Mount Kirishima fifty-eight, and Mount Iōgatake sixty-eight. And these are only the most active. Mount Fuji, however, has attracted the greatest attention. It is a perfectly conical volcanic mountain, 12,388 feet high, and surrounded at its base by five deep lakes.

Tradition insists that Mount Fuji came into existence shortly prior to our era during the reign of the legendary Emperor Kōrei—seventh in the imperial line—at the same time that Lake Biwa was formed. Another legend alleges that the earthquakes are produced by an immense catfish that supports Japan; its head and its tail are joined by a stone column, to be seen in Ka-shima in the province of Ibaraki, which is considered to be the center of the earth. The Japanese islands, moreover, are said to be attached to this column by wisteria *(fuji)* roots, and it is for this reason that Japan is sometimes called "the country of the *fuji* roots." One of the sons of the Tokugawa shōgun, feudal lord of Mito, had the ground excavated around the stone column in an attempt to verify the legend, but lack of equipment capable of penetrating to a sufficient depth forced him to abandon the project. A popular superstition, which is probably a vestige of an ancient phallic cult, insists that if a woman finds a white worm at the base of this column, it is a sign that she will bear a child within the following year. It is interesting to note, however, in connection with these legends, that it has been scientifically proved that catfish are capable of sensing an impending earthquake much sooner than men.

The most catastrophic earthquake Japan has ever known was that of September 1, 1923, which in Tokyo alone destroyed 366,000 buildings and caused the death of at least 143,000 people.

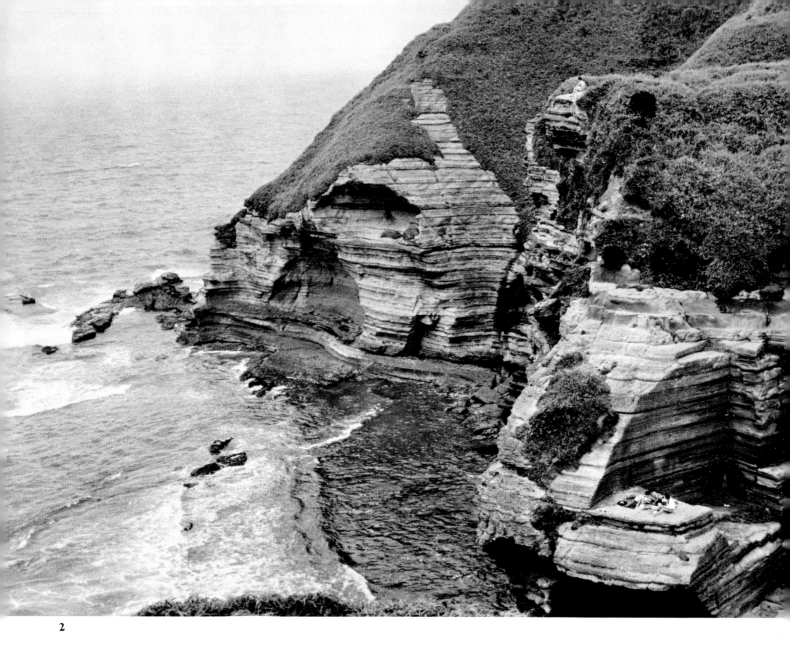

2

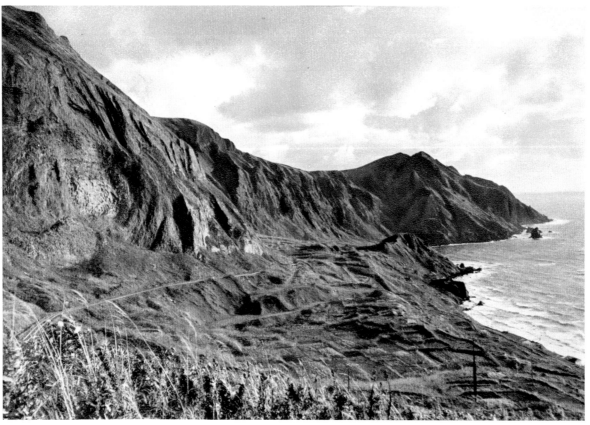

3

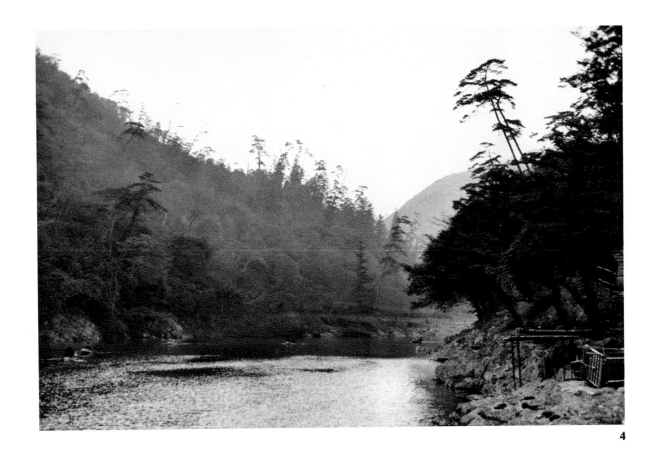

4

5

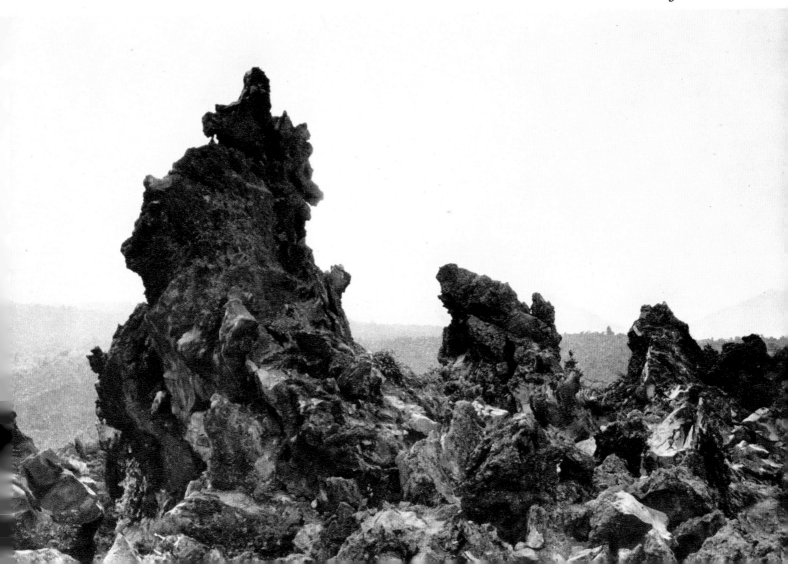

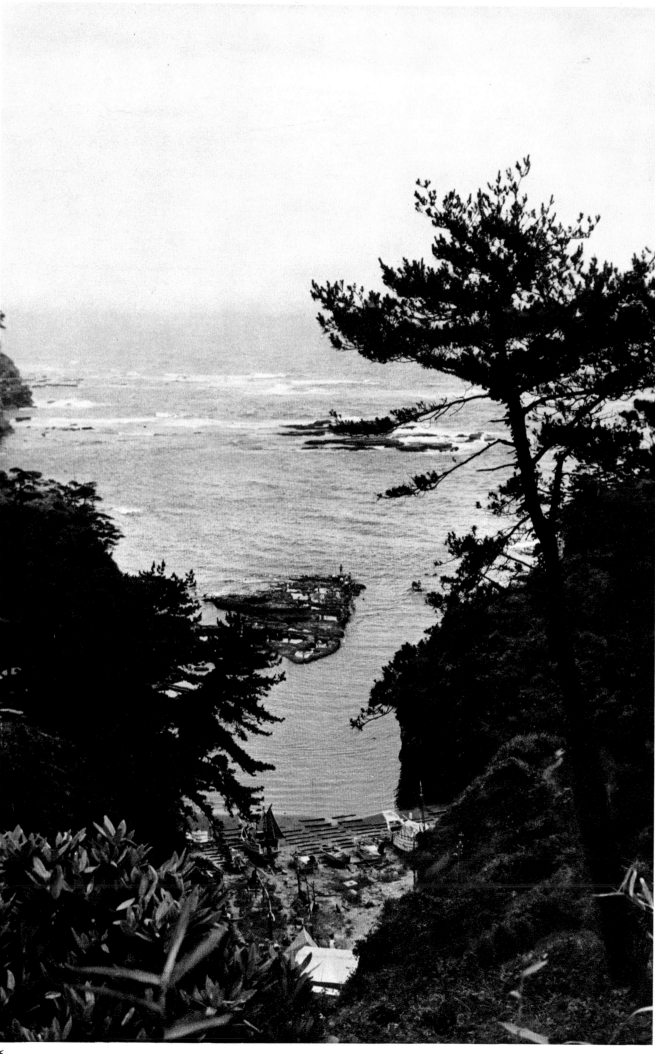

II. THE PREHISTORY OF JAPAN
(Until A.D. 552)

The First Hunters

GEOLOGISTS generally agree that during the beginning of the Quaternary the islands which form modern Japan were linked to the continent and most probably to the Ryukyu Archipelago, the Philippines, Formosa, and Java. The movements of the earth's crust in this geologically unstable part of the world have on many occasions been the cause of the rising or sinking of the land, and the sea has periodically uncovered or submerged large areas. In fact, the raising or the lowering of the sea level caused by the successive waves of glaciation during the Quaternary—the most recent recession began about 12,000 years ago in northern Europe and perhaps a little earlier in northeast Asia—accentuated even more the geographical modifications created by the most recent subsidences. The cold Oyashio current, which even today has a notable influence on the Sea of Japan and on the Sea of Okhotsk, is a vestige of the marine transformation dating from the beginning of the last withdrawal of the glaciers (still under way).

Japan was probably first settled in a period when it was still linked to the continent. In fact, chipped stone tools have been found, although in limited quantities, in the strata below those generally containing pottery. These rough stone implements, even though it is impossible to determine their exact age, are certainly of a prepottery era. They indicate for the most part a cultural level and a technique similar to the peoples of the upper Paleolithic or early Mesolithic.

Three different strata containing chipped stone implements have been uncovered at Iwajuku in the Kantō Plain, and those found throughout the upper level (Iwajuku III) are definitely microlithic. Since utensils produced with similar techniques have been found in other regions, attempts have been made to classify the cultural standards of these primitive societies of hunters according to the shape of the implements they used, as compared with those found on the Kantō Plain.

Certain experts have suggested that the most ancient tools that have been brought to light may have a morphological affinity with those of the lower Paleolithic culture of Java, which have turned up as far north as Mindanao in the Philippines. Other scholars have noted that the ax heads discovered in the upper levels (Iwajuku II and III, Takei I and II) correspond in type to the upper Paleolithic implements found in Alaska and in the Amur basin of eastern Siberia. Yet it is impossible to give precise details with certainty, because prehistoric research in Japan is extremely difficult, owing to the thinness of the geological strata (often a question of a few inches) and the incessant geological movements (volcanic eruptions, intense erosion, floods) which often make calculations risky. At best we can merely affirm that man existed in Japan prior to the birth of Neolithic pottery cultures, but it would be difficult to fix any specific date, in view of the lack of geological precision regarding the stratification of the soil.

The Jōmon Period

The recent discovery at Fukui near Yoshii (Nagasaki) of microlithic pottery, which Carbon 14 analysis shows to be 9,450 years old (with a margin for error of 400 years), could lead to an eventual reevaluation of the dates that have been hitherto accepted for Asian pottery. Professor Chōsuke Serizawa has actually been able to identify four strata of soil, the lower two exclusively containing late Paleolithic remains, whereas the two upper have produced Mesolithic stone blades and fragments of pottery. This extremely important discovery tends to prove that the art of pottery had its origin in Japan at a much earlier epoch than had been generally believed. Another more troublesome and unexplainable fact is that this pottery is in the form of plates and is decorated with ropelike cords made from twisted clay applied in relief. Yet the present classifications of Jōmon-type ceramics state that the earliest pottery had a round or pointed base and that flat plates appeared only later.

It remains to be explained, therefore, how this "pre-Jōmon" pottery came into existence. Was it invented by men belonging to a Mesolithic culture who at first made use of solely microlithic inspiration? Or were these plates imported or brought to Japan by a group of invaders? In the latter case the problem then arises as to the origin of these foreigners. It now seems that the opinion advanced by certain archaeologists that Jōmon pottery might have had its origin in the Siberian ceramics of Serovo and Isakovo is incorrect, because the continental pottery is of a much later date. Yet if the age attributed to the Fukui pottery is confirmed, we shall also have to push Siberian culture further back into the past. We can only wait for additional discoveries and the results of studies now being carried out.

The Jōmon-type ceramics—the word *Jōmon* refers to the cord form—are characterized by a decoration consisting at times of twisted clay cords pressed onto the vessel. In other instances, however, the potter, with a small stick on which the clay cord was rolled, unwound the cord on the rotating plate or, with a regularly or irregularly notched stick, engraved the still-moist clay, which was then fired. Yet there are still other characteristics that distinguish this pottery from other known types: the length of the period (more than 7,000 years) during which it developed in a continuous evolutionary process, the vast area in which this art was practiced (extending from the Ryukyu Islands to Hokkaido), and finally the extraordinary variety of types created when geographical conditions and population factors are taken into consideration. The opinion has also been expressed that this pottery could have been related to certain Melanesian ceramics. Quite recently an American professor, Dr. Clifford Evans, basing his theory on certain pieces of pottery discovered in Ecuador, has suggested that men of the Jōmon period were able to make their way as far east as the coast of South America.

At any rate the theories concerning the origin, development, and geographical distribution of this type of Japanese pottery are numerous. All still have to be proved, for the evidence offered to date has been far too frail and too scarce. Yet, basing our conclusions on what definite knowledge we do have, it is possible to distinguish six stages in the evolution of Jōmon pottery—and in the styles and ways of life of Japan:

PRE-JŌMON PERIOD

This preliminary stage is that of the flat plates with decorations in relief, which can be linked to the microlithic (or perhaps late Mesolithic) knives found on the islands of Shikoku and Honshu, but not in the northern part of Honshu or on Hokkaido. This pottery was produced by hunters who were perhaps contemporaries of the Proto-Eskimo tribes.

PROTO-JŌMON PERIOD (SŌ-KI)

This stage is also known as the Sō-ki or old Jōmon period. It was characterized by the conical pottery, with pointed or slightly rounded bases, which in the beginning was decorated with

incisions in the clay (western Japan) or with clay cords applied vertically in relief (eastern and northern Japan). Toward the middle of this period a new style of decoration, consisting of sharp circular incisions made on the wet clay with notched sticks, was also developed, and in eastern Japan one can find pottery with decorative imprints of shells retouched with spatulate instruments. The use of stone tools continued throughout this era, although the cutting blades became larger, particularly on the island of Hokkaido, and the arrowheads assumed a triangular shape with a concave base. The huts in which the people lived were partially underground, had a rectangular ground plan, were without doorposts, and most probably had hearths that were set up outdoors. Pottery used for cooking must have been sunk upright into the hot cinders. A few flat plates also appeared (or reappeared) in this period.

EARLY JŌMON PERIOD (ZEN-KI)

Known as the Zen-ki era in the Japanese system of classification, this period was characterized from its beginning by an extraordinary diversity of types of pottery. Flat plates became common, thus proving that the population possessed not only articles used exclusively for cooking but also those for eating and drinking. This pottery was decorated when it was still on the potter's wheel either with twisted clay cords or with incisions made by notched sticks.

In western Japan particularly one can find articles with edges that were decorated with relief motifs. The edges also became thicker and were more prominently raised. The stone arrowheads were sharper and more strongly indented at the base, thus assuming the appearance of polished ax heads. In fact, prior to this time only some of the axes had been so finely polished. At the end of this period curved scrapers of sharpened stone, to which was added a short tongue, became common in northern Honshu.

The people lived in very small communities, and in addition to the rectangular huts, which by now had definite doors, there were round cabins, also partially underground.

According to all available evidence, the dog had been domesticated and was used in hunting. The coastal fishermen, armed with harpoons with bone tips, ventured far out at sea in small one-man boats that may have been supplied with outriggers.

One can distinguish in this period at least six different types of pottery, according to the region in which they originated. These types, however, may correspond to the differences in the population and to the type of life that was led:

Hokutu—in the northeastern part of Hokkaido and on the island of Rebun, which seems to have been occupied from the very beginning and to have followed the entire development of Jōmon pottery.

Ento-kaso—in southwestern Hokkaido (principally near Muroran and Hakodate) and in the northern part of Tōhoku.

Daigi—in southern Tōhoku.

Moroiso—in the Kantō and in the mountains of central Honshu (eastern Chūbu).

Kitashirakawa—in the rest of Honshu.

Senokan—on the island of Kyushu.

MIDDLE JŌMON PERIOD (CHŪ-KI)

In this age, which the Japanese call Chū-ki, the forms of the pottery continued to vary and to assume local characteristics. The decoration tended increasingly to be applied in relief to the point of being excessive, with the extravagant flame-shaped decoration to be found in western Japan. The articles were also large, heavy, and bulky, and were supplied with "ears" and "horns."

Aside from the fantastic forms, however, which were perhaps reserved for the magic cults, there were also numerous domestic types created for daily needs: large jars with flat bottoms, flasks with small necks, tall vases decorated with incisions or ropelike scrolls in relief. Toward the end of the epoch there appeared on the scene certain spiral and freely applied motifs, which

indicate perhaps a continental influence, possibly China, together with some statuettes, which were definitely anthropomorphic in character, as were the round or notched heads of the stone clubs and the pestles of the mortars.

The huts usually faced south, the floors were paved with stone, and the hearth was placed inside and was built of stone. There is also good reason to assume that a phallic cult was practiced, at least in certain areas, because the huts contained altars of a sort bearing an erect stone. One is also inclined to believe that taro was cultivated in some of the small village communities. It is possible to see in these new communities the influence of a new cultural group, which could perhaps be called Melanesian. Was there a migratory influx by way of China (the Melanesians and the Proto-Malays originated far to the south of China) or was it solely a question of cultural influence?

It is still very difficult to answer this question with certainty. Some etymologists support this thesis by the fact that they have found points of correspondence between the Japanese language and the one spoken on the island of Almahera in Indonesia. Others have been inclined to discover in this cultural influence the origin of the matriarchal organization of Japanese society and numerous surviving elements of folklore (particularly in the Ryukyu Islands).

The use of cut and polished stone utensils was still customary and, together with stemmed arrowheads, there appeared rectangular ax heads of polished stone, which strongly resemble those used in the greater part of Southeast Asia. Flat mortars (similar to the pre-Columbian *metates*) were employed at that time for the grinding of the grain gathered from wild plants. There is still no evidence of a systematic agriculture.

Fishing was also customary on the high seas. The boats at that point were almost certainly outriggers. Harpoons and hooks, together with weights for the fishing lines, have been found in abundance. Small horses existed from this time onward, but they do not seem to have been either ridden or employed as draft animals.

LATE JŌMON PERIOD (KŌ-KI)

The pottery was simplified, and three styles seem to have been employed. The ceramics, which were very slightly decorated on Kyushu and in western Japan, displayed a flat and spiral ornamentation, together with a motif—later to be called "flowing water"—in which parallel lines crossed and intersected. Basketry and lacquerwork articles made their appearance; the arrowheads were enlarged; the statuettes of slender figures with raised heads were made wider starting from the base. Some of these statuettes portrayed pregnant women with small, flat breasts.

One can distinguish three phases in this period, each taking its name from a particular site (beginning with the oldest): Ubayama, Haranouchi, Aomori (Kamegaoka). A very large number of forms were created. Almost all of them were taken up again by later styles. Harpoons with multiple barbs, typical of the North Pacific cultures, began to make their appearance, introduced perhaps by the Ainu, a Caucasian tribe which came down from the north, perhaps by way of Sakhalin or perhaps along the chain of the Kuril Islands. And from the beginning of the following period, or possibly at the end of this—at any rate about the third century B.C.—a new group of peoples made its appearance in south Japan, bringing with them a new culture based on the cultivation of rice.

LAST JŌMON PERIOD (BAN-KI)

These newcomers, who have been called Yayoi from the name of a district in Tokyo where certain of their ceramics were first excavated, most probably came from Korea, and they first settled in the northern part of Kyushu. They brought with them rice and the potter's wheel. They practiced certain methods of burial—up until then it appears that the Japanese did not have any systematic type of interment, although the presence of ocher powder on some bones possibly indicates funeral rites involving secondary burial. These newcomers also brought the

saddle horse, which was larger than the indigenous variety. At the same time that the Ainu culture and the Jōmon ceramic forms of Kamegaoka influenced the population of eastern Japan, the Yayoi culture began to make itself strongly felt, and thereby modified the way of life of the inhabitants of the western part of Honshu and of the northern areas of Kyushu.

The pottery forms which survived there were very simple. In the north, where there also appeared the *magatama*—jewelry of Siberian origin in the form of hooks, as can be seen in the hangings and other objects found in the tombs of Pazyryk, dating from the fifth and fourth centuries B.C. and now displayed in the Hermitage Museum in Leningrad—and pedunculate scrapers of a Manchurian type, the ceramic decorations became geometric and almost symbolic. The hollow, baked-clay statuettes in powerful forms were characterized by frogs' eyes. Masks were then quite common, and they seem to indicate a nature-spirit cult: a religion of symbols involving an elaborate ritual.

Wooden objects have also been discovered—daggers, swords, and bows—with decoration that appears to be of an Ainu style. Dating perhaps also from this epoch are some stones set up in circles found especially in the northeastern part of Honshu and on Hokkaido and which possibly have some relationship to burial rites.

The Ainu seem to have migrated progressively toward the southwest and to have mixed with the Jōmon population. Another migration, from the southwest toward the northeast, carried with it the Yayoi culture which met with that of the Ainu.

Prehistoric sites in Japan are extraordinarily numerous, especially the *kaizuka* or kitchen middens of shells left by the peoples that inhabited the areas not far from the seashore or rivers and whose diet consisted principally of cold-water scallops *(Platinopecten yessoensis)* or warm-water bivalves *(Anadara granosa)*, as well as oysters and fish. Because of the peculiar chemical nature of these shell mounds, skeletons buried in them are often very well preserved, although only a small number of them have been found. These human skeletons permit us, however, to affirm that the Japanese of the Jōmon period were not Ainu, whose origin was different. The oldest skeletons that have been brought to light indicate that the Japanese population was originally composed of an extraordinarily mixed group of peoples. How, by that time, that mixture had taken place is a question that must remain unanswered.

The Yayoi Period (300 B.C.–A.D. 300)

It is customary to attribute the Japanese word for the Neolithic era, *Jōmon*, to a certain period. As a matter of fact, it was a late Mesolithic era, because agriculture was practically unknown, except for the sporadic cultivation of taro and yams. The true Neolithic era in Japan began with the appearance of the Yayoi peoples who brought with them the cultivation of rice. Yet, since these migrants also brought with them a knowledge of iron metallurgy, we are confronted with a hybrid development that somewhat upsets our ideas regarding the normal succession of civilizations: with Japan, we pass from a late Mesolithic culture, which was acquainted with pottery, almost without transition to an iron age with a Neolithic culture.

The passage from the Jōmon period to its Yayoi counterpart was, however, almost imperceptible in the beginning, because the first arrivals must have been few in number; later the number of migrant groups entering northern Kyushu must have increased rapidly. During the entire first century of the Yayoi penetration one notes very few changes in the inhabitants' way of life. There were only a few improvements: the beginning of the cultivation of rice, the employment for agricultural purposes of wooden utensils reinforced with iron, the first appearance of weaving.

The pottery of the first years of the Yayoi period can be distinguished only with difficulty from that of the last of the Jōmon era, and it was still shaped without the wheel.

There were burial grounds, however, and those of the migrant groups assumed a more definite character. Instead of simply burying the bodies, the Yayoi peoples excavated tombs and lined them with flat, squared stones. It appears, however, that this type of interment was reserved for the Yayoi chiefs. The common people were buried in simple graves that were sometimes covered with a flat stone or a wooden plank.

Soon afterward there appeared another type, which subsequently was widely employed and which lasted until the sixth century (although interment in graves lasted until the beginning of the Christian era in northern Kyushu and even later on the island of Tsushima). The new method introduced the use of funerary urns and was most probably of Chinese origin. It would appear, in view of the enormous concentration of funerary urns in northern Kyushu, that this system of burial rapidly became normal for all the migrants, whatever their social status; at first in northern Kyushu and at a later date in the Kansai where, however, it appears that interment in urns was reserved especially for children. Whereas in the graves the dead were buried without objects (with a few exceptions), interment in urns was always accompanied by the presence of objects belonging to the deceased, many of which had been imported. One finds this type of burial particularly in China, but also in Korea and Manchuria.

This fact would seem to confirm, therefore, that the Yayoi migrants (or, at least, the first ones) came from eastern China and had mixed in Korea with other peoples who came down from Manchuria. In fact, one of the varieties of rice imported in this epoch originated in east China. Yet it can be affirmed that other ethnic elements, already established for some time in Korea, must have soon joined the early migrants.

Whereas the first funerary urns were shaped without a wheel and were buried horizontally in pairs, soon another type, made on the potter's wheel, appeared. These urns were buried at an angle of thirty degrees in relation to the surface of the earth and were covered by a low dolmen that was typically Korean. In order to avoid the possibility that the urns might be crushed by the weight of the earth, the angle of inclination was modified little by little until it reached a position of forty-five degrees in relation to the surface. Certain of the urns, however, were buried vertically with the aperture toward the bottom: a practice still prevalent today in the province of Saga.

The use of dolmens was then customary in Korea, and in Japan they may be found (at Ishigasaki in northern Kyushu) even as protections for the graves. The majority of the burials of the native population, however, continued to be performed in the traditional fashion.

The urns have provided us with important objects of imported bronze, especially those which date from the first century B.C. to the first century A.D. This material consists of Chinese coins (certain ones, found in northern Kyushu and the Kansai, date from the period of Huo-Ch'uan in the first century of the Christian era), mirrors, weapons, bracelets, and beads of Han production. It is known that the Han emperors had a military post at Lo-lang in Korea and that the relations between Wa (Japan) and Lo-lang were continuous: one has only to remember the dispatch by the Han sovereigns, in A.D. 57, of a solid-gold seal bearing five significant characters, "Kuang-wu [to the] King of Wa-Nu [region of Hakata]." This seal was found on the island of Shiga in 1784.

During the entire early Yayoi period the newcomers were busy organizing their society. Their technical superiority assured them an easy control over the native population. It seems that from the very beginning the clan chiefs divided the people into three categories: themselves, the metalworkers and potters, and the others, such as hunters, fishermen, and farmers. Iron, which was relatively scarce in that epoch, was used frugally and only under the direct control of the chiefs. It was remelted whenever prolonged use had worn out the instruments or tools. The bronzes were always imported and consisted principally of objects such as mirrors, halberds, and spears, the use of which, however, appears to have been essentially symbolic (signs of power or of divinity?).

When, toward the middle of the first century A.D., the importation ceased with the end of

34

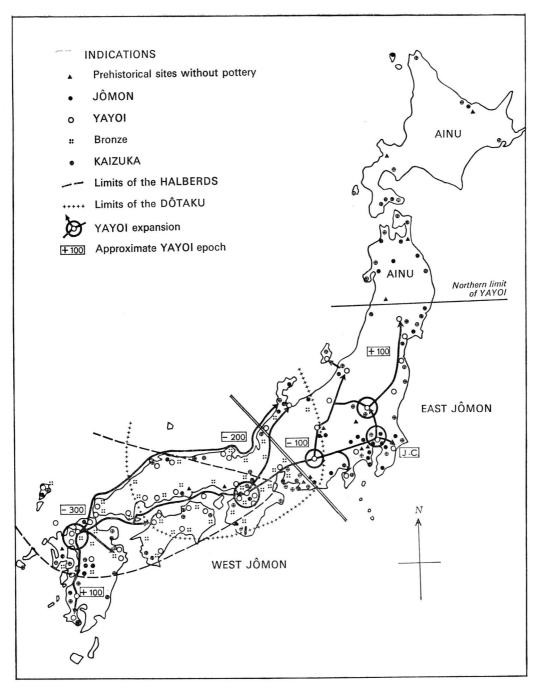

6. LOCATION OF PREHISTORIC SITES, PROGRESS OF YAYOI CULTURE, AND AREAS IN WHICH
BRONZE OBJECTS OF THE PERIOD 300 B.C.–A.D. 500 HAVE BEEN FOUND

Han supremacy, the Japanese were constrained to substitute in the tombs copies made of cut and polished stone for the ritual metal objects, which had become difficult to obtain. Because of the reduced proportion of tin contained in them, the Japanese bronzes of this same period can be easily distinguished from those imported from China. The blades of the Japanese halberds and spears (symbols of creation analogous to those of the Jōmon phallic cults: symbolizing the power of penetration, perhaps, representing the gem-encrusted spear the gods plunged into the sea, which became the symbol of the creation of Japan) were larger and broader than those that had been imported and had served as models. The Japanese mirrors (perhaps images of the sun, symbols of the soul, of power, or of divinity) have more symbolic decorations than their Chinese counterparts, and at times the decorative patterns become completely geometric.

Finally, toward the middle of the Yayoi period there appeared (farther to the east, however,

35

and on the island of Shikoku) some bell-shaped bronze objects *(dōtaku)* which are found (like the spears and halberds) buried shallowly in groups within mounds that dot the countryside.

The most varied opinions have been expressed as to the reason for the existence of these *dōtaku* and their significance: percussion instruments, covers for stone phallic objects (although the objects themselves have never been found), offertory vessels. Our impression is that these *dōtaku*, made of a thin and fragile bronze, often decorated with subjects relating to nature and human activities (hunting, agriculture, fishing), and at times interred on the edge of a field (at least one has been found in such a position), were intended to represent symbolically a divinity that protected human activities. They must have been mounted, during certain ceremonies, on wooden stakes (the notches on the base could have served to attach them).

These representations of protective divinities could not have been constantly displayed; they were doubtless set up during certain periods of the year and in connection with the events symbolized in the decorations appearing on them. On one of them, for example, the decorative pattern is divided into twelve panels, six on each side of the bell-shaped object. On one side we find a dragonfly, a tortoise, a tortoise with a salamander, some insects, two men walking on stilts, and a wild-boar-hunting scene with dogs; on the other side, first a salamander, then a man dancing, two persons grinding grain in a mortar, a hunter drawing his arrow against a deer, a granary built on piles. These panels could easily symbolize twelve divisions of the year, similar to the Chinese calendar, and it was possibly during one or more of these that the *dōtaku* were erected for ritual reasons. Once the rites had come to an end, the *dōtaku* were probably taken down and hidden in a secret place (known only to the shaman) situated on an elevation. From this vantage point the divinities could continue to protect the human activities of the village or agricultural group.

This hypothesis would explain why the *dōtaku* (sometimes together with spears and halberds) are found buried in places far distant from the inhabited centers and located on the slopes of hills or in mounds on the edges of rice fields in carefully arranged groups. It also accounts for their form. It remains to be seen, however, whether the *dōtaku* had some relationship to a phallic cult and whether the tops of the wooden columns on which they were mounted during the ceremonies were decorated.

We are inclined to believe that these wooden columns, since they served solely as temporary supports, were devoid of ornamentation. At best, some emblems could have been attached to them and an offering could have been placed at the base. (In certain regions, particularly Southeast Asia, there is a custom of capping with a piece of inverted pottery a stake set up in the middle of a field for the purpose of driving off evil spirits. These objects represent a divinity which protects agricultural work.)

The divinities symbolized by the *dōtaku* may have been set up in the hope of invoking rain, a possibility that would explain the use of such decorative motifs as running water or waves frequently found on these objects. The *dōtaku* could also be symbols of the *ta-no-kami* or gods of the rice fields—one of them, called Mitashi-no-Kami, is the perpetual guardian of the crops— who, according to popular belief, live inside the mountains *(yama-no-kami)*. After descending to the fields in order to protect the work and the harvest, these divinities supposedly return to the mountains, whence they will come forth the following year "blind from having remained buried for so long a time." This belief might explain the openings (eyes) to be found on the *dōtaku*. These *ta-no-kami* are always associated with water or with water-inhabiting animals, such as the salamander, the frog, or the tortoise (animals often portrayed on the *dōtaku*).

If we examine, moreover, the area in which these *dōtaku* have been found, we are immediately struck by the fact that not a single one has been discovered in the northern part of Kyushu, which was a fief of the foreign migrants. These objects were, therefore, intended and created for purely local purposes, and they were the tangible representations of an old source of indigenous beliefs perhaps of Yayoi origin. The diversity of the decorative motifs of the *dōtaku* could also correspond to the varying divinities—rice, rain, the village—and to the rites and ceremonies

attendant on their veneration. In Japanese folk customs, particularly in the Chūbu region and on Shikoku, the *yama-no-kami* are often represented in the form of vertically planted staffs topped by sculpted heads, sometimes wearing hats. This could well be a survival of the village divinities symbolized by the *dōtaku* placed on wooden stakes. The *dōtaku* were at first rather small, about six inches in height; they were roughly cast, and their tops did not bear pierced decorations. As time passed their surfaces became more refined and their size increased; sometimes up to four feet in height. At the highest point of their evolution they were supplied with perfectly regular openings.

They disappeared completely toward the beginning of the third century when invaders, probably from Korea (originally, however, from Manchuria and perhaps of the Tungus or another Altaic people), dominated the village-states *(kuni)* of the Yayoi farmers. The question arises as to why the making of the *dōtaku* was abandoned and why they were so quickly effaced from man's memory. In fact, one of these *dōtaku*, rediscovered in the seventh century, evoked no response whatever. This may have been due to the fact that the *dōtaku*, buried in secret places known only to the initiated and destined to continue to watch over the people and their activities from the hilltops, could in no case be utilized by the noninitiated. If we admit that the shaman was also the chief of the *kuni*, he could not reveal to the conquerors the location of the secret deposit without committing sacrilege and arousing the anger of the divinities. The chiefs of the *kuni*, moreover, directly controlled the smelting of metal and the work of the artisans, and, therefore, the making of these *dōtaku* was brought to a halt. And if the people retained a vague memory of these agrarian divinities, the new masters completely ignored them.

Yayoi pottery is much less varied and the types less numerous than that of the Jōmon period. The Yayoi era lasted only six centuries. The clay of Yayoi pottery is, generally speaking, purer and more refined than that used for Jōmon ceramics. If, in the beginning, Yayoi pottery can barely be distinguished from Jōmon, the development of the potter's wheel toward the halfway point of the middle period (near the beginning of the Christian era) sharply divided the two groups. Yayoi pottery was only slightly decorated, but one can distinguish three types, corresponding, at least in northern Kyushu, to the three chronological subdivisions of the period: Ongagawa, characteristic of the first Yayoi period; Sugu—decorated solely with horizontal bands, but toward the end painted entirely red—the middle period; Takamitsuma, the final period. Rough, common pottery for daily use is found mixed with fine ceramics, created possibly for religious rites.

Toward the end of the Yayoi period, probably under the influence of the newcomers, the pottery was sometimes decorated with a comb motif consisting of a series of vertical lines (a technique found also in Manchuria). In the Kantō, far removed from the new influences, the pottery was occasionally decorated by pressing a cord into the wet clay, which was the continuation of the Jōmon technique.

Statuary is represented by rough little effigies on an enlarged base portraying pregnant women, and by heads, still in Jōmon style, used to decorate the necks of some jars. This motif is similar to that of another type of Jōmon vase which portrays in relief a personage, representing perhaps the protective divinity of the contents, which might have contained an offering of grain.

At this time a change occurred in the habits of the fishing communities. They no longer subsisted solely on shellfish (the shell mounds became far less numerous during this period), but with the development of a new type of boat (a deeper craft with high prows and sterns and equipped with ten or more paddles), they concentrated on larger fish. Salmon and dolphin became a part of their diet, which also included fruit, walnuts, soya, and rice.

The various groups of Yayoi migrants differed somewhat according to their origin—Manchuria or south of the Yangtze—and social organization. The first were organized into classes according to the age of the individuals, who were subjected to initiation rites (of Southeast Asian origin) in a society of a probably matriarchal type. The others adopted a patriarchal and exogamous system of Tungus origin. Elements of the language of these two principal groups (there

were others as well) mixed with those of the native language or languages. The result was the basis of the Japanese language, containing Austronesian (Proto-Malay and Melanesian), Altaic, Ainu (in the north), and Chinese elements.

An examination of three village sites—at Toro, at Karako near Nara, and at Yamaki (Shizuoka)—reveals the organization of the village communities with economies based on the cultivation of rice. The houses, in little groups of from six to ten, were built of sod and placed on low, easily irrigated land. Each village or group of houses contained one or two granaries, erected on stilts, which were reached by means of a notched tree trunk that served as a ladder.

Not far distant was the forest, which provided wood for the construction of huts, tools, boats, and household utensils. These villages were protected from floods by levees reinforced by planks and stakes. The fields around the villages were subdivided into plots of varying dimensions corresponding perhaps to the social status of the members of the group or to the number of members of a single family.

It is probable that the village chief was also the religious leader (the shaman), a fact that could explain the temporal power that made him the legitimate proprietor of the land. Certain chiefs combined several groups of villages into *kuni* or small states and became petty kings *(kuni-no-miya-tsuko)*. Although the Chinese chronicles mention more than one hundred *kuni* existing in the country of Wa, this figure seems to be applicable only to the northern part of Kyushu. In fact, third-century Japan—in other words, Japan at the end of the Yayoi period—must have consisted of many more of these little village-states. One of these *kuni*, as a result of a series of struggles mentioned in the Chinese chronicles, appears to have obtained control over the others in northern Kyushu and to have become so powerful as to want to shift the political center to Yamato (Nara), perhaps after a vain attempt to conquer the southeastern part of the island.

The technical level of the Yayoi agrarian population indicates considerable progress beyond that of the Jōmon: better housing, cultivation of such grains as rice and millet (knives of a Manchurian type for cutting straw have been found), wells, wooden implements reinforced with iron for digging the soil, frames for weaving, twine for fishing and for hanging up pottery, paddles, wooden mortars and pestles, and bowls. Weapons, however, remained very primitive. The bows, smaller versions of the Jōmon type, shot arrows with heads of cut stone (four different types have been discovered), bone, iron, and even bronze. Perhaps iron spears and halberds were also used.

Mirrors made in Japan at that time prove that metalworking had already attained a high degree of technical proficiency. With the arrival of the Altaic warriors, the importation of mirrors (from Wei and Wu this time) was resumed. The country was now socially and technically ready to be organized.

Although the long Jōmon period was of comparatively little importance in the historical evolution of Japanese civilization, the Yayoi period, despite its relatively brief duration, included a chain of events that had enormous influence on the formation of the people and spirit of Japan. In fact, it was the Yayoi period which in large part determined Japan's language, customs, and probably the fundamentals of its religion and established the beginnings of a civilization capable of providing historical records. Furthermore, the period witnessed the exertion of Chinese influence on the dawning Japanese civilization, and the infusion of new blood (the Mongolization of a large part of the population) resulted in the composite character of the country.

The Kofun Era (Third to Seventh Centuries)

Toward the middle of the third century clans of horsemen-archers moved into Korea, probably from the steppes of Siberian Asia. They subsequently pushed on into Japan where they met little resistance from the poorly armed Yayoi agrarian population. The probability that these horse-

men-archers made their first appearance in Japan at the end of the Jōmon era is indicated by the presence of the *magatama* and other objects of Siberian origin in the Japan of that period.

The rural population was barely affected by the changes brought about by the invasion. The people even appear to have found that the order introduced by the invaders was beneficial, since it permitted them to continue their work in peace. History remains silent regarding the invaders, but evidence of their presence and influence has been discovered so extensively in Japan that one cannot ignore it.

The horsemen-archers introduced, in addition to perfected armaments, use of the saddle horse, a new method of burial derived from the Altaic kurgans, new decorative motifs reminiscent of those adopted on the steppes, and certain religious beliefs that crystallized the relatively imprecise concepts of the Jōmon people. Legends and myths peculiar to peoples of the steppes and propagated by the Siberian shamans entered Japan and became inextricably mixed with native legends. Most probably the first Shintō shrines can be dated from this period, as well as the establishment on a more concrete basis of a religion which already existed at the time of the Yayoi. It is possible that the shaman-queens—Himiko and Iyo, whom the Chinese chronicles mention and who seem to have dominated a large part of northern Kyushu—were members of the very first groups of those peoples from the steppes or at least a part of the Korean or Manchurian advance force which had been driven from its homeland by the Siberian invaders.

One finds in Japan the same myths regarding the foundation of the state that were current in Korea and even certain elements of Ural-Altaic folklore that have survived as far west as Hungary. The names of the sacred trees, as well as those of the clans and the patriarchal units, are the same in the Japan of this period as among the Korean, Tungus, and Mongol peoples. Here is certainly a multiple superimposition of cultures: the Altaic nomads of Siberia, having conquered the Tungus population and amalgamated with it, invaded North Korea where they installed themselves for a certain period of time, created a number of kingdoms, and again assimilated the native population. Subjected to certain pressures developed after the defeat of Hsiung-nu (Huns) by the Han, these people began once again their migration toward the south of Korea and halted only when they reached Japan.

The Japanese chronicles, the *Kojiki* and *Nihon-shoki*, are incomplete and cannot be regarded as an exact source of the history of this period; the myths, however, coincide with certain archaeological facts. The legend of the Emperor Jimmu, founder of the imperial clan, who came from the southeastern part of Kyushu to Yamato, tends to prove that the imperial line has been continuous from mythical times and had its origin in the country itself. In reality, however, this imperial clan was too closely organized along the political lines then existing in Korea. Perhaps, therefore, this clan was formed by a group of horsemen-archers who, having landed in Kyushu and ventured into the southern part of the island, found that living conditions there were difficult and, having heard of a more hospitable country, decided to reembark for Honshu, where they founded the state of Yamato. This original tribe became the aristocratic element governing the country, and it preserved from its Altaic past only those customs and religious beliefs which were gradually adopted by the chiefs of the native groups that had submitted to its domination. The *tennō*, or Japanese emperors, have descended from this aristocracy.

The tombs of these emperors, and of other chiefs influenced by the diverse groups of horsemen-archers scattered throughout the country, were immense tumuli surrounded by water-filled moats; they supply us with abundant information about certain cultural elements of this people. These tumuli, or *kofun*, are of several types: some are merely wooden tombs made of two hollow tree trunks; others are reminiscent of the sepulchral chambers of the megalithic era in Korea and were made of enormous, more or less well-cut blocks of stone, sometimes decorated with paintings and reliefs. In the beginning these tumuli were barrow-shaped, a sort of elongated mound of sod; later they became round or square, and finally they took the form of a keyhole.

This keyhole type, particularly in Japan, could have been derived from the fact that the body, while the tumulus was being built, had to be placed in a temporary shrine. The construction

of the tumulus was begun in front of the provisional shrine and then, the spot on which it had been erected having become sacred, the shrine was demolished when the body was transferred to the sepulchral chamber. There was then added to the tomb a raised platform on the site of the temporary shrine, and it too was surrounded by water.

It is difficult to explain this particular form by the presence of a sepulchral vault with the function of a vestibule, because some keyhole tumuli have no corridor, whereas others have two sepulchral chambers, with no link between them, and the vault existing under the long projection contains only the objects belonging to the departed. The construction, therefore, probably took place in the following order:

1. Elevation of the provisional structure reserved for the coffin during the period of construction of the tumulus.

2. Lowering of the coffin along an inclined plane into the sepulchral chamber, which had been left open for this reason.

3. Completion of the tumulus, closing of the sepulchral vault, covering it with the soil drawn up from the moat excavated around the tumulus, demolition of the temporary structure.

4. Elevation of the adjoining platform, above the spot previously occupied by the temporary shrine, with the earth taken from the surrounding moat.

5. The joining of the moats and the introduction of water into them.

The evolution of the forms of the various Japanese tumuli from the simple barrow to the perfect keyhole type must have followed the same stages of construction. The narrow shape of the middle of the keyhole mausoleums can be attributed to the fact that the elevation of the tumuli took place in two successive stages: first, the tumulus itself; second, the projecting platform. We cannot exclude the possibility, furthermore, that another shrine, reserved for the post-funeral ceremonies, may have been constructed later in wood on the platform adjoining the principal tumulus. This custom, however, must have been quickly abandoned, due to lack of sufficient space for the rites and the processions.

Great numbers of *haniwa*—tubular objects of clay—were then planted vertically in the earth around the tumulus and served both to circumscribe the entire sacred area and to give the deceased a guard protecting him against evil spirits and a group of servants to bring the comfort of the presence of his court to him in his life after death. Once the deceased had been buried with many objects that had belonged to him, the chamber was sealed with large rock slabs, which did not, however, prevent pilfering and pillaging. These crimes were so common that in the seventh century an imperial edict threatened the profaners with heavy penalties.

The deceased was usually presented lying on his back, and he was surrounded by his arms, spears, and mirrors. Near his head were his helmet and armor. Numerous pieces of funerary pottery of the Sue type were placed at his feet, together with pearl necklaces. The head of the deceased rested on a block or decorated headrest. The sepulchral vault (and even a single coffin) sometimes contained several bodies. Some vaults, however, were merely frames or slabs of cut stone fitted together to make a sort of box; others lodged coffins of stone or terra cotta or even, much later, of lacquer. The walls of some tombs were decorated with paintings and low reliefs.

These tombs, several thousand of which are to be found in Japan, seem to have been constructed toward the end of the third century and at first in the Kansai area (where they were developed during the fourth century), and later on the island of Kyushu and near the Kantō region. The very first tumulus appears to be the one attributed to the Emperor Suinin, who has also been identified with the Emperor Jimmu, but the traditional chronicles place the Emperor Jimmu in the seventh century B.C. Tombs of the Kantō were those of the local chiefs; some of them belonged perhaps to the families of the descendants of the horsemen-archer immigrants. The fifth century A.D. brought with it the construction of the largest tumuli as a form of political affirmation of the first true emperors.

The seventh century saw the end of this economically ruinous tradition with the decree of the Emperor Kōtoku (in 646) which regulated the construction of the tumuli. (At that time, more-

over, interment tended to be superceded by the Buddhist rite of cremation, which had been introduced in the year 610 when the Korean monk, Donchō, seems to have begun to advocate this method.) The tombs had been constructed, at least in the beginning, on the slopes of hills near the large centers of population, because a great number of people were required for the work involved. Later the tombs were erected on the plains themselves, in the middle of the fields, or alongside the most important roads.

In the fourth century the tombs began to assume a definitely round or square form with a low, narrow projection. During the fifth century, even though the construction of round and of more or less rectangular tumuli continued, the so-called keyhole form made its appearance; it contained somewhat corridor-like chambers, and was raised, with sloping sides, widening at the base. The coffins, which in the beginning had been made of wood and had been interred at the top of the tumuli in narrow vaults made of large stone slabs, were gradually sunk lower and lower until they were to be found in sepulchral chambers constructed with enormous stone blocks, some weighing more than one hundred tons, placed one against the other.

At that time, moreover, the coffins were cut from stone blocks and shaped like houses or boats. Another type was perfectly executed in terra cotta and raised on pottery cylinders that separated them from the ground. These coffins were generally in two parts (container and cover), but they were also made of six slabs of squared stone or, in the case of the use of terra cotta, four separate elements. They were often painted red, a color which seems to have been reserved at that time for funeral rites and which was believed to have magic prophylactic or propitiary powers. The same color was also used for painted decorations and for *haniwa*.

In some cases the coffin was buried directly in the tumulus without other protection. Some detached chambers have been found under the projections or extensions of the tumuli (especially in the keyhole varieties), and now and then the corridors themselves contain coffins. In these cases it may be assumed that, since the sepulchral vault was too small to take more than one body, the second coffin was deposited in the corridor, or perhaps the entry to the sepulchral chamber was too narrow and the coffin was too large, with the result that the coffin had to be left in the entry. In most cases, however, these corridors or accessory chambers contained only an assortment of articles and armor.

DECORATION OF THE TOMBS

The paintings are often executed in three colors: red, blue, and yellow ocher. They consist either of concentric and juxtaposed circles (a Korean motif) or realistic scenes depicting in most cases boats, horses (in the mythology of the steppes, horses were supposed to speed the spirits of the dead to the afterworld), and archers with quivers of arrows (the arrowheads pointing upward, contrary to Japanese custom), the importance of which has always been exaggerated in comparison to that accorded other motifs. These quivers represent, without doubt, a sacred and symbolic object. Certain drawings, moreover, depict ceremonial fans which are placed upright and seem to indicate the entry to a sacred place or to a palace. There are also stars with double tails, which may represent comets, and other unidentified motifs.

In the fourth century in the Kansai there appeared an abstract decorative motif (apparently reserved solely for objects), the significance of which has remained an enigma up until now. Certain authors have seen in this motif, called *chokkomon*, the stylization of a belt of braided leather; others have described it as distorted Chinese script. The theories are numerous, but none of them is satisfactory. We believe that this motif was, at the beginning of its evolution, an attempt to represent the cracks produced by fire on the horny plates of the shells of tortoises during divinatory rites, and therefore one can suppose that the objects bearing this motif had a prophetic or propitiary value.

These representations of cracking were drawn as a series of juxtaposed motifs (their number giving potency to the magic). They were gradually stylized by the artists who, no longer comprehending the prototypes, attempted to endow a rhythm to the composition that they evidently

were unable to derive from the originals. They therefore divided in a regular fashion the crooked lines of the cracks with straight lines forming triangles, the magic value of which was thus added to the propitiary value of the cracking itself.

At the end of the evolution of this motif some artists attempted to create a design which, even though it remained the same, could appear to be different simply by making the triangle change its position by a turn of ninety degrees. This idea of the triangles joined at the apex from which depart spiral lines resulted from observing that the tortoise's shell, thicker in the center, cracked under the action of heat in a series of lines radiating from the center, and these crooked lines gradually spread out as they moved from the center to the thinner edges. These crooked lines obviously came to an end at each break in the radial cracks and thus created irregular spiral designs. Apparently the *chokkomon* motif was exclusively Japanese and originated in the Kansai area. It was probably created for specific reasons, after the divinatory shells had been imported from China or Korea and the Japanese soothsayers had begun to utilize this system of divination.

ARMOR

The armor that has been found in the tombs is of iron, and there are numerous types. One is a kind of rigid corselet. Another is made of thin iron strips riveted together to form bands that are joined by leather thongs. The helmets, varying in form from region to region, are of iron or leather, with or without visors. Some are made of iron bands decorated with engravings depicting animals. Pieces of armor for horses and iron saddles have also been discovered. Whereas the stirrups of the early horsemen were in the form of a simple ring, a new wave of Korean migrants in the sixth century seems to have imported clog-shaped stirrups into Japan, together with new decorative motifs which had their origins in Chinese art and, more particularly, in the art of Central Asia.

The headdresses found in these tombs are either stylizations of their Korean counterparts or bear Scythian motifs in which lines of horses alternate with lines of trees, possibly symbols of the accession to divinity. On some, however, series of articulated rings, typical of the art of the Siberian steppes, replace Scythian brass studs.

Weapons are represented principally by long broadswords with a single-edged blade, which seem to have been preferred at that time to the double-edged short swords of the Yayoi period. Bows with asymmetrical curves and eccentric points of aim were also found in these tombs. The broadswords have handles terminating in a pommel in the shape of a ring on which were incised pairs of animals facing each other, a motif derived from the art of the steppelands of the Near East. These pommels, however, were gradually stylized and were finally replaced in the seventh century by completely round, solid, or perforated ones of gilded bronze. A cylindrical sheath and a type of short sword with an enveloping guard seem, instead, to have been reserved for religious rites: one finds them depicted only on the *haniwa*. Numerous iron arrowheads and spearheads have also been discovered, completing our knowledge of the weapons of the horsemen-archers.

JEWELRY

The jewelry, aside from the decorated mirrors imported from China or made in Japan, consists for the most part of *magatama* (stones in the form of hooks, which also must have been of Siberian origin, because they resemble those found in the Altaic tombs dating from the fifth and fourth centuries B.C. in Pazyryk) and cylindrical, colored stone beads. Some gold pendants have been found, however, principally in the tombs of the sixth century A.D. In the tombs of the early years of the period one finds many reproductions of objects (normally made of iron, bronze, or wood) executed in polished stone: knives in their sheaths, and wooden clogs, which are often painted red. This custom of substitution, inherited from the time when bronze and iron were too rare to be immured in tombs, appears to have continued into a period when the reproduced

objects existed in sufficient quantities, probably with the idea of conferring on the articles a sort of immortality, since stone is infinitely more durable than iron or wood. The numerous stone or shell bracelets seem to have been signs of rank. Another object has been identified by Japanese archaeologists as a *tomo* or archer's wrist piece, often called the "bracelet in the form of a hoe." Perhaps it was in effect a piece of wrist armor capable of being used either to inflict a wound with the sharp point, or to deliver a riveting blow to a piece of armor with the side resembling a hammerhead.

THE HANIWA

The cylinders of terra cotta were placed all around the tombs in several rows, widely spaced externally and then gradually placed closer until they touched at the center (the tomb of Nintoku was protected by twenty thousand *haniwa*). In the beginning they were simple ringed cylinders, some of which were decorated with vertical reinforcing bands, perhaps derived from the *dōtaku*, and surmounted by cups with flared openings. By the fourth century the tops of these *haniwa* began to assume the shape of objects, animals, and even human beings. Their abundance and their diversity constitute one of the richest sources of documentation concerning the clothes, arms, armor, headdresses, and musical instruments adopted by the people of this period (fourth to seventh centuries).

Certain Japanese chronicles attribute the origin of the *haniwa* to the Hajibe potters of Izumo (where many Koreans were employed), who first made them at the request of Emperor Suinin. The emperor according to these accounts had the *haniwa* made as substitutes for the human sacrifices performed on the tombs at the moment of burial. However, this can only be a late attempt at explanation, because up to now we have had no evidence of massacres at funeral services at that time in Japan, although such a custom was followed in China and perhaps also in Korea. The Chinese chronicles inform us that Queen Himiko was interred under a tumulus with a very large number of slaves—a fact, however, that has not yet been proved.

These *haniwa* supposedly had a magic protective value. Furthermore, they were not always associated with the tombs. In fact, the latest discoveries at Nara seem to prove that protective *haniwa* were also set up around certain sites that were considered sacred. At any rate, these *haniwa* display in some instances a remarkable sculptural quality both in their realism and in their stylization.

Portrayed in a masterly fashion are human beings and animals of all sorts, except cats, which were imported later from Korea, and pigs, which would come subsequently from China. There are depicted servants, warriors, priestesses, bearers of offerings, actors, singers, musicians, horses, monkeys, roosters (according to a legend, their crowing chased away the demons of the night and drew forth Amaterasu, the sun goddess, from the cave where she was hidden). Whereas the women (with the exception of the seated priestesses) are depicted only down to the hem of their gowns, the rest being a simple cylinder driven into the ground, the warriors are always modeled upright, standing on their feet, with their helmets, armor, and weapons.

Some *haniwa* are representations of quivers of arrows or of other objects of daily use. The effigy of a man putting on a bell-shaped cap ornamented with triangles is suggestive of certain shamanistic cults. The figures of human beings are ritually decorated with red paint, and the magic triangles ornamenting their clothes are always painted in the same color. Such details may also have denoted the social status of the personages being depicted.

These *haniwa* are made of a coarse, reddish clay comparable to that used for *Haji*, the common domestic ware of the period. As the direct descendant of Yayoi ceramics, Haji pottery, generally with a round base (designed for use on stone hearths or suspended), was used by the people up to the eighth century at least. It was only slightly decorated or, usually, left plain. However, a vase from Nagano was found embellished with a head.

In addition to this folk pottery there were also the Sue—or Iwaibe—ceramics, fired at high temperatures, and more refined in appearance. Characterized by a delicate, light clay, these

ceramics were probably brought from Korea by the potters of Japan about the middle of the fifth century by the Emperor Yūryaku. The various vessels made with this technique were reserved for funeral ceremonies. Their color varies from gray-brown to black, and they are decorated only with horizontal lines, left by the hands of the potters when the clay was turned rapidly on the wheel, to which at times were added fine vertical lines applied in a straight or zigzag fashion with a comblike instrument.

The forms of Sue ceramics (which, fired excessively, are often only lightly glazed) are many and varied, although they usually have a flared neck. Among the Sue-ware objects are little stoves for steaming rice; they were made in three pieces and consisted of footed cups with covers. The high pedestals of some Sue vases, following a Korean fashion, were often perforated by triangular, rectangular, or square openings. The funeral libation pottery was often embellished with small animals or scenes, sculpted separately and applied to the shoulders of the vases. The rough modeling of these embellishments indicates that there was less experience among the Sue potters than among the Hajibe who traditionally made the *haniwa*.

It is from this Kofun period, which continued almost without transition far into the Asuka era (the Asuka era can be distinguished from the Kofun epoch—the period of the great tombs—only by the introduction of Buddhism among the aristocratic classes), that we can date with all probability the first Shintō shrines, the *torii* (sacred gateways), and numerous customs that were to be subsequently adopted by the populace. The legends were to be collected and "arranged" in accordance with an imperial edict intended to resolve certain political exigencies of the era. We must now refer, therefore, to the more reliable Chinese chronicles in order to re-create the political climate of the period, which was one of the most important in the history of Japan. It was an era which saw the birth and development of the Japanese imperial system as a Shintō cult which promptly found itself a rival of Buddhism that had also been introduced from Korea.

Japan in the First Centuries According to Chinese Chronicles

The history of Japan of the first centuries, as described in the two most ancient Japanese annals —the *Kojiki*, A.D. 712, and the *Nihon-shoki*, A.D. 720—belongs more to the domain of legend (and is arranged according to the imperial point of view) than to that of reality. There exist, however, at least three Chinese texts which, although not richly informative, offer certain facts that can be historically verified: *The History of the Kingdom of Wei* (*Wei Chi* in Chinese) written about A.D. 297, *The History of the Liu-Sung Dynasty* (*Sung Shu*) written about 488 (or 513), and *The History of the Dynasty of the Latter Han* (*Hou Hon Shu*) written in 445. In certain passages relating to the "barbarians on the frontiers," these writings give us valuable information concerning Japan and some of its manners and customs prior to the sixth century. These Chinese chronicles, although generally trustworthy, unfortunately say nothing of the origin of the Japanese people or of their language, except for a passage in *The History of the Kingdom of Wei* that asserts that the inhabitants of Wa (at that time Kyushu) called it "Ha," which corresponds to the modern "Hai" of the Japanese language, at times still pronounced "Ha." The country of Wa is described in that history as consisting of mountainous islands situated in the ocean to the southeast of Han (North Korea, where, from 108 B.C., Emperor Han Wu-ti had established a command post called Lo-lang, in order to have better control of the movements of the nomadic tribes to the north of the Great Wall). The history adds that Wa was populated by more than one hundred tribes, each one with its own hereditary king.

The chronicles also relate that, when the delegations of these tribes came to Lo-lang in China, they brought with them a man who was obliged not to comb his hair, to wash, to eat meat, or to

have sexual relations with women. Depending on the fortune of the voyage, this man, who must have been a type of shaman, was either rewarded or sacrificed.

The chronicles also tell that in A.D. 57 Emperor Kuang-wu dispatched 160 slaves and a gold seal inscribed with the name of the king of Wa-Nu (or Nu) with the return of an embassy that had been sent to his capital of Lo-lang. The seal is probably the same one that was discovered on the island of Shiga (Kyushu), although some archaeologists are inclined to doubt its authenticity.

During the Wei period and the epoch of the Three Kingdoms, the Japan known to the Chinese consisted of more than forty kingdoms. These kingdoms, according to the Chinese chronicles, were ceaselessly at war among themselves, and at least thirty of them maintained continuous relations with the Chinese court at Lo-lang through the dispatch of special envoys, who were accompanied by scribes or scholars with a knowledge of the Chinese language and script. The dynastic history of the Latter Han relates that about 445 each one of the Wa states was under the sovereignty of a king, whose functions were hereditary, and that the most important of them, the king of the Grand Wa, ruled over Yamato (the Japanese pronunciation of two Chinese characters signifying "Grand Wa" or "Great Peace"). The chroniclers also speak of a kingdom called Wa-Nu, which existed at the time of the Chinese emperor Kuang-wu and which was situated in the extreme southern part of the Wa country.

The Chinese, who were very curious about the politics of their neighbors, speak of incessant conflicts that took place approximately between the years 150 and 230, but these struggles seem to have come to an end, at least in the area of Yamato, with the accession to the throne of a woman-shaman with the title of Daughter of the Sun (Himiko). She governed with her brother acting as intermediary, and after imposing her authority on twenty-five states she maintained friendly relations with the Kingdom of Wei and paid her allegiance to the Chinese emperor by sending, among other things, ten slaves and some lengths of cloth. The emperor, Ching-ch'u, conferred on her the title of Queen of Wa, Friend of Wei, and made her a present of one hundred mirrors in the year 239.

Apparently the royal succession after the reign of Himiko, Daughter of the Sun, was difficult: her brother was banished for having tried to seize the throne but subsequently the Chinese ambassador intervened and proclaimed a thirteen-year-old girl as queen. The new queen, who had the name of Iyo, was perhaps the daughter of Himiko's banished brother. Iyo recognized her position as a vassal of China by sending to Lo-lang a tribute of thirty slaves and some precious stones.

This obscure phase of political struggles in the Japanese states may have been the basis of a myth set forth in the annals of the early years of the eighth century. The sun goddess, Amaterasu, weary of the excesses of her brother, Susano-o, retired to a cave, thus plunging the world into darkness. The alarmed gods then met and devised a stratagem that would bring forth the goddess. They made another goddess dance lewd dances before a tree covered with jewelry on which they also hung a mirror. Then they made a rooster crow. Hearing the gods laughing at the antics of the dance, and hearing the crowing cock, Amaterasu was curious and emerged from the cave to see what was happening. Seeing her reflection in the mirror she believed that she had to deal with a rival, and she left the grotto. One of the gods took advantage of the opportunity to seal it forever, and the world rejoiced again in the light of the sun.

As for the historical interpretation of the myth, if we identify Queen Himiko with the goddess Amaterasu (the divinity is the shaman who created her or at the same time was created by her) and her brother with Susano-o, then all the rest can be explained. Withdrawing from the world, she plunged it into darkness and desolation. The rebirth of the sun in the person of another sun queen, Iyo, restored peace to the kingdom. (In the legend, moreover, Susano-o was exiled to Igumo where he set up another state.) If we bear in mind that in this period the rooster was worshiped in Korea (and therefore most probably in Japan), by extrapolation we can identify this rooster of the legend with the ambassador who came from Lo-lang.

45

Contacts between Korea and Japan were frequent at that time, and the myths of the two countries were interwoven. Much earlier the Japanese had established themselves in the southern part of the peninsula in the area known as Karak, or Mimana. In 364 and again in 382 the Japanese attacked the Korean state of Silla (Shiragi), but they were repulsed on both occasions. In 386 an envoy from Japan arrived at the court of Syoko, the king of Kudara (Paekche), and three years later the Mimana state finally conquered Silla.

At that point the Koreans began to migrate *en masse* to Japan, where they introduced horses, the use of Chinese script, the art of weaving brocade, and Sue pottery. In 409 Achi, a nobleman of Kudara, installed himself with all the members of his clan on the island of Kyushu. Aided by his sons, he acted a liaison agent between the Chinese and Japanese courts. The Japanese sovereigns pretended to be—and wanted confirmation of it from the Chinese court—"the commanders-in-chief maintaining the peace with the military command and the war hatchet in the seven countries of Wa, Paekche, Silla, Imna, Kala, Chin-han, and Mok-han." In the fifth century the Chinese emperors confirmed this title, which was purely honorary, however. One of the Japanese sovereigns, a member of the imperial clan who resided in Yamato (the southern part of Nara), and who was called by the Chinese "Bu," is identified as Emperor Yūryaku, 457– c. 480. In 478, this Bu, in a report to the emperor of China, Ching-Ti, boasted of his ancestors "clothed in armor" who had conquered fifty-five tribes of "hairy men" (called Ezo in *Nihon-shoki*) on the eastern borders of the kingdom (in the Kantō, therefore, where the Ainu had descended) and numerous other tribes of barbarians (Kumaso) to the west (probably on the island of Kyushu). Then, having crossed the sea, his ancestors had overwhelmed several kingdoms in southern Korea. The Japanese sovereign complained that the Kōguryö State (north Korea) had prevented him from going to the Chinese court in order to pay his tribute to the emperor, and he asked for military aid from China and the recognition of his titles. His request concerning his titles was granted, and Bu (or Wu) was proclaimed a faithful vassal of the Liu-Sung court in south China.

In actual fact the vassalage of Japan to China was purely theoretical and was essentially a title that the sovereigns of Yamato were fond of using to impress their neighbors. Nothing is known in detail of the political activities of the Japanese kings during the first five centuries of the Christian era, and the Chinese chronicles offer little information on this point. It may be assumed, however, that the sovereigns of Yamato, having subjugated the tribes of southern Honshu and northern Kyushu and being more or less firmly established in the southern part of Korea, were regarded by the Chinese as the sole authority in the country of Wa, and, therefore, the Chinese court maintained frequent contact and exchanged ambassadors with them.

The importance of the influence of China on the development of Japan during this period is difficult to evaluate. It seems that this influence was more nominal than real and that in actuality the two peoples remained strangers to each other.

The Chinese do not appear to have attached great importance to these "barbarians" of the islands who in no way could threaten the peace of China. On the contrary, they seem to have been amused by the stories the Japanese envoys must have related at court. The chronicles, in fact, supply us with details about the life of the people of Wa, revealing the complete difference in that period between the Chinese and the Japanese civilizations. In all the reports emphasis is placed on the behavior of the Japanese. We learn that they stained their bodies with various colors, that they ate with their fingers, and that they practiced the art of divination with bones thrown into the fire (a practice of Chinese origin).

Although the men and the women lived separately, no distinction seems to have been made in rank between the sexes. Japanese society, however, appears to have been organized into classes; the most important class possessed slaves. Polygamy existed; the state derived its resources from agriculture, having created markets and granaries on which taxes were levied; and alcohol appears to have been commonly consumed.

As in the present-day Shintō cults, veneration was expressed by the clapping of hands. The

46

laws were severe, and punishment could involve even the extermination of the entire family or clan of a man judged guilty of a crime. The people are described as honest, little inclined to jealousy, gay, and superstitious. They were also considered to be great lovers of singing, dancing, and strong drink. The Chinese make no mention of the religion of the people of Wa except in the case of funerals, which always involved a large number of mourners and purification with water *(misogi)*.

In dating certain reigns of Japanese emperors, only comparisons and rough guesses can be made. In 438 an imperial Chinese edict bestowed on King Chen the titles of "King of Wa" and the "Superior Commander of the Pacification of the East." King Sai has been identified with Emperor Inkyō who received the title of "Commander of the Armies of Silla [Shiragi] and Mimana." The "Kō" of the Chinese annals was probably Emperor Ankō. The *Sui Shu, The History of the Sui Dynasty*, written about 630, completes our knowledge, because in that period the emperor of China entrusted a commission with the task of informing him regarding the manners and customs of the kingdom of Wa.

In the Wa country, c. 600, the report states:

There are about 100,000 households. It is customary to punish murder, arson, and adultery with death. Thieves are made to make restitution in accordance with the value of the goods stolen. If the thief has no property with which to make payment, he is taken to be a slave. Other offenses are punished according to their nature—sometimes by banishment and sometimes by flogging. In the prosecution of offenses by the court, the knees of those who plead not guilty are pressed together by placing them between pieces of wood, or their heads are sawed with the stretched string of a strong bow. Sometimes pebbles are put in boiling water and both parties to a dispute made to pick them out. The hand of the guilty one is said to become inflamed. Sometimes a snake is kept in a jar and the accused ordered to catch it. If he is guilty, his hand will be bitten. The people are gentle and peaceful. Litigation is infrequent and theft seldom occurs.

As for musical instruments, they have five-stringed lyres and flutes. Both men and women paint marks on their arms and spots on their faces and have their bodies tattooed. They catch fish by diving into the water. They have no written characters and understand only the use of notched sticks and knotted ropes [a very ancient technique, originating in China and Southeast Asia, which is to be found also in the Ryukyu Islands and in Peru].... They are familiar with divination and have profound faith in shamans, both male and female....[1]

There will be found this precise detail in *The History of the T'ang Dynasty (Hsin T'ang Shu)*, compiled in the eleventh century from ancient sources: "The family name of the king is Ame (heaven). The Japanese say that from their first ruler, known as Ame-no-minaka-nushi, to Hikonagi, there were altogether thirty-two generations of rulers, all bearing the title of *mikoto* and residing in the palace of Tsukushi [northern Kyushu]. Upon the enthronement of Jimmu, son of Hikonagi, the title was changed to *tennō* and the palace was transferred to the kingdom of Yamato...."[2]

The Legends and Primitive Shintō

In 712 Empress Gemmei had the *Teiki* (genealogy of the imperial family) and the *Kyūji* (ancient tales and legends) transcribed by Ō-no-Ason-Yasumaro under the dictation of the old (male or female?) Hieda-no-Are. The three volumes, written in Chinese characters, make up the *Kojiki*,

[1] and [2] Ryūsaku Tsunoda (tr.) and L. Carrington Goodrich (ed.), *Japan in the Chinese Dynastic Histories: Later Han through Ming Dynasties* (Perkins Asiatic Monographs, No. 2), South Pasadena, 1951.

7. BIRD'S-EYE VIEW OF THE SHINTŌ SHRINE OF IZUMO

1. HONSHA (HONDEN)	7. TORII	13. CORRIDOR
2. HAIDEN	8. SHRINE OFFICE	14. KAGURADŌ (HALL FOR RITUAL DANCES)
3. AI NO MA (CORRIDOR)	9. SECONDARY SHRINE	15. STABLE OF SACRED HORSE
4. CISTERN	10. LIBRARY	16. MEETING HOUSE
5. TAMAGAKI	11. HŌZŌ	17. CHŪMON
6. ITAGAKI	12. HALL OF OFFERINGS	

the oldest Japanese chronicle. Other nobles had received the imperial order to transcribe the legends, and these were collected in 720 in a new work of thirty volumes entitled the *Nihon-shoki* or *Nihongi*. The originals have disappeared and the oldest extant copy of the *Kojiki* must have been made by a Buddhist monk or priest in 1371. The interpretation of these texts is complicated, however, by the fact that they were written in Chinese characters. Their transcription into Japanese is difficult and gives rise to many different interpretations.

The myths and legends included in the *Kojiki* and the *Nihon-shoki* afford a glimpse of the origin of the Japanese, of the political events that preceded the introduction of Buddhism into Japan, and of the religion that took form in the first centuries of the Christian era. The principles of this religion were first formulated at the beginning of the eighth century in the *Jingiryō*, or *Laws Relative to the Affairs of the Kami*, which united tribal beliefs in a national Shintō.

Various legends deal with the universe prior to the creation of the Japanese islands. They take for their principal theme a Chinese idea: out of Chaos there appeared an egg from which was born the fundamental and indistinguishable Principle that separates the Sky from the Earth and creates the divinities which rule one and the other. This idea perhaps arrived in Japan from Southeast Asia by way of China. On the other hand, we have already seen that the first divine

48

couple, Izanami and Izanagi, from the top of the bridge of heaven (rainbow?) plunged "the spear of heavenly jewels" (lightning?) into the sea and cried, "*Kōro, kōro!*" This cry, associated with the act, could be considered to be the very essence of creation: it is the Word.

Where did it come from? What does it mean? Is it a very ancient word or a word added afterward with the aim of justifying the idea of the Creation? We do not know. The foam drops from the point of the spear and forms an island on which Izanami and Izanagi erected the "pillar of Heaven" that divides Heaven from Earth. With this act they consecrated the existing difference between Heaven and Earth and definitively prevented their reunion (because in the beginning Heaven and Earth had been mixed and, according to a legend of the Ryukyu Islands, "men hopped between one and the other like frogs").

Simultaneously there were thus created the positive and the negative, the male and the female, the day and the night, and this duality was guarded by the phallic pillar. Izanami and Izanagi, having then "known the differences" and having divided the parts, the active and the passive, coveted each other in order to procreate.

This theme is found in all primitive cosmogonies, but the motif of the phallic pillar could have been derived from Southeast Asia. Yet it could be even more ancient. It was confirmed at a later date in the Chinese cosmogony with its separation of the two Principles.

After some unfruitful attempts Izanagi and Izanami finally begot the eight principal islands and subsequently the *kami* (gods) of the sea, the trees, and the mountains. The birth of the *kami* of fire burned the sexual organs of Izanami, who died as a result (a legend also found in the folklore of Melanesia, Indonesia, and Indochina). Izanagi then buried his sister-spouse and killed the *kami* of fire with a sword. Subsequently he betook himself to Yomotsu-kuni (the Kingdom of Death, or of Darkness) in order to ask Izanami to return and continue her creative work. Having become repulsive because "she had tasted earthly food," Izanami did not want Izanagi to see her in a state of decomposition. He, however, ignored her protests, penetrated the Kingdom of Darkness, and in order to see clearly, lit a tooth of his comb (animated his consciousness?). Izanami became furious. Izanagi, horrified by what he had seen, then fled, pursued by his spouse. He was able to escape from her only by flinging between them his comb, his "hair ornaments," and a fish.

The myth of burial and pursuit is characteristic of the primitive folklore of prehistoric agrarian peoples (in Egypt the myth of Isis and Osiris). In flinging to Death, who pursues him, his comb (his strength?), the ornaments of his own body (talismans that protect him from death?), and a fish (can it be analogous to the Western Apple of Knowledge, the rejection of which confirms oblivion?), Izanagi became a mortal: he never again found the path to the World of Darkness, and he was destined to die in his turn. Defiled by his sojourn in the Kingdom of Death, Izanagi felt the need of purification and of ridding himself of his "immortal skin" in order to be completely human. From that skin, washed off in the water of a stream, were born the other divinities. From his left eye Amaterasu, the sun, was born; from his right eye, Tsukuyomi, the moon. From his nose came forth Susano-o. Finally, after many other *kami* were thus created, Izanagi cleansed himself of all his defilements in the river which becomes the sea: and now fearful of death, was henceforth naked, subject to heat and cold, to light and darkness, to life and death.

This is an ancient myth that is also found in the Near East and that may have arrived in Japan by the roundabout route of India and Southeast Asia; it is a leitmotiv that was taken up and developed in different ways in both India and Greece. In the myths of both those civilizations one discovers the same search for the Kingdom of Hades and the story of the birth of the secondary gods from the living parts of the primordial creator (Zeus or Brahma). The purification rite with water is also found in all the agrarian societies of the Old World: it is the regenerating contact with the primordial element from which all life springs forth, the element into which Izanagi and Izanami drove the celestial spear, the element which the *deva* and *asura* (gods and demons) of India churned in order to obtain the elixir of immortality.

There is a difference of interpretation, however, between societies of a patriarchal type (Greece

49

and the Middle East) where the element earth is female, and those of a matriarchal organization in which the sea is the source of all life. In Japan the sun is female because it comes from the water; because each morning it rises from the sea and in turn it gives life. The earth, which sustains men and raises its mountains in phallic forms in order to support the vault of the sky, is naturally male.

Thus one can reasonably believe that from Japan's prehistory onward there were three cults, which were rather indeterminate but were influenced to a greater or lesser degree by the contributions of the successive waves of migrant peoples: an informal cult of the spirits of nature, particularly of water and of the mountains; a solar cult; and a phallic cult. The agricultural Yayoi migrants, who brought with them a type of agrarian culture based on water and certain new myths, gave concrete form to some ancient beliefs and transformed others. On the myth of the separation of the earth from the sky they superimposed others relating to the separation of the earth from the waters. Kunitoko, the spirit of the earth, was born from the mud; it became man's task to prevent the unification of water and soil (mud) by setting up stakes to separate them, but these stakes driven into the soil could only signify a phallic action of the male earth against the female water. It was the earth which became the active element, and the water, passive, flowed in the irrigation ditches opened by man and lent its creative body to the earth.

In Japan it is the earth which fecundates the water. It is difficult, therefore, to attribute to these myths a Polynesian origin, as some authors have attempted; the myths are far more Indonesian or Southeast Asian, but we still lack the necessary elements to make this claim with certainty.

As to the solar myth, there can be no doubt that it was reinforced to the detriment of the others at the time of the migration of the first clans of Altaic origin that came from Manchuria and Siberia by way of Korea. This cult had already existed for a long time in Korea, where the rooster which announced the appearance of the solar disk, was considered to be the sun's messenger. In the seventh century the Chinese traveler I Ching asserted that the rooster was considered sacred by the Koreans; in fact, a text dated prior to 1195 of Cheng Ta-chang of Sung states: "The rooster is revered by the people of Silla as a divine being, and the country itself was born from the semen of that fowl...."

The mirror became the symbol of the stars, and the shamans, who at the time of the primitive Shintō cults disguised themselves as women, danced at the *matsuri* (the ritual feasts) and entered into a trance before a sacred tree at midnight. The myth of Amaterasu concealed a legend of Siberian origin and at the same time some of the political facts mentioned previously. The sun-priestesses could be no other than the sun itself on earth, and from this fact was derived the thesis that her role was both temporal and religious.

Thus the emperors were inevitably likened to the sun, since they were the legitimate shamans. In reality it is probable that prior to the unification of Japan there were many "sun-shamans" at the head of the clans. The victory of one among them—apparently it was Himiko —united in a single person the functions of shaman and temporal chief. The rival house of Izumo, founded by Susano-o, always existed, however, and tended continually to eclipse the house of Yamato. The sun—Amaterasu or the emperor—then sent a general, Takemikazuchi-no-Ogami, with an army in order to crush the power of Izumo. The general was only partially successful in his efforts, and the sanctuary of Izumo remained inviolate. In fact, the two kingdoms of Yamato and Izumo did not reach an agreement until the sixth century: Izumo became the protector of the religious privileges; Yamato (Ise) assumed the temporal power.

Beginning in the fourth century—the probable date of the mass arrivals of newcomers from Korea—the legends and myths, at least those of the aristocratic class, began to overlap and become mixed with political elements, although their spirit continued to be influenced by that of the steppes. The shamans still had an important function, at least during the entire Nara period, with their ritual processions, their theatrical performances (such as those relating the events before the cave where Amaterasu took refuge), their invocations *(norito)*, and their

50

symbolism, which consisted of three objects: a sword (temporal power), jewelry (material power), a mirror (religious power). It was the possession of these three treasures conferring divinity (the mirror), power (the sword), and wisdom (the jewelry), which endowed the possessors with religious, military, and civil supremacy.

The Japanese people remained somewhat outside of this Altaic current of myths and legends. The Japanese continued to be attached to their ancestral beliefs and to venerate the nature spirits, at first without established shrines other than their sacred trees, through which it was possible to communicate with the *kami* (analogous to a Siberian belief), the mountains, and the water. This tree-cult may have arrived in Japan at a very late date by way of Korea, where it was believed that divinity would descend from Heaven to a tree on the top of a mountain called Sohori. This tree was later identified with the palace of the emperor-shaman (in the Korean language *Sohori* is the equivalent of Seoul). In Korea, moreover, there is a legend concerning a tree, the mediator between Heaven and Earth, from which was suspended a gold box (the sun) which, when opened at the moment of the cock's crow above it, liberated a little boy called Kin-achi, who became the first of the Kin family.

Other popular myths, probably from southern China, enliven the shamanist sphere. One of them tells how the sun (Amaterasu) was lured forth from the grotto by the lewd songs and dances of the goddess Ame-no-Uzume-no-Mikoto and by the glitter of jewelry and a mirror. In a legend from Assam the sun was drawn forth by the songs of the birds and the perfume of the flowers. Moreover, a theme of man's impurity is found in varying degrees among many peoples of Southeast Asia and in particular among the Munda of Bengal where, it is related, Thakur, the sun, became angry with the filthiness of men, who could save themselves from the purifying celestial fire only by the moon, Ninda, who hid them in the darkness of a cave.

The folk legends reveal ancient customs: the young people were subjected to a ritual initiation involving certain tests (a rite to be found in Southeast Asia and Formosa). While living in the men's house (Malaysia), an engaged youth had to work for a certain period for the parents of the girl he was to marry (Southeast Asia). The king or shaman-chief also had to submit to tests and to pass through a "rebirth" (Southeast Asia).

This complex mythology, outlined here only briefly, indicates that on a very ancient cultural base of Indian, Proto-Malaysian, and Melanesian origin there had been grafted a cosmogony derived from southern China (or Burma or Yunnan) that in turn was modified by concepts from eastern China (south of the Yangtze). Later this mixture was enriched by shamanistic practices and myths of varying origins (Tungus and Altaic) and remodeled in a Sino-Korean fashion. All these elements were adapted to the Japanese way of thinking and were infused with a political symbolism which is not always self-evident.

As a final result Shintō was born: a sort of mythical-religious syncretism with shamanist influence. The first Shintō shrine was probably constructed toward the middle of the third century at Kasami-mura in Yamato (perhaps during the reign of Himiko) and dedicated to Amaterasu. We learn from the *Nihon-shoki* that twenty-four years later the shrine was transferred to Ise. The shrine must have been more or less of the same type seen there today. The *torii*, according to some legends, appeared simultaneously and symbolized perhaps the perch of the solar rooster. Passing beneath them, the faithful leave the night and enter day and in this way undergo a spiritual rebirth. They clap their hands "in order to imitate the flapping of the cock's wings when he crows to call forth the sun."

In primitive Shintō the female played a very important part (which she still does in certain Indonesian cults). Young virgins served in the shrines, and the two most important Japanese divinities were female: Amaterasu, the goddess of the sun; Ukemochi, the goddess of the grain. There is no equivalent in Shintō of a God in the Western concept; there are only the eight million (a figure symbolizing the infinite in Japan) *kami* or "spirits" of people and things, and these *kami* live between Heaven and Earth and descend temporarily into objects (or surrogate objects) found in the shrines or into the trees or rocks.

It is almost impossible to define Shintō, because it possesses neither a theology nor a system of ethics. In the beginning it did not even have a name; it was only in the seventh century that the title of Shintō or "way of the *kami*" was adopted in order to distinguish it from *Butsudō*, "the way of the Buddha" or Buddhism. A *kami* is also inexplicable: it is the unsubstantial essence of a thing (everything is endowed with life in Shintō) or of a person. A human being will become a *kami* after his death in the same way that a tree or rock is a *kami*. One cannot represent a *kami* in an orthodox fashion; one can only suggest or inspire its presence with an abstract object or surrogate such as a *gohei* (a strip of white paper or fabric folded in a zigzag fashion and symbolizing, according to some people, the multiple hands of the *kami*), a mirror, a sword, a piece of wood.

No religion in the world is so loosely formulated and so impossible to formulate. It is fundamentally a nature cult, and only its strange rites, evolved over the centuries, permit us to distinguish it from the more primitive cults. Yet Shintō is the very justification of existence for the Japanese people: a person is Shintō in the same way that he is born Japanese. From thousands of myths and beliefs—and we have noted how they may have the most diverse origins—was formed a way of life in which no one truly believes (there is no concept of faith in Shintō). However, it seems that the Japanese are able to overcome the vicissitudes of life solely by employing a single remedy of self-purification: beginning with lustral rites *(misogi)*, then, relatively later, with the rites of veneration, finally with prayer or invocations *(norito)*. Yet *misogi* continues to be considered the most efficacious means of purifying oneself. And one does not pray to the *kami*; one venerates them. They are the primordial pure beings, the models to be emulated, the guides of individuals as well as of the nation.

The agrarian origin of the primitive *kami* is evidenced by the presence of a *shimenawa* or rope made of strands of rice straw twisted to the left (the positive direction) and hung on a *torii* at the entrance of a shrine or coiled around a tree trunk or rock, thus indicating the sacred character of the place or the object. From this rope sprigs of rice straw (in ancient times the ears of grain) are suspended at regular intervals together with some *nigite* or *nusa* (analogous to the *gohei*) of white paper or fabric. The legend states that when Amaterasu had been lured forth from her grotto the divine Prince Futodama closed the grotto and sealed it with a rope of straw in order to bar the retreat to the goddess. This rope, indicating the prohibition, was called *shirikume-nawa* from which, as a contraction, we have its modern name, *shimenawa*. The indication of a prohibition was subsequently transformed into a sign denoting the sacred character of a place or object.

The Ainu

Numerous studies have been made of the Ainu, the last descendants of a prehistoric race of which traces can perhaps be found in some primitive tombs in the form of flat bones (particularly humeri and thighbones) characteristic of the Ainu skeleton. Another indication of the Ainu is the presence of bears' skulls near the remains of this almost extinct race, proof of the continued existence of the religion and rites of the "bear culture" that appears to have spread in prehistoric times over a vast area extending from the Alps to east Siberia and Japan.

Driven onward by more powerful tribes or by cold, these men who, the ancients asserted, came from a "country of snow and ice where no bird sings," seem to have arrived in Hokkaido around the fourth century B.C. from Siberia by way of Sakhalin, or from the Kamchatka Peninsula by way of the Kuril Islands. They came in successive waves, but each group was composed solely of a few families. These latecomers of prehistory intermarried with the Jōmon population scattered about on the inhospitable island of Hokkaido.

Subsequently they crossed the straits separating Hokkaido from Honshu and once again intermarried with the hunter folk of the Jōmon civilization established in Tōhoku (northeastern

Honshu). They even grew bold enough to descend as far as the Kantō where they came up against the settlers who had brought from the south the cultivation of rice and a type of agrarian society. Hardy hunters and fishermen accustomed to the northern climate, these "hairy men," many tribes of whom Emperor Yūryaku had boasted of having defeated, were formidable adversaries of the "peace-makers" of Yamato. Only after centuries of struggle—the last of the Ainu were not totally defeated until the Edo era—was Yamato finally able to push the Ainu back onto the still sparsely populated and unexplored island of Hokkaido. These Ainu, whose area seems to have been confined principally to the coast of Siberia, the southern part of the Kamchatka Peninsula, Sakhalin, the Kuril Islands, and Ezo (Hokkaido), adopted in part the Eskimo culture of the North Pacific, although they retained their own customs and religion.

The present number of Ainu is extremely small: little more than 10,000 on Hokkaido and perhaps an equal number on the other islands. This population, moreover, constantly decreases. The Ainu youth often marry Japanese, although the Ainu have physical characteristics that definitely distinguish them from the Japanese: a broad-based nose, high cheekbones, a swarthy complexion, and, above all, a hirsuteness that must make them the hairiest people in the world. They are not much taller than the Japanese, but they have a much stronger build. Their present customs are certainly very different from those that they must have had at the time of their arrival in the Japanese islands, and those customs, through contact with the Japanese people, must have been transformed so rapidly that it is fruitless to go back in their history for more than two or three hundred years.

Their language has been studied in detail, especially by R. P. Batchelor, which is fortunate, since it is expected to fall into complete disuse within a few decades. These studies demonstrate that numerous toponyms were derived from it: the name of Mount Fuji is the most remarkable example among them, because it proves that for these Emishi or Ebisu or Ezo, as the Ainu were sometimes called in the Japanese chronicles, it was the domain of the divinity of fire.

The Ainu youth now learn Japanese, forget the language of their ancestors, work in factories, and no longer know how to fish or to hunt bear. It is now predicted that within twenty years the only remaining evidence of Ainu customs will be picture postcards and tourist exhibits.

One of the most curious of their customs and probably the most ancient is the sacrifice of the bear. (The Ainu identify themselves with this plantigrade animal.) After having reared a bear, they sacrifice it collectively and address prayers to it in order that it may transmit them to their ancestors. One of the characteristics of the Ainu village is the log cabin in which the bear for the future ceremony is kept. These sacrifices have gradually become quite rare because the young people no longer attach much importance to the ancestral myths and the bears have practically disappeared from Hokkaido and other northern areas of Japan.

Also characteristic of the Ainu villages are log cabins, which follow a style of architecture seemingly derived from an ancient Jōmon era type. These huts are roofed with thatch arranged in horizontal rows, which gives them a very different appearance from typical Japanese thatched roofs. The cabins are rectangular, and inside the ground is covered with straw mats. The hearth is located near the entrance in a covered vestibule, which also serves as a storeroom.

Of the few—generally only two—windows, the one toward the east, called *kamui-buyara*, is the window through which the Ainu venerate their divinities and through which they can see the skulls of the sacrificed bears, wherein the soul supposedly resides, mounted on stakes. The Ainu believe in the spirits of nature *(kamui)*, represented by a stick decorated with curled shavings. This stick corresponds to the *gohei* of the Shintō cult and is perhaps a derivation or imitation of it. In the general beliefs of the Ainu it is difficult to distinguish the elements that are peculiarly their own from those borrowed from the Japanese folklore of northern Honshu. For example, was the name of their divinities—*kamui*—original? Was the Japanese word *kami* derived from it, or was it borrowed from the Yayoi language?

The Ainu have no system of writing; their tales, legends, prayers, and invocations have been preserved orally, and only recently have they been set down in Japanese. Ainu art is very simple.

It makes use of materials found in nature and consists principally of rough images of carved wood; although when trained by the Japanese, the Ainu sculptors prove to have astonishing skill.

The Ainu also weave fabrics with geometric designs that are extraordinarily original, whether created with dyed threads or a type of appliqué. Black, white, red, and blue are the dominant colors. Each village has its own particular design, which is reproduced in all the clothing of the inhabitants. In addition there are special designs for ceremonial vestments and shrouds. Like the ancient Japanese described in the Chinese chronicles, the Ainu love strong drink and indulge in ritual libations of sake for which they use little carved sticks or "libation wands" that some scholars have called "moustache raisers."

With the exception of a Japanese-derived broadsword, Ainu armament has remained quite primitive: simple bows, spears, harpoons, knives. The Ainu still make use of stone tools, particularly on ritual occasions. They seem to be organized socially on the pattern of the patriarchal clan, but wives have a very important place in their society. A custom of the women, which disappeared some years ago, was that of tattooing their hands and the skin around the mouth. Some authors have attempted to compare these tattoos with those of the men and women of the Ryukyu Islands. Although some have agreed that the custom has been derived from the people of those islands, it seems to us to be nothing more than coincidence, since the custom of tattooing was widespread among the most distant and diverse peoples who had absolutely no connection with one another.

Further light may be cast on the Ainu by two quotations, the first by G. Bousquet in his book *Le Japon de nos jours* (Paris, 1870), and the second by a nineteenth-century journalist named Zabrowski who visited Hokkaido about 1870:

> The earth, which is the only floor in most of the houses, is covered with ashes that fall from the hearth set up in the center on a few stones.... In a dark corner there are some old lacquer bowls; on the wall are hanging some harpoons of a special form designed for salmon fishing, some paddles, fishline, iron knives in roughly carved wooden sheaths, a broadsword, a battle dagger, some bearskin or deerskin garments, gourds, a wooden bow, and... bamboo arrows fletched with crows' feathers and with bone arrowheads that are used to kill the bear. Above the hearth some smoked salmon are hanging and the entrails of a deer are stretched on rods....
>
> At the foot of their tombs on Sakhalin Island a strong stake is driven into the ground, and the top of the stake is carved to resemble the head of a man, with two notches, cut from within and downward, symbolizing a torrent of tears. The tomb is formed by two thick planks placed as a roof over other planks, thus forming a box. The deceased is placed within, dressed in his garments, together with wooden bowls, a knife, a tinderbox, some tinder, and a pipe. In front of each cabin some sacred branches are planted upright; on them there are the little sticks with curled shavings of the type to be seen in the house. The bear skulls are suspended from them....

Zabrowski, who wrote for the *Revue Universelle*, was an excellent observer, and thus described the bear ceremony:

> The host is not crowned with the leaves and the branches of the grapevine... but with a braid made of the bark of the wild grape and embellished with thin wood shavings that hang down in spirals like ringlets of hair. It is placed on the head, and various little wooden objects are suspended from it. The guests are received with all the evidence of consummate courtesy. They are greeted by raising the arms in the air with hands turned inward; then one hand is placed over the other and there begins a slow clapping. A long speech and compliments follow. A bear cub, god and victim, has been reared for the ceremony. Nothing has been spared in its upbringing. Since it had been taken from its mother when still too young, an

54

Ainu woman served as its wet nurse. This woman is the only person present who is saddened by the ceremony. She even cries as the ceremony proceeds, because it consists, in fact, of putting her foster child to death. First of all, the men offer a sacrifice to the divinity of fire. They squat with their legs crossed around the hearth. They pour out a few drops of sake—Japanese brandy—on the fire and then pass through the flame a little carved pointed stick that has been previously soaked in sake. Prayers are said in a low voice and then with the little stick they raise their long beards to a horizontal position and swallow a long gulp of sake. Once this first part of the ceremony has come to an end, they make further libations in front of their carefully decorated gods. During all this time the women comfort the caged bear and the young girls joke and laugh. The youngest and the boldest man then drags the bear out of the cage and walks it around the house. Then the assistants shoot the bear with arrows that are without points but tipped with wooden knobs. Finally one of these penetrates its mouth; the bear is knocked down with its neck stretched over a log, and nine men, kneeling on the beast, choke it to death. This cruel execution is carried out without spitefulness or maliciousness, because the Ainu offer the animal to the family of bears in expiation of all the deaths of bears for which they had been responsible in order to ask pardon and reconciliation with the other species. Crying, the women and girls dance and slap the men who are strangling the animal. The body of the bear is then laid out on a mat.... The bow and quiver of the household god are hung around its neck; necklaces and earrings adorn it; then a plate of boiled millet, cakes made with millet and fish oil, and a flask of sake are offered to it. All the men seat themselves around the body and in its honor devote themselves to a long libation. This libation never comes to an end; the women also take part and become as drunk as the men. The bear is carved up the next day. Sometimes, however, the carcass is cut up the same day. The blood, collected in cups, is drunk greedily. The liver is eaten raw with salt, and the brain is consumed with sake. The man who acts as butcher eats the eyes together with the fat of the sockets. All the assistants partake in this way of various parts of the bear and thus absorb the spirit of the species and become, in their own way, bears. The head, to which the skin is left attached, is finally suspended from the top of a pole about six feet high and decorated with an *inabo*—a stick decorated with curled shavings....

1. KYOTO. COLUMN OF HIGASHI-HONGANJI. Keyaki wood (Caucasian elm) from trees felled in 1895 at the time of the reconstruction of the temple that had been the seat of the Jōdo-Shinshū sect.

2. THE JAPANESE COAST. View of the rocky coast of the Bōsō Peninsula, near Katsuura, southeast of Tokyo.

3. REBUN ISLAND. View of the rocky (basaltic) west coast of Rebun Island to the north of Hokkaido. A prehistoric Jōmon site.

4. KYOTO. THE KATSUURA RIVER. In autumn, looking upstream. In the background can be seen Mount Arashiyama.

5. MOUNT ASAMA. A lava flow from one of the most active volcanoes of Japan.

6. THE JAPANESE COAST. One of the numerous rocky coves of the east coast.

7. HOKKAIDO. ABASHIRI. A type of partly underground hut. This type of "winter" cabin must have been typical of the Jōmon era and, at least until the tenth century, of Hokkaido.

8. HOKKAIDO. ABASHIRI. MOYORO KAIZUKA. Bear skulls. This group of skulls was found together with pottery in the northwest corner of the interior of the hut shown in plate 7. An ancestral altar? A sacred cult place? Hunting trophies?

9. HOKKAIDO. REBUN ISLAND. JŌMON VASE IN DARK TERRA COTTA. Height c. 3″. Collection Dr. S. Horie.

8. THEORETICAL RECONSTRUCTION OF NEOLITHIC CABIN (TATARA)

10. HOKKAIDO. REBUN ISLAND. JŌMON VASE OF DARK POTTERY. Height c. 3¾″. Collection Dr. S. Horie.

11. HOKKAIDO. ABASHIRI. MOYORO KAIZUKA. JŌMON POT. A Jōmon piece of pottery discovered in a bed of red earth mixed with shells in a *kaizuka (kjökkenmödding)* in Abashiri. An ancient type of Jōmon ceramic made of thick clay and decorated with coarse, dark gray clay cords. Moyoro Kaizuka Kan Museum.

12. NAGANO. MIYANOMAE. JŌMON VASE. Typical pottery of the middle Jōmon era. Tokyo National Museum.

13. CHIBA. HORINOUCHI. JŌMON VASE. Wide-mouthed vase of the late Jōmon era. Dark terra cotta. Height c. 19¾″. Tani Teizō Collection, Tokyo.

14. HOKKAIDO. ABASHIRI. STATUETTE. Female figure carved from a walrus tusk. Probably late Jōmon period (or perhaps Ainu). Height c. 4″. Abashiri Municipal Museum.

15. GUMMA. GŌHARA. JŌMON STATUETTE. Discovered lying flat in a trapezoidal enclosure made of stone near Yamazaki Kane in Gumma Prefecture. Reddish terra cotta. Height 11¼″. End of Jōmon era.

16. NORTHERN HONSHU. DOGŪ. This Jōmon statuette, or *dogū*, with its curiously slit eyes (possibly as protection against the reflection of the snow), in gray terra cotta was found in the northern part of Tōhoku. Osaka Municipal Museum of Art.

17. STONE HEAD OF A STAFF. It can be attributed to the end of the Jōmon era. It may have been the head of a club. The solar motif is curiously reminiscent of the swastika. Kyoto National Museum.

18. BARBED HARPOON HEADS CARVED FROM DEER ANTLERS. They have slits for attaching the line. Jōmon period. Length of longest point c. 2¾″.

19. HOKKAIDO. ABASHIRI. A SEAL. Carved from a walrus tusk. Marvelously stylized, it is reminiscent of modern Eskimo art. Perhaps end of the Jōmon era. Height 4″. Abashiri Municipal Museum.

20. BRONZE HALBERDS. Found in the northern part of Kyushu, they were probably ritual symbolic objects. The upper one can perhaps be dated from the beginning of the Christian era (middle Yayoi period); the lower one is more typically Japanese and is of the late Yayoi period. Kyoto National Museum.

21. NARA. KARAKO. VASE. Typical of the villages of the middle Yayoi period, this piece is decorated with an incised drawing depicting a boat with five oars. Yet only two rowers can be discerned. The prow of the boat seems to be decorated. Height c. 11″. Tokyo National Museum.

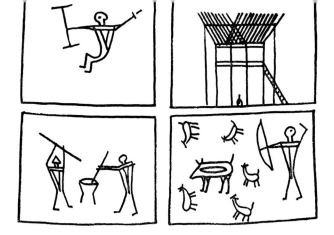

9. DRAWINGS IN RELIEF ON A BRONZE DŌTAKU OF KAGAWA; MIDDLE YAYOI ERA

(There are twelve different panels, six on each side)

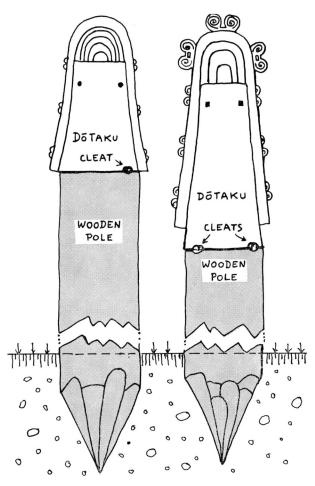

10. THEORETICAL SYSTEM OF MOUNTING THE DŌTAKU

Height 53″. Tokyo National Museum.

25. TOMB OF EMPEROR ŌJIN. Model of the tomb of the Emperor Ōjin (c. 395) showing the keyhole form of the *kofun*. Length of the original c. 1,280′. It was surrounded by two moats, one of which is now dry. Alongside this enormous tomb, the second largest in Japan, there are smaller ones. The shrine is to be seen in the lower part of the photograph on the edge of the moat.

26. TOMB OF EMPEROR SUININ. This very large tomb is located near Nara and is surrounded by moats filled with water. Of keyhole form, its height varies from 43′ to 59′, and it is 400′ wide and c. 700′ long. It is covered with trees. One sees here a *torii* rising above the embankment of the moat: an indication that the site is sacred. According to tradition, this tomb is older than the *kofun* of Ōjin and thus would date from the end of the third century. However, it must have been constructed much later. It is not certain, moreover, that Emperor Suinin was buried here.

27. ISHIBUTAI. A large *kofun* located to the south of Nara, which, according to tradition, was the burial site of Soga-no-Umako (c. 626?). This tumulus rises on a series of terraces and is surrounded by a moat banked with stones. The earth that formed the tumulus has been removed, revealing the burial chamber constructed of enormous stone blocks.

11. STAGES IN THE CONSTRUCTION OF A "KEYHOLE" KOFUN

I. CONSTRUCTION OF THE TUMULUS IN FRONT OF THE TEMPORARY SANCTUARY. II. TRANSFER OF THE SARCOPHAGUS INTO THE SEPULCHRAL CHAMBER. III. COMPLETION OF THE TUMULUS AND DEMOLITION OF THE TEMPORARY SANCTUARY. IV. ELEVATION OF THE SACRED PLATFORM; SOMETIMES THE CONSTRUCTION OF A SECOND CHAMBER; FINISHING OF THE MOAT SURROUNDING THE KOFUN

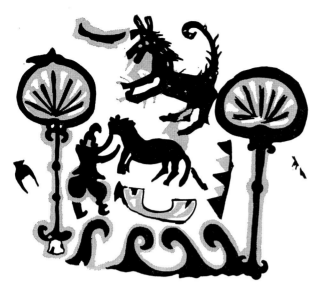

12. PAINTING ON STONE IN THE TAKEHARA TOMB AT FUKUOKA; BLACK AND RED ON YELLOW OCHER BACKGROUND; SIXTH CENTURY; LENGTH 90½″

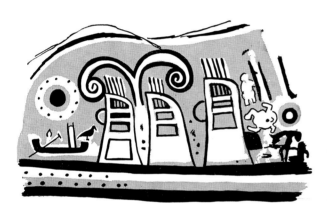

13. RED, BLUE, AND WHITE PAINTING ON STONE AT THE FAR END OF THE MEZURASHIZUKA TOMB AT FUKUOKA; SIXTH CENTURY; LENGTH 60″

28. ISHIBUTAI. Interior of the burial chamber of the preceding *kofun*. Each of the blocks weighs one hundred tons. The tomb is not decorated. Length 24½′, width 10½′, maximum interior height 15½′.

29. STONE COFFIN. Discovered in a tomb at Ikaruza dating from the seventh century, this sarcophagus is made of three pieces cut from soft limestone. The corpse was inserted through the opening at the end which was then sealed with a carved stone. Apparently this sarcophagus was left unfinished. Height 21⅝″, length 90½″, width 27⅝″. Yamato Rekishi Kan, Kashiwara Jingū, Nara.

30. TERRA-COTTA COFFIN. Discovered in a *kofun* in the Nara region (fifth–sixth centuries), it consists of four parts made of reddish terra cotta. It is mounted on numerous *haniwa*, or cylinders of terra cotta. Length

78¾″, width 27⅝″. Yamato Rekishi Kan, Kashiwara Jingū, Nara.

31. HANIWA. HOUSE. This terra-cotta model represents a type of abode with two stories and a large roof of a special variety similar to those built by certain peoples of Southeast Asia. It was found on a *kofun* at Miyayama. Fifth century. Yamato Rekishi Kan, Kashiwara Jingū, Nara.

32. HANIWA. HOUSE. A house (or perhaps a shrine) with *katsuo-gi*, cylindrical shapes (originally logs) placed at right angles to the ridgepole and intended to hold the roof thatching in place. Terra cotta. Yamato Rekishi Kan, Kashiwara Jingū, Nara.

33. TRUMPET-SHAPED HANIWA. Tubes of terra cotta of a special form discovered on the *kofun* at Miyayama. Fifth century. Yamato Rekishi Kan, Kashiwara Jingū, Nara.

34. HANIWA. WARRIOR. Portrait of a warrior or a noble. Terra cotta. Found at Gumma. Fourth century. Yamato Rekishi Kan, Kashiwara Jingū, Nara.

35. HANIWA. MAN. Perhaps a portrait of a warrior. Found at Saitama Ken. Fifth century. Yamato Rekishi Kan, Kashiwara Jingū, Nara.

36. HANIWA. FALCONER. A head of a noble warrior bearing on his gloved hand a bird, probably a hunting falcon. Found on a *kofun* in the area near Gumma. Sixth century. Height 29⅞″. Yamato Bunkakan, Nara.

37. BRONZE MIRROR. The mirror was found in a *kofun*. It was made in Japan, on the basis of a Chinese model, perhaps during the Yayoi era. It is decorated with archaic Chinese characters. Kyoto National Museum.

38. HANIWA. QUIVER. Terra cotta, with *chokkomon* motifs as decoration. Height 59″. Yamato Rekishi Kan, Kashiwara Jingū, Nara.

39. WOMAN SEATED ON CHAIR. Terra-cotta statuette depicting a noblewoman seated on a uniquely shaped chair. Coiffure in rolls. Found in a *kofun* near Ōizumi-machi, Gumma Prefecture. Sixth or seventh century. Tokyo National Museum.

40. STONE BRACELETS. Discovered near Kogane Zuka. Kofun period. Osaka Municipal Museum of Art.

41. BRONZE MIRROR. Japanese mirror in bronze with a highly stylized *chokkomon* decorative motif. Found at Shinyama, Nara. Fourth or fifth century. Diameter 10½″. Imperial Household Collection.

42. HANIWA. ANIMAL. Either a dog or a bear in terra cotta. Found on a *kofun* at Sakaimachi, Gumma Prefecture. Sixth or seventh century. Tokyo National Museum.

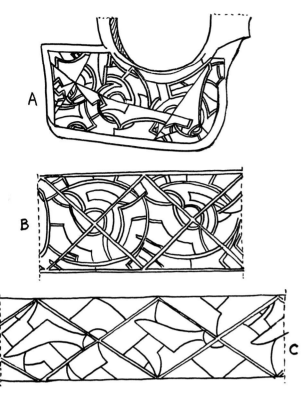

14. EVOLUTION OF THE SO-CALLED CHOKKOMON MOTIF
A. SHELL BRACELET; SHIKINZAN TOMB, OSAKA; FOURTH CENTURY. B. SARCOPHAGUS OF THE SEKIJINYAMA TOMB, FUKUOKA; FIFTH CENTURY. C. SARCOPHAGUS OF THE NIKENJAYA TOMB, FUKUOKA; SIXTH CENTURY

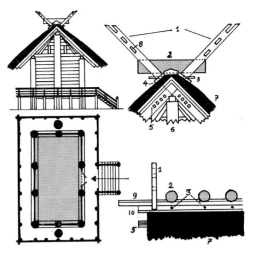

15. PLAN OF THE GREAT TEMPLE OF ISE (SHIMMEI STYLE)

1. CHIGI	6. SUPPORTING COLUMN
2. KATSUO-GI	7. THATCH
3. HINUKI	8. KAZU-KIRI
4. AFURI-ITA	9. IRAKA-ŌI
5. MUCHIKAKE	10. AFURI-ITA

43. HANAMAKI SHIKA ODORI. Statuette of painted wood depicting a dancer performing the "dance of the deer" at a Shintō festival. A type of effigy that was peculiar to the northern part of Japan. This one was found in the province of Iwate. Height 9″. R. de Berval Collection.

44. SHINBOKU. *Kami* tree whose sacred character is indicated by the *shimenawa*, or taboo cord. The shrine of Fuji-Sengen, Kawaguichi.

45. HOKKAIDO. REBUN ISLAND. TORII. From the top of the hill the shrine watches over the fishing village of Funadomari.

46. SHINTŌ SHRINE. SACRED MIRROR. Interior of the *honden* or main hall of the shrine of Shimagomo Jinja with its sacred mirror.

47. NARA. THE GREAT KASUGA SHRINE. LANTERNS.

48. OSAKA. THE GREAT SUMIYOSHI SHRINE. Barrel-shaped bridge leading to the shrine.

49. ISE JINGŪ. The interior shrine at Ise dedicated to Amaterasu, the sun goddess. It is the imperial shrine sheltering the *Yata-no-Kagami*, or large sacred mirror that is part of the imperial regalia.

50. ISE JINGŪ. A small subsidiary shrine. The supporting columns are driven deeply into the ground.

51. NAGOYA. ATSUTA JINJA. Constructed according to the traditions of Ise, this Shintō shrine (rebuilt in 1950) shelters the sacred sword of the imperial regalia. The sacred jewels are under the protection of the emperor in Tokyo.

52. OSAKA. THE GREAT SUMIYOSHI SHRINE. Principal shrine *(honden)* in the Taisha style based on the method of construction used in the Izumo Shrine.

53. NARA. ISO-NO-KAMI JINJA. A small shrine of the Nagare type.

54. OSAKA. THE GREAT SUMIYOSHI SHRINE. A subsidiary shrine built in the hollow of a *kami* tree *(shinboku)*.

55. HOKKAIDO. SHIRAOI. AINU CHIEF. A photograph of an Ainu chief in full costume, spear in hand, broadsword hung from his belt. He is posing in front of the bear skulls that face the east window of the largest cabin in the village.

56. AINU ON SKIS. This engraving, made in the nineteenth century as one of a collection of illustrations entitled *Kita Ezo Zusetsu (Images of North Ezo)*, portrays an Ainu on short skis, with spear in hand, returning from hunting or fishing. On the upper right the title reads as follows: "Image from the Extremities of Ezo Land." J.-P. Hauchecorne Collection.

57. HOKKAIDO. SHIRAOI. HOUSE OF AINU CHIEF. On the left, the entry and storeroom. The windows (this is the

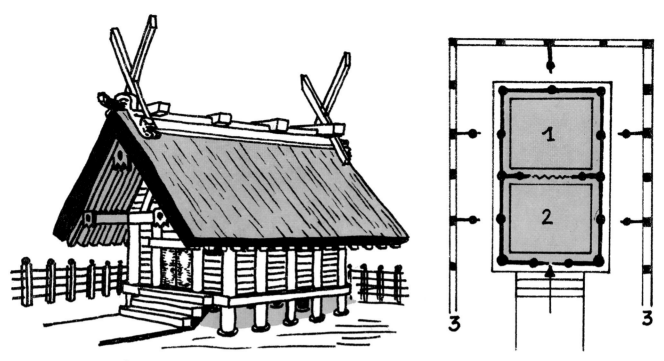

16. PLAN OF A SUMIYOSHI STYLE SHRINE: 1. SANCTUARY; 2. ANTEROOM; 3. FENCE

south side) are closed by reed screens. The roof is made of layers of rushes and reeds. These houses are very different from the typical Japanese ones.

58. HOKKAIDO. SHIRAOI. INTERIOR OF HOUSE OF AINU CHIEF. On the north wall are hung the consecrated objects, the ceremonial vestments, braids of hair, the tops of rice plants *(inabo)*, and the lacquer boxes containing the necessary utensils for the ceremonies. The dirt floor and the chair are covered with *tatami* (a modern addition).

59. HOKKAIDO. SHIRAOI. COFFIN PALL. The decorative motifs were cut from cotton cloth and appliquéd to a fabric of woven grass. Deep blue background, light blue and white appliqué.

60. AINU "MOUSTACHE RAISERS." These libation sticks are decorated with symbols the true meaning of which is unknown because modern Ainu have forgotten it. During libations of sake and the veneration of the *kamui*

of fire, the sticks serve to sprinkle the holy liquids and to hold the beards of the Ainu when they drink during these rites. They are made of hard wood. Length c. 11¾". J.-P. Hauchecorne Collection.

61. HOKKAIDO. SHIRAOI. AINU CANOE. This type of boat, called *chipu*, was formerly employed on a wide scale. The Ainu no longer make them. This one, still in good condition, is kept filled with water in order to prevent the wood from splitting when it is not used for a long time.

62. HOKKAIDO. SHIRAOI. AINU RITUAL DANCE. Three women and the chief, with a broadsword in his hand, dancing in the interior of a house. They are dressed in their ritual costumes.

63. AINU DANCES. This engraving, from the same collection mentioned in the caption for plate 56, depicts the costumes of the women for the ritual dances. J.-P. Hauchecorne Collection.

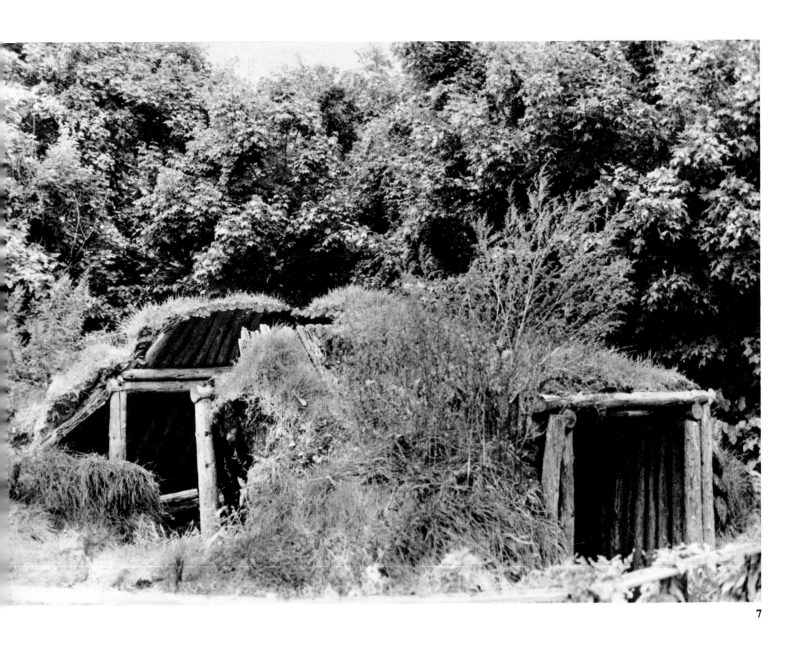

7

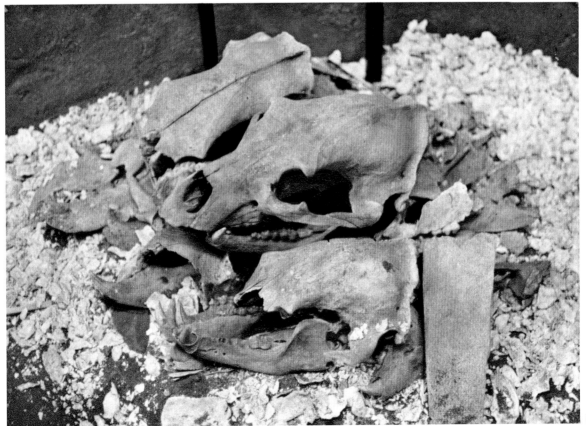

8

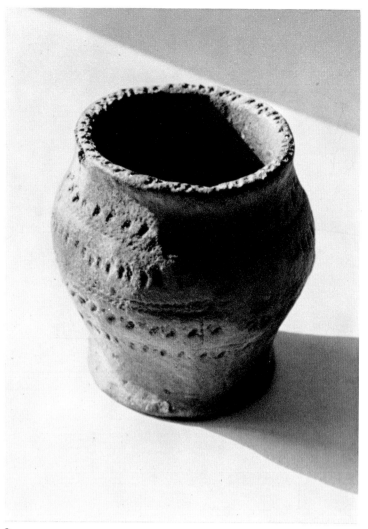

9

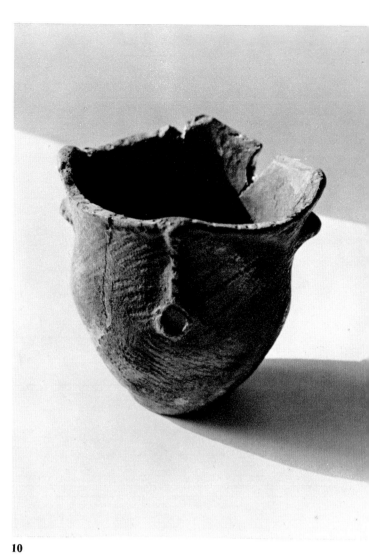

10

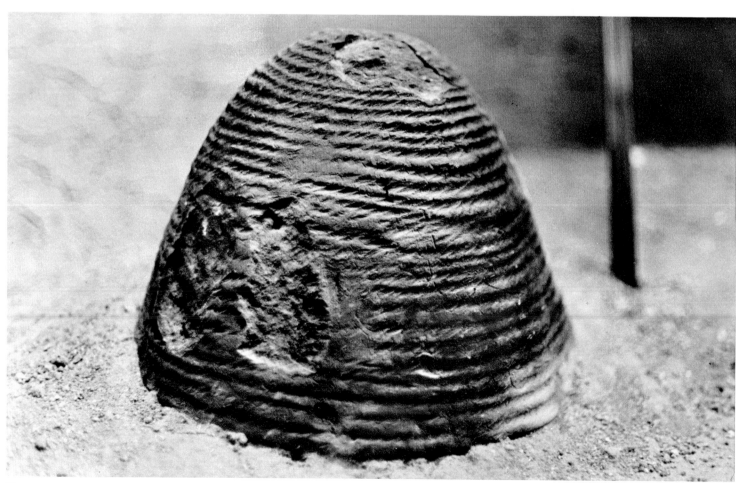

11

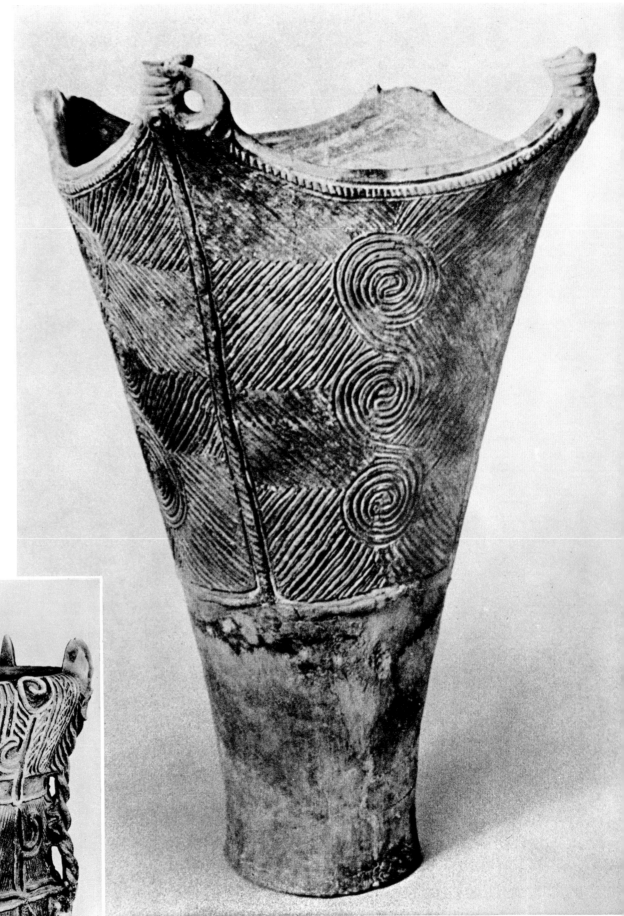

12

13

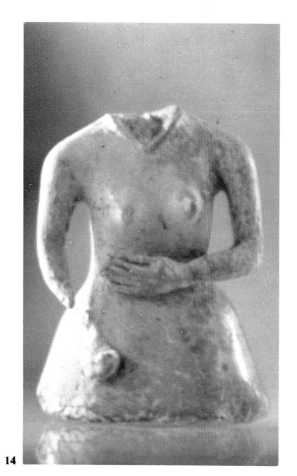

14

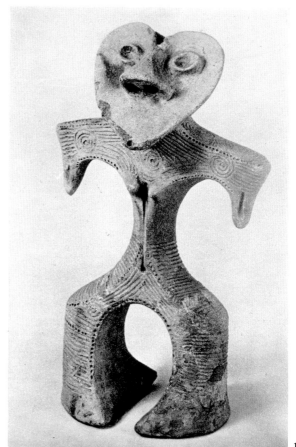

15

16

17

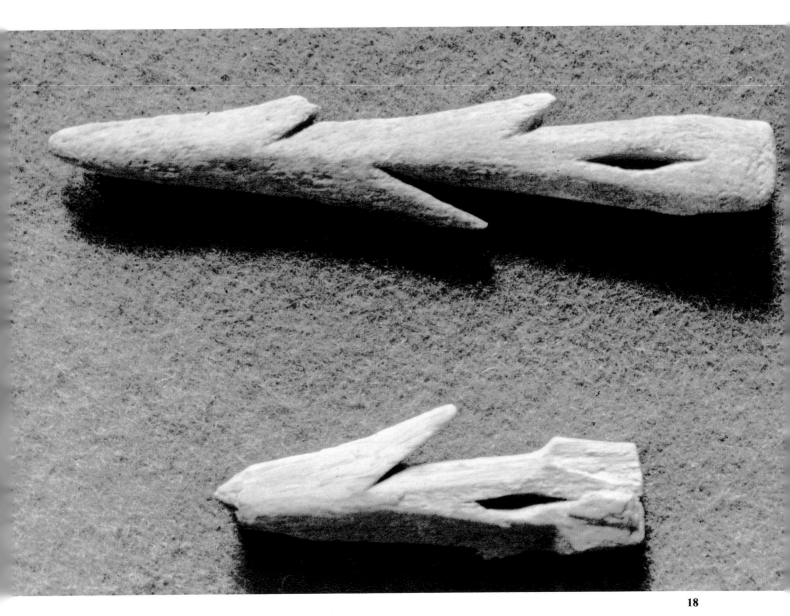

18

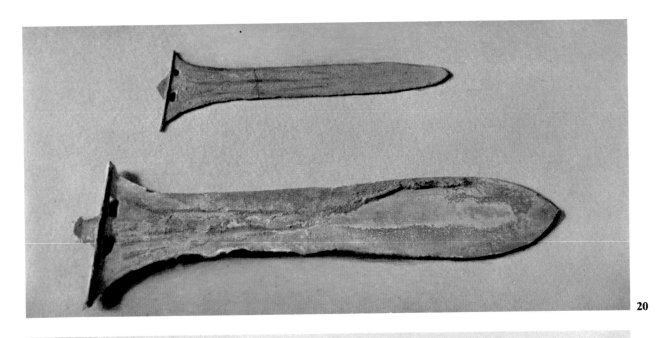

20

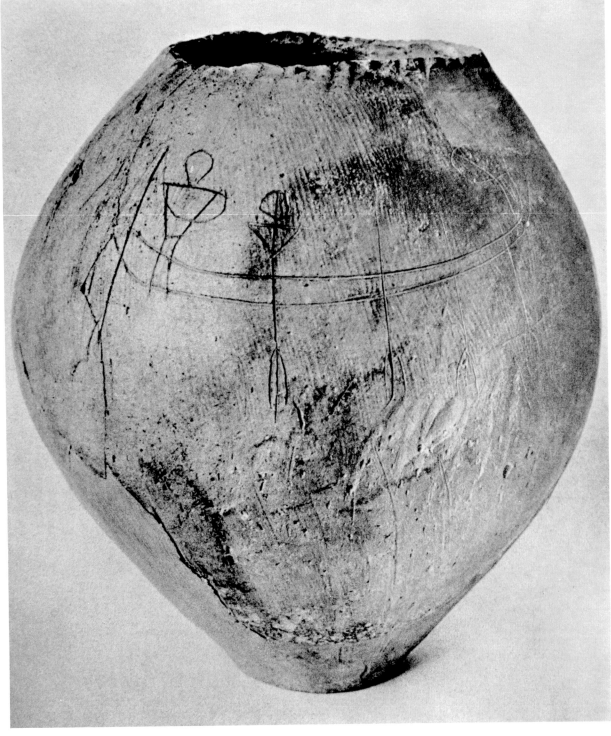

21

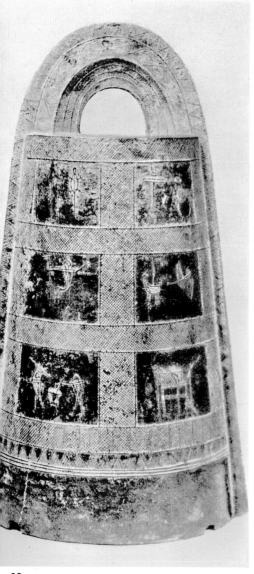

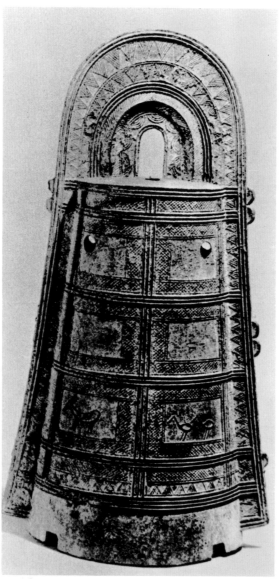

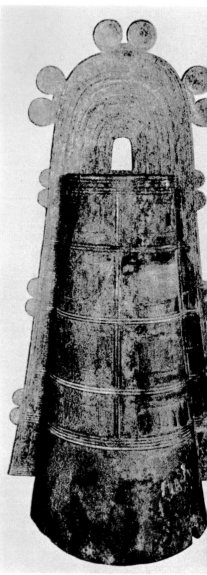

22 23 24

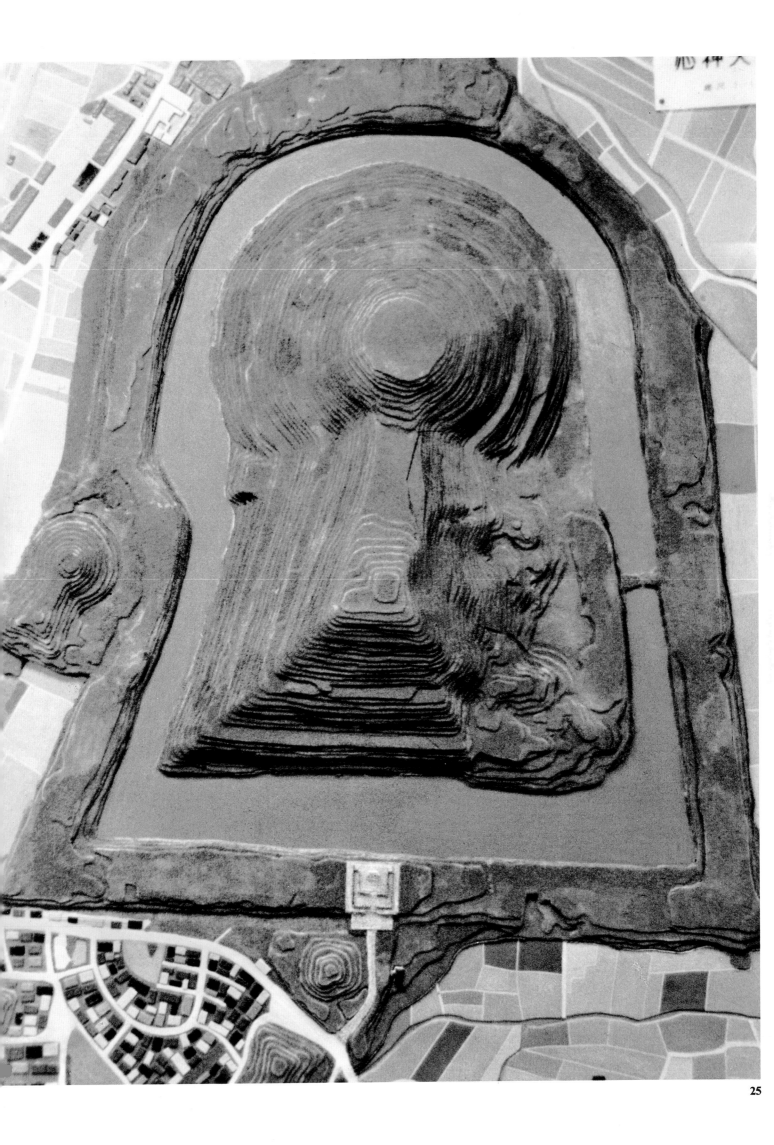

26

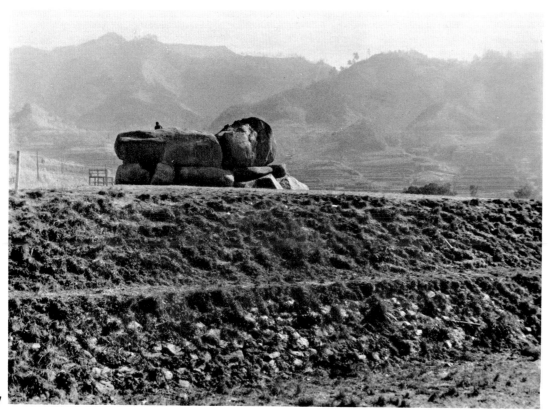

27

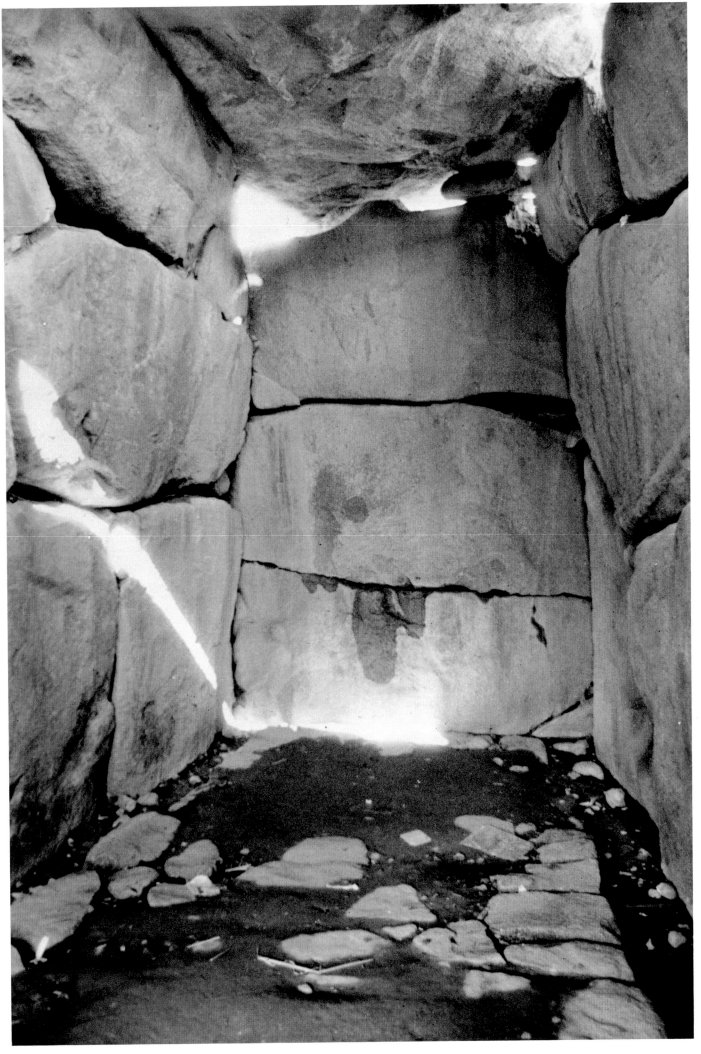

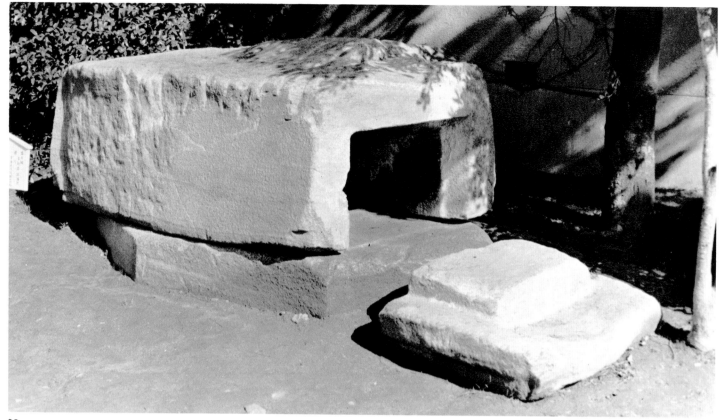

29

30

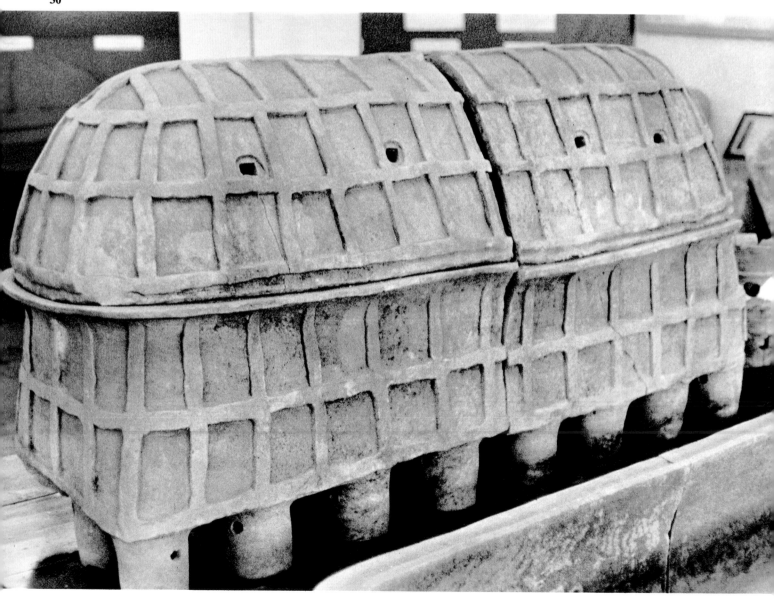

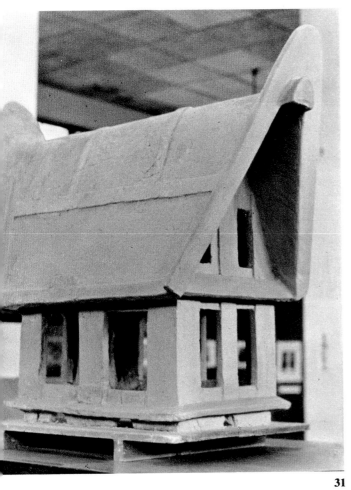

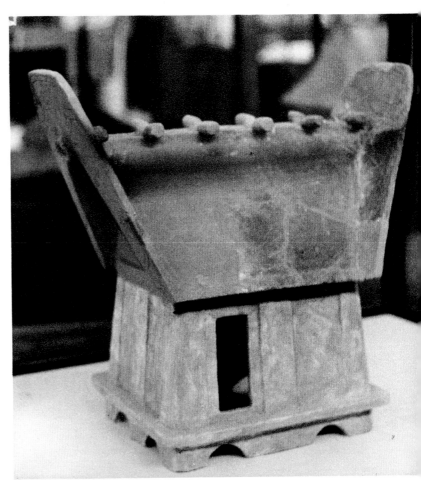

31

32

33

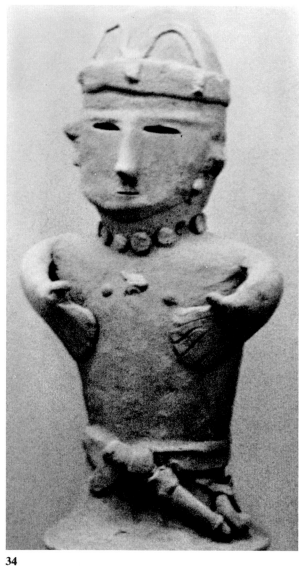

34

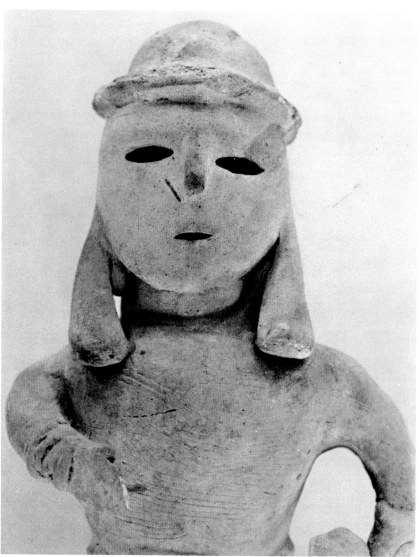

35

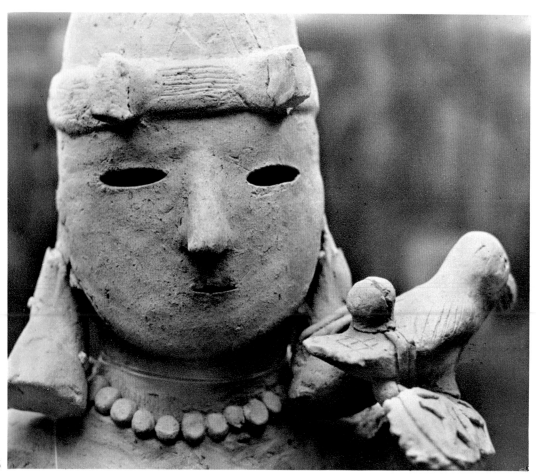

36

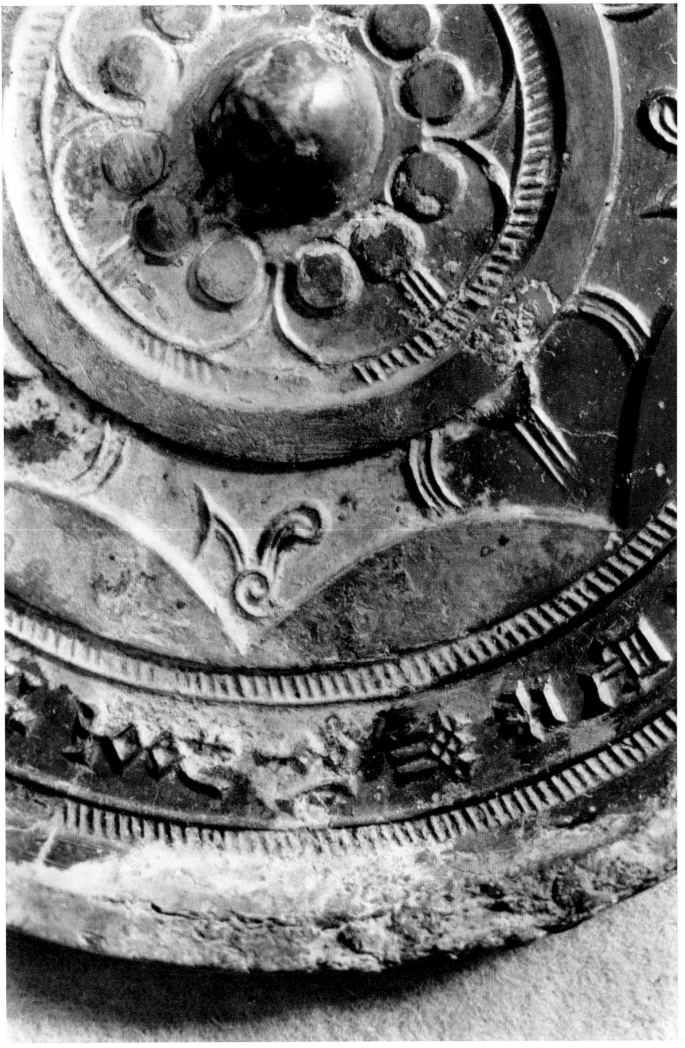

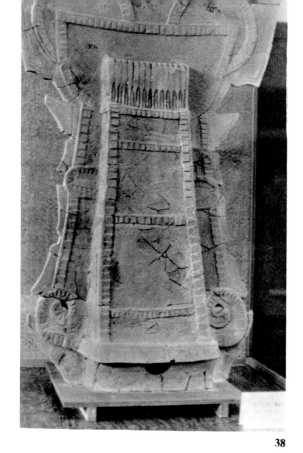

38

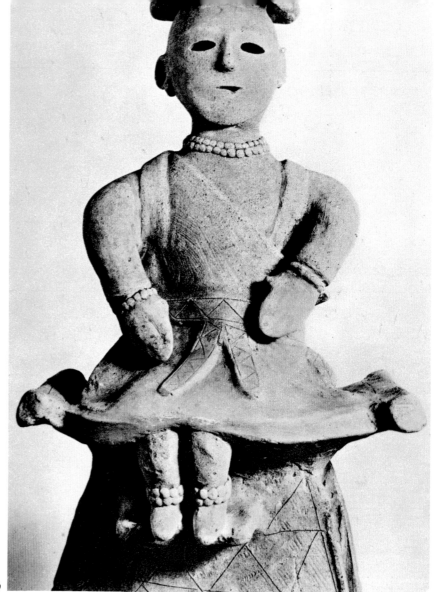

39

40

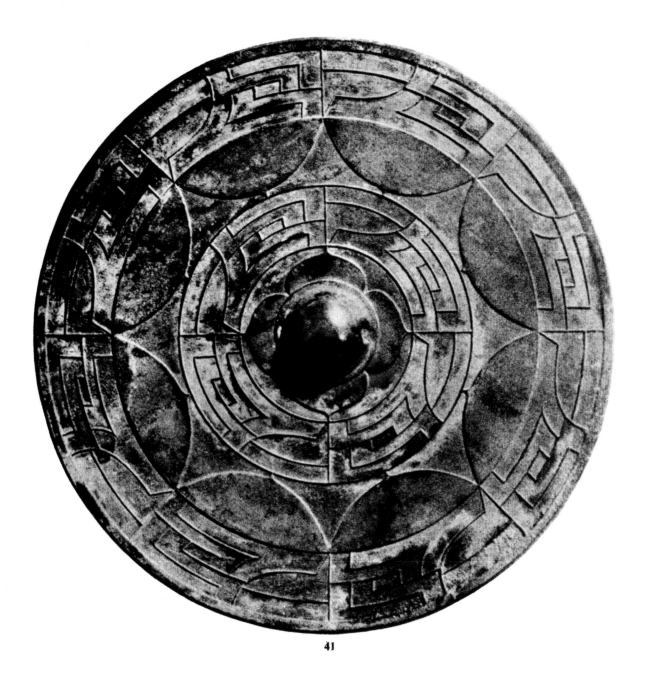

41

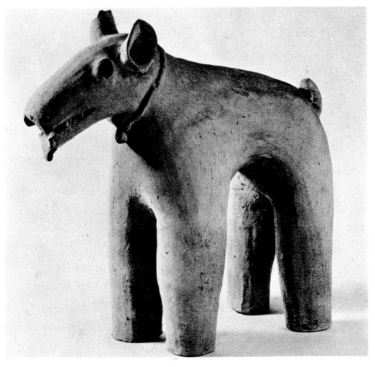

42

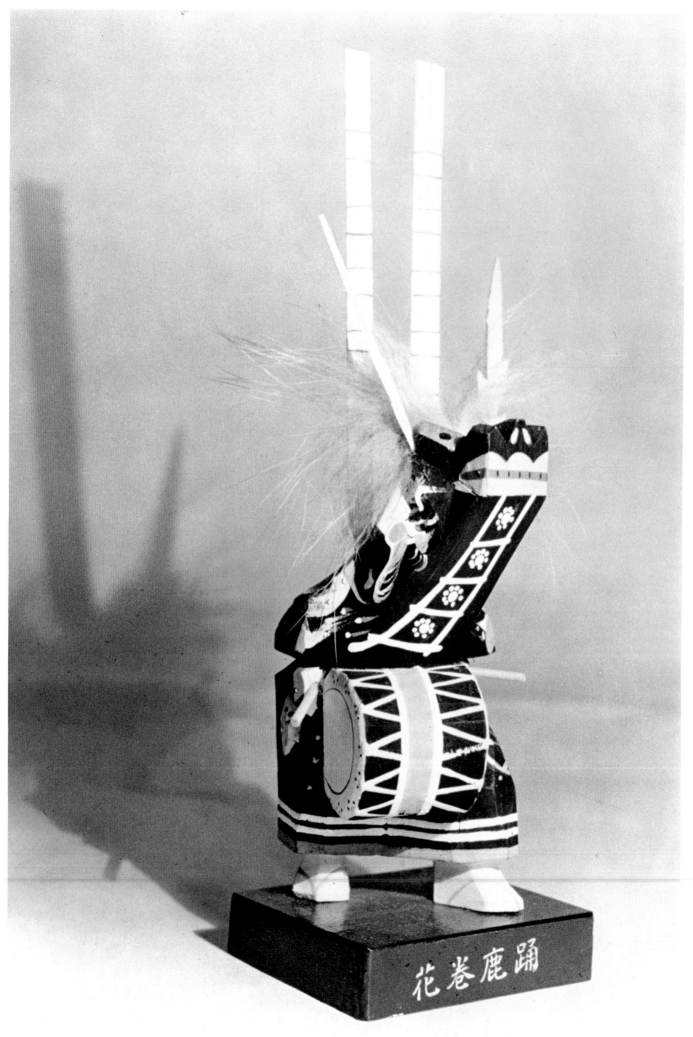

花巻鹿踊

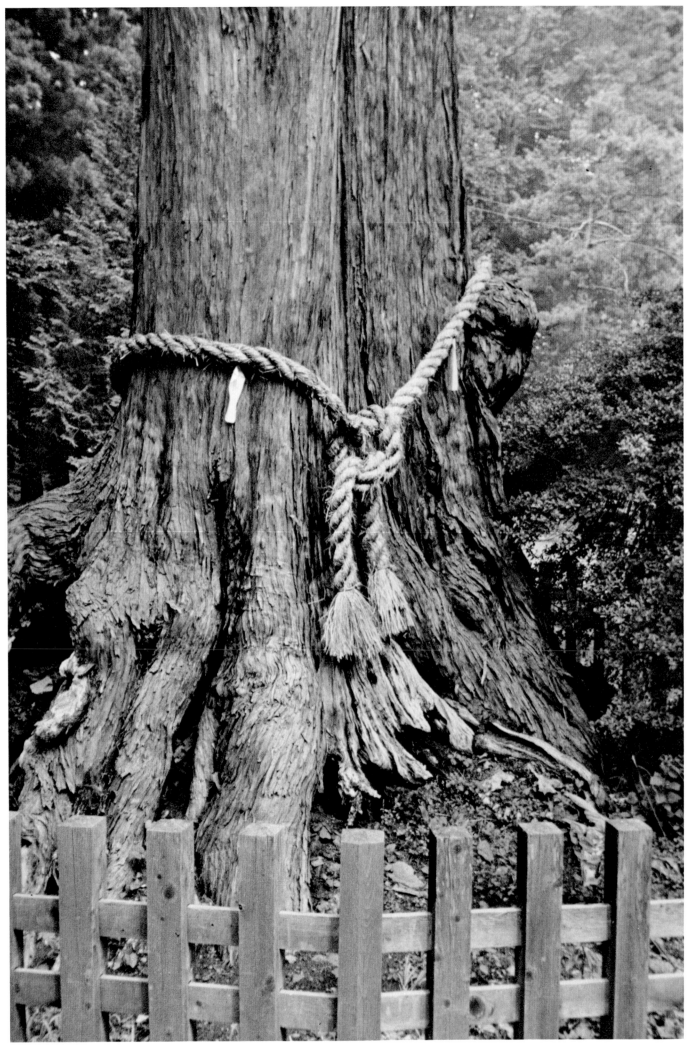

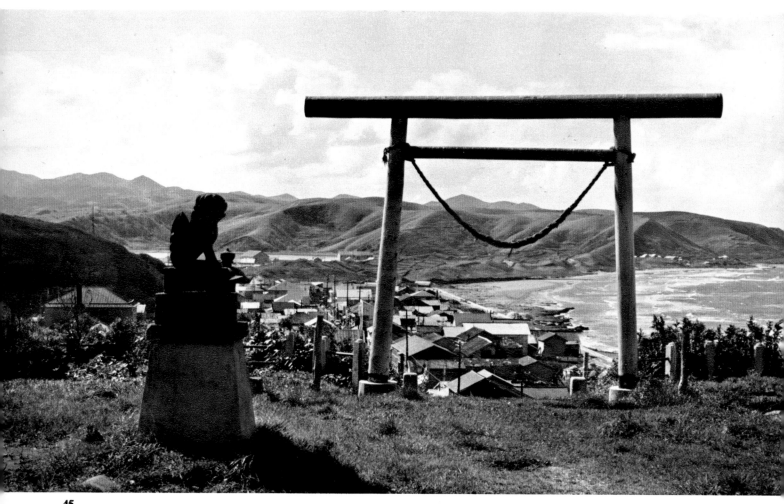

45

46

47

48

49

50

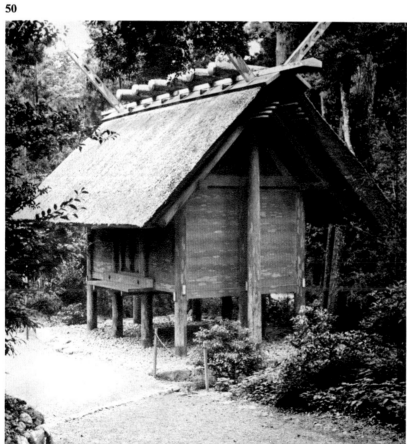

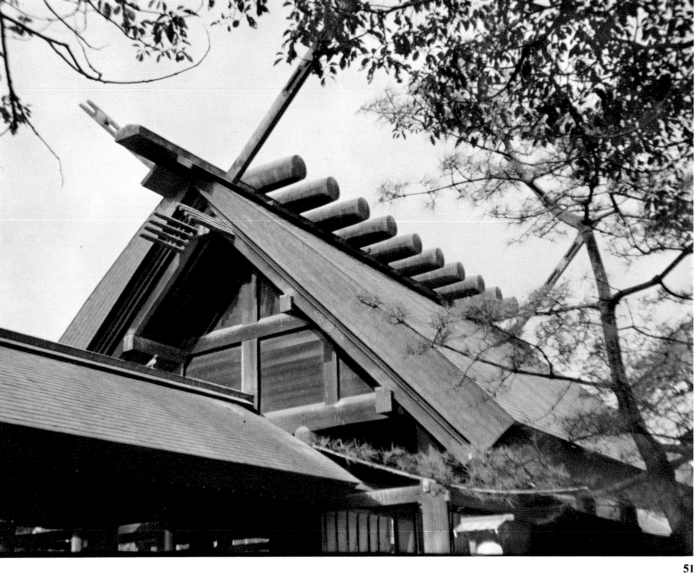

51

52

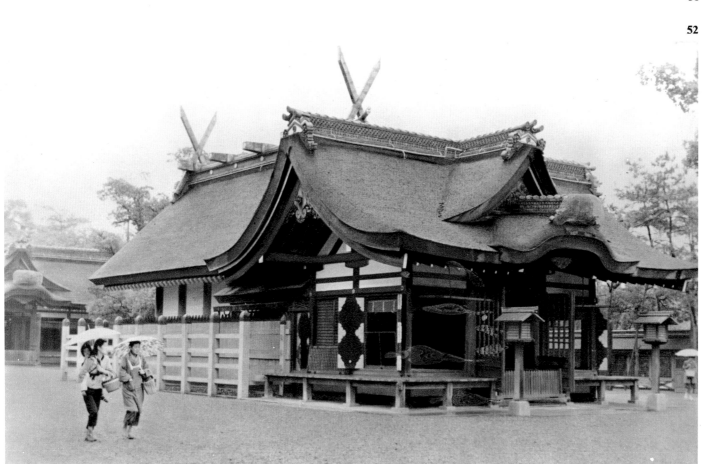

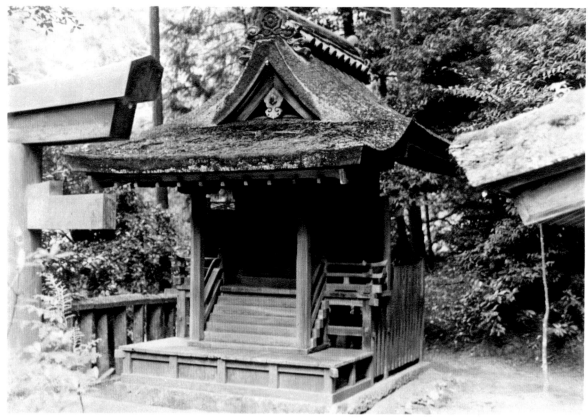

53

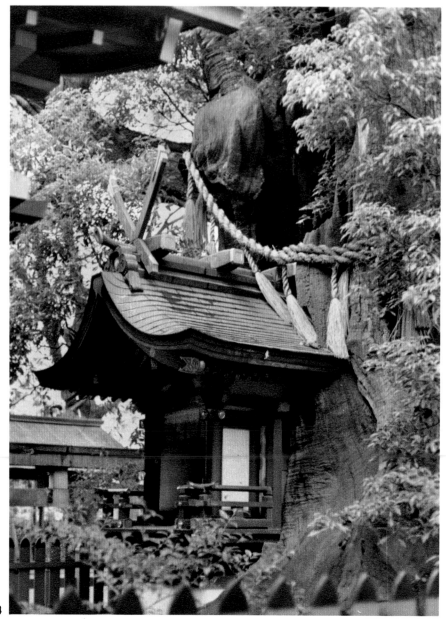

54

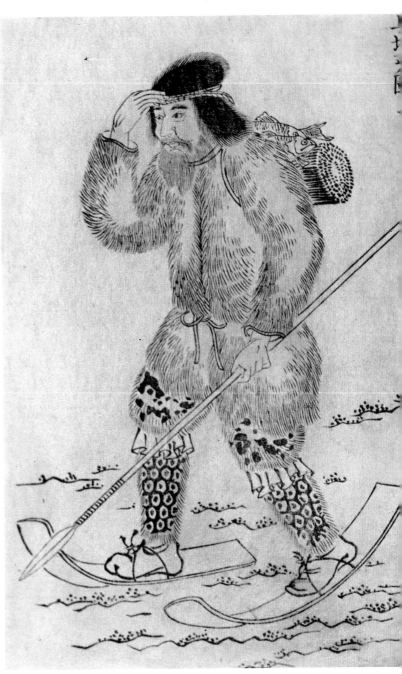

55

56

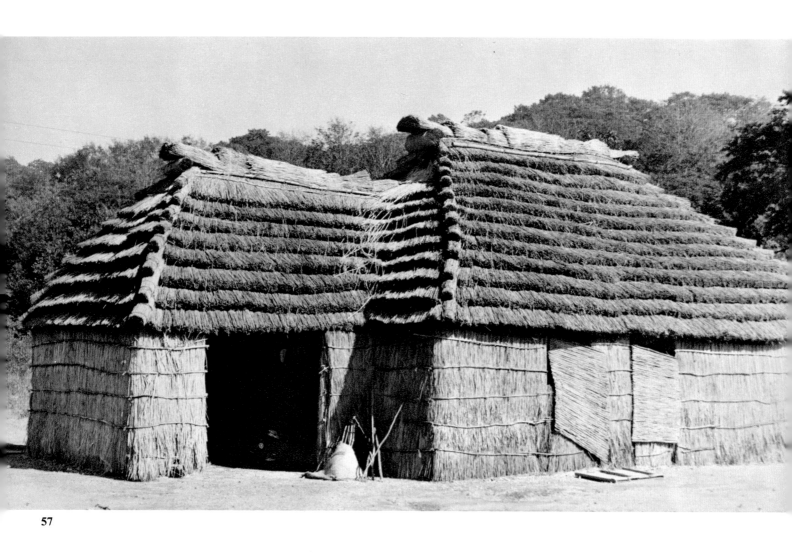

57

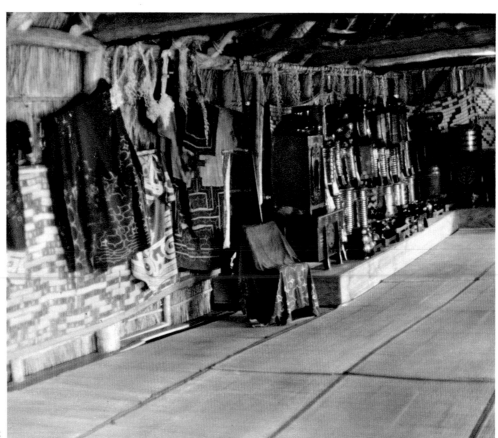

58

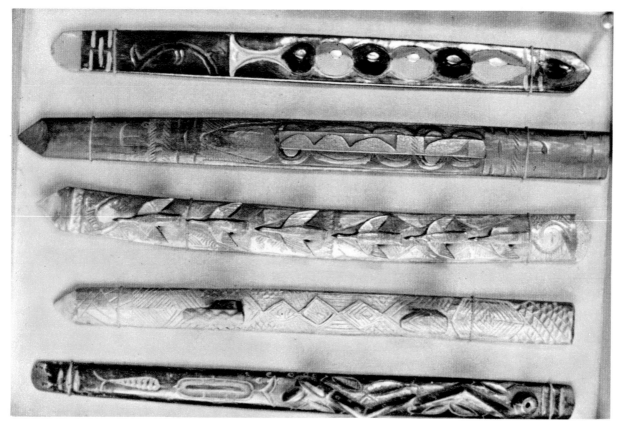

60

59

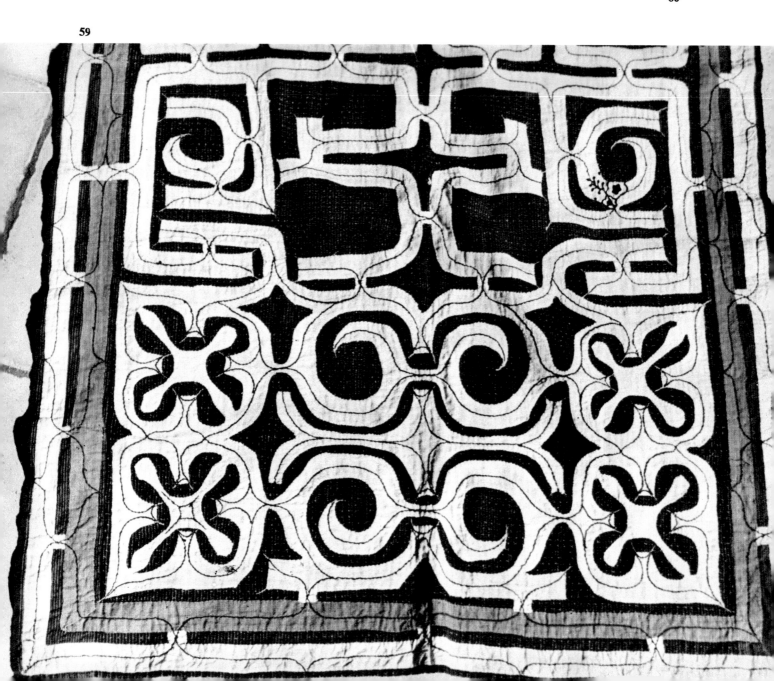

61

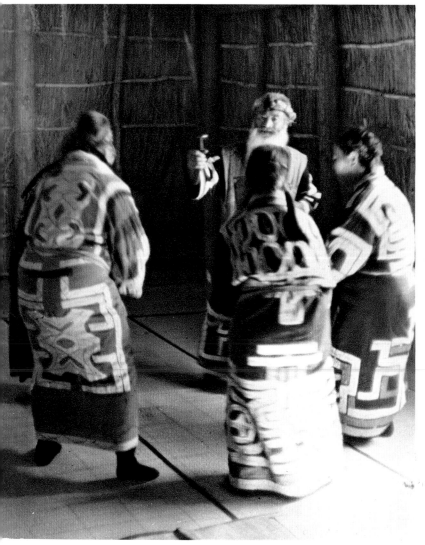

62

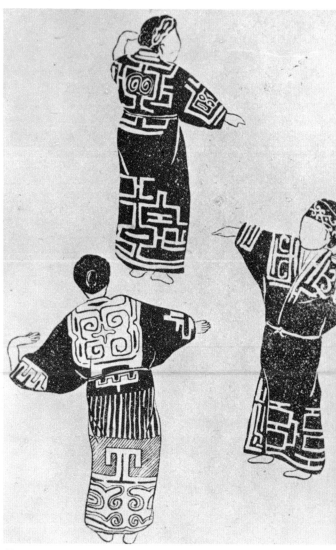

63

III. THE BEGINNINGS OF IMPERIAL JAPAN
(552–794)

THE ASUKA PERIOD (552–645)

Introduction of Buddhism

"THIS RELIGION contains the most excellent teachings, although they are difficult to know and to comprehend; even the wise men of China do not find them easy to understand. It offers infinite and immeasurable blessings and benefits and at the same time illumination. . . ."

It was more or less in these terms that the Prince of Kudara (the kingdom of Paekche in Korea) presented in 552 (or perhaps as early as 538) the Buddhist religion to the sovereign of Yamato (perhaps the Emperor Kimmei), then in his capital at Asuka (in the modern province of Nara), from whom the Prince was asking help in his struggle against his too-bold neighbor, the kingdom of Silla. Together with this letter, presented by a friendly delegation (perhaps led by Shiba Tatto, a Chinese refugee, who emigrated to Yamato in 552), were several scrolls of holy scriptures written in Chinese, a bronze image of Buddha, perhaps other images of Buddha in wood, as well as banners and other objects typical of the cult. Thus, officially at least, Buddhism, which was born in India in the sixth century B.C. and reached Korea at a late date by way of central and southeastern China, began its penetration of the Japanese islands.

It is probable, however, that this religion or fragments of its philosophical doctrines, brought by Korean and Japanese refugees from the state of Mimana, had appeared prior to this date. Yet, without official support, it had been impossible for this new faith to spread, and in 552 it probably had few supporters.

In the same year, the sovereign of Yamato sent an army to assist Paekche, but in spite of the bravery of the Japanese soldiers, Yamato was unable to prevent the defeat of Paekche by the kingdom of Silla. All hopes of the Japanese to reconquer Mimana (entirely occupied by Silla in 562) had to be abandoned.

The sovereigns of Yamato, astonished by this defeat and the power of Silla, were impressed by its organization and the efficacy of its divinities. For this reason they were anxious to bring themselves up-to-date by adopting their enemy's principles of administration, religion, and, therefore, architecture and art. Some clans were converted to the new faith, listened to the missionaries or monks, and employed the talents of the artists and artisans who emigrated from Korea after the loss of Mimana. Two opposing parties were quickly formed which plunged the country, already divided by the internecine struggles of the nobles, into even greater confusion.

The Nakatomi clan, whose leaders served as official court shamans, and the Mononobe clan, xenophobe warriors attached to tradition, revolted against the prime minister and chief of the Soga clan, Iname, who defended the Chinese reforms and the adoption of the Buddhist faith. The people passively followed the development of events and attributed their good or bad fortune to the installation or removal of a wooden Buddhist image in a shrine dedicated to the Buddha.

89

After the death of Emperor Yōmei in 587 the succession was bitterly contested by Iname's son, Soga-no-Umako, who wished to place on the throne the son of Yōmei and a Soga princess. However, the Mononobe clan saw in this move the loss of political support. The other clans formed groups according to their own particular interests, and the armed struggle began. In the same year, after the battle of Shigisen, Soga-no-Umako, the victor, massacred the entire family of Mononobe Moriya and placed his protégé, the new Emperor Sujun, on the throne. The court, together with some of the noble families, was converted to Buddhism at that point. This religion, however, was still merely a means for the clans to assert their political superiority. Soga-no-Umako quickly had Sujun assassinated and replaced him with a relative, the widow of the Emperor Bidatsu. The emperor had died in 585; his widow assumed the title of the Empress Suiko in 593.

These political maneuvers, based on the influence of the clans on the imperial family through matrimonial alliances and inaugurated by Iname, were pursued for several centuries and caused fierce rivalries and bloody civil wars. In order to establish the power of the Soga, Umako nominated as crown prince and regent another son of the Emperor Yōmei, Prince Umayado, known later as Prince Shōtoku (Shōtoku Taishi), an ardent proselytizer of Buddhism. Once the new faith had been firmly established on the throne, the Soga clan saw that its power had been consolidated. In ever-increasing numbers the other clans were won over and began to accept the new religion, at least to all appearances.

The most immediate result of this was that the country became united to a degree, at least temporarily. The central authority was reinforced and new doctrines, art, sciences, and certain Chinese administrative methods advocated by the monks were introduced into Yamato.

In the meantime in China the Sui dynasty had unified the country in 601 and officially accepted Buddhism. The sovereign of Yamato took advantage of the situation and exchanged missions with the new Chinese dynasty. At that point Sui culture penetrated Japan with examples of its art and science. Relations with Silla were reestablished, and numerous religious figures crossed the straits.

It was due to Prince Shōtoku that the principles of Buddhism were disseminated and made applicable not only to the administration but to the people as well. His "Constitution in Seventeen Articles" was issued in 604, according to the chronicles, and was the first authentic act of government. It was a statute that was to transform Yamato politically, socially, and religiously and have a profound and durable effect on the development of Japanese civilization. Some historians believe that this constitution, attributed to Shōtoku Taishi, was in fact drawn up some time after his death in 622, but it is certain, at least, that it embodied his ideas:

1. Respect Wa first of all. *("Wa" means "peace," but it also refers to Japan, because it was the name by which the Chinese knew the country. With this initial commandment Shōtoku Taishi or the authors of the constitution for the first time gave voice to a feeling of Nationalism.)* Your first duty is to avoid discord. *(An appeal to national unity.)* There are people who do not love their parents, and there are others who do not obey their masters. These people are the cause of dissension between themselves and their neighbors. If the upper class lives in harmony with even the lowest class and if the lower classes follow good counsel, everything will go well and there will be few problems that cannot be resolved. *(Here one finds not the influence of Buddhism but rather that of Chinese Confucianism and the recognition of one social class subordinated to another, confirming an already existing condition.)*

2. Venerate with whole heart the three treasures: Buddha, Dharma [Buddhist law], Sangha [the Buddhist community]. In these will be found the ideal path and the wisdom of the nation.... There are not many really bad men; all are capable of acquiring good instruction [in Buddhism]. One cannot hope, however, to correct the crooked paths of mankind without the help of the three treasures. *(With this article Buddhism was officially endorsed, which was the equivalent of making it the state religion.)*

3. Listen with reverence to imperial edicts. If the Emperor is linked to Heaven, his subjects are bound to the soil. *(A faint assertion of imperial divinity, a Shintō belief.)* With Heaven above and Earth below united in the loyal accomplishment of the functions allotted to their respective positions, we shall see the world regulated in the same perfect order as the harmonious rotation of the four seasons [a Chinese idea]. If the Earth attempts to replace the sky, the result will be a catastrophe. When the Master speaks, let his subjects listen and obey. When he sets the example, they must follow him faithfully. If they disobey, they do so at their own risk. *(At this point Shōtoku Taishi asserted the emperor's supremacy and his absolute authority.)*

4. All the nobles of high or low rank must observe the laws [of the state] as the roots of all virtue. In governing the country the first duty is to establish the law. If the upper class does not obey the law, the lower classes cannot be governed. If the lower classes do not obey the law, they commit crimes. As long as the law is observed in the relations between the upper and lower classes, perfect order will prevail and the stability of the state will be assured. *(Here one is aware of a warning to everyone, nobles included, intended to assure the authority of the state and to maintain the social order.)*

5. In hearing judiciary cases involving common people [the nobles exclusively were the beneficiaries of imperial justice], the judges must curtail their own comfort and have an aversion for their own interests. If there are a thousand cases to judge each day, how many will there be to be judged in a year? Thus there is a need of diligence [on the judges' part].

6. Our ancient sages taught us to punish the wicked and to reward the virtuous. Do not let the good qualities of anyone be hidden, or their crimes, if they are not expiated....

7. Every person has a duty to discharge, and he must do it with unfailing diligence. If wise and capable persons occupy high places, unanimous joyful voices of approval will arise, but if evil individuals occupy high places, the result will be perpetual dissension and trouble.... All affairs of state, small or great, will be carried out with ease if good people have responsible positions. This is the basis of a strong state and of the durable prestige of the dynasty. The good leaders in ancient times employed good men for the high offices and not favorites for the best places. *(This was contrary, naturally, to the then customary habit of granting important positions to the nobles of the favored clans.)*

8. Let all the nobles, great or petty, appear in their places early in the morning and let them return home late. Our public affairs are too numerous to permit anyone to settle all of them by the end of each day....

9. Sincerity is the soul of good conduct. Be sincere in each and every moment of your life. The success or failure of every work undertaken depends on your sincerity or lack of it. When masters and servants are bound by the bonds of sincerity, there is no task they cannot assume. All work will end in failure if it is not thus carried out.

10. Do not let yourself be carried away by anger. Pardon the wrathful eye. Avoid resentment if others are different from you. Each person has his own spirit and his way of thinking. If you are right, I must be wrong. I am not always a saint, and you are not always a sinner. We are both weak mortals. And who is wise enough to judge which one of us is good or evil? We are both alternately wise and foolish....

11. Make a distinction between meritorious acts and misdeeds, and reward or punish them justly. In our times merit is not necessarily rewarded, and punishment is not always true chastisement. Let the nobles, both great and petty, receive the rewards or punishment that are due them. *(Thus the law was extended to those who did not recognize it as applying to them.)*

12. The governors and rulers of the new territories [those recently conquered by the military chiefs from the aboriginal tribes who lived beyond the frontiers of Yamato] must not impose taxes on their people. In this country there are not two sovereigns, and there are not two masters to be served. There is only one lord in the person of the Emperor. Governors and officials appointed to administer local affairs must themselves be part of the people and subjects of the Emperor. *(Here we have the reaffirmation of the imperial authority not only over the people but also*

over the local governors, who often tended to believe themselves sovereigns in their territories and levied taxes for their own enrichment.)

13. All governors and officials must share their knowledge of the duties of their offices, because otherwise their absence, due to illness or a trip, could cause an interruption of official work for a certain period of time.

14. All major or minor officials must take care not to be jealous of one another. If you are jealous of others, the others will be jealous of you: thus the vicious circle is perpetuated. . . .

15. Service to the public at the sacrifice of one's own interests is the duty of a good noble. If a noble acts in his own interest, he will arouse the ill will of the people. If there is selfishness on the one side and ill will on the other, the result will be the sacrifice of the public welfare. The personal ambition of officials precludes the reign of law and order. Thus, as has been stated in a preceding article, the importance of harmony: it cannot be overestimated.

16. The ancient sages have taught us that it is wise to choose the appropriate moment for employing common people on public works. It would be profitable, therefore, to employ them during the winter months when they have free time. From spring to autumn they are busy with farming and the breeding of silkworms and cannot be commandeered. Without agriculture how could we be fed? And without the cultivation of the mulberry tree how could we all be clothed?

17. In important business never act alone according to your own judgment, but take counsel with several people. In affairs of little importance you need not take the counsel of many people. . . .

One can imagine the enormous impact that the imperial imposition of these ethical concepts must have had and the feelings they aroused. The people could only have rejoiced in such laws, which, even if they did not give them their liberty, at least loosened the shackles and alleviated the abuses imposed by the upper classes and clan chiefs. The promulgation of these seventeen articles was to condition the course of Japanese civilization. And although it is certain that the nobility did not always take into consideration the recommendations of the constitution, the people adhered to it so completely that even today the Japanese continue to observe these fundamental principles without realizing it. The people, moreover, still rather distrustful of Buddhism, began gradually to take an interest in it and were converted, because of the reforms introduced by the spirit of this new religion. One can say that the first stage in the diffusion of Buddhism among the Japanese people dates from the moment of the promulgation of the constitution and from the reforms that followed.

Shōtoku Taishi was not only a Buddhist saint: even if he was not the author of the constitution which bears his name, he was a chief of state without rival, considering the fame he enjoyed during his lifetime and the cult that has perpetuated his memory to the present day. Although missions had continued to be exchanged with the Korean kingdoms with the aim of bringing artists, artisans (carpenters, tile makers, weavers), Buddhist scriptures and works of art to serve as models in Yamato, Shōtoku Taishi never gave up hope of reconquering lost Mimana. Taking advantage of the fact that in 612 some Chinese troops sent against Koguryö had been defeated, he attempted a reconquest, but his efforts were fruitless.

All that we know with almost complete certainty about the regent is that following the Chinese example he instituted twelve degrees of nobility or rank (the beneficiaries of these various titles could be distinguished by the different colors of their caps). Shōtoku Taishi also intended to do away with the privileges of certain clans and to demonstrate that he would bestow the highest ranks on whoever might please him. These degrees of nobility were subsequently to form the nucleus of the entire administrative system of the state.

Fulfilling the vow made by his prime minister, Soga-no-Umako, Shōtoku Taishi made every effort to introduce the essentials of continental culture into the Japanese islands. He himself was a cultivated person; he had studied the Chinese classics and the Buddhist scriptures, and he

acted with intelligence and discernment. His Yamato must have seemed quite barbarian to him. He sent several missions to China with instructions to bring back knowledge of the Sui epoch in such fields as astronomy, art, architecture, and public administration, together with secular literature and Buddhist scriptures.

Ono-no-Imoko was appointed the first official ambassador from the court of Yamato to that of China in 607. He took with him a letter proudly inscribed: "The Emperor of the Country of the Rising Sun to the Emperor of the Country of the Setting Sun." Shōtoko Taishi thus placed the Japanese on an equal footing with the powerful Sui dynasty. The Chinese emperor, more than irritated by such pretensions, nevertheless received the ambassador with all honors. The ambassador returned to Yamato the following year in the company of a Chinese envoy bearing a letter beginning with the words: "The Emperor speaks to the Prince of Yamato." In his reply Shōtoku added to the honorifics of the Japanese emperor the title of Tennō—celestial sovereign— which from then on was used to embellish the names of all Japanese emperors.

Sound relations between China and Japan were thus established, and they were destined to exert a profound influence on the rising Japanese civilization. Prince Shōtoku himself devoted his efforts to the propagation of Buddhism, and he wrote commentaries on three important texts: the *Hokekyō (Saddharma-Pundarika)* or *Sutra of the Lotus of True Law*, the *Yuima-kyō* or *Sutra on the Discourses of Vimalakirti*, and the *Shōman-kyō*. They were texts which gave Buddhist examples of the doctrine of health, of the Buddhist citizen, and of the perfect Buddhist woman, and they proposed to the people a system of ethics and a pattern of conduct.

Shōtoku had several temples built by architects summoned from Korea; some of them are still in existence as admirable proof of the spirit of his government. The temple of Hōryū-ji was begun in the year the Empress Suiko ascended the throne, and it was dedicated to the memory of Prince Shōtoku's father, the Emperor Yōmei, who had first conceived the project. It was completed in 607. Prince Shōtoku was also responsible for the construction of the Shiten-nō-ji of Osaka, and the Chūgū-ji and the Hōkō-ji (begun by Soga-no-Umako in 588) to the south of the city of Nara. The prince also increased the number of charitable institutions. The chronicles inform us, furthermore, that at the time of his death there existed in Yamato 46 temples with 186 monks and 569 nuns. The doctrines followed were those of three principal sects: Sanron, which adhered to the philosophy of Nāgārjuna; Kusha; and Hossō, which was to be the essential basis of Japanese Buddhism until the return from China of Kōbō Daishi and Dengyō Daishi in 806 and 805.

Architecture

The only structures which survive from this period known as Asuka—from the name of one of the first capitals of Yamato and now only a small village to the south of Nara—are Hōryū-ji and the small portable shrine called the Tamamushi-zushi. It is not possible to assign a precise date to the present structure of Hōryū-ji, because it was almost completely destroyed by fire in 670, rebuilt shortly afterward, restored in 1439, and after another fire reconstructed in 1955. However, the principal characteristics of the structure survive: columns narrowing toward the top, simple brackets with sculpted edges, projecting curved roofs, a massive general appearance.

For the first time tile makers were employed in Japan. This craft must have been introduced from Korea at the beginning of the seventh century. The plan and arrangement of Hōryū-ji is strictly Japanese and consists of a five-story pagoda *(gojū-no-tō)* and a main hall *(kondo)* situated in the center of a quadrilateral formed by a roofed cloister in which will be found the main gate. Another plan, with buildings placed along a north-south axis (instead of an east-west arrangement), on which the Shitennō-ji of Osaka was based, was more directly inspired by the Chinese monasteries; it was perfectly symmetrical in contrast to the asymmetry of Hōryū-

ji. This simple plan was subsequently modified in order to make way for later Japanese temples. We know nothing about the styles of nonreligious structures of this period that was so fertile with innovations, yet it is possible that the palaces were built according to the principles of the Shintō shrines. The Buddhist religious edifices, on the other hand, were based on their Chinese counterparts for which one can find models both in the houses of the Han era and in the architectural examples depicted on the sculpted rocks in the caves of Yün-kang and Lung-mên in China.

Sculpture

During the thirty years of the regency of Shōtoku Taishi the country was considerably enriched not only with a new religious point of view but also with art that marked a point of departure for the development of Japan's spiritual civilization. The new religion was an inexhaustible source of inspiration for artists. It was a fount that previously had been practically nonexistent, because the shamanistic faith of Shintō—a new word, signifying the "way of *kami*," was invented at that time in order to distinguish it from Buddhism—did not approve of materialistic images of the divinities.

The new architecture, of Chinese and Korean inspiration even in the methods of construction, became the point of fusion of all the arts, which up to that time had been totally separated in Japan. The new temples displayed sculpture and painting, symbols of the cult, and embroidered fabrics, and some of the ceremonies involved music and the dance. Prior to the seventh century most of the works of art and the religious articles had been imported or made in Japan by artists who had come from Korea or China. There was, however, one famous sculptor born in Japan: Tori, the grandson of the monk Tatto, who had come from South China.

Several examples have come down to the present that are characteristic of this period. They are replete with charm and appeal, delicately modeled and illuminated with an archaic smile. They are the Far Eastern counterpart of Western early Romanesque sculpture in which the ingenuous yet profound faith of the artists is revealed. The triad of Shaka (Sākyamuni), completed in 623 in memory of the "Saintly Virtuous Prince," Shōtoku Taishi, is clear evidence, despite its conventional drapery derived from Chinese art of the Northern Wei period, of the ability of the Japanese sculptors to adapt from a given style. Other artists, such as Tori's father, Kuratsukuribe-no-Tasuna, reputed to have sculpted a monument to the memory of the Emperor Yōmei, filled the fast-growing number of monasteries with statues of Buddha. Most of the names of these artists, however, are today unknown. Other works of art arrived continuously from Korea. The *Nihon-shoki* relates that statues arrived from Koguryö (in Japanese, Kōkuri) in 562, from Silla in 579, and from Paekche in 584.

Numerous artists and architects emigrated to Japan from Paekche in 577. This wave of immigration continued during the regency of Shōtoku and even brought with it art from China. The sculpture that arrived by way of Korea generally followed the Wei style of the North (typically represented in the caves of Lung-mên in China), whereas the works that came directly from China were examples of Sui art or even of the more regional production of the southern dynasties: Eastern Ch'in, Liu Sung, Southern Ch'i, Liang, and Ch'en.

Tori, however, created a style that was peculiarly his own. It was characterized by a rigorous frontality, an overall symmetry inscribable within an isosceles triangle, a certain disproportion (probably intended, rather than due to a lack of ability) of the hands and head in relation to the whole, and the appearance of imposing dignity. Among the sculptures that are most representative of Tori's style, aside from the bronze triad already mentioned, are the seated figure of Yakushi Nyorai, dated 607 (also in bronze), in the Kondō of Hōryū-ji; the fifty-one statuettes of the group known as Shijū-hattai Butsu (forty-eight images of Buddha, in bronze)

now in the Tokyo National Museum; another triad in bronze, dated 628, also at Hōryū-ji; and the Guze Kannon, now in the Yumedono (Hall of Dreams) of Hōryū-ji.

Shortly before 645, two other styles made their appearance. One of them is represented by a wood statue known as the Kudara Kannon, now at Hōryū-ji; it was probably imported, as its name indicates, from Korea, and it seems to be typical of Sui art. The second style is epitomized in two statues of figures seated in meditation (right ankle on the left knee), reputed to be representations of Miroku Bosatsu (Maitreya), now at Chūgū-ji and Kōryū-ji. They are extremely realistic, characterized by extraordinary gentleness, and were probably imported from Silla in Korea where numerous examples of such sculpture existed at that time. In addition there is a series of statuettes of wood covered with gold leaf, known as the Six Kannon and now at Hōryū-ji, which are clearly of the first style. We have a few examples of the second, but it is impossible to say whether they were made by Japanese or by Korean sculptors. Their drapery is more flexible than that of the preceding styles, but the faces still bear that archaic smile that links them to the Asuka period.

According to the *Nihon-shoki*, masks employed in the dance, called *gigaku*, arrived from Paekche in 612. It is probable that the majority of Japanese theatrical masks were subsequently derived from those imported models, and some of them have a certain relationship to the style of sculpture of the Asuka era.

The bronze sculptures were usually covered with gold leaf, whereas the works in wood were gilded—over a special undercoat based on calcium carbonate—and painted. All were embellished with ornaments—crowns and necklaces—of gilded metal that were delicate and valuable masterpieces of the metalworkers' art.

In brief, sculpture of the Asuka period is distinguished by an archaic smile, a symmetrical silhouette triangular in shape, a deliberate disproportion of the hands and face, a relatively rigid concentration on a frontal pose, an almost Gothic lengthening of the bodies of the standing figures, almond-shaped eyes under eyebrows that almost meet, an elongated and rectangular face, and stylized hands with long fingernails.

Painting

The painting of the Asuka period is characterized most of all by its decorative elements. The first instance in which the name of a painter has been preserved seems to be that of Hakuga, an artist who came to Japan about 588, probably from Korea. The chronicles of the reign of the Empress Suiko mention the master artists from Kibun, Yamashiro, Suhata, Kawachi, and Nara, to whom were given the names of Yamato-no-Aya-no-Maken, Aya-no-Nukakori, Komo-no-Kasei, and so forth. We have no knowledge of their style or of their works, with the exception of a few fragments of a tapestry woven at the time of the death of Shōtoku Taishi and now still preserved at Chūgū-ji.

These artists were probably foreigners. The last three names mentioned are traditionally regarded as those of the artists who designed the cartoon for the tapestry. One can perhaps attribute to them as well the paintings that adorn the pedestal and doors of a portable wooden shrine or tabernacle called the Tamamushi-zushi, originally decorated with the wing cases of a certain variety of beetle *(Chrysochroa elegans)*. This work can probably be dated prior to 645 and is preserved at Hōryū-ji.

The style of the paintings is related to that of China and Central Asia of the same epoch. The decorative elements are painted in a conventional fashion, whereas the figural images are treated more freely. The figures are all of the same size (there is no perspective), a dominant feature that will reappear at a later date in the figural compositions of Japanese illustrated scrolls.

The End of the Asuka Period

Shortly after the death of Shōtoku Taishi, Soga-no-Umako also disappeared from the scene, and his son, Emishi, succeeded him. With the death of the Empress Suiko in 628, Soga-no-Emishi placed on the throne a grandson of the Emperor Bidatsu, Jomei, who died in 641. Once again the Soga clan named as empress one of Bidatsu's grandchildren, named Kōgyoku. These successions did not take place, however, without a series of crises, and the Soga clan did not hesitate an instant to assassinate its adversaries, one of whom, Yamashiro-no-Ōe, was one of Shōtoku Taishi's sons.

Emishi, moreover, appointed his own sons to the highest offices, a fact that quickly led them to become tyrants. The power of the Soga clan was then incontestable, but the extortions exacted by Emishi and especially by his son, Iruka, aroused such resentment among the nobles that a conspiracy led by the Nakatomi clan—which had been ousted by the Sogas—and Prince Naka-no-Ōe resulted in 645 in the assassination of Iruka and the deposition of the empress. In place of the empress another grandchild of Bidatsu, Prince Karu, was chosen, and he became the Emperor Kōtoku. In China the T'ang dynasty in 618 had succeeded the Sui, and in 645 its army prepared to attack once again the state of Koguryö, thus following the policy of the Sui and menacing Japanese security.

Japan, in spite of the introduction of the new doctrines, had not yet had time to organize its forces and thus remained a primitive state in which disputes were settled in a brutal fashion. Civilization had merely grazed it. Yet the appearance both of new philosophies and new techniques had left a profound impression on its spirit. At that point it was necessary to organize the state according to new principles and, above all, to speed reforms. Laws had to be applied in accordance with the new spirit. The imperial party was not sufficiently armed to be able to enforce the law, because it was only one clan among many. Nakatomi-no-Kamako, the founder of the Fujiwara family and adviser to the Emperor Kōtoku, was the man who, through a series of reforms, was destined to impose the law of the imperial clan on the entire country and to build the new Japan.

64. NARA. OVERALL VIEW OF HŌRYŪ-JI. One sees here the temple complex, dating from the beginning of the seventh century, which is the most ancient one surviving today. The main complex is surrounded by a cloister-gallery with various entrance gates. In the center of the area enclosed by the gallery are a five-story pagoda and the Kondō (main hall); around them are buildings of a later date.

65. NARA. HŌRYŪ-JI. KONDŌ. The construction of the temple was completed by Prince Shōtoku in 607. The Kondō caught fire in 1949 and its wall paintings were partly destroyed. The Kondō (height 59', length 29½', width 24½') houses the famous bronze triad of Shaka, the work of the sculptor Tori. The tile-covered double roof is supported by twenty-eight columns with a slight entasis. The *mokoshi* (roofed porch) directly above the foundation is probably an addition made at a slightly later date. The interior of the Kondō was decorated with wall paintings (see plates 103–6) related in style to those of Ajanta in India. One can assume that this building was the work of architects brought from Korea by Prince Shōtoku. The pagoda is on the right; one can see a corner of the roof of its first story in the photograph.

66. PRINCE SHŌTOKU. A portrait on silk, very faint in coloring, and in the style of a Buddhist triad, depicting Prince Shōtoku with one of his brothers, and his son, Yamashiro-no-Ōe. This detail portrays the prince with his younger brother, Eguri. The dress is typical of the T'ang period in China. This posthumous portrait probably dates from the beginning of the Nara period (middle of the seventh century). Imperial Household Collection.

67. NARA. CHŪGŪ-JI. THE PARADISE TAPESTRY. This piece of tapestry, now in poor condition, is preserved at Chūgū-ji near Nara. The cartoon was perhaps the work of Komo-no-Kasei and Yamato-no-Aya-no-Maken, who were court painters. This embroidered mandala might have been commissioned in 622 by Princess Tachibana-no-Ōiratsume in memory of her husband, Prince Shōtoku. Its characteristics are more Chinese or Korean than Japanese. Since only a part of the work survives, it is impossible to imagine its original appearance. It has been suggested that it depicts Paradise *(Tenjukoku)*.

68. OSAKA. SHITENNŌ-JI. GOJŪ-NO-TŌ. This temple complex was built by Prince Shōtoku in 593. It has been devastated by fire on numerous occasions, and the present structure is a reconstruction undertaken after 1945. On the left one can see corners of the roof of the Kondō.

69. NARA. HŌRIN-JI. SANJŪ-NO-TŌ. The three-story pagoda of Hōrin-ji, which is a subsidiary temple of Hōryū-ji and situated to the north of it, was erected in 622 on order of the eldest son of Shōtoku Taishi. It

dates, therefore, from the end of the Asuka or the beginning of the Nara period.

70. A CORNER BRACKET OF THE ASUKA PERIOD.

71 and **74.** NARA. HŌRIN-JI. BOSATSU. This camphor-wood sculpture in the Kondō of Hōrin-ji is said by the monks of the temple to be a portrait of Kozūkō Bosatsu (the Bodhisattva Ākāshagarbha), although it appears to be that of Kannon (the Bodhisattva Avalokiteshvara). It is undeniably Asuka in style, although quite different from the Kudara Kannon with its extremely slender forms. This Japanese work seems to have been influenced not so much by Korean as by Chinese art: the smile does not have the archaic character typical of Korean sculpture of the period, and the treatment of the eyelids is similar to that of Chinese sculpture. There is no trace, moreover, of the furrowed neck so characteristic of Buddhist art. The taut treatment of the lines of the face would lead one to believe that this work was executed as a model for a bronze statue. The halo, of the same type that adorns the head of the Kudara Kannon, is less elaborate, however. Altogether, one finds here the hand of an artist less familiar with his subject and less free in his technique. It is, nevertheless, a very beautiful and majestic work, slightly reminiscent of Western Romanesque art. The crown and jewelry that must have adorned this statue have disappeared, leaving only traces of their mounting. The head and torso were restored at a later date. Height 69½".

72–73. KYOTO. KŌRYŪ-JI. MIROKU BOSATSU. This work, a copy of contemporaneous Korean statues, was derived from the Silla style which, in turn, was close to the Chinese style of the Northern Ch'i Dynasty (see, for example, the seventh-century Maitreya of gilded bronze from Silla, now in Toksu Palace in Seoul). This work was probably commissioned by Prince Shōtoku, who presented it to the founder of Kōryū-ji, Hata-no-Kawakatsu. It most likely portrays Maitreya in a meditative pose (right ankle on the left knee) which was characteristic of the style employed by the Korean and Japanese sculptors at the beginning of the seventh century. The concentration on the frontal is evident. The disproportion of the head, however, is barely noticeable. The treatment of the drapery imitates that of bronze statues. It was probably the translation into wood of a prototype in metal. The base is unusually shaped. The headdress was sculpted in such a way as to support a metal crown, which has disappeared together with necklaces, affixed with nails, that must have adorned the chest. Originally, the statue was lacquered and gilded; a few traces remain. It was restored more or less successfully on several occasions (legs, knees, fingers, cheeks, nose, lips). The figure and base were carved from a single block of pine, hollowed out at the back. Height 48½".

75–76. NARA. CHŪGŪ-JI. MIROKU BOSATSU. This very

97

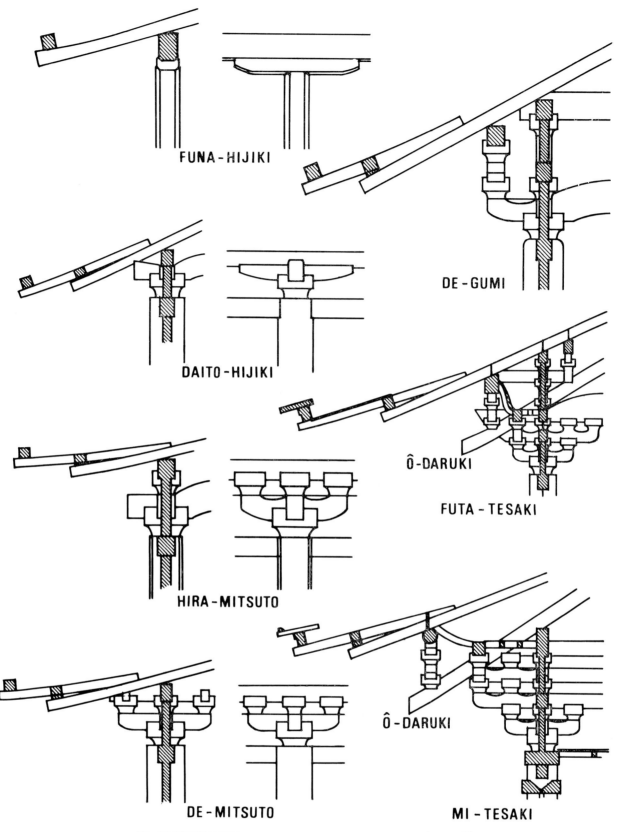

FUNA-HIJIKI

DAITO-HIJIKI

DE-GUMI

HIRA-MITSUTO

Ô-DARUKI

FUTA-TESAKI

DE-MITSUTO

Ô-DARUKI

MI-TESAKI

17. PRIMITIVE EVOLUTION OF THE JAPANESE BRACKET (TO-KYŌ)

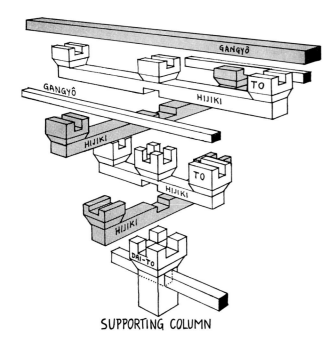

SUPPORTING COLUMN

18. ANALYTICAL ILLUSTRATION OF THE MOUNTING OF
A SIMPLE BRACKET

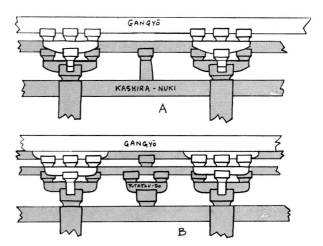

19. TWO TYPES OF ENTABLATURE BETWEEN BRACKETS:
A. AMA-GUMI; B. TSUME-GUMI

beautiful statue, characterized by suppleness and flawless technique, is one of the most remarkable works of the Asuka period. The carving is even more excellent here than in its counterpart at Kōryū-ji (plates 72–73). In fact, there is a great difference in style between the statues. This one raises a problem concerning its origin: was it executed in Japan or Korea? The treatment of the face, the hands, and the feet reveals great ability, and as a whole it suggests bold stylization. The folds of the drapery, which fall down over a very high circular pedestal, are both realistic and conventional, especially since the work is conceived in two main parts, one on top of the other: the lower is symmetrical, the upper magnificently irregular. The coiffure with a double chignon and the eyes with lowered eyelids give the face a strange charm. The decorative motifs were either carved from a block of wood (the pendants of the crown and the hair spread out on the shoulders) or added separately (the halo reminiscent of a flame-shaped jewel). The other ornaments (the crown itself, necklaces, bracelets) have disappeared, leaving only traces of the nails that fixed them in place. The pedestal is so high that the left foot rests on a raised lotus flower. This masterpiece was not carved from a single block of wood, as seems to have been the custom in the Japan of the Asuka period, but from several pieces that were skillfully mounted (*yosegi* technique). The halo, or *kōhai*, behind the head is supported by a wooden pole. It must be admitted that, if one compares this work with those of the same epoch still surviving in Korea, one must agree that its style is incomparably superior. In other words, this is a typically Japanese sculpture and the work of an unknown genius. The present color of the statue is black, and it is impossible to say whether or not it was originally lacquered and gilded. It is

made of camphorwood. The name Nyoirin Kannon has been given to it at times, but it is not known for what reason or according to what tradition. Height 52⅜″.

77. NARA. HŌRYŪ-JI. GUZE KANNON BOSATSU. This magnificent portrayal of Kannon Bosatsu (the Bodhisattva Avalokiteshvara) is in the Yumedono (an octagonal pavilion) of Hōryū-ji. It was carved from a single block of camphorwood, and originally covered with gold leaf applied over a thin coat of *gofun* (calcium carbonate). It is a typical work of the Asuka era, although it has distinct characteristics derived from the sculpture of the end of the Northern Wei period in China. The halo, for the most part of camphorwood, is held in place by a metal support attached to the back of the head. The symmetrical quality and the S outlines are characteristic of Japanese sculpture of this period. The work possesses, however, some new elements: the three "beauty bands" *(sandō)* around the neck, the unreal stylization of the hair falling to the shoulders, the position of the hand uncovering a *hōshu*, or sacred gem *(mani)*. The metal crown, remarkably well preserved, is a fine example of the metalworkers' skill at the time. The general style reflects an imitation of bronze sculpture. The sculptor is unknown, but the work clearly seems to be in the style of Tori who, according to tradition, should have executed it as a portrait of Prince Shōtoku. It was installed in the new Yumedono, built in 739 to replace the one in which the prince was accustomed to meditate. The pedestal is a simple *renniku*, or upside-down lotus flower with a double row of petals. Height, including base, 82¼″.

78. NARA. HŌRIN-JI. YAKUSHI NYORAI. Of similar style and characteristics as the Bosatsu belonging to the same temple (plates 71, 74), this work, if not by the same sculptor, was at least of the same school and must have been carved at the same time. The resemblance of the heads is, in fact, quite striking, as is the treatment of the clothing in thick and rigid folds. The statue

99

was carved from a single block of camphorwood, and only the curls of the coiffure were added separately. A halo in the form of a *hōshu* was placed behind the head of this representation of Yakushi Nyorai (the Buddha of Healing), which must have held a medicine jar in its left hand. The wood originally must have been covered with a base of *gofun* and then painted or gilded.

79. NARA. HŌRYŪ-JI. BOSATSU. A statue belonging to a series entitled Six Bosatsu in Wood and portraying perhaps Gakkō Bosatsu, the lunar Bodhisattva. Carved from a single block of wood. The ornaments and hair were modeled in lacquer. End of the Asuka period. Height c. 31½″.

80. NARA. HŌRYŪ-JI. CELESTIAL ATTENDANT. Of painted wood, this figure is an ornament of the canopy above the dais in the Kondō (main hall) of Hōryū-ji. Of special note is the widely separated double chignon. Height 6¾″.

81. NARA. KINRYŪ-JI. BOSATSU. Small statuette portraying a Bosatsu (Bodhisattva), carved in wood and painted. The two knots of the chignon of the figure shown in plate 80 are here joined and thus anticipate the "eggshell" headdress of the statuette in plate 82. The present one is more unified in form and therefore most probably belongs to the transition period between the Asuka and Hakuhō eras (c. 650). Height 18¾″.

82. NARA. HOKKE-JI. KANNON BOSATSU. A small statuette of gilded bronze that was cast as a solid block and then chiseled and engraved. Roughly enclosable within an isosceles triangle and emphatically frontal in its presentation, this little figure is quite typical of the Asuka style. It was inspired perhaps by Chinese works and anticipates the style of the Guze Kannon shown in plate 77. Height 9″. Nara National Museum.

83. NARA. KŌNODERA. MIROKU BOSATSU. Cast in iron, this statuette imitating Korean models bears a curious coiffure shaped like a stupa from which emanate the rows of curls. The style is rather rough and very stiff, which may have been due to the type of metal employed. It dates, perhaps, from the beginning of the Asuka period. Height 10″. Nara National Museum.

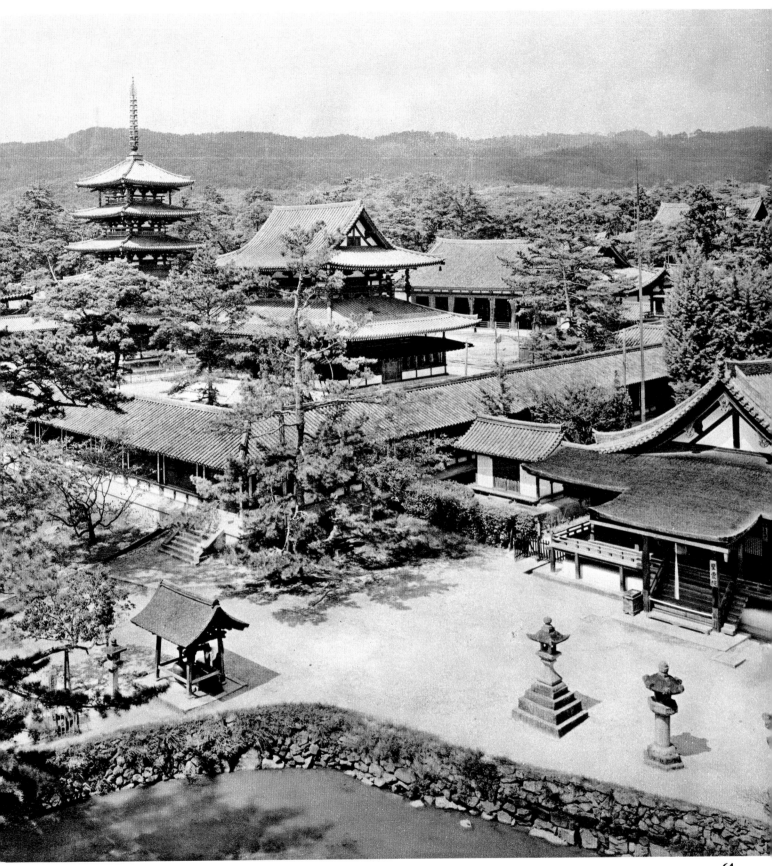

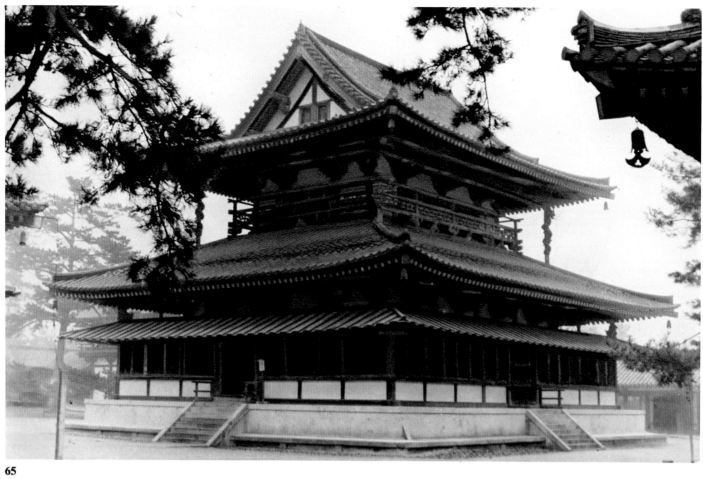

65

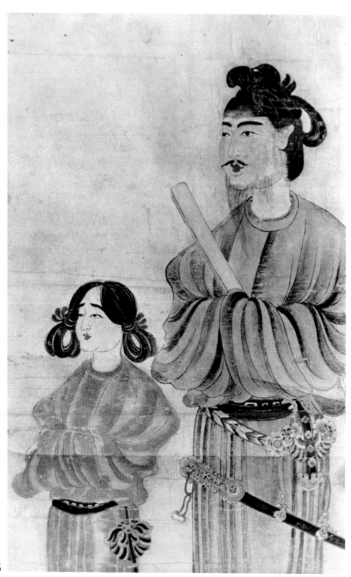

66

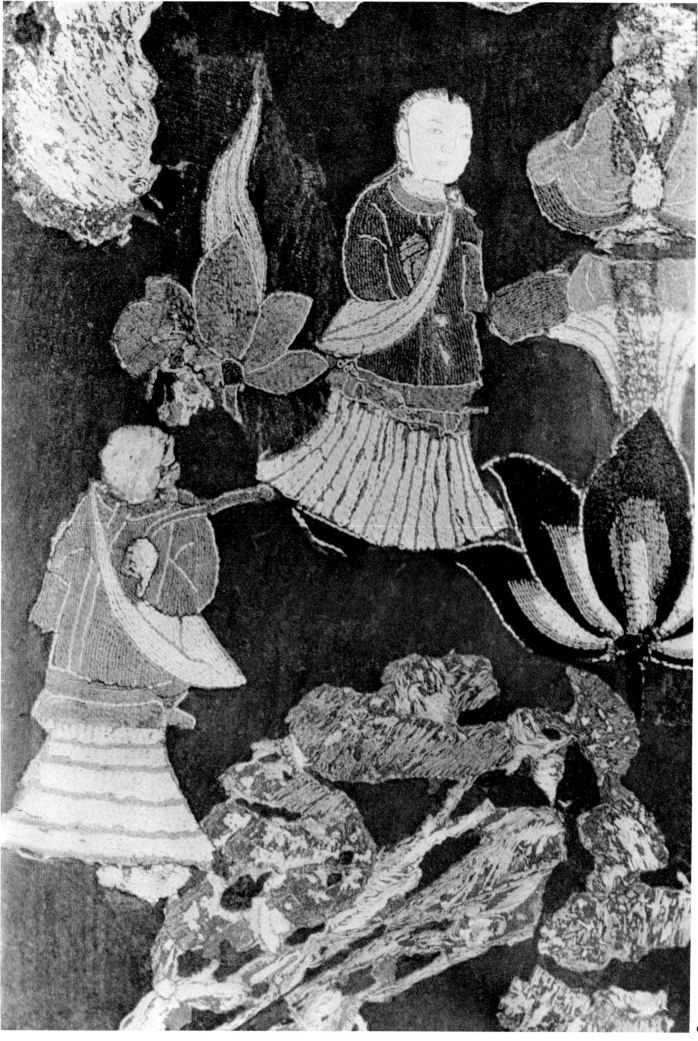

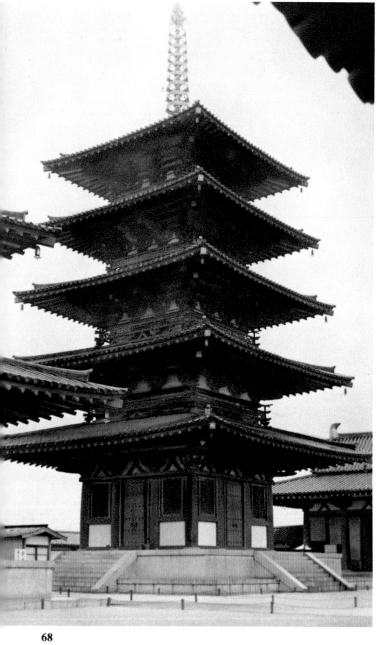

68

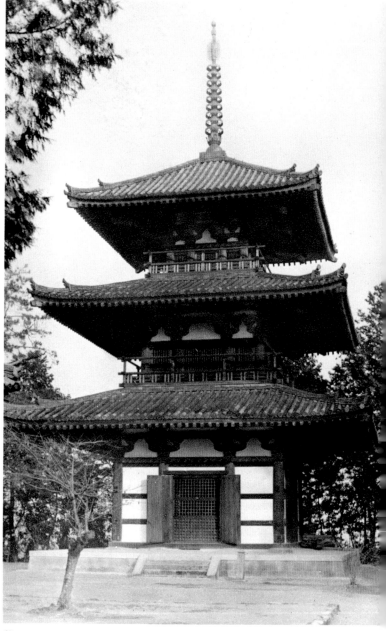

69

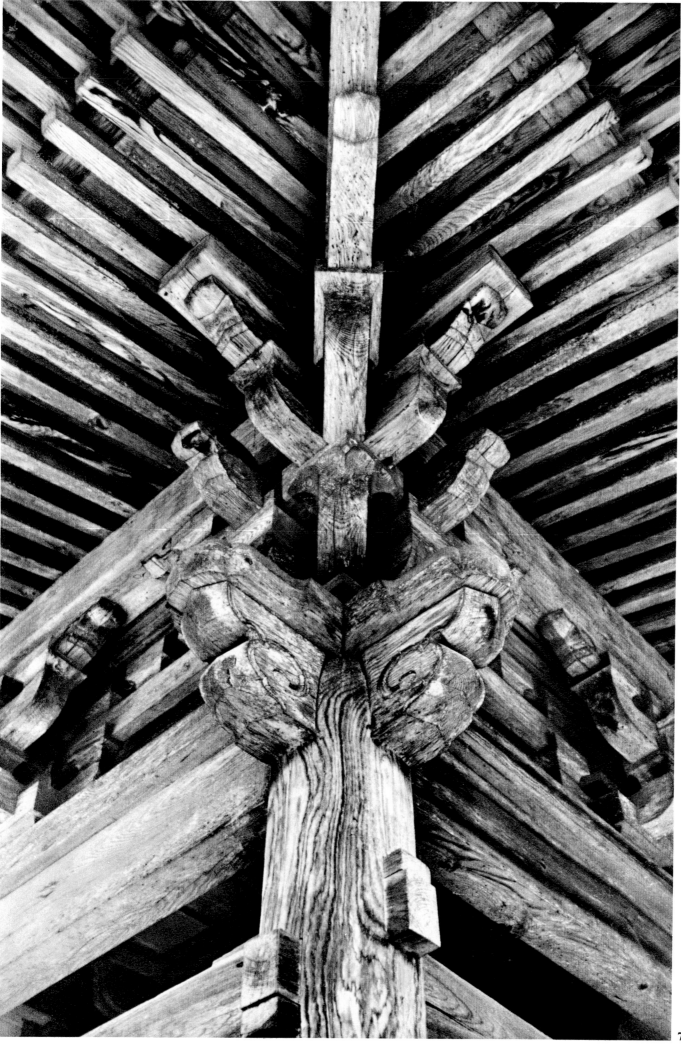

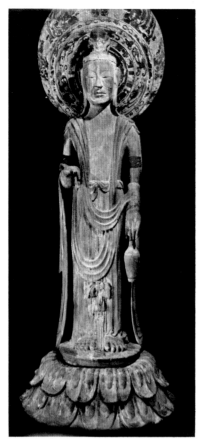

71

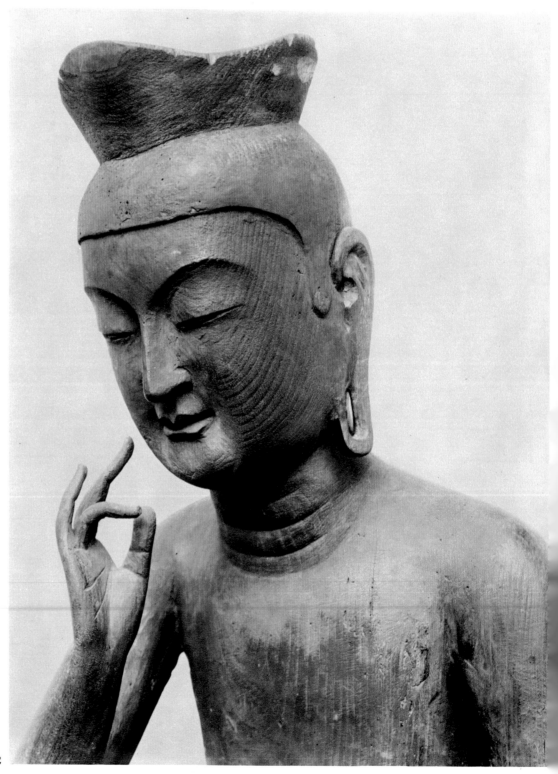

72

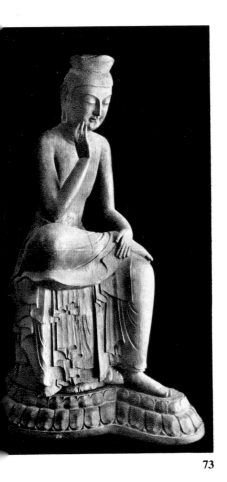

73

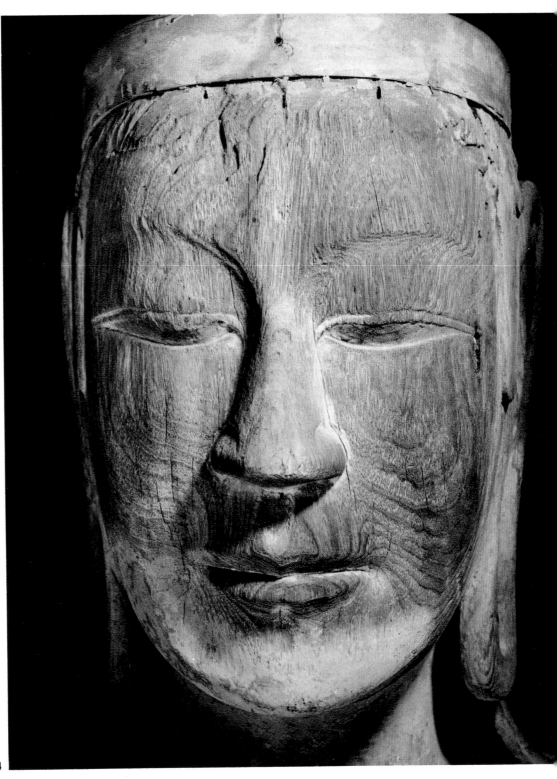

74

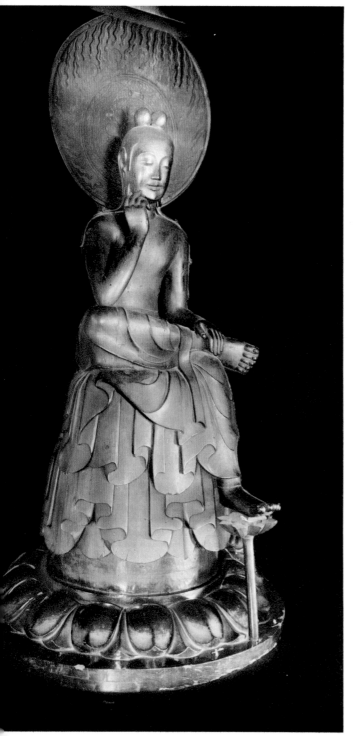

75

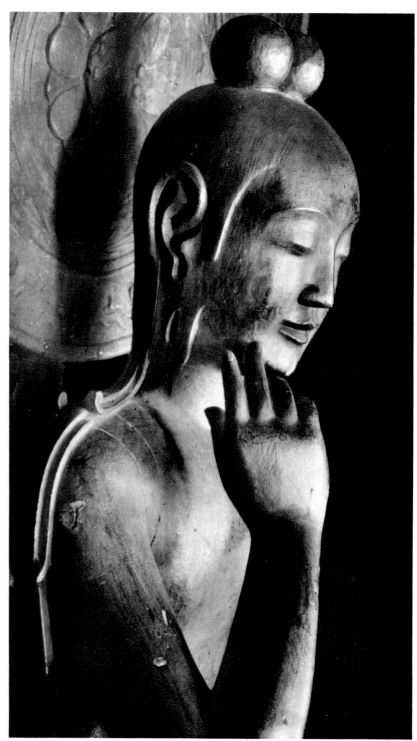

76

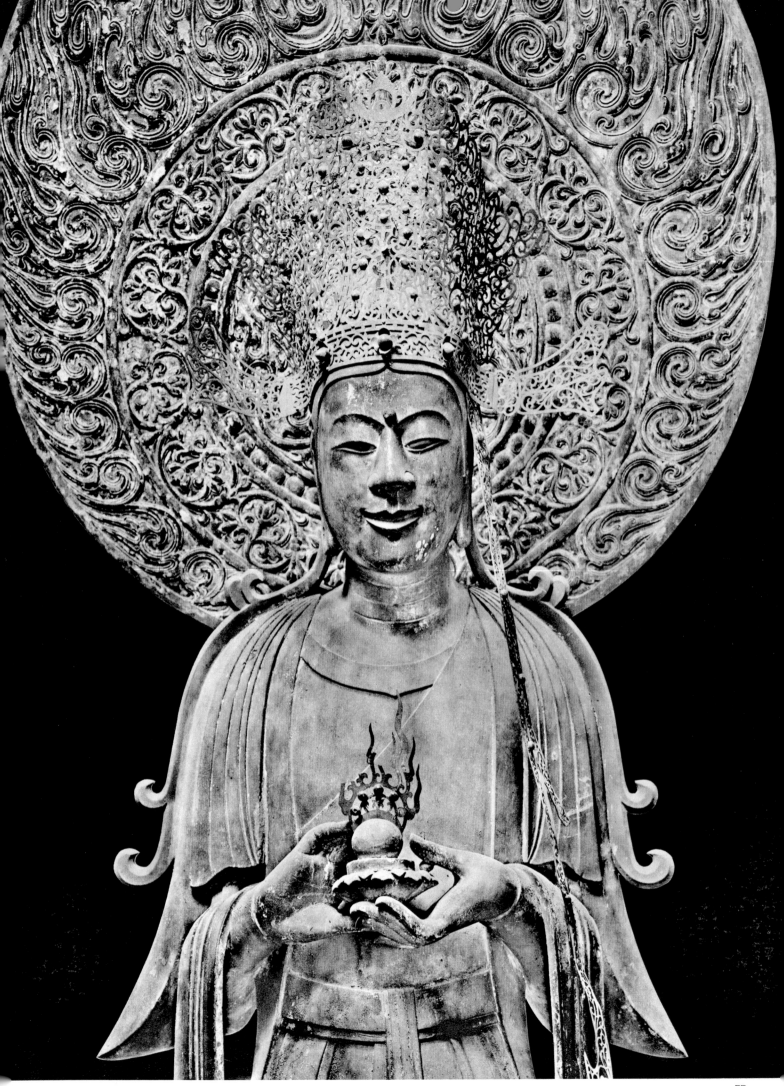

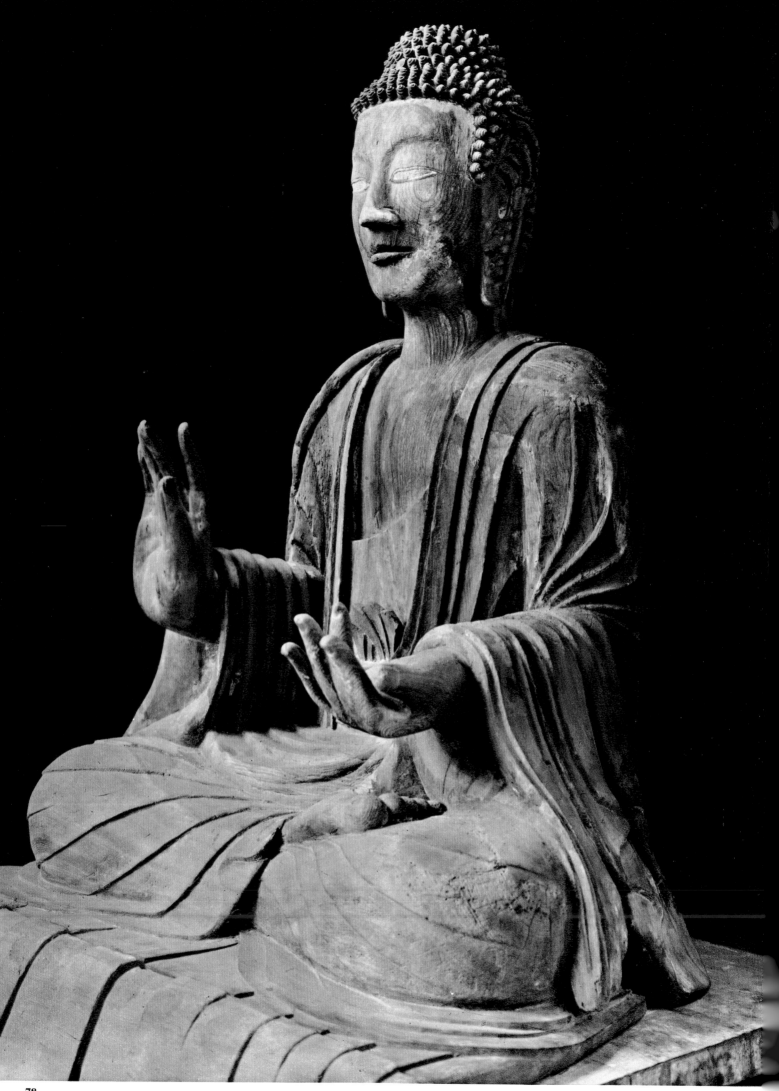

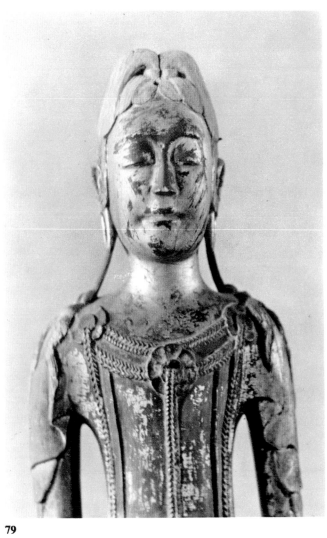

79

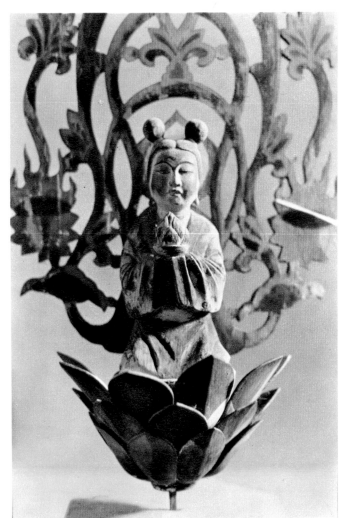

80

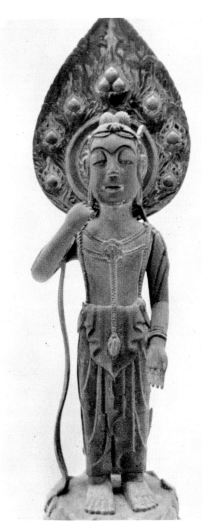

81

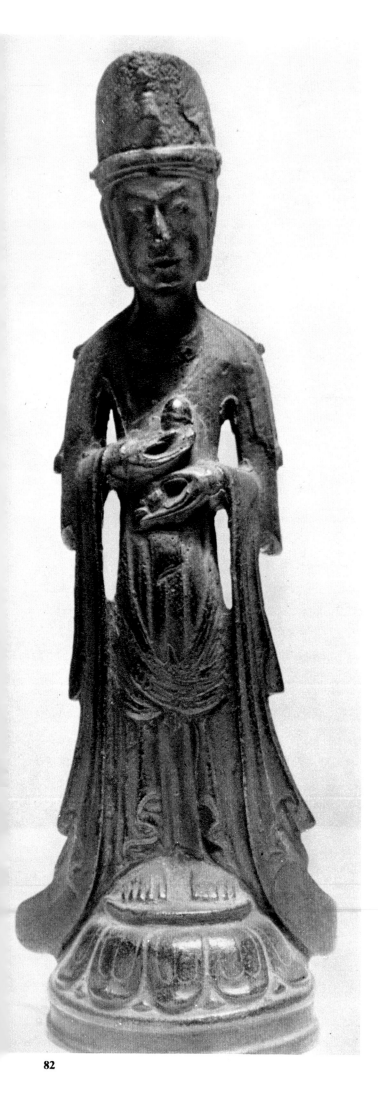

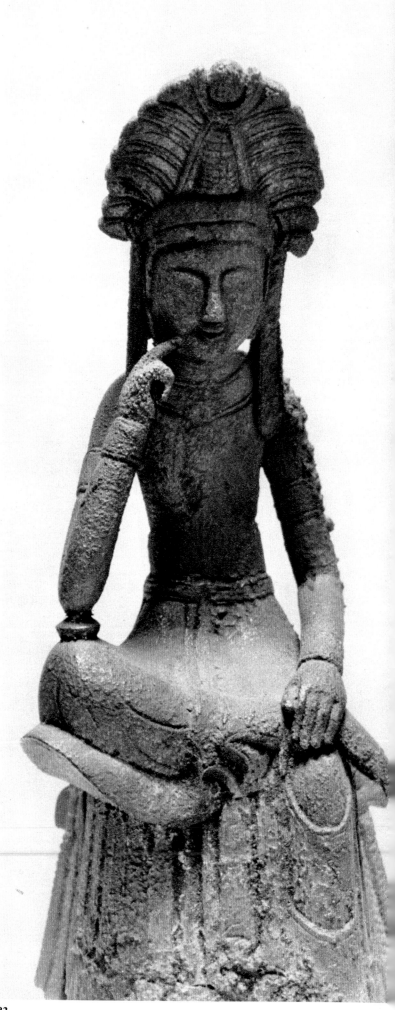

82

83

The Taika Reform

As soon as Emperor Kōtoku had succeeded to the throne (645), the new masters of the country took measures to prevent any resumption of hostilities by the chiefs of the clans that would place the throne in danger and plunge the nation into disorder. Following a solemn reassertion of the principle of the sole authority of the emperor, an edict was issued in 646 declaring that all lands belonged to the state and that no noble could possess in his own name either land or subjects as a result of conquest, purchase, or inheritance. This edict also decreed the establishment of central government in Yamato, with governors selected for the other regions, and a general census with a view to distribution of the land. In addition, it introduced a new system of taxes.

The edict, entitled *Kaishin-no-Chō*, was dated in the second year of the Taika (Great Reform) era which began with the accession of Kōtoku. Other measures were taken to assure imperial primacy and to reduce the power of the nobles. The construction of private tombs was forbidden, thus bringing to an end the age of Kofun building some three centuries after it began. The new administrative system followed approximately the one introduced into China by the T'ang.

These reforms met with little opposition. The dispossessed nobles received salaries compensating them for the loss of the taxes they had previously collected. The farmers were granted plots of land corresponding in size to the number of mouths they were obliged to feed and they had to pay a fixed tax in advance.

The application of these new measures, or rather, the establishment of a new governmental system would never have been possible if it had not been for the example of China. Relations with China, more on a private than on the previously official scale, assumed such proportions that the seat of government was transferred from Asuka to Toyosaki (Naniwa), a seaport situated at the mouth of the Yodo River not far from the modern city of Osaka.

The attraction exerted by Chinese culture was great. Students, artists, and the clergy left continually for the continent and returned not only with books and art objects but also with extremely valuable information concerning the administrative system of the T'ang, the organization of the armed forces, the distribution of the land, and the regulations governing cities, monasteries, and temples. Artists acquired experience abroad, which they made haste to exploit on their own account in Yamato. As an immediate result, Yamato adopted the legal code of the T'ang (which in Japan was called Ritsuryō); in the beginning some difficulty was experienced in adapting it to local needs, but it finally took Japanese form in 701 with the Taihō Code.

The nobles, not yet completely subjugated, revolted in 672 on the death of the Emperor Tenchi, who had succeeded Kōtoku and the Empress Saimei. After the brief reign of Tenchi's son, who was killed the same year in the civil war, Tenchi's brother, Temmu, assumed the title of emperor. On the continent the T'ang armed forces had completely subdued Korea after having destroyed a naval expedition of 27,000 men sent by Yamato to the aid of Paekche in 663. Believing itself to be in danger, Yamato abandoned its policy of reconquest of Mimana and devoted itself primarily to the protection of its own frontiers against a possible invasion. The establishment of a strong and centralized government became more and more necessary.

Temmu, too, insisted on the reforms and was anxious to apply the Ritsuryō. The governmental administration was divided into two parts. The superior section, called *Jingi-kan*, was in fact a Ministry of Shintō and was given—a curious phenomenon in a period when Buddhism had been made the state religion—sole responsibility for the regulation of all matters pertaining to the worship of the native divinities; it had no authority whatever over the Buddhist clergy. This is proof that the imported religion continued to be a civilizing element and that at the same time the Japanese were still profoundly attached to their ancestral cults.

The importance of Shintō in the life of the nation should not be underestimated. Underlying both Buddhist thought and Chinese philosophical doctrine in Japan, Shintō permitted the Japanese population to resist Chinese "spiritual colonization" by continuously adapting new contributions to Shintō principles, which, although not formally recognized, had taken deep root in the minds of the people. This Ministry of Shintō thus guaranteed Japan's independence against the invasion of Chinese ideas and civilization. Although the sovereigns of Yamato were fervent Buddhists who strove to propagate the "True Law" among the people, they were no less attached to the common beliefs. All the official ceremonies, like all the folk festivals *(matsuri)*, took place according to Shintō custom and ritual. The official oracles were always uttered by shamans with the rank of priest.

In addition, this Ministry of Shintō had precedence in the administration over the Department of State *(Dajō-kan)* itself, an indication that the *Dajō-kan* existed only by virtue of the protection of the country's original divinities. The existence of the supreme religious department gave the new administrative system of Japan (even though typically Chinese) an absolutely national spirit. Thus the religious syncretism of the following centuries was prepared for, and this development gave Japan the distinctive character that prevails today.

The *Dajō-kan*, the Council of the State, was presided over by a prime minister *(Dajō-daijin)* assisted by four major councillors *(Dainagon)* and three minor councillors *(Shōnagon)*. Aiding the *Dajō-daijin* were two ministers (for the Left, the *Sadaijin*; for the Right, the *Udaijin*), each of whom was charged with the regulation of four ministries and had the assistance of a controller *(Sadai-ben* and *Udaiben)*. In practice, however, the reforms were carried out in a far different spirit from that set forth in the declaration of Prince Shōtoku. For example, an edict of 682 specified that the official posts be given to men of noble birth and that their personal qualities and capacities were of only secondary importance.

In these reforms the influence of Confucianism made itself as strongly felt as the Buddhist spirit. In fact, the nobility of Japan accepted from foreign doctrines only those features which could reinforce its own position. In addition, certain characteristics of the Confucian philosophy of the T'ang dynasty harmonized more easily with the Japanese mentality (the natural order of things, the study of natural phenomena for divinatory ends, the principle of the double nature of things—yin and yang) than did the more abstract principles of Buddhist doctrines.

Butsudō (Buddhism), however, expanded very rapidly, due to the tolerance practiced by this religion. Buddhism was no menace to the state nor to Shintō beliefs; the majority of new converts continued to respect the Shintō customs and cults. Buddhism represented the path of culture from which sprang the arts, literature, and new ways of life. It was the voice of progress, and it brought to certain people a philosophical nourishment that had been lacking.

The effort of the imperial court to propagate Buddhism was not due solely to a desire for mystical proselytism. Buddhism contained within itself an important social ethic. In 685 an imperial decree ordered that a Buddhist altar be set up in every house and that every *kuni* or province have a Buddhist temple. By 692 there were 525 temples and monasteries in Yamato. The people were sympathetic to these religious establishments and were quick to follow the new teachings that were capable of alleviating their wretched condition. Their lives continued to be precarious in spite of the reforms: "About 3 percent of the rice harvested was due as a tax on the land, and, in addition, each adult man had to donate a certain quantity of silk fabric, silk thread, silk floss, and hempen cloth to the capital and was obliged to work sixty days each year without pay on public works. That was not all: he had to serve in the local militia and in the imperial guard of the capital for a year, and to serve for three years in the frontier guard in the northern part of Kyushu" (Inoue Mitsusada).

It was impossible, however, to have real governmental stability or an efficient administration without a permanent capital. The sovereigns of Yamato had been in the habit of changing their residence with each accession to the throne. It was a question of ritual purity, since a palace was considered to be defiled by the death of the sovereign who had resided in it. The Empress Jitō,

114

having succeeded Temmu, followed the custom and settled in Fujiwara, to the north of Asuka, with all her government. These moves and the expenses involved on each occasion became intolerable in a state organized on the Chinese model. The reforms having been completed, it was decided to build a permanent capital. The location chosen was Heijō, a little to the west of modern Nara, and the construction of the new capital, Heijō-kyō, according to the plan of the T'ang capital, Ch'ang-an, was begun. The imperial court and the government were settled there in 710.

Civilization

The numerous Japanese who visited China mastered the Chinese language and on their return to Yamato propagated Chinese ideas in the original language, which became the sole cultural medium of the Imperial University founded in 702. The study of the Chinese texts was at that time the basis of classical studies. As yet no way had been found to write Japanese; thus it was not employed for normal academic studies. Confucian even more than Buddhist ideas profoundly influenced the spirit of the upper classes and nobility, who alone had access to Chinese culture. The people were given no exposure to the new learning except through the sermons of a few monks. The people's knowledge was that of their ancestors, based on daily experience and handed down from father to son.

Some groups, however, had developed through the centuries certain talents that had become family secrets transmitted from the master to his disciples, and, on the basis of these, associations or corporations *(be)* had been formed. Among them were the *Ishizukuribe* (masons), *Kinunuibe* (tailors), *Takumibe* (carpenters), and *Hajibe* (potters). These groups formed clans; the oldest and most skilled member of each was naturally the chief. It was the chief's duty to transmit to his sons, as well as to the other members of his clan, the secrets of his skill and to instruct them in their trade.

There did not exist, however, any school system for the people. Only the nobles could learn Chinese in the imperial institutions, the first of which were perhaps created during the reign of Emperor Tenchi. In 676 a college was founded for the nobles, but it was the Taihō Code that officially established a university with attendance limited to officials of high birth. A few religious schools were run in connection with the monasteries, but they were not really organized.

Whereas the Confucian writings in Chinese *(The Five Great Classics*, *The Thirteen Classics*, *The Four Books)* were studied in the original language by the aristocracy, the arts were disseminated principally by the Buddhist monasteries. Thus one cultural current was superimposed on the other in Yamato: an aristocratic one impregnated with Confucian precepts, a middle-class one (artists, architects, master craftsmen, monks) saturated with Buddhist concepts. It is to the middle-class category of cultural figures that we owe the admirable evidence of the art of this period and the period that followed.

Architecture

Little remains of the temples *(kokubun-ji)* built throughout the country. In fact, only Yakushi-ji survived the fires and disasters attendant on the civil wars. Yakushi-ji consists of two pagodas (of which only the one on the east is still intact) and was laid out on a perfectly symmetrical plan developed from that of Shitennō-ji. Originally consecrated at Fujiwara in 697, it was moved like other temples to the new capital of Heijō-kyō. The fact that there were no foundations and that the structure could be disassembled made this move relatively easy, and such moves became

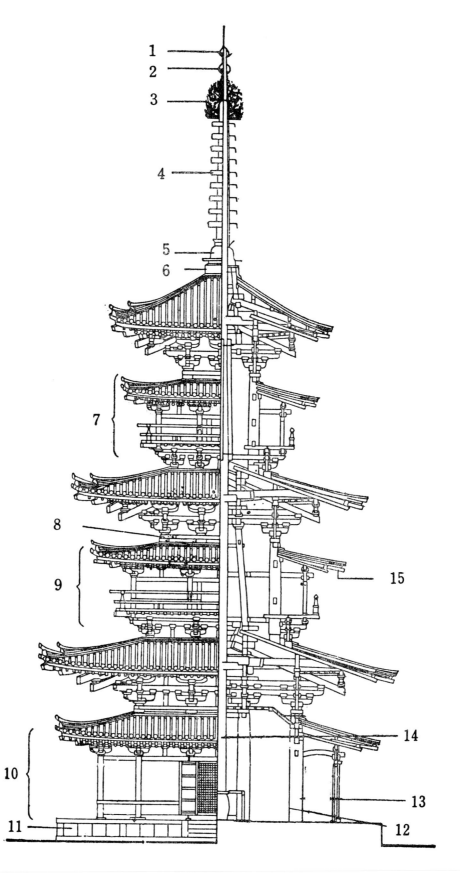

20. THE PAGODA OF YAKUSHI-JI

1. HŌSHU	6. FUKUBAN	11. KIDAN (TERRACE)
2. RYŪSHA	7. MOKOSHI	12. EXTERNAL COLUMN
3. HŌRIN (SUI-EN)	8. TOP OF COLUMN	13. COLUMN OF THE MOKOSHI
4. SŌRIN	9. MOKOSHI	14. CENTRAL COLUMN
5. FUKUBACHI	10. MOKOSHI (PORCH) OF THE BASE	15. JOISTS

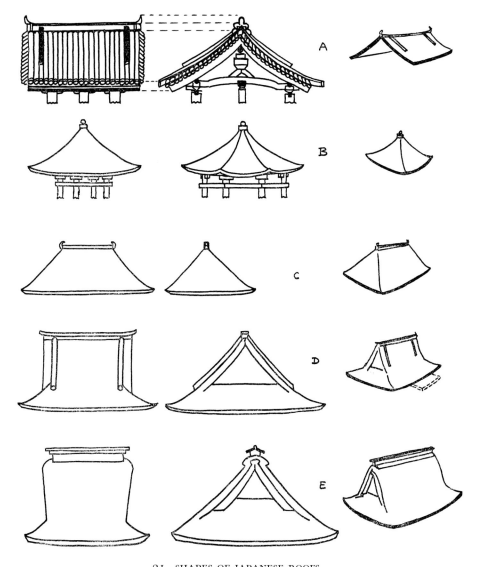

21. SHAPES OF JAPANESE ROOFS

A. KIRIZUMA B. HŌGYŌ C. YOSEMUNE OR SHISHŪ D. IRIMOYA (DOTTED LINE INDICATES THE GOHAI)

E. ENGAKU-JI TYPE (THIRTEENTH CENTURY)

frequent. On the other hand, certain temples, such as Daikandai-ji, were built according to the plan of Hōryū-ji and had pagodas that were as high as nine stories.

The art of construction, therefore, had already been well developed. It is quite probable that the Korean and Chinese architects who came to Japan to erect some of the Buddhist temples found that Japan had excelled for generations in the art of carpentry and in the construction of the Shintō shrines. We know that the shrine of Ise now appears exactly as it did when the Emperor Temmu ordered its faithful reconstruction every twenty years; its form is described in detail in the *Kōdai-jingū Gishiki-chō*, a manuscript preserved in the Shōsō-in and dated 804. The palaces of the emperors must have traditionally followed the plan of the Shintō shrine of Izumo with some slight differences; the chronicles relate that the Emperor Suinin (probably in the third century) had had this shrine built on the model of his imperial palace.

The early shrines were very simple structures with columns sunk deep into the ground (whereas the pillars of Buddhist structures rest on stone bases). The roofs had a double declivity dropping straight down (the curved lines of the roof of the shrine of Izumo reveal a late Chinese influence introduced at the time of reconstruction). The roofs were decorated with *chigi*, two pieces of wood joined in an X-shape and projecting at either ends of the ridgepole resembling either antlers or monsters' heads, possibly a substitute for the animal skulls originally placed on

117

the gable ends. Considerable use was made of the *katsuo-gi*, the round or squared logs laid at right angles to the ridgepole in order to secure the thatch covering. These shrines were built in the center of vast areas fenced in by a succession of palisades. In front of the symmetrically placed entrances were erected the *torii*. Face to face with Buddhism, Shintō defended the traditions of ancient Japan.

Sculpture

During this period the art of T'ang China was influenced to a certain extent by the Buddhist sculpture of India. Such travelers as Hsuang-Tsang had returned from India with sacred writings and statues from the flourishing monasteries of Nalanda and Mathura. Gupta sculpture had reached its zenith, and Buddhist art drew its most glowing inspiration from it. Japanese artists returning from China created sculpture directly inspired by the Gupta style.

The Asuka school was not abandoned, however. It developed by introducing into its statuary certain characteristics clearly derived from India: a fully rounded treatment of the torso and the limbs, fuller faces, lines or folds on the neck, large curls in the coiffures of Buddha images, a certain suppleness in the pose reminiscent of the Indian *tribhanga*, and the appearance of the *mudrā* or *inzō* (the symbolic position or gesture of the fingers and hands). The oldest example of this seems to be a triad in embossed copper at Hōryū-ji portraying a seated Buddha with its hands in the preaching gesture *(Dharmacakramudra)*. It is a faithful imitation of a T'ang prototype which, in turn, was a copy of an Indian statue. A certain realism, already perceptible in the statues of the Asuka period, seems to have been accentuated. The archaic smile disappeared from almost all statues and was replaced by a less idealized mouth that was also more typically Japanese. The treatment of the folds of the clothing and drapery was somewhat simplified, and the headdresses tended toward the adoption of a form called "three mountain peaks."

The art of working with bronze attained a high level. The castings were a little less thick and reveal a technical perfection both in the figure and its ornamentation.

Painting

Here again we find T'ang characteristics permeated with Indian influence. The wall paintings decorating the Kondō of Hōryū-ji (unfortunately almost entirely destroyed in the fire of 1949) are similar in some respects to the cave paintings of Ajanta. The Hōryū-ji paintings were probably executed at different times, because certain ones (panel 6, for example) have characteristics that appear to belong to the Tempyō era rather than to the beginning of the Nara period. They were executed on a plaster wall almost six inches thick, the contours of the figures were drawn with a fine, iron wire-like implement, and they are skillfully painted with metallic oxide pigments. Some of these remarkable paintings resemble certain stone bas-reliefs discovered at Yün-kang near Ta-t'ung. We also possess from this period a portrait of Prince Shōtoku with his brother and son, in which all three are dressed in the Turfan fashion. In both the execution and style of this work, one notes a strong influence of Central Asian art.

The Hakuhō period was one of borrowings and experiments during which Guptan art and the styles of Central Asia, the Sui, and the T'ang penetrated Yamato, where an attempt was made to fuse them into a typically Japanese form of expression. Some scholars regard this as a period of transition. We are more inclined to view it as the beginning of an art searching for its own way in the midst of many influences. In other words, it reveals the first attempts at the creation of an authentic Japanese art.

84. NARA. OKADERA. GATEWAY. This is at one of the five temples (Goryū-ji) founded by the monk Gien. It belonged at first to a Hossō sect and was later taken over by the Shingon sect. This gateway, known as Rō-mon, may have come from the palace of the Emperor Tenchi (673–686), but it is probably a reconstruction in the ancient style dating from the beginning of the Edo period or a little later.

85. NARA. HŌRYŪ-JI. YUMEDONO. This "hall of dreams," or Yumedono, which legend indicates as the place of meditation of Prince Shōtoku, was probably built somewhat later, in 739. It is the oldest octagonal building in Japan and the best preserved. The building is set on a double platform of stone, with access gained by four separate flights of stairs. The pillars are octagonal and larger at the top than at the base. The roof is curved upward at the eaves in the Chinese style and decorated with bronze ornaments. The interior is divided into two parts by eight columns that delimit two shrines which contain statues, including the Guze Kannon (plate 77). The Yumedono was originally called Hakkaku Butsuden, "octagonal hall of Buddha."

86, 87, 88. NARA. YAKUSHI-JI. EAST PAGODA. The monastery of Yakushi-ji, originally with two pagodas, was built at Fujiwara between 690 and 698 by the Empress Jitō, but it was later disassembled and reconstructed at Heijō-kyō (Nara) when the Empress Gemmei changed the capital. This temple complex was built on a square plan enclosed by a roofed cloister-gallery; in the central space was the Hondō flanked on the south by two pagodas presumably facing east and west respectively; the Lecture Hall was to the north close to the surrounding cloister, and one entered the temple complex by the south gateway. The pagoda, which is the only surviving building, is a remarkable example of the architecture of the period. It has only three functional stories, but the spaces between the roofs permitted the addition of *mokoshi* (a type of roofed porch). The series of roofs was characteristic of the period and typically Japanese. The roofs permitted the enlargement of the usable space of each story without adding needless additional weight to the structure; because of this type of construction, the ground floor of the Yakushi-ji pagoda could be divided into five bays between the supports instead of the normal three, and the very thin supports of the *mokoshi* give an air of lightness to the whole and conceal the enormous load-bearing columns of the structure itself. Although it has only three floors, the pagoda has the appearance and proportions of a five-story structure with six roofs. It has a total height of 110′ and rises from a large, low stone base. The topmost roof is crowned by a bronze *sōrin* (plate 87), which accounts for a third of the total height of the pagoda and gives it a pyramidal silhouette. This *sōrin* is made up of nine rings (reminiscent of the parasols topping an Indian stupa) surmounted by a bronze ornament called a *sui-en*. The interior of the pagoda is paved with stone, and the five supporting columns are quite simply placed on bases of squared stone blocks. The roofs are tiled and are supported by a double row of rafters, one row square, the other round. The brackets are of the *mitesaki* type and reflect a transitional period between the Asuka period brackets and those of the Tempyō era.

89. NARA. YAKUSHI-JI. DETAIL OF THE SUI-EN OF THE EAST PAGODA. This detail of the four-leaved ornament topping the *sōrin* depicts a musician. The ornament as a whole consists of a series of heavenly musicians and other celestial figures linked by arabesques created by the *ten-e*, the scarves worn by heavenly beings. Height of the *sui-en*: 75″. Total weight of the *sōrin* and the *sui-en*: 3 tons. Entirely in bronze.

90. NARA. YAKUSHI-JI. YAKUSHI NYORAI. This bronze statue with a glossy black patina is in the Jōroku style and is seated on a high dais over which falls drapery executed in bronze. The style is an imitation of that of T'ang art of the same period. The date of execution of this splendid statue has not yet been agreed upon: according to some scholars, it dates from 697; according to others, from the Yōrō era (717–24). There is also the theory of Tamura Yoshinaga (*Bukkyō Bijutsu*, No. 15, 1952) which assigns it to the Taihō period (701–04). Despite its large size it was cast by the lost-wax process. This figure, together with its two attendants—Nikkō and Gakkō Bosatsu—was damaged by fire several times and repaired on each occasion. Originally it must have been gilded. The present gilded wood halo was made in 1685 to replace the original which had been destroyed. The pedestal, decorated in bas-relief with plant and animal motifs and grotesque figures, was probably cast separately in four parts. The statue itself appears to have been cast in a single block, with the exception of the head, the right arm, and certain parts of the robes. This image of Yakushi Nyorai (Bhaisajyaguru) is in the Kondō (main hall) of the temple. Height of statue 8′ 4¾″.

91. NARA. YAKUSHI-JI. GAKKŌ BOSATSU. This statue of Gakkō Bosatsu (the Bodhisattva Candraparbha) is—with Nikkō Bosatsu (Suryaprabha)—one of the two attendants of Yakushi Nyorai (plate 90). The group forms the triad of the Kondō of the temple. Gakkō and Nikkō are portrayed standing and are of black-patinated bronze. Their pose is the same. They both have slightly swiveled hips with the weight of the body resting on one leg. This is a pose, however, that is quite different from that of the statues of the Asuka period, and even of the epoch in which they were executed, when the essential characteristics were rigidity and a rigorous concentration on the frontal pose. We have here, instead, a fully rounded conception perfectly executed. The sculptor was certainly influenced by T'ang art. The same problem of date of execution arises for these two statues as for the central figure of the triad. The gilded wood halo was remade in the Edo period. Height 10′ 1⅝″.

92. NARA. KŌFUKU-JI. HEAD OF BUDDHA. This majestic head of large proportions—it must have belonged to a statue of the Jōroku style—in green-patinated bronze is perhaps that of the *honzon* (principal divinity) of the Kōdō or Lecture Hall of the Yamadadera which was moved into the Tōkondō of Kōfuku-ji in 1187 and destroyed by fire in 1411. It must have been executed between 678 and 685. At that time it probably portrayed Yakushi Nyorai. Although badly damaged (a piece of the casting on the left side is missing), it has the characteristics of the early T'ang period sculpture and could have been executed under the supervision of Chinese artists. Height 41¾″. Kōfuku-ji Museum.

93. NARA. YAKUSHI-JI. SHŌ KANNON BOSATSU. This representation of Shō Kannon Bosatsu (Avalokiteshvara) in black-patinated bronze is now the principal work in the Tōindō, the East Hall of Yakushi-ji where it was moved to take the place of the statue of Shaka Nyorai (the Buddha Sākyamuni). Although the general style of the work is reminiscent of that of the attendants of the Yakushi Nyorai (plates 90 and 91), the pose is more rigid and the features resemble those of the Buddha of the preceding plate, which would date the execution of the work between the completion of the head of Buddha in Kōfuku-ji and that of the triad at Yakushi-ji. The halo is a late restoration. Height 74″.

94. NARA. HŌRYŪ-JI. HEAD OF YUME-TAGAE KANNON. This small bronze statuette represents the Kannon (Avalokiteshvara) "who changes dreams." While certain elements of the work reveal aspects belonging to the Asuka style, other details induce us to attribute it definitely to the Hakuhō period: the general fluidity of the lines, the absence of a smile. A little image of the Amida Buddha (Amitabha) is set into the front of the diadem of this divinity. It could have been executed at the same time as the Amida triad executed for Lady Tachibana. Height of figure 34½″; height of base 10¼″.

95. NARA. TŌDAI-JI. NIGATSUDŌ. DETAIL OF THE HALO. The left side of a halo of the *funagata* type (boat-shaped) of gilded bronze, now broken into sixty-seven fragments, and incised with the Buddha and Bodhisattvas standing on lotus flowers. The background consists of small interlocked rings looking somewhat like chain mail. The complete subject incised on this *kōhai* (halo) depicts the Buddhist cosmos according to the *Lotus Sutra*. The work was originally part of a statue of Jūichimen Kannon Bosatsu (Avalokiteshvara with eleven heads). Total height 91⅜″. Nara National Museum.

96. NARA. KAKURIN-JI. SHŌ KANNON. A small bronze statuette with a slender body and fluid lines. Many of its characteristics remind us of the Yume-tagae Kannon (plate 94). The neck, however, is massive and inelegant, and the *sandō* ("beauty folds") are incised, not modeled. This would permit us to date the work a little prior to the Yume-tagae Kannon, in spite of its archaic smile. Nara National Museum.

97. NARA. HŌRYŪ-JI. BOSATSU. A small bronze statuette revealing characteristics of both the archaic period (lack of proportion, smile, concentration on a frontal pose) and of a later epoch (fullness of face, stylization of the robes), which permit us to date it in the Hakuhō era. On the diadem set against a triangular halo is a seated Buddha image.

98. NARA. HANNYA-JI. AMIDA NYORAI. This perhaps portrays either Shaka Nyorai or Yakushi Nyorai. It is clad in a monk's robes *(kesa)* decorated with motifs sculpted in the mold itself. The disproportion of the figure's head and hands is noteworthy. Executed toward the end of the seventh century. Of bronze, and cast in a single mold together with the base, it was found in the interior of a thirteen-story stone pagoda dating from the Kamakura epoch, and it was intended as a relic. (See plate 220.) Height 7⅜″.

99. NARA. HASE-DERA. HOKKE SESSŌ DOBAN. This plaque of thick, embossed bronze shows two Buddhas (Sākyamuni and Prabhutaratna) seated in a three-story pagoda crowned by three *sōrin*. It is a type that is not normally found in Japan. In fact, this mandala is a faithful imitation of a Chinese model executed in a technique employed by the Japanese artists of the Asuka period and derived from prototypes of early T'ang art. Kyoto National Museum.

100. NARA. HŌRYŪ-JI. JIKOKU-TEN. Head of one of the four guardian kings of the four cardinal points (Shi Tennō), who defends the Eastern Quarter or Dhritarashtra. Clay, formerly painted red. Armor of the T'ang type. Seventh century.

101. NARA. SHIN-YAKUSHI-JI. INDARA TAISHŌ. This statue of a warrior was one of a series of twelve generals of Yakushi Nyorai (called Jūni Jinshō), personifying either the twelve hours of the day or the twelve vows or prayers of Yakushi Nyorai. A similarity to the Jūni-Shi, or animals of the hours of the day (see page 473), has also been attributed to them. The statues are made of clay first coated with *gofun* (calcium carbonate) and then either painted or gilded. The color has almost completely disappeared. The Indara Taishō seen here must have been painted in red. He corresponds to the Brahman divinity Indra. The eyes of the warriors are made of obsidian. Tempyō period (710–94), or the end of the Hakuhō era (see plate 119). Height 63″.

102. NARA. HŌRYŪ-JI. ONE OF THE NI-Ō OF THE DOORWAY. These statues of the *vajra*-bearing guardians of the Chūmon of Hōryū-ji were placed in their present position in 711 during the Wadō era. They are the most ancient images of the Ni-ō (two guardian divinities). Made of clay, one (shown here) was originally painted red and the other green. Unfortunately they have often been retouched and repaired. This one is the image of Agyō; the other is called Ungyō.

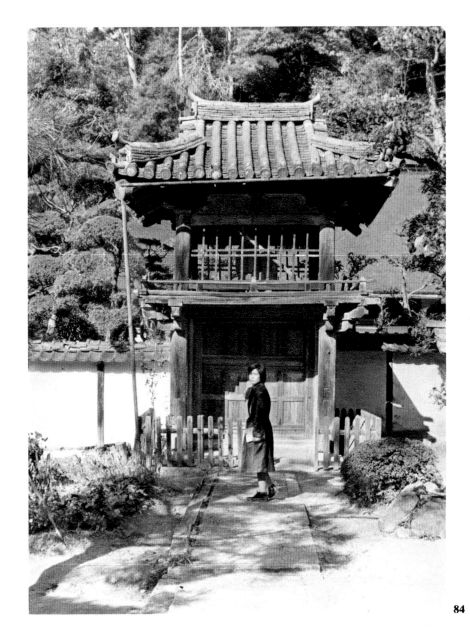

84

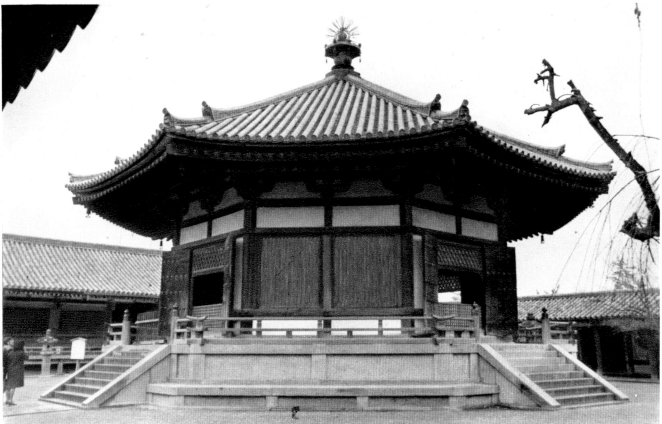

85

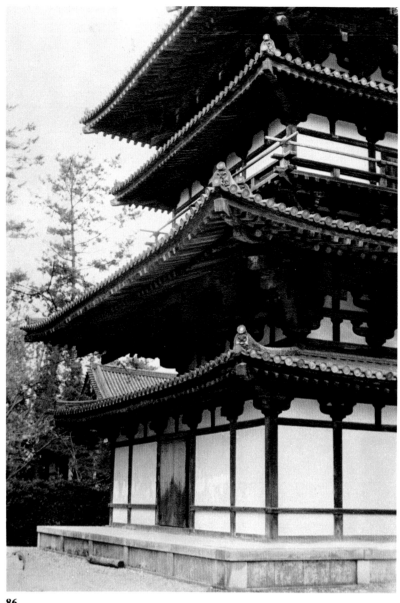

86

87

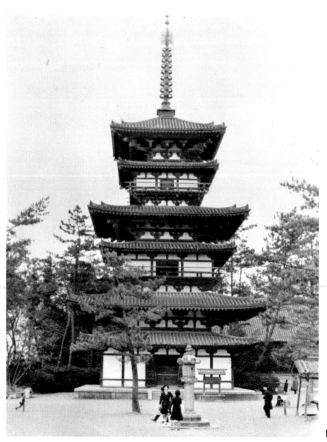

88

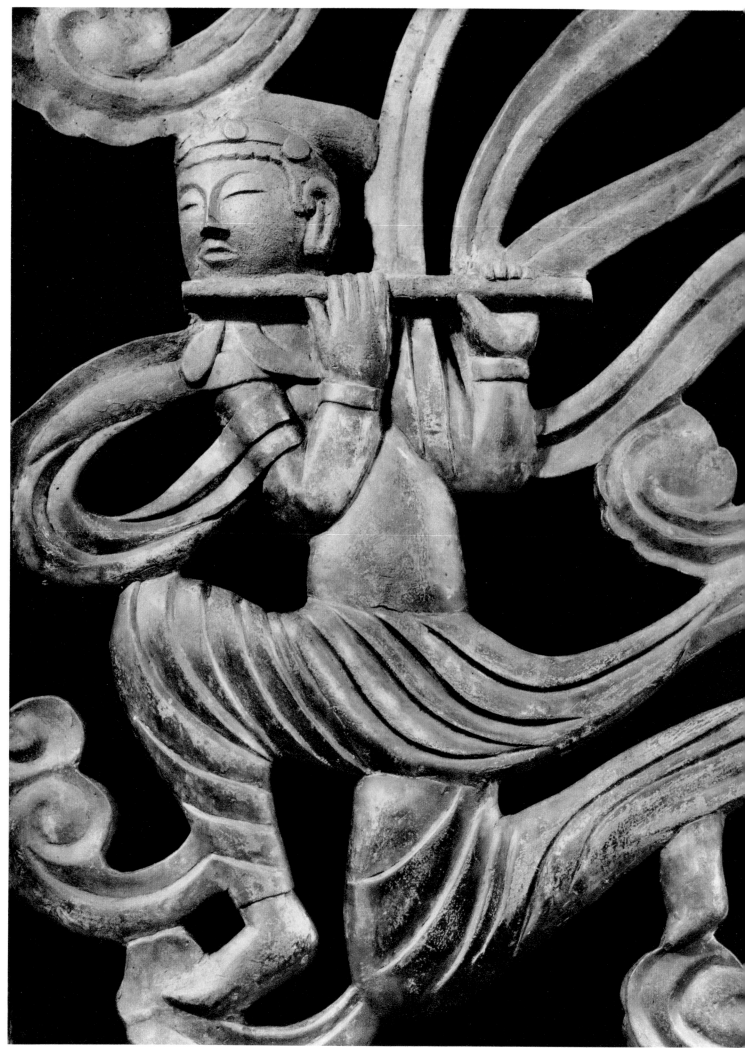

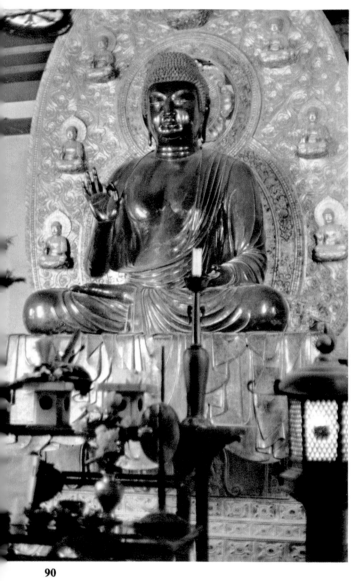

90

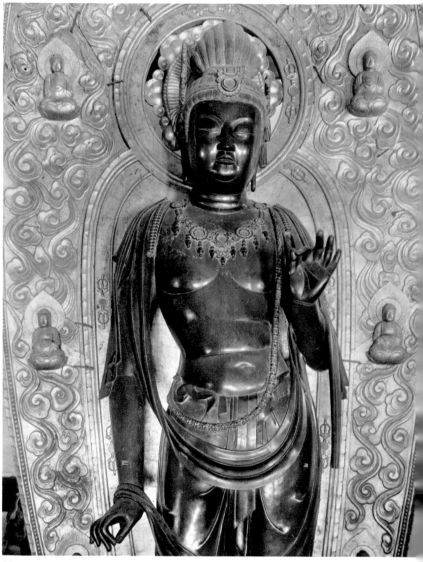

91

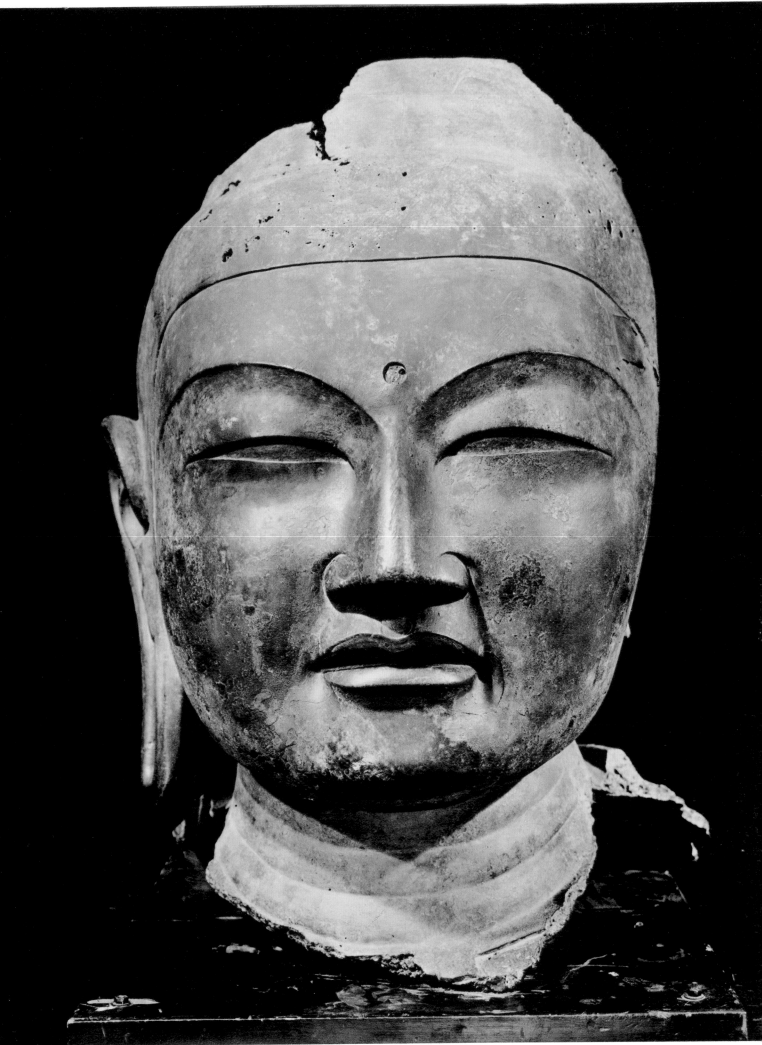

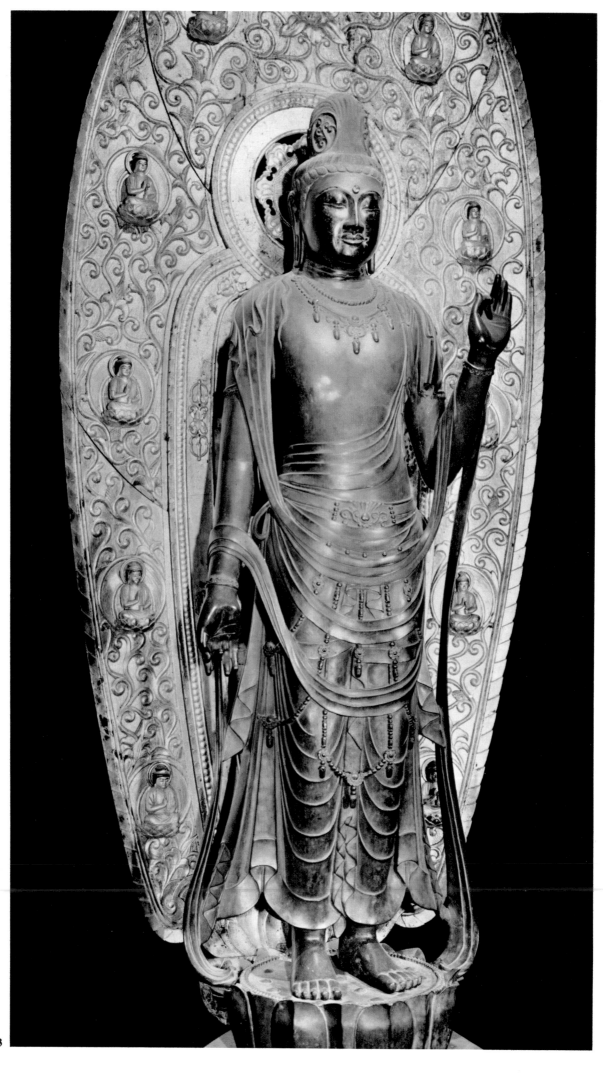

93

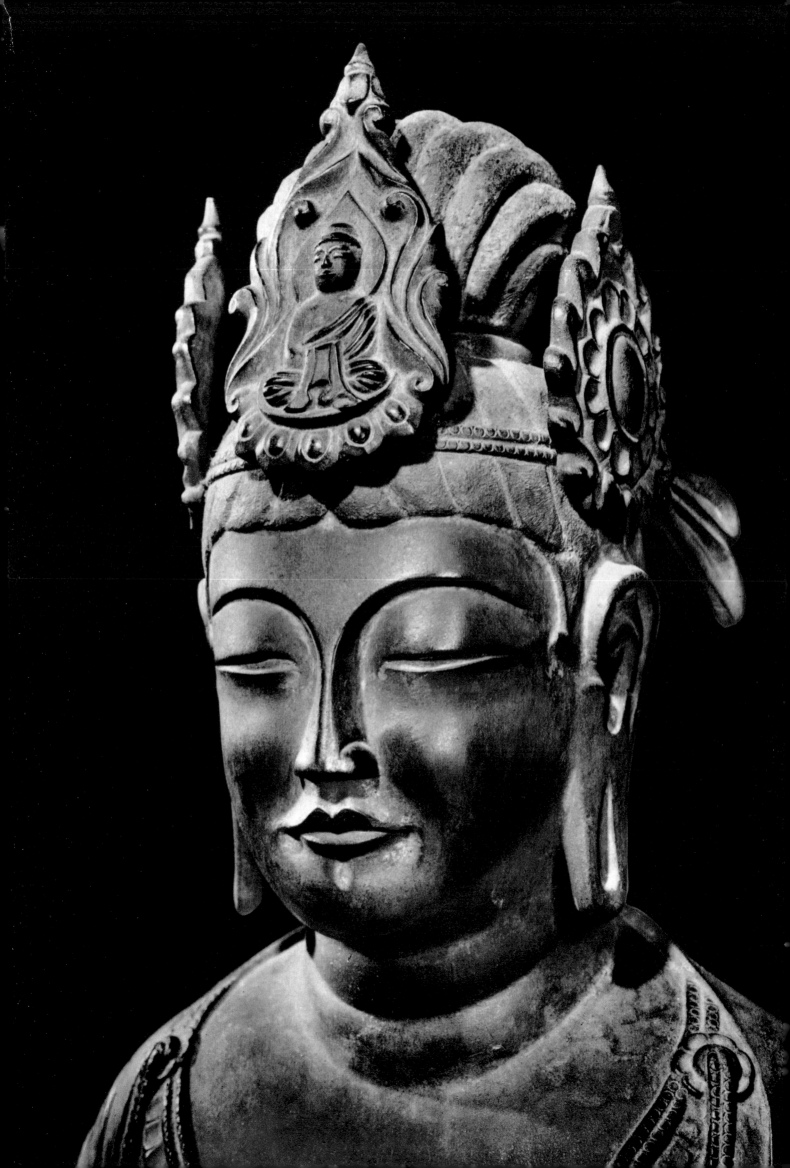

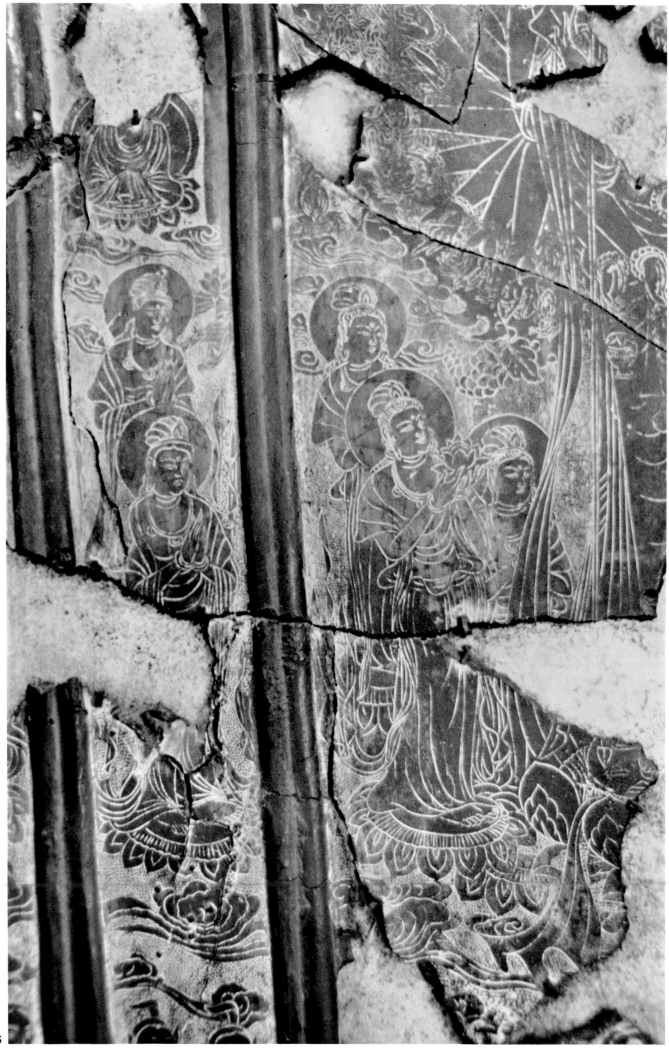

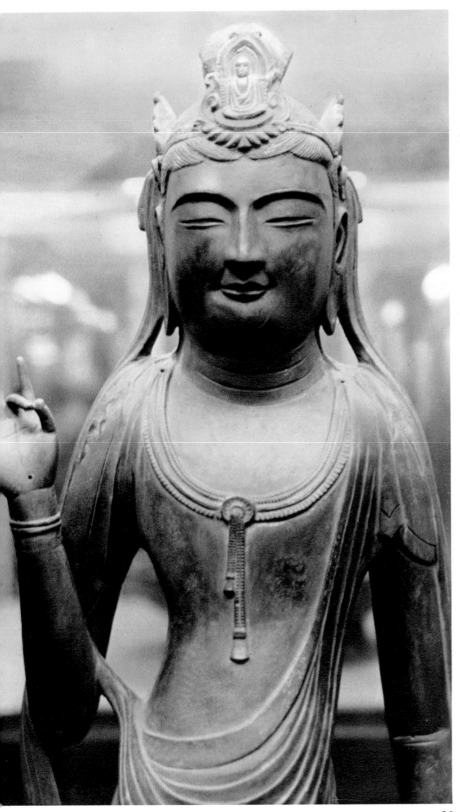

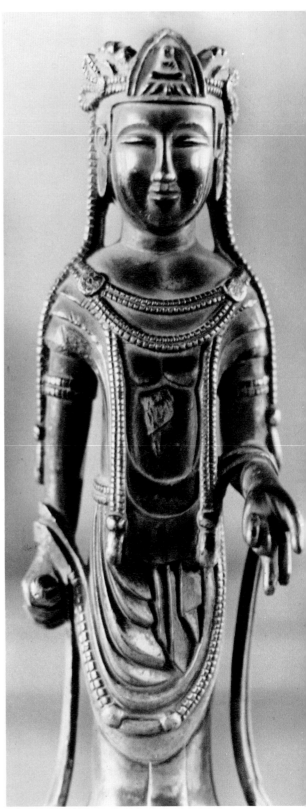

96

97

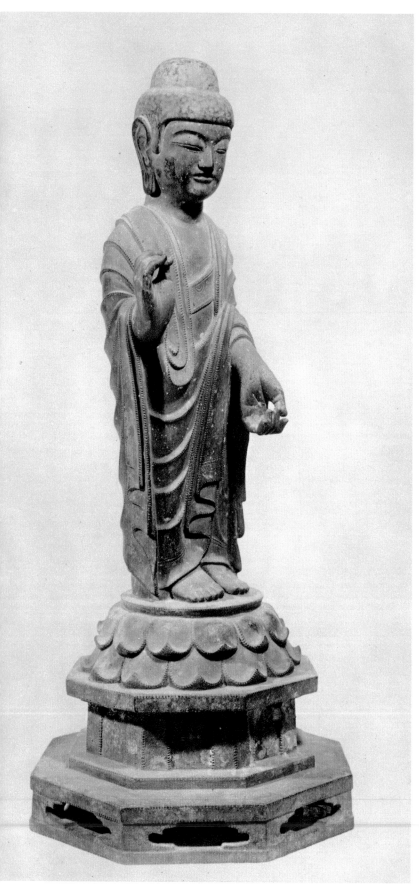

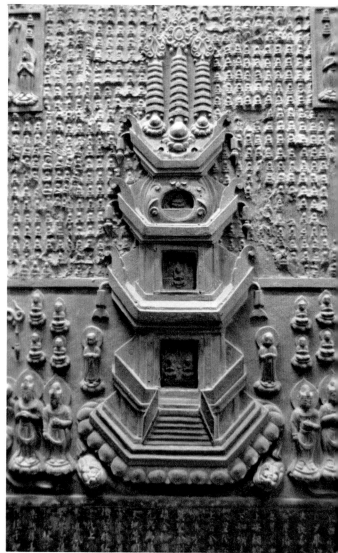

99

98

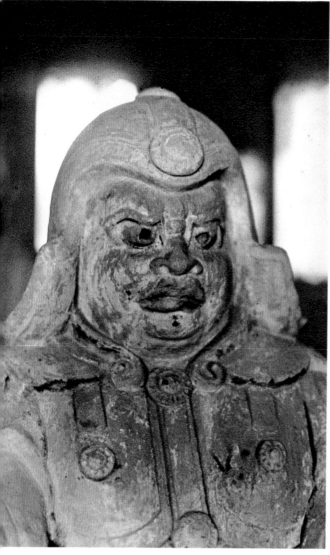

100

101

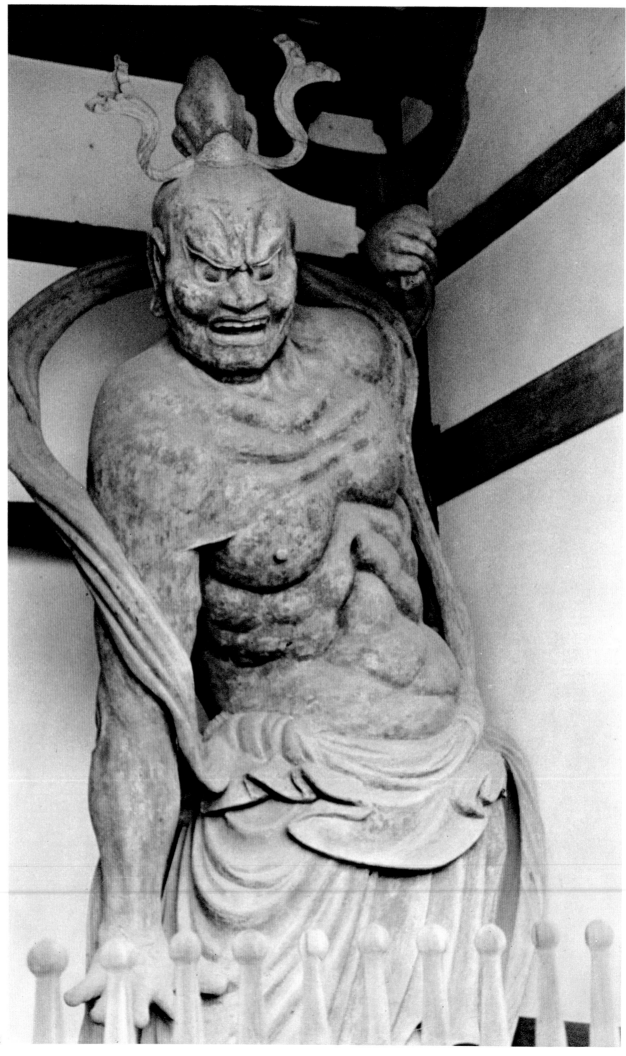

THE TEMPYŌ ERA (710–794)

The site of Heijō-kyō (Nara) had been chosen for the capital not only in accordance with the precepts of Chinese geomancy but also because it was near the great monasteries from which all culture was disseminated at that time. By 710 the capital had been completed, and the Empress Gemmei settled in it. It was laid out so that its streets formed a grid-like pattern and covered a vast quadrilateral measuring more than three miles in length from east to west and about two and one-half miles in breadth from north to south. The royal palace or *Dai-dairi* was situated in the northern part of the city, which was bisected by a large avenue that extended south from the entrance of the royal residence. The city must have also included the monasteries of Saidai-ji, Yakushi-ji, Tōshōdai-ji, and Hokke-ji. In addition there were two marketplaces.

The artists and artisans (metalworkers, armorers, weavers, lacquerers, potters) were grouped near the palace. The nobles, clergy, and nuns lived in the main part of the city. The common people were limited to the outskirts.

The difference between the townsmen and the peasants was thus firmly established. The townsmen dedicated all their efforts to living at the expense of the peasants. The government set up by the Ritsuryō regime attempted, however, to apply the principles of the code of the Taihō era, especially as far as taxes were concerned. But the construction of the new capital and the temples, together with the salaries of the new officials, had drained the treasury.

The affairs of state of the Tempyō era (roughly speaking, the eighth century) were highlighted by a prodigious cultural leap forward and by two series of events: the first agrarian, the second purely political, although derived from the first. It was an epoch of violent contrasts and contradictions, yet the very precariousness of material life, the insecurity, appeared to favor the development of art and literature.

The Situation of the Peasants

It was the peasants, more than the fishermen, who created the essential Japan. At the beginning of the eighth century the social structure of Yamato was based on an almost exclusively agrarian economy. The establishment of the Ritsuryō code together with the Taika reform had aimed to improve the condition of the peasants, but the application in Japan of a system that was completely Chinese (and that was to fail in China as well) proved to be extremely difficult.

The first problem arose because the peasants were too heavily taxed and were also obliged to labor without pay for long periods on public works, and for these reasons scarcely had time to cultivate the land allotted them. Although the obligation to pay the taxes in silk had contributed to the progress of sericulture, the burden of payment in rice forced the peasants to look for methods of improving the yield of the rice paddies. Their own living conditions did not improve, however. The population increased rapidly, and a census had to be taken every six years in order to readjust the subdivision of the family plots. The smaller families were thus inevitably the poorest.

Taxes weighed so heavily on the peasants that many of them preferred to abandon their land and to hire out their services (although remaining free men) to the more important families, the nobility, or to the monasteries. Having paid their taxes, the farmers found themselves at times even without seed grain and were obliged to borrow it at a high rate of interest (30, 50, even 100 percent), which made it impossible for them to continue to cultivate their land. Since the land belonged to the state, however, they could not even dream of renting or selling it.

The amount of land lying fallow because of this situation increased from year to year until it reached alarming proportions. The rural economy declined. The government finally decided

to open to cultivation new lands obtained from the elimination of forests or from the ejection of aboriginal tribes. In order to encourage the peasants to cultivate these new lands, their tax burden had to be lightened. Unfortunately, isolated individuals could not hope to cultivate these vast areas that had been cleared, irrigated, and leveled; the work of many men acting together was required. These new lands were allotted, therefore, with an exemption from taxes and corvée, to the great families, to the nobles (often at the time of their appointment to an official post or of their promotion in rank as a reward for services rendered), or to the monasteries. With these new concessions the situation that the Taika reform had attempted to avoid was quite naturally brought into being, and the new lands became the property of those who had the means of cultivating them. The result was that the poor peasants could not have access to these tax-free lands, and in order to avoid taxes and compulsory labor on public works, they hired themselves out to the new landowners. As early as 685 an imperial edict, designed to relieve the danger to the nation posed by defection of the peasants, had canceled the debts of those unable to pay them. In 722 the government opened to cultivation some 2.5 million acres of new land, which became private property and not subject to allocation or subdivision among the heads of the families in the years that were to follow.

At first (about 712), the new lands could not be claimed by either the nobles or the monasteries, but the government could not deny, if it wanted the new land to be effectively cultivated, to the landowner class—the only ones with the material means to place the land under cultivation— the right to demand these *konden*. In 749 the Emperor Shōmu, a pious Buddhist, donated to the monasteries the fallow land that had not been claimed by others; his example was followed by the empresses who succeeded him. Although overall agricultural production improved considerably—rice and wheat, as well as mulberry trees—due to these tax-free gifts to those with the necessary labor available for the cultivation of the new lands, the imperial position was proportionately weakened.

The nationalization of the land provided for by the Taika reform had aimed to dispossess the great nobles and reduce their power. The contradictory measure taken in the eighth century by the various rulers could not prevent the nobility from regaining its power or the monasteries from extending their holdings. In fact, the monasteries became so powerful that, like the nobles, they soon claimed political influence. With the ever-increasing extension of tax-free land, the public treasury grew poorer, and the little peasant lived only in order to pay the expenses of the state. At that point he preferred to see his land pass to a monastery or to a noble, because they imposed on him lighter taxes than the state and the obligations of corvée were less burdensome. Thus the embryo of a feudal society was formed. It led to the ruin of a system of government that had only good intentions but was not adapted to the conditions of life of the Japanese people.

About 780 Emperor Kōnin as an economy measure decided to abolish compulsory military service for the peasants and to create a class of specialized warriors. These warriors, recruited from the minor nobility or the younger sons of the great families, constituted a regular army that benefited from a special statute practically separating it from the people. The people at that point saw in this move only an alleviation of their misery and quite happily accepted the idea of still another class to respect. From the free man that he had once been, the Japanese peasant was to become in less than a century a social slave obliged to conform to a set of rules for the sake of sheer survival, and those rules were to remain profoundly impressed on him until modern times. The exaggerated class consciousness of the nobles of the epoch sifted through all strata of society and separated the monk from the peasant, the peasant from the artisan, the farmer from the hired worker, the potter from the metalworker, with the result that there was gradually formed a social hierarchy subdivided into almost watertight compartments. At the end of the Tempyō era (or of the magnificent Nara period, which in other respects was so rich in innovations) Japanese society had acquired a form that remained unchanged for centuries. As a result the entire history of Japan, from that moment onward, was in the hands of the upper classes, and only rarely were the people participants in it.

It was from the people, however, that the spirit of Japan arose. Beginning with the Nara period, it is possible to discern in the evolution of the spirit of the Japanese two parallel currents, and it would be impossible to express the opposition between them too strongly. The first: aristocratic, Buddhist, brilliant, superficial, and warlike. The second: plebeian, serious, hardy, Shintōist, and peaceful. These are the diametrically opposed elements—although they may seem complementary—which from this point onward would constitute the basis of Japanese civilization.

The Political Situation

The addition of the new lands and their increased agricultural yield had been made possible only by the mining of new sources of iron (in ferrous sand) which permitted the manufacture of iron hoes. During this period these implements were so highly prized that the court made gifts of them to the nobles and the monasteries. The clergy, who received numerous gifts from the faithful, were nevertheless anxious to cultivate their land holdings, which in some instances were widely separated and thus escaped government control. Their power increased constantly; the priests ended up by dictating their law to the sovereigns.

In 737 an epidemic of smallpox ravaged the country, decimating both the peasants and the aristocracy. Buddhist ceremonies assumed great importance at that point, and gifts flowed into the monasteries. It was decided to build a new temple, the Tōdai-ji at Nara, to house a colossal image of Buddha as a propitiatory gesture in the hope of ending the epidemic.

The discovery of gold and the mining of this source permitted the imperial court to assume the expense, and the new monastery received as a donation almost 12,500 acres of land, thus making it a power without equal in all Yamato. In addition to the increasing power of the priests, who formed almost a state within the state, the government experienced other difficulties of succession and conquest.

The Emperor Shōmu, who had dedicated the enormous bronze statue to Buddha at Tōdai-ji in 749, abdicated in that same year in favor of his daughter, who became the Empress Kōken. The empress, a fervent Buddhist, favored the monasteries to such a point that a priest by the name of Dōkyō obtained the post of prime minister and even attempted to have himself designated crown prince, thus taking advantage of the fact that the Fujiwara family, hitherto politically all-powerful, had been considerably weakened by the smallpox epidemic. The Empress Kōken abdicated in favor of the Emperor Junnin, who favored Fujiwara Nakamaro (the minister Oshikatsu). Fujiwara Nakamaro was assassinated, however, and the Emperor Junnin was deposed in 764, and the following year the Empress Kōken returned to the throne under the name of the Empress Shōtoku. The priest Dōkyō once again became all-powerful and ruled the country until the death of the empress in 770. The throne then passed to a grandson of Tenchi who assumed the name of the Emperor Kōnin. Dōkyō was banished, and the new emperor ordered the religious orders to return to their monasteries and to limit the construction of new temples, thus separating powers of church and state.

At the death of Kōnin in 781 the council of ministers refused to place a woman on the throne, claiming that the empresses bestowed too many favors on the priests. The succession thus passed to the eldest son of Kōnin, Prince Yamabe, who assumed the name of the Emperor Kammu.

In addition to these dynastic difficulties the government also had problems in north Honshu where the Ainu were in continuous revolt against the Japanese. Some of the Emishi tribes had even destoyed the small forts built on the frontier by Oshikatsu. A project for the reconquest of Korea failed even before it took definite form, but the cost of arming some five hundred boats weighed heavily on the state budget.

At that point the Emperor Kammu decided to move the capital. We do not know for exactly what reasons, but we assume that his aim was to free himself from the encroachments and in-

fluence of the monasteries and to effect the separation of the Buddhist church from the state. In 794 he ordered the building of a new capital to the north of Heijō-kyō on the site of modern Kyoto. He called it Heian-kyō and moved the seat of his government there. A new era was about to begin.

Cultural Development

Despite the dynastic difficulties and the trouble created by the nobles and clergy, civilization made considerable progress, at least among the aristocracy. The vogue for Chinese culture increased; a knowledge of Chinese classics and literature was necessary to attain a position of any importance. At that time a university education was reserved for the sons of the nobles, in rare cases for a few scholars. The monasteries remained the real sources of culture; even though they did not teach the Chinese classics, religious literature and scripture were studied there.

Japanese scholars began to make use of Chinese ideograms to transcribe the sounds of the Japanese language, and Japanese culture expanded. The people, incapable of writing their own language because they had no access to Chinese culture, remained completely illiterate, with the exception of a few brilliant protégés of the clergy. Yet the people had a no less animated spirit, centered in the contemplation of nature and an innate sense of poetry which was translated into songs and ritual invocations to the Shintō divinities of Heaven and Earth, the *norito*.

The *Man-yō-shū*, an anthology of nearly 4,500 poems, all composed between 670 and 759, has preserved these masterpieces of spontaneity and delicacy, the true essence of the Japanese soul. All the poems were not composed by nobles; there are also those by simple peasants. For the most part they are *tanka* (or *waka*): court poems of thirty-one syllables (5–7–5–7–7) in which the hemistich is to be found at the end of the third verse. There are also *chōka*, a sort of typically Japanese ballad in alternating verses of five and seven syllables. Here is an example:

> *My poor seamed hands are*
> *Cracked by the husking of rice.*
> *This evening, again,*
> *The young lord of the manor,*
> *Sighing, will take them in his.*

Or this other, which, like the first, is anonymous:

> *Near to the valley,*
> *Although my home*
> *Is among the large trees*
> *And a village is nearby,*
> *The cuckoo*
> *Has not yet sung.*
> *Desiring to listen to*
> *His singing voice*
> *In the morning*
> *I go toward the gateway.*
> *In the evening*
> *I walk in the valley,*
> *But despite my impatience*
> *Nothing sings*
> *Nor comes to charm my ears.*

One of the greatest poets—neither prince nor emperor—who has left us his name, Kakinomoto-no-Hitomaro, also penned some classical ideas, in no way influenced by foreign philosophies, in which one finds again the simple accents of the soil, the pining for nature, and the dignity of the free man.

> *Remember then your dog*
> *That jumped over the hedge,*
> *You who hunt the birds.*
> *And on the leafy slope*
> *Of the verdant mountain*
> *Rein in for a moment your horse...*
> *If you will die of love,*
> *Let it be so.*
> *My love seems to feel this too*
> *When in front of my house*
> *She passes....*

During the eighth century the poets of the nobility were totally immersed in classical Chinese culture, and their poetry tended to imitate that of the Chinese writers. Quite often they also reflected a Buddhist ideal. Although certain poets remained typically Japanese in spirit, the majority of the cultured courtiers wrote their poetry in Chinese. The *Kaifūsō*, written in 751, is a collection of these poems, polished works in which delicate sentiments are the rule. During that period, anxious to instill in their subjects the concept of the divine ancestry of the emperors, the sovereigns commissioned two chronicles, the first histories of Japan: the *Kojiki*, in 712; the *Nihon-shoki* (or *Nihongi*), about 720. The chronicles, although historically unreliable, contain much useful information regarding the beliefs and customs of the clans of pre-Buddhist Japan. More or less in the same period, the *Fudoki* (topological surveys of a province and of its resources) were collected, but of these only four partially complete reports have survived.

The development of literature proceeded at an equal pace with the study of law. The nobles did not neglect, however, the sciences that had arrived from China: medicine, astrology, the art of divination, military strategy. The Buddhist monks devoted themselves to the techniques of architecture, sculpture, and painting, which were so necessary for the decoration of their temples and monasteries. The artisans, too, developed their own techniques, following the new teachings and the objects imported from China.

One of the most remarkable examples of their achievements in the field of bronze casting is the immense statue of Buddha in the temple of Tōdai-ji in Nara. It is 52'6" high; 490 tons of copper and $7\frac{1}{2}$ tons of lead and tin were needed for the alloy, and 990 pounds of gold dissolved in a mercury solution were used for the gilding.

The manufacture of bronze mirrors with a high proportion of tin, coins—the first, called *Wadō-Kaihō*, were struck after Chinese prototypes in 708—sword blades, and hoes and other implements and tools, all display the exceptional skill acquired by the metalworkers of the period. In the eighth century ferrous sand, found in large quantities in Japan, was utilized, and gold, tin, lead, and mercury mines were worked. With the aid of techniques that were certainly still primitive, fine results were obtained. We also know that in this epoch the first glass colored with metallic oxides was made, although its use was quite limited.

Chinese pharmacology, brought back by the scholars and priests returning from the continent, also consisted of many elements of pure magic. There was a widespread administration of medicinal herbs *(honzō-gaku)*, the use of which was assiduously studied by the monks. The Shōsō-in (an ancient storehouse) at Nara preserves among the treasures of the Emperor Shōmu numerous local or imported medicaments (such as rhinocerous horns, ginseng roots), together with various other objects (most of which were imported from T'ang China) and remarkably

well-preserved Japanese fabrics that clearly indicate the high technical level of the weavers of the period.

Yet it must be admitted that all these techniques were employed solely for the use of the aristocracy. The peasants dressed as they always had. With the exception of the iron hoes lent them by the priests or lords who owned the property, they made their own tools. They lived in huts built on the same model as those their ancestors occupied three centuries previously. While the level of material civilization was relatively high in the capital and among the provincial nobles, the rural population still lived in an almost Neolithic cultural stage, even though they made use of bronze and iron.

The Buddhist clergy was a hierarchical aristocracy in and of itself; its influence was even greater than that of the nobility, since the majority of the religious orders had the imperial household as their protector. In 741 the Emperor Shōmu ordered a seven-story pagoda erected in each and every province for the conservation of the Sacred Scriptures, and with each pagoda there was to be added a temple for the monks and priests and another for the nuns. The members of the religious orders attempted to improve the lot of the peasants by having bridges built and wells dug (which proved equally profitable for them), organizing crafts, and building homes to shelter indigents and orphans. These were feeble attempts, however, despite the efforts of such priests as Gyōgi (670–746) and Ganjin. The number of sects multiplied; all were brought by Chinese monks who came to Japan in the trains of returning Japanese ambassadors *(kentōchi)*. In Heijō-kyō (Nara) alone, six sects (Sanron, Hossō, Kegon, Ritsu, Jōjitsu, Kusha) were established; they divided the temples and religious organizations among themselves. The doctrines of the sects of Nara promised salvation only to the chosen few. The people, however, were indifferent, and continued to have faith in their ancestral cults and even to regard with a certain mistrust this religion which seemed to have been brought in for the sole benefit of the state, the nobility, and the monks.

Architecture

Architectural progress was most evident in the construction of temples, which grew in number and in ostentation as the monasteries became wealthier and Buddhism ever more powerful. The monastery of Tōdai-ji was the masterpiece of the Tempyō era, and nearly twenty years were needed to complete its construction. According to the *Tōdai-ji Yōroku*, 50,000 carpenters, 370,000 metalworkers (including miners), and 2,180,000 laborers, painters, sculptors, and artisans were employed. In addition to the gigantic Daibutsu-den (height 164'), there were two seven-story pagodas (height 295') that have since been destroyed, enormous gateways (of which only the Nandai-mon survives), and numerous other buildings reserved for preaching or the living quarters of the clergy. Unfortunately the magnificent group of buildings was destroyed by fires in 1180 and 1567: although rebuilt each time, there were considerable variations in style and technique. The monastery of Saidai-ji was also enormous and was reconstructed after its destruction by fire. It was built in the overdecorated and exaggerated style typical in China during the T'ang and the Sung dynasties.

Of all the temples constructed in Japan during this epoch, perhaps only the Kondō of Tō-shōdai-ji, a monastery established by the Chinese priest Ganjin (Ch'ien-chên) can impart an idea of the architectural tendencies that prevailed toward the end of the Nara era when the builders were in full control of technique. The Hokkedō of Tōdai-ji is also an interesting example of a composite temple in a later and more complicated style. It was built about 748, but as it was partly reconstructed during the Kamakura era the roof no longer has its original shape. At Hōryū-ji the octagonal hall of the Yumedono and the Dempō-dō together with a few less important structures still survive from the Nara period.

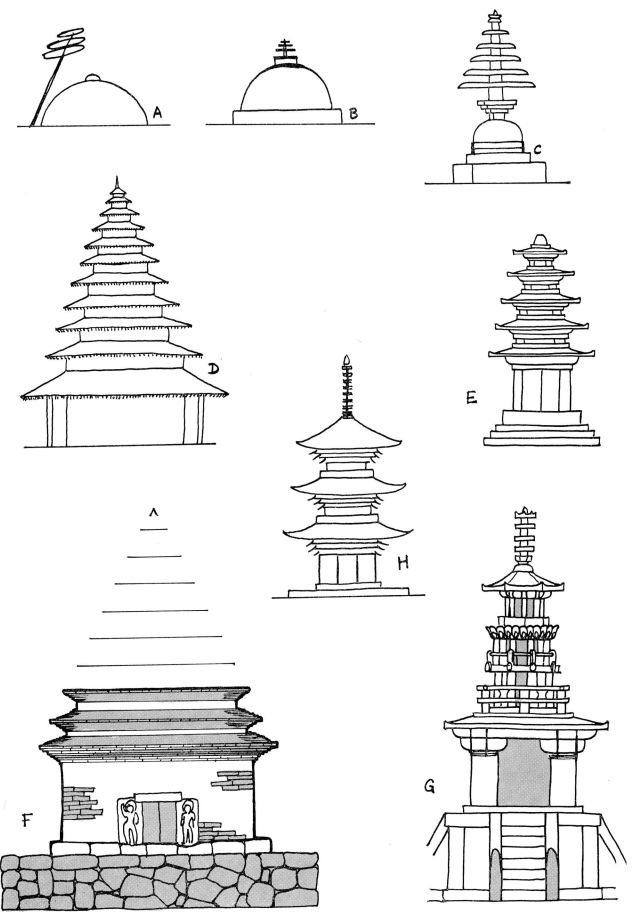

22. EVOLUTION OF THE PAGODA FROM THE STŪPA

A. HILLOCK OF THE FERTILITY CULT OR TUMULUS (INDIA)

B. STŪPA OF SĀNCHĪ (INDIA)

C. STŪPA OF GANDHĀRA AND CENTRAL ASIA

D. MERU OF BALI

E. PAGODA OF CHONGYIN-SA, PAEKCHE, KOREA; SIXTH C.

F. PAGODA OF PUNWANG-SA, SILLA, KOREA; SEVENTH C.

G. PAGODA OF PULGUK-SA, SILLA, KOREA; SIXTH C.

H. A PAGODA IN THE JAPANESE STYLE

The architecture of this epoch was characterized by low but widely projecting roofs, the use of massive cylindrical columns, and the introduction of supports between the bracketing, which were called, according to their shape, *kaerumata* or *taihei-zuka*. In 756, when the Dowager Empress Kōmyō decided to donate to Tōdai-ji some of the art treasures and personal property of her deceased husband, Emperor Shōmu, a special building was constructed that was to become the prototype of numerous other structures for the housing of the treasures of the temples. Raised on numerous massive pillars of wood, the Shōsō-in looks something like a log cabin, with walls constructed of horizontally laid tree trunks, notched and fitted together at the corners. Instead of being cylindrical, however, the logs have been planed so that they are triangular. In rainy periods the logs swell and thus effectively prevent the dampness from penetrating the building's interior, thereby avoiding the danger of mildew. This type of structure, called *azekura-zukuri*, was normally utilized only for the construction of a type of granary. The Shōsō-in has only one door and no windows; the tile-covered roof has eaves extending far out over the walls, thus protecting them from the elements.

Sculpture

Even though strongly influenced by T'ang art, sculpture of the Tempyō era reveals consummate originality. The Japanese artists were no longer inclined, as in preceding periods, to imitate Chinese or Korean works; they created new images on the basis of the T'ang prototypes. In these cases, however, the Japanese artists went far beyond their models in both style and technique. T'ang realism here became extraordinarily animated, due to the use of more supple materials than bronze and to the keen observation which at all times has been a characteristic of Japanese art. Although bronze was still utilized, other and quite diverse materials were employed for the sculpture decorating the temples: clay, lacquer, wood, and even—although rarely—stone. Stone apparently had little appeal for the Japanese artists. Since it was primarily granite or volcanic rock, it was not especially workable because the sculptors lacked the proper tools. During the entire history of Japan, stone—except in its rough state as a decorative motif in gardens—was used only rarely for sculpture or in architecture. Practically speaking, stone served only for the construction of solid foundations on which to place the columns supporting wooden structures.

In sculpture the Indian style of clothing, which up until then had been preferred by artists, gave way to heavy, realistic drapery. Bodies became stiffer and more powerful; arms and legs, although not full-fleshed, were arranged in dignified poses, which did not exclude, however, a sense of movement. With the exception of representations of Buddha, which were inevitably conventional, the faces are strongly realistic and mirrored not only individual physiognomy but also expression. The eyes of the Buddhas are more slanted than those of the preceding period, and the middle portions of upper eyelids have a tendency to curve over the pupils. The mouth is smaller; the lips form a pronounced arch, with the lower lip almost as strongly crescent-shaped as the upper one. The mouth appears more dour and pessimistic, because of the downturned corners. A thin moustache is often painted over the upper lip. The faces are rather heavy, square, and perfectly symmetrical. The Buddhas bore a large, heavy *ushnisha*—the topknot *(nik-kei* in Japanese)—adorned with thin, tight coils or ringlets, usually attached separately, and the hairline was slightly arched over the middle of the forehead. Statues of other divinities were executed in a more realistic fashion. The hands have strongly rounded fingers with short nails and are bent slightly backward. They seem sensitive, almost feminine.

Whereas, however, the statues of the preceding period followed a sinuous line with shoulders thrown back, statues of the Tempyō era have a tendency to lean slightly forward. The numerous ornaments were always added afterward. The extraordinarily elaborate halos, often decorated with multiple images of Buddha and other celestial figures, were the delicate work of either

goldsmiths or woodcarvers and lacquerers, although often gold and wood were combined.

The bronze statuettes were usually cast in two parts. The head was made separately by the *rōgata* technique utilizing the lost-wax process employed in the preceding periods. The castings were still thick and heavy, and in the case of the smaller works they were solid. The large bronze sculptures, such as the Daibutsu of Nara, were probably executed with the so-called *igarakuri* technique: the models were cut up into horizontal sections which were then mortised so that after being cast separately the sections could be reassembled without any danger of their slipping apart. The Daibutsu, however, having been repaired on several occasions, particularly after the fires that destroyed the Daibutsu-den, is now quite out of proportion; it is considered more of a technical tour-de-force than a true work of art.

After having depleted the country's metal reserves in casting this immense statue, Japanese sculptors abandoned bronze almost entirely. It had become more and more expensive, because every time a work was restored it had to be regilded either with gold leaf or with liquid gold prepared in a mercury solution.

New sculptural techniques had been brought in from China. The use of clay and dry lacquer was not only less expensive but offered greater freedom in execution. Japanese artists were encouraged to employ these new technical possibilities. Clay statues were modeled on wooden armatures wrapped in straw and cloth over which was added coarse clay mixed with chopped straw. The general outline was formed by an application of a more refined clay to which was added paper fiber. The statue was completed with a type of glaze into which was mixed pulverized mica. Once it dried, it was either polychromed or gilded with gold leaf.

Statuary executed in the dry-lacquer technique followed one of two processes. The first and oldest—called *dakkatsu kanshitsu*, or hollow dry lacquer, and employed at the beginning of the Tempyō era—consisted of soaking several thicknesses of hemp cloth in liquid lacquer and applying them on a rough clay model. Once this "skin" had dried, the statue was completed by modeling the major surface details with a mixture of liquid lacquer and *kokuso*: sawdust, rice flour, and incense. The surface was then painted or gilded with gold leaf. Finally, the inner clay core was removed and replaced with a more or less complicated wooden armature for internal support. Such fine details as fingers and ornaments were made by the same process and then applied to the main body with metal wire which was then concealed with lacquer-soaked bands of hemp cloth.

The second technique—called *mokushin kanshitsu*, used especially at the end of the Tempyō era—employed a rough wooden core covered with hemp cloth saturated with lacquer mixed with *kokuso*; in this process the lacquer was modeled after it had dried. The wooden core was either a solid block or made up of several pieces nailed together. This core was not removed, but it was often hollow or open at the back so as to reduce the weight of the statue and also to prevent the lacquer covering from becoming damaged through swelling caused by humidity or cracking due to dryness. Toward the end of the Tempyō era some works were carved from wood after examples executed in dry lacquer or clay.

Although the doctrines of esoteric Buddhism had not yet made their official appearance in Japan, there were some multi-armed or -headed images of divinities appertaining to Ko-Mikkyō (ancient esoteric Buddhism) such as representations of Kannon (Kuan-yin in China), whose prototypes had come from the continent; during this same period numerous Japanese works representing the twelve generals of Yakushi Nyorai (the divinity of healing, the Buddha who cured all ailments) or of the Ten Great Disciples of Buddha were also created. It is possible that some of the statues that have survived from this period were executed by Chinese artists who had come to Japan at the same time as the priest Ganjin (754). This would seem to be borne out by certain characteristics that are definitely in the T'ang style as well as by the refined technique used for the armature of some of the hollow dry-lacquer statues *(dakkatsu kanshitsu,* then called *kago zukuri)*. Secular subjects—which include some remarkable portrait statues of the two priests, Ganjin and Gyōshin—of this period inaugurated an exceptional series of realistic works, which

reached their peak of perfection during the Kamakura period and constituted a means of expression among the finest ever realized in the domain of the plastic arts. Through the calm dignity of these portraits one becomes aware of the character of the subject and can even fathom his thoughts. The acute power of observation that the Japanese artists possessed to such an extraordinary degree is supremely apparent in these works.

Painting

The painting of the Tempyō era has decided T'ang characteristics both in portraiture—such as that of a woman of the nobility (now in the Shōsō-in of Nara)—and in the illustrations to the sutras *(Kyō)*, or Buddhist scriptures, which in this period were widely copied from the Chinese scrolls by a department of copyists, a group assigned by the government for this particular type of work. Similarly, the painters commissioned to create the decorations of the monasteries were grouped in a department of painters under the jurisdiction of the Ministry of Internal Affairs. In addition to the administrative staff, this department consisted of four master painters and sixty professional artists, including a few Chinese. When necessary, these official artists could enlist the assistance of local painters. Apparently the painting of this period was often a matter of teamwork; certain artists were specialists in backgrounds or landscapes, others in portraiture or coloring. (The social status of painters during this period is interesting to note: official scribes could only aspire to the eighth degree of rank in the hierarchy of the imperial court, but the painters could rise to the fifth degree.)

The paintings preserved in the Shōsō-in at Nara show the influence of T'ang art, which, in turn, was influenced by the art of Central Asia, particularly that of Turfan. These works were usually executed in India ink (subsequently colored) on finely woven hemp or linen cloth. The contours of the drawing were more or less subtle, according to the ability of the artist. The colors were brilliant and at times were replaced by appliquéd feathers (reminiscent of the iridescent beetles' wing cases which at one time decorated the small portable shrine or tabernacle known as the Tamamushi-zushi). Other examples that have survived bear designs that were either stenciled on dyed fabrics or applied with a wax process similar to the batik method of Indonesia. The fabrics on which these motifs were drawn were probably imported; they often have Persian and even Byzantine characteristics.

103–6. NARA. HŌRYŪ-JI. WALL PAINTINGS OF THE KONDŌ. Although a tradition attributes these paintings to the Korean priest Donchō (who imported paper and paintbrushes into Japan for the first time and was the first person in Japan to be cremated), it is far more probable that they were executed at the beginning of the Tempyō era or perhaps even in the Wadō period (c. 711). On the interior walls of the Kondō of Hōryū-ji four panels were painted with subjects representing paradise and eight others portraying Bodhisattvas. The theories vary as to the relationship between the paradise panels and those of the Bodhisattvas, although it is almost certain that the subject of panel 6 depicts the Paradise of Amida (on the west wall—plates 103, 105, 106). Plate 104 is a detail of panel 10 (on the north wall) and is perhaps a portrait of one of the attendants of Shaka Nyorai. Each one of the paradise panels is approximately 10′2″ × 8′9″; the Bodhisattva panels are slightly narrower. Color was applied on thick plaster in a shading technique reminiscent of that used at Ajanta in India and also in Central Asia. The principal colors are red, yellow, dark green, and white, and the lines were also drawn in color. The painting proper was executed in pigment mixed with size and applied to a ground consisting of a layer of fine white clay spread over a wall made of clay mixed with chopped straw and fine gravel.

Unfortunately the major part of these paintings have been almost completely destroyed, having been severely damaged in the fire that consumed a part of the Kondō in 1949.

103. AMIDA NYORAI. The hands are making the gesture of *Dharmacakramudra* (act of turning the Wheel of the Law, generally assigned to Shaka Nyorai). Central figure of panel 6, on the west wall.

104. ONE OF THE TWELVE GENERALS OF YAKUSHI. A subsidiary figure on the upper right of the northeast wall

105. ATTENDANT OF AMIDA. A figure seated on the upper right above that of Shō Kannon. Panel 6, on the west wall.

106. SHŌ KANNON BOSATSU. Recognizable by the little image of the Amida Buddha in the headdress. To the right of the central figure. Panel 6, on the west wall.

107. NARA. TŌDAI-JI. NIGATSUDŌ. This building was constructed in 752 by a disciple of Rōben, the founder of Tōdai-ji. It was destroyed in 1667 and later rebuilt. Because it was built on the slope of a hill, it was erected on a large number of wooden supports. The structure shelters a sacred well, the water of which is used in ceremonies dedicated to the principal divinity, the so-called eleven-headed Kannon, which is kept hidden. The name of the building (Second-Month Hall) is derived from the ceremony of the drawing of the sacred water that takes place each year at the beginning of the second lunar month (Nigatsu—"second

month," generally February–March). On the first floor there is a small chapel devoted to Shintō worship.

108. NARA. TŌDAI-JI. SANGATSUDŌ. Also called the Hokkedō, the Sangatsudō (Third-Month Hall) is the oldest of the original buildings of the group (or at least its front part; another hall was added in the rear during the Kamakura period). The older part (729–48) dates from the Tempyō era. The roofs are supported by brackets of a very simple type *(degumi)* placed on strong pillars. The ceiling of the interior was painted. The architecture is balanced, even majestic, despite its limited dimensions.

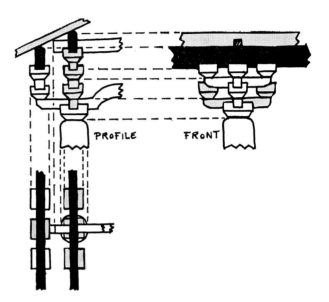

PROFILE FRONT

23. TYPE OF WA-YŌ BRACKET: DEGUMI

109. NARA. TŌSHŌDAI-JI. WEST SHIBI ON THE ROOF OF THE KONDŌ. (See plate 110.)

110. NARA. TŌSHŌDAI-JI. KONDŌ. The only main hall still surviving from the Nara epoch, the Kondō of Tōshōdai-ji is longer (seven bays) than it is wide (four bays). Its unique hip roof with its gently tapered lines gives the structure the appearance of great stability (the roof was originally even flatter before its reconstruction at a later date). It is supported by bracketing of the *mitesaki* type surmounting massive red-painted columns with a slight entasis. One of the peculiarities of the building is that its bays are not identical in width: those in the middle are widest, while the flanking bays diminish in width. The entablature is divided by horizontal beams bearing the weight of small vertical posts *(kentozuka)* placed between the bracketing, a characteristic of this method of construction *(Wa-yō)*. The ridgepole is embellished with terra-cotta *shibi*, acroterions shaped like animals or monsters (here, stylized horses' heads). The one shown in plate 109 is on the west and is original, the east one was remade in 1323; both were originally gilded.

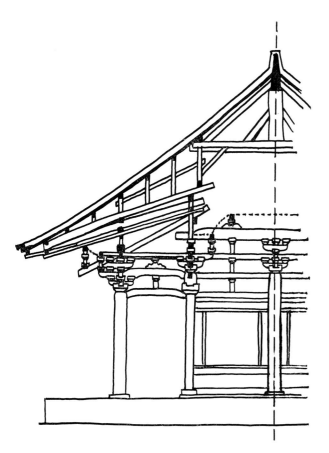

24. SECTION OF A BUILDING IN THE WA-YŌ STYLE

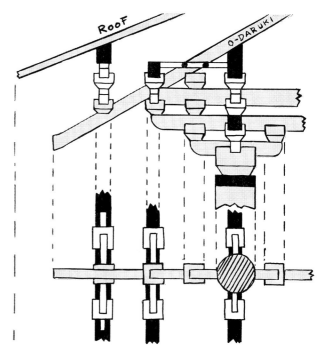

25. TYPE OF WA-YŌ BRACKET: MITESAKI

III. NARA. TŌDAI-JI. DETAIL OF A CORNER OF THE HOKKEDŌ KYŌKO. The Kyōko, a sutra library, is located a little to the south of the Hokkedō and is generally considered to be the work of the same period. Its method of construction is comparable to that of the Shōsō-in of Tōdai-ji and the Kyōzō (see plate 112) of Tōshōdai-ji.

112. NARA. TŌSHŌDAI-JI. KYŌZŌ. This *azekura*-style structure was used to house sacred objects (images, scriptures, and various treasures). It dates from the Nara period (although it was repaired at a later date) and is a splendid example of this particular type of construction. It will be seen again in the Shōsō-in (now a museum) of Tōdai-ji. The building is supported by sixteen massive wooden pillars. Like the Shōsō-in, the walls are built like a log cabin's, and the logs have been planed into 3-sided posts. The ends interlock and extend at each corner. This method of construction permits the stacked logs to expand or contract according to the degree of humidity in the atmosphere, thus helping to conserve the objects kept in the structure. There is a single entrance to this *kura* (literally "granary") reached by a wooden stair that can be raised like a gangplank.

113. NARA. TŌDAI-JI. DAIBUTSU-DEN. This immense building—the largest wooden structure in the world— is more than 150 feet high, but it is not as high as it

was when originally erected. It was built to house an enormous bronze statue of the Buddha (plate 115). Having been destroyed by fire in 1180, it was rebuilt in the Kamakura period. The original structure had a facade eleven bays wide, and the bracketing was of the *wa-yō* type, one of the more typical in many Japanese buildings. The original *kara-hafu*-type roof no longer exists. The overall appearance re-creates somewhat the general aspect of the original Daibutsu-den (Great Buddha Hall). To the right and the left of the main entrance were two immense seven-story pagodas (one of which is shown in a scale-model reconstruction in plate 114). The Daibutsu-den was again destroyed by fire in 1567, and it has been repaired and redecorated on numerous occasions since then.

114. NARA. TŌDAI-JI. MODEL OF ONE OF THE TWO PAGODAS.

115. NARA. TŌDAI-JI. DAIBUTSU-DEN. THE DAIBUTSU. This immense bronze statue of the great solar Buddha is, despite its impressive size, an unsatisfactory work of art. When it was cast—in 749, as the result of a vow made by the Emperor Shōmu in the hope that the power of this image would alleviate the sufferings of his people after several years of disasters—it must have been much more beautiful. Earthquakes and a series of fires have severely damaged it. On three occasions the head fell to the ground, and the hands were shattered. The statue was repaired, but the successive restorations greatly reduced its splendor. Only a few details remain intact to permit us to imagine how magnificent it must have been in the beginning. The figure is seated on a gigantic pedestal shaped like a lotus flower, with beautifully engraved designs on its

144

petals (plate 116). The immense halo, decorated with figures of Buddhas, is an addition dating from the eighteenth century. Visible in the background are architectural details of the Daibutsu-den.

116. NARA. TŌDAI-JI. DAIBUTSU-DEN. THE DAIBUTSU. DETAIL OF LOTUS-BLOSSOM PEDESTAL. A Buddha engraved on one of the original bronze petals of the lotus-blossom pedestal gives us some idea of the original appearance of the great image of the Daibutsu. The style of the drawing is definitely T'ang, and it embodies a fine example of the engraver's art. The lower portion of the petals are incised with twenty-five horizontal lines and between them can be seen small engraved figures of divinities as well as architectural motifs. Unfortunately most of the original petals have been damaged in the various fires.

117. NARA. TŌSHŌDAI-JI. PORTRAIT OF PRIEST GANJIN. Ganjin was a Chinese priest. Invited to Japan by the Emperor Shōmu, he became blind during the course of an extraordinary series of events in the course of a ten-year odyssey, during which he was beset by shipwreck, storm, and capture by tribesmen of southern islands. He finally arrived in Japan in 753 or 754 and, after officiating at a series of ordination ceremonies, he founded the monastery of Tōshōdai-ji in 759. He died in 763. Legend has it that this portrait was executed by one of his disciples shortly before Ganjin's death at the age of seventy-seven. This sculpture is hollow and made in the dry-lacquer technique. The wooden core usually found within dry-lacquer statues has disappeared. The original paint is still visible on certain portions, despite several unskilled attempts at restoration: pink for the flesh, green for the undergarment, and red for the robe, which is decorated with a delicate design of low hills. The pose is one of extreme simplicity, the expression remarkably tranquil and humanly alive. Without doubt it is a true portrait from life. Height 31⅝".

26. SIX PLANS OF MONASTERY-TEMPLES OF THE ASUKA AND NARA ERAS

A. HŌKŌ-JI, C. 580	D. HOKKI-JI, C. 650
B. SHITENNŌ-JI, C. 580	E. YAKUSHI-JI, C. 690
C. HŌRYŪ-JI, C. 610	F. TŌDAI-JI, C. 740

118. NARA. TŌDAI-JI. BRONZE LANTERN. This large octagonal lantern situated in front of the Daibutsu-den of Tōdai-ji is mounted on an octagonal pillar that is surrounded by a stone balustrade (see plate 113). The lantern has four pierced doors and four panels exquisitely decorated with dragons and celestial musicians, one of which is shown here playing a flute and standing on two lotus flowers against a background of *hōsōge* (an imaginary flower resembling a peony). The movement of the figure's robes gives an extraordinary impression of lightness. Cast in bronze by the lost-wax process. Total height of the lantern and pillar 15'.

119. NARA. SHIN-YAKUSHI-JI. BASHARA TAISHŌ. This celestial guardian, one of twelve forming the retinue of the Yakushi Nyorai, is exceptionally dynamic. Made of clay, the eyes inset with obsidian, it is a work typical of the art of the Tempyō era. This sculpture appears, however, to have been executed a little later than the Indara Taishō of the same group (see plate 101). The

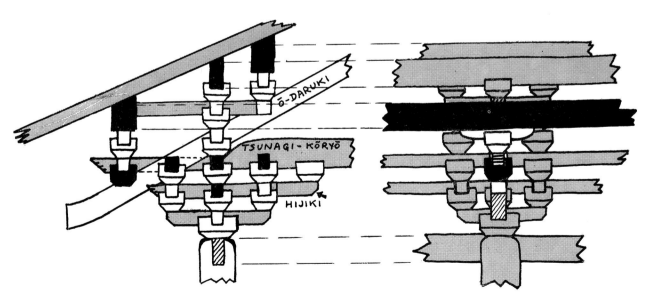

27 . TYPE OF WA-YŌ BRACKETS: FUTA-TESAKI

145

figure corresponds to the Indian Vajra and should be (theoretically) painted white, but what little remains of the color is very dark. Height 63″.

120–21. NARA. KŌFUKU-JI. ASHURA. This sculpture was once part of a group called The Eight Guardians of Shaka Nyorai, representing the Hachibu-shū or eight classes of supernatural beings mentioned in the *Lotus Sutra (Hokekyō)*. They were executed (probably in 734) in dry lacquer. Ashura was the king of hunger and wrath, and was rarely portrayed. Here he is shown with six arms, two hands of which are joined in a gesture of prayer. He has three faces, and their expressions are quite beautiful. He is curiously dressed in a sort of tunic and skirt decorated with *hōsōge* patterns, and his armlets are decorated with gold leaf. The paint has retained its brilliant colors: vermilion hair, green clothing. Ashura stands on a base in the form of a rock carved from a block of wood and lacquered. Height 60¼″.

122. NARA. KŌFUKU-JI. HEAD OF GOBUJŌ. Like Ashura (plates 120–21), Gobujō is one of the Eight Guardians, but this is the only statue of the present group of which only the upper part survives. It is impossible to state definitely who the figure was originally intended to portray. As a headdress, the image wears a wild boar's head. The statue was made of dry lacquer and then painted. All the statues of the Hachibu-shū (with the exception of Ashura) were portrayed garbed in armor of the T'ang period.

123. NARA. HŌRYŪ-JI. YAKUSHI NYORAI. This small statue in the Chinese style made of copper-sheathed wood with a halo of gilded bronze was probably intended as an image for a family altar. Tempyō era.

124. NARA. HŌRYŪ-JI. MIROKU BOSATSU. This dry-lacquer statue with a wooden core *(mokushin kanshitsu)* is in a very simple style that anticipates the more elaborate works of the Heian period. Nara National Museum.

125–26. KYOTO. HŌON-IN AND JŌBON RENDAI-JI. TWO PORTIONS FROM THE KAKO GENZAI INGA-KYŌ. *The Sutra Regarding Past and Present Causes and Effects* was illustrated in Japan on a set of eight scrolls written in Chinese and narrating the previous lives of Buddha. The first Japanese version of these scriptures was copied in 735 by court painters who probably based their work on a Chinese prototype. The illustrations develop from right to left in a continuous fashion on the upper part of the scroll; the lower part is reserved for the text. The greatly simplified color scheme was limited to red, orange, green, and white. Both the type of architecture and the clothing illustrated are typical of the T'ang period in China. The drawing is at times quite ingenuous with little attention paid to proportions, but the illustrations as a whole have unity and the subject is treated in a charming fashion. This is the earliest

example of a Japanese *emakimono* that has come down to us. It was painted on paper with watercolors. Width of the scroll c. 10″. The length varies from one scroll to another: the one at the Hōon-in (plate 125) almost 50′, that at Jōbon Rendai-ji (plate 126) 34′.

127. NARA. TŌSHŌDAI-JI. TORSO OF A NYORAI. This splendid torso of extraordinary plasticity is also known as Tahō Nyorai (Prabhutaratna), but that is probably an error. We do not know what divinity this statue was originally intended to represent. The arms and legs are missing, and it has sometimes been assumed that, since the right arm was bent at the elbow, it might have been Yakushi Nyorai. The paint has completely disappeared, leaving the wood bare. Height c. 33″.

128. NARA. TŌSHŌDAI-JI. NYORAI RITSUZŌ. It is impossible to know who this so-called Standing Nyorai was originally intended to represent. It is a beautiful, powerfully modeled headless statue in wood, and the style embodies elements that look forward to the art of the early Heian period. Height 73″.

129. KYOTO. HŌON-JI. KANNON BOSATSU. The face and ornaments of this bronze statuette indicate that it can be attributed to the end of the Tempyō era, although this tiny work is sculpted in a style of the preceding epoch. Height c. 11¾″. Kyoto National Museum.

130. NARA. HŌRYŪ-JI. KUMEN KANNON. This small sculpture is an extremely fine piece of work. It was carved from a single block of sandalwood, using a technique known as *ichiboku*, and may have been made in China and brought to Japan. The eyes and the mouth are painted. It represents Jūichimen Kannon (Avalokiteshvara with eleven heads), but quite unexplainably this example has only nine, which accounts for the name Kumen ("nine-faced"). Each one of the *kebutsu* (aspects of divinity: forms to lead mankind to salvation) is crowned with a diadem on which there is an image of Amida Buddha. The vase held in the left hand originally contained a lotus flower, but it has disappeared. The right hand holds a rosary. This work has all the characteristics of the art current at that time in T'ang China. Height 15⅝″.

131. NARA. HŌRYŪ-JI. SAIENDŌ. YAKUSHI NYORAI. This is the principal image in the western octagonal hall (Saiendō) of the monastery of Hōryū-ji. It is a splendid statue of dry lacquer gilded with gold leaf, and is seated on a high pedestal in the shape of a lotus flower. The pierced halo of carved wood seems to be of a much later date. Yakushi Nyorai holds in his left hand a medicine jar said to be of beryl; it too must have been added at a later date. Height of the statue without pedestal 51″.

132. KYOTO. YAKUSHI NYORAI. A seated statue in dry lacquer originally gilded. The *rahotsu* coiffure (small snail-shell curls typical of representations of the Bud-

dha) has disappeared, revealing the basic form of the topknot *(nikkei)*. The eyes are painted, and the treatment of the entire work is somewhat heavy. There is evidence here of the beginning of a detachment from Chinese forms and a move toward a more definitely Japanese style. Kyoto National Museum.

133. NARA. AKISHINO-DERA. HEAD OF GIGEI-TEN. This delightful figure of a "divinity of the arts" is one of the most sensitive works produced at Nara. The statue's original body (dry-lacquered and painted) was destroyed in a fire, and only the head was saved. During the Kamakura era the sculptor Unkei, charmed by the grace of the figure, created a new body in wood, on to which he skillfully attached the head. In its present form the statue is about 79″ high and is seated on a lotus-flower pedestal. Gigei-ten presided over the arts and the dance, and this work is the only known Tempyō representation of this divinity extant in Japan.

134. NARA. TŌDAI-JI. SANGATSUDŌ. FUKŪ-KENJAKU KANNON. This large statue portraying one of the aspects of Kannon (here, the divinity who protects from error, saves, and heals: Amoghapasa) is hollow and made of dry lacquer *(dakkatsu kanshitsu)*. From the time of the founding of Tōdai-ji it has been the *honzon* (principal divinity) of the Hokkedō of this temple. It is beautiful in its poise and symmetry; the many arms do not give it a monster-like appearance. The serene head, with a third eye in the middle of the forehead, in addition to the *byakugō* or *urna* (a tuft of white hair between the eyebrows, symbolized here by a jewel), is crowned with an ornate pierced-silver diadem set with numerous pearls and gemstones. A small figure of Amida Buddha is set into the center of the diadem. The statue's halo is unique, and is composed of a large number of outward-shooting rays held in place by concentric oval strips. The interstices are alternately decorated with *hōsōge* motifs. The figure stands on a double lotus-flower pedestal, and it is flanked by statues representing Nikkō and Gakkō Bosatsu, made of unbaked clay and more than 6½′ high. These two figures originally must have been gilded and painted in vivid colors. They are magnificent examples of the style of the Tempyō era. On the left in the photograph one can see the Gakkō Bosatsu. Height of Kannon 12′.

135. NARA. TŌDAI-JI. TANJŌ BUTSU. The appellation Tanjō Butsu is given to Shaka Nyorai at the moment in which he is about to be born, when he invokes Heaven and Earth as witnesses of his arrival on earth and proclaims his Buddhahood. Images of Tanjō Butsu were made for the ceremony celebrating the anniversary of the birth of the great Sage. One of them is placed in the center of a pool in a pavilion decorated with flowers (Hanamidō). The custom calls for pouring a "sweet tea" (made from a type of hydrangea) over the statue. Thus sanctified, the beverage *(ami-cha)* is reputed to have numerous healing powers and, mixed with ink, guarantees beautiful handwriting. This small bronze statuette is seen here in the center of a pool. Height 18½″. Nara National Museum.

136. NARA. TŌDAI-JI. KICHIJŌ-TEN. This painted clay statue was severely damaged in 954 during a fire that destroyed the building that housed it (the Kichijō-tendō), and where it was paired with a statue of Benzaiten. The heads of the two divinities of the Buddhist pantheon (Kichijō-ten, or Mahasri, divinity of good luck and merit, and Benzai-ten, or Sarasvati, the goddess of love, music, and the arts) are childlike and enchanting. Unfortunately they are badly damaged. Height 78¾″.

137. NARA. TŌSHŌDAI-JI. SENJU KANNON BOSATSU. This very tall statue in the Joroku style, made of dry lacquer and wood, represents a Kannon with "a thousand arms." It was probably the work of a sculptor named Takeda-no-Sakome. Like Jūichimen Kannon (or Kumen Kannon), it wears a crown decorated with *kebutsu* (aspects of divinity). One can count 42 principal arms and 911 small hands (47 are missing). The work is in the same style as the Fukū-kenjaku Kannon (plate 134) and reflects the majestic stability that seems to be one of the outstanding characteristics of Tempyō era sculpture. On the statue's left can be seen one of the Shi-Tennō (the four guardian kings of the cardinal directions), made of lacquered and painted wood *(ichiboku)*. It was executed during the same period as the Senju Kannon Bosatsu. Height of Kannon 18′.

138. NARA. TŌSHŌDAI-JI. KONDŌ. HEAD OF RUSHANA BUTSU. A large statue of dry lacquer gilded with gold leaf, representing a seated figure mounted on a high pedestal (height 8½′). It is the principal divinity of Tōshōdai-ji. The coiffure composed of tight ringlets was carved of wood and joined to the lacquer head. The halo behind the statue is of gilded wood decorated with 864 small figures of Buddha in katsura wood. According to tradition, this work was executed by three Chinese priests who arrived in Japan in the company of the priest Ganjin. If this was the case, it must have been completed around 760, or a little later than the gigantic Buddha of the Daibutsu-den (plate 115). The facial features are still definitely of the T'ang style, but one notes a decidedly Japanese technique in the execution. A thin moustache was painted over the upper lip of this beautiful statue. It may have been a copy of the great Buddha in its original state. The pedestal is in the form of a lotus flower with numerous rows of petals, and painted on each petal is an image of Buddha. The statue creates an impression of power, perfectly suited to the idea of Vairocana, the supreme Buddha. Height of statue, without pedestal, about 11′.

538 or 552	C	Official introduction of Buddhism.
587	H	Triumph of the pro-Buddhist faction in the battle of Shigisen following which the temples of Hōkō-ji in Nara and Shiten-nō-ji in Osaka were built.
c. 606	A	Construction of Hōryū-ji temple, Nara.
610	C	The first cremation on the death of Donchō, initial importer of paper and paintbrushes from China.
612	C	Introduction from Korea of *gigaku,* a type of dance performance.
623	Sc	Completion of the Sakyamuni triad of Hōryū-ji by the sculptor Tori Busshi.
650	Sc	*Shitennō,* the four guardian kings now in the Kondō of Hōryū-ji.
670	A	Destruction of Hōryū-ji by fire.
672	A	Decree ordering the reconstruction every twenty years of the Shintō shrine at Ise.
678–85	Sc	Bronze head of Yakushi Nyorai, the main image of the Yamadadera temple.
697	A	Consecration of Yakushi-ji temple.
690–700	Po	Poems of Kakinomoto-no-Hitomaro.
710	A	Foundation of Heijō-kyō (Nara), the new capital.
711	Sc	Clay sculptures in the pagoda of Hōryū-ji. Ni-ō (the guardian divinities) of the Chūmon (middle gate) of Hōryū-ji.
c. 700–10	P	Wall paintings in the Kondō of Hōryū-ji.
712	H	The *Kojiki:* a collection of ancient historical narratives.
715	H	*Harima Fūdoki:* a survey of Harima province.
718	A	Removal of Yakushi-ji to a site near the center of the new capital.
720	H	*Nihon-shoki* (sometimes called *Nihongi*): a chronicle of ancient Japan, one of the six imperially sponsored histories of Japan.
721	H	*Hitachi Fūdoki:* a survey of the province of Hitachi.
731	H	*Izumo Fūdoki:* a survey of the province of Izumo.
734	Sc	The Ten Disciples of Buddha and the Eight Guardians of Shaka Nyorai in dry lacquer at Kōfuku-ji, Nara.
735	P	Earliest version of the *Kako Genzai Inga-Kyō,* the illustrated *Sutra of Past and Present Causes and Effects* copied from a Chinese model.
739	A	Yumedono of Hōryū-ji, Nara.
741	A	Beginning of the construction of the provincial monasteries (*kokubun-ji*) affiliated with the central temple of Tōdai-ji.
748	A	Hokkedō of Tōdai-ji, Nara.
749	Sc	Casting of the enormous bronze Buddha at Tōdai-ji, Nara.
751	Po	*Kaifūsō:* a collection of 120 poems written by Japanese poets in Chinese.
753	C	Arrival of Ganjin from China with twenty-four disciples.
756	C	The storehouse, Shōsō-in, in Nara founded by the Dowager Empress Kōmyō.
759	Po	Date of composition of the latest poem to be included in *Man-yō-shū:* a collection of Japanese poetry compiled in the last half of the eighth century.
	A	Foundation of the monastery of Tōshō-dai-ji, Nara, by priest Ganjin.
763	C	Death of Ganjin.
794	A	Building of Heian-kyō, the new capital, on the site of modern Kyoto.

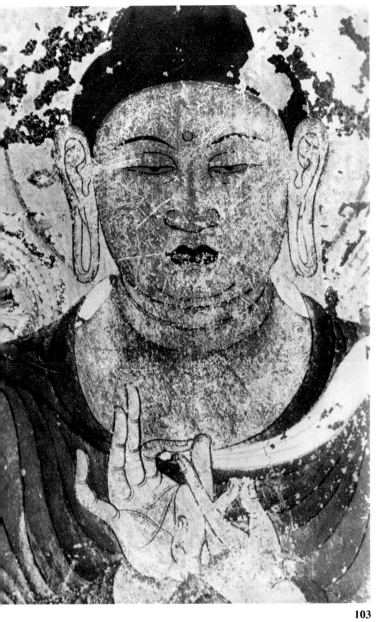

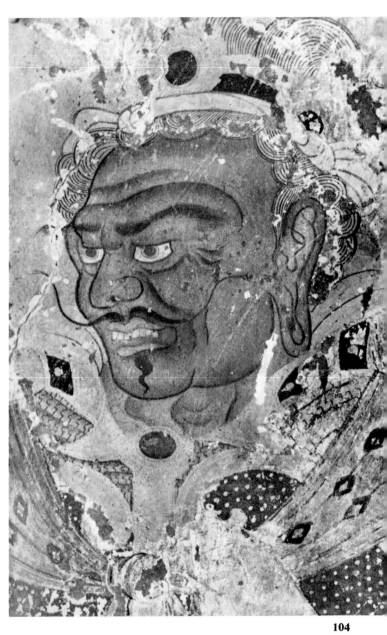

103

104

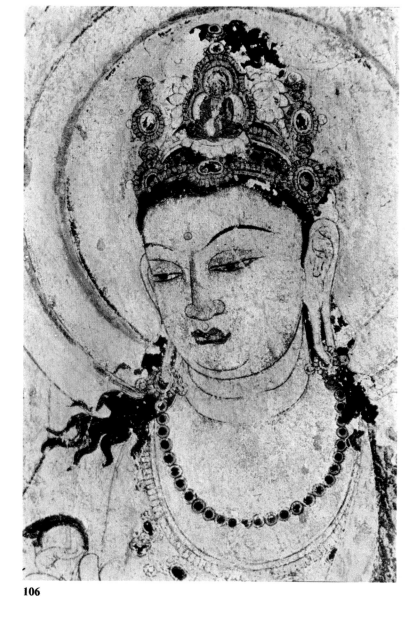

106

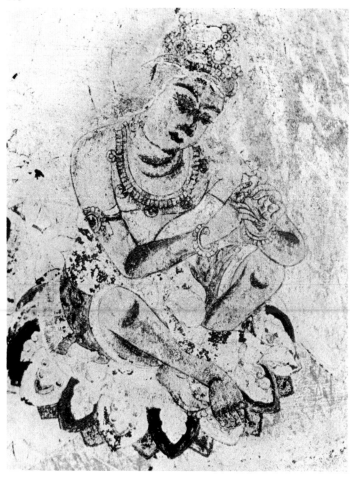

105

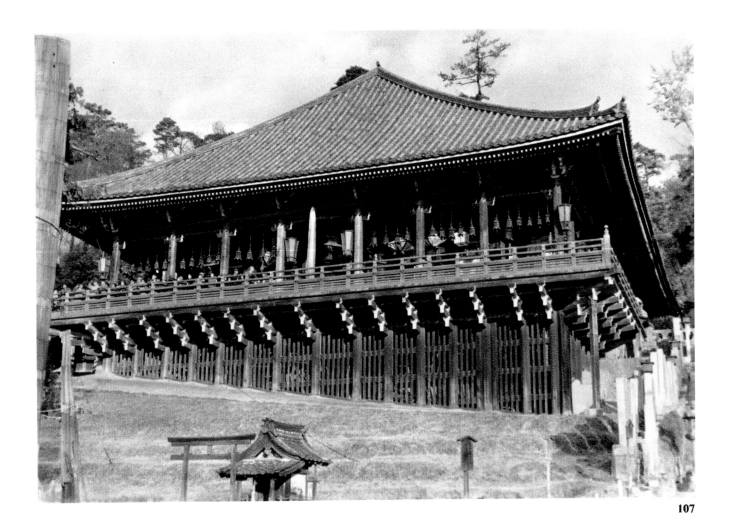

107

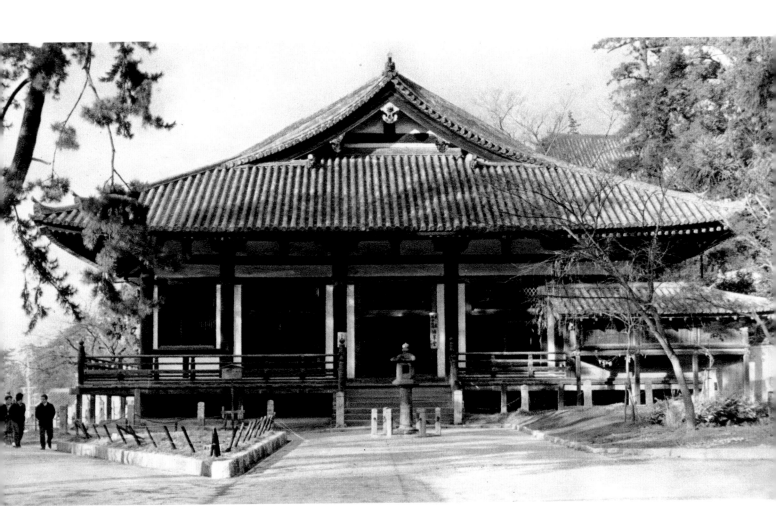

108

109

110

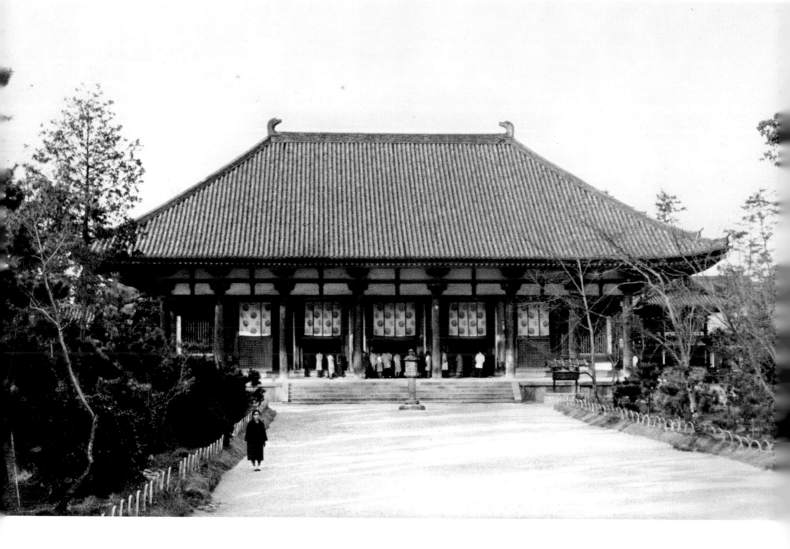

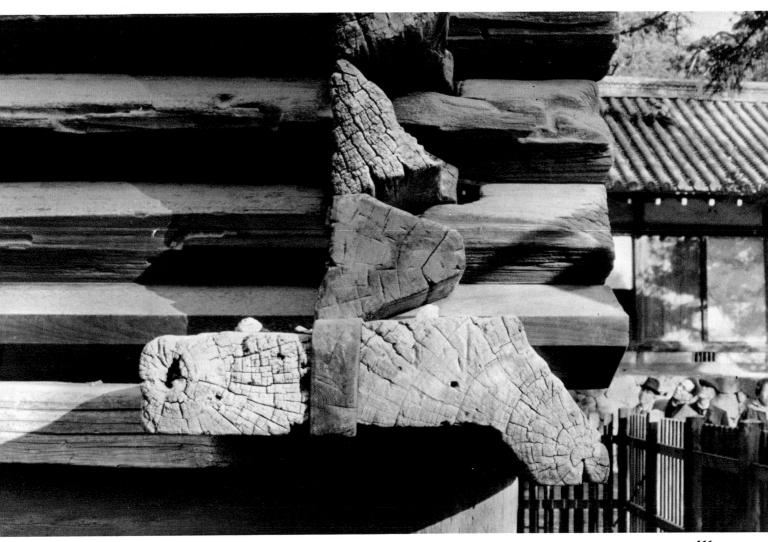

111

112

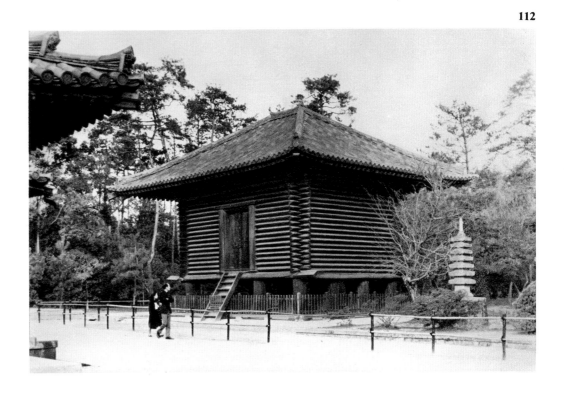

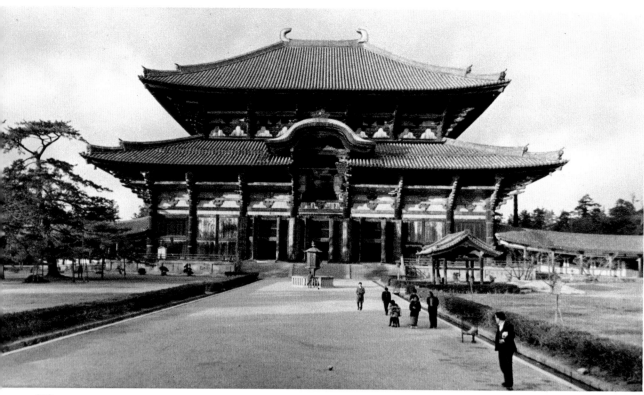

113

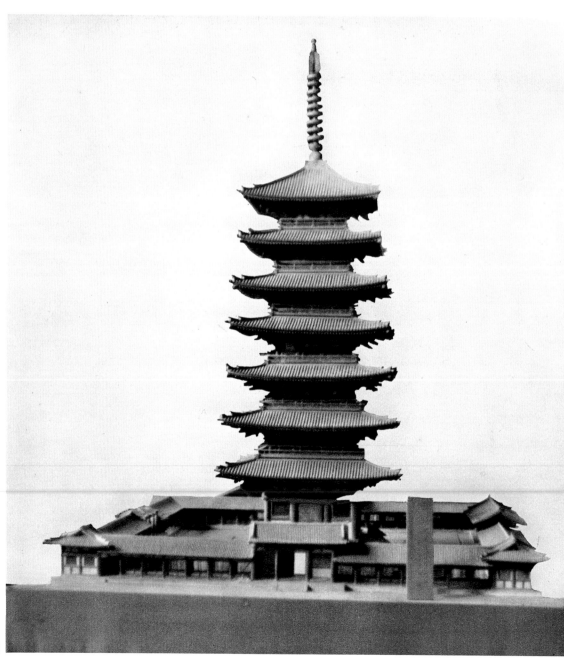

114

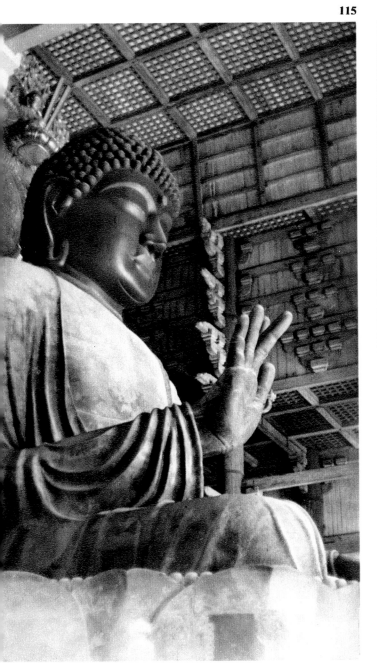

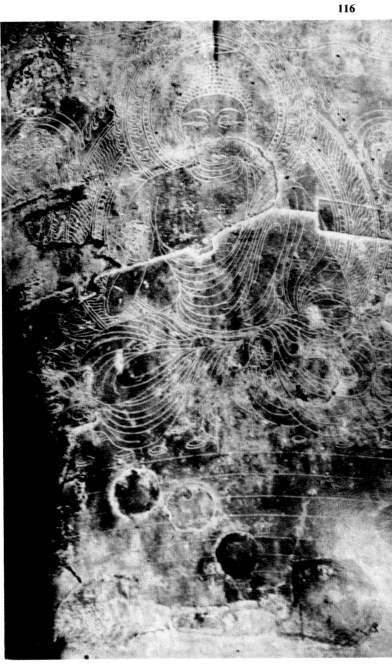

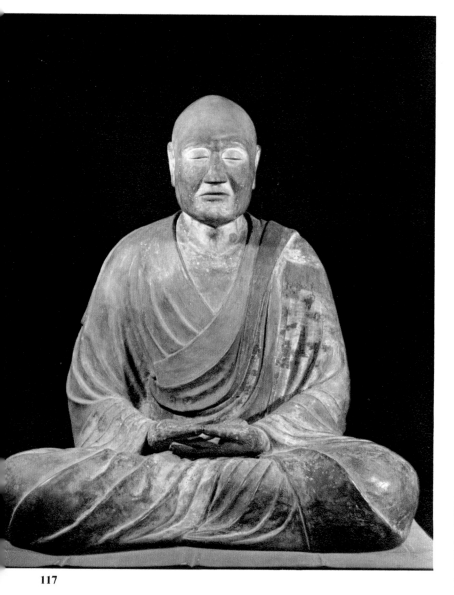

117

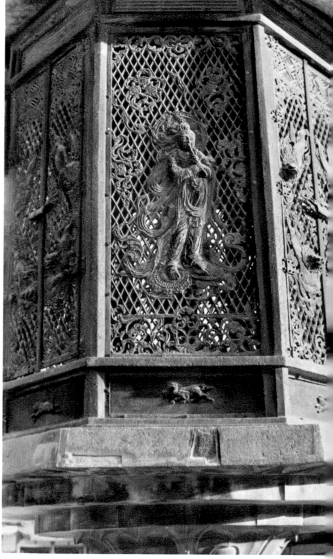

118

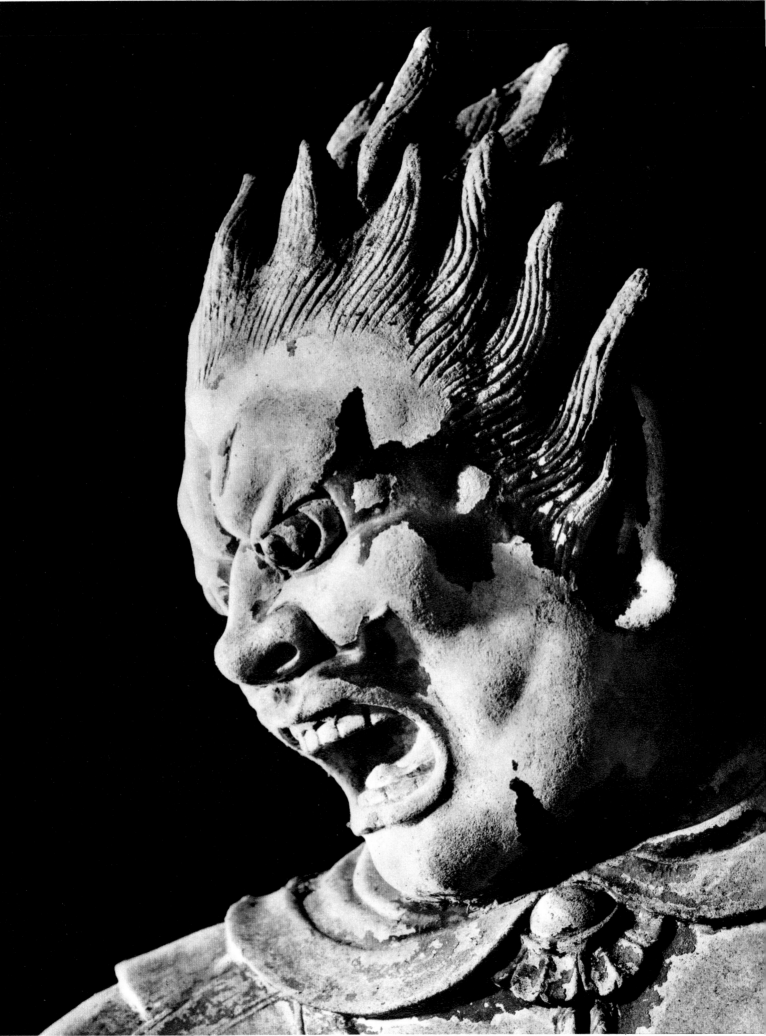

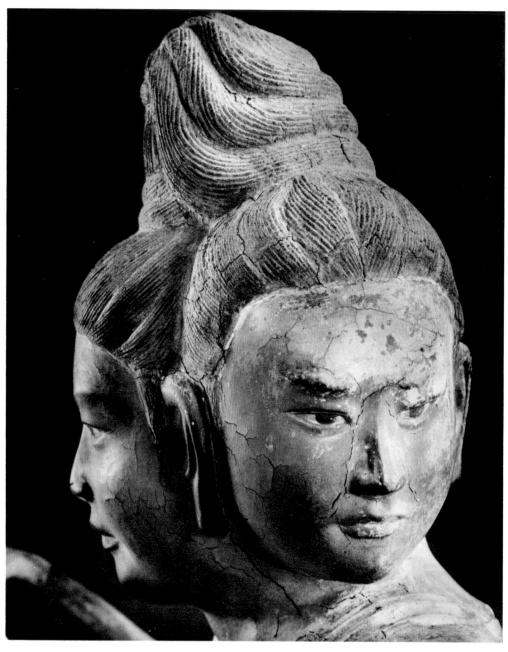

120

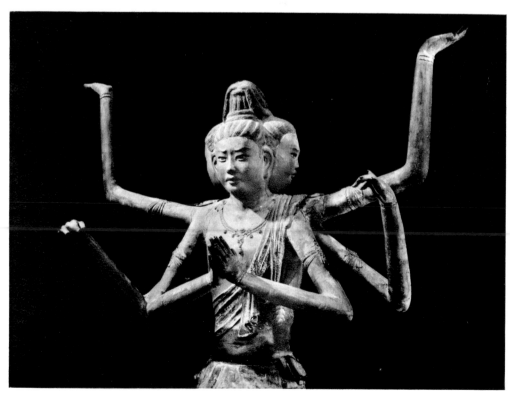

121

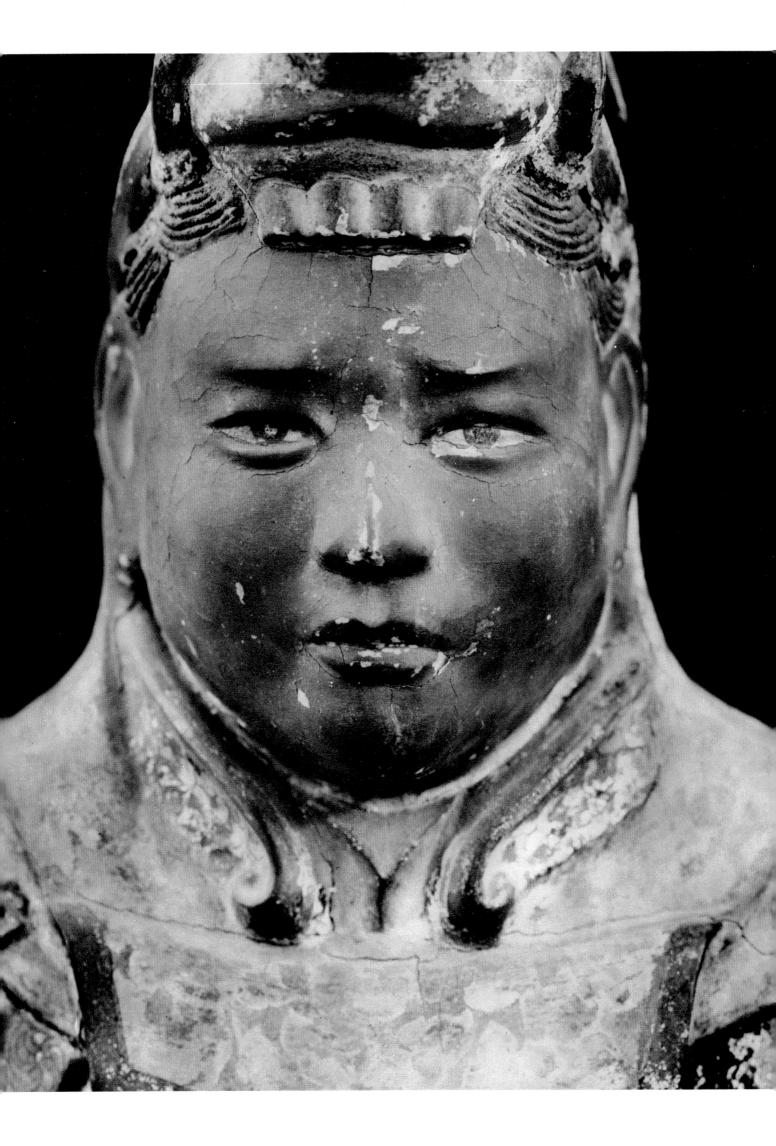

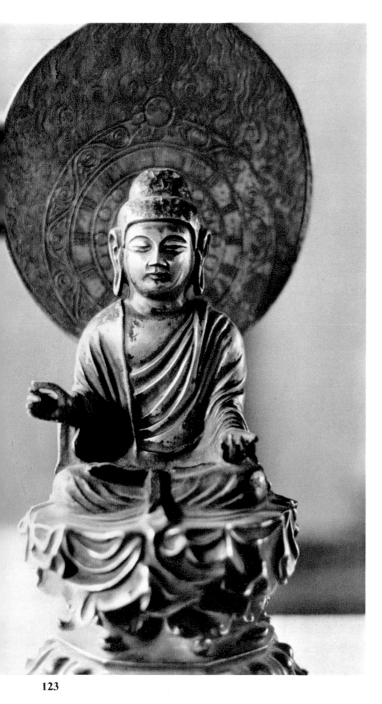

123

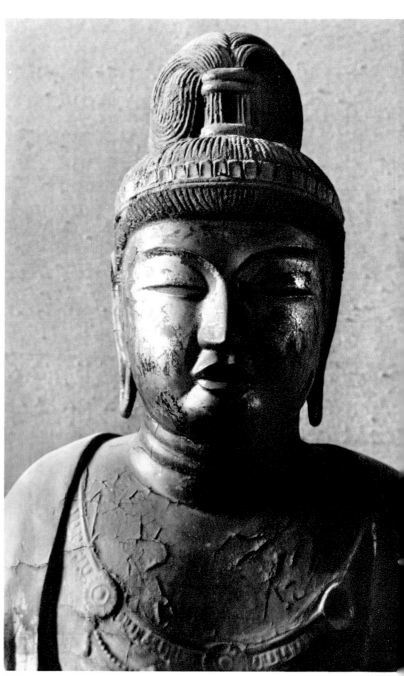

124

男

尒時太子聞諸伎女
歌詠園林華菓茂盛
流泉清涼太子忽便
欲出遊觀即遣伎女
往白王言在宮日久
樂欲輙出園林遊戲
王聞此語心生歡喜
而自念言太子當是
不樂在宮行夫婦禮
所以求出園林去耳

125

及无
遠八
器不
廣門
壏蚶
垢自
聽惡
視狂
病普
華麻
瀾香
翠島
衆昌
雅音
祥瑞
北淡
尒時

126

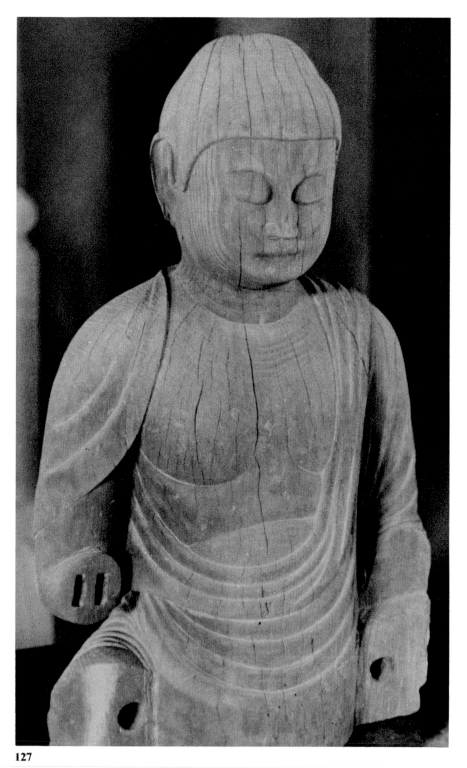

127

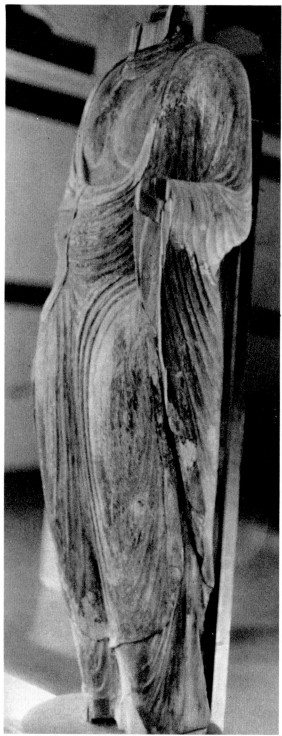

128

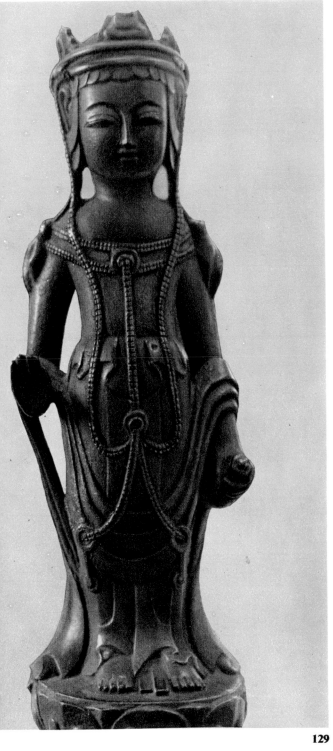

129

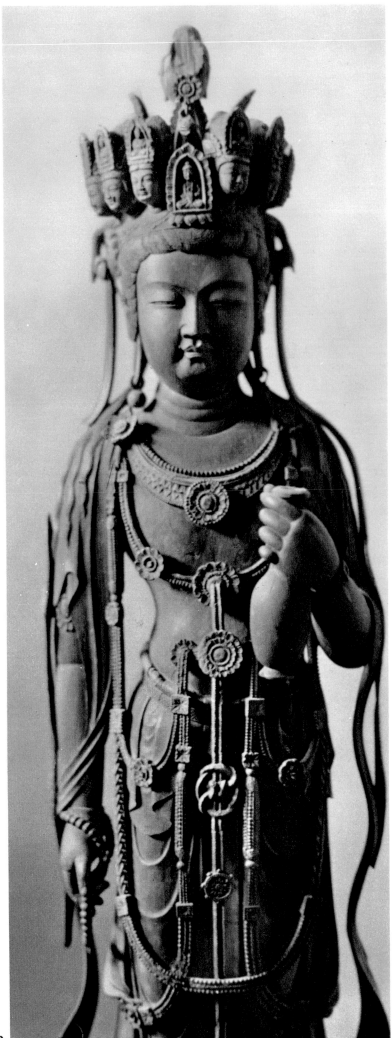

130

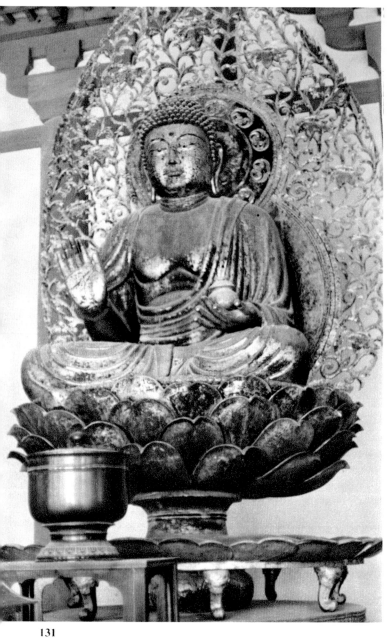

131

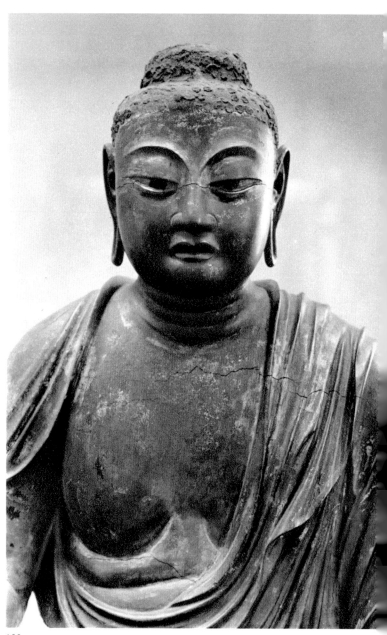

132

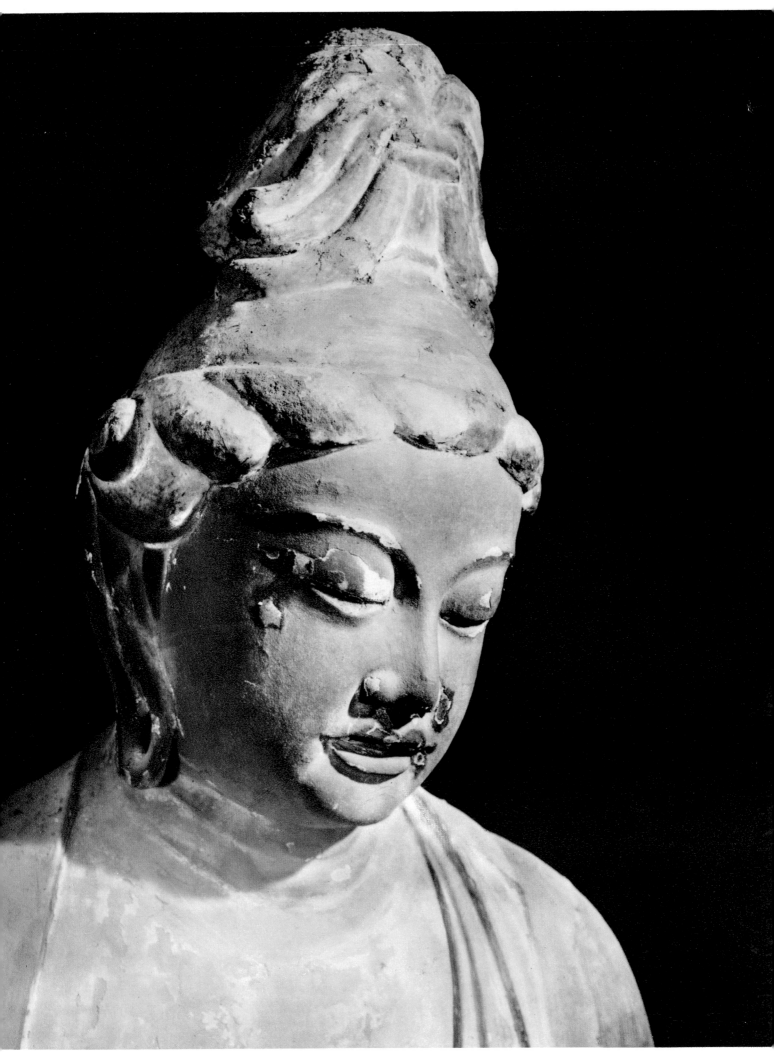

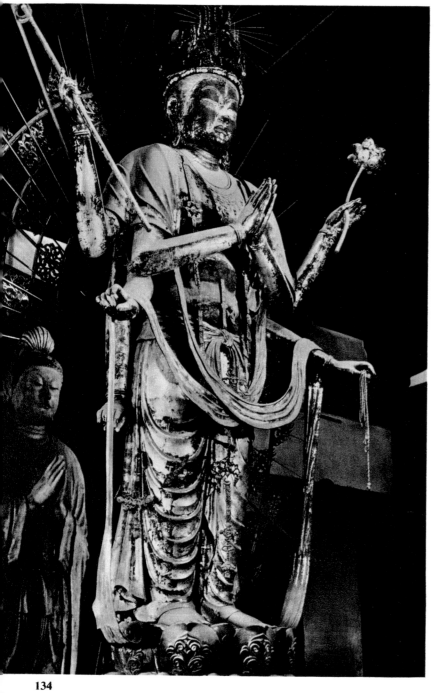

134

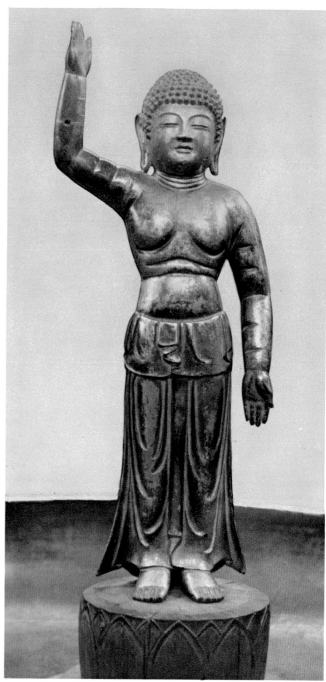

135

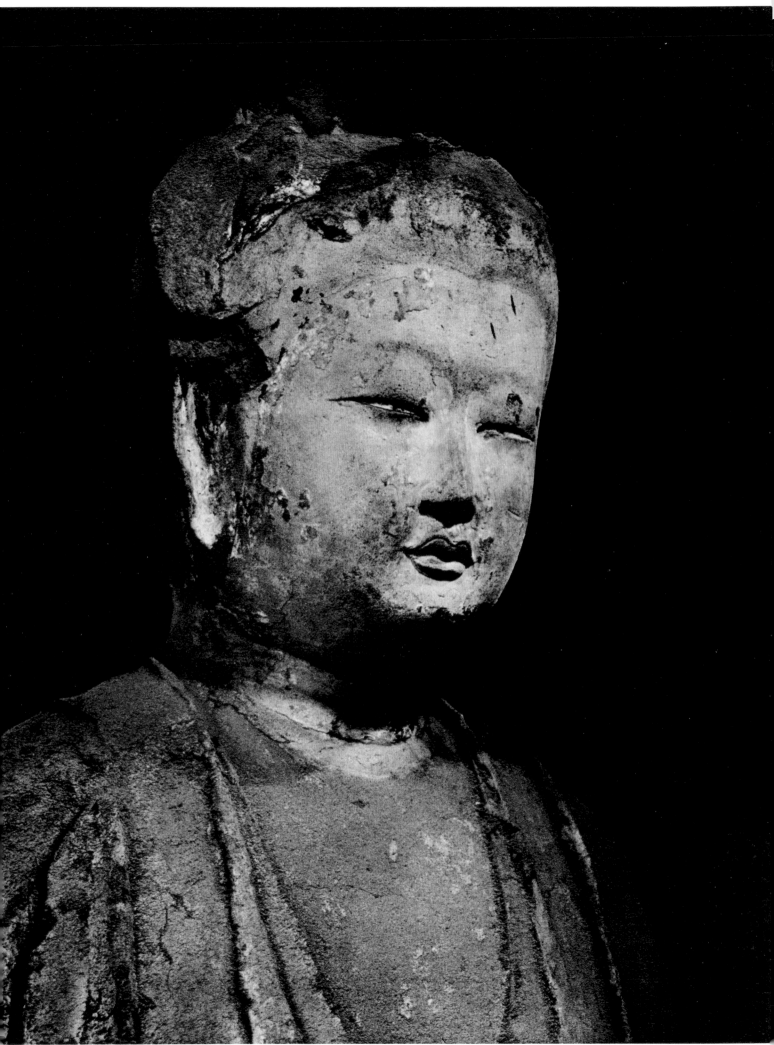

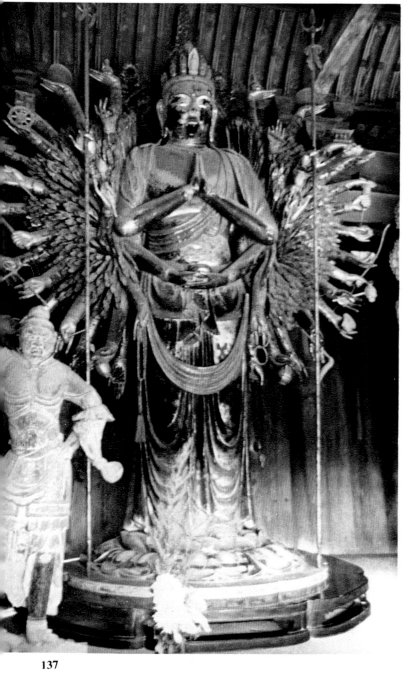

137

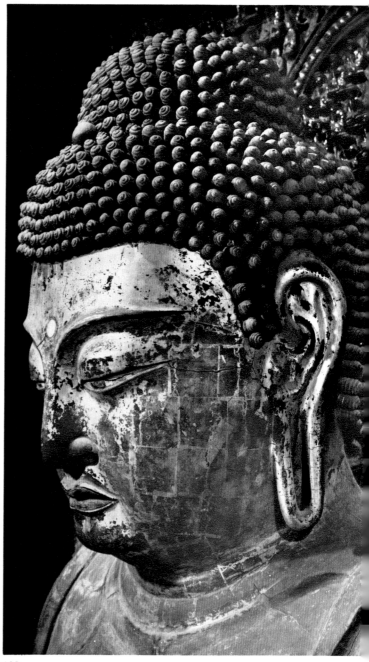

138

IV. THE NEW CAPITAL

THE KŌNIN AND JŌGAN ERAS (794–894)

The Political and Social Situation

In 783 the Emperor Kammu began the construction of another capital at Nagoka, not far from modern Kyoto, but the site, having been judged unpropitious for reasons now unknown to us, was changed once again on orders of the emperor. The new capital of Japan, which was to remain such until the accession to the throne of the Emperor Meiji in 1868, was chosen by the Emperor Kammu on the recommendation of Wake-no-Kiyomaru, Minister of the Interior, in accordance with the geomancy of the period. It was located to the north of Heijō-kyō (Nara) on a well-irrigated and accessible site at the base of the largest plain in the Kansai. It was laid out following the plan of Ch'ang-an, the capital of the Sui emperors of China, and was a far more ambitious project than the construction of Heijō-kyō.

The seat of the government was transferred to the new capital in 794, and the new city was called Heian-kyō, the "peaceful capital." The Emperor Kammu prohibited the transfer of the monasteries of Nara to the new capital and, in order to counterbalance the influence of the religious groups of the older city, attempted to introduce some new sects. Accordingly he sent a number of dissident priests to China for the purpose of bringing back Buddhist philosophies adapted to the people, not only to a privileged class. Among these envoys were two priests, Saichō and Kūkai, who were to become famous for several reasons. At the same time, the emperor reduced taxes to some extent, as well as the expenditures of the imperial household. Since there were too many sons of nobles at court and no employment for them, it was decreed that they would become ordinary subjects, provided, however, with a title, and that they would settle in the provinces. They were destined to create powerful families and the basis of a decentralized society that had a tendency to break all ties with the imperial government.

Only the Fujiwara family, living near the seat of power, subsequently had the right to occupy the key positions of the state. A register of the families, the *Shinsen-shōjiroku*, classified the titles as follows: *Kōbetsu* or imperial, *Shimbetsu* or of divine lineage, *Shoban* or descendants of the local chiefs. Only a few families were recognized as members of the *Shimbetsu* group: the Fujiwara, the Minamoto, the Taira, and the Tachibana (or the Fuji). According to this classification, these aristocratic families were recognized as the rulers of the country; only the members of the imperial family were above them. This subdivision of the nobility was to have great political and military influence on the destiny of Japan.

In the northern part of Honshu the Emishi (Ainu) tribes were in constant revolt, thus threatening the security of the new territories and preventing the unification of the country. The Emperor Kammu, having decided to eliminate this persistent threat, sent one of his generals, Sakanoue-no-Tamuramaro (who was given the title "Chief of the Expedition for the Pacification of the

East"), into the northeast provinces. In 783 and 789 similar military expeditions had suffered defeat, due both to a lack of enthusiasm on the part of the commanders and to the ill will of the colonists of the recently opened up territory, who thought they should be free of the authority of Kyoto and who refused to pay taxes. The majority of the peasants recently settled in the north had become allies of the Ainu or even belonged to families related to them.

In a series of campaigns lasting from 800 to 803, Tamuramaro succeeded in pushing back the warlike tribes to the north of the city of Shiba where important fortresses had been erected. The conquered region, however, was still the subject of Ainu raids for many years. Thousands of persons were transferred to the new territories; it was agreed that they would be exempt from taxation provided they as-

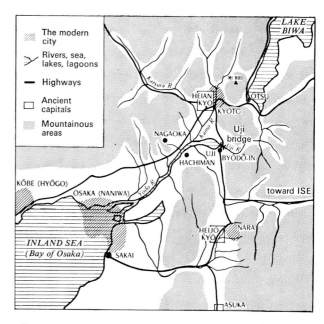

28. THE CAPITALS OF NARA AND HEIAN-KYŌ AT THE BEGINNING OF THE TENTH CENTURY

sumed the defense of their lands. In this way militarily organized families were settled in the area. They not only resisted the pressure of the Ainu; they also tended more and more to free themselves from the influence of the capital.

At the same time, the agrarian laws of the Taihō Code, which had never been completely enforced, fell into disuse, thus leading to the almost total breakdown of an economic and agricultural system that had been modeled too closely on the Chinese system and had been administered by inexperienced politicians who often had more concern for their personal prosperity than for public welfare. In addition, this system was not adapted either to the geographical disposition of the country, which was far different from that of China, or to the native customs. The extremely burdensome system of administration, of allocation of land, and of periodical census-taking necessitated the employment of a large number of government workers who were hampered by the enormity of their task and thwarted in their activities by gifts of land made more or less arbitrarily by the court.

The code was all the more unworkable because the new territories were outside its area of jurisdiction and the majority of the peasants abandoned the land allotted them by the government in order to work for the monasteries or the nobles. The taxes had become heavy and unjust. Because of a lack of manpower, public works could not be undertaken. The rudimentary means of communication prevented the government of Kyoto from controlling the governors of the distant provinces. These governors took over the authority of the state, collected taxes on their own account, and even bought back from the peasants the land the government had given them.

Although the Emperor Kammu and his successors tried on many occasions to enforce the Taihō Code, it was wasted effort. The government, impoverished by the lack of taxable land, gradually became weaker. The great nobles took advantage of this state of affairs to enrich themselves and to create domains of which they were the absolute masters; because they were on the spot, their power was greater than that of the emperors.

Since the official posts had in practice become hereditary (the spirit of the constitution of Shōtoku Taishi had long been forgotten), the seizing of power by the noble families and the corruption of provincial officials, who for the most part were paid by the local lords, were greatly facilitated. At that point in Japan those who possessed land were the most powerful.

The illegal system of shōen (domains belonging to the landlords and exempt from taxes)

inevitably replaced that of *handen* (allocation of the land to the peasants) sanctioned by the Taika reform. The taxes imposed by the landlords were not as exorbitant as those of the state, with the result that many free peasants *(ryōmin)* preferred to cede their land to the local nobleman and become, although officially still free, serfs attached to the manorial domain. The legal and judicial instability encouraged men to revolt or at least to try to avoid the law. The authorities pretended to regulate the life of the people in all civil *(ryō)* and disciplinary *(ritsu)* aspects, but conditions changed constantly, and the laws *(ritsuryō)* were subjected to perpetual revisions that were difficult to follow.

The Japanese people were sorely tried by the changing edicts of the imperial court and preferred to resign themselves to the more practical and suitable laws promulgated by the local landlords. At the court in Kyoto the nobles became ever more powerful and, with the Fujiwara family in command, constantly put forth new "extra-legal" orders in an attempt to remedy the inefficacy of the law.

The office of Regent *(Kampaku)* was legitimized to the point that it was filled even when the sovereign had come of age. In practice these regents governed in place of the emperors who, although respected and venerated, could not intervene in the affairs of state.

Beginning with the regency created during the minority of the Emperor Yōzei (877–84), the Fujiwara family assumed the title of *Sesshō* (regent-governor during the minority of a sovereign) with all the governmental prerogatives it entailed. Other posts—originally temporary, created arbitrarily in moments of need—remained under the control of the nobles. Despite its legality, the system of government established in 701 was totally inefficient and far slower and more complicated than the one set up by the Fujiwara, with its extra-legal departments *(Ryōge-no-kan)*: the legislative office *(Kurōdo)* and the police *(Kebiishi)* became the most important branches of the government. Toward the end of the ninth century the last opponents of the Fujiwara machinations had been eliminated, and these powerful nobles became the absolute masters of the country or at least of the government of Heian-kyō.

Literary and Religious Developments

Although the Emperor Kammu decided at the time of his accession to put a brake on the political activities of the clergy of Nara, he and his court remained profoundly Buddhist. Saichō, a priest of Nara in conflict with the monasteries of Heijō-kyō, settled in 788 on Mount Hiei, northeast of Heian-kyō. There he founded a hermitage to protect the capital from evil spirits, which, according to Chinese geomancy, could come from the northeast. In 804 the emperor sent Kūkai, another priest, to China to study. At the beginning of the following year Saichō obtained from the emperor permission to create a new sect called Tendai (from the name of a Chinese sect established on Mount T'ien-T'ai, many of whose teachings and sacred texts he brought back with him to Japan). Saichō founded his monastery on the site of his hermitage on Mount Hiei. Contrary to the sects of Nara which offered salvation only to a limited number, the Tendai sect permitted each person to attain redemption according to his own merits. This doctrine began to interest the Japanese people who up until that time had felt themselves far removed from Buddhism and had therefore clung to their own traditions.

In 806 Kūkai returned from China and founded his own sect called Shingon, or "The True Word," which was inspired by Mahayanist Tantrism then very popular in China where it was known as Chenyen. This doctrine identified the universe with the supreme Buddha, the great solar Buddha, Dainichi Nyorai or Rushana-Butsu (Vairocana), and all the divinities, Buddhist or otherwise, were considered emanations of this Buddha and no longer solely protectors of Buddhism.

From that declaration of faith only one more step was needed to include the tutelary divinities

of Japan (the *kami*) among the emanations of the supreme Buddha. However, almost two centuries were needed to make this step, at least officially. Yet the basis for the syncretism of Shintō and Buddhism had been created, and this doctrine began to exert its influence on the intellectuals of the period.

The Japanese people remained indifferent to these new philosophies because the monasteries of the Tendai and Shingon sects were situated far away on mountains (Mount Hiei and Mount Kōya) and the monks lived either in their retreats or in Heian-kyō. Apparently Buddhism, the agent of Chinese civilization in Japan, had been imported only for the benefit of the aristocratic classes.

The civilization of the Japanese people developed slowly, separated as it was by the abyss dividing the classes. The people heard only very feeble echoes of Buddhism. The temples, including those that had been built in the provinces *(kokubun-ji)*, continued to be solely official edifices; and although the people were not forbidden to enter them, they were actually reserved for the nobility. (Shintō shrines, which only a few priests are permitted to enter, are venerated from the outside, and the officiating ministers of the cult offer no instruction or gospels.)

The universality of the doctrines preached by the new Buddhist sects, on the other hand, aroused renewed curiosity and enthusiasm for Chinese culture among those sufficiently educated to have access to it; in time it exerted some influence over the people, permitting them to understand their own cultural heritage. The great families, anxious to guarantee that official positions would be inherited by their descendants, founded—besides the *daigaku* or imperial university—colleges for the education of the children of the noble families and their clans. For this reason the Fujiwara family created Kangaku-In; the Tachibana, Gakkan-In; the Ariwara, Shōgaku-In: institutions in which the students were taught the classics and Chinese poetry and literature, the essential subjects at that time if one wanted to obtain an official post.

Obviously, with such a system, it was impossible for a man of the common people to attempt to raise himself above the class into which he had been born. The few available instructors (some Chinese priests and Japanese men of letters) were hardly sufficient for instruction in the colleges of Heian-kyō. Schools in the provinces suffered from a lack of instructors, and since the only requirement for a teaching appointment was the ability to read Chinese, the scholastic standards must have been quite rudimentary. With the capital absorbing all the talent (and the court the best of that talent), culture became more and more centralized. Students and instructors were held in esteem, and some became famous for their writings, especially poetry. Poetry was written entirely in Chinese and was couched in a style copied from Chinese authors. Subsequently these works were collected in anthologies such as *Ryōun-shū*, the *Bunka-shūrei-shū* and the *Keikoku-shū*. Among the best-known writers were Kūkai, Sugawara-no-Michizane (845–903), Miyako-no-Yoshika (834–879), and Ono-no-Takamura (802–852). There were also the historical collections: the *Rikkoku-shi*, the six historical books of Japan which included the *Nihon-shoki*.

The priest Kūkai, whose activity extended into every field, founded a school reserved for the children of the people that was the first of its type in Japan; however, his example was not copied during his lifetime (he died in 835). Kūkai's personality was one of the most attractive in the entire history of Japan. He gave his country the means of freeing itself to some extent from the Chinese "cultural invasion." As far as religious thought was concerned, Kūkai (particularly in his treatise *Sangyō-shiki*) attempted to reconcile the three great philosophical doctrines contested so bitterly in China: Confusianism, Taoism, Buddhism. He clearly stated the principles of tolerance and the interpenetration of moral and spiritual concepts that was to become one of the characteristics of the Japanese attitude toward religion. The esoteric doctrine of Shingon (even more esoteric, perhaps, than that of Tendai), based on the two great mandalas (religious diagrams), the Kongō-kai and Taizō-kai (the Diamond World of Spirit and the Womb World of Form), permitted the painters to execute numerous works inspired by the descriptions of the divinities or of the different aspects of the Buddha found in the different sutras.

In the field of literature tradition has attributed to Kūkai the invention of a method of tran-

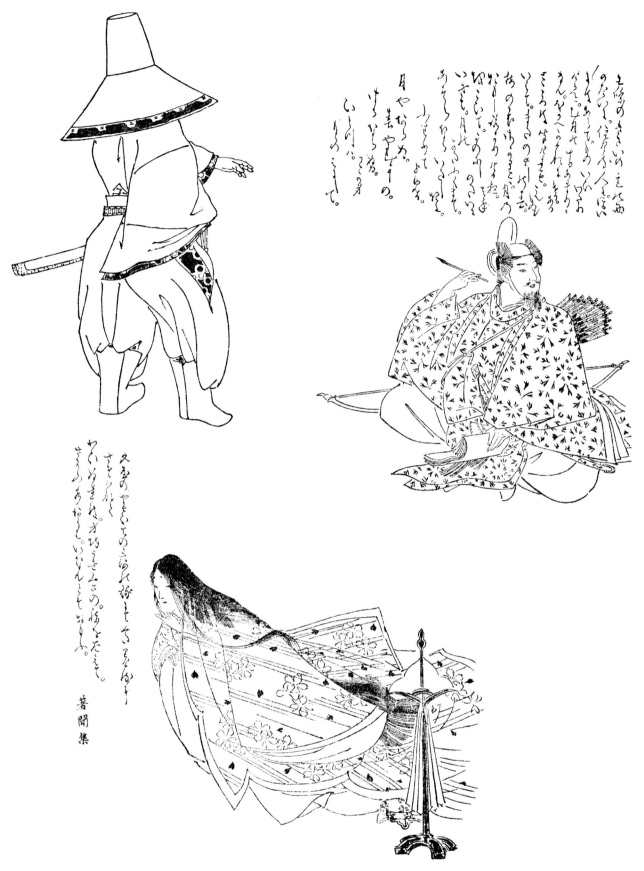

29. LEFT: KI-NO-NATSUI, ADMINISTRATOR, DOCTOR, AND CALLIGRAPHER. RIGHT: ARIWARA-NO-NARIHIRA, POET (825–880).
BOTTOM: ONO-NO-KOMACHI, POETESS (830–880)
(FROM THE KENKEN KO-JITSU BY KIKUCHI [YŌSAI] TAKEYASU)

scribing the Japanese language that permitted the writing of its syllables without resorting to Chinese ideograms. This new script, called *hiragana*, was derived from elements of Chinese cursive characters and comprised symbols of each of the fifty monosyllables that make up the Japanese language. These symbols permitted a person to write in a comprehensible fashion all his letters, reports, and even stories without making use of the Chinese language and its numerous ideograms. The words of foreign (but not Chinese) origin could be distinguished in the writing by equivalent characters derived from the Chinese ideograms but drawn in a square fashion (i.e., "printed" rather than written in a cursive style) or, in other words, in *katakana*. In order to distinguish between the extremely numerous homophones of the Sino-Japanese language (the adaptation of characters taken with the phonetic value in order to differentiate the sounds) certain Chinese ideograms had to be utilized. This system simplified studies to a large extent, because one needed to know only 152 ideograms in order to write the language: 51 *hiragana*, 51 *katakana*, and 25 ideograms that assumed the diacritical marks in each of these two systems.

The first beneficiaries of this new and typically Japanese method of writing were the women of the aristocratic classes, to whom the study of Chinese had not been open, and the poets who wished to compose verse in Japanese. As an exercise for memorizing the sounds and signs of this writing, Kūkai was traditionally reputed to have composed with them in the language of Yamato a short poem of Buddhist inspiration entitled *Iroha* (a name derived from the poem's first three syllables):

Iro ha nihoheto	Although gaily colored
Chiri nuru wo	They pass, alas (the flowers)!
Waka yo tare so	In this world, what then
Tsune naramu	Can eternally endure?
Ui no oku yama	Traversing today
Kefu koete	The limits of the apparent world,
Asaki yume mishi	I shall no longer see floating dreams
Ehi mo sesu(n)	And I shall no longer be inebriated.

The order of these sounds, memorized by everyone, was to serve for the enumeration and order of classification for dictionaries, lists, or other works where it was necessary to count in a certain order.

Despite these accomplishments, the real effect of which would not be evident till the beginning of the following century, Chinese culture remained dominant among the cultivated classes of Japan: everything came from China, and only that which was Chinese was esteemed. This progressive "Sinization" of Japan (limited, of course, solely to the Japanese aristocracy) affected not only literature and poetry, but also all of the official edicts, which tended to divide more and more the governors from the governed and the people of Heian-kyō from the inhabitants of the provinces. Beginning toward the middle of the ninth century, however, a reaction began to make itself felt. The intellectuals, who were now equipped to write their language, developed a certain impatience with the "servile" attitude of the official literary figures who, they said, "copied the style of the Chinese without having its spirit."

Because of the dangers of the sea voyage and the fact that Japanese ships were poorly designed for the high seas, contact with China was difficult. The "envoys" to China became less and less inclined to undertake such journeys and preferred to leave the dangers to the Chinese, Korean, or Japanese traders who brought from China perfumes, art objects, Buddhist images, and manuscripts and took back local products. As a matter of fact, from 838 onward, official missions to China were practically unknown. In 894 the great minister of state and author, Sugawara-no-Michizane, refused to serve as ambassador.

The intellectuals claimed to have nothing more to learn from China and preferred to write in the Japanese language. Although Chinese literature was still widely appreciated, one notes a

tendency, near the end of this peaceful century, toward the creation of an authentically Japanese literary art. The cursive script of *hiragana*, which was easy to read, began to be employed simultaneously with Chinese ideograms.

The Buddhist sects of Japan flourished and absorbed various new philosophic tenets and conceptual processes that differed considerably from those of China, which thereby allowed educated people to assimilate in a Japanese way foreign sciences and concepts and to create from them a truly Japanese intellectual consciousness. The two great sects, Shingon and Tendai, split into numerous subdivisions which increased the number of monasteries, especially those founded on mountainsides far from the turmoil of the urban centers. Another doctrine also began to be disseminated: Jōdo, which declared that one could attain paradise solely by having faith and repeating the name of Amida-Butsu, the supreme Buddha of the Jōdo sect; it was the doctrine of the "Pure Land" (the paradise) of Amida.

This century was rich in more than literary and religious innovations. Cotton—introduced into the country in 799 by a traveler who had possibly come from China—began to be planted in the provinces of Mikawa, Kii, Awaji, and on Kyushu. In 839, aware that the Japanese ships were not particularly seaworthy, the emperor had new vessels built on the model of the Korean ships, which were considered to be steadier on the high seas. The first Japanese tract dealing with medicine, the *Daidō-ruijūhō*, was written in 808 and consisted of one hundred volumes. Unfortunately now lost, it appears to have been based on both Chinese medical practice and Japanese folk remedies; in addition, it also contained useful observations regarding nature and botany. In metallurgy there was little technical progress in comparison with its progress in the eighth century, although the technique of mining ore from horizontal shafts was improved and production thereby increased.

The exact sciences developed slowly and were little appreciated. The mathematicians continued to employ the *sangi*, a group of wooden rods that permitted the user to count and perform a few other simple operations; no abstract speculation was possible. In the ninth century the direction of Japanese thought continued to follow practical lines, and various methods continued to be handed down from father to son. Spiritual initiative, too, found no place and had no opportunity to express itself.

This century of peace, which in art history is known as the Jōgan and Kōnin eras, marks the beginning of the Japanization of Japan. With the failure of the Taika reform from both a political and agrarian point of view, and with the rise to power of an almost feudal society based on the landholdings of the few great aristocratic families, imperial authority was progressively undermined and was replaced by the all-powerful domination of the Regents. The country, now beyond the direct influence of China, began to develop its own civilization.

Architecture

BUDDHIST

The introduction into Japan of new sects that selected remote mountain sites for their monasteries (such as the Tendai sect on Mount Hiei and the Shingon sect on Mount Kōya), led to plans for monasteries quite different from previous ones. The buildings were erected in a new style adapted to the needs of the new philosophies and esoteric practices. The location of the new monasteries (Enryaku-ji and Kongōbu-ji) necessitated that they be broken up into smaller units better adapted to the terrain. The main buildings were built on deeper foundations, were less massive, and were topped with a type of roof known as *irimoya*. They usually contained a prayer hall and an adjoining chamber for the holy images.

The Shingon sect created for its own particular practices a new type of structure based on that of the Indian stupa: a sort of enlargement of the shrine known as the *hōtō*. This new building

(the Tahōtō) was a type of pagoda-cum-stupa with two or more stories and built on a circular ground plan; however, one or more roofed porches *(mokoshi)* were added below the roof of each story which gave a square appearance to the exterior of this type of pagoda. They were topped with the usual pagoda-type roof and crowned by a *sōrin* or bronze finial similar to those raised above the traditional temples. In some instances a circular gallery ran around the upper story instead of a squared-off *mokoshi*. This particular form of shrine, typical of the monasteries of the Shingon sect, was supposed to represent one of the two mandalas—Kongō-kai or Taizō-kai—which were the symbols of the esoteric Shingon doctrine. The monastery of Kongōbu-ji at Mount Kōya, the principal shrine of the Shingon sect, had two structures of this type. The traditional pagodas continued to be built, however, but on a smaller scale. The delightful little pagoda of Murō-ji, not far from Nara, remains a fine example of these small structures scattered about on the mountainsides and hidden among the trees. Like the monastery buildings of the period, they were roofed with cypress-bark shingles.

SHINTŌ

Alongside a flourishing Buddhism, the Shintō cult was prospering, too. Shrines continued to be erected throughout the country, and the great Buddhist families themselves were not remiss in honoring the *kami*. At the beginning of the tenth century more than 2,800 Shintō shrines, both local and governmental, were listed. It was impossible to count either the private or village shrines; they were far more numerous than the Buddhist temples.

As has been mentioned, the shrine of Ise was reconstructed every twenty years on the same plan and in the same style and thus remained unchanged. Other new shrines were built, however, in manifestly new forms often influenced by Chinese styles: columns were painted red (a color which still distinguishes them today); roofs were characterized by Chinese-type curves; the entrances began to have doors resembling those of the Buddhist temples, and a type of cloistered arcade replaced the palisades that had traditionally fenced in the sacred area. The Ise type was called Shimmei; that of Izumo, Taisha. New types appeared in the ninth century known as Nagare, Kasuga, Hachiman, and Hie.

In the Taisha type the entry staircase, situated on the narrower side of the rectangular structure, is covered by a small roof separate from the main roof. With the Nagare type the entrance is in the middle of the wide side of the shrine and is covered by an extension of the main roof *(gohai)* which gives it an asymmetrical pitch. The Kamo-Jinja shrine in Kyoto, rebuilt in 794 by imperial order, exemplifies this type of architecture: its roof has slightly curved lines and is covered with cypress-bark shingles.

The Kasuga type, such as the shrine built by the Fujiwara family at Nara, has smaller dimensions. The entrance is situated on the narrower side of the building and is covered by a very deep *gohai* attached to the main roof, giving the shrine the appearance of wearing a cap with a visor. The crossed timbers *(chigi)*, which had disappeared from the roofs of the shrines of the Nagare type, reappeared again on the ridgepole at the gable ends.

The Hachiman type is made up of a hall divided into two parts covered by two roofs placed edge to edge, but the roof over the forward section is extended into a straight *gohai* above the entrance. This type is sometimes given the name of Gongen when the two parts of the shrine, instead of being joined, are separated and linked solely by a portico with an independent roof (in other words, a tripartite building).

The Hie type, created near the end of the ninth century, has a large hall subdivided into various sections and covered with a roof in the *irimoya* style. A *gohai* protects the entry, although the edge of the roof is turned up at the corners as if two stakes were raising it. This type of roof was subsequently employed in some Buddhist buildings.

Almost all these types of Shintō shrines had been created by the end of the ninth century and their style had been copied throughout the country. The first three, however, are those one sees most frequently even now.

176

ARCHITECTURE OF THE PALACES AND HOUSES

With the transfer of the new capital to Heian-kyō, plots of land were granted to the noble families to enable them to build residences in the new city. For the most important nobles these plots were generally one *chō* in size, or approximately two and one-half acres. These manors were made up of a main house *(shinden)*, the entry of which faced south, and various other auxiliary buildings *(tai-no-ya)* placed along the sides, enclosing in front of the *shinden* a space reserved for the garden. The buildings were linked by raised and covered passages. The overall plan was generally quite regular, but could be modified for greater utilization.

The *shinden*, in which the head of the family resided, was roofed with cypress-bark shingles; the subsidiary buildings were roofed with thatch. At times the size of the *shinden* was increased by the addition of roofed galleries *(hisashi)* on one or more sides. The use of *tatami* (straw mats) was still unknown. Since the floors were made of wood, simple straw cushions *(enza)* were used for seating. The immense single room of the *shinden* could be subdivided by movable partitions to form separate units. The veranda opened directly onto the garden. The kitchen, the sanitary facilities, and various other installations, together with the stables and the servants' quarters, were sometimes located in the *tai-no-ya* (auxiliary buildings) or often in cabins placed far from the central residence and hidden from its view.

The imperial palace had three parts. To the north was the palace or imperial residence proper, built in traditional style and roofed with cypress-bark shingles. In the center around a vast quadrangle were the official buildings: ministries, halls for state occasions, and those reserved for the ceremonial dances. They were all roofed with tiles. To the south were meeting halls and buildings reserved for the courtiers.

Beyond the south entrance a wide avenue divided the city into two parts. Immediately outside the gate was the *daigaku* or university. The Kōdō of Tōshōdai-ji is now the only existing example that corresponds to the type of official buildings erected during the Heian period.

The appearance of the streets in the quarters set aside for the common people must have been extremely monotonous; the majority of the houses were identical and were squeezed together in

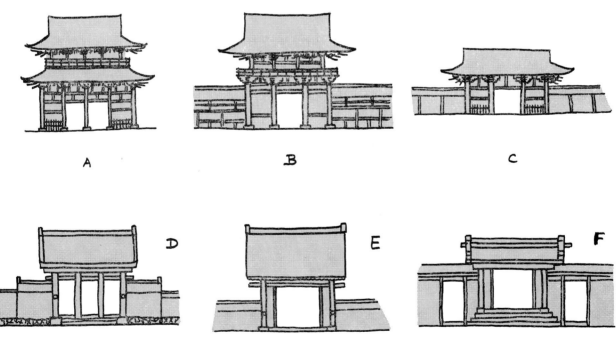

30. SIX TYPES OF JAPANESE ENTRANCES

A. WITH TWO STORIES; HŌRYŪ-JI, SEVENTH CENTURY

B. RŌMON TYPE; ONJŌ-JI, 1467

C. HAKKYAKUMON TYPE; HŌRYŪ-JI, 1438

D. KARAMON TYPE; HŌRYŪ-JI, FOURTEENTH CENTURY

E. SHIKYAKUMON TYPE; TŌFUKU-JI, FOURTEENTH CENTURY

F. AGETSUCHIMON TYPE; SAION-IN, HŌRYŪ-JI, EDO ERA

uninterrupted lines along the major thoroughfares. They were one story in height and were built of wood with woven bamboo walls covered with mud. The roofs were made of wooden planks, with one declivity descending toward the street and the other toward the garden in the rear. We do not know how the peasants were housed in this period, but it is probable that they lived in wretched cabins with dirt floors and thatched roofs.

It was necessary that the palace gardens and the *shinden* be planned and laid out in observance of the rules of Chinese geomancy, but even though the gardens were designed in a fashion imported from China, the inherent Japanese love of nature gave them a typically native character. It was obligatory that they contain a pond studded with islands (three in the beginning) linked by a series of bridges. The bridge which joined the central island to the shore nearest to the *shinden* had to be built in the form of an arch and placed at an angle. The pond had to be filled by a source flowing from the north or the northeast and passing under one of the covered passages linking the buildings. Rocks symbolizing waterfalls, plants, and trees were arranged in such a way as to appear entirely natural. Although there no longer exists even one garden dating from this period, traces of them are found in those which were illustrated at a later date, or in certain elements that still survive—for example, at the temples of Jōruri-ji and Onjō-ji.

Sculpture

The Kōnin and Jōgan eras, during which art attained its zenith in the ninth century, are characterized by various tendencies in the field of sculpture. In fact, these one hundred years were important as the period of transition from the T'ang art of Nara to the boldly Japanese art that asserted itself at the beginning of the Fujiwara era. One could almost say that Japanese art made its debut at this point with the sculpture of new Buddhist images that conformed to the philosophical canons brought from China and "Japanized" by Saichō and Kūkai.

Up to that time the Japanese sculptors, satisfying the clergy of the exoteric Nara sects, had been content with reproducing with varying degrees of talent those images brought from Korea or China: the statues of Tathagata or Nyorai (the supreme Buddhas) and some of the guardian divinities (Ni-ō, Shitennō, and others). The esoteric doctrines of Shingon and Tendai endowed the artists (who were usually members of the clergy) with a profusion of new prototypes, formalistic in appearance, but into which it was necessary to infuse a divine inner power. Saichō and Kūkai had brought back with them from the continent sandalwood sculptures that aroused great admiration. The scroll paintings and the mandalas illustrate in detail the forms necessarily given to representations symbolizing gentleness, wisdom, knowledge, anger, strength, and the virtues and power of Dainichi Nyorai, the supreme solar Buddha. There are texts which describe the poses, attributes, and colors that these representations were required to have both in sculpture and in painting.

Little was demanded of the sculptors in the way of imagination. First they had to compensate for the formalistic aspect of their works with a "hidden" feeling. From this difficulty arose the tentative gropings—at times attributed to a lack of skill on the part of the artists—seen in the first works of this period. The theory is sometimes advanced that some of the defects of these sculptures are due to lack of familiarity with the then-new technique of carving blocks of wood. For a long time previous, however, artists had possessed excellent tools and a tradition of working with wood, which must have made them familiar with carving in this material. We believe that we should see instead of this apparent heaviness, and in the lack of proportion, an attempt on the artists' part to make the work speak beyond the mere visual significance of its traditional attributes.

Because bronze was rare, lacquer expensive, and clay lacked a "noble" quality, these mediums were abandoned at the beginning of the period for a finer material available in abundance in

Japan: wood. The style adopted tended to imitate that of the imported Chinese statues, which were usually executed in sandalwood *(byakudan)*. This wood, which came from the East Indies, was quickly appreciated for its fragrance, its strength and resilience, and its very fine grain, which permitted the carving of finely detailed images from a single block of wood. It was a technique that required of the artist a perfect knowledge not only of the material employed but also of the image to be produced. This technique, *ichiboku-zukuri* (a single piece), could be only approximated with the wood the Japanese had at their disposal, since it was softer and more fibrous than sandalwood. For this reason it was difficult to carve the head and torso of a statue from a single block, and it was necessary to carve the protruding elements (the knees of seated figures, the forearms of standing figures) from several pieces of wood. These and the accessories or subsidiary elements, carved independently, were assembled at the end of the work.

Generally speaking, these wooden statues were not painted, except for the hair, the eyelids, and the lips; the bare wood gave more life to the image than paint and, in the case of sandalwood, permitted the exhalation of its fragrance. At the beginning of the ninth century a few works, however—a logical evolution of the wood-core dry-lacquer technique *(mokushin kanshitsu)* employed at the end of the Tempyō era—were covered with a thin coat of lacquer or were gilded with gold leaf.

The sculpture of the Kōnin era was, on the whole, less realistic than that of the preceding century. The drapery was stylized in successive folds (*hompa-shiki* or rolling-wave pattern) and occasionally still adhered to the body "like a wet garment." The bodies had slightly swiveled hips and rested their weight on one leg. They were also rather corpulent. The arms, particularly those of the seated figures, were exaggeratedly long. The hands had cylindrical fingers, very short nails, strongly emphasized knuckles, and strongly shaped and lined palms. The heads were large with very round eyeballs and heavy, half-closed eyelids. The curls were very prominent, and the *ushnisha* was barely distinguishable from the skull; only its height was increased. The well-modeled mouths were a little larger than those of the Tempyō era statues. The hair fell to the shoulders and was occasionally added in the form of cut-metal strips. The pedestals often had the chalice form of a lotus flower with a characteristic base.

Three types of sculpture belonging to this era are distinguishable: those that were derived directly from the Tempyō style and were the continuation of them, those that were directly influenced by the Chinese style of the late T'ang period, and the local styles that differed somewhat from the works executed at Kyoto or Nara and that seem to have retained some of the characteristics of the Tempyō era. There also appeared another type that was the result of an ever more pronounced syncretism then permeating the Japanese religious spirit: the Shintō images. These, according to the *honji-suijaku* theory (of Shintō-Buddhist syncretism), when placed in the shrines, should also portray emanations of Buddha or of Buddhist divinities (which were themselves emanations of Dainichi Nyorai) or historical figures who had become *kami*. It is probable that there were Buddhist artists or even members of the clergy who sculpted these effigies of *kami* on commission from the Shintō priests. The oldest examples that we have of these images date from this period, which was one of the most innovatory in the history of the arts in Japan.

Painting

The doctrines of esoteric Buddhism inspired not only numerous new forms of sculpture in Japan, but also paintings that served both as illustrations clarifying religious concepts and ideas and as sanctified icons before which the rites were celebrated. These paintings were copied from prototypes brought from China by priests and monks who had visited the continent, in particular by Saichō, Kūkai, and Ennin. The paintings were of two types: mandalas and representations of

divinities. The mandalas were essentially diagrams illustrating the written rules governing the universe of esoteric Buddhism.

They were executed either in India ink or in gold or silver on colored silk. Aside from the two great mandalas (the Kondō-kai and the Taizō-kai), innumerable others—referring particularly to one of the many sutras—were elaborated or copied by the monks. Although their form left the artists little freedom of expression, some of the painters displayed a real aptitude for simple sketching in India ink (the *sumi-e* technique) which subsequently had considerable success in Japan. The second category of paintings depicted the terrible forces (Myō-ō or Enlightened Kings) emanating from Dainichi Nyorai. These elemental forces were reputed to be so dangerous that certain sects (Tendai) believed that some of these images were in themselves secret divinities (the "yellow" Fudō of Onjō-ji). At times these images were painted in violent colors (the "red" Fudō of Mount Kōya, for example). Another group of paintings consists of the portraits of the patriarchs of Buddhism and of the founders of the sects and monasteries. Kūkai had brought back from China such portraits, but the subsequent copies soon lost all traces of the vivacity and spirit that had breathed life into the Chinese prototypes: the Japanese portraits of this period are heavy and lack life.

Almost all the painters were either members of a particular monastery or temple or officials who executed commissions for the *Edokoro*, a type of governmental department directed by a master painter *(Edokoro Azukari)*. The most important temples, such as Kōfuku-ji at Nara, had their own *Edokoro*. For the most part the artists were also monks or priests.

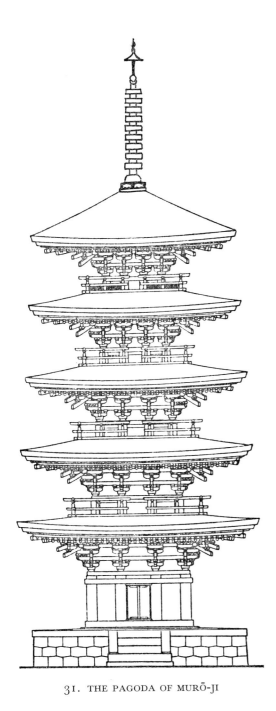

31. THE PAGODA OF MURŌ-JI

almost imperceptibly in size as the building rises in height, are still more or less of the Nara type, yet are in strong contrast with it. This new style henceforth dominated. The ground floor, instead of being paved in stone or left bare, is now covered with wooden planks. The roofs are covered with cedar-bark shingles. A peculiar and almost unique detail: the bronze *sōrin* surmounting the pagoda was not crowned with the traditional *sui-en* (see plates 88 and 89) but with a vase or *hōbyō (kalasa)* and a type of parasol-baldachin *(hōgai)*—this baldachin was temporarily removed at the time this photograph was taken, but is shown in the line drawing. The harmonious proportions of this delightful little five-story pagoda make it one of the most beautiful structures of this type.

141. KYOTO. IMPERIAL PALACE. FACADE OF THE SHI-SHINDEN. Reconstructed in 1855 on the lines of the ancient imperial palace of the Heian period, this building in the *shinden* style reflects few unique characteristics, with the exception of the extending eaves and the staircase, which continues to be the typical Japanese flight of stairs. The porch or veranda was added at a later date, as clearly evidenced by the fact that its supporting columns rest directly on the ground and not on stone bases.

142. NARA. KASUGA-JINJA. A Shintō shrine in the Nagare style, this sanctuary, founded at the beginning of the Heian period, has been reconstructed many times since then.

143. NARA. SHIN-YAKUSHI-JI. RIGHT HAND OF YAKUSHI NYORAI. The statue of which this hand is a detail was carved from a single block of wood following the *ichi-boku* technique, and portrays the seated Yakushi Nyorai. The fingers are partially webbed, one of the characteristic attributes of the Buddha. Jōgan era (beginning of the ninth century). Height $75\frac{3}{4}''$.

144. WAKAYAMA. NEGORO-JI. DAIDEMPŌ-IN. TAHŌTŌ. This type of pagoda—which somewhat resembles an Indian stupa—has a circular ground plan, but the four-sided roof, as well as the squared-off *mokoshi* and its roof, gives it a square appearance. Basically, it has a cylindrical upper story with circular gallery, from which slopes a dome that is partly covered by the roof of the *mokoshi*. This type of pagoda was peculiar to the Shingon sect and was first built at the beginning of the ninth century. The few extant Tahōtō, however, date mostly from the Kamakura era. They are, nonetheless, a rather rare architectural form.

145. NARA. SEIRYŌZAN KIKŌ-JI. KONDŌ. No longer in use, this deserted monastery situated in the countryside to the south of Nara is reputed to have been founded by the priest Gyōgi in 721. However, its style seems to be of a slightly later period: it could date from the beginning of the ninth century, and it was most certainly restored during the Muromachi period (fifteenth

139–40. NARA. MURŌ-JI. GOJŪ-NO-TŌ. Situated on a wooded hillside, the temple of Murō-ji was founded at the end of the eighth century by Kenkei (a priest of Kōfuku-ji) on a site that had been venerated from prehistoric times as the residence of the *kami* of rain, Ryūketushin. Since the temple was repaired by Kūkai during the Tenchō period (824–33), it is not certain whether or not all the buildings date from the end of the eighth century. This is one of the smallest pagodas in Japan (height 53' with an 8'-square base). It may perhaps be considered typical of the early Heian period. Its massive supporting pillars are slightly thinned at the top; its brackets are of the *mitesaki* type (plate 140) with a double row of joists *(shige-daruki)*; each level is enclosed by low railings. The roofs, which decrease

181

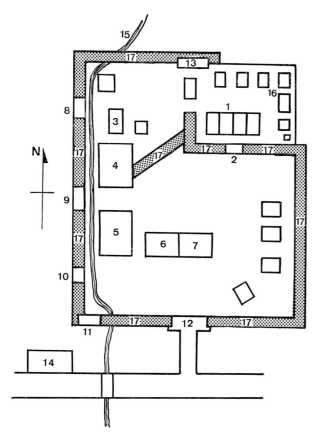

32. PLAN OF KASUGA TAISHA IN NARA

1. HONDEN (PRINCIPAL SANCTUARY)
2. CHŪMON (MAIN ENTRANCE GATE OF THE INNER PRECINCT)
3. HŌDEN (HALL OF THE SACRED TREASURES)
4. NAISHI DOKORO (HALL FOR THE LADIES-IN-WAITING)
5. NAORAI DEN (HALL OF REJOICING)
6. MAIDONO (HALL OF SACRED DANCES)
7. HEN DAI (HALL OF OFFERINGS)
8. ENTRANCE OF THE MIKO (SERVANTS)
9. SHŌJŌMON (GATE)
10. KEIGAMON (GATE)
11. SUBSIDIARY SANCTUARY
12. NAMMON (SOUTH GATE)
13. CLOSED GATE
14. PAVILION OF THE IMPERIAL AMBASSADOR
15. STREAM
16. SUBSIDIARY SANCTUARIES
17. COVERED CORRIDORS

century). Despite additions and repairs, the Kondō (main hall) still displays an undefinable charm reflecting an architectural style that was possibly typical of ninth-century buildings.

146–47. NARA. HOKKE-JI. JŪICHI-MEN KANNON. This wooden statue (*ichiboku* technique) is an image of Avalokiteshvara with eleven heads. It was carved from a single block of sandalwood and, according to legend, should be the portrait of the Empress Kōmyō (701–

760) executed by an Indian sculptor (South China is more probable, because eighth-century Japanese often confused the two regions). The crown, ornaments, and attributes are made of metal; the eyes, lips, and hair are painted. Each head of the *kebutsu* (aspects of divinity) is crowned with a diadem topped with a tiny image of Amida seated on a lotus flower. The full face and the rather fleshy figure of this image are typical of Japanese statuary of this period. The arms are very long, and the folds of the robe are illustrative of the *hompa-shiki* (or wavy) style that characterized almost all ninth-century works. Height $39\frac{3}{8}''$.

148. NARA. HŌRIN-JI. HEAD OF JŪICHI-MEN KANNON. This immense wooden image is the main figure *(honzon)* of the Kōdō (Lecture Hall). It was carved in the *ichiboku* technique. The painted halo is original, but the crown was added at a later period. The statue is unpainted except for the lips, hair, a thin moustache, and a tiny wisp of a goatee just beneath the lower lip. The style is heavy, massive, and typical of the Jōgan–Kōnin period. Height of entire statue (exclusive of base) c. 12'.

149. KYOTO. TŌ-JI. FUDŌ MYŌ-Ō. Fudō Myō-ō, one of the five great Enlightened Kings, is a terrifying manifestation of Dainichi Nyorai, the great solar Buddha. He represents the immutability of the resolution to conquer the forces of evil and of human passions. This statue was part of a large mandala placed in the Kōdō (Lecture Hall) of the Shingon monastery of Kyō-ō-Gokoku-ji (more commonly known as Tō-ji). It was carved from a single block of pine except for the arms and lower legs, which were made separately. The body was painted blue; the sword is of gilded bronze. The halo dates from the beginning of the twelfth century. The statue was repaired in 1197 by Unkei, and again in the Edo era. It retains, however, all the characteristics of the early Heian period sculpture.

150. NARA. MURŌ-JI. MIROKU BOSATSU. This small sandalwood piece may have been brought from China (T'ang dynasty). Never painted, it is extremely archaic in style, as indicated by both the hairdo and the hieratic pose. It must have served as a prototype for numerous Japanese works. Height 37".

151. NARA. BOSATSU. A seated Bodhisattva, delicately modeled in dry lacquer, representing Miroku (Maitreya), or perhaps Nyoirin Kannon. It has an original double halo, characteristic of many esoteric Buddhist images. Nara National Museum.

152. NARA. JUNTEI KANNON. In gilded wood, this badly damaged image is an effigy of Cundi, "the pure," one of the aspects of Avalokiteshvara. Nara National Museum.

153. KYOTO. SENJU KANNON. This wooden statue was originally in the temple of Kōmyō-ji. It represents an

the *ichiboku* technique, with arms, crown, ornaments, and attributes sculpted separately. The robe is an example of the *hompa-shiki* style. Middle of the ninth century. Kyoto National Museum.

154. KYOTO. KICHIJŌ-TEN. Originally from the temple of Kōryū-ji, this wooden statue is an example of the *ichiboku* technique, and represents Mahasri, the divinity of Good Luck and Merit. Dressed in the Chinese style, the image is stiff and massive. It has also been called Kisshō-ten or Kudoku-ten. Kyoto National Museum.

155. KYOTO. TŌ-JI. HEAD OF BON-TEN. This statue in the dry-lacquer technique portrays a Japanese version of the Hindu divinity Brahma, the Master of Heaven.

156. KYOTO. JINGO-JI. KOKŪZŌ BOSATSU. This is the image of one of the five Kokūzō Bodhisattvas: specifically Renge Kokūzō, or Akasagarbha of the Lotus, a Sky-womb deity. Wood and dry lacquer. Height 38¼". Middle of the ninth century.

157. NARA. MURŌ-JI. NYOIRIN KANNON. A wooden statue originally gilded with gold leaf, this image is now bare. Middle of the ninth century. Height 31⅛".

158. KYOTO. DAINICHI NYORAI. This gilded-wood image was originally housed at the Anshō-ji temple. Middle of the ninth century. Kyoto National Museum.

159. NARA. MURŌ-JI. SHAKA NYORAI. This typical work, the principal image of the Mirokudō (Miroku Hall), of the early Heian period, has robes that are an excellent example of the *hompa-shiki* (wavy) style of drapery. Wood. Middle of the ninth century. Principal image of the Mirokudō. Height 53½".

Kyūkaku Ninnōgyō, part of the *Prajñāpāramitā* sutras (the *Sutras of Wisdom*). Ryū-ō-ku Bosatsu is described as one of the five Bodhisattvas of Power sent to earth by Buddha as protectors of the domains of sovereigns faithful to the Law. Height of entire work 10′ 7″. Ninth century.

161. NARA. PORTRAIT OF GIEN. Because of certain characteristics this dry-lacquer work is sometimes dated from the Nara period. However, the stylization of the facial features and of the robes seems to indicate that this portrait should at the earliest be dated to the beginning of the Heian period. Nara National Museum.

162. TOKYO. KANNON. Wood. Dating from the beginning of the Heian era, this wooden image bears traces of its original colors. Height 55⅛". Private collection.

163. KYOTO. JIZŌ BOSATSU. This represents the Bodhisattva Ksitigarbha, the guardian of travelers and the protector of those condemned to Hell. It is carved from wood in the *ichiboku* technique. Originally at Akishino-dera, it embodies the characteristic style of the ninth century. Height c. 47″. Kyoto National Museum.

164. KYOTO. SHINTŌ DIVINITY. Originally in the Matsunoo Taisha shrine in Kyoto, this female Shintō divinity is carved from a single block of wood and painted. Shintō divinities were first portrayed at the beginning of the Heian period, at a time when the initial efforts to attain a Shintō-Buddhist syncretism were made. It is probably the work of a Buddhist workshop. Middle of the ninth century. Height c. 37⅜". Kyoto National Museum.

797 L–H Completion of the *Shoku Nihongi*, a collection of historical writings and a continuation of the *Nihon-shoki* (*Nihongi*).

 L *Nihon Ryōiki*: a collection of tales and legends of supernatural events of Japan attributed to the priest Keikai.

800–802 C War against the Emishi, barbarian tribes of the northeast frontier.

805 C The return of Saichō (Dengyō Daishi) from China and the founding of the Tendai sect with its headquarters at Enryaku-ji on Mount Hiei.

806 C The return of Kūkai (Kōbō Daishi) from China and the establishment of the Shingon sect in Japan with its headquarters at Kongōbu-ji on Mount Kōya.

814 Po The *Ryōun-shū*: an anthology of poetry written in Chinese.

818 Po The *Bunka-shurei-shū*: second anthology of poetry written in Chinese.

822 C Death of Saichō.

824–33 A Construction of the pagoda of Murō-ji (south of Nara).

827 Po The *Keikoku-shū*: an anthology of poetry written in Chinese.

835 C Death of Kūkai.

840 L–H The *Nihon Kōki*: one of the six imperially sponsored histories of Japan.

840–50 Sc The *Godai Kokūzō* of Jingo-ji, Kyoto.

852 Po Death of Ono-no-Takamura, poet (b. 802).

 Po Activity of the poetess Ono-no-Komachi.

869 L–H The *Shoku Nihon Kōki*: a continuation of the *Nihon Kōki* and one of the six imperially sponsored histories of Japan.

879 L–H The *Montoku Jitsuroku*: fifth of the six imperially sponsored histories of Japan.

880 Po *The Toshi Bunshū*: a collection of poetry.

 L Death of the poet Ariwara-no-Narihira (b. 824).

882 Sc The Nyoirin Kannon of Kanshin-ji, Osaka.

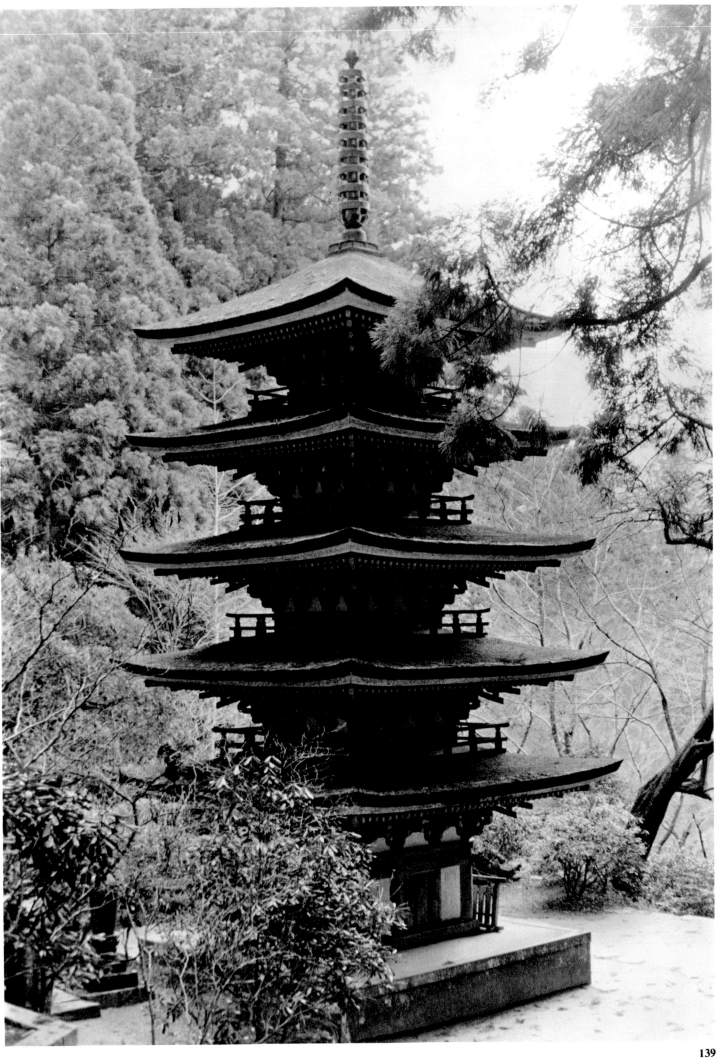

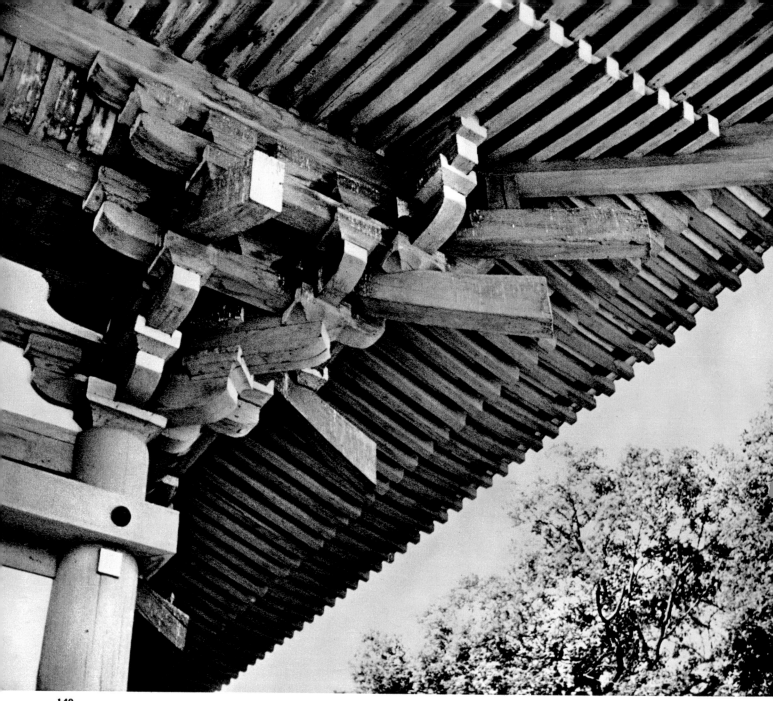

140

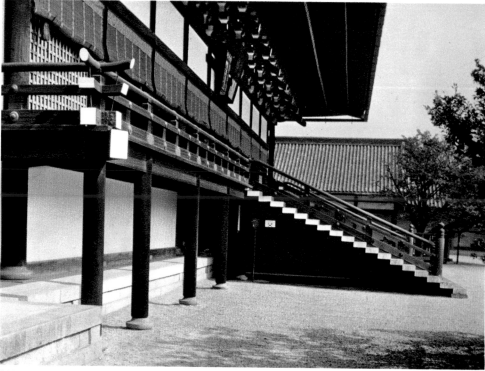

141

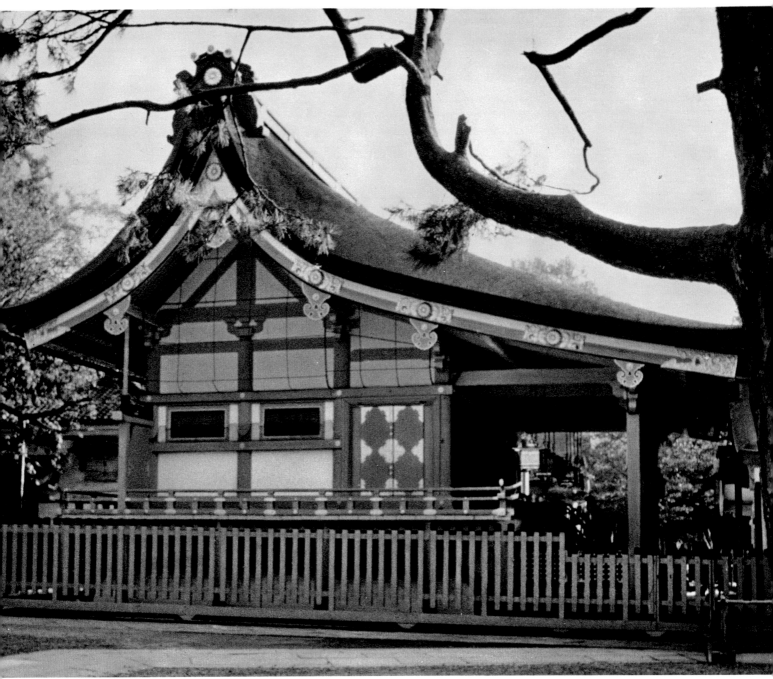

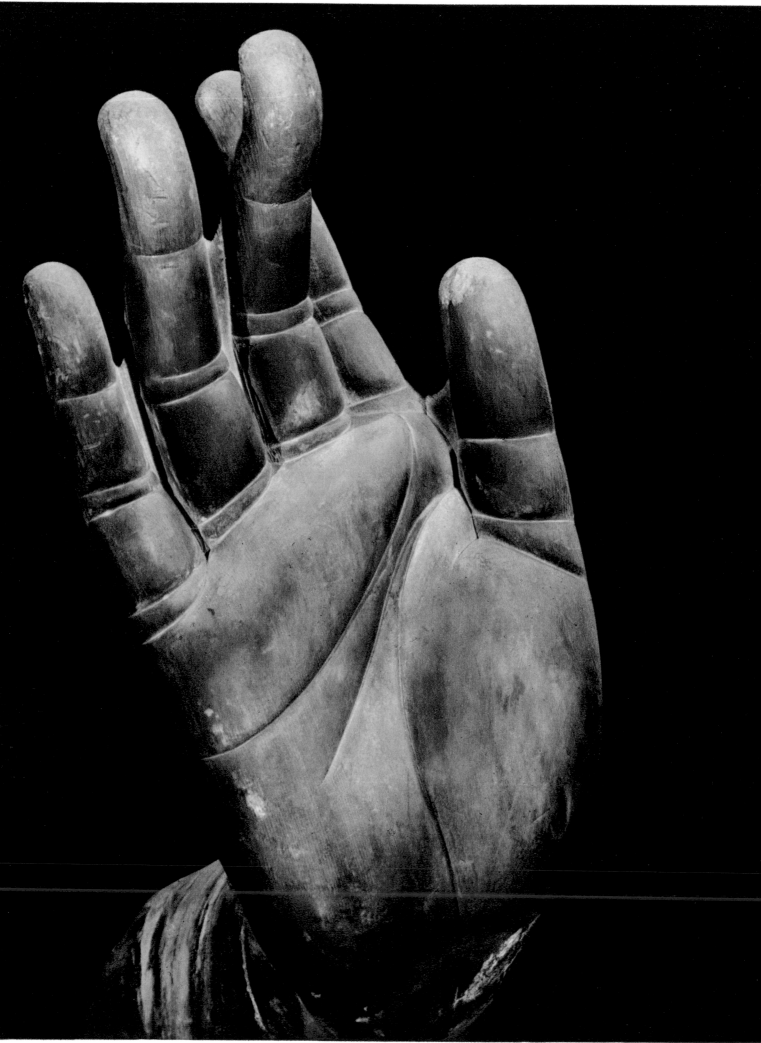

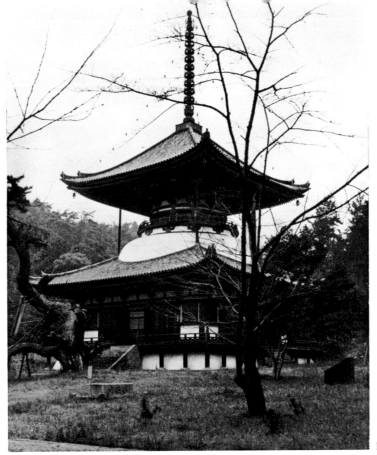

144

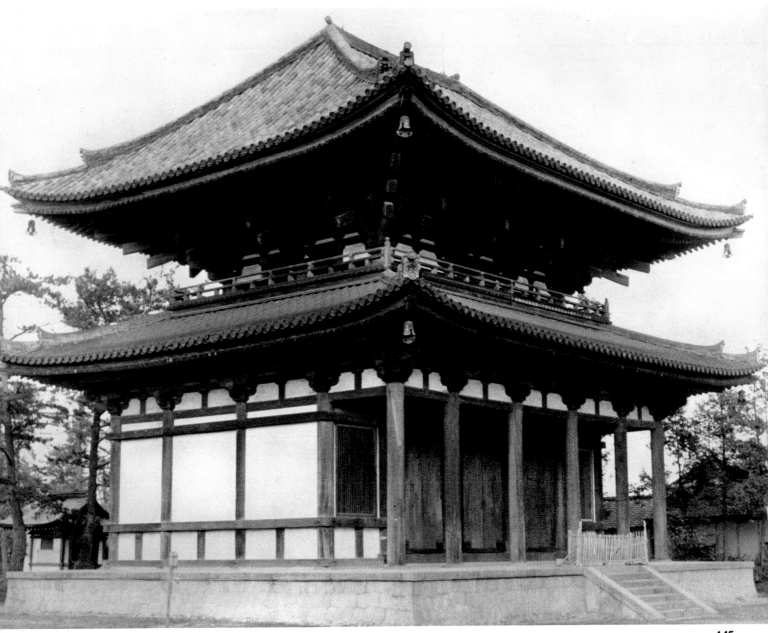

145

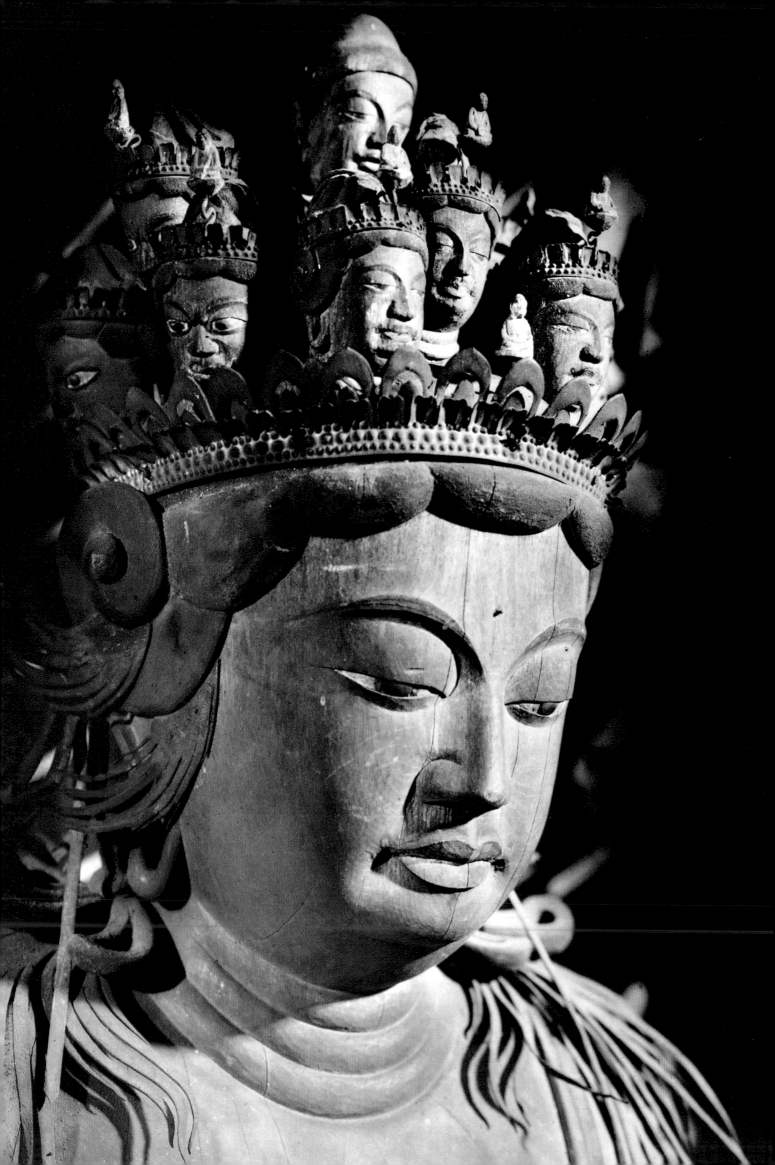

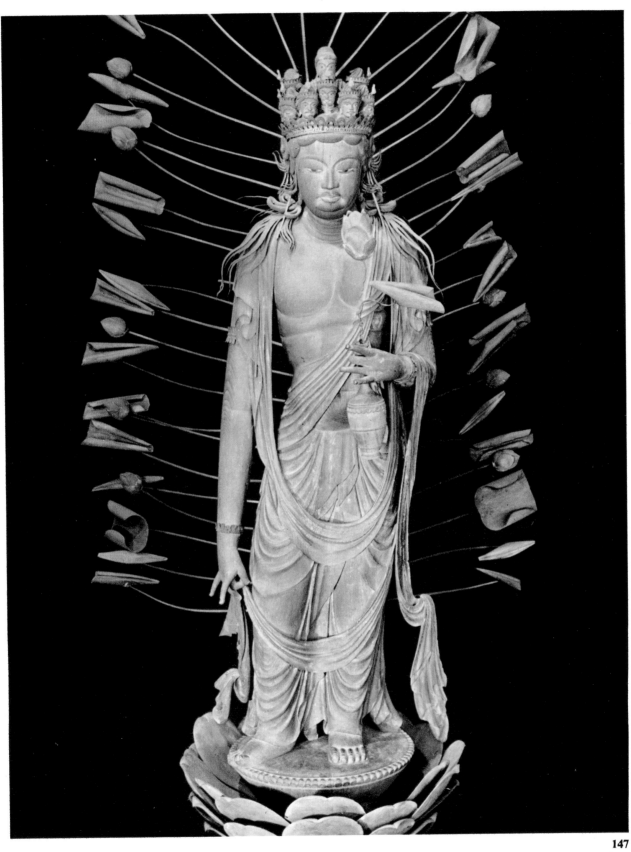

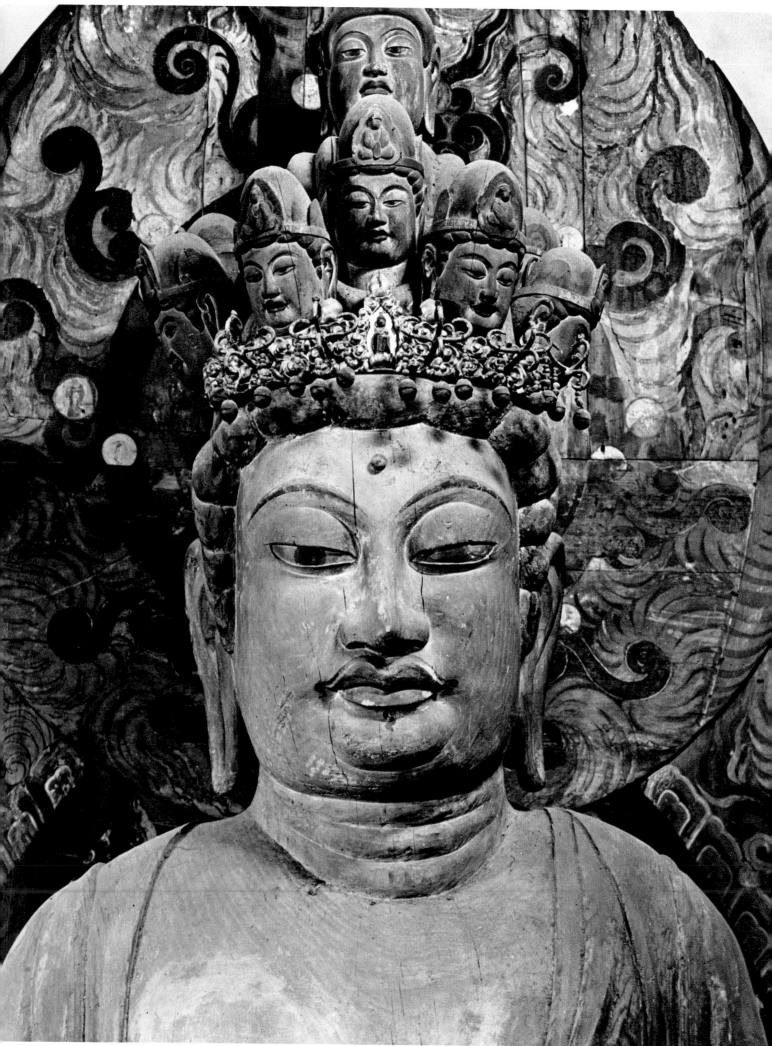

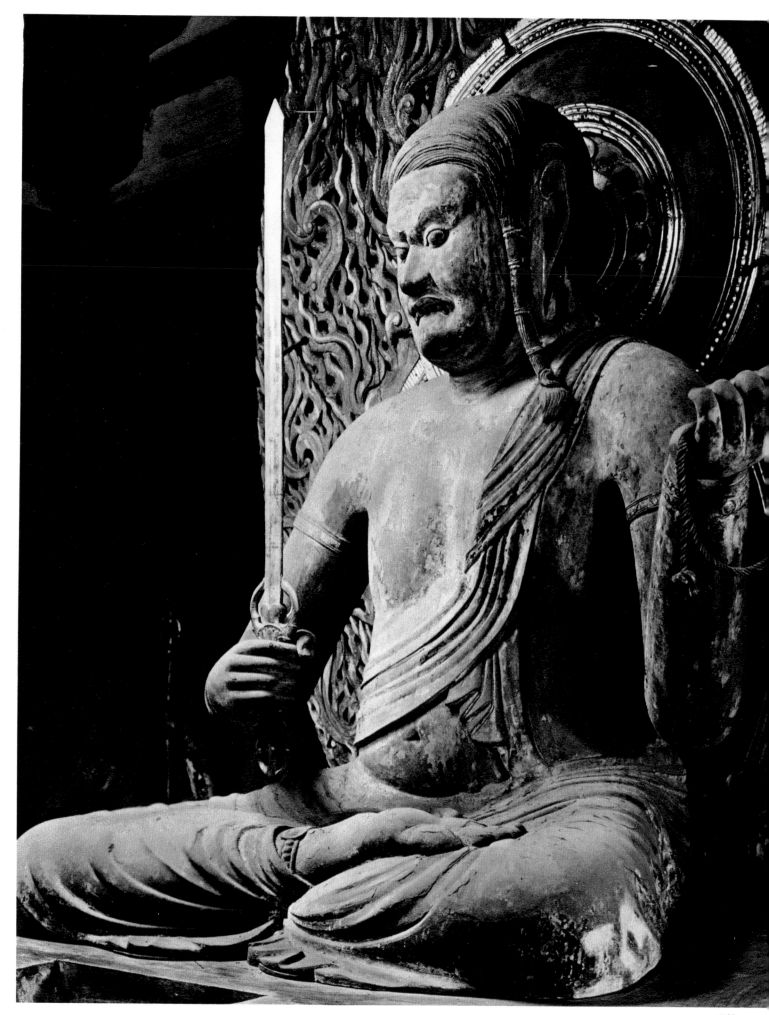

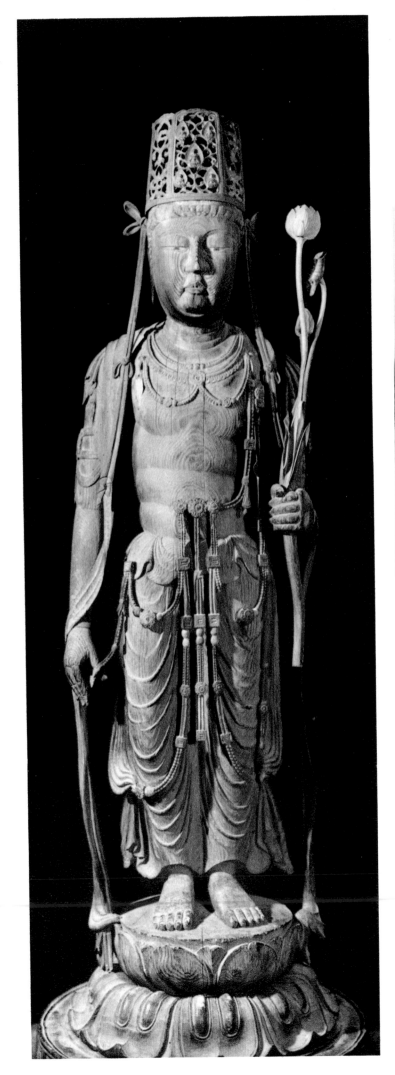

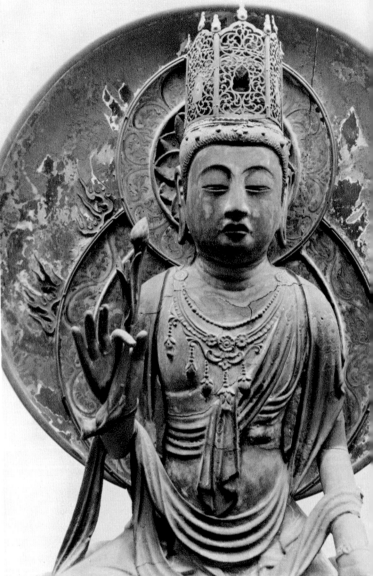

151

150

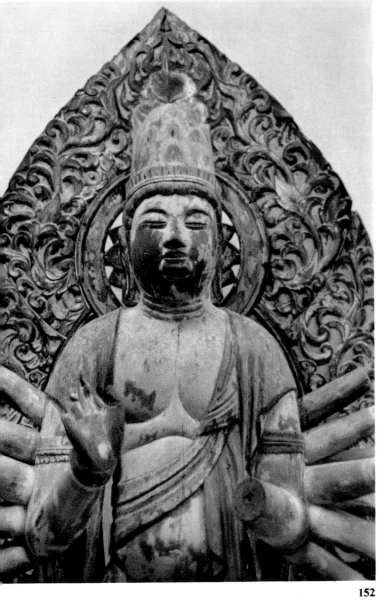

152

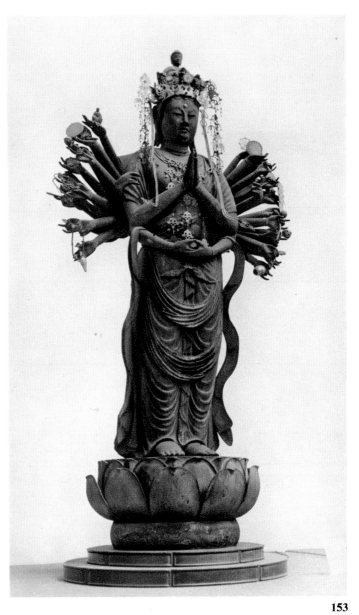

153

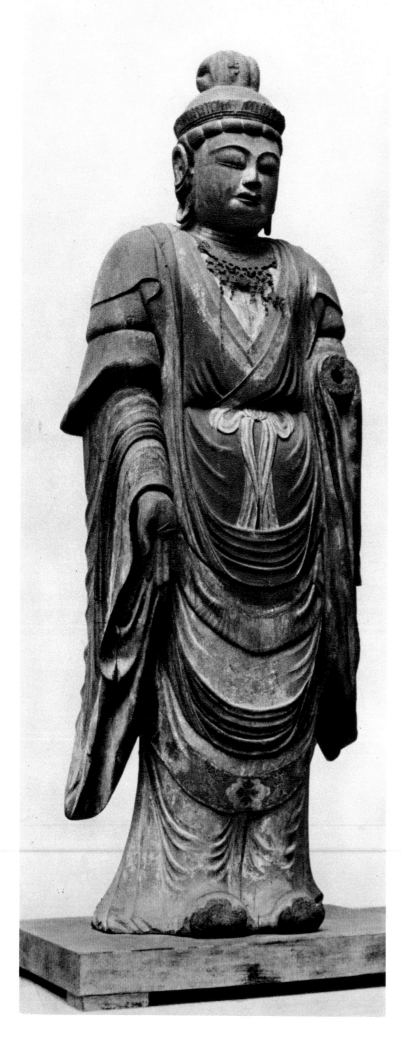

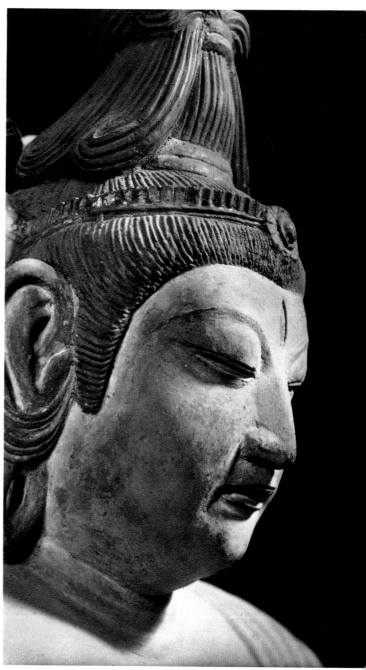

155

154

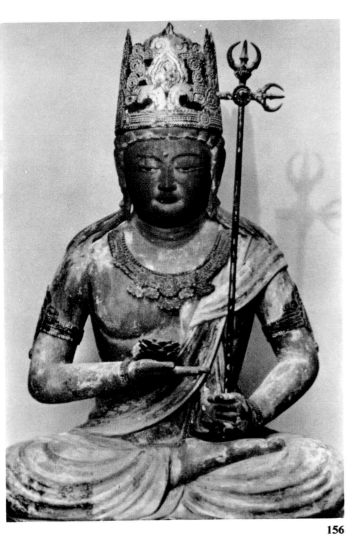

156

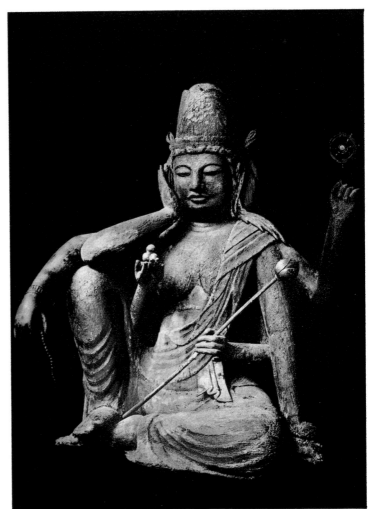

157

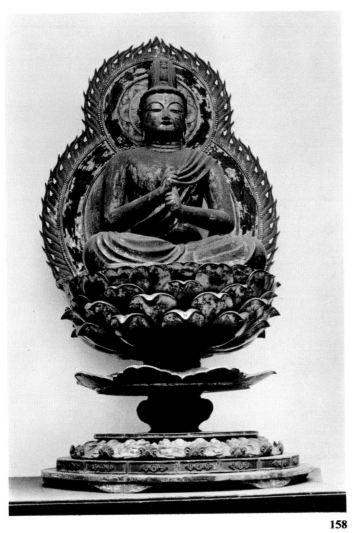

158

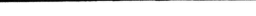
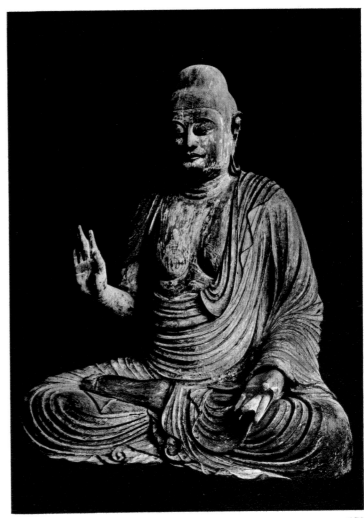

159

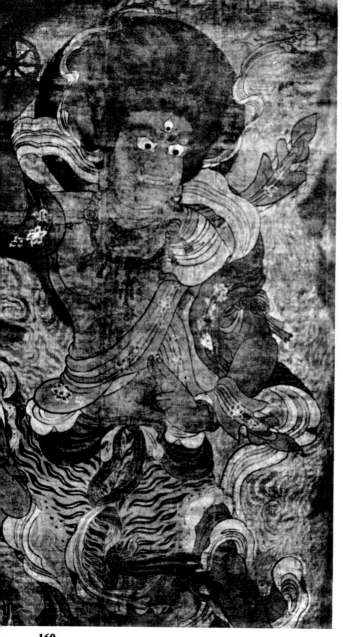

160

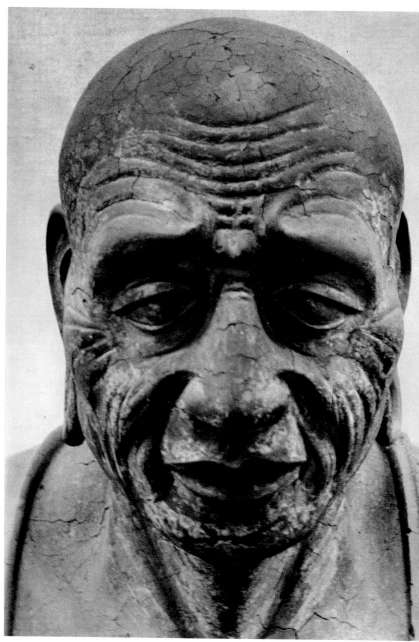

161

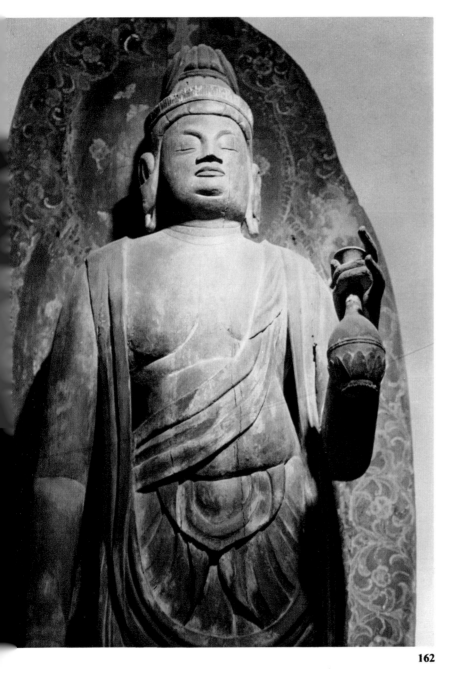

162

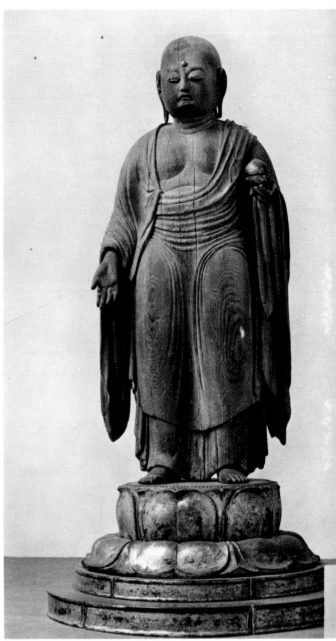

163

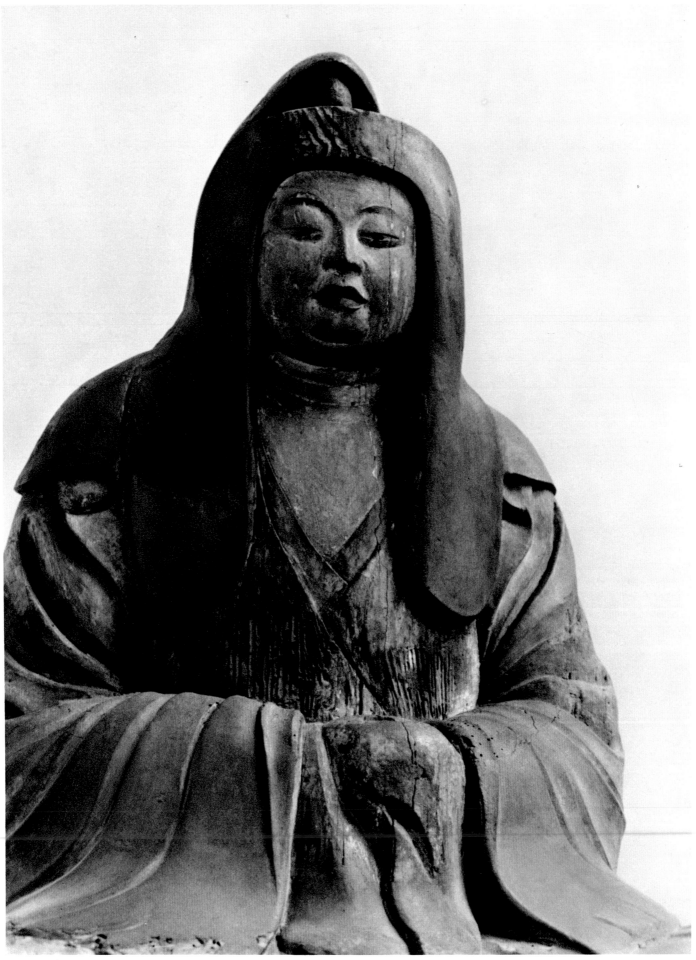

V. THE FUJIWARA REGENTS

HEIAN POLITICS UNDER THE FUJIWARA (984-1185)

THE PERIOD of Japanese history from the end of the ninth to the end of the twelfth century was initially dominated by the rise to power of the Fujiwara family, which became all-powerful in the first half of the eleventh century. There followed a brief resumption of power on the part of the emperors, then bitter struggles for supremacy between two of the most important clans.

From the social standpoint there was a general decadence, accompanied, however, by the creation of a brilliant, aristocratic milieu in sharp contrast to the growing misery of the people. In the field of art this prolific epoch was characterized by great ostentation, and this "great century" of Japanese history, as this period dominated by the splendor of the Fujiwara has been called, was in reality "great" only for the aristocrats. The Japanese people became so alienated from the cultural life of the country that they no longer seemed to be participants in its history. There was no class struggle in Japan at that time; the gap between the group in power and the exploited was too great for a class struggle to exist. Morally and physically crushed, the exploited could not even hope to improve their situation.

The history of ancient Japan is in reality only a chronicle of the smallest population group, the great families and the chiefs of the warrior clans. In order to study the cultural evolution of this crucial period—which, with its excesses, ended by provoking a reaction from which was born the true essence of the Japanese spirit—we must divide the political development of Japanese society into distinct periods and discuss them before taking up the history of the nation's cultural accomplishments.

The Rise to Power of the Fujiwara

The northern branch of the Fujiwara family had succeeded in gradually eliminating the emperor's relatives from the imperial court and, through a system of matrimonial alliances (the Fujiwara daughters were forced on the emperors in marriage), had effectively assumed most of the governmental prerogatives. They had presumptuously and arrogantly assumed as a hereditary right the positions of *Sesshō* (Regent of an emperor not yet of age) and of *Kampaku* (Regent exercising power in the name of the emperor and in his stead). In actual fact the power had been in their hands since 858, when Fujiwara Yoshifusa, having married his daughter to Emperor Saga, was named *Sesshō* for the young Emperor Seiwa who was only ten years old. Fujiwara Mo-

tosune succeeded Yoshifusa as *Sesshō* of Emperor Yōzei, and then later, in 880, became *Kampaku*.

The power of the Fujiwara increased steadily. Their territorial possessions in the provinces expanded, due both to purchases and the voluntary renunciation of land by the peasants. Broken under the weight of taxes and terrified by outlaws, many of the peasants placed themselves and their lands under the protection of the powerful nobles. Discharged soldiers, deserters from their allocated land (the *rōnin*), and, most of all, peasants who had been reduced to utter misery, formed bands of robbers and highwaymen that terrorized the countryside. Not even the city of Kyoto was safe from these brigands. The coastal villages were often the prey of Korean, Chinese or Japanese pirates. For these reasons the peasants and fishermen found it advantageous to place themselves under the protection of one of the great manors *(shōen)* of the nobles who, with their private armies and police forces and their willingness to impose reasonable taxes in return for property turned over to them, were able to guarantee a life of relative security to the common people.

Holding the key posts in the government, the Fujiwara enjoyed great prestige among the peasants as their "protectors" and thus, after a very few years, became the most important landowners of Japan and built an enormous fortune for themselves. Aside from their unquestionable political ability, the factor that contributed most to their power was their sense of solidarity which, in confrontation with the other great families, such as the Minamoto and the Tachibana, enabled them to repel all attacks, including those of the imperial family.

In the beginning the Regents and ministers were interested solely in lining their own purses, but they did so honestly. Men such as Fujiwara Ōtsugu and Tokihira, together with ministers opposed to the Fujiwara, such as Sugawara-no-Michizane and Miyoshi Kiyotsura, were not disreputable individuals. They attempted to introduce reforms (with no lasting results, however). They even tried to limit the power of the provincial nobles who had become arrogant (such as a certain Masakado of the Taira family who had dared to rebel against the ruling house, and proclaimed himself emperor in 940) as well as those who indulged in deplorable excesses (for instance, the governor of the province of Iyo, Sumitomo, organized piracy).

With the country in such a state of disintegration, the best-intended efforts, however, proved completely futile. The provinces were in a turmoil—the Ainu in the northern part of Honshu were in constant revolt—and taxes were collected with ever-increasing difficulty. The Fujiwara preferred politics to violence, and once their political adversaries had been eliminated peacefully (Michizane had been sent into exile to the island of Kyushu at the beginning of the century by Tokihira and had died there in 903), the Fujiwara ruled as masters after the death in 930 of the Emperor Daigo (who, as the success or of theEmperor Uda, had not chosen to nominate a Regent). However, Fujiwara Tokihira, who became Minister of the Left in 899, assumed the functions of Regent until 930 when his brother, Tadahira, was appointed *Sesshō* for the young Emperor Suzaku and subsequently *Kampaku*, his term lasting from 941 to 949.

The power of the emperor declined more and more, principally for economic reasons: the crown received ever-decreasing revenues, especially since the *shōen* (tax-exempt lands) of the great families grew ever more vast and absorbed the peasants' lands which had previously yielded taxes. Although the *shōen's* very existence was illegal, the imperial government could eliminate neither the owners, their strong private armies, nor their effective control over the provincial territories. Land in the provinces was either administered by agents appointed by landlords living in the capital or it belonged to the monasteries.

The emperors made a few attempts to control the revenue of this land, but were soon obliged to submit to the power of the Fujiwara and the monasteries. Either the local authorities refused to obey imperial commands that had not been approved by the Regent or they bribed the poorly paid imperial inspectors.

Until the accession of the Emperor Go-Sanjō in 1068 the Fujiwara Regents were the absolute rulers of the country. They upheld imperial decrees only when they had no bearing on their own domains or prerogatives. When officials loyal to the emperor put up a resistance, they were

eliminated. The Fujiwara Regents had the political wisdom not to limit the monasteries' ever-growing *shōen*, because the power of the monasteries reinforced their own power against the imperial strictures.

The absolute authority *(de facto* if not *de jure)* of the Fujiwara had two important effects on the life of Japan: (1) during the period of their regency the entire country lived in peace and all difficulties were settled politically and therefore peacefully; (2) the living conditions of the peasants—especially those who had surrendered their lands to the nobles—were somewhat improved. The policy of arranging marriages between the emperors and the daughters of the Fujiwara family gave the Fujiwara a means of putting continuous pressure on the sovereigns. The law of heredity, which made all the Regents and ministers virtual relatives of the emperors, bestowed absolute power on the head of the family. The father-in-law of the emperor (inevitably a Fujiwara) thus attained supreme rank in the state, and the empresses were given sole authority for the nomination of the Regents, according to the age of the candidates, even if their choice ran contrary to the desires of the reigning sovereign.

With such a system the running of the state became a family affair. The imperial family was not superseded by the Fujiwara themselves merely because—since their power was derived from their relation by marriage to the rulers—eliminating the emperors would have jeopardized their title of "Protectors of the Throne" and their legal position as Regents "in the name of the emperor." Therefore the Fujiwara took care to respect the imperial person, if not his edicts.

There was no national consciousness in tenth-century Japan; there was only a sentimental tie within a social group, such as the family or the clan in which the elders had complete authority. Extremely strong in medieval Japanese society, this feeling of subservience to the authority of the oldest members of the family still exists today (although mostly concealed below the surface). It is felt on occasions in which a social, industrial, commercial, educational, or political question arises, and advancement is often attained only on the strength of an individual's seniority.

The matrimonial policy of the Fujiwara reached its culmination with Michinaga, chief of the clan, Minister of the Right, and *Sesshō* from 1016 to 1017. Although he did not have the official title of *Kampaku*, Michinaga (who, in his role of *Nairan*—confidant of the emperor—assumed the attributes of a despot) married successively his five daughters to the emperors Ichijō, Sanjō, Go-Ichijō, Go-Suzaku, and the son of Sanjō. This policy, based on hereditary rights, was also followed by all the other noble families who claimed certain official positions as their own property. The Shirakawa were in possession of the *Jingi-kan* (the Department of Shintō); other families—the Ōe, the Nakahara—occupied other posts.

The families engaged in bitter struggles and intrigue that divided or united them. At times disputes among the rival groups culminated in armed conflicts in the streets of the capital (which was totally without police protection). The Imperial Guard was careful not to become involved in such clashes and even the palace itself was poorly protected. Brigands did not hesitate to set fire to private homes in order to plunder them with greater ease. The *Kebiishi* (municipal police), often commanded by men unfit for their posts (in reality, the only police force the sovereign had at his disposal), was at the end of the tenth century practically powerless.

The Regents, therefore, attempted to gain the support of the provincial warrior clans, such as the Minamoto and the Taira who, in turn, made every effort to obtain favors and official positions from the court. Most of the posts had become purely honorary; the Regents governed directly without taking the administration into account.

The court was made up of people of noble birth. They were idle but rich, since titles, rank, and official position were rewarded with the allocation of lands. Extraordinary importance was attached to ceremony, etiquette, rites, and the observance of various customs of Chinese origin. Numerous contemporaneous memoirs and chronicles give us a picture of the life led by these nobles of Kyoto. On the other hand, we know practically nothing about the life of the common people who were not only despised, but for the most part ignored by the aristocrats.

The Rise of the Warrior Clans

The landowning families in the provinces began to envy the wealth and ostentation of the aristocracy of Kyoto. The great lords, such as the Fujiwara, who possessed the land could not be simultaneously in their provincial domains and at the court. Thus they often delegated their powers to governors.

In the remote provinces, which escaped the power of the central government, a strong tendency toward autonomy began to make itself felt. The peasants grouped themselves around the local chiefs who, in turn, organized district police forces and even small armies as a protection against the invasions of the Emishi (Ainu) tribes in the north, petty landowners (who attempted to increase their own property at the expense of others), outlaws, and pirates. As the government itself was unable to supply a police force, it entrusted the local nobles with organizing armies of defense.

Life in the capital was so dangerous that the noble families often brought groups of armed warriors to the city from their remote *shōen* in order to protect themselves and their property from the bandits. In general, these fighting men came from distant regions that were exempt from Taihō Code land allocations—for the most part on the northern frontier where life was rough and the struggle against the Emishi was ceaseless. The peasant pioneers of land recently opened to cultivation were organized into armed forces. They openly opposed the central power with the approval of the noble families of Kyoto who governed their own *shōen*. In this way groups began to form which naturally claimed their own autonomy under the more or less tacit protection of the nobles of the court who hoped to free themselves from the power of the Fujiwara and the emperors. In order to resist the government more effectively, these groups amalgamated.

Two of these groups from the Kantō, the "Eight Taira of the East" and "Seven Groups of Musashi," were led by chiefs of two military clans, the Taira and the Minamoto, who were nobles of imperial origin. Most of the other clans (armed family groups) were controlled by princes of the sixth generation at least (according to the Taihō code, they had officially become subjects provided with titles of nobility), or by the younger sons of the great families who, not finding employment at court, had retired to their estates in the provinces.

One cannot, therefore, attribute the creation of these provincial armed forces to sporadic insurrections on the part of the peasants. No such insurrections took place in Japan during the tenth and eleventh centuries. The formation of the warrior clans arose from the fact that the nobles who united the peasants of their lands under their own command were the most able in wielding arms, obliged as they had been for generations to defend themselves individually. These clans, already firmly established in the tenth century and enriched both by revenues from their *shōen* and from the additional lands ceded by the peasants, began to form military forces with which the great families of the capital (including the Fujiwara) were anxious to ally themselves.

The rebellion of Masakado, a chief of one of the branches of the Taira clan in the province of Hitachi, was an indication of the impatience with which the new chiefs wished to assert their superiority, at first in internecine struggles and later openly against the central power of the Fujiwara. So as to prevent other clan chiefs from joining Masakado, the court promoted Minamoto Tsunemoto and Taira Sadamori, governors of the provinces of Musashi and Hitachi, to a superior rank. Yet it was not the government troops (practically nonexistent) which subdued Masakado in battle but those of the Taira and Minamoto clans.

Similarly, when Tadatsune, a chief of the Taira clan, revolted in 1028, it was a general of the Minamoto clan who put down the rebellion for the government. Between 1050 and 1062 it was again the task of the Minamoto to fight on the government's behalf against a rebellious governor belonging to a frontier clan of the Abe, and later still they subdued the Kiyowara clan in the extreme northern part of Honshu. Thus, because of the weakness of the central government,

these warrior clans, under the influence of the Fujiwara family (and often in spite of it), came into being. The clans operated on the pretext of protecting the imperial family, but their activity culminated in establishing their hegemony over the provinces that they already possessed *de facto*, and over other provinces that they wrested from the rebels.

The Cloistered Emperors

With the accession to the throne of Emperor Go-Sanjō in 1068, a sovereign came to power who had no family connections with the Fujiwara. In fact, since Emperor Go-Reizei had no male progeny, the most direct heir was the second son of Go-Suzaku whose wife was Princess Yōmei-mon-in. The Fujiwara could not oppose this succession even though it deprived them of all their power over the emperor. Thirty-four years old when he was crowned, Go-Sanjō decided to govern by himself and left to the *Kampaku* (at that time Norimichi, brother of Yorimichi, who had occupied the post for fifty years as the successor to Michinaga) only his title.

One of Go-Sanjō's first acts was the creation of a registration office for all lands in order to gain more efficacious control over the *shōen*. It was a measure that placed the Fujiwara and the monasteries (whose titles to their property were for the most part illegal) in a very awkward situation. Go-Sanjō, however, died only a few years after his accession to power, and his attempts at reform did not have their hoped-for effect. Fortunately, Go-Sanjō had abdicated in 1072, a year prior to his death, and had retired to a monastery in order to govern with a free hand through his son. It was customary then (and still is to this day) for the heads of upper-class families to withdraw to a monastery as soon as their heirs became old enough to succeed them. These cloistered patriarchs continued to manage their affairs in complete freedom, because a member of a religious community was not obliged to comply with the complicated and punctilious rules of the social etiquette of the era. With his retirement Emperor Go-Sanjō thus eliminated the ceremonial burden and at the same time escaped from the intrigues of the court. In this way he was able to govern more freely.

This withdrawal was to become a custom known as *insei* (the government of the cloistered emperors); it permitted a sovereign to retire but at the same time to maintain the functions of a Regent. The titled emperor, in fact, had no real power, while his father, the cloistered emperor, retained full authority over him. The cloistered emperors thus took the place of the Fujiwara Regents, who had attained their power because, for the most part, they had been the fathers-in-law of the reigning emperors.

Subsequently there were occasions when there were two cloistered emperors per reigning sovereign, each with his own government. In such circumstances the warrior clans, always ready to meddle in court affairs, assumed the role of protector of one or the other emperor, who required such support in order to govern.

At this point the powerful Fujiwara family was split by family dissensions. The various branches took opposing sides in supporting one or another of the emperors. At the end of the eleventh century almost half of the official posts previously occupied by the Fujiwara had passed to the control of the Minamoto. Other great families of rich landowners and merchants placed their fortunes at the disposal of the *Hō-ō* (emperor-monks) and thus acquired great influence. Once having retired, Emperor Shirakawa lived extravagantly at the expense of the public treasury and, being constantly in need of money, raised ignorant men to high rank when they assisted him financially—a practice that would have been inconceivable during the Fujiwara regencies.

These split governments favored all sorts of intrigue. Both the aristocratic class and the warrior clans fought bitterly for official positions and power. In order to protect their domains against the emperor and against rival communities, certain monasteries organized troops. Once armed, the monks often descended from Mount Hiei in attempts to impose their political ideas on the

court through force or terror. They incited riot in the city of Kyoto, engaged the monasteries of Nara in bloody battles, burned temples and other sacred buildings, and molested the peasants and commoners in raids throughout the countryside.

The only forces capable of imposing their authority on these groups devastating the country were the military clans, the Minamoto and Taira, which "protected" the emperors. The death of the Emperor Konoe in 1155 provoked a succession dispute which divided the aristocracy into two partisan groups: the supporters of the Retired Emperor Sutoku and the Minister of the Left, Fujiwara Yorinaga; and the champions of Go-Shirakawa, who was backed by the chiefs of the Taira clan. The struggle ended in the Hōgen Rebellion *(Hōgen-no-Ran)* in which Yorinaga was killed and the palace of Sutoku burned. Go-Shirakawa—whose accession to the throne provoked the dispute—consolidated his position and had Sutoku exiled to Shikoku where he died. This contest over the crown left the most powerful of the warrior clans as dual masters of the situation: the Taira and the Minamoto. Their struggle for supremacy occupied the last years of the century, when the effective power of the reigning emperors was counterbalanced by the influence of Go-Shirakawa, a cloistered emperor who was morally dissolute and a master of intrigue.

The Rise to Power of the Taira (Heike)

The fame of the Minamoto clan increased after its chief, Yoshiie, was victorious in skirmishes against the rebels of northern Honshu. In tribute, many clans thereby tendered their lands and services in vassalage to this valiant commander. Yoshiie's success aroused the jealousy of the court (Yoshiie was responsible for the protection of the emperor) and the distrust of the Emperor Shirakawa who, as a devout Buddhist, disapproved of the war. The Minamoto warriors, however, were the only force (together with a part of the Taira clan) capable of imposing order and controlling the monk-bandits who periodically descended from their mountain strongholds. The power of the Minamoto was derived primarily from their numerous vassals in the interior, whereas the strength of the Taira was based principally on the maritime activities of their vassals along the coast of the Inland Sea. The revolt of one of Yoshiie's sons (who was in exile) was repressed by a Taira general; this victory obtained the favor of the court for the Taira clan. From then on it was the policy of the Taira to ally themselves with the emperors against the Minamoto. The unfortunate tumult (involving only a few troops) that arose over the succession of Konoe was fatal to the Minamoto, because as a result fifty of their clan chiefs were mercilessly executed. The cultivated and gentlemanly politics practiced by the Fujiwara (who were opposed to bloodshed) was superseded by an administration of ruffians who were mostly illiterate and accustomed solely to making war.

A reign of violence thus followed two centuries of relative peace. Kiyomori, the chief of the Taira clan at that time, supported by Counselor Shinzei (whose lay name was Fujiwara Michinori), took up the defense of the reigning emperor, Nijō, against the Retired Emperor Go-Shirakawa, who had the support of Fujiwara Nobuyori and a chief of the Minamoto clan, Yoshitomo. In 1159, taking advantage of a temporary absence of Kiyomori, who had gone on a pilgrimage, the opposition attacked the palace, deposed the Emperor Nijō, assassinated Shinzei, and burned his house.

Kiyomori returned, however; and the emperor, who had been held prisoner by Nobuyori, succeeded in escaping and placed himself under the protection of the Taira in their palace in Rokuhara (a district of Kyoto). The inevitable battle that followed in the streets of Kyoto was won by the Taira clan. After the executions of the rebellious leaders only three young children of the Minamoto clan survived: Yoritomo, Noriyori, and Yoshitsune. They were sent in exile by Kiyomori to the Izu peninsula.

Kiyomori, who like his father, Tadamori, was well-versed in science and literature, was able to deal on an equal footing with the great nobles of the court who usually assumed an attitude of disdain toward the warriors. In 1167 he was raised to the highest rank of the court and became Prime Minister.

More than a decade later Antoku, Kiyomori's grandson, succeeded to the throne. The Taira clan now followed the policy of matrimonial alliances previously practiced by the Fujiwara. His harshness in executing the Minamoto chiefs and the priest Saikō, who had taken part in a conspiracy organized against him, had cost Kiyomori the sympathy of the people, to whom the clergy were holy figures. He had also aroused the antagonism of the monastic armies which, although relatively weak and composed of unscrupulous men often acting in their own interests rather than in the interests of the monasteries, represented a permanent danger to civil authority. Kiyomori was contemptuous of the clergy. He was very careful, however, not to offend too seriously those of the monastery of Enryaku-ji (on Mount Hiei) who, despite their bellicose excesses, were respected (and also feared) by the court and the commoners. Yet he did not hesitate to raze to the ground the monastery of Kōfuku-ji near Nara, property of the Hossō sect which had supported the Minamoto in 1180.

Kiyomori and the Retired Emperor Go-Shirakawa were far from being on good terms, because the cloistered emperor had confiscated for his own profit certain lands which rightfully belonged to Kiyomori's children. The Minamoto clan still had some influence at court, through their wives and daughters who were ladies-in-waiting, and Minamoto Yorimasa who—an exception to the rule—was considered a friend by Kiyomori after the battle of 1159 because he had been careful not to take part. However, in 1180, Yorimasa attempted to foment a rebellion of the Minamoto partisans in the name of the second son of Go-Shirakawa, Prince Mochihito, whom Kiyomori had decided to send into exile. Kiyomori got wind of the plot, and in the subsequent Battle of Uji Bridge the prince was killed and the wounded Yorimasa committed suicide in front of the Byōdō-in temple.

All these troubles seriously affected the tenor of life in the capital, which had fallen prey to famine, brigandage, arson, and epidemics. Although the brigands and outlaws were punished without mercy this did not relieve those who were dying from hunger and disease.

In 1177 a great fire destroyed almost half of the city, and the provinces also suffered from an accumulation of disasters. Kiyomori died in 1181 after having seen Minamoto Yoritomo—now grown to manhood—succeed in reuniting his partisans and opposing the Taira troops in the battle of Ishibashiyama.

The Rise to Power of the Minamoto (Genji)

The Minamoto clan continued to nourish ideas of revenge. Young Yoritomo, who had been spared by Kiyomori and had become chief of the clan, opened hostilities against the Taira in the name of Prince Mochihito, and even after the prince's death the Minamoto continued to pretend that they were acting in the name of the emperor. In fact, after the death of Kiyomori the Retired Emperor Go-Shirakawa came to an agreement with Yoritomo. The war lasted more than four years, during which the number of partisans of the Minamoto clan constantly increased.

In 1182, however, famine was so severe and epidemics so widespread that the war had to be suspended. In the western part of Japan—which was under the control of the Taira—the drought was appalling and the resultant failure of the rice crop a disaster. Weakened and decimated by sickness, the Taira soldiers were victims more of famine than of the attacks of the Minamoto forces. The Minamoto troops, on the other hand, had been recruited in eastern Japan where the crops had been excellent even during those difficult years.

The struggle was resumed in 1183, but the Taira, although greatly superior in number to the

Minamoto, were too weakened and disorganized to defend themselves. The defense of depopulated Kyoto became difficult. It was easy for Go-Shirakawa to escape from the clutches of the Taira and to take sanctuary with the monks of Mount Hiei. (Accounts of this fratricidal war—replete with both courageous military ventures and acts of treason and villainy—are set forth in the narrative epics of the period.)

In 1184, having been defeated at Ichi-no-Tani by Yoshitsune, brother of Yoritomo, the Taira were obliged to flee to the island of Shikoku. The following year Yoshitsune landed in Shikoku and forced the Taira—who had by then seized the young emperor, Antoku, as well as the imperial regalia—to escape in their boats. On April 25, 1185, Yoshitsune attacked and completely defeated the Taira naval forces by taking advantage of the tide, which was driving the Taira ships in their attempted flight through the Shimonoseki Strait onto the rocks of Dannoura. Antoku and most of the Taira nobles were drowned, and it is probable that part of the imperial regalia (the mirror, the sword, and the jewels) was also lost. The power of the Taira family had been completely destroyed and the Minamoto (or Genji) clan assumed absolute control of the government with the assent of the cloistered emperor, Go-Shirakawa.

The following six years were notable for the development of the antagonism between Yoshitsune (his brother accused him of treason and intrigues with the court) and Yoritomo, who, from his capital in Kamakura, was completely absorbed in consolidating his possessions in the North. In 1189 Yoshitsune took refuge with one of the powerful nobles of the Fujiwara family in the province of Mutsu. Betrayed by one of his host's sons, Yasuhira, and attacked by his brother's troops, Yoshitsune committed suicide. Yoritomo then turned against the Fujiwara. Yasuhira fled to Hokkaido where he was killed by a traitor.

At that point all the northern provinces came under the control of Yoritomo, who thus became the most powerful lord of the country and could dictate orders even to the cloistered emperor (Go-Toba, who reigned officially, was a boy of ten). In 1192, the year of Emperor Go-Shirakawa's death, the new emperor, Go-Toba, appointed Yoritomo to the highest military command, naming him *Seii-Tai-Shōgun* ("Military Chief against the Barbarians"), and thus he became the key figure of the imperial government. The death of Go-Shirakawa also put an end to the reigns of the cloistered emperors.

Yoritomo set up his government in Kamakura, the seat of the Minamoto, while the emperors and their court continued to reside in Kyoto. The glorious period of the Fujiwara had ended in disaster; the country, ravaged by war and famine, was in a deplorable state; and even the succession to the throne was in question. Such problems, however, were not such as to daunt a man with the ambition and intelligence of Minamoto Yoritomo.

Koto tareba	Affluence becomes poverty
Taru ni makasete	Thanks to its own openhandedness.
Koto tarazu	Happy is he who can find
Tarade koto-taru	Affluence in poverty.
Miko koso yasukere	

Sugawara-no-Michizane

Development Within the Aristocracy and Other Social Groups

During the tenth and eleventh centuries a unique social structure developed in Japan that was characterized by two features: it was confined solely to the city of Kyoto, and it was limited to one social class, the aristocracy of the court. It would be difficult to apply to such a static and temporary society the term "civilization," because this word generally embraces all parts of a country and the entire population. In this case the term "culture," in a restricted sense of time and type of society, fits much better.

Beginning with the twelfth century, other elements of the populace began to make themselves heard: those that identified themselves more deeply with the life of the country. Only at that point could one begin to speak of Japan as a civilization. Until then only two classes seem to have existed, leading two parallel lives between which there was practically no link: the peasants, who had barely evolved beyond a Neolithic stage of development, and a small group of aristocrats whose principal aim was increased temporal power. The few people who formed a class between these two extremes—a type of middle class composed of artisans, artists, and the clergy—tended to ally themselves more with the aristocracy than with the peasants.

The entire history of Japan up to the twelfth century is a chronicle of the woes the more powerful group inflicted on those less powerful. Never, perhaps, in the history of the world were the rulers more widely separated from the ruled and more indifferent to their fate. The gap was so great that in reading the chronicles, memoirs, and tales of the epoch, one wonders at times if the aristocrats of Kyoto were even conscious of the existence of their countrymen.

Imbued with Chinese culture and occupied solely with their own interests, the nobility represented but a fraction of the population. The overwhelming majority—the peasants—wallowed in silent misery and could in no way create a civilization worthy of the name. It was only at the beginning of the twelfth century, with the formation in the provinces of new warrior and merchant classes, that a national conscience began to make itself felt and Japan (or, rather, the Japanese people) began to create its own history. Emphasis has generally been placed on the literary and aesthetic accomplishments of this era, but it has not been made clear that these accomplishments never really affected the Japanese people, and that in the centuries that followed only the aristocrats and well-to-do were inspired by and glorified through them.

The influence of religion was preponderant. With its numerous sects, imported Buddhism was a faith for the nobility, and it almost excluded the masses. Confucian philosophies and the Chinese theories regarding the concept of yin and yang also exercised profound influences on the nobles of the Fujiwara era. Poorly assimilated and improperly understood, these varying philosophies and faiths blended with an indigenous Japanese undercurrent of diverse beliefs and shamanistic practices, and the result was an incredible number of prohibitions and strictures in both the rules of etiquette and everyday life that had to be scrupulously observed if one was to avoid the wrath of Heaven. Nothing pertaining either to the personal conduct of an individual or affairs of state could be accomplished without consulting astrologers or geomancers. Among these beliefs the most prevalent were the *monoimi*, a group of circumstances which imposed a total abstention from action, and the *katatagae*, a means of freeing oneself from a directional taboo—that is to say, a route or a direction of travel which would cause one to cross the path of a divinity or spirit, and that is therefore proscribed.

No steps could be taken if the moment was judged unpropitious by the astrologers. There was a special government office, the *Onyō Ryō*, composed of astrologers, geomancers, and other seers,

whose function it was to determine the auspicious and inauspicious days and hours for the promulgation of laws and for the court ceremonies. Each great family employed its own official astrologer. Hundreds of soothsayers and charlatans were constantly occupied in regulating the most trivial act in the life of an individual (and thereby making the greatest possible amount of money from their consultations).

It is probable that the lower classes were relatively uninvolved in these practices, because they had to work during the entire day and therefore had no leisure time. The shamanistic belief in magic and occult powers was founded on ancient and traditional Japanese and Asian beliefs, and called for numerous exorcism ceremonies and propitiatory rites conducted chiefly by Buddhist priests. All calamities—sickness, death, ill fortune, fires, storms, earthquakes, tidal waves, disastrous rains, or crop failures—were attributed to vengeful spirits or wrathful gods. In order to mitigate these disasters, enemies one had killed or mistreated were canonized as *kami*. (Sugawara-no-Michizane who died in exile was deified by the Fujiwara family with the name of Tenjin-sama in 986; and the Kitano shrine was built in Kyoto and dedicated to a cult created in his name.) Other methods involved the recitation of prayers or the sutras by Buddhist priests, the monastery drums beaten, or other rites performed. It was believed that people could be possessed by evil fox spirits endowed with numerous magical powers. It was not unusual to see Buddhist priests and monks conducting rites of exorcism by reading from Chinese Taoist scriptures or acting as if they were the shamans of Siberian tribes.

In reality all the beliefs blended into a sort of incoherent syncretism: the indulgences and prohibitions of one faith added onto those of others. One of the most widely held beliefs was that breaches of etiquette were not only to be considered unworthy of a noble person, but would inevitably bring down the wrath of Heaven. The extremely complicated rules of etiquette, moreover, had to be scrupulously observed not only in questions of protocol among the nobility but also in matters of demeanor and dress. Clothes varied according to the occasion, making it necessary for the courtiers to change their attire several times a day. Every unusual or unexpected event—a sneeze, the barking of a dog, a chance encounter with a peasant—was taken as an omen to be exorcised if it was of a malignant nature; aristocrats led an existence encumbered with endless superstitions.

Shintō ceremonies were always observed at court, despite the ever-increasing influence of Buddhism, and Shintō shrines were frequently visited. Even the Buddhist clergy did not neglect to venerate the *kami* on occasions when reverence was expected. The great sun goddess Amaterasu was identified with Dainichi Nyorai, the great solar Buddha of Truth, and the other *kami* were considered to be emanations of Buddha.

Although the two religions were very different, they took the greatest care not to offend each other. Each Buddhist monastery contained at least one Shintō shrine, and most of the major Shintō shrines had Buddhist altars. This strange fact can be explained perhaps by a certain disinterest on the part of the Japanese in everything related to metaphysics or, more simply, to religious philosophy. Religion is for them merely a group of rites that should be prudently observed so as to avoid the wrath of the divinities. This attitude toward religion clarifies to a considerable extent what otherwise might seem strange in the conduct of the Japanese of that era: a line of conduct that one can still perceive in present-day Japanese society. The utmost importance is attached to externals, to the attitudes proper to assume on each occasion, because "appearance" is a thousand times more important than "being."

This emphasis on observing the correct attitude at all costs reached a peak during the Fujiwara era. The Japanese of that period were neither Buddhists nor Shintoists nor Taoists, but a mixture of all three, combined with residual beliefs dating from prehistoric times. Since none of these beliefs ran counter to the imperial position—in fact, the emperors more or less supported them—it was normal to accept them all. This was perfectly in accord with the Japanese soul, which is far more attracted to aesthetic than to emotional aspects.

Thus, extremely elaborate rituals were developed: religious ceremonies above all, but also

other ceremonies governing public affairs as well as the everyday life of an individual. Since Buddhism had the most elaborate rites, it naturally attracted the aristocrats, who often obtained from it more of an aesthetic satisfaction than an act of faith. The Japanese demanded first of all from Buddhism and its divinities (considered omnipotent) the satisfaction of their desires in this world and, less importantly, a peaceful existence in the next.

The esoteric doctrines of Shingon and Tendai brought from China by Kōbō Daishi and Dengyō Daishi (the posthumous names, respectively, of the priests Kūkai and Saichō) were in actual fact understood only by those two religious figures. The laymen found in them only a group of rites imperative to observe, as well as an explanation of the meaning of life—the doctrine of karma (the relationship of cause and effect between past and future lives)—which satisfied their extremely limited curiosity concerning metaphysics and philosophy. The imperial family and the nobles protected and supported the monasteries by endowing them with sumptuous gifts, by commissioning sculpture and paintings for them, and by spending lavishly for the religious ceremonies and the construction of buildings. Yet the same aristocrats, including the Fujiwara, endowed with equal generosity their large family Shintō shrines, such as Kasuga at Nara and Kamo at Kyoto.

It was considered good form to be conversant not only with the Chinese classics but also with a few passages of the sutras as well. The doctrines and rites of the Shingon and Tendai sects were abstruse, however, and the need for a simpler religion began to make itself felt. Toward the middle of the ninth century the priest Kūya proclaimed that the simple act of saying the name of the Buddha (Nembutsu) was sufficient to affirm one's faith in Amida Buddha and, consequently, to assure rebirth in his Paradise of the West ("The Pure Land"). Priest Eshin with his *Ōjōyōshū (The Essentials of Salvation)* contributed considerably to the diffusion of this new religious form, which evolved during the twelfth century when the excesses of the warrior monks of Mount Hiei and Nara oppressed the populace, whose existence was additionally threatened by many natural calamities (the aristocrats were not spared these, but they were rich).

This simple doctrine of salvation offered a consolation based on hope, if not in this world, at least in the next. And the most powerful members of the court, trapped in an inextricable web of ritual prohibitions and obligations, found in the teachings of this new Jōdo sect a basis for the expectation of a better life in the world to come without having to worry unduly about comporting themselves too carefully in this one. The "Total Compassion" of Amida could be obtained merely by repeating his name.

Since the emphasis was placed on the transitory and unstable aspects of all things, the behavior of men was conditioned in a certain sense by this attitude; it contributed to the creation of that rather melancholy culture that characterized the nobles of the Fujiwara era. The sense of Good and Evil was felt most of all in the external and social aspects of life. It was essential to show that one was extremely sensitive to feelings or pleasures in which form or ceremony assumed an exaggerated and principally aesthetic role.

The novels of the period, such as *Genji Monogatari* by Lady Murasaki Shikibu or *Makura-no-Sōshi (The Pillow Book)* by Lady Sei Shōnagon, written in Japanese and in *hiragana* characters for the women of the aristocracy, show the sentimentality affected by the nobility from the end of the tenth century onward, but it is also clear that a relatively liberal moral code was accepted as normal and that the sentimentality was sometimes replaced by explosions of long-repressed violence. The characteristic nervousness of the Japanese temperament—evident in every aspect of life but kept in check by social prohibitions, rites, and etiquette—in certain moments breaks its bonds and finds a sort of safety valve in devotional practices, sports or hunting, or warlike escapades. As this repressed nervousness could not be openly expressed without causing a breach of etiquette, the aristocrats obliged to live under its constant pressure displayed an extreme degree of sensitivity. For those with supersensitivity, expressiveness could manifest itself in an ultra-refined sense of the aesthetic. A courtier could fall in love with a woman merely at the sight of her kimono sleeve; an emperor could be overcome with joy on being reminded of soldiers

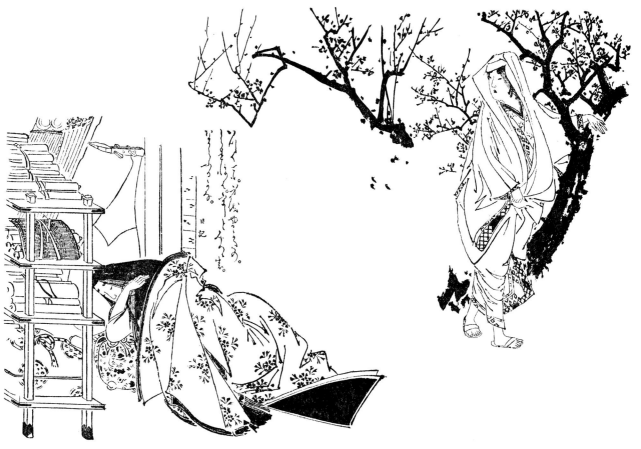

33. LEFT: MURASAKI SHIKIBU: AUTHOR OF THE GENJI MONOGATARI (978–1013?)
RIGHT: THE POETESS "X," DAUGHTER OF FUJIWARA-NO-FUSHIMI

marching in a light flurry of snow; a noble could be moved to tears by the sight of petals falling from a flowering cherry tree. The usual aristocratic amusements at court seem somewhat superficial: flute lessons, contemplation of statuary, recitations of poetry, identification of perfumes, admiration of flowers. Yet such activities were natural among people whose sensitivity was refined to the nth degree, who were always on the alert to circumvent a *faux pas* in comportment or speech which could result in a catastrophe, and for whom the very fact that they were alive seemed almost a miracle every morning. Great attention was devoted to clothing, coiffures, calligraphy. Even more stress was placed on gracious deportment than on physical beauty. Perfumes and makeup were extensively employed not only by the women but also by the men, and the height of fashion was to dress in Chinese style. The courtiers and nobles played a game with painted shells which had to be arranged according to certain precise rules. They also played *kemari*, a ball game that originated in China and is still widely played today in Southeast Asia, and that is similar to football. *Kemari* was played in official court costume. Today in some monasteries of modern Kyoto it is still customary to play the game on certain ceremonial occasions, but the rules differ from those of several centuries ago.

Although it was apparently gay, the court life was tinged with pessimism and sentimentality and characterized by the Buddhist idea of the instability of the material world, though not of its futility (that which would seem futile today had great importance during that era). The life of the aristocrats of the Fujiwara era has often been described as dissolute and effeminate. Yet it must be remembered that during this period aesthetics dominated ethics, actions were judged not on the basis of their substance but of their form, and discretion could normally conceal any action which, if publicly disclosed, might have appeared as an offense (not from the standpoint of morality but of etiquette and correct behavior).

The splendor of multicolored garments, the grace of a gesture, subtlety of deportment, the aesthetic perfection of fine calligraphy, and a sound acquaintance with the Chinese classics were considered to be the true virtues. Our modern concepts of honesty, loyalty, common sense, and courage did not have the same value in that period in which everything was related to a visual or intellectual sense of beauty.

This society, however, was far from lacking in earnestness or profundity. In order to be considered for an official post, a candidate had to undergo intensive literary preparation and be capable of "writing": in other words, he had to know not only how to draft a report in Chinese, taking into account all the prescribed forms, but also how to compose poems in the Japanese language.

What is surprising, however, is that along with this important literary culture there existed (with a few rare exceptions) only a very limited curiosity concerning the natural and physical sciences, even among the best minds of the time. The simple, even elementary principles of the natural universe laid down by Confucianism and Buddhism were accepted without question and except perhaps for a few priests, no one bothered to make any serious investigations in any area but religion. No philosophical spirit of inquiry and no interest of a scientific nature seem to have arisen during the era. Although the past was sentimentally evoked, it was basically ignored, because everyone's attention was directed solely on that which was new, up-to-the-minute, or *imamekashi*.

At the same time everyone preferred to ignore the future. On the basis of an ancient prophecy the Buddhist clergy had announced an era of disasters (the *Mappō*), which would witness the end of the Law of Buddha and would culminate in the destruction of the world in 1051. In a certain sense, the end of the eleventh century and the beginning of the twelfth was an epoch in which—despite the existence of some fine intellects—the power of carefully considered thought seemed to pass into a decline. The Jōdo doctrine, which demanded absolutely no intellectual speculation on the part of the faithful, was adopted on an ever-widening scale. Since relations with China had been officially severed for some time, the curiosity concerning foreign developments and discoveries which had been so strong in the eighth century had completely vanished. Fujiwara society appeared to be refined, tolerant, fatalistic, and little inclined to war. In reality, however, these qualities were merely the result of the great indifference of individuals in their relationships with one another. Fujiwara Morosuke, for example, advised his heirs not only to observe the rites strictly but also "not to frequent the houses of others" unless it was a question of a social obligation or of business, and in those cases the visit was to be made in the most formal fashion possible.

There was an even greater indifference toward intellectual speculation. In their egoism, the nobles' sole aim was to secure comfort and honors in this life and unlimited happiness in the next. Yet these sentiments, which were peculiar to a small segment of the Japanese people, affected the civilization of the country only slightly.

In that period, without doubt, the life of the citizens of Kyoto was completely separated from that of the masses. Yet it seems that the "behavior of the society of the Heian era," as one could call certain aspects of the culture of the aristocracy of the ninth, tenth, and eleventh centuries, created norms and supplied criteria that were followed by the aristocrats, middle classes, religious figures, and warriors during all the succeeding epochs, and those norms and criteria were to condition the evolution of the thought processes and the aesthetics of the Japanese up to the present day.

During the twelfth century, however, a few men seemed to be exceptions to the rule—in particular, Taira-no-Kiyomori, chief of the Taira or Heike clan, and Minamoto Yoritomo, chief of the Minamoto or Genji clan. Kiyomori, son of Tadamori, the warrior whose blunt manners estranged him from the court, even though he was an extremely well-educated person, received imperial favors early in his career because of his valor. Kiyomori and Counselor Shinzei, who was killed during the disturbances of 1159, were two of the rare people at that time who

had a vast perception of the problems of the Japanese people and of the needs of the country.

Kiyomori recommended that commercial relations with foreign countries, particularly China, be increased, and in order to facilitate trade he created new ports on the Inland Sea (Hyōgo, in particular), and with the construction of docks and breakwaters improved those ports already in existence. In general he used all available resources to encourage navigation and commerce on the Inland Sea and in the surrounding territories under his control. There is a legend that when Kiyomori attempted to build a large breakwater to protect the port of Hyōgo (now Kobe) fifty thousand peasants (the figure is certainly exaggerated) were brought to the site from the provinces of Yamashiro, Yamato, Ise, Iga, Harima, and Settsu. However, because of the difficulties involved, the work could not be completed. Kiyomori therefore turned to a sooth-sayer for help, and the latter told him that thirty human victims would have to be sacrificed to the *kami* of the sea. Kiyomori immediately prepared a barrier on the road to Ikuno, planning to obtain his victims from the first thirty persons who passed. A young page, Matsuo, offered to sacrifice himself in their place—a single voluntary sacrifice pleased the *kami* far more than numerous forced ones—and he plunged into the sea on horseback and disappeared beneath its waves. Ten years later, in 1173, the port was completed.

For centuries in Japan (as well as in China and the Middle East) there had existed the custom of burying living victims in the foundations of houses and other buildings because it was be-lieved that their spirits would live on as the guardians of the edifices. These victims were known as *hito-bashira* or "human pillars." This custom was finally abolished at the beginning of the six-teenth century by Mōri Motonari who, during the building of the castle of Chūgoku, refused to sacrifice a man merely because it was customary to do so.

Kiyomori, it seems, was also aware of the necessity of introducing into Japan shipbuilding techniques that could be adapted to his ambitious maritime projects. After having improved numerous ports—including Hiroshima—on the Inland Sea, he entered a religious order follow-ing a long illness. He then concentrated his activities on the decoration of the Taira family shrine —Itsukushima at Miyajima—and endowed it with some splendidly illuminated manuscripts of the sutras. This exceptional man died in March, 1181. He had been almost the only person of his time who attempted to bring prosperity to his country. Yet he was more warrior than statesman, and despite his ambitions his plans eventually failed. All that can be said is that they favored the subsequent development of Japanese commerce with China.

Life in the provinces was very different from that in the capital. The chiefs of the warrior clans did not have the same difficulties collecting taxes encountered by the court, and their land rendered rich profits. Property is essential in Japan for power, and the warrior chiefs bene-fited even more from the support of the inhabitants. Between the clan chiefs and the heads of the families settled on the land a close relationship of vassalage was gradually created. The lords gave aid and protection to their vassals; the vassals supplied men for the armies and the police. Since the peasants were protected, agriculture developed rapidly, and the fortunes of the clan chiefs grew ever greater.

The peasants living on the estates of the warrior clans probably led a much easier life than those living in the imperial territories, but as we have no documents of the period that deal with the living conditions of the peasants, this is conjectural. As far as the lords of the provinces were concerned, it is certain that they lived a far less luxurious life than the courtiers of Kyoto. Reared to fight, they passed most of their time hunting, engaged in training with arms, inspecting their vast estates, or concerning themselves with the administration of the land rather than with poetry writing—although literary accomplishments were neither despised nor disregarded.

The Buddhist philosophies extolling gentleness and condemning the horrors of violence had little influence on them. The provincial nobles, although Buddhists when convenient, continued to be faithful in their devotion to the divinities of the soil. The innumerable sects and faiths that complicated the lives of the townspeople of Kyoto were not followed to any extent outside the capital, and the observance of their rites was far less rigorous in the provinces. The provincial

nobility enjoyed much more freedom in their thoughts and actions than the courtiers of Kyoto. The nobles of the imperial court scorned these "educated warriors," with their brusque manners, strong, harsh voices, and straightforward actions. Yet the real strength of the country continued to lie in the land, and the people of the provinces certainly realized that the handful of literary lights who made up the government could not reasonably pretend to represent the overall population of the empire. Despite its prestige, the court of Kyoto did not serve as an example, and although some of the customs of the courtiers were imitated (and then more through snobbery than conviction), they had in reality little influence on the tenor of life in the provinces.

As has been indicated, the society and cultural milieu of the Heian period was primarily literary. After the cultural exchanges with China had lapsed in 838, new forms of expression were conceived, obviously based on those previously received from China. The development of a script adapted to the Japanese language also permitted the development of completely new literary forms. Emphasis was placed on poetry. In the structure of a thirty-one-syllable poem *(waka)*, an author was able to express concisely an emotion or thought without having to formulate it precisely: an aspect, a fleeting instant which expressed an evocative mood to the highest degree. The most profound depths of the Japanese soul are revealed in these *waka*. In them, rather than expressing a thought or stating an emotion, the poet permits his ideas to emerge indirectly through a simple description or declaration. The reader or the listener must discover for himself what the author felt at the moment of writing.

In this sense nothing is nearer to music than these *waka*, which reveal to us, beyond the limits of a refined poetic form, all the sentiment, emotion, and sensitivity of cultivated Japanese society. We cannot hope to re-create the spirit of the period if we do not read these *waka*, yet we must not attach too much importance to the exact sense of the words, which often are ambiguous. The Japanese language does not describe; it evokes or suggests. A translation of these *waka* cannot really recreate their underlying emotion.

Beginning with the tenth century, numerous anthologies were compiled, often at the request of the emperors. These anthologies were later collected in the *Nijūichidai-shū (Anthology of Twenty-one Reigns)*. The prose of the Heian era was notable for the development of the *monogatari* or tales. The oldest of these is the *Taketori Monogatari* or *Tale of the Bamboo Cutter*. Others, such as the *Ise Monogatari* and the *Yamato Monogatari*, followed the same line. Still others, like the *Konjaku Monogatari* and the *Uji Shūi Monogatari*, were of a type known as *setsuwa*—collections of anecdotes, legends, and tales on various subjects. In addition there were diaries and intimate papers *(nikki)*; for the most part, they were written in Japanese by the women of the aristocracy. The *Tosa Nikki*, the *Kagerō Nikki*, the *Murasaki Shikibu Nikki*, the *Izumi Shikibu Nikki*, and the *Sarashina Nikki* are among the most representative examples of this type.

Novels also made their appearance with the *Genji Monogatari (The Tale of Genji)* of Lady Murasaki Shikibu. There were also historical narratives, such as the *Eiga Monogatari* and the *Ōkagami*, which took as their subject the history of Japan between the end of the ninth and the middle of the twelfth centuries. These histories, together with the *Makura-no-Sōshi* of Lady Sei Shōnagon (a book of random thoughts and personal experiences), are a valuable source which describe—admittedly in a fictionalized fashion—the life of Heian-kyō society. The great families also wrote chronicles recounting their history. We also have the innumerable official documents (written in Chinese) which illuminate various aspects of these centuries of splendor and misery.

Architecture

Unfortunately, practically none of the architecture of the Fujiwara era has survived; most of the buildings were destroyed in the course of battles between the monks of the various sects or during the wars of later periods. However, a few buildings were reconstructed at a later date on the

basis of the original plans and today present an approximation of their original appearance. The most important of these structures are: the Sanjūsangen-dō (or Rengeō-in) at Kyoto, a thirteenth-century reconstruction which has also been called "The Hall of the Thousand Buddhas" and is characterized by its extreme length, and the Gosho or imperial palace of Kyoto, which was rebuilt during the Edo era. The Heian Jingū erected in 1895 is a faithful reproduction of a great Shintō shrine of the Heian era.

Aside from these two temples and the palace, the only original examples of Fujiwara architecture still extant are the temples dedicated to Amida that were erected by the Jōdo sect. They are square structures built especially to house an image of the Amida Buddha. Around them there is a type of cloister or gallery intended for the circumambulatory rites or the display of depictions of the "Paradise of the Pure Land," exemplified by the Hō-ōdō of the Byōdō-in at Uji. The Shiramizu Amida-dō of Fukushima and the Amida-dō of Hōkai-ji are also examples of this type of structure. A few other temples reserved for the Amida cult were built on an oblong ground plan and housed multiple images of this divinity. The Hondō of Jōruri-ji in Nara is typical.

Architecture followed two contradictory tendencies: the first is characterized by elegant simplicity with roofs shingled in cypress or cedar bark, slender and well-shaped columns, and wood flooring; the second is extremely elaborate and is embellished by complicated pavilions intended to harmonize with a re-created or artificial landscape (Byōdō-in at Uji). Civic architecture was inspired by that of the temples and monasteries, and in some cases the buildings were later converted into shrines. The *shinden-zukuri* type of aristocratic residence created in the preceding era continued to be the dominant style for the houses and gardens of the nobility.

Sculpture

The sculpture of the Fujiwara period, like that of the preceding Kōnin era, was for the most part executed in wood, but the early technique of carving a complete work from a single block *(ichiboku)* gradually gave way—due probably to an increase in the number of works commissioned—to the *yosegi* technique which consisted of carving the work in separate parts and then assembling them. This method enabled the sculptors to work more rapidly and efficiently, and the individual components were made in multiples and were suitable for mounting onto innumerable works which resembled one another.

It is believed that this new technique was developed by Jōchō, an artist in the employ of Fujiwara Michinaga. Instead of working in the place where the piece was to be installed, as his predecessors had done, he set up a studio *(bussho)* on his own premises in which numerous apprentices were employed. Jōchō was the son of the sculptor Kōshō and, like his father, was a priest. Together with his own sons and pupils he created the school know as Shichijō-bussho.

Together with a certain Ensei, Chōsei, one of Jōchō's apprentices, later set up another studio —also in Kyoto—which acquired its name from the street on which it was situated: Sanjō-bussho. These two studios prepared most of the artists who worked during both the Fujiwara era and the following Kamakura era.

In a general sense, sculpture of the period tended to become more Japanese, to evolve its own forms in the absence of new models from China because after the last of the official missions sent to China in 838, few continental prototypes found their way to Japan. In reality, however, the Japanization of sculpture was more a question of technique than of the creation of an authentically new style.

The *yosegi* technique made it possible for the sculptors to carve every single detail to the point of perfection, whereas with a single block the treatment was more or less dictated by the grain of the wood. The first Fujiwara period works were massive and hieratic, and apparently followed

the style introduced with the founding of the new capital. The later works gradually evolved into more elegant forms. The large eyes often look down with an air of secret contemplation on the *mudra* (ritual and symbolic gestures). The noses are smaller and more delicate; the faces are rounder, but the features are more refined.

The masterpiece of this period, as far as images of Amida are concerned, is the Amida of the Hō-ōdō of Byōdō-in executed by Jōchō toward the end of his life. The figure reflects utter repose; the body seems to be more relaxed; and the treatment of its drapery is also more flowing than in any previous work. The images of the accompanying divinities, however, give an impression of vital strength that seems to have been influenced by the work of the Kōnin era. But here the overall treatment is a little more flexible and the details more elaborate.

This era also marked the birth of regional schools. Yamato was no longer the only province producing works of art. The temples at Iwate, Kanagawa, and Aichi contain powerful sculptures (not polychromed) in a sober style in which the marks of the chisel are clearly visible. Stone sculpture, although rare, and found mostly on the island of Kyushu, followed the same lines as the works in wood. The treatment of the drapery continued to embody the *hompa-shiki* style, which is more easily executed in stone than the fluid lines of the "Fujiwara" robes.

In late twelfth-century sculpture a tendency toward naturalism is evident as well as a return to the Nara style. This sculpture was almost entirely polychromed. Certain works of this period can perhaps be included among the nearly perfect sculptures in the world: the Kichijo-ten of Jōruri-ji, the Shōtoku Taishi of Hōryū-ji, and the Dainichi Nyorai of Onjō-ji at Shiga (the latter being the work of the sculptor Unkei).

Painting

Painting of esoteric content dominated in the works of the Kōnin era, a time when art was increasingly dependent on the patronage of the aristocrats. During this period, painting developed in a less austere style and tended to become delicate, elegant, and slightly affected. In the twelfth century painting was associated primarily with the cult of Amida and portrayed this divinity surrounded by Bodhisattvas (semidivine beings destined for Buddhahood who have temporarily postponed attaining complete Enlightenment in order to help suffering mankind to redemption) receiving the souls of the deceased. Saturated with mysticism and emotion, these paintings depicting the descent of Buddha—called *raigō*—were characterized by their brilliant color and adroitly harmonized tones which conveyed an impression of gentleness and tranquility.

Another style which made its appearance at this period has been classified under the generic name of *yamato-e* (Japanese painting). Works in this style drew their inspiration from Japanese subjects, in contrast to examples in the *kara-e* style of previous periods which drew upon themes common to Chinese painting. Houses and temples in the Fujiwara period began to be decorated with paintings, either on wall surfaces or on doors and screens. The subjects of these paintings were drawn from the common, everyday tasks performed during the various months *(tsukinami-e)* or seasons *(shiki-e)* of the year, or from descriptions of famous locales celebrated for their scenic beauty *(meisho-e)*, or even from works of literature, such as the *monogatari (monogatari-e)*. The latter type of painting appeared most frequently in the illustrated versions *(emakimono)* of these romanticized chronicles. The major examples include the *Genji Monogatari Emaki*, traditionally attributed to Fujiwara Takayoshi in the first half of the twelfth century, and the *Nezame Monogatari Emaki*. The drawing style is characterized by fluid lines, and the artists depicted the scene as if seen from above, so that the observer seems to be looking down through the ceiling or roof (both of which were eliminated). This type of perspective allowed the artist to arrange his figures and objects one above the other and thereby gave his work a three-dimensional quality and the illusion of great depth. The colors were pure, even brilliant. The subjects were calm,

almost static. The faces, simplified in the extreme, tended to resemble one another and were delineated by a line or two for the eyes and a hook for the nose.

The same style of illustration was employed to decorate the frontispieces of sutra rolls, although the subjects depicted seldom bore any relationship to the text. This was equally true of sutras written on paper or silk cut in the shape of a folding fan.

Authors of the period distinguished at least two principal styles of painting: that which constituted a transition from the *kara-e* (Chinese) to the *yamato-e* (Japanese) style (the most important artists working in this transitional style were Kose-no-Kanaoka who founded the Kose school in the ninth century, and Asukabe Tsunenori in the tenth century); the second was the *yamato-e* style (the most famous artist working in this style was probably Kose Hirotaka in the eleventh century). Other painters whose names have survived include: Tamenari, eleventh century; Kose Kintada, tenth century; Tametō, twelfth century; and Kimmochi Koreshiga. The few extant works from these centuries cannot be attributed with any certainty to any one of these artists.

There was yet another style, however, which anticipated the subsequent emergence of typically Japanese illustration. It consisted of drawing in black ink and using no color, or sometimes employing an extremely limited range of colors. In these works, lines were strongly and rapidly brushed in, which imparts to the viewer a sense of dynamic movement. When painted on scrolls, these drawings sometimes depict several scenes or events, simultaneously or in rapid succession, one next to the other—from the right to the left—in such a way as to indicate the time element: each scene is thereby consecutively revealed to the reader as he unwinds the scroll.

Generally speaking, the artists who created these drawings also adopted a perspective that showed the scenes as though they had been observed from a high vantage point. The most famous of the scrolls are the anonymously painted *History of Mount Shigi (Shigisan Engi)* and *Caricatures of Animals and Birds (Chōjū-Giga)* attributed to Abbot Kakuyū, better known as Toba Sōjō. These drawings embody frank caricature and evidence both a keen power of observation and a delightful sense of humor, providing a singular contrast with the style espoused by the official court painters of the period.

Calligraphy had been raised to the level of a noble art and was considered to be an important virtue. Often the reputation of a man or woman was based on the appearance of his or her handwriting. It was generally believed that a noble character must necessarily be reflected in perfect calligraphy. Printing from type blocks (not movable type), which had been introduced into Japan from Korea in the eighth century, was rediscovered during the Fujiwara period and was employed primarily by the monks for printing copies of the sutras. The characters were carved onto wooden blocks, inked with a thick India ink, and painted on handmade paper made from the bark of the mulberry tree.

165. KYOTO. HEIAN JINGŪ. PAVILION. Constructed in 1895, the Heian Jingū in Kyoto is an authentic replica of a Heian period shrine of the tenth to the twelfth centuries. This is one of the pavilions linked to the main building by covered galleries built on piles over the lake. It is characteristic of the *shinden* style adopted for the residences of the aristocracy, for palaces, and for some of the shrines during that flamboyant and ostentatious period.

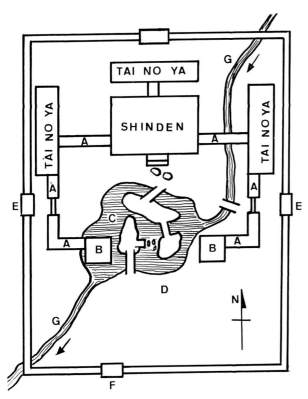

34. THEORETICAL PLAN OF A SHINDEN STYLE RESIDENCE
A. COVERED CORRIDORS E. CHŪMON (GATEWAYS)
B. PAVILIONS F. SOUTH GATEWAY
C. POND (MAIN ENTRANCE)
D. GARDEN G. STREAM

166. KYOTO. HEIAN JINGŪ. STEPPINGSTONES. This type of steppingstone is typical of Heian period gardens. The arrangement shown here, however, dates from the reconstruction of 1895.

167. NARA. SAIDAI-JI. FOUNDATION OF A PAGODA. These are the stone bases of the supporting columns of the pagoda formerly in front of the Saidai-ji's Kondō. The largest base—in the center of the photograph—must have held the central supporting column. The pagoda was burned down and rebuilt on several occasions, but was not reconstructed after the fire of 1502.

168. UJI. BYŌDŌ-IN. HŌ-ŌDŌ. Known as the Phoenix Hall, the Hō-ōdō was built by Fujiwara Yorimichi and was converted into a monastery in 1052 in order to house an image of Amida Nyorai by the great sculptor Jōchō (see plate 202). It consists of a central hall that

is flanked by two covered galleries and backed by a connecting hall. Its ground plan suggests a bird with spread wings coming in for a landing. The interior of the Amida-dō (Amida Hall) is decorated with relief sculptures and paintings depicting the *raigō* (the descent of the Buddha to receive the souls of the faithful into Paradise). On the upper part of the walls there are numerous relief carvings depicting various Bodhisattvas (see plate 210). This building is the only one of its type to have survived intact, although it has undergone extensive restorations in recent years. In front of the Amida-dō there is an irregularly shaped pond in which lotuses may have been planted. The entire complex— building and reflecting pool, with its lotus blossoms— is reminiscent of traditional representations of Amida's Paradise.

169. UJI. THE GREAT BRIDGE. This reconstruction in reinforced concrete is an exact replica of the ancient wooden original. The Uji Bridge is famous in the history of Japan because of the many crucial battles that took place on it. Although it was destroyed on numerous occasions, each reconstruction was probably carried out in the style of the very first bridge.

170. KYOTO. HEIAN JINGŪ. FERRULES AND PLATES ON THE GUARDRAILS OF THE BRIDGE. The ancient style of this bridge has been faithfully reproduced in the modern reconstruction. The gilt-metal ferrules and plates on the wooden guardrails are decorated with characteristic motifs of the Heian period.

171. KYOTO. TŌ-JI. KONDŌ. A single-story structure with two roofs (the lower belonging to the *mokoshi*), this building is typical of Heian period architecture. It was rebuilt in 1599. Dimensions 110 × 40'.

172. NARA. JŌRURI-JI. SANJŪ-NO-TŌ. This small three-story pagoda was built in 1178. *Mitesaki*-type brackets support each of the three roofs. There are railed-in galleries on each floor, and the roofs are shingled with hinoki bark over double rows of joists and beams *(shige-daruki)* in perfect Wa-yō style. The interior was painted with numerous decorations, but few traces remain of these except for some celestial winged musicians and flowers. It houses images of the sixteen Rakan (Arhats).

173. KYOTO. TŌ-JI. DAISHI-DŌ. This structure dedicated to Kōbō Daishi (Kūkai) was built in 1830 in imitation of the ancient style and is roofed with *hinoki*-bark shingles. Legends assert that Kōbō Daishi lived on this site. The exact date this temple was founded is not known.

174. OSAKA. SHITENNŌ-JI. HOKE-KYŌ. The *Sutra of the Lotus of True Law* was often copied on fans during the Heian period (twelfth century). The secular scenes that comprise the illustrations (in the *yamato-e* style) have no relationship to the sacred text. This scene depicts a nobleman reading a poem to a young girl who rests

her elbow on a small table on which are arranged several writing utensils and a few leaves from a tree or shrub. It was painted on paper spangled with tiny flecks of gold and silver leaf *(kirikane)*. The text was printed from an engraved wood block. Height 10″.

175. TOKYO. HOKE-KYŌ. This copy of the *Sutra of the Lotus of True Law* is decorated with floral and foliate motifs and dates from the eleventh century. Height 10½″. Tokyo National Museum.

176. MURASAKI SHIKIBU NIKKI. A portion of the text of an *emakimono* (twelfth century) reproducing one of the chapters of the diary of Lady Murasaki Shikibu. The calligraphy is executed in ink on varicolored paper. The diary deals with events which occurred in the early years of the eleventh century, but this illustrated version dates from the thirteenth century. (See also plate 180.) Height 9″. Hachitsuka Collection.

177–78. KYOTO. KŌZAN-JI. CHŌJŪ-GIGA. The delightful, subtle, and witty drawings in this famous scroll depict natural-looking animals performing human tasks. It has traditionally been attributed to Toba Sōjō (the Abbot Kakuyū) who died in 1140. There are also four similarly illustrated scrolls attributed to this man; two of them could have been painted by him, whereas the others appear to have been executed at a slightly later date. The scroll bears no text or inscription (with the exception of the seal of the Kōzan-ji temple) that could clarify the true meaning or story related in these marvelously executed drawings. As may be seen in these two details, the artist's brush was both agile and satirical. Plate 177 depicts a pair of elephants, but these must have been derived from Chinese drawings because elephants were unknown in Japan. Plate 178 portrays a monkey garbed like a monk receiving a bridled deer from a rabbit walking on its hind legs. Height 12¼″.

179. MAKURA-NO-SŌSHI EMAKI. Painted on paper in the *yamato-e* style, the technique of the drawing is characterized by very fine and fluid lines. As is usual in this type of illustration, the artist shows us the scene from a high vantage point: the ceiling eliminated to permit an unobstructed view of the interior of the house. This is an illustration from the famous *Pillow Book* of Lady Sei Shōnagon, written toward the end of the tenth century. The scene shown here depicts a nobleman listening to a young woman who is playing a *biwa*, a type of four-stringed lute. The scroll was produced in the Kamakura period. Asano Collection.

180. MURASAKI SHIKIBU NIKKI. This illustration from the diary of Lady Murasaki Shikibu, painted in colors on paper, is in the *yamato-e* style. (See also plate 176.) Thirteenth century. Hachitsuka Collection.

181. NARA. YAMATO BUNKAKAN. SCROLL OF DISEASES (YAMAI-ZŌSHI). Painted in colors on paper, this scroll in the *yamato-e* style is by an unknown artist and dates from the end of the twelfth century. This illustration shows a doctor, assisted by an old man, making an incision in the back of a patient. A woman observes the scene through a small opening in a curtain.

182. BATŌ KANNON. This large painting on silk portrays one of the divinities of esoteric Buddhism, the Horse-Headed Batō Kannon (Hayagrīva). The symbolic horse's head can be seen in the halo above the center head of this image (see also plate 261). The work is in the classic style of Buddhist painting and the artist is unknown. It was probably executed in a monastery studio in the twelfth century. Boston Museum of Fine Arts.

183. WAKAYAMA. KONGŌBU-JI. THE PARINIRVANA (detail). This painting in color on silk depicts the death of the Buddha and his entry into Nirvana. An inscription bears the date 1086. The detail here shows the Buddha lying on a bier, his head resting on a cushion. He is surrounded by grief-stricken disciples mourning his departure. The complete painting includes various Bodhisattvas and Arhats (humans who have reached the utmost state of perfection), as well as animals and attendants. This painted scene is usually displayed during the ceremony commemorating the death of Buddha instead of (or in front of) the principal image of the temple. Size of entire work 106 × 107″.

184. YOKOHAMA. SŌJI-JI. ZAŌ GONGEN. Engraved on bronze in very fine lines, this plaque depicts Zaō Gongen, one of the temporary incarnations—and a divinity of Shintō-Buddhist syncretism—of Dainichi Nyorai often associated or confused with Fudō Myō-ō. Around him there are numerous demonic figures. Dated 1001. Height 26⅜″.

185. NARA. JIGOKU-DANI. STONE BUDDHAS. Near the summit of Kasuga Hill are many caves, the walls of which have been sculpted with representations of the various Buddhas. The identity of each of these images in high relief cannot be established with any certainty; however, they were undoubtedly made in the Heian period. Traces of color are still visible on some of the figures.

186. NARA. HAIRA TAISHŌ. This cypresswood bas-relief formed part of a series of twelve panels probably portraying the twelve generals of Yakushi Nyorai. The execution typifies a style of sculpture found only rarely in Heian period works; the dynamism of the poses is remarkable. The relief was originally polychromed and could perhaps be attributed to Genchō. Height 35⅞″. Nara National Museum.

187. KYOTO. SENJU KANNON. This statue in wood was originally in the temple of Daihō-Hon-ji. The arms and ornaments were carved separately, and the crown is of a later date. End of Heian period. Kyoto National Museum.

188. NARA. JŪICHI-MEN KANNON. This statue of blackish wood, with its full form, supple pose, and very long arms, is a typical late Heian work. Nara National Museum.

189. KYOTO. JIKOKU-TEN. This impressive statue of painted wood was originally in the temple of Roku-haramitsu-ji (Kyoto). It represents Jikoku-ten (Dhritarāshtra), one of the four guardian kings of the cardinal directions: he commands the East and "upholds the Kingdom." He is portrayed here with a helmet and armor typical of the T'ang period in China. End of Heian period. Kyoto National Museum.

190–91. KYOTO. TOBATSU BISHAMON-TEN. This is the guardian king of the North (Vaishravana), the "one who knows all that happens in the Kingdom" (see plate 189). He is painted blue and is standing on two demons: Biramba (Vilambā) and Niramba (Lambā). Between his feet is the figure of Chi-ten (Prithivi), the divinity of the Earth. It is impossible to state with certainty that this was made in Japan; it may be of Chinese origin. The armor is of the tight-fitting type typical of the T'ang period in China. Kyoto National Museum.

192. KYOTO. YUIMA KOJI. Sculpted in wood and then lacquered, this piece was originally in the temple of Seiryū-ji. It portrays Yuimi Koji (Vimalakirti) in a discussion of doctrine with Monju Bosatsu (Manjusri). Because he is ill, Yuima supports himself on a semi-circular armrest. It is an eleventh-century work. Height 20". Kyoto National Museum.

193. NARA. HŌRYŪ-JI. SHŌTOKU TAISHI. Prince Shōtoku is portrayed here at the age of seven (see also plate 266). An inscription found inside the statue states that it was completed in 1069 by the sculptor-priest Enkai and the painter Hata Chitei, and that it was repaired by the sculptor Shunkei in 1384. This small work was carved according to the *yosegi* technique: several parts were executed separately and then assembled on a hollow base *(uchiguri)*. The wood was given a coat of *gofun* (calcium carbonate) and then painted. The statue is kept in a small shrine or tabernacle *(zushi)* of lacquered wood decorated with mother-of-pearl inlays and metallic ornaments. Height of statue 23".

194. KYOTO. HŌSHI OSHŌ. This is a portrait of the priest Hōshi, who lived in China at the beginning of the T'ang period and who was reputed to have been an incarnation of Jūichi-men Kannon. In fact, one sees the face of this divinity appearing through the cleft visage of the priest; almost like an insect emerging from its chrysalis. It is a curious, even unique work, and is remarkably executed from a technical standpoint. End of Heian period. Kyoto National Museum.

195. KAMAKURA. YAKUSHI NYORAI AND ATTENDANT. These works were carved in the *natabori* technique with strong, undisguised chisel marks on the surface. This style in which the tool marks were left clearly visible was developed primarily in the provinces during the Heian period. The Yakushi has a smoother surface than the attendant Bosatsu which was left in a "rough" state. The play of light on the surface planes is extremely beautiful, and endows these works with a live quality. Kamakura Museum.

196. NARA. SENJU KANNON. Made of lacquered and painted wood, this image was originally in the temple of Bujō-ji. It dates from the end of the Heian period. Nara National Museum.

197. NARA. SHAKA NYORAI. Of painted wood, the piece is dated 1138. Nara National Museum.

198. KYOTO. AMIDA NYORAI. Originally in the temple of Manshū-ji, this is made of wood and bears traces of gilding. It dates from the end of the Heian period. Kyoto National Museum.

199. KYOTO. YAKUSHI NYORAI. A gilded-wood statue originally at the Ishibe-Jinja. It was made toward the end of the Heian period, in the eleventh century. Kyoto National Museum.

200. KYOTO. TŌ-JI. HANNYA BOSATSU. This is one of the very rare representations of Prajñāpāramitā (the goddess of Transcendental Wisdom) to be found in Japan. Made of gilded wood, the statue is the central Bodhisattva image in the sculptured mandala installed in the Kōdō (Lecture Hall). (*Editorial note:* The images composing this sculptured mandala were first installed in the ninth century. Repairs were carried out in the late Heian period, and subsequently in the Kamakura, Momoyama, and Edo periods. The Hannya Bosatsu as well as the Dainichi Nyorai [see plate 204] are generally considered to be works of a later period made to replace the original images that were too badly damaged to be repaired.)

201. NARA. ASUKA-DERA. AMIDA NYORAI. The gilded wood halo is of a more recent period than the figure, which dates from the end of the Heian era, perhaps the early twelfth century.

202. UJI. BYŌDŌ-IN. AMIDA NYORAI. The figure is of impressive proportions and is of gilded wood. It was carved in 1053 by Jōchō in the *yosegi* technique. This work established the technical rules followed by all later sculptors in the Heian period. One can even say that all Heian statues of Amida were in the "Jōchō" style, because this great artist's concepts and techniques were faithfully followed by succeeding sculptors.

203. NARA. DAINICHI NYORAI. This lacquered-wood sculpture, now in poor condition, belonged to a temple of the Shingon sect. The hands of the Dainichi Nyorai image are in the *mudra* (ritual gesture) of the six

221

玉匣將見圓山乃狹名葛
佐不寐者遂尓有勝麻之目

35. FUJIWARA-NO-KAMATARI: FOUNDER OF THE FUJI-WARA CLAN IN THE SEVENTH CENTURY. SKETCH BY KIKUCHI YŌSAI

elements and symbolize the two worlds of the Kongō-kai and the Taizō-kai. The style is severe, almost geometric, but the execution is clumsy. Nara National Museum.

204. KYOTO. TŌ-JI. DAINICHI NYORAI. In gilded and painted wood, this divinity is the central figure of the sculpted mandala in the Kōdō of Tō-ji temple. The beautiful halo is studded with numerous tiny Bodhisatt-vas seated on lotus flowers. Like the Hannya Bosatsu (plate 200), this Buddha image is generally considered to be later in date than the original ninth-century sculptures comprising this mandala.

205. KYOTO. TAMON-TEN. An aspect of the guardian king of the North (Vaishravana), with armor typical of T'ang-period Chinese images. Of painted wood, it dates from the end of the Heian era. Kyoto National Museum.

206. KYOTO. TŌ-JI. GUNDARI MYŌ-Ō. This image of one of the Enlightened Kings is part of the sculptured mandala in the Kōdō (see plates 149, 200, 204, 207, 208). With its terrifying face, it represents the wrathful manifestation of Hōshō Nyorai (the Buddha Ratna-sambhava), and is the Japanese equivalent of the In-dian Kundali. He is portrayed here in a dynamic pose

with each foot resting on a lotus flower and arms en-twined with serpents. He has eight arms, a third eye in the forehead, and flamelike hair. Painted wood. Height 6' 6".

207. KYOTO. TŌ-JI. TAISHAKU-TEN. This image rep-resents the Indian divinity Indra, originally the Ve-dic god of war. In Buddhist iconography he is paired with Bon-ten and symbolizes the submission of non-Buddhist divinities to the "True Law." This represen-tation shows him mounted on a white elephant and holding an unadorned *vajra* (thunderbolt) in his right hand. It is a powerful work; behind it is seen Zōchō-ten (Virūdhaka), the guardian king of the South, a stat-ue with a green face. The Taishaku-ten dates from the ninth century and is of painted wood. Height 41¾".

208. KYOTO. TŌ-JI. BON-TEN. This triple-faced statue represents Brahma, the Lord of the World and the Master of Heaven: the supreme divinity of the ancient Indian pantheon. The birds supporting his lotus throne are representations of Brahma's sacred gander *(Hamsa)*. The work dates from the ninth century and is of paint-ed wood. Height 39⅜".

209. NARA. JŌRURI-JI. KICHIJO-TEN. This exquisite small cypresswood statue, executed in the *yosegi* tech-nique and representative of the Chinese style, is painted in brilliant colors. All its ornaments are carved from wood instead of the usual metal. According to an entry in the temple's annals *(Jōruri-ji Kuki)* the statue was delivered there in 1212. It cannot in any case be later in date. The very delicate rainbow-like colors were painted over an undercoat of *gofun*. A gilded phoenix crowns the image's headdress, and the rich robes clothing the figure are in the style of a great Chinese lady. The heavy hair is arranged like that of female Shintō divinities (see plates 211 and 213).

210. UJI. BYŌDŌ-IN. UNCHŪ-KUYŌ-BOSATSU. This small wooden figure comprises one of a group of more than fifty Bodhisattvas accompanying Amida Nyorai during his descent *(raigō)*, forming the wall decorations of the Hō-ōdō of the Byōdō-in. It is a delicate eleventh-century work in cedarwood, originally painted. Height 14⅝".

211. NARA. A DIVINITY. This painted wood image of a Buddhist divinity (possibly Kichijō-ten) was treated in the same style as Shintō sculptures. End of the Heian period. Nara National Museum.

212. NARA. HOKAN AMIDA NYORAI. This painted wood-en statue, originally in the temple of Taima-ji, is executed in a simple, even geometric style. It greatly resembles Shintō works of the same epoch. End of the Heian period. Nara National Museum.

213. NARA. JINGŌ KŌGŌ. A small Shintō image of Empress Jingō originally installed in the Hachiman Shrine of Yakushi-ji temple. It was carved from a

single block of cypresswood and brilliantly painted. The massiveness of the work does not detract from its quality of life or movement. The hair is black, forming a sharp contrast with its white skin and brilliant red lips. At one time it may have worn a crown (there are nail holes in the head), but if so, it has been lost. Late ninth century. Nara National Museum.

214. NARA. AMIDA NYORAI. This forms the central figure of an Amida triad that was originally in the temple of Jōshōkō-ji. Of lacquered wood, it dates from the end of the Heian period. Nara National Museum.

215. KYOTO. JŪCHI-MEN KANNON. Originally in the temple of Getsurin-ji, this sculpture bears only four *kebutsu* (aspects of divinity) on its crown, which is a somewhat rare phenomenon. Perhaps the others —possibly encircling the entire crown—have been lost. The hair is dressed in a series of scallops. It is made of painted wood and dates from the end of the Heian period. Kyoto National Museum.

216. NARA. BINZURU SONJA. This seated wooden statue represents the first of the sixteen Rakan (Arhats), virtually a divine healer. Images of this figure are generally placed at the doors of the temples, and the faithful prayed to them to cure their illnesses. End of the Heian period. Nara National Museum.

217. KYOTO. YAKUSHI NYORAI. This gilded-wood image was originally in the temple of Saimō-ji. It is dated 1047. Kyoto National Museum.

218. NARA. KEMAN. This bronze ceremonial pendant with traces of gilding depicts *hōsōge* flowers and celestial musicians, half man, half bird (*karyōbinga*—the Indian Kalavinka, a type of Kinnari). Diameter 11¾". Nara National Museum.

219. KYOTO. VASE. This brown-glazed pottery piece with four feet might have served as a temple vessel. Height 4¾". Kyoto National Museum.

CULTURAL CHART

Indications: *A = architecture;* *Sc = sculpture;* *P = painting;* *Po = poetry;* *L = literature;* *H = history.*

c. 892 L *Shin-senji-kyō*: a dictionary of Chinese script characters.

900 H *Sandai Jitsuroku*, last of the six official chronicles of Japan.

903 L Death of Sugawara-no-Michizane in exile at Dazaifu on the island of Kyushu.

907 Po *Kokin Waka-shū*: a collection of *waka* poems.

909 Sc Yakushi Nyorai of the temple of Daigo-ji.

927 H *Engishiki*: judicial and administrative book of ceremonials.

935 L *Tosa Nikki* of Ki-no-Tsurayuki: a poetical diary.

c. 946 Sc Amida Nyorai of the temple of Gansen-ji.

c. 950 P Kose Kanaoka was active, painting landscapes in the Chinese style.

Po *Ise Monogatari*: a collection of 125 poems with prose introductions attributed to the poet Ariwara-no-Narihira (d. 880).

951 Po *Gosen Waka-shū*: a collection of *waka* by Emperor Murakami.

951 L *Yamato Monogatari*: a collection of 170 tales and 300 poems of Yamato.

c. 960 L *Taketori Monogatari*: *The Tale of the Bamboo Cutter.*

965 P The painter Asukabe Tsunenori was active.

970 Sc *Juntei Kannon* of the temple of Shin-Yakushi-ji, Nara.

974 L *Kagerō Nikki*: a poetical diary.

985 H *Ōjōyōshū*, the *Essentials of Salvation*, by the priest Eshin: a religious text extolling devotion to Amida Buddha.

988 L *Ochikubo Monogatari*: a novel of court manners.

993 Sc Yakushi Nyorai of the temple of Zensui-ji.

1000 L *Makura-no-Sōshi* or the *Pillow Book*: the random jottings *(zuihitsu)* of Lady Sei Shōnagon.

P Kose Hirotaka, the painter, was active working in a purely Japanese style.

1004 L *Izumi Shikibu Nikki*: intimate diary of a lady-in-waiting at the court.

1007 L First appearance of *Genji Monogatari*, the famous novel of Lady Murasaki Shikibu.

1008–10 L *Murasaki Shikibu Nikki*: intimate diary of Lady Murasaki Shikibu.

1012 Po *Wakan Rōei-shū*: a collection of *waka* in Chinese and Japanese.

1016 L Death of Lady Murasaki Shikibu (b. 978).

1047 Sc Yakushi Nyorai of the temple of Saimyō-ji.

1052 A The villa of Byōdō-in at Uji converted into a monastery.

1053 Sc Amida Nyorai by Jōchō at the Byōdō-in.

1050–60 L The appearance of the novels *Tsutsumi Chūnagon Monogatari, Sagoromo Monogatari,* and *Hamamatsu Chūnagon Monogatari.*

1057 Sc Death of Jōchō.

1069 Sc Statue of Prince Shōtoku by Enkai at Hōryū-ji.

1078 Sc Kichijō-ten and Bishamon-ten in the Kondō of Hōryū-ji.

1086 Po *Goshūi Waka-shū*: a collection of *waka.*

P *Parinirvana* of Kongōbu-ji temple at Wakayama.

1109 L *Sanuki-no-Suke-no-Nikki*: diary of one of the ladies of the Fujiwara family.

1116 L–H *Ōkagami*: a long historical narrative.

1121 Sc Shōtoku Taishi in the Shōryō-in of Hōryū-ji.

1124 L *Konjaku Monogatari*: a collection of short anecdotal tales from the histories of India, China, and Japan.

1127 Po *Kinyō Wakashū*: a collection of *waka.*

P The Five Enlightened Kings in the temple of Tō-ji, Kyoto.

c. 1130 P The priest-artist Kakuyū (Toba Sōjō) was active.

P *Genji Monogatari Emaki*: illustrations for the famous novel.

1140 Sc The Jūni Jinshō, the Twelve Generals of Yakushi, in Kōfuku-ji temple, Nara.

1151 Po *Shika Waka-shū*: a collection of *waka.*

1160–80 P *Shigisan Engi Emaki*: scroll paintings illustrating the legends concerning the founding of a temple on Mount Shigi.

1164 P *The Lotus Sutra* dedicated by the Taira clan at Itsukushima Jinja.

1169 Po *Ryōjin Hishō*: a collection of poems by Emperor Go-Shirakawa.

1170–95 L–H Period of activity of Nakayama Tadachika to whom the historical chronicles, the *Ima Kagami* and the *Mizu Kagami*, are attributed.

1178 Po *Chōshūeisō*: poems by Fujiwara Shunzei.

c. 1178 L *Eiga Monogatari*: a historical novel covering the years 887 to 1092.

1180–1236 L *Meigetsuki*: diary of Fujiwara Teika.

1185 H Defeat of the Taira clan in the Battle of Dannoura bringing to an end the Gempei Civil War.

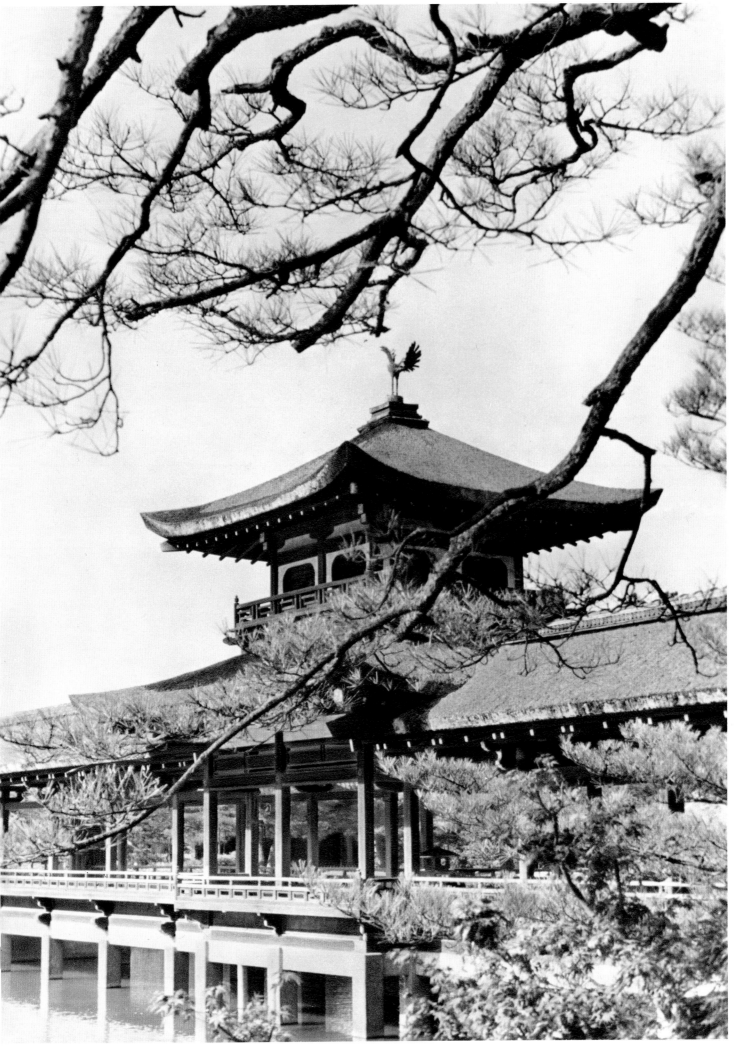

166

167

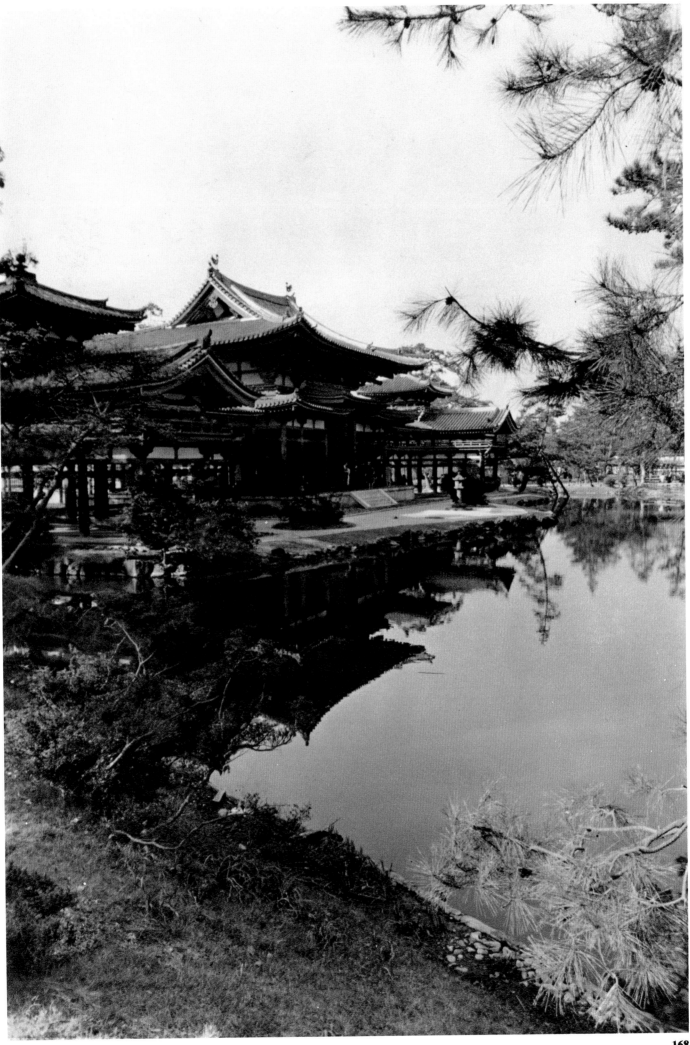

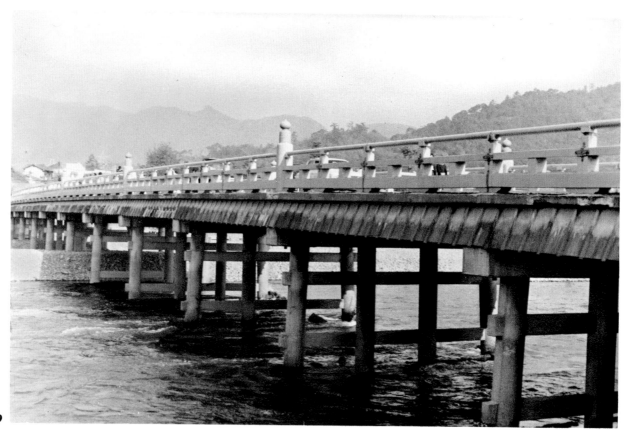

169

170

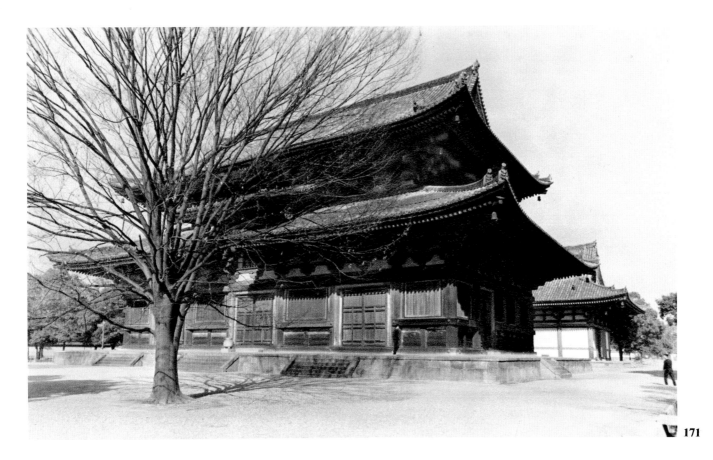

171

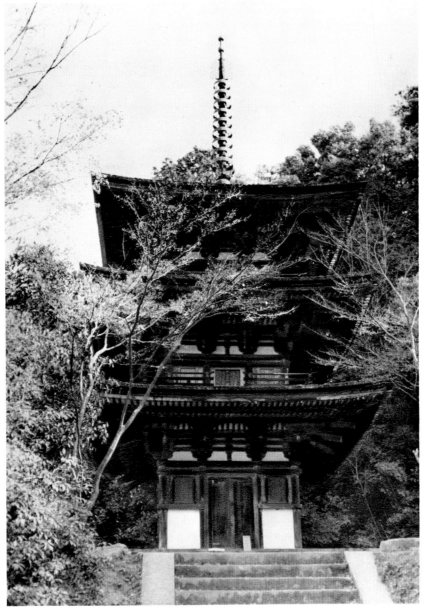

172

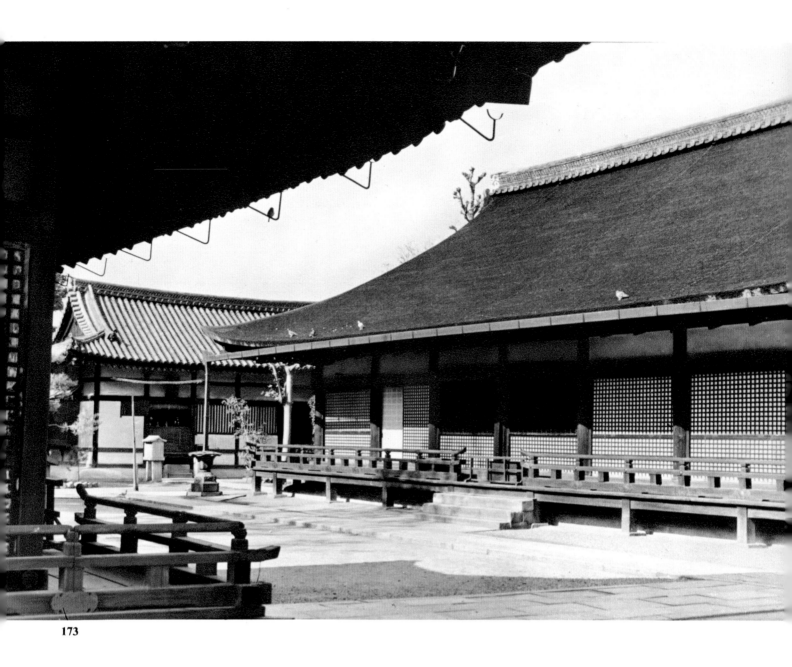

173

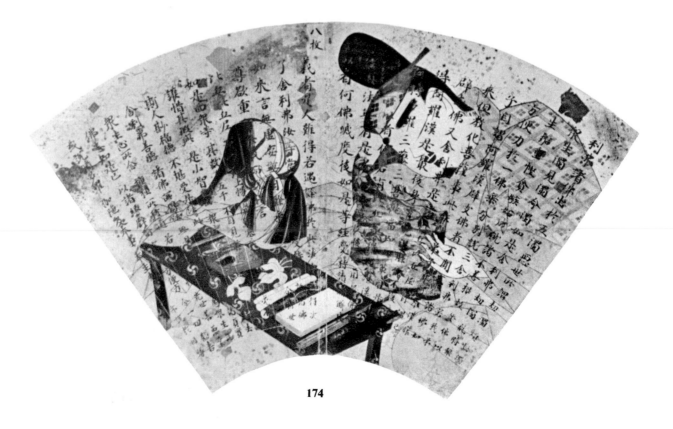

174

諸佛智慧甚深無量　其智慧門難解難入　一切聲
聞辟支佛所不能知　所以者何　佛曾親近百
千萬億無數諸佛　盡行諸佛無量道法　勇猛
精進名稱普聞　成就甚深未曾有法　隨宜所
說意趣難解　舍利弗　吾從成佛已來　種種因
緣種種譬喻　廣演言教　無數方便　引導眾生
令離諸著　所以者何　如來方便知見波羅蜜
皆已具足　舍利弗　如來知見廣大深遠　無量
無礙力無所畏禪定解脫三昧　深入無際　成
就一切未曾有法　舍利弗　如來能種種分別
巧說諸法　言辭柔軟　悅可眾心　舍利弗　取要
言之　無量無邊未曾有法　佛悉成就　止舍利
弗不須復說　所以者何　佛所成就第一希有
難解之法　唯佛與佛乃能究盡諸法實相所
謂諸法如是相　如是性　如是體　如是力　如是
作如是因　如是緣　如是果　如是報　如是本末
究竟等　爾時世尊欲重宣此義　而說偈言
世雄不可量　諸天及世人　一切眾生類　無能知佛者
佛力無所畏　解脫諸三昧　及佛諸餘法　無能測量者
本從無數佛　具足行諸道　甚深微妙法　難見難可了
於無量億劫　行此諸道已　道場得成果　我已悉知見
如是大果報　種種性相義　我及十方佛　乃能知是事
是法不可示　言辭相寂滅　諸餘眾生類　無有能得解

175

176

178

177

179

180

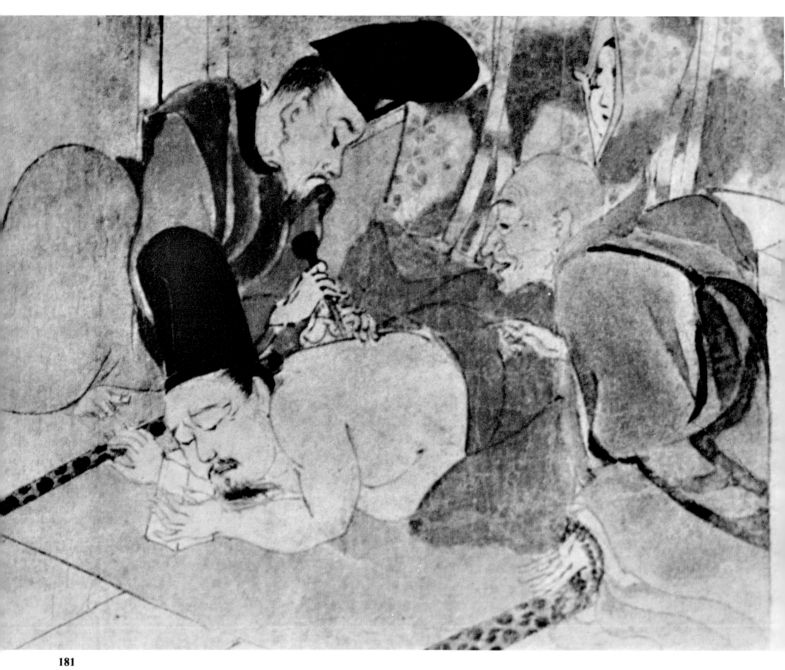

181

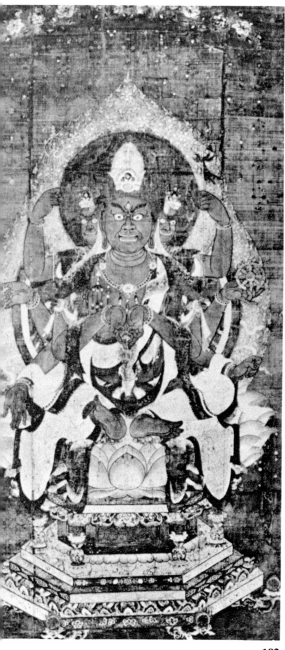

182

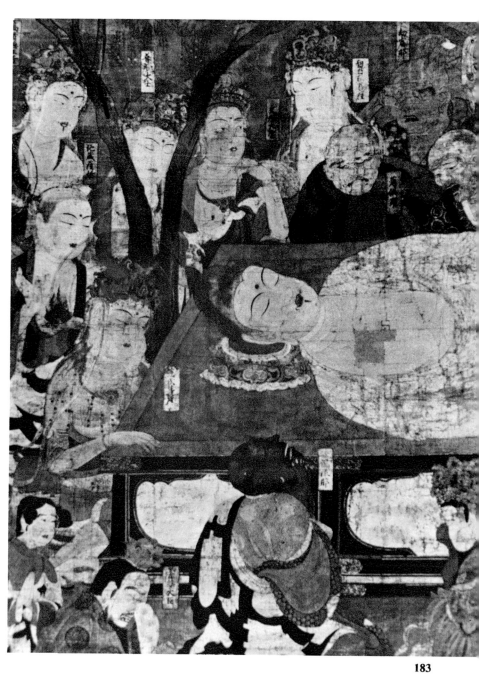

183

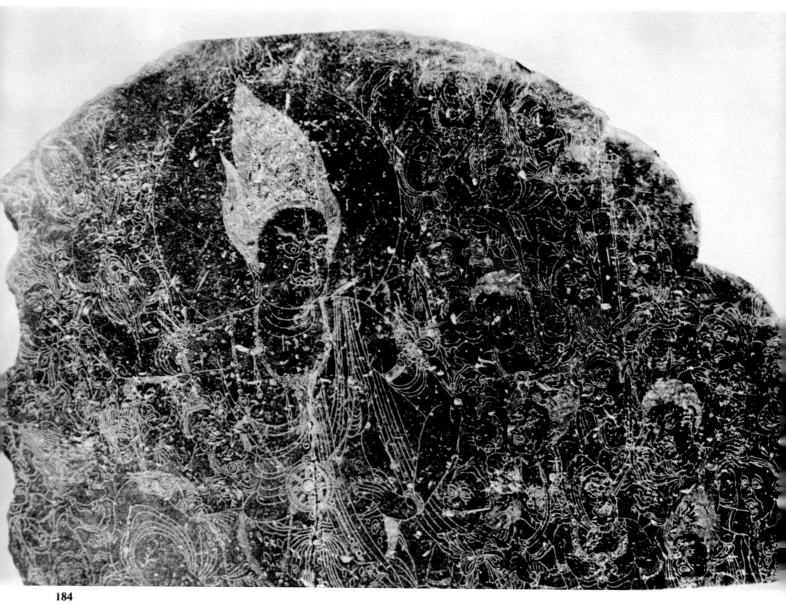

184

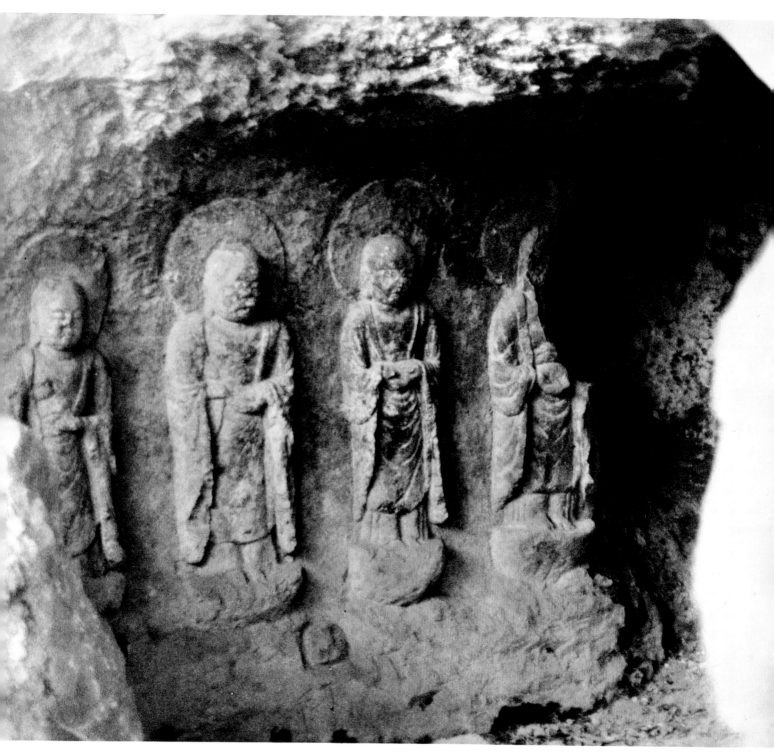

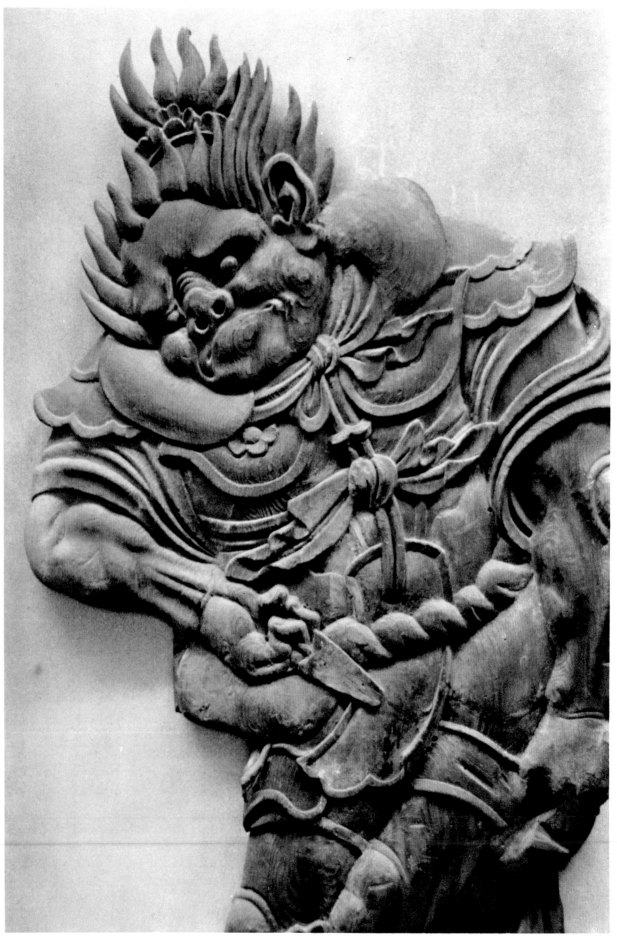

186

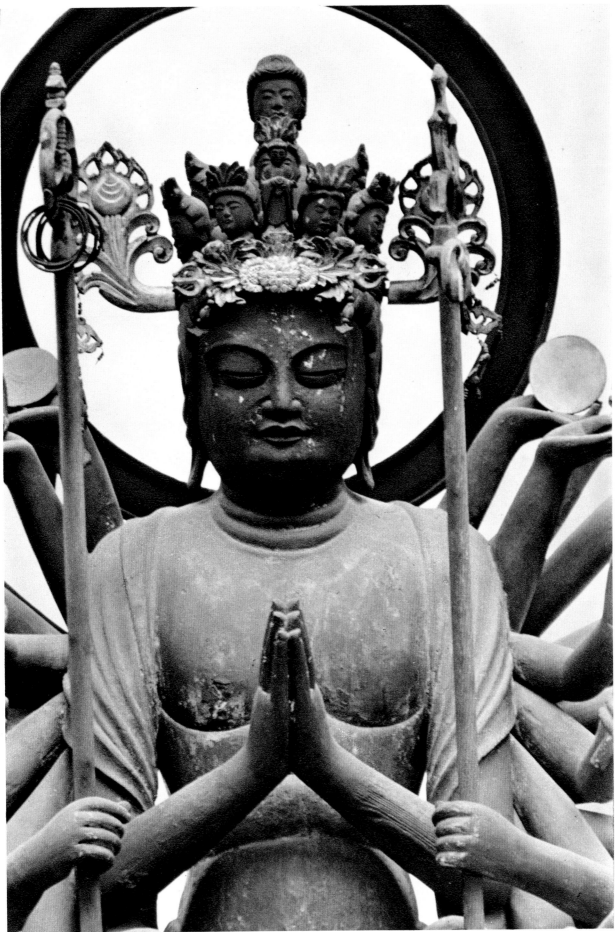

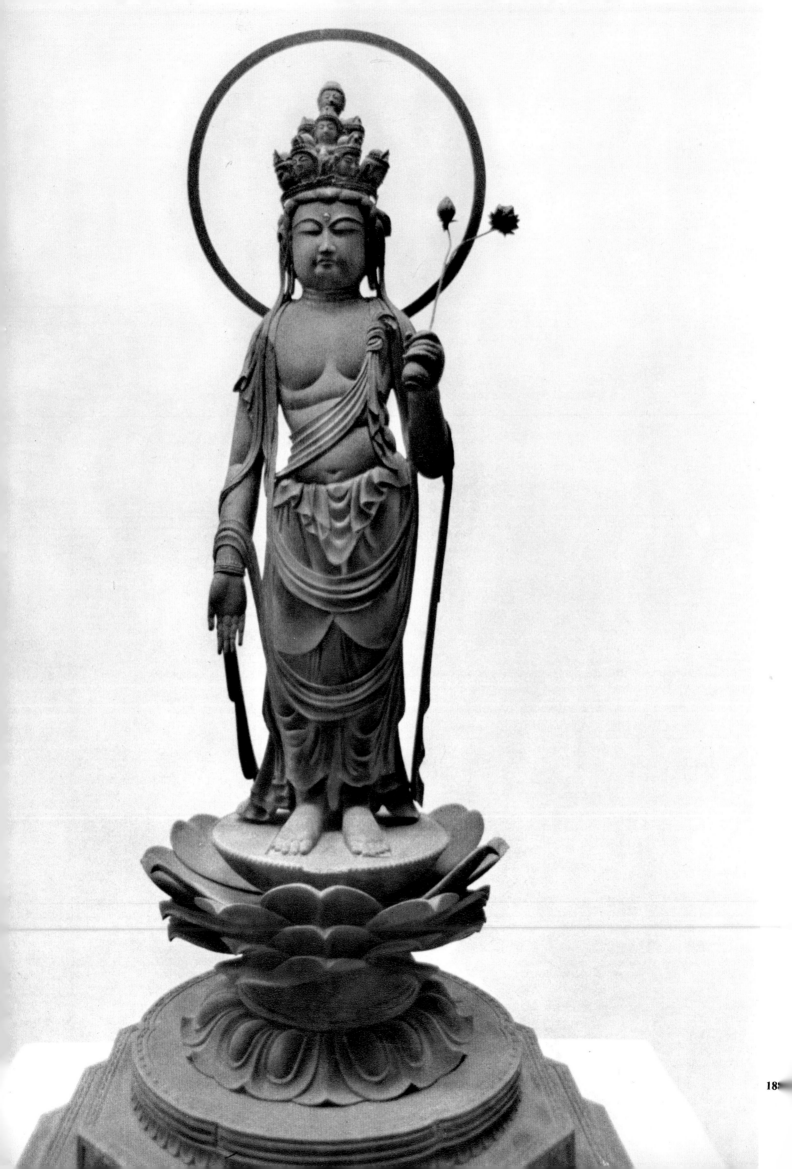

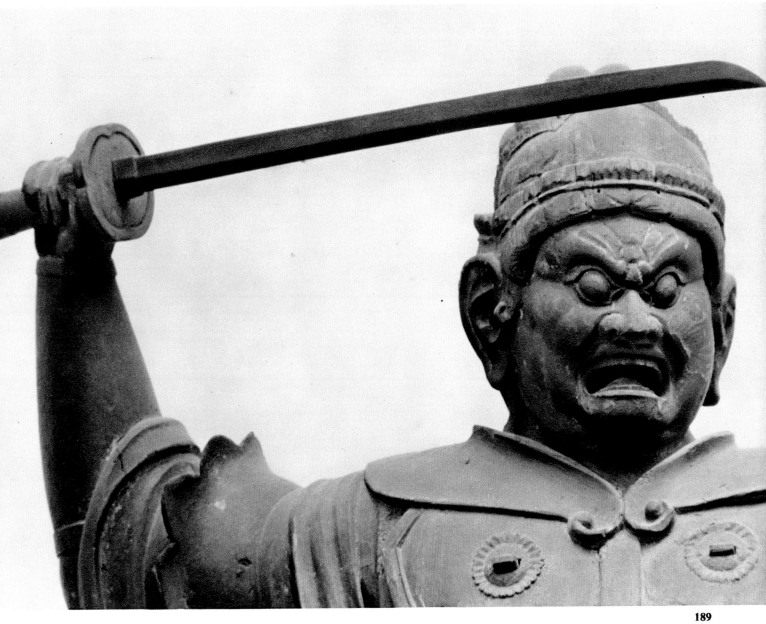

189

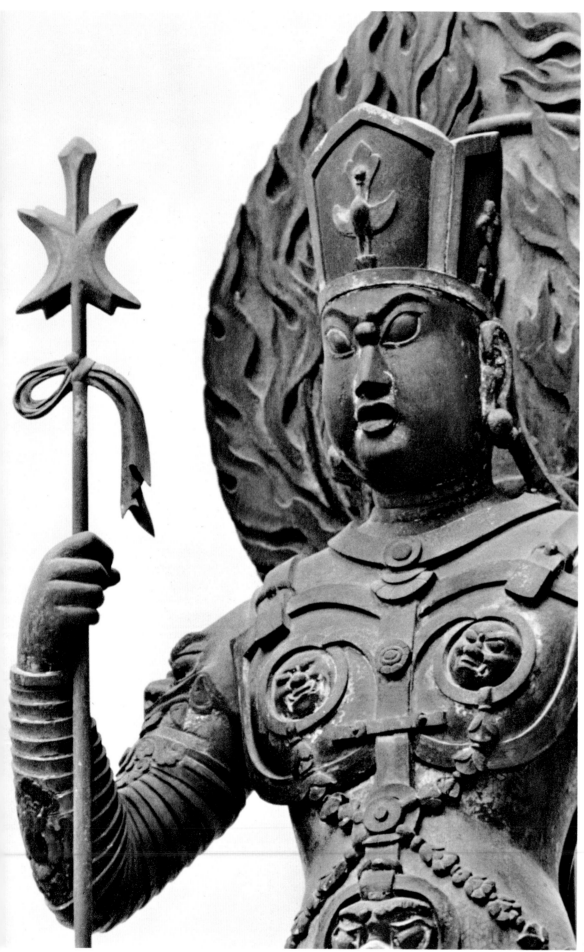

190

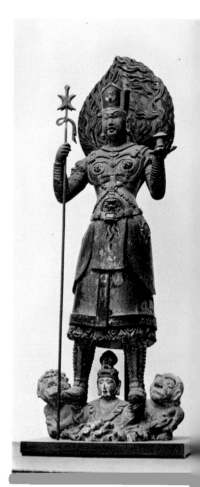

191

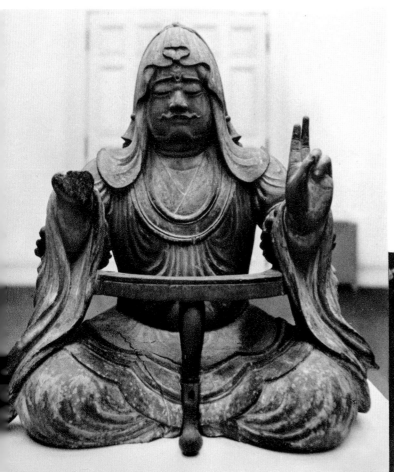

192

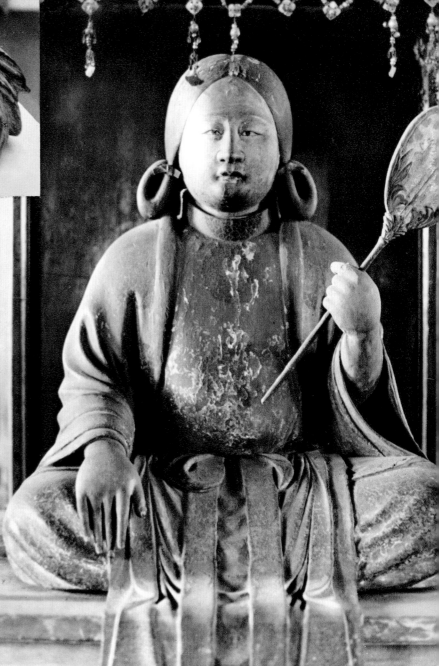

193

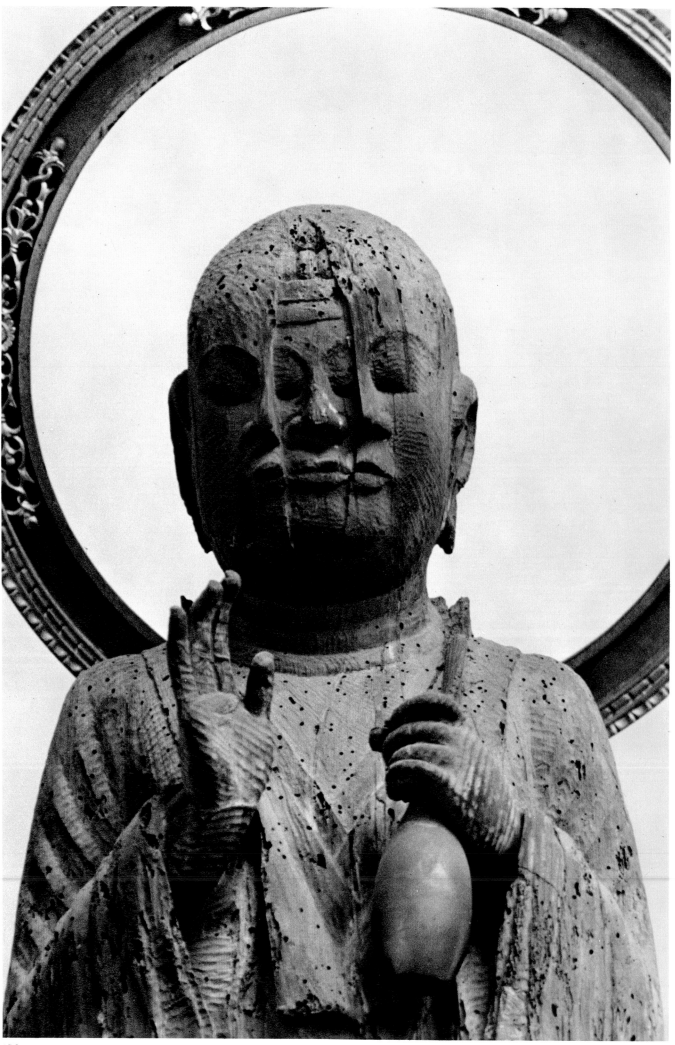

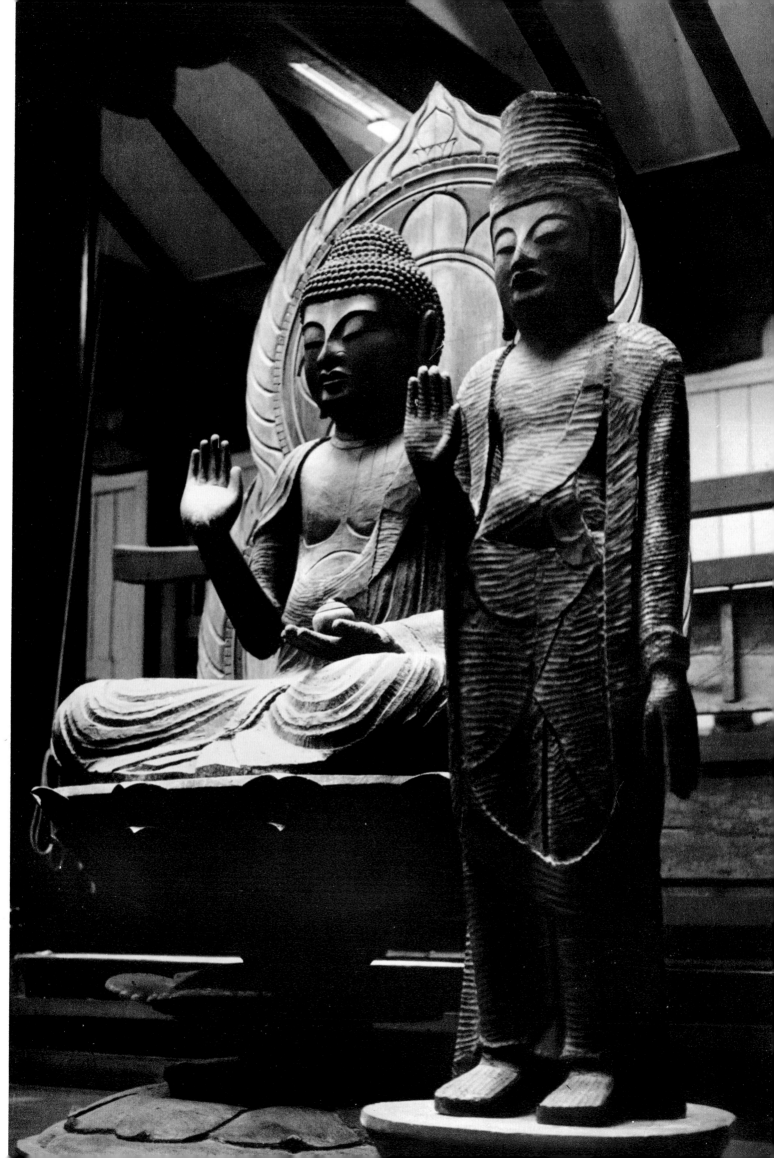

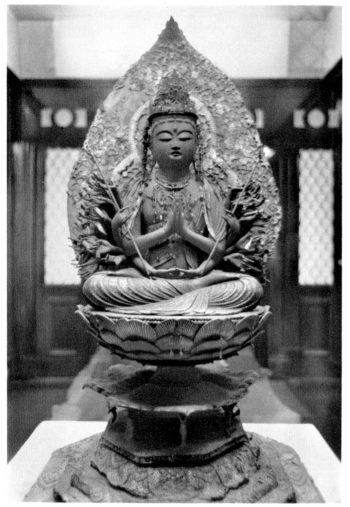

196

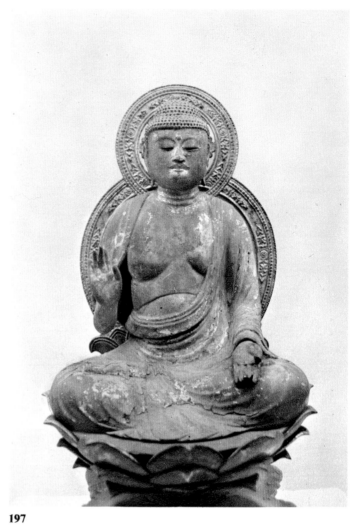

197

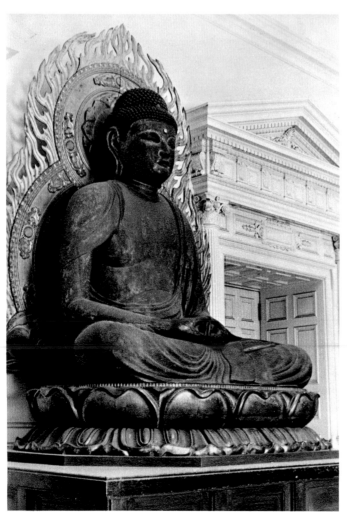

198

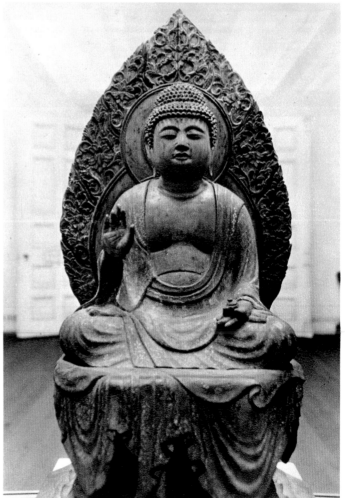

199

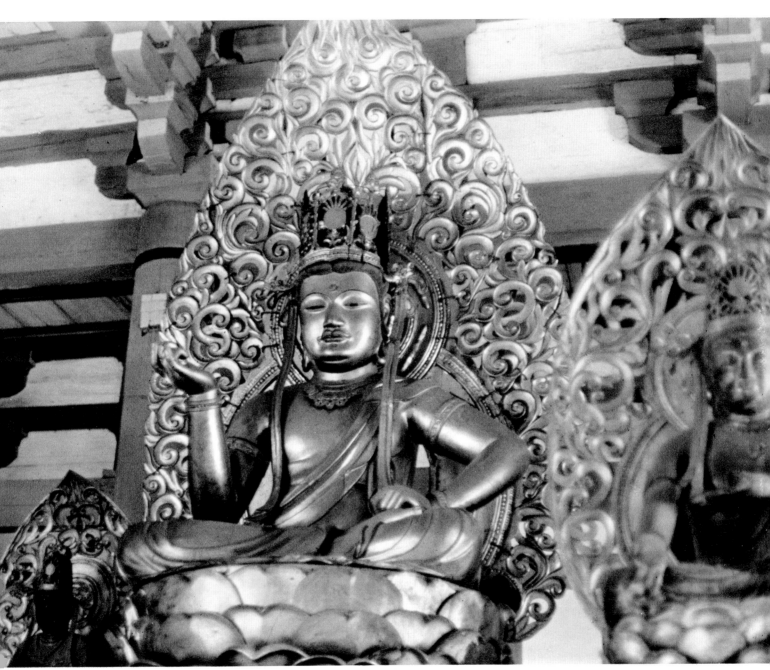

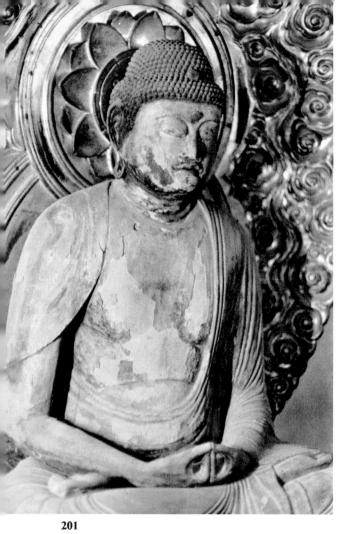

201

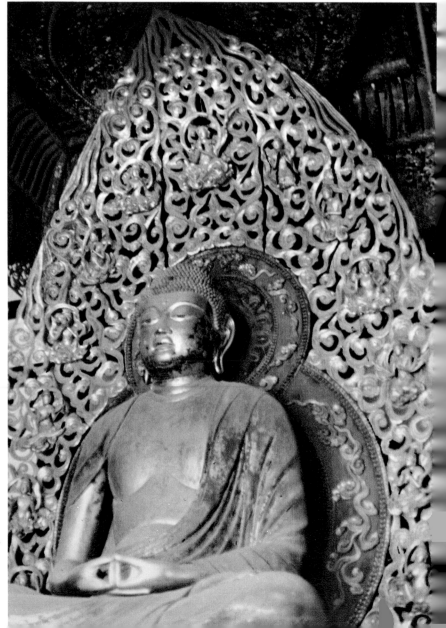

202

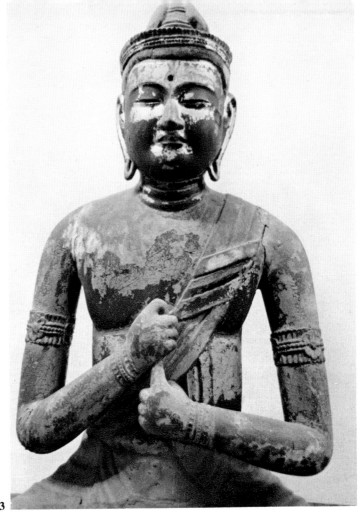

203

204

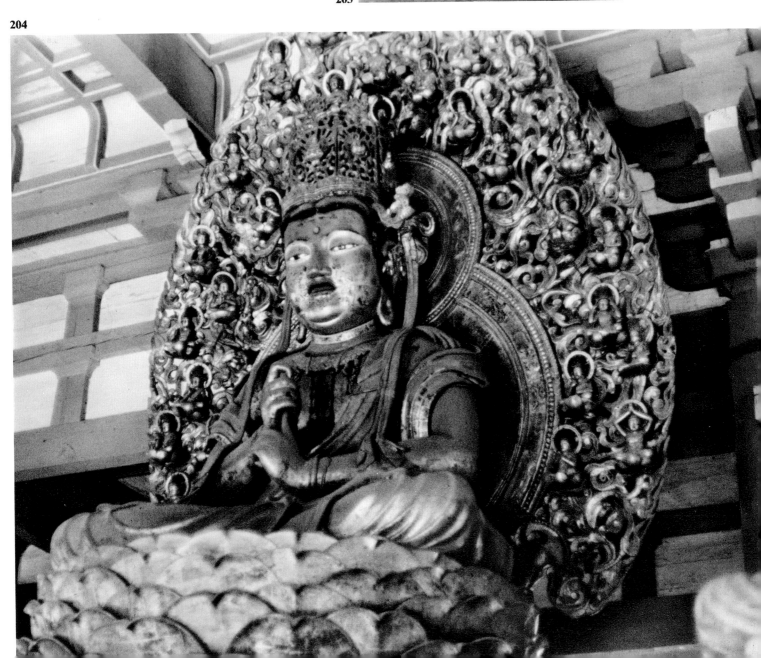

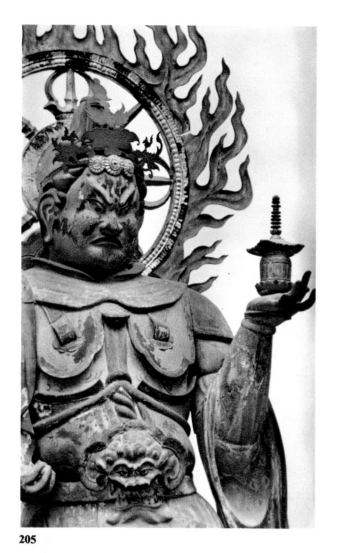

205

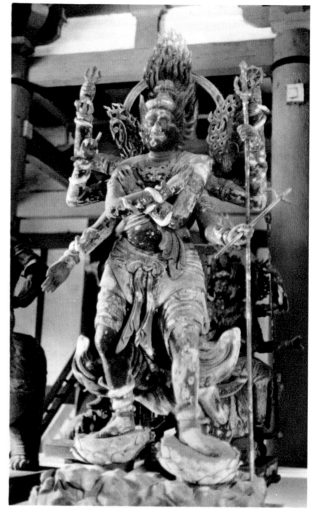

206

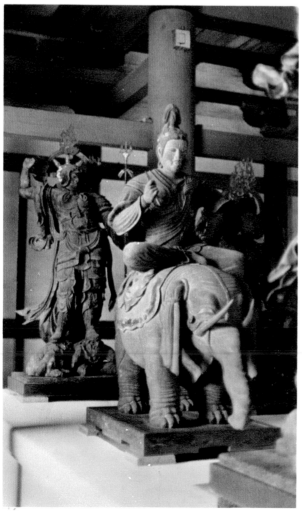

207

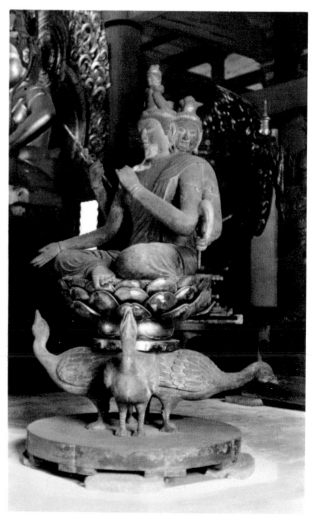

208

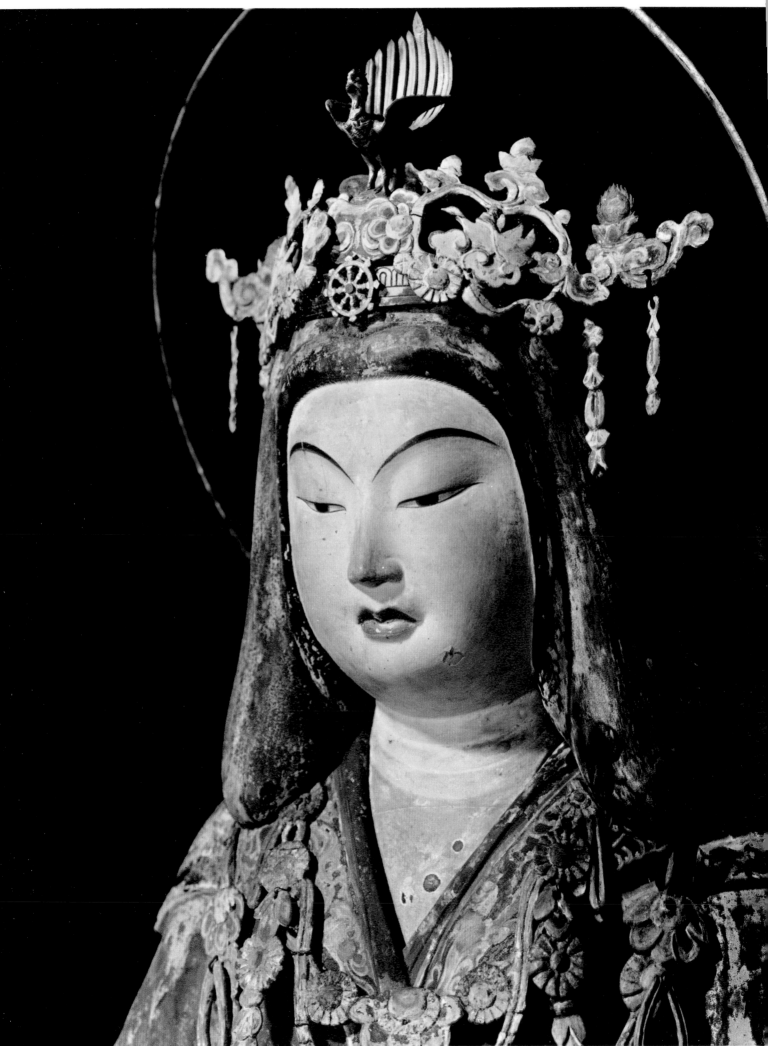

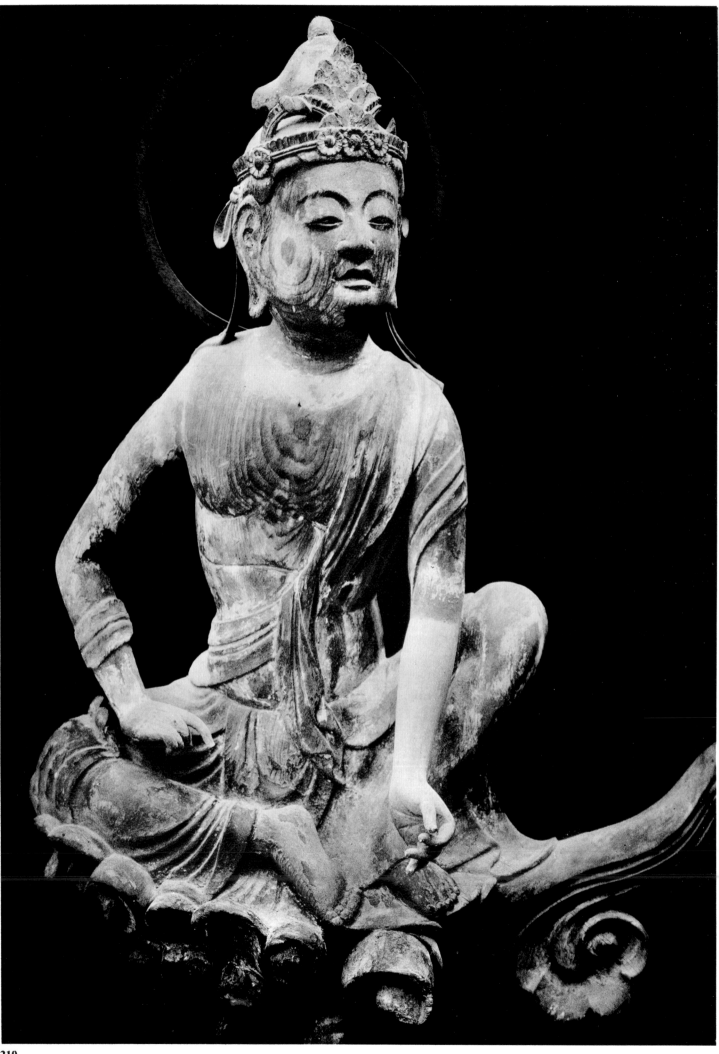

210

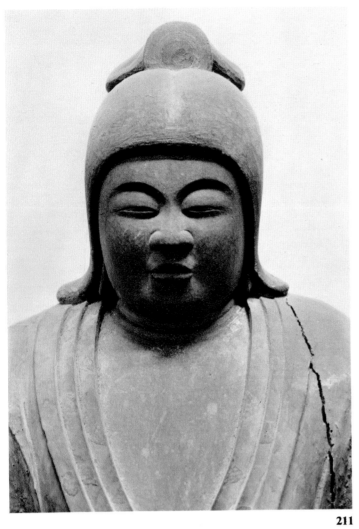

211

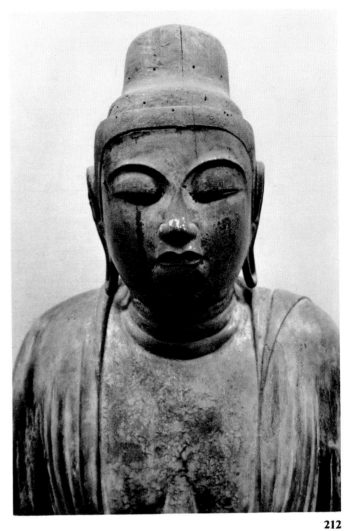

212

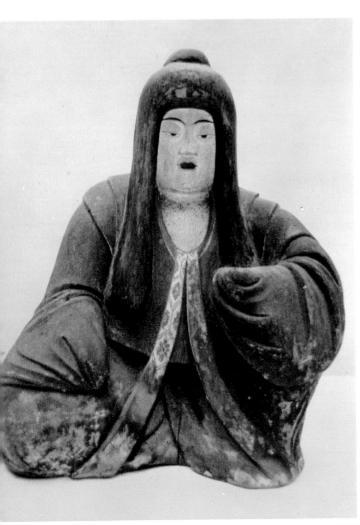

213

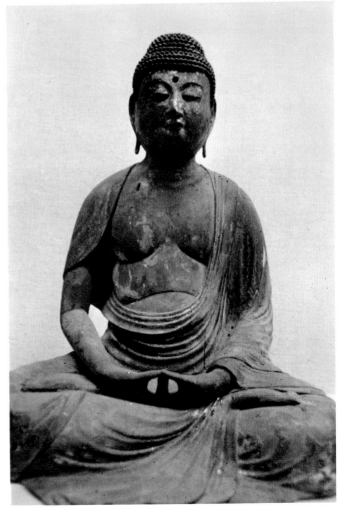

214

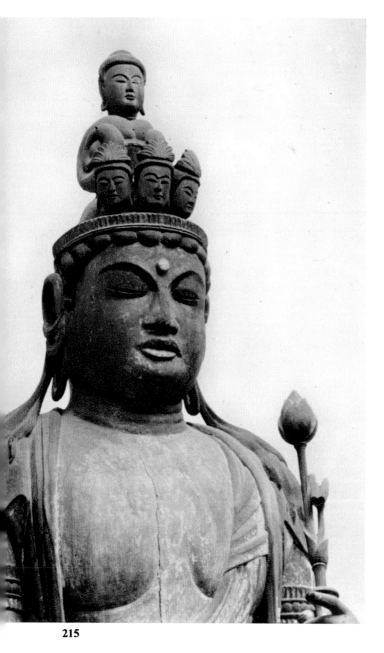

215

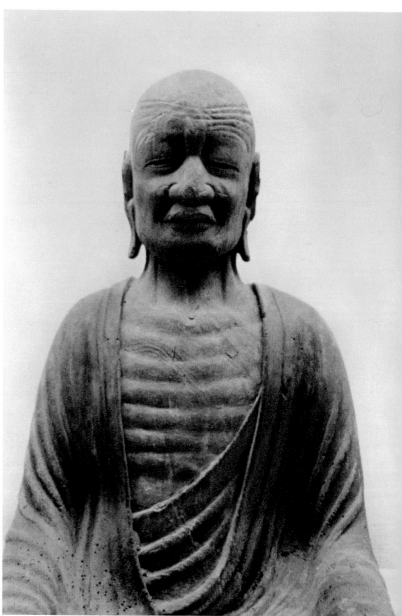

216

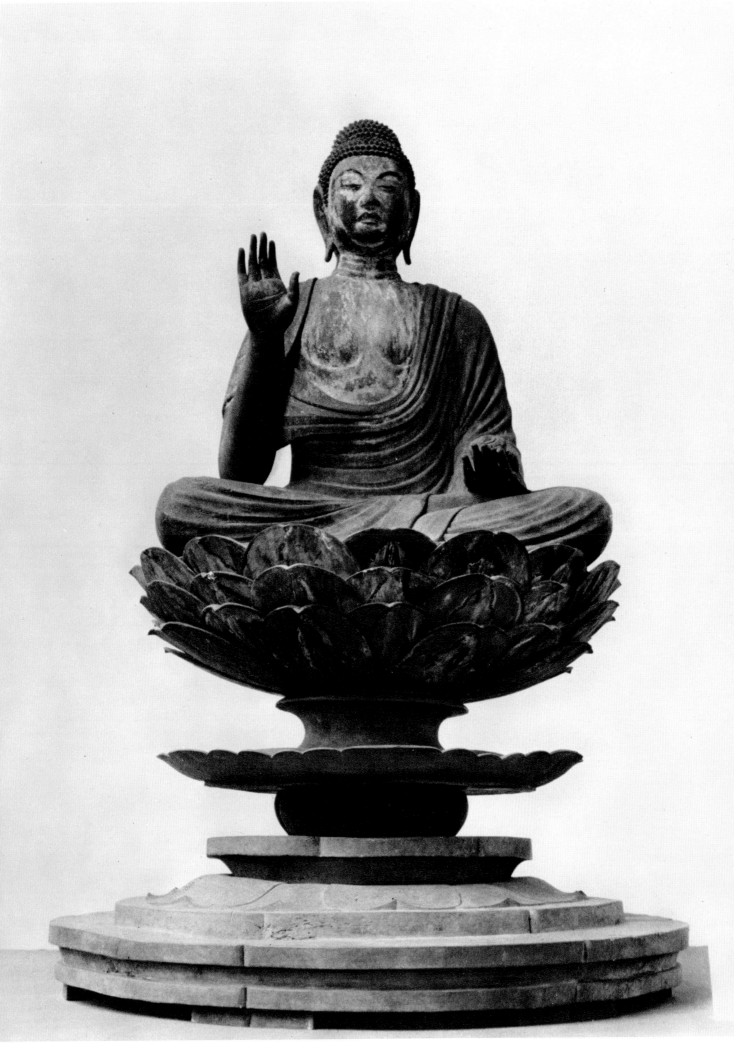

218

219

VI. THE KAMAKURA PERIOD
(1185-1333)

THE FEUDAL POLICY OF THE SHŌGUNS

Yoritomo

Having established his general headquarters at Kamakura, Minamoto Yoritomo created a *Bakufu*, or military government, with no intention, however, of replacing the emperor's administration in Kyoto. Theoretically at least, this *Bakufu* was subordinate to the emperor. The nomination of Yoritomo to the post of Shōgun ("General Pacifier of the East"), a move which Emperor Go-Shirakawa had refused for some time to make, bestowed on Yoritomo absolute military authority over a large part of the country.

Yet the power of the *Bakufu* was overestimated, because in reality the Minamoto clan—although retaining all its accumulated glory—owed its success to the precipitous fall of the Taira clan. If there had never been the Battle of Dannoura in 1185 (in which, thanks to the high tide, the Taira clan was unexpectedly and totally annihilated) Yoritomo would have been ready—his correspondence with the emperor proves this—to come to terms with his adversaries, because by that time his troops, too, had been considerably weakened.

Certain of the clans in eastern Japan—the Hōjō and the Chiba, among others—continued to profess their allegiance to the Taira interests, because of their family ties, and their offers of assistance to Yoritomo had to be accepted with caution. The Minamoto clan, moreover, was divided into several branches: the Seiwa, the Ashikaga, the Toda (or Settsu), the Kawachi Genji (of which Yoritomo was a member). These branches were far from united. After the Battle of Ishibashiyama in the pass of Hakone when they were defeated by Kiyomori in 1180, Yoritomo's forces amounted to only a few hundred men, and his allies were hardly to be trusted. In fact, Yoritomo owed his strength to a member of the Taira clan, Hirotsune, who shortly afterward brought to him a starving army of about twenty thousand men, and with these Yoritomo was able to defeat Kiyomori.

Yoritomo still had enemies in his own family, however, particularly the members of the Ashikaga branch. Yet owing to the support of a few powerful warlords—among whom were the chiefs of the Satomi and Nitta—Yoritomo was able to impose his power over almost all the clans of northern Japan. Consequently, the defeat of the Taira assured him undisputed supremacy.

Yoritomo, unlike Kiyomori, was a warrior educated in the harsh school of action and had a cold nature dominated by jealousy and desire for power. He realized that he could not set up his state solely on the basis of the power and prestige of his own army; he also had to gain the support of the people of the countryside. In order to obtain this, he advocated agrarian reform and a redistribution of land to be seized from the aristocrats living in Kyoto. Strongly backed by his adviser, Hōjō Tokimasa, he became an authentic reformer with a profound sense of legal

processes and an awareness of the need of efficient organization, but notwithstanding, he also retained a respect for tradition and established practices.

As a deeply religious man, he showed great devotion to Hachiman—the Shintō divinity of his family and the *kami* of war—and at the same time he protected the Buddhist monasteries, whose support he needed. Contrary to the teachings of Buddhism, however, he did not abandon bloodshed because first and foremost he remained a warrior; his cruelty and his methods of governing obtained for him a bad reputation.

Nevertheless, Yoritomo remains one of the most important historical figures of Japan, because he was the initiator of the most profound social changes that had taken place in the country up until that time, although he did not live to see all of them realized. He cleverly manipulated the great landlords (whose exclusive aim was gaining power), and knew how to make extraordinary use of them in order to create a unified government of a military type and to impress upon his vassals a feudal system of ethics that furthered his ambitions and projects. In certain aspects, Japanese feudalism may be said to have been born from the reaction of the nobles against foreign-influenced governmental systems. (It will be remembered that the Taika land reforms had been a copy of a Chinese system, and that it had never been workable.) Therefore, the new feudalism may be considered typically Japanese.

In order to establish his power and set up his *Bakufu* at Kamakura, Yoritomo needed land. His exile in Izu and his position as a rebel during the period of Kiyomori's domination had left him with a fraction of his original landholdings. As soon as possible, he began to requisition land on any pretext from landlords inimical to the emperor. He was thus able not only to increase his estates, but to demonstrate his position as the emperor's champion.

In 1181 he set up at Kamakura a *Samurai-dokoro*, a department of the *Bakufu* that was to be responsible for all relations with the landlords who were under the jurisdiction of the military government. This department also had the power to mobilize troops and to control the private lives of the vassals, thus bringing them under its complete control. Its most important aim was to unite all the warriors under a single command and to create a class with total allegiance to the head of the military government. In 1184 Yoritomo set up another governmental department with administrative functions, known as the *Kumonjo*. It had the responsibility of mediating quarrels that arose among the vassals. At a later date it was called the *Mandokoro* and was placed under the control of a *Shikken* or Director. Finally, a third department was created with the functions of a court of civil justice, known as the *Monchūjo*.

In this way the military government or *Bakufu* was completed. On the surface it was no different from that of the Fujiwara regents, and like its predecessor it was derived from the regulations of the Taihō Code governing the civil organization of the household of a noble. It was, however, a practical application of a theory that had become obsolete.

As in all feudal societies the power of the lord depended on the fidelity of his vassals, and the shōgun (and later the *Bakufu*) could prosper only when harmonious relations existed between himself and the other nobles. In the beginning personal relations were of primary importance, and the vassals *(kenin)* had to swear fealty to the shōgun in person. In return the shōgun owed aid and protection to the samurai who recognized him as sovereign.

The policy of matrimonial alliances, practiced by the Fujiwara and continued by Kiyomori, was widely used as a reinforcement of the bonds of vassalage. The *go-kenin* constituted a type of feudal aristocracy of which the samurai (as these warriors were called) formed a group similar in certain ways to the European knighthood of the Middle Ages. Appointed personally by the shōgun, the samurai were given horses and wore distinctive insignia, whereas the *zusa*, ordinary soldiers, went on foot.

In this new form the prefeudal society of the Kamakura period regulated the lives of the peasants (who could own the land they cultivated), the artisans, the artists, and the clergy. The domestic servants, who were of the peasant class, became practically members of the families who employed them, even though they occupied a lower social level. Despite their great number,

it cannot be said that these servants formed a specific class, but they were placed in the same category as the *semmin* (serfs), and thus were associated with those whose tasks (butchers, for example) ran contrary to the Buddhist laws. (Although seemingly slaves, the *semmin* enjoyed in actuality the status of free men except in certain rare cases.)

The *Bakufu* appointed an administrative officer *(Shugo)* in each one of the vassal states, as well as other officials for public and private property. The *Shugo*, who were the successors of the imperial *Kebiishi*, had police powers. It was also their responsibility to transmit the orders of the shōgun to the chiefs of the vassal provinces. Yoritomo maintained special representatives at Rokuhara in the province of Kyoto, the former residence of the Taira clan, and in the Dazaifu on Kyushu. The Kyushu representative was given the specific task of disciplining those clans which had not yet sworn allegiance, and of pacifying and organizing the inhabitants of the island. These *Tandai*, or Inspectors, had their own semi-autonomous governments organized along the lines of the *Bakufu* at Kamakura and answerable solely to it.

The local administrative officials *(Jitō)* were entrusted with the responsibility of verifying the revenues of the estates *(shōen)* belonging to the nobles, of the lands belonging to the peasants, and also those owned by the monasteries. These officials also superintended the uncultivated land and upheld the hereditary rights of the warriors who had appropriated (even illegally) the domains formerly belonging (also illegally) either to the Kyoto aristocrats or to the imperial government. However, Yoritomo was careful not to send these *Jitō* into areas that were the private property of the imperial family. He thus took advantage for himself (as well as for the *Bakufu*) of a long-established tradition that had obtained in areas remote from the capital, a traditional custom that had also been practiced by Kiyomori in order to control the provinces. But Yoritomo did not appropriate all the revenues for himself; he took only part of them and passed the rest to the emperor. Thus he did not risk the accusation of being called an enemy of the imperial court.

By giving land to his soldiers and the peasants, he obtained their support. Such gifts, made directly by the shōgun or by his *Jitō*, imposed a series of obligations on the part of the recipients that could not be easily ignored. With his careful consideration of agrarian problems and his firm sense of justice in settling civil conflicts, Yoritomo reinforced the relationship linking the vassals to the sovereign that was the basis of the Japanese feudal structure with an authentic native spirit that was free of all foreign influences.

In his relations with the imperial court at Kyoto, Yoritomo proved to be an expert diplomat. In order to eliminate the suspicions of Emperor Go-Shirakawa and to guarantee his own influence at court—most of the nobles regarded him with disdain or even hostility—in 1186 he imposed on the *In* (the cloistered emperor) the appointment of Fujiwara Kanezane—a powerful but honest man—as Regent and then had Fujiwara Kanezane's son marry the daughter of his own brother-in-law. Yoritomo himself married Masako, the sister of Hōjō Yoshitoki and the daughter of Hōjō Tokimasa (a Taira). Respectful of the imperial power, at least to all appearances, Yoritomo always informed the court of his actions and requested its approval. However, he himself did not personally come to Kyoto until the end of 1190.

After the death of Go-Shirakawa in 1192, Kanezane, with Yoritomo's help, was able to eliminate his enemies at court and, in turn, supported Yoritomo in his effort to win the favor of the imperial circles and finally, in 1192, to obtain the desired title of shōgun. In 1195 Yoritomo paid a second visit to Kyoto, ostensibly to attend the dedication of the monastery of Tōdai-ji, which had been reconstructed after the Taira had burned it to the ground. The following year, however, one of Kanezane's enemies, Minamoto Michichika, succeeded in overthrowing Kanezane's position as Regent by selecting as crown prince the brother of the young Emperor Go-Toba. The aim of this move was the restoration of imperial power. Yoritomo, however, made no immediate moves to counter this turn of events. He died in 1199 as the result of a fall from a horse while returning from a ceremony. He was only fifty-two years of age.

The Hōjō Regents

The administrative system set up by Yoritomo was so strongly entrenched that despite the partial revolt of Kyoto, the death of the first shōgun did not result in the collapse of the *Bakufu*. The investiture of Yoritomo's son, seventeen-year-old Yoriie, as shōgun did not take place for three years, because the new government at Kyoto wanted to prove that it intended to be master. In the interim, Yoritomo's father-in-law, Hōjō Tokimasa, assumed the presidency of a council of Regents made up of war chiefs and famous jurists originally from Kyoto. The members of this council soon became jealous of one another's powers and even resorted to killing one another. Yoriie, himself quite brutal, was incapable of carrying on his father's work and maintaining law and order. It is possible that his grandfather, Hōjō Tokimasa, had Yoriie assassinated in 1204 despite the fact that Yoriie had been forced to abdicate the year before in favor of his brother, Senman. Senman, whose name at court was Sanetomo, was appointed shōgun in 1203. Sanetomo, however, was a minor, and Hōjō Tokimasa was nominated *Shikken* (Director, but comparable to the post of Regent).

The situation nevertheless remained clouded. Yoritomo's widow, Masako, and her father's second wife, Makiko, became rivals and fomented various plots. Masako was successful in her efforts, and Hōjō Tokomasa was forced to resign as *Shikken* at the end of 1205. Masako's brother, Hōjō Yoshitoki, was then chosen as *Shikken*, and the position of Masako's son, Sanetomo, was assured. The resulting period of relative peace was not disturbed until 1213, when a minor revolt of the nobles occurred that was quickly suppressed. Yoshitoki was selected at that point as chief of the *Samurai-dokoro*. In 1219, however, Sanetomo was assassinated at the instigation of his nephew, Kugyō, Yoriie's second son. The young Emperor Go-Toba, who had been trying for some years to win over to his side some of the officials of the Kyoto *Bakufu*, in 1221 declared the *Bakufu* to be in a state of rebellion. The *Bakufu* answered this by sending a strong army to Kyoto under the command of Yoshitoki. The emperor's troops were defeated at the Uji Bridge south of Kyoto, and the capital was surrounded and occupied. Go-Toba was exiled, and his wealth and possessions—as well as those of the nobles who had supported him—were confiscated and handed over to the warriors who had remained loyal to the *Bakufu*.

The imperial position had been destroyed; peace returned. The *Bakufu* became the sole authority in Japan, with even the right to choose the cloistered emperors. The first of those who succeeded Go-Toba was not even an emperor but an imperial prince: Morisada, the second son of Emperor Takakura. As *In*, Morisada assumed the name of Go-Takakura. Therefore, as the emperor was required to be the son of an *In*, Morisada's son ascended the throne, taking the name of Go-Horikawa.

Obviously the *Bakufu* was not leery of upsetting the established traditions. Yoshitoki took more than two years to redistribute the confiscated lands and to punish those *Jitō* who had proved too rapacious. The just qualities of the new officials of the *Bakufu* finally satisfied everyone. A garrison was installed at Rokuhara to prevent any new attempts at rebellion on the part of the court, and its commander, a Hōjō, was invested with powers almost equal to those of the *Bakufu* of Kamakura. In 1222 an inventory of all lands was ordered, and this permitted the military government to organize itself on a solid basis.

On the death of his father (Hōjō Yoshitoki) in 1224, Hōjō Yasutoki assumed the title of *Shikken*. He continued the social reforms already undertaken and attempted to transform the rudimentary governmental organization of the *Bakufu* into an authentic administrative system adapted to the needs of the country. One of his first measures was to create a council of state *(Hyōjōshū)* to assist him. It was a legislative assembly of eleven members, the majority of whom were great lords *(go-kenin)* in the service of the shōgun. In 1226 Yoritsune, a child of eight, was chosen as shōgun, and in 1230 he was married by proxy to the daughter of Yoriie, even though she was fifteen years his elder.

At the time of the marriage, Yasutoki, in order to alleviate conditions resulting from a series of natural disasters (floods, famines, smallpox epidemics), called a moratorium on the payment of debts, suspended the taxes, and ordered the distribution of rice to the poor. The warlike clergy of Mount Hiei, however, continued in their violent fulminations directed toward the court, which was terrified of the threats posed by these bellicose monks. The private army of the temple of Kōfuku-ji near Nara was no less bellicose. It was a time that precipitated the *Bakufu* to demonstrate its strength and reestablish law and order.

In 1232, in order to make clear its policies, the *Bakufu* promulgated a series of laws and edicts known as the *Go Seibai Shikimoku* (it was later known by the name of the era, *Jōei Shikimoku*), which comprised a code of fifty-one articles. Through this, the *Hyōjōshū* (Council of the Regency) defined the rights and duties of the individual, the basic rules of discipline for the vassals, and the punishments meted out to lawbreakers. This code was directed principally toward the vassals and the samurai, because justice for the common people was to be administered by the local lords according to the law then accepted in their domains. The nobility continued, however, to follow the *Ritsuryō*. The instructions of the *Jōei Shikimoku*, even though written in Japanese, could easily be understood by everyone, while the edicts of the *Ritsuryō* were difficult to interpret and for the most part were ignored by the commoners.

In a letter addressed to Shigetoki, the *Tandai* (Inspector) of Kyoto, Yasutoki summarized the basic principles of the *Jōei Shikimoku*: "A man must be loyal to his master; a child must observe the principles of filial devotion; a wife must obey her husband; and everyone must be sincere and righteous from the depths of his heart." He added, not without irony: "Certain people of Kyoto laugh, and affect to see in these instructions the work of the 'Eastern Barbarians.' Yet these are the principles that we want you to follow."

This code, together with its subsequent additions—in particular the *Shimpen Tsuika* of 1234 and the *Samurai-dokoro Sata-hen* (which was a code of conduct for the samurai) of 1286—was the most important reform of the government of Kamakura. Its principles were applied continuously through the centuries until the accession of the Emperor Meiji in 1868.

Yasutoki died in 1242: his grandson, Tsunetoki, assumed the title of *Shikken*. Two years later Shōgun Yoritsune was deposed. His son, Yoritsugu, still a child, was put in his place in order to avoid the problems of choosing a Regent. Yoritsune, however, had made many friends at the court of Kyoto when his father had been Regent. Trouble followed, instigated by the supporters of Yoritsune, the deposed shōgun, among whom were members of the influential Miura family. The new *Shikken*, Tokiyori (who had succeeded Tsunetoki in 1246), sent Yoritsune back to Kyoto and in 1247 attacked the estate of the Miura. Rather than surrender, the Miura family, together with five hundred of their warriors, chose to commit suicide. Tokiyori confiscated their immense domains.

The *Bakufu* no longer had any enemies to be feared. It made peace with the court, and the cloistered Emperor Go-Saga was favorable to the idea of selecting a Regent. The only question that remained was the choice of a new shōgun, who was to be a member of the imperial family. The young Shōgun Yoritsugu "resigned" and in 1252 was replaced by Prince Munetaka, son of the cloistered emperor. The relations between the *Bakufu* and the court became friendly, linked as they were by family ties. The prestige of the *Bakufu* was correspondingly increased, and the government of Kamakura, in contact with the nobles of the court, became progressively more aristocratic.

In 1256 Tokiyori retired as *Shikken* because of illness and was replaced by his son, Tokimune. As a minor, Tokimune was first assisted by a Vice-Regent, Nagatoki, who was a member of the Council of the Regency *(Hyōjōshū)*, and later by Masamura until 1268. Until his death in 1263 Tokiyori continued—despite his retirement—to exercise control over the government. In the meantime further disasters had overwhelmed the country—an earthquake in 1257, an epidemic in 1259—which resulted in crop failures, famine, and a dearth of farm workers. In 1266 Shōgun Munetaka fell under the suspicions of the Regent, who sent him back to Kyoto with the request

that his position should be filled by Prince Koreyasu. The appointment was made without any difficulty.

The Mongol Attacks

In China the Sung dynasty had been overthrown by Kublai Khan, who proclaimed himself emperor and established his capital at Peking in 1264. Korea had also been attacked, and the independence of Japan was thus threatened. In fact, in 1266 and 1268 Kublai Khan sent to the Dazaifu, the seat of the *Tandai* (Inspector) in Kyushu, ultimatums demanding the submission of Japan and the "King of the Little Country." The military government of Kamakura rejected the demands and ordered the immediate reinforcement of the defenses along the coast of Kyushu, which was where Chinese and Korean trading ships touched at Japanese ports. Troops were mobilized for every possible contingency, and the Japanese were aided in their emergency measures by the Koreans, who kept them informed of Mongol troop movements.

In 1271 a third note from Kublai Khan was received as coldly as its predecessors, and the Mongol envoy was summarily sent home. As a result, at the end of November, 1274, approximately fifteen thousand Mongols, together with about the same number of Korean troops, occupied the islands of Tsushima and Iki and invaded the Bay of Hakata in the northern part of Kyushu. All the warriors of the island immediately joined forces under orders of the Dazaifu commander Shōni Tsunetsugu. The Mongols attacked in closed ranks backed by such powerful weapons as crossbows and various engines of war. The Japanese were at a disadvantage at first, as they were accustomed to fighting in hand-to-hand battle, employing small hand weapons such as the bow and arrow, spears, and swords.

Fortunately for the history of Japan, it was only a surprise attack, probably to test the resistance of the Japanese army. During the following night the Mongol cohort withdrew, much to the amazement of the Japanese, who saw divine intervention in this unexpected turn of events.

Although Japanese historians have often attributed the retreat of the enemy to a typhoon, such a hypothesis is not probable. In fact, no mention is made in the Chinese or Korean chronicles of such a natural phenomenon; they speak of the retreat only as a planned withdrawal. Japanese almanacs of the time are also silent regarding this typhoon, which hardly could have escaped notice because it would have been a truly extraordinary event at that season of the year. At any event, Japan had been saved, but knowing that Kublai Khan would try to return, the *Bakufu* reinforced the defenses and kept its troops mobilized.

During this period the imperial court prayed to the ancestors, made offerings to the *kami*, and organized ceremonies in the Buddhist temples. In 1275 a new group of envoys from Kublai Khan arrived. They brought his demand for the complete submission of Japan, and after their reception they were sent to Kamakura where they were all slaughtered. A naval force was created to attack the Mongol invaders while they were still on the high seas. A stone wall was built along the coast of the Bay of Hakata. Plans for both attack and defense were carefully studied. All the military forces of Japan and all its resources were mobilized against a possible invasion.

In August, 1281, a fleet bearing 40,000 Korean troops set sail from the island of Iki and landed on the promontory of Shiga, which protects the Bay of Hakata. A Chinese fleet disembarked 100,000 men farther south at Hirado. Battles were fiercely fought on both land and sea and lasted seven weeks, during which time the invaders were held in check. It was at that point that a providential typhoon struck and destroyed more than half the enemy fleet. The Mongols who had remained on Japanese soil were either slain or made prisoners of war.

Japan had obtained a victory, thanks to the bravery of its soldiers and the miraculous intervention of the *kamikaze* (divine wind). The economic consequences of the victory were disastrous, however; Japan did not have the resources to maintain so large an army for such an extended

period. The country had been on a war basis since the first attempted invasion of 1274 and remained mobilized until 1294, when Kublai Khan died. The Mongols had made preparations for a new invasion to take place in the autumn of 1293, but the plan was abandoned at the last moment, because the great Khan decided to devote all his efforts to the unification of his immense empire.

In 1294, the Regent Tokimune died, leaving his son, Sadatoki, who was still a minor, as his successor. The warriors were demanding reimbursement for their expenses and back pay from the *Bakufu*, but the *Bakufu's* treasury was exhausted. The religious institutions were also clamoring for reparatory funds. The country was at the end of its resources, and the *Bakufu* found itself in the perilous position of losing its power and control. Having made a few slight concessions, the *Bakufu* decreed in 1294 that no further claims could be taken into consideration and thus placed its very existence in jeopardy.

The samurai spirit had so profoundly infused the spirit of the country, however, that there was no rebellion. In any case, the feudal lords were not rich enough to indulge in the luxury of a civil war. Many of the vassals of the *Bakufu*, in fact, were forced to sell parts of their domains to those who were not samurai or members of the feudal ruling class. The need of money was so great that they were forced to ignore the strictures of the *Jōei Shikimoku*. The buyers were principally members of the lower classes: merchants, moneylenders, and pawnbrokers who had made fortunes in trade with southern China during the Sung dynasty, prior to the Mongol invasion.

These land transactions considerably weakened the relations of the vassals to the sovereign, since the new landowners did not belong to the warrior class *(bushi)* and consequently were not enfeoffed to the *Bakufu*. Made apprehensive by this development that it was powerless to check, the *Bakufu* canceled the debts contracted by the vassals (1297) and reinforced the prohibition regarding the transfer of land to individuals not already enfeoffed to the military government.

The samurai thus became poorer and poorer. The Kamakura government itself was insolvent. A new class began to arise: one made up of merchants and artisans.

The *Bakufu* desperately needed the guidance of a strong and wise man. The premature death, at thirty-four, of Tokimune had left a void that Sadatoki, although capable, could not possibly fill. His two advisers were enemies and killed each other. In 1301 Sadatoki abdicated as *Shikken*, entered a monastery, and transferred his responsibilities to one of his cousins, Hōjō Morotoki. In 1316 Sadatoki's son, Takatoki, succeeded to his father's post as *Shikken*. The integrity of the *Bakufu*, which had inspired the respect of the vassals, had disappeared, however, together with the authority of the Hōjō Regents.

In 1326, when, despite the demands of the Kamakura government, Emperor Go-Daigo refused to abdicate in favor of a son of Go-Fushimi and named his own son as heir apparent, numerous nobles defended him against the Hōjō clan. In 1331 Takatoki, having heard of a plot organized by Go-Daigo, sent an army toward Kyoto. Fearful of being obliged to surrender, the emperor fled the capital: his vanquished troops deserted. He was banished in 1332, but succeeded in escaping to the island of Oki. In 1333 he was able to return to Kyoto, due to the treason of Ashikaga Takauji, a member of the Minamoto clan, who had annihilated the troops of the *Bakufu* stationed at Rokuhara. The warriors revolted on all sides and attacked Kamakura, which was easily captured. At that point Go-Daigo was abe to regain his throne. It was the "Restoration of the Kemmu" era. (See the following chapte)

He had not counted, however, on the ambition of Ashikaga Takauji, who turned against him in 1336. Once again, Go-Daigo was forced to flee and established his court in the southern part of Yamato at Yoshino. Takauji placed an emperor of his own choice on the throne at Kyoto. Thus there were two courts, one of the North and the other of the Soutq, and there was also a new *Bakufu* installed at Kyoto. Ashikaga Takauji was given the post of *Seii Taishōgun* in 1338 by Emperor Kōmyo' whom he had placed on the throne. The struggle between the two courts and the *Bakufu* was destined to plunge the country into a long series of civil wars.

Bushidō, "The Way of the Warrior"

The history of Japan abounds with accounts of glorious exploits extolling the virtues of warriors. These tales are often highly romanticized and infused with a cautionary tone, but through the fiction shines those rules of conduct that molded the code of deportment that later writers called the *bushidō*, or "way of the warrior." The conduct of the samurai during the Kamakura period was dictated by a few rigid, simple principles that permitted few exceptions: to be loyal to one's sovereign or feudal lord; to be fearless of death in the service of one's recognized chief; to be proud of one's name and to keep it unsullied.

As a matter of fact, there was no written code for a warrior. These principles developed spontaneously within a society that had evolved during the course of the struggles in the North. To a lesser degree, however, the basic ideals had already existed in all classes of Japanese society from the earliest years of the state of Yamato. These social attitudes were an aspect of the spiritual patrimony of the Japanese and owe only a fraction of their origin to foreign influences. Perhaps it was logical for people descended from Altaic stock and the horsemen-archers, who were the progenitors of the Japanese aristocracy, to think along these lines.

Bushidō also showed traces of Confucian teaching, particularly that concerning the obedience of women to their fathers, husbands, and sons. This latter, however, was modified by the *Bakufu*, which recognized the rights of women to succession, the fealty of vassals, and ownership of property. Women played an active part in all matters during the Kamakura period (for example, Masako, Yoritomo's wife, controlled the destiny of the *Bakufu*, which took on life and power only after the death of her husband), as they had done in the past, exemplifying the tenacious survival of Japan's protohistoric matriarchy.

Chinese and Korean, Buddhist and Confucian influences did not modify the basic social conduct and emotions of the Japanese. These beliefs were merely superimposed on them and at times even concealed the truly Japanese attitude. Even today, Japanese society—although apparently transformed by World War II—maintains its basic character, which manifests itself in one form or another in all aspects of social life: schools, the armed forces, public and private life. This traditional Japanese spirit is often disregarded or undervalued, because it is attributed to the influence of solely one or another class. The truth is that these behavioristic attitudes (which could be termed feudal) are ingrained in the Japanese nature, and without them a national individuality could not exist. And it is because of this profound feeling of identity, of closeness to nature, that the Japanese have been able to rise above and survive so many catastrophes. *Bushidō*, the way of the warrior, was fundamentally also a frame of mind embodying a deep sense of proper conduct. It was not and could not be a moral attitude in the Western sense of the word.

A certain similarity may be noted between medieval European chivalry and the world of the samurai. They came into being due to similar economic necessities, and their basic ideals were not radically different. However, the sense of honor as understood by the European knights did not exist for the samurai; it was replaced by the concept of an absolute, overriding sense of fidelity. Instead of the Christian ethos and faith that guided the knights, the samurai cherished a desire for recognition of their personal self-sacrifice for the sovereign, a desire to protect the reputation of their immediate family (and not the honor of the clan, as has so often been stated). Gallantry toward women was unknown among the samurai, because women themselves were active participants in the code of action. Far from being secluded and protected and considered inferior like the damsels of the European chivalric ideal, the Japanese woman of this era was treated as an equal and was subject to the same rules of conduct as a man (and in cases of dire

emergency they also took up arms). It was their duty to educate their children in the same spirit.

These natural tendencies of the Japanese people were extolled, encouraged, and even enforced by the new society of hardened warriors. A samurai was a faithful Shintoist. He profoundly revered the *kami* of his own clan or, more correctly, those of his clan chief. He was also a faithful Buddhist, but he took from Buddhist philosophy only those elements suited to his own temperament: he could kill without mercy and yet end his days in a monastery in prayer and meditation (not to repent his past misdeeds, but to pray for the salvation of the souls of those he had killed); he believed in the doctrine of karma—the relationship of cause and effect of this life on future lives—but his ethics in no way corresponded with his conduct. Only deportment was of importance. The samurai believed that everything was ephemeral: not from a philosophical point of view, but because one had to be ready at any moment in life to die for one's sovereign.

Such is the image of the ideal samurai. Fortunately the reality was at times very different. And a work written in that period, the *Azuma Kagami*, contains accounts not only of episodes of bravery and the spirit of sacrifice in battle, but also episodes revealing more human elements that emerge from behind the stern facade—qualities that had not been forgotten: love of nature, tenderness, compassion. These characteristics encourage one to reconsider the stereotyped samurai of literature with all his faults (jealous, indolent, debauched, ambitious, self-seeking), which, after all, make him appear very human.

In reality, this underlying frame of mind exalted during the Kamakura period under the influence of the *Bakufu*—and which has survived to the present day—can be well understood only through examples taken from those Japanese stories corresponding to the Western *chansons de geste*. In the typical Japanese way, however, this all-pervading mental attitude was never defined; it was only suggested. In reading these tales, we find samurai who challenge each other to duels by loudly proclaiming their names and the exploits of their ancestors, or who decapitate their enemies and carry away their heads as trophies, or who die with joy in their hearts in order to save the life of their sovereign. Yet along with these indisputable acts of bravery, unswerving loyalty, fearlessness in the face of death, and self-sacrifice, history also offers an equal number of accounts of pure and simple murder, cowardice, and treachery. It was the rule to kill all prisoners, too, because a samurai who surrendered was not fit to live. There were exceptions even to this, however, save during the time of the Mongol invasions when no mercy was shown.

Religion

In sharp contrast with the harshness of this era was the expanding influence of religion. The cult of Amida the All-Compassionate was simple and demanded little in the way of elaborate ceremonials. After the aristocracy of Kyoto had fallen under its spell, it spread more widely and took root among the samurai. In 1175 the priest Hōnen founded the Jōdo sect, which enabled the masses to comprehend and practice the doctrines previously promulgated by the priests Kūya and Eshin exclusively for the nobility and the imperial court. Having been further simplified, the doctrine of Hōnen promised salvation by merely invoking the name of Amida as one's act of faith.

It was, however, the preaching of Shinran (1173–1262), the creator of Jōdo-Shinshū—an aspect of Jōdo—which attracted the warriors and even the great feudal lords. Shinran declared that men should allow their every action to be completely guided by Buddha (who denied no one—whoever he might be—entry into Paradise). It was mainly the ill and afflicted, the downtrodden lower classes, and the common foot soldiers who accepted this doctrine of resignation. Aside from all its virtues and wisdom, the faith preached by Shinran was somewhat similar to the Christian concept of Divine Grace—it was a gift of Buddha; and merely the

repetition of Buddha's name bestowed salvation. This continuous repetition may be compared to the Hindu *japa*, the constant reiteration of a mantra (a sacred formula phonetically representing the divinity) or even certain Christian litanies. Shinran also wrote hymns—known as *wasan*—in Japanese.

> *The number of vows to be fulfilled are forty-eight*
> [a sacred number in the Amida cult]
> *The Buddha of infinite light* [Amida] *has attained His goal.*
> *Now we are certain of being reborn in His Land,*
> *We who have faith in Him and who repeat His name.*

Contrary to the practices of earlier Buddhist sects, Shinran's doctrine made no distinction between monks and the laity. He was a married man and lived among the people, and his descendants formed a sect—the administration of which became virtually hereditary—whose leaders were sometimes thought to be reincarnations of Amida. Our interest in the doctrines expounded by Shinran is primarily sociological: he brought Buddhism—or at least a form of worship in the name of Buddha—to the common people, whereas other sects of this religion seemed to have been reserved for the upper classes alone. Shinran's beliefs, which were a form of democratization of those of Hōnen, were revised subsequently: Ippen (1239–1289) and Shinsei (1443–1495) gave them renewed vigor.

Other forms of Buddhism adopted by the samurai were Zen and the doctrine of the *Hokekyō* (*The Lotus Sutra*) proclaimed by Nichiren. From a historical point of view, these two sects were perhaps more important than the preceding because they contributed to a definition of the Japanese spirit (which subsequently manifested itself in a great variety of ways), gave a religious support to the social attitudes of the Japanese, and imbued them with a type of moral justification.

The doctrines of Zen Buddhism—a school of meditation originating in China (Zen=*Ch'an* in Chinese), which in turn was derived from Indian teachings of the sixth century—were introduced into Japan toward the end of the twelfth century by priests returning from the continent on merchant ships. Eisai (1145–1215), a Tendai priest of Mount Hiei, had brought back certain elements of the doctrine, but it was the priest Dōgen (1200–1253), a disciple of Eisai, who introduced the complete philosophy into Japan after a visit to China. Having retired to the northern provinces, far from the turmoil of the court at Kyoto, he first taught the Way of Zen to the warriors and a few priests and monks.

Zen proclaims that no doctrine can teach the true spirit of Buddha without denying His very existence and declares that the Supreme Being can be known only through silent and instantaneous communication *(satori)* established between the Supreme Being and man. Zen is also presented as a method of attainment to spiritual rapture through the assiduous practice of "nonmeditation" *(zazen)*, which permits the human spirit to transcend limits of thought in order to attain an intuitive perception that abolishes differences and transitory states of appearances. Consequently, the normal activities of life must be considered not as an end in themselves, but rather as the normal expression of the spirit. Strict training, both physical and spiritual, is indispensable.

This type of philosophy—one is unable to define Zen Buddhism, because it transcends formulation or doctrine—fulfilled the spiritual needs of the samurai class for whom firmness of resolve was an essential virtue. Hōjō Yasutoki was the first important figure to be converted by the Zen priest Myō-e (1173–1232), and he was followed by other Hōjō Regents, Tokiyori and Tokimune in particular. Zen was easily adopted because it extolled simplicity, straightforwardness, courage, and a fearlessness of death. It suited perfectly the basic Japanese mentality, which up until then had been reflected only in Shintoism: its love of nature and its taste for rustic simplicity.

266

These spiritual values were in absolute contrast to the effete philosophies of the Kyoto aristocrats. The new society created by the warrior clans of the north found in Zen spiritual support and another way of asserting their complete independence from the aristocracy of the imperial capital. Japanese Zen can be considered to be almost a spiritual distillation of primitive Shintoism and a logical evolution of it. The sense of the aesthetic—one of the outstanding characteristics of the Japanese—found in Zen a means of expression far different from the artificiality then fashionable in Kyoto. The character of the samurai of the Kamakura period, which in the beginning was rough, rude, and amoral, gradually became more refined through contact with Zen, and during the following centuries it became disciplined to such a degree that the bushidō or way of the warrior became in practice an aesthetic attitude toward life and not an ethical way of life. The entire artistic and spiritual tenor of Japan was transformed by Zen.

The doctrine preached by Nichiren (1222–1282), on the other hand, was far more adapted to the masses than to the samurai. The son of a fisherman, educated as a monk at Kamakura and on Mount Hiei, convinced that the doctrine of Saichō was the only one which truly expounded the teachings of Buddha, Nichiren simplified and popularized the concepts of the esoteric Tendai sect. Saichō had derived the clearest of his doctrines from the Sutra of the Lotus of True Law (Saddharma Pundarika Sutra in Sanskrit, Myōhōrengekyō in Japanese): Nichiren was convinced that the mere repetition of the sutra's title was sufficient to permit the faithful to attain Buddha.

Expelled from Mount Hiei by the clergy, he took refuge in Kamakura. There he preached to the populace, who were at that time afflicted with many misfortunes—political insecurity, earthquakes, famine, typhoons. Nichiren asserted that all these disasters could be attributed to the fact that Buddha had withdrawn his grace from Japan because false religions were practiced there. Nichiren attacked the Jōdo, Ritsu, and Zen sects, which he claimed were responsible for the disasters that had overwhelmed the country. He assumed the position of a prophet and announced the direst calamities (foreign invasions in particular) if the government did not accept his conviction that the Myōhōrengekyō should be declared the sole vehicle of doctrine and that all others should be prohibited.

He was arrested on several occasions as a troublemaker and was then deported to Izu where he drew up the five articles of his "mission." On his return from exile in 1263, Nichiren continued to preach; he found many adherents. It was the time of the Mongol invasions, however, and his subversive activities annoyed the military government, which exiled him again, this time to the island of Sado for three years. It was there that he wrote down the fundamentals of his doctrines. He claimed that he was the savior chosen by Buddha himself as the sole promulgator of the true Buddhist religion.

When he returned to Kamakura, he rejected the idea that his doctrine should be accepted as a mere equal to the others. He retired to the slopes of Mount Fuji in order to prepare for the advent of Kaidan, the universal, all-embracing Buddhist faith. His disciples continued to disseminate his exclusivist doctrine at the imperial court at Kyoto and even in such remote places as Siberia.

Nichiren's teachings found numerous followers among the illiterate peasants and soldiers, for whom his intransigence and inflammatory nationalism had a great appeal: Nichiren presented Japan as the center of world Buddhism. For the first time in Japanese history a religious idea aspired to exclusivism and preached that all other religions or sects were false.

Contrary to Zen, the doctrine of Nichiren—which even today has many followers split up into various denominations—had no effect on art, because it was practically destitute of a basic philosophy. It had sociological influence, however, because it developed in the people a spirit of pride, a confidence in themselves, and a tendency to lay active claim to their rights. If Nichiren was solely a visionary as far as doctrine was concerned, from a sociological standpoint he was a revolutionary.

Commerce with China increased during the Kamakura period—in reality it was only the exchange of official ambassadors that had been terminated—and numerous monks and priests

took passage on merchant ships leaving for China and Korea. They returned with manuscripts, scriptures, and new doctrines. Some Chinese priests also took up residence in Japan. Dōryū (the Chinese missionary Tao-lung) became the abbot of the monastery of Kenchō-ji near Kamakura in 1253. He was succeeded by Kotsuan (Wu-An in Chinese) in 1260, Daikyū in 1270, Mugaku and Bon Jikusen in 1330. Certain religious philosophies, which had spread throughout China during the Southern Sung dynasty (1127–1276), were introduced into Japan by these religious figures.

Trade between the two countries flourished, and the court corresponded fairly regularly with the mainland. Japan imported silks, brocades, perfumes, sandalwood, and copper coins, and exported gold, fans, swords, paintings, and certain types of precious woods. Coins were of great commercial importance, and almost all of those that circulated in Japan were of Chinese origin. Some pieces *(Wadō-kaihō)* had been struck as early as 708 in Japan, but they had a limited circulation.

The Zen priests often brought back tea and porcelains. Tea had been known for a long time in China, and in Japan since 806 when—according to tradition—it was imported for the first time by Saichō; however, it was still regarded more as a medicine than as a refreshing beverage. The Zen priests, particularly Eisai, who recommended it in 1191, were responsible for adopting tea as a drink for daily use.

Cultural Tendencies

The relative peace which existed in Japan during the wise administration of the first Hōjō Regents permitted the development of exports in the same way that it encouraged imports. Metallurgical techniques had attained such an extraordinary degree of excellence that Japanese swords, as well as numerous other objects made by the metalworkers, had become highly prized in China.

The Heian cultural milieu continued at the court of Kyoto and infiltrated the upper classes at Kamakura despite the efforts of the *Bakufu* to limit its influence. Literature, poetry, and fine calligraphy were held in great respect at Kamakura once the imperial prince, Munetaka, had been appointed shōgun (1252). Warlike sports, which were the basis of training of the young samurai, were widely practiced both as diversion and for ceremonial reasons: competitions of archery; *yabusame*, or shooting at a target with bow and arrow while riding on horseback; and various games entailing physical skill.

There were also occasions for the display of elegance. Numerous Kyoto literary lights and well-known artists were invited by the *Bakufu* to come to Kamakura. New monasteries were established and soon became cultural centers. Although the culture of the Heian era had survived at Kyoto, it could no longer equal its earlier glory: the great nobles had lost many of their estates; the city had been ravaged by arson and pillaging; famines and epidemics had often afflicted it. The samurai of Kamakura had also introduced a new spirit, and the distinction between the classes began to blur. Nevertheless, Kyoto retained its prestige.

From a literary point of view, the writers followed the main currents and, aside from religious texts, there were quite a number of epic novels (the *Heiji Monogatari*, for example) written in Japanese; chronicles like the *Azuma-Kagami*, written in Chinese; and a type of epic poem (such as the *Heike Monogatari* written in rhymed verse) that was recited to the accompaniment of a musical instrument such as the *biwa* (a type of lute). There were also legends or histories like the *Kokon-Chomon Shū* written by Tachibana Narisue in 1254.

In the field of poetry, Emperor Go-Toba, friend of Shōgun Sanetomo, sponsored the creation of an anthology of *waka* (poems of thirty-one syllables): *Shin Kokin Waka Shū*, which contained 1,980 individual works. Aside from the emperor, the most important poets of the period were

Fujiwara Teika and Minamoto Sanetomo, the author of the *Kinkai Shū*. Some diaries of extraordinary sensitivity describing journeys have also survived: the *Izayoi Nikki* of Abutsu-ni, a woman of the Fujiwara family, who related the account of her trip from Kyoto to Kamakura in 1277 and sprinkled her text with *waka*; the *Kaidō-ki* (1223) and *Tōkan-kikō* (1240), written by unknown authors. Finally there were various poetical or descriptive essays: the *Hōjō-ki* of Kamo-no-Chōmei (1212) and the important *Tsurezure-gusa* of Yoshida Kenkō (or Kenkō Hōshi), who lived from 1283 to 1350 and whose work, because of the penetrating subtlety of his observations, and his skepticism, could be compared to that of Montaigne.

Architecture

There is a tendency to speak of a Japanese "style" of architecture, as if it were analogous to various European styles. Such a term cannot be applied to Japanese buildings, because their architecture depended neither on changing fashions nor established rules of proportion but on the type of construction, especially on the techniques employed by the carpenters. Their techniques were determined more by the bracketing *(to-kyō)* than by the columns (which are always load-bearing supports) or capitals.

From the beginning of the Heian era the same general structural types were almost always employed. The only distinguishing "styles" were evidenced in various structural details employed by the carpenter, and the decorative ferrules or bosses on beam or rafter ends, various shapes of the gable ends, and styles of doors and windows. However, these differences between one structure and another are often minute and are apparent only on very close scrutiny. Aside from the plans of the monastery buildings or the palaces—plans which varied from period to period according to the specific needs of society or the religious sects—the following are the principal styles:

Wa-yō. The traditional Japanese style. Brought from Korea in the sixth century, it was employed primarily in the architecture of the Asuka, Nara, and Heian eras. It evolved gradually and was based on Korean or Chinese structural methods slowly adapted to the traditions of the Japanese carpenters. It received its name only in the Kamakura period in order to distinguish it from two new types of construction brought from the mainland at that time: the *Kara-yō* and the *Tenjiku-yō*. The chief characteristics of the *Wa-yō* style are the slight curve of the roofs; the introduction of the roofed porches *(mokoshi)* in order to increase the interior space; square or rectangular windows covered by very narrow vertical strips or latticed grills *(renji-mado)*; and pillars, distinguished by entasis (during the Asuka era), a thinning at their tops (Nara period), or perfectly cylindrical. There was also a variety of sculptural decorative motifs. The doors were usually made of plain wood and swung on socket hinges. The windows had wooden panels or shutters that opened out horizontally. The floors were generally of wood, although some of the temples were paved with stone.

Kara-yō. The Chinese style. Introduced in the Kamakura period by Chinese priests, it was first employed in the construction of the Zen monasteries, but was rapidly adopted by the other sects for many of their temples. It was chiefly characterized by more steeply pitched roofs with more sharply turned-up edges than those of the *Wa-yō* style. The bracketing was more complex, with extended curved beams *(ebi-kōryō*, and so named because of its resemblance to a shrimp's tail), and windows topped by a more or less cusped arch *(katō-mado)* were often used.

Tenjiku-yō. The Indian style. This came from the Southern Sung dynasty, and was brought to Japan by a Japanese Buddhist priest, Shunjō-bō Chōgen, who during a pilgrimage to the mainland in 1167–68 had participated in the construction of a reliquary hall at the temple of A-yü-wang-ssu (near Ning-po in Chenkiang province). On his return he was entrusted with the task of rebuilding the Daibutsu-den of Tōdai-ji temple, which had been destroyed by fire. The colos-

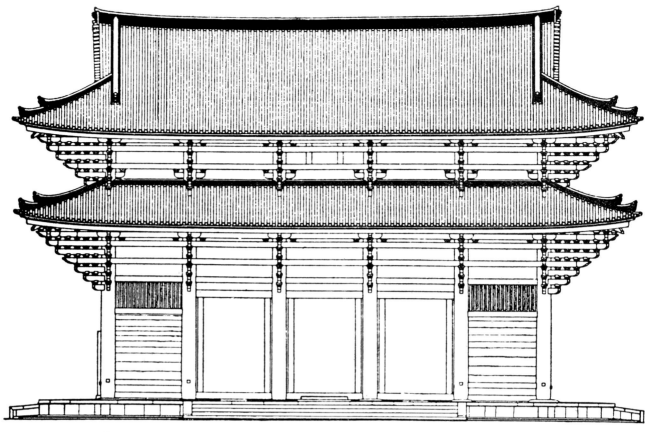

36. THE NANDAIMON OF THE MONASTERY OF TŌDAI-JI IN NARA; TENJIKU-YŌ STYLE

sal bronze Buddha also had to be recast, and with the help of two Chinese, Chōgen used new techniques he had learned in China for assembling the image. Having been promoted to the position of *Dai-kanjin*, or "Chief Promoter," he standardized the elements of construction in such a way that within a relatively short time and with a minimum of expense he was able to complete this enormous edifice, which is one of the largest wooden buildings in the world (however, the present structure dates from the 1708 rebuilding). He reduced the number and dimensions of the beams and pillars and increased the tiers of the bracketing up to thirteen (this is one of the major innovations of the "Indian style"). Although they appear complicated, buildings in the *Tenjiku-yō* style were constructed with relative speed and ease because of the well-organized labor of carpenters and woodcarvers. However, after Chōgen's death this method of construction was rarely employed in its pure form, although many of its principles were incorporated with the *Wa-yō* and *Kara-yō* styles. One of the main structural characteristics of the *Tenjiku-yō* style is an intercolumnar system of beams and supports. The major structures employing this technique include the Sammon of Tōfuku-ji (end of the fourteenth century, beginning of the fifteenth); the Nandaimon (Great South Gate) and the Daibutsu-den of Tōdai-ji; the Jōdo-dō of the Jōdo-ji in Harima.

At the end of the Kamakura period composite styles were employed for most buildings. The first of these combined *Wa-yō* with *Tenjiku-yō*; the second was a combination of *Wa-yō* and *Kara-yō*; the third made use of elements taken from all three. The formulas of any one of these three composite styles varied with the individual architect and with the changing taste of the times, and therefore allowed Japanese artists to satisfy their predilection for originality and perfection. Although one never finds two strictly similar structures in Japan, the types of buildings can be reduced to a limited number of general categories: pagodas *(tō)*, monumental gates

270

(mon), main halls *(dō)*, utilitarian structures, bell towers *(shōrō)*, lecture halls *(kōdō)*, libraries *(kyōzō)*, and the warehouses of the *azekura* type.

Shintō architecture was influenced more and more by Buddhist structures and soon became quite similar in both the methods of construction and decorative motifs. The overall plans of the shrines, however, remained similar to those of preceding periods, although most of the older shrines were enlarged and numerous subsidiary buildings were added. For this reason their general plan became more complex, and the various buildings were linked by roofed cloister-like galleries as in the Buddhist monasteries. The buildings were decorated more or less lavishly according to the wealth and the generosity of their patrons: emperors, aristocrats, or even commoners.

During the Kamakura period the residences in Kyoto and the estates of the provincial nobles followed the *shinden* style. The shōgun himself lived in houses of this type. Yet it is probably true that the common soldiers lived in dwellings constructed along the traditional lines of the houses of the peasants found throughout the countryside; such houses were enclosed by a simple palisade fence. The residences of the samurai were made up of a central building situated in the middle of an enclosed plot. In front of the main building there was an open space and the house was flanked by structures housing the kitchen *(daidokoro)* and the stables *(umaya)*. Behind the main house there was a small garden for meditation and rest. These gardens tended to be miniature versions of *shinden*-style landscaping, but they were adapted in such a way that they eventually evolved a style of their own *(buke-zukuri)*. Zen priests believed landscaping would facilitate the concentration necessary for meditation; these "gardens" consisted principally of a unique arrangement of gravel paths and a few largish rocks. During the following era, however, the Zen priest Musō Kokushi created gardens that subsequently served as a prototype for this type of landscape art.

Sculpture

The Kamakura period witnessed the beginning, the development, and the end of the final phase in the evolution of Japanese sculpture. As a matter of fact, very few works worthy of mention (except for *nō* masks) were created after the deaths of the artists of the Sanjō-bussho (or En-pa) and Shichijō-bussho (or In-pa) schools. The first was traditionalist and continued the work of the Heian period, although it was also strongly influenced by the art of the Southern Sung dynasty. (Several paintings and sculptures had arrived from there at the end of the twelfth century, and two brothers by the name of Ch'ēn came from China and were employed by a friend of Chōgen to assist him in recasting the monumental Buddha at Tōdai-ji.) The only sculptors of the En-pa school who attained any kind of fame were Mei-en and his two pupils, Chō-en and Kan-en.

On the other hand, the artists of the In-pa school—particularly Unkei and his spiritual heir, Kaikei (who also knew one of the Ch'ēn brothers, Ch'ēn Ho-ch'ing)—produced a series of remarkable works. Buddhist sculptors of the In-pa school continued to follow the Heian style, but they introduced into it an element of realism that indicated a definite return to the Nara tradition. The new style was full of vigor and possessed an inner strength that had been somewhat lacking in works of the Heian period. The priests or monks executed realistic and remarkably animated sculpture in which character was revealed in a concentrated way, as in a portrait.

The sculptors of the early part of this period produced some works of extraordinary power, such as the two Ni-ō by Unkei still at the Nandaimon Tōdai-ji in Nara, and the Tentōki and Ryūtōki (two demons) by Kōben and now at Kōfuku-ji. Unkei's sons—Tankei, Kōben, and Kōshō—and their descendants—Kōen and Kōsei—and pupils—Jōkei, for example—followed the style of their father and master and produced some strongly modeled works characterized

271

by an exceptionally dynamic realism. They best symbolized the Japanese spirit of the era even though they also copied Sung models occasionally.

Works in wood were almost always carried out in the *yosegi-zukuri* technique, with the heads made separately and fastened onto the shoulders by a massive bolt. In order to give even greater realism to their works, the sculptors inlaid the eyes with painted glass *(gyokugan)* and embellished the figures with precious metal and gems. The wood was given an undercoat of *gofun* (calcium carbonate) and then painted with naturalistic colors. The portrait statues depicting important priests and patriarchs were executed with a minute precision that had never been attained before and has hardly been equaled since. Not only were these works carved with exquisite accuracy, they also reflect the sculptors' striving for a lifelike quality in both the pose and the facial expression. The forms and contours of both the bodies and the clothing were simplified, though realistically represented. The style of Unkei's school extended beyond the limits of Kyoto and Nara into the provinces as far as Kamakura, where in 1252 a large Amida was cast in bronze. Its style was incomparably superior to that of the Tōdai-ji's colossal Buddha.

Painting

The new sects that sprang up, those which reappeared (Kegon, Ritsu) and which developed in new directions during the Kamakura period, needed an iconography adapted to their doctrines. Since sculpture was relatively scarce and also expensive, it became necessary to rely on painters to create images of the divinities with which to grace the temples. At the start of the Kamakura period paintings from the Southern Sung dynasty injected new life into Japanese art. Even the hitherto static works of esoteric Buddhism became animated. The Amida cult inspired innumerable representations of Amida Buddha—generally *raigō* scenes (his descent from the Western Paradise to receive the souls of the faithful)—but new works depicting Amida's descent accompanied by Bodhisattvas were far more animated and less tight in their execution than calm portrayals of the Heian period. However, traces of this early serenity can be discerned in the paintings depicting the Amida rising from behind the mountains, radiant with light—works splendidly enriched with gold leaf. In addition to these subjects, there were those showing Hell, in which demons and their methods of torment were rendered with animation and emphatic realism. There were also pictures of goblins and phantoms (grotesque figures, almost caricatures) and infernal deities (such as the Taoist-inspired Ten Judges of the Underworld). Like the holy icons, portrayals of individual figures were precisely and realistically rendered even though the features of the Buddha were often stylized: the eyes were almond-shaped slits, the mouths small and finely shaped. Clothing was depicted with elaborate care and often reflected Chinese styles.

Paintings created for the Zen monasteries primarily depicted either monks or the Rakan (Arhats), and were often copies in pure Chinese style of Sung prototypes. In fact, most of the portraits were influenced by Chinese art, although there was a definite search for *nise-e* (likeness). Those of Emperor Go-Shirakawa, of Minamoto Yoritomo, of Taira Shigemori, of Hōnen, and of Kōshō were the works of such famous portraitists as Fujiwara Takanobu (1142–1205) and his son Nobuzane (1176–c.1265), and from them we can gain some idea of the personality of the sitters. Some of the portraits, drawn with fine and minute lines, were lightly colored (the portrait of Emperor Hanazono at Chōfuku-ji temple, for instance), while others were painted with bright colors.

Perhaps the most numerous works produced in this period were the illustrated tales and chronicles painted on long horizontal scrolls *(emakimono)*. Religious subjects, histories of holy men or temples, descriptions of Hell, narratives of wars, and chronicles of voyages, or even simple tales were treated in an identical fashion. In most cases the illustrations were incisively drawn with

India ink on paper, although silk was sometimes used. Often they were brilliantly colored; and in these cases the paint concealed the original underdrawing and the details (facial features and textile patterns) were applied last in black ink. This technique is known as *tsukuri-e*.

Works in the *tsukuri-e* technique were characterized by a far more intense realism (the *Sagoromo Monogatari E*, for instance) than the *emakimono* paintings of the preceding era. Some scrolls contain swift sketches in India ink, very faintly colored (the *Emakimono of the Attendant Cavalrymen*), while others are almost as brilliant as the most lavish medieval illuminated manuscript (the *Miracles of the Kasuga Shrine*, for instance).

As in Heian period scrolls, the observer looks down on the scene, and roofs and ceilings are eliminated in the interiors. However, now the subject matter was depicted from a different vantage point in order to give added scope to landscapes or interiors. The drawings were no longer derived solely from literary sources, but also included scenes showing animals, soldiers, common people—they are always lively: sometimes violent, sometimes caricatured *(The Illustrated Handbook on Long-nosed Goblins*, and the *Chōjū-giga)*. *Emakimono* illustrations were primarily faithful depictions (and often sarcastic commentaries) of the life during that period *(The Story of the Painting Master* and *The Poetry Competition of Tōhoku-in)*.

Finally, a special new type of painting was developed: a panoramic bird's-eye view depicting monastery complexes, shrines, or other sacred places. Sometimes the image of a deity was shown hovering over these scenes, thus associating the Buddhist idea of the divinity with the Shintoist concept of the sacred site (the *Mandala of the Kasuga Shrine* or the *Mandala of the Three Mountains* at Kumano). Primarily, however, these were landscape paintings.

Yet the significant contribution which gave Kamakura period painting its unique importance was that for the first time in the history of Japanese art real persons were accurately portrayed in works that depicted them as living beings who inhabit a real environment.

220. NARA. HANNYA-JI. STONE PAGODA. This thirteen-tiered stone pagoda topped by a *sōrin* was erected in 1261 by a Chinese stonemason, I Hsing-chi. The interior of this unusual structure contained several relics, including a small bronze image of Shaka Nyorai (see plate 98). Height c. 49′.

221. NARA. TŌSHŌDAI-JI. KORŌ. This charming two-story building is the Drum Tower or Korō. Constructed in 1240, it is an example of the pure *Wa-yō* style. The roof is of the *irimoya* type.

222. KAMAKURA. FUNA-GATA-STYLE BRACKET. This type of wood bracket is called *funa-gata* because of its boat-like shape. It is the least complex type of bracket.

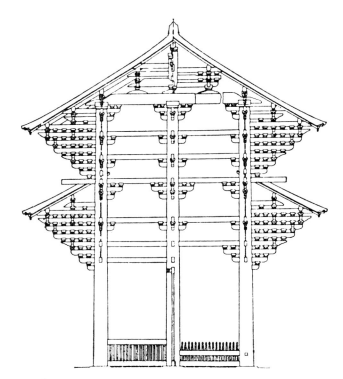

38. CROSS SECTION OF THE NANDAIMON OF TŌDAI-JI

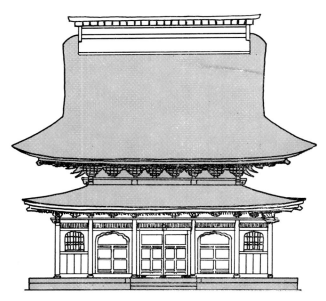

37. THE SHARIDEN OF THE MONASTERY OF ENGAKU-JI
IN KAMAKURA (1279)

223. NARA. ISO-NO-KAMI JINJA. GATEWAY. This two-story gateway *(rōmon)* was built in 1317. The general structure is in the *Wa-yō* style, and the roof is of the *irimoya* type.

224. NARA. TŌDAI-JI. SUPPORTING PILLAR OF THE NANDAIMON. This is a portion of one of the ancient pillars of the Nandaimon. Built in 1199, it is the largest Kamakura period gateway extant today (see also plates 226–27).

225. NARA. TŌSHŌDAI-JI. THE RAIDŌ. A very long building, nineteen bays by four, this unusual hall actually consists of two separate structures linked by a passage and further unified by a single *irimoya* roof.

226–27. NARA. TŌDAI-JI. BRACKETING OF THE NANDAIMON. This two-storied gateway was reconstructed in

1199 in pure *Tenjiku-yō* style, which is characterized by *sashi*. The photograph shows the intercolumnar *hijiki*, or brackets, which are inserted through the pillars. This unique "Indian style" bracketing, peculiar to Kamakura period construction, was used in the reconstruction of the great Daibutsu-den of Tōdai-ji. Plate 227 gives one an idea of the Nandaimon's great size.

228. NARA. ISE MONOGATARI SHITAE BONJI KYŌ. This Sanskrit sutra was printed over scenes illustrating the *Ise Monogatari*. Thirteenth century. Height 8⅝″. Yamato Bunkakan Museum.

229. KYOTO. NISHI HONGAN-JI. A prayer written by Shinran (1173–1262).

230. KYOTO. NAKI-FUDŌ ENGI. This thirteenth-century *emakimono* narrates the legend of the weeping Fudō (Acalanatha), and is called *The Miracles of Fudō Myō-ō*. This detail shows a peasant woman washing clothes by treading on them in a small stream. (See plate 235.) Kyoto National Museum.

231. NARA. SANJUROKU KASEN EMAKI. PORTRAIT OF KODAI-NO-KIMI. This portrait of the famous poetess (sometimes known as Ko-ogimi) has been attributed to Fujiwara Nobuzane (1176–c. 1265). Originally a work in two scrolls, the *Sanjuroku Kasen Emaki* presents a brief description of the lives of thirty-six renowned poets and poetesses, alongside portraits of them and a sample of their poetry, a *waka* of thirty-one syllables.

The scrolls have been cut up into individual sections and distributed among various museums. Kodai-no-Kimi was a lady-in-waiting in the household of Prince Sanjō. The portrait here is representative of *nise-e*, or the "likeness" style. Color on paper. Height 14". Yamato Bunkakan Museum.

232. NARA. GENJI MONOGATARI. This is an illustration for the Chapter of Ukifune from Lady Murasaki's famous novel, *Genji Monogatari* (beginning of the eleventh century). The artist is unknown, but the scroll probably dates from the Kamakura period. *Sumi-e* style of painting on paper. Height 7½". Yamato Bunkakan Museum.

233. OSAKA. GENJI MONOGATARI. An illustration from a later version of the *Genji Monogatari*. In colors on paper. Osaka Municipal Museum of Art.

234. HASEO SŌSHI EMAKI. A detail from the last section of an illustrated scroll which presents the story of Lord Haseo who triumphed over a demon in a game of backgammon *(sugoroku)* and won a beautiful girl. The demon made Haseo promise not to touch her for one hundred days but Haseo broke his word and the girl turned to a puddle of water. Late thirteenth to early fourteenth century. Hosokawa Collection.

235. KYOTO. NAKI-FUDŌ ENGI. Another illustration from *The Miracles of Fudō Myō-ō.* (See plate 230.) Kyoto National Museum.

236. KYOTO. NISHI-HONGAN-JI. SHINRAN SHŌNIN. This portrait of the priest Shinran by Sen Amida Butsu, the son of Fujiwara Nobuzane, dates from the thirteenth century. It is a *kakemono* (vertically hung scroll) painted in the *sumi-e* style.

237. TOKYO. IPPEN SHŌNIN E-DEN. Painted by En-i on silk, and dated 1299, this work consists of twelve scrolls (this is from scroll No. 7) narrating the life of the priest Ippen (1239–1289). Here we see the crowd pressing forward to hear the chanting of the *nembutsu* (repetition of Buddha's name). Height 15". Tokyo National Museum.

238. NARA. BON-TEN. A divinity of esoteric Buddhism, Bon-ten (Brahma) is one of the Jūni Ten, the Twelve Heavenly Kings, or devas. A *kakemono* in color on silk, it dates from the thirteenth century. Nara National Museum.

239. KYOTO. THE DEATH OF BUDDHA. This is a detail from a large *kakemono* in color on silk dating from the beginning of the fourteenth century. Depicting the death of Buddha, this portion shows the uncontrollable grief of several mourners. It was originally in the monastery of Zenrin-ji. Kyoto National Museum.

240. JIZŌ BOSATSU. This wooden image, originally in the monastery of Shinzenkō-ji, portrays the Bodhisattva Jizō (Ksitigarbha), the guide of travelers and savior of souls consigned to Purgatory or Hell, holding his staff *(shakujō)* in his right hand and the miraculous jewel, *hoshū*—which grants all desires and illumines the Region of Darkness—in his left. The figure is depicted seated on a rock, with its left foot resting on a gilded lotus. The necklace is of metal. Thirteenth century. Kyoto Municipal Museum of Art.

241. NARA. JIKOKU-DANI. JIZŌ BOSATSU. This stone image is situated at a crossroad. It holds its staff in one hand and the jewel, *hoshū*, against its chest with the other. The faithful have tied a bib around its neck, symbolizing their prayers to this divinity, one of whose functions is the protection of the souls of children in Purgatory. Height 73".

242. NARA. RAKEI BUDDHA. This unpainted wooden image represents an unclothed Buddha (an unusual occurrence in iconography). The figure's halo is made of gilded metal. This statue belonged to a temple of the Jōdo sect. End of the Kamakura period. Nara National Museum.

243. NARA. TŌDAI-JI. SANGATSU-DŌ. JIZŌ BOSATSU. This image is of painted wood and is seated on a rock-shaped pedestal. The *yosegi* technique was employed, as was the case with most wooden statues of this period. In this photograph, Jizō is seen through the legs of a statue of Zōchō-ten. Both of these works form part of a group of many divinities surrounding the hall's central figure, the Fukū-kenjaku Kannon. Height 32⅝".

244. KAMAKURA. KŌTOKU-IN. THE GREAT DAIBUTSU. This colossal bronze statue of Amida Nyorai (Amitabha) is reputed to have been cast by a certain Ōno Gorō-zaemon, of whom nothing is really known except his name. It was a replacement for a huge wooden image erected through the devout efforts of Lady Idano-Tsubone (who had been an attendant of Minamoto-no-Yoritomo) and the priest Jōkō, whom she enlisted to help her in this pious endeavor. Jōkō traveled all over the country to obtain funds, and the wooden Buddha was finally completed in 1243. However, in 1248 it was badly damaged by a severe storm, and Lady Idano-Tsubone and Jōkō once again raised funds, this time to erect a bronze statue which was finally completed in 1252. The great hall built to house the wooden Buddha was also ruined in the 1248 storm, and a new one was constructed for the bronze image; however, it too was destroyed in 1495 by a tidal wave of unprecedented fury, and since then the statue has remained exposed to the elements. The bronze was cast in horizontal sections by the *igarakuri* technique—like the enormous Daibutsu of Tōdai-ji at Nara. It is hollow, allowing one to ascend its interior, which is illuminated by two windows cut into the Buddha's back. It was last repaired and thoroughly reinforced in 1960–61. Height c. 44'. Weight 124 tons.

275

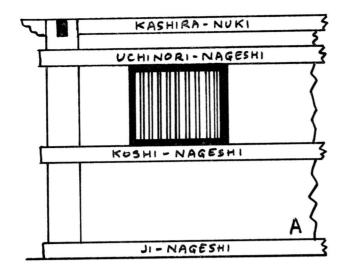

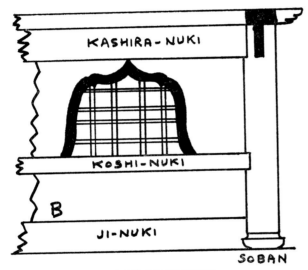

39. TYPES OF WINDOWS
A. RENJI-MADO (WA-YŌ STYLE);
B. KATŌ-MADO (KARA-YŌ AND COMPOSITE STYLES)

245. NARA. SEPPŌ-IN AMIDA BUTSU. Made of lacquered and gilded wood, this image of the Amida Buddha preaching shows the hands in the ritual gesture of *Seppō-in (Vitarkamudra)*. The fingers are webbed. The statue was originally in the monastery of Saidai-ji. Thirteenth century. Nara National Museum.

246. KYOTO. ROKUHARAMITSU-JI. KŪYA SHŌNIN. This is a portrait of the priest Kūya of the Jōdo sect, the founder of the monastery of Rokuharamitsu-ji and one of the expounders of the efficacy of *nembutsu* (the invocation of the Amida Buddha by endlessly repeating his name). The invocation is shown issuing from his mouth in the form of tiny Amida Buddhas. This unusual work in painted wood was carved by Kōshō, one of the sons of Unkei. The figure is shown holding

his pilgrim's staff in his left hand and striking a gong hanging from his neck with his right hand. The eyes are inset with glass *(gyokugan)*. Height 5' 10".

247. NARA. NEHAN-ZŌ. This type of image is known as a Sleeping (or Dead) Buddha. The work shown here is of gilded wood and was originally in the monastery of Shōgen-ji. Thirteenth century. Nara National Museum.

248. NARA. ZENKŌ-JI. AMIDA SANZON. This Amida triad in gilded wood, composed of two Bodhisattvas and a central Amida is one of the many triads made in imitation of the secret images preserved in Zenkō-ji temple in the village of Nagano in Shinano province. Thirteenth century. Tokyo National Museum.

249. RYOSAN-JI. NYOIRIN KANNON. This large wooden statue represents a seated Nyoirin Kannon. The folds of the robe are remarkably well executed, but the facial features are somewhat heavy. A realistic work which conformed to the dignified and rather austere style of the Kamakura period. Height 78".

250. NARA. HANNYA-JI. MONJU BOSATSU. This small image of Monju Bosatsu (Manjusri) mounted on a lion has been attributed to Kōshun. It is dated 1324. Total height 17¾".

251. NARA. HOKKE-JI. MONJU BOSATSU. Like the previous work, this gilded wood image is seated on a lotus, mounted on a lion, and holds a lotus blossom topped by a scroll of sacred scriptures in its left hand and the sword of wisdom in the other. The very beautiful body halo *(kōhai)* is delicately carved in wood.

252. NARA. SAIDAI-JI. EISON. The work of Zenshun, this polychromed wood statue was made in 1280 and is a realistic portrait of the Zen priest Eison (1201–1290), famed for his charitable works. In 1262 he was invited by Hōjō Tokiyori to preach in Kamakura. Height 35⅞".

253. NARA. KŌFUKU-JI. NANENDŌ GYŌGA. This is a portrait of the priest Gyōga, one of the Six Patriarchs of the Hossō sect. It is executed in lacquered wood, and the eyes are inset with obsidian *(gyokugan)*. Together with the statues of the other patriarchs, this work was executed in 1189 at the beginning of the Kamakura period under the supervision of the sculptor Kōkei. Height 32¼".

254. NARA. YAKUSHI NYORAI. A relief on an imitation mirror of wood, this image is typical of representations of divinities of Buddhist-Shintō syncretism. Objects such as this could be hung on the walls of either the Buddhist temples or the Shintō shrines. Kamakura period. Nara National Museum.

255. NARA. SAIDAI-JI. MIROKU BOSATSU. This huge

statue of gilded wood, in the *yosegi* technique, has been attributed to a disciple of the priest Eison (see plate 252). The same sculptor probably executed the *honzon* (the principal image) of the Kondō (main hall) of this temple. Kamakura period. Height 10′.

256. NARA. EN-NO-GYŌJA. This is an idealized portrait of the priest En (634–?), who is known as the founder of the Way of Mountain Asceticism (Sangaku-jujutsu). This wooden statue was made in 1286 by Kōshun, and was originally in the Sainan-in temple. Effigies of En are always accompanied by two demons *(oni)*. (See plate 272.) Private collection.

257–58. KYOTO. MISSHAKU KONGŌ AND KONGŌ RIKISHI. The two guardian divinities that protect the temples (Ni-ō) personify two aspects of the power of Dainichi Nyorai. Misshaku Kongō is the guardian of the East (Garbhavira) and expresses strength: he is shown with his mouth open, and his body is painted red. Kongō Rikishi is the guardian of the West (Vajravira) and symbolizes hidden power: he is shown with his mouth closed, and his body is green. The statues are of painted wood, and their eyes are inset with colored glass. They were originally in the monastery of Manjū-ji. Height of both figures c. 84″. Kyoto National Museum.

259. KYOTO. SANJŪSANGENDŌ. GOBUJŌ. One of the twenty-eight Nijūhachi Bushū (the protectors) of Senju Kannon (the thousand-armed Kannon), Gobujō is reputed to have extraordinary strength and has the power to overcome all obstacles. Of painted wood with eyes inset with glass *(gyokugan)*, this work is attributed to Unkei or to sculptors of his school. Height c. 66″.

260. KYOTO. SANJŪSANGENDŌ. MAKORAKA-O. This is an image of the snake deva king, one of the Nijūhachi Bushū (see caption above), and it is shown strumming a lute. This statue of wood painted a pinkish white has eyes inset with glass *(gyokugan)*, and a crown of wrought metal. It has been attributed to Unkei or to a sculptor of his school. Height c. 66″.

261. NARA. JŌRURI-JI. BATŌ KANNON. This is the Bodhisattva Hayagriva, the Horse-Headed Kannon, a wrathful aspect of Shō Kannon Bosatsu (see also plate 182). Of painted wood, it is dated 1241.

262. NARA. AIZEN MYŌ-Ō. This divinity, known in Sanskrit as Ragarajapaga or Vajrarajapriya, destroys lust and greed through the purity of his Buddha-loving spirit. Of red-lacquered wood, it dates from the Kamakura period. Nara National Museum.

263. KYOTO. ONE OF THE JUNI-JINSHŌ. This is one of the twelve generals of Yakushi Nyorai (see also plates 101 and 119). Of painted wood, it was executed by Chōsei at the beginning of the Kamakura period. Kyoto National Museum.

264. NARA. JŌRURI-JI. FUDŌ MYŌ-Ō. This statue of Fudō Myō-ō (see also plate 149) with two attendants, Kongara and Seitaka, is of painted wood and is dated 1311. It is the work of Kōen, and was executed in the *yosegi* technique; the eyes are inset with glass *(gyokugan)*. The body halo is composed of flame shapes *(karura-en)*. Height c. 36″.

265. KYOTO. SANJŪSANGENDŌ. KARURA-Ō. Another of the Nijūhachi Bushū (see also plates 259 and 260), this represents the king of the Garudas (mythical birds). He is reputed to swallow evil and devour wickedness. Of painted wood, the work belongs to the school of Unkei. Height c. 66″.

266. NARA. GOKURAKU-IN. THE INFANT SHŌTOKU TAISHI. This splendid work portrays Prince Shōtoku as an infant (see also plate 193). Of painted wood, it dates from the end of the Kamakura period.

267. NARA. ZENDŌ DAISHI. This thirteenth-century statue of painted wood portraying the Zen priest Zendō was originally in the monastery of Kōmyō-ji. His headgear is the insignia of his priestly rank. Nara National Museum.

268. KYOTO. ROKUHARAMITSU-JI. TAIRA-NO-KIYOMORI. This presumed portrait of the great chief of the Taira clan, who was vanquished by Minamoto-Yoritomo, depicts Kiyomori toward the end of his life garbed as a monk and reading a sutra. The work dates from the beginning of the Kamakura period. Height 33½″.

269. KYOTO. ROKUHARAMITSU-JI. TANKEI. This is a self-portrait of the sculptor Tankei, son of Unkei. It is of painted wood, and the eyes are inset with glass *(gyokugan)*. Height 31⅛″.

270. KYOTO. SANJŪSANGENDŌ. BASŪ SENNIN. Dated 1254, this work is attributed to Tankei or to one of his disciples. Basū Sennin was a traveling hermit who devoted his life to saving souls in distress. He is sometimes called Seshin Bosatsu (see following caption). The piece is of painted wood and was executed in the *yosegi* technique. Height 61″.

271. NARA. KŌFUKU-JI. HOKUENDŌ. MUCHAKU BOSATSU. Together with Seshin (Vasubandhu), Muchaku (Asanga) was an attendant of Miroku Bosatsu (Maitreya). Executed by Unkei in 1208 at the beginning of the Kamakura period, the work is of painted wood with eyes of inset glass *(gyokugan)*. Height 76″.

272. NARA. HŌRYŪ-JI. DEMON. This is one of the two demons *(oni)* which are always shown accompanying the priest En-no-Gyōja (see plate 256). Of painted wood, it dates from the thirteenth century.

273. KYOTO. SANJŪSANGENDŌ. FŪJIN. The god of the wind, Fūjin is usually paired with Raijin, the god of

277

thunder. Fūjin carries a billowing sack containing the winds on his shoulders. (Raijin strikes on a series of gongs arranged in a circle around his head.) Painted wood. Height c. 10′.

274. NARA. KŌFUKU-JI. RYŪTŌKI. This demon is one of a pair sculpted by Kōben, one of Unkei's sons, and is dated 1215. Ryūtōki carries a lantern (not shown in this detail) on his head; the other, Tentōki, on his shoulder. Of painted wood, they were executed in the *yosegi* technique. The eyes are inset with glass *(gyokugan)*, and the bristling eyebrows are of cut metal. Height 30¼″.

275. KYOTO. ROKUHARAMITSU-JI. EMMA-Ō. The judge of Hell, Emma-ō is portrayed here wearing the robes of a Chinese magistrate. His cap of office bears a Chinese ideogram signifying "king." Of painted wood,

the work dates from the Kamakura period. Height 57⅞″.

276. KYOTO. ROKUHARAMITSU-JI. UNKEI. This detail from the self-portrait of the great sculptor Unkei shows his hands holding a rosary *(juzu)*. Of painted wood, the work dates from the beginning of the Kamakura period. Height 30¾″.

277. KYOTO. VASE. This glazed ceramic piece comes from Seto and dates from the Kamakura period. Kyoto National Museum.

278. KAMAKURA. TSURUGAOKA HACHIMAN-GŪ. BUGAKU MASK. Used in the dance-dramas, this mask is of lacquer and is a deep red color. It represents one of the characters of the *Ona-Ninomai.*

CULTURAL CHART

Indications: A = architecture; Sc = sculpture; P = painting; Po = poetry; L = literature; H = history; C = cultural influence.

c. 1185 A — Reconstruction of Nara monasteries destroyed in the Gempei Civil War. Sanjū-no-tō, the three-storied pagoda of Kōfuku-ji temple, Nara.

1187 Po — *Senzai Waka-shū* edited by Fujiwara Shunzei; anthology of *waka*.

1190 Po — Death of the priest-poet Saigyō (b. 1118).

1194 A — Tahōtō of Ishiyama-dera, Shiga.

1199 A — Death of Minamoto Yoritomo (b. 1147). Nandaimon of Tōdai-ji, Nara.

1201 Po — *Sengohyakuban Uta Awase*: anthology of 1,500 *waka* poems.

1202 A — Construction of Kennin-ji temple in Kyoto founded by Eisai, the priest who introduced Zen Buddhism into Japan.

1203 Sc — Kongō Rikishi of the Nandaimon of Tōdai-ji temple.

1204 Po — Death of the poet Fujiwara Shunzei (b. 1114).

1205 Po — *Shin Kokin Waka Shū*: anthology of *waka* poems.

1207 A — Reconstruction work begun on the Hokuendō of the monastery of Kōfuku-ji destroyed by fire in 1049 and 1180.

1208 Sc — The Muchaku and Seshin by Unkei in the Hokuendō of Kōfuku-ji temple, Nara.

c. 1210 Po — *Mumyō-shō*: anthology of poetry.

1211 Sc — The Jizō Bosatsu by Kaikei in the monastery of Tōdai-ji, Nara.

1212 Sc — Kichijō-ten of the monastery of Jōruri-ji, Kyoto.

L — The *Hōjō-ki* of Kamo-no-Chōmei: an essay.

1215 Sc — The Tentōki and Ryūtōki of Kōben in the monastery of Kōfuku-ji, Nara.

1215 Po — The fashion for the so-called *Uta Awase* poems linked by a common subject.

1216 L — The *Uji Shūi Monogatari*: collection of folk tales.

1219 Po — Death of Minamoto Sanetomo, poet and shōgun (b. 1192).

1220 L — The *Heiji Monogatari* and *Hōgen Monogatari*: epic novels.

1223 L — The *Kaidō-ki*: diary recording the events on a trip from Kyoto to Kamakura.

1224 L — *Kyōgyō Shinshō* by Shinran: a work which set forth the basic tenets of the Jōdo Shinshū sect which he founded.

P — *Portrait of Myōe Shōnin* in the monastery of Kōzan-ji, Kyoto.

L — The *Heike Monogatari*: epic novel of the Gempei Civil War.

1227 C — Dōgen founded the Sōtō sect of Zen Buddhism.

1234 Po — The *Shin-chokusen Waka Shū*: anthology of *waka*.

Sc — *Portrait of Abbot Shunjō* in the monastery of Jōdo-ji, Hyogo.

c. 1240 L — The *Tōkan Kikō*: description of a journey across the eastern barrier to Kamakura.

1241 Po — Death of the poet Fujiwara Teika (b. 1162).

1247 P — The *Emakimono of the Attendant Cavalrymen*, Ogura Collection, Tokyo.

1252 Sc — Amida Nyorai (Daibutsu): colossal bronze sculpture in Kamakura.

L — The *Jikkin-shō*: collection of "instructive" tales in three volumes.

1253 A — Construction of the Zen monastery of Kenchō-ji in Kamakura.

1254 L — The *Kokon-Chomon-Shū*: collection of legends in twenty volumes.

Sc — The Senju Kannon attributed to Tankei in the Sanjūsangendō of Rengeō-in temple, Kyoto.

c. 1265 L — The *Gempei Seisuiki*: historical novel of the Minamoto and Taira families, a variant of the *Heike Monogatari*.

1270 L–H — The *Azuma Kagami*, "Mirror of the East," a historical chronicle covering the years 1180–1220 written in *Kambun*.

1274 H — The first Mongol attack.

1281 H — The second Mongol attack.

1282 P — The *Fudō Myō-ō* by the priest-painter Shinkai in the monastery of Daigo-ji, Kyoto.

A — The Shariden of the monastery of Engaku-ji, Kamakura.

1284 A — Reconstruction of the Shōryō-in of the monastery of Hōryū-ji.

1299 P — The *Pictorial Biography of Priest Ippen*, Tokyo National Museum.

1301 Po — The *Enkyokū Shū*: an anthology of rhythmic songs.

1312 Po — The *Gyokuyō Waka Shū*: anthology of *waka*.

c. 1320 L — Great literary activity in the Five Great Zen monasteries.

c. 1330 L — The *Tsurezure-gusa* of Yoshida Kenkō: literary essay.

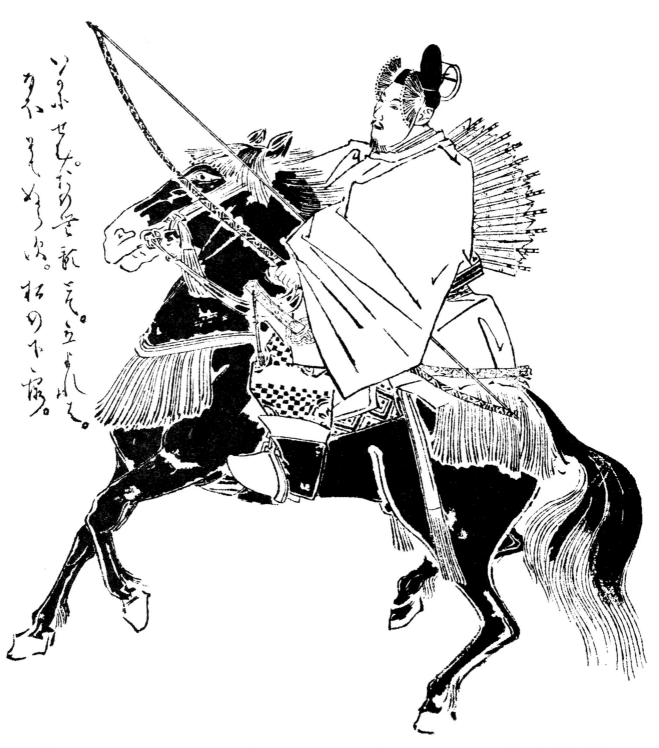

40. NOBLE WARRIOR ON HORSEBACK (FOURTEENTH CENTURY). SKETCH BY KIKUCHI YŌSAI (1788–1878)

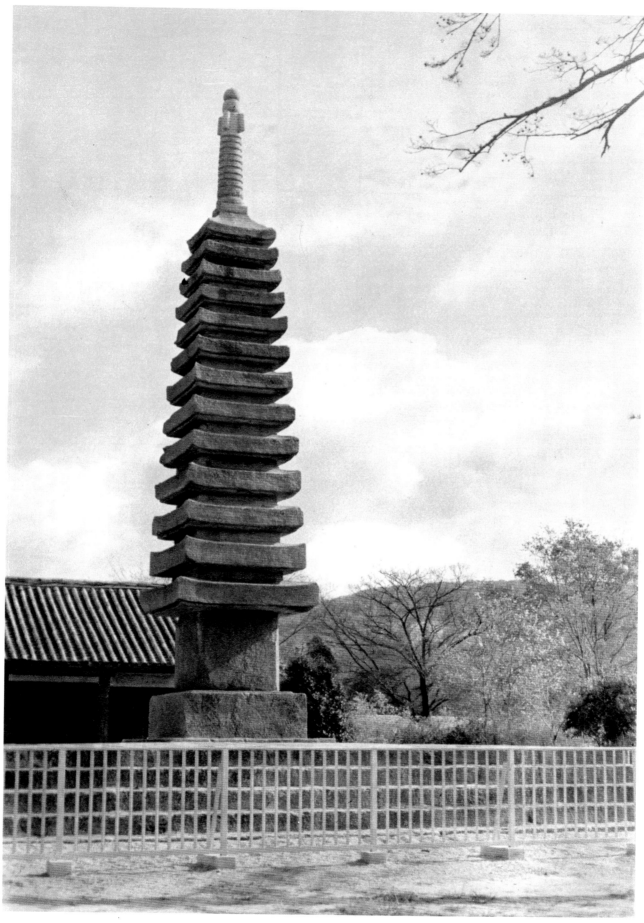

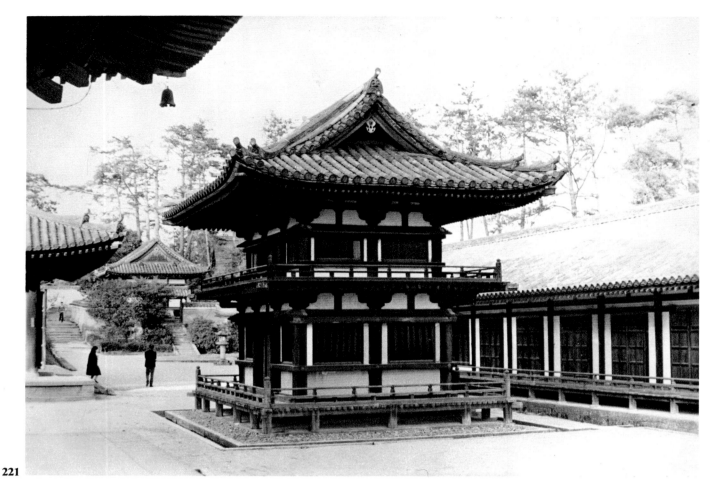

221

222

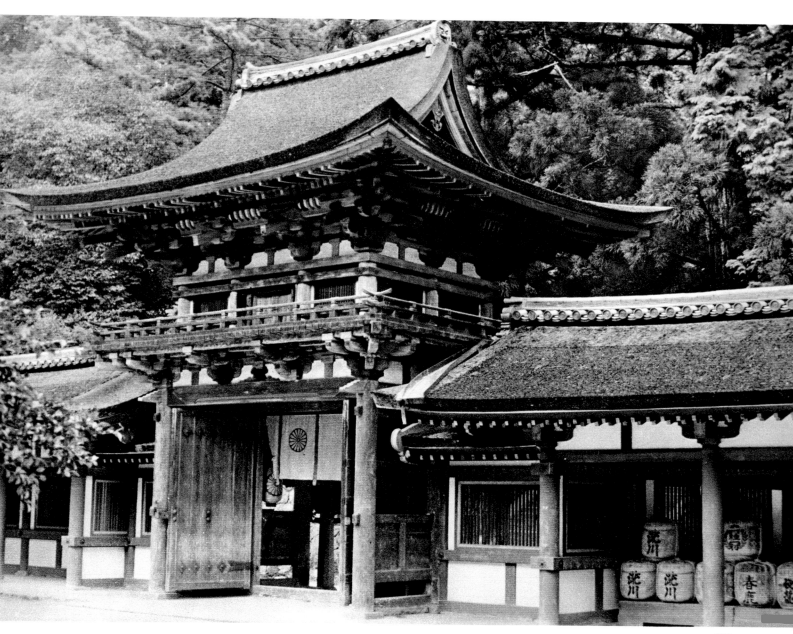

223

224

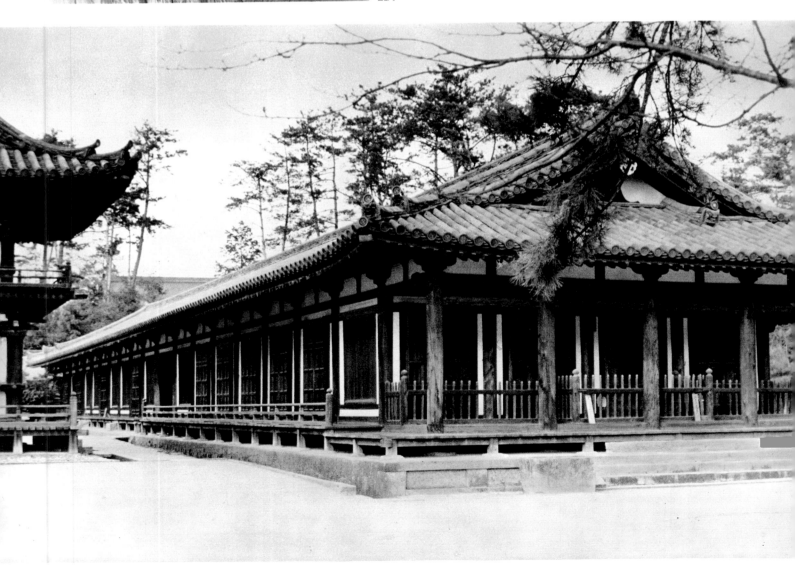

225

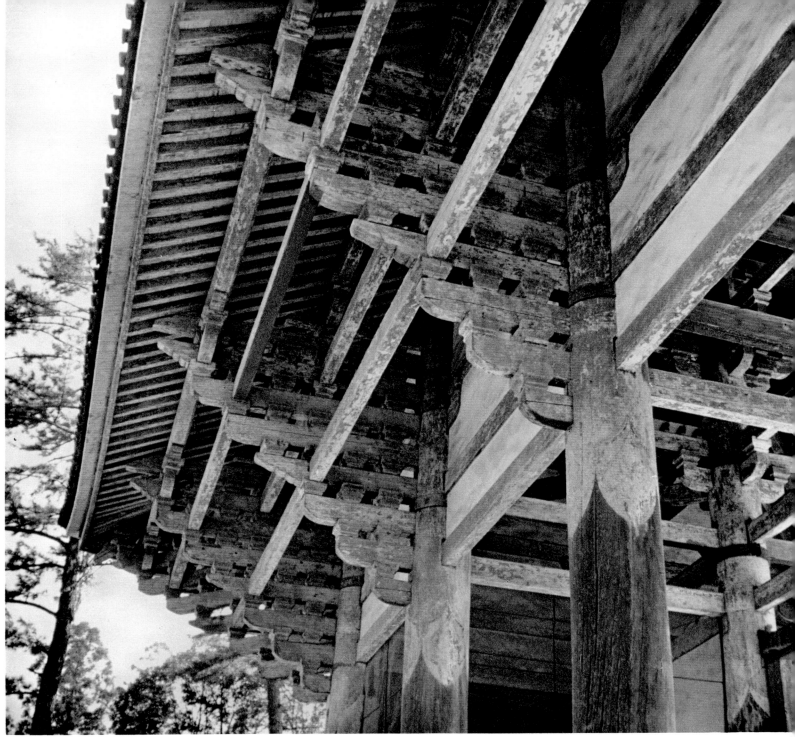

226

227

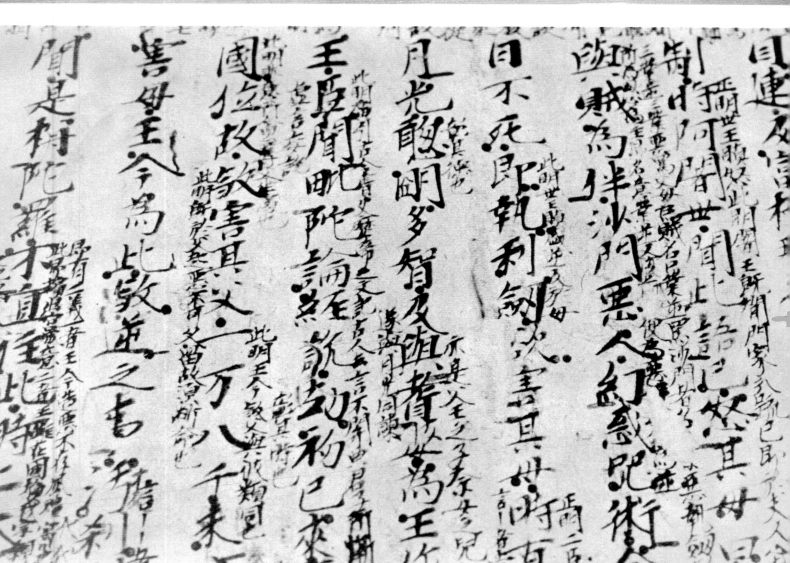

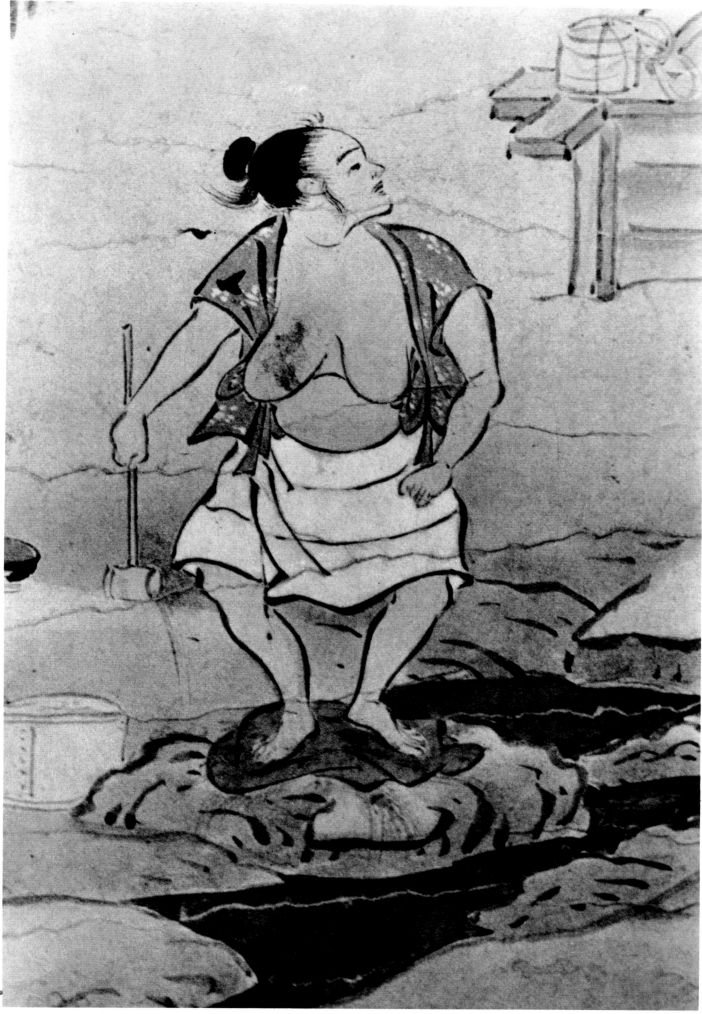

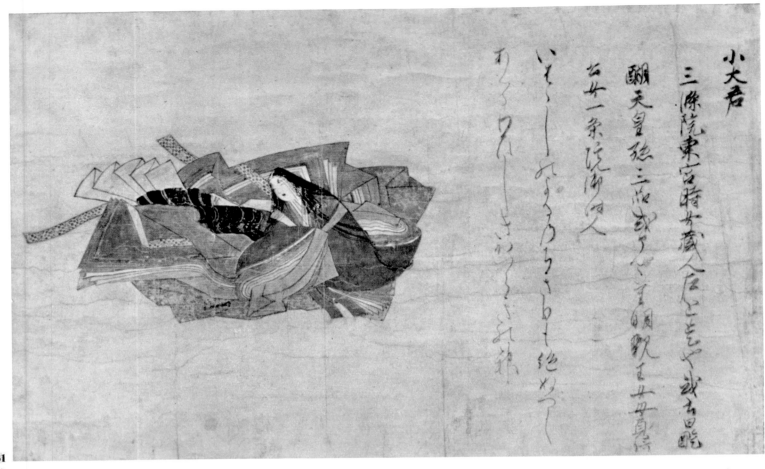

小大君

三條院東宮時女蔵人后とをや或云日眦

醍醐天皇孫三條或云天明歟王廿頁侍

右女一條院御父

いそしれするのみて絶わて

ちそれ祁てくまれ祢

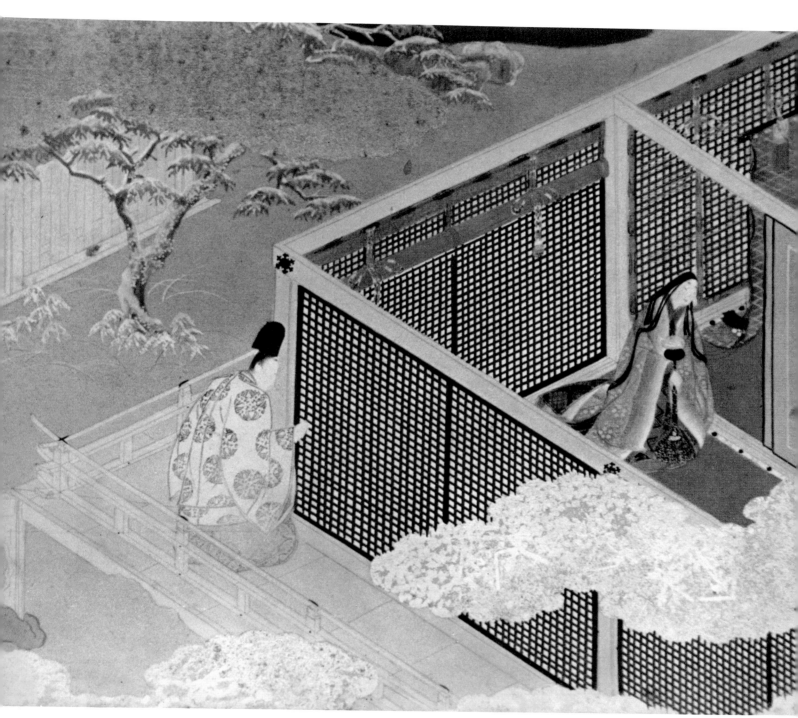

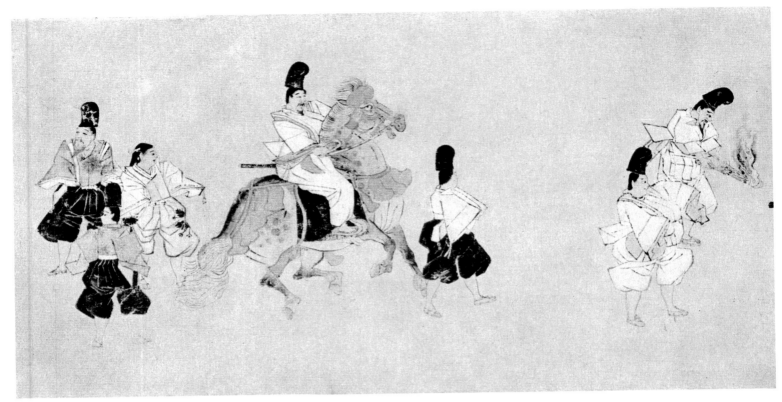

234

235

236

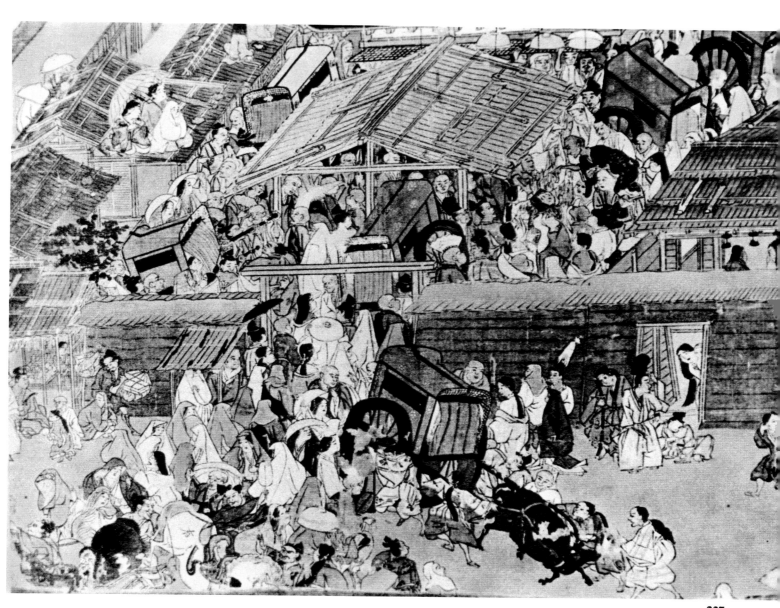

237

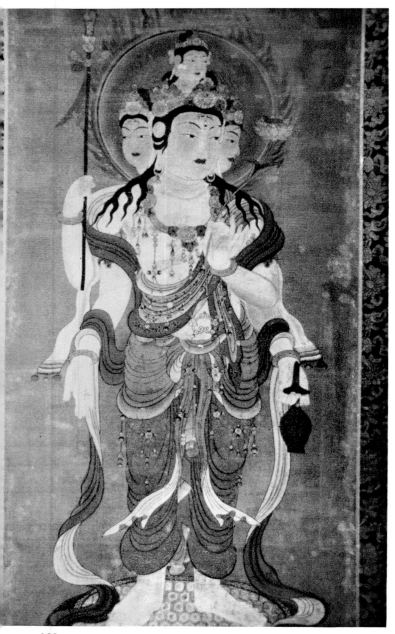

238

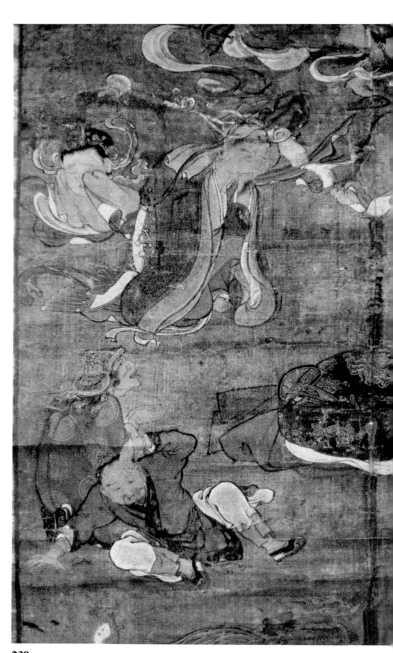

239

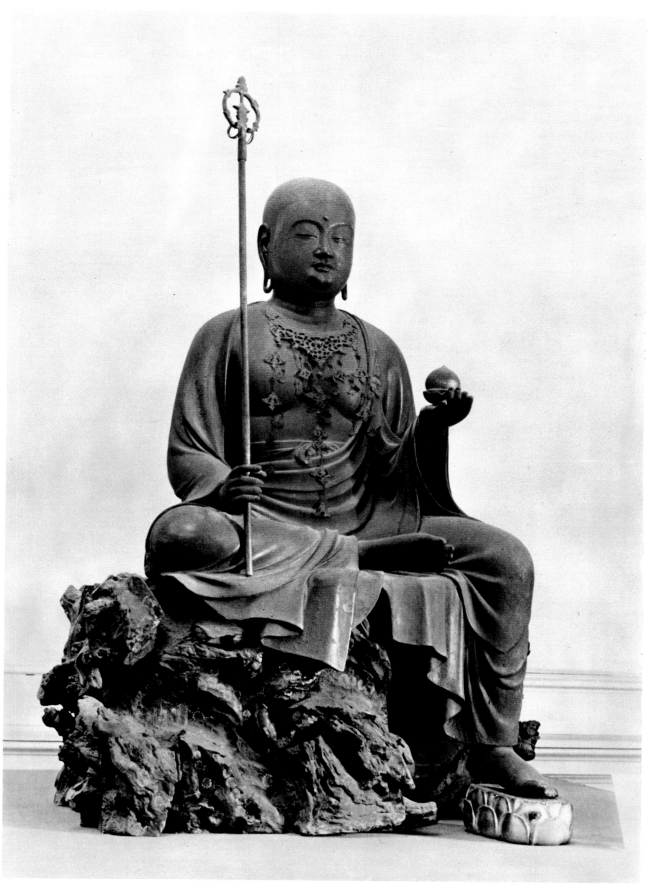

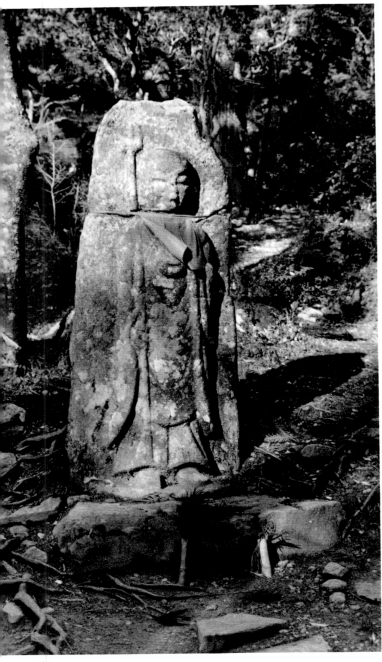

241

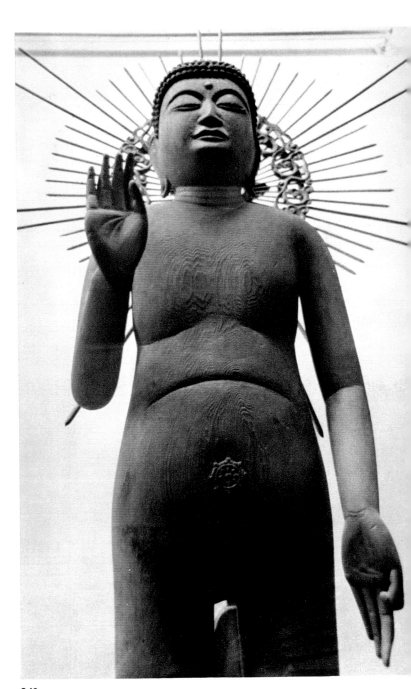

242

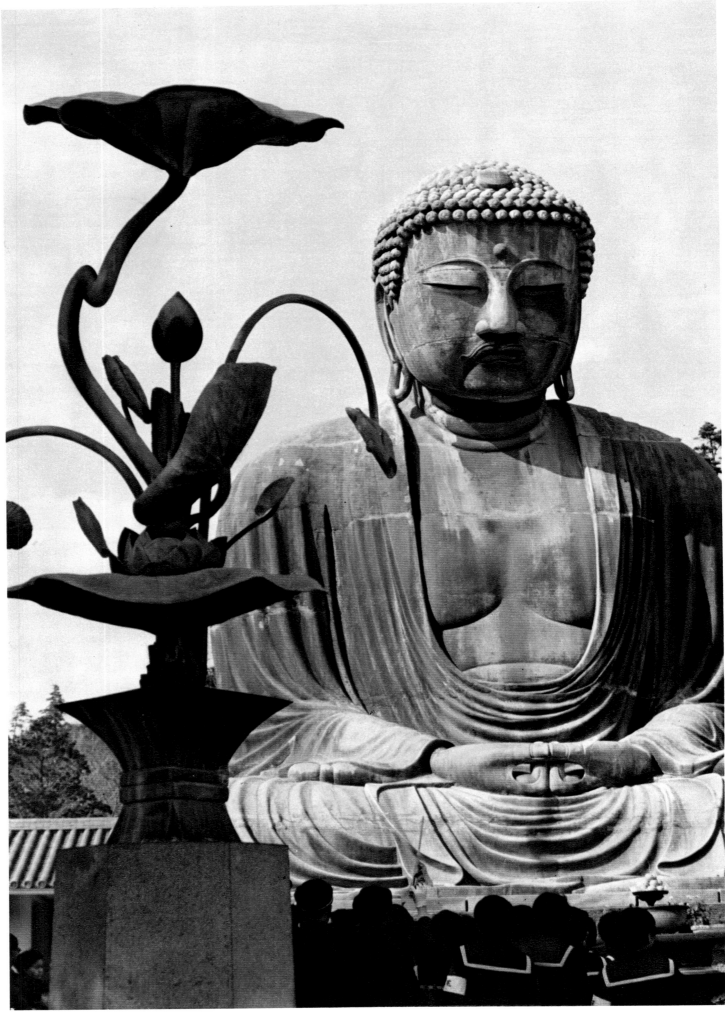

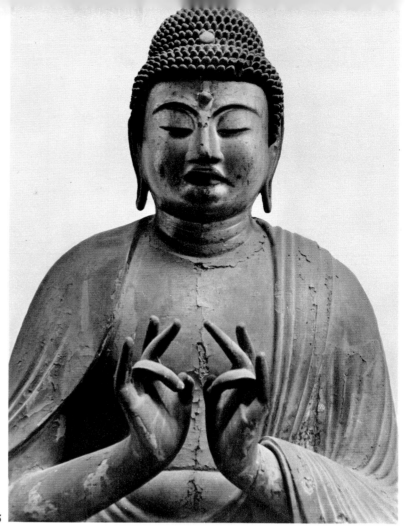

245

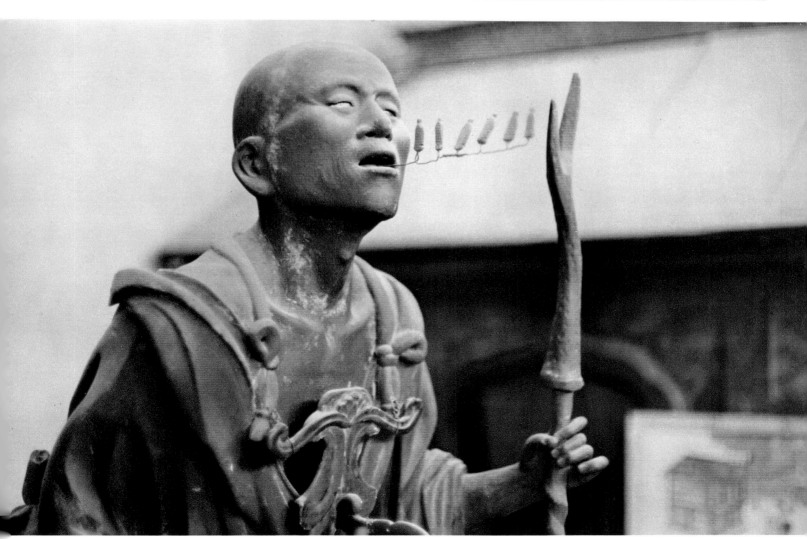

246

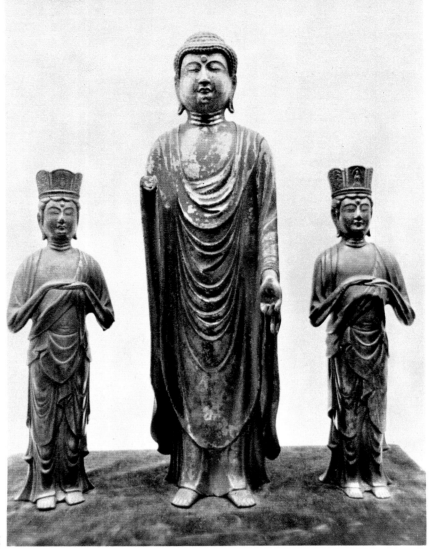

248

247

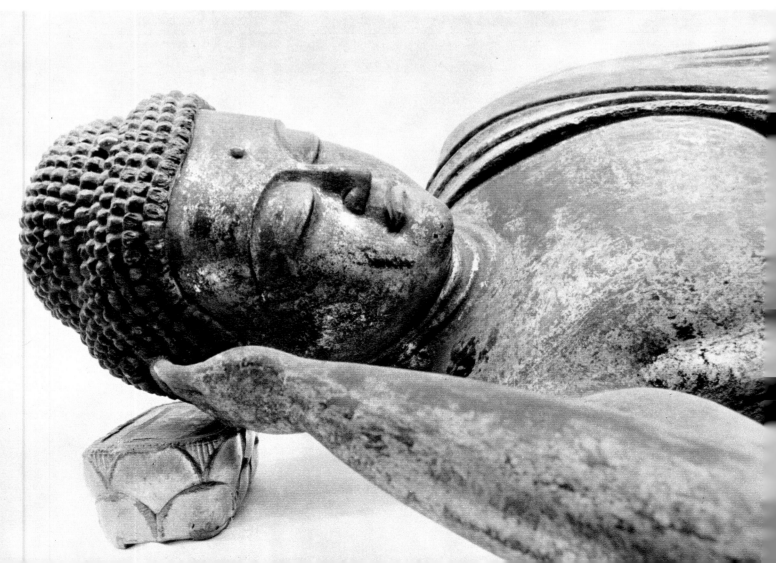

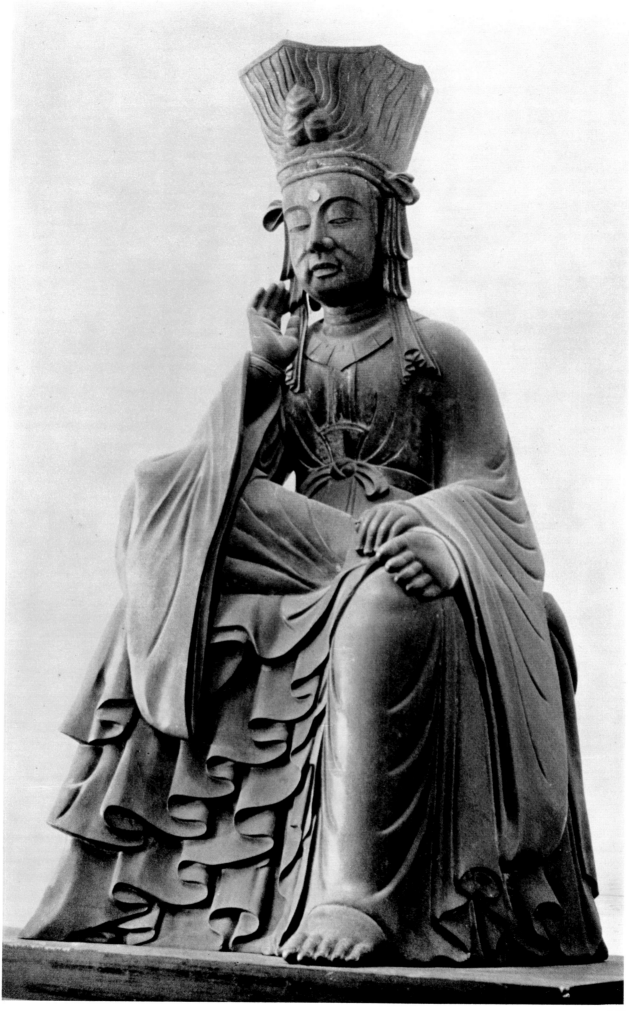

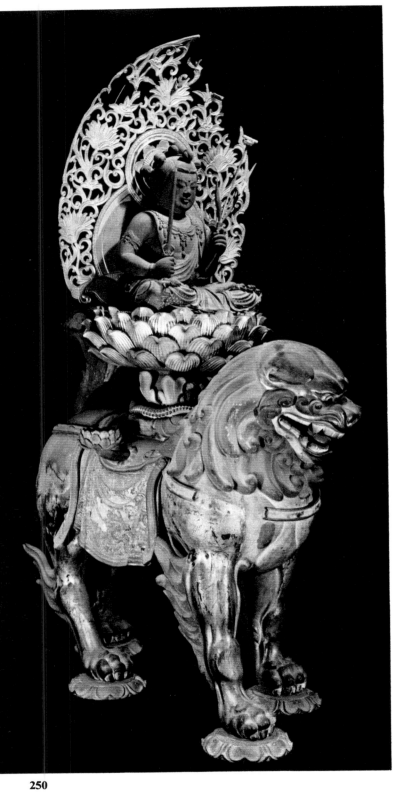

250

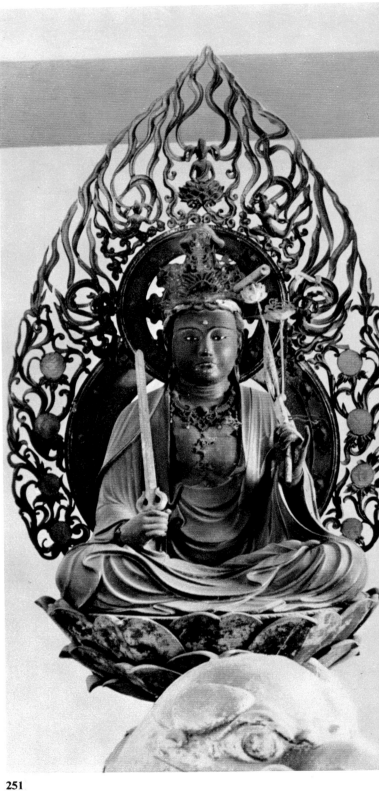

251

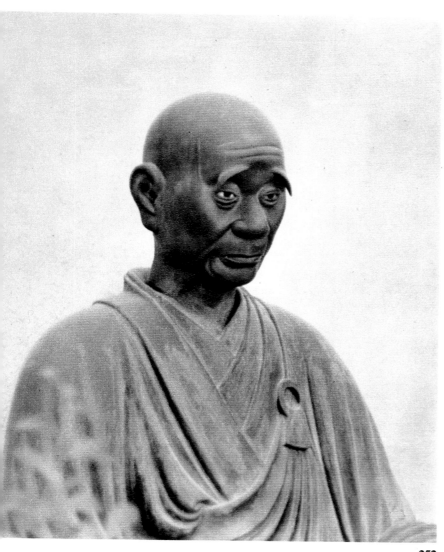

252

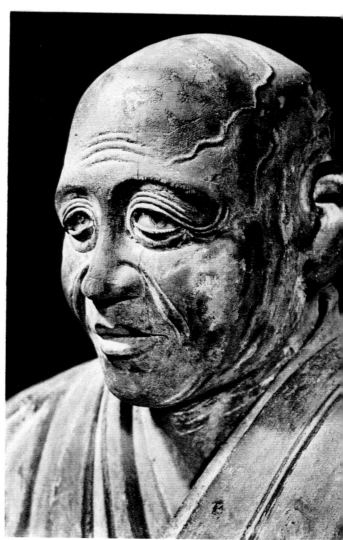

253

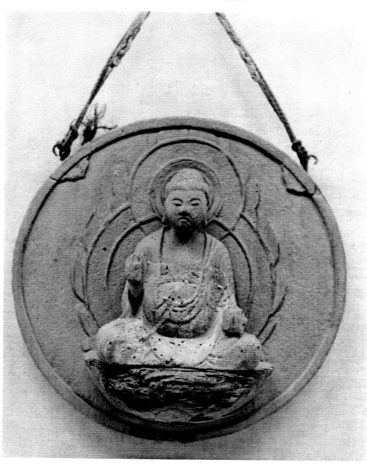

254

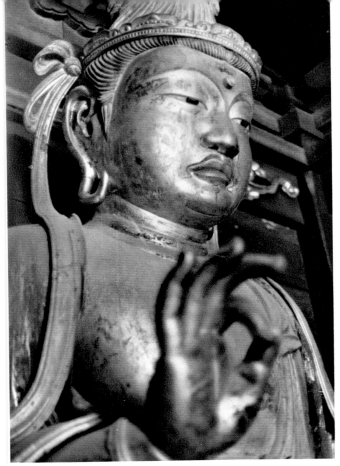

255

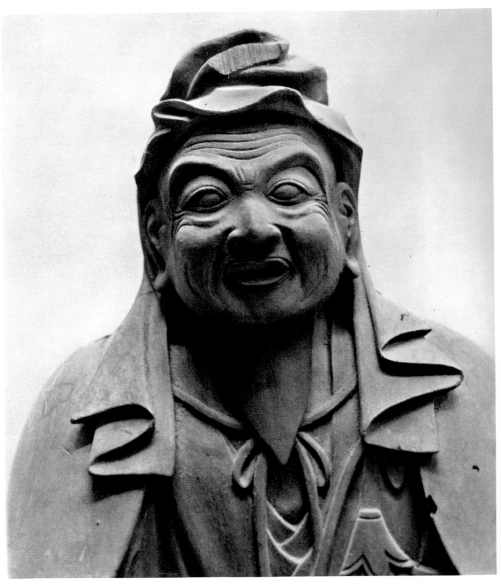

256

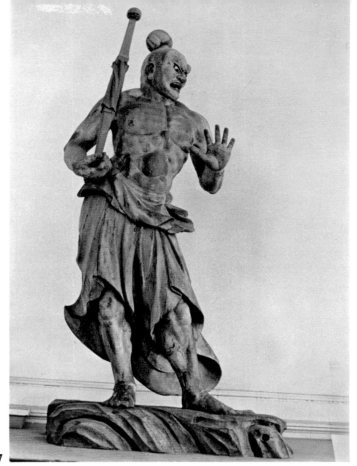

257

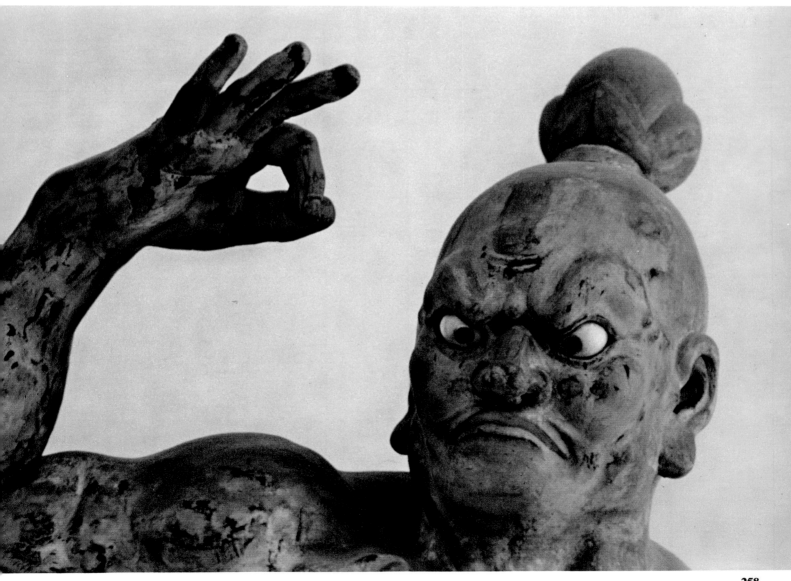

258

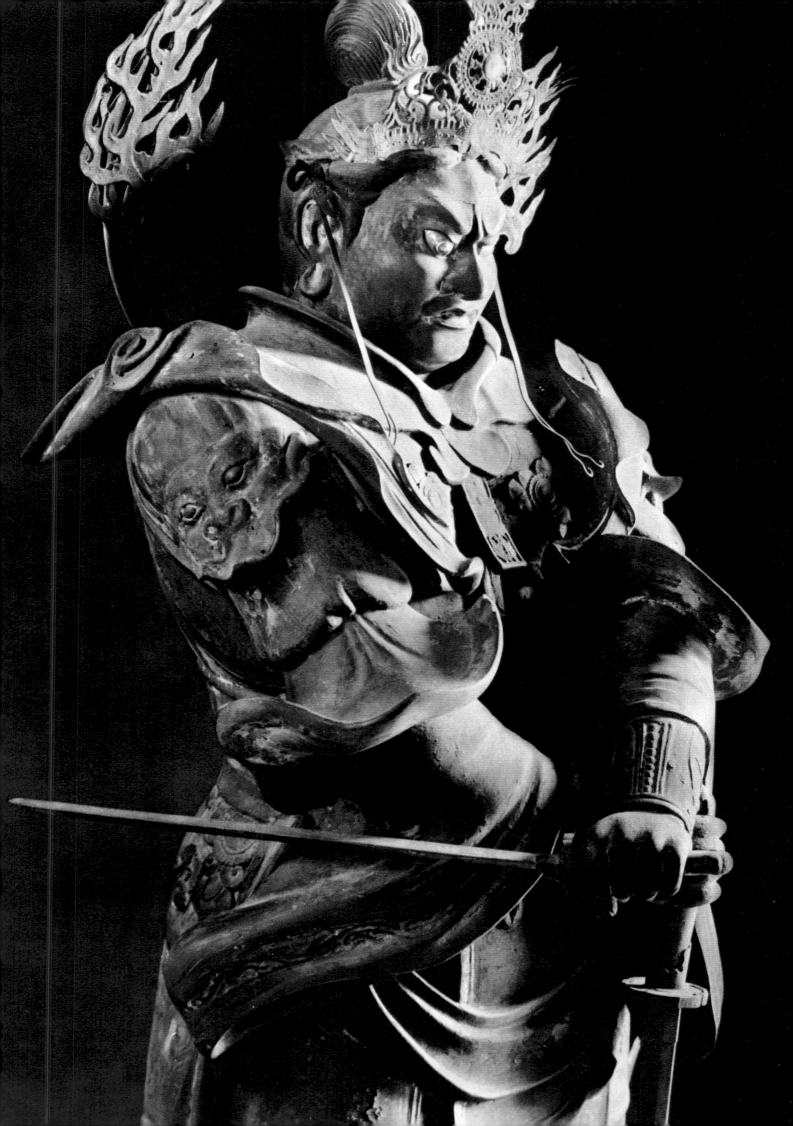

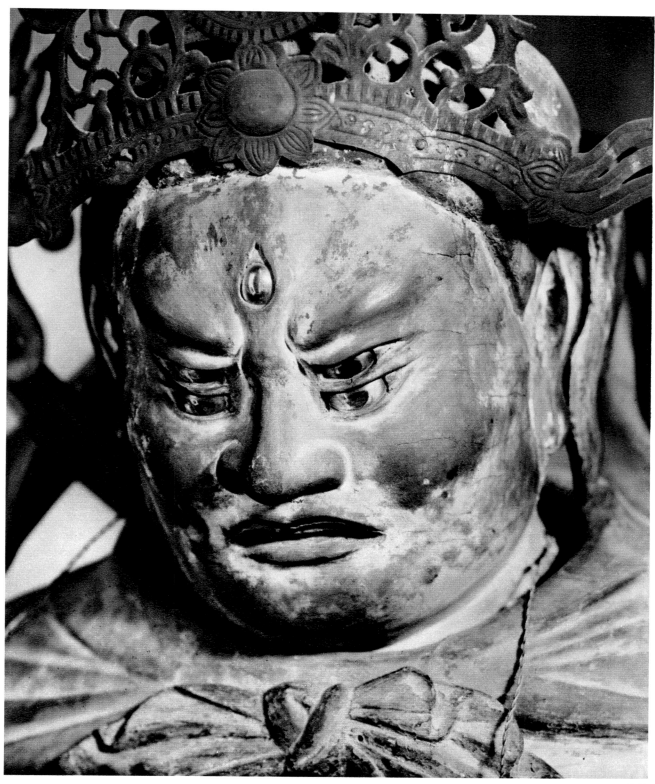

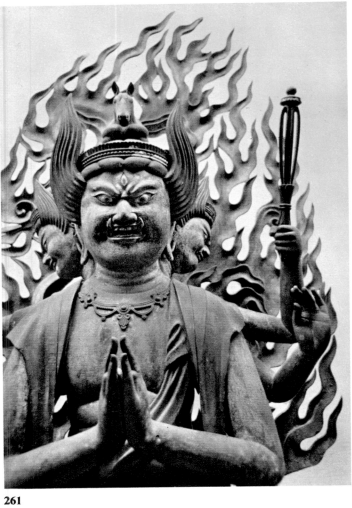

261

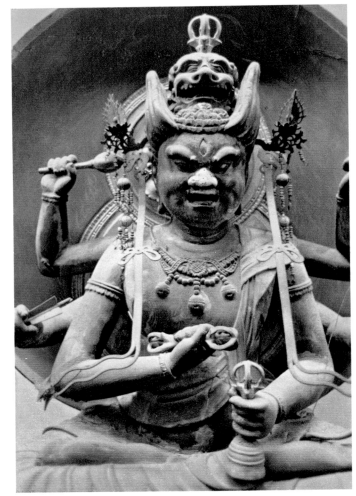

262

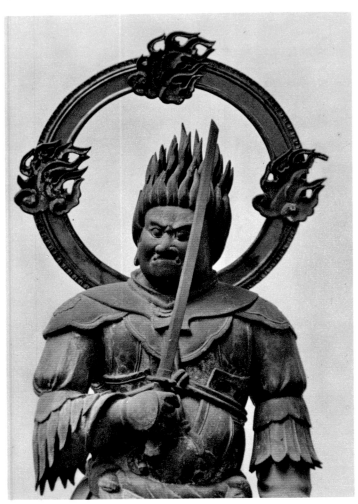

263

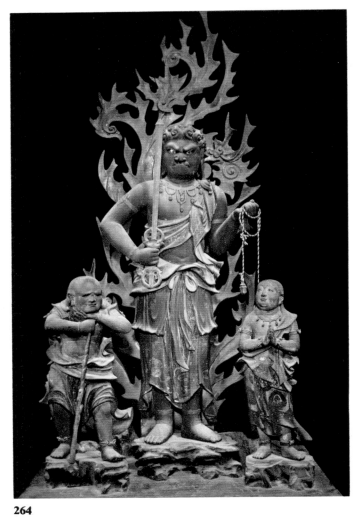

264

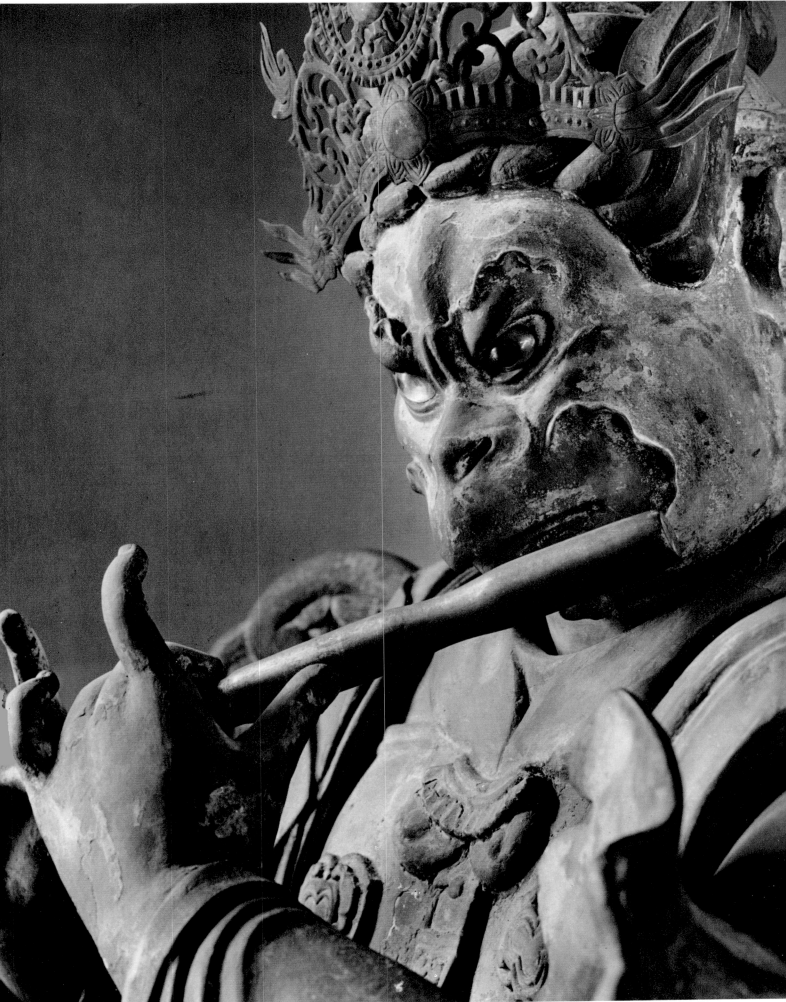

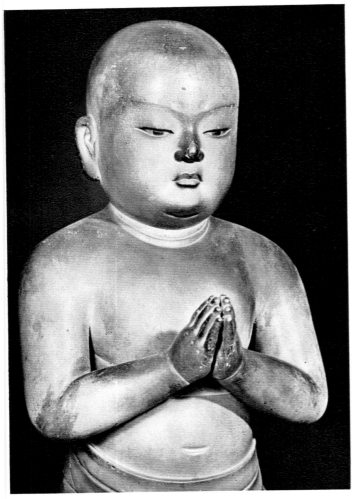

266

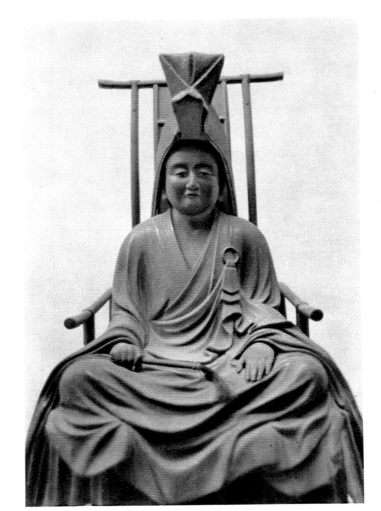

267

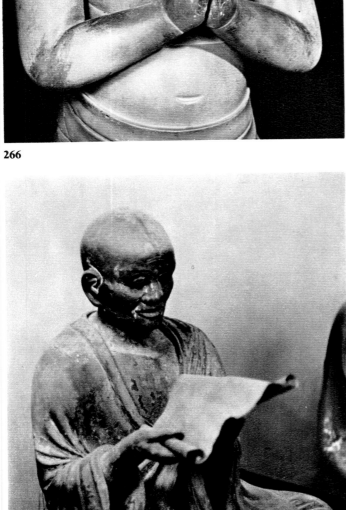

268

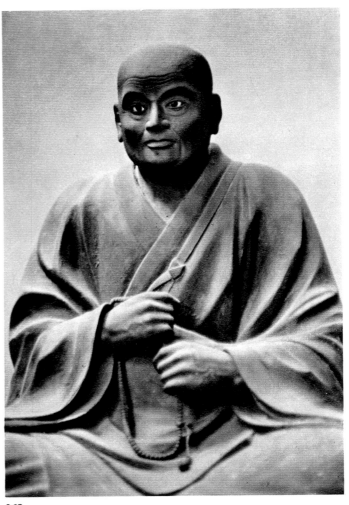

269

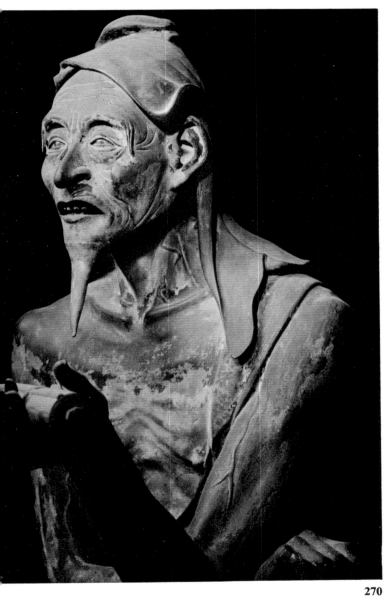

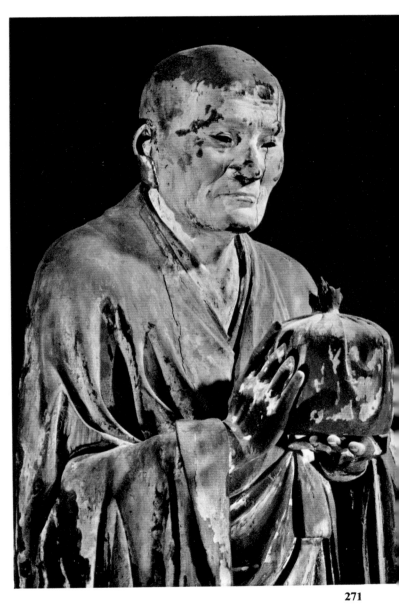

270

271

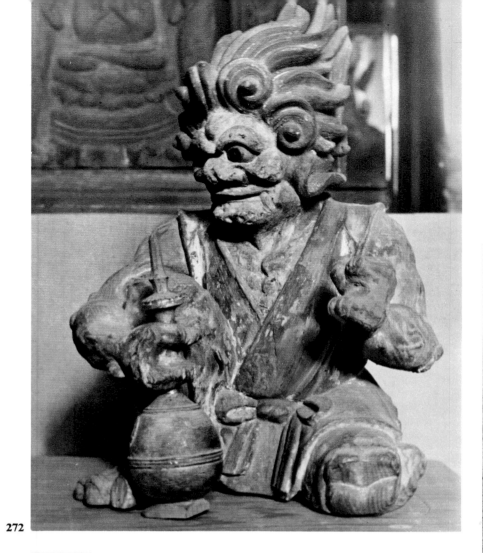

272

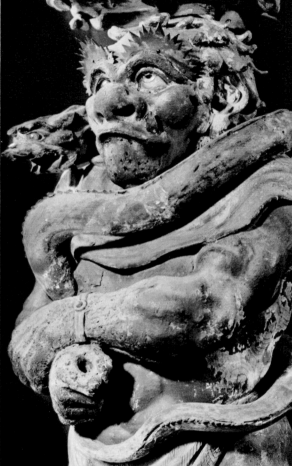

274

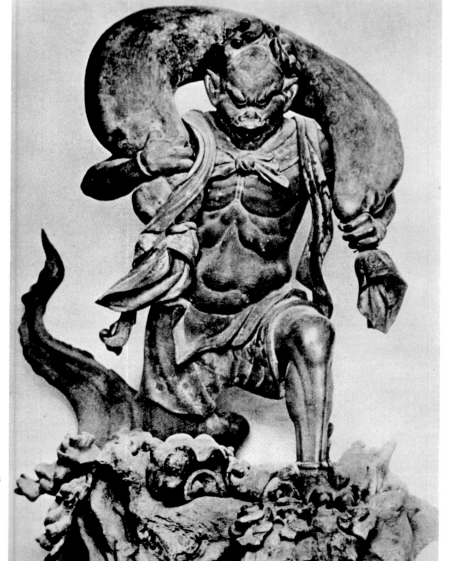

273

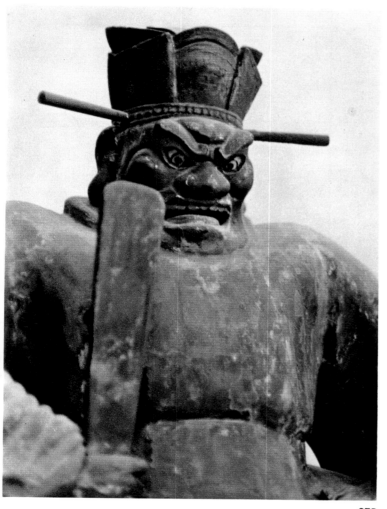

275

276

277

278

VII. THE AGE OF TURMOIL

POLITICS IN THE MUROMACHI PERIOD (1333–1582)

The War of the Northern and Southern Dynasties (1336–1392)

WHEN Ashikaga Takauji first established his military government in Kyoto, his headquarters were not far from the imperial palace; at a later date, however, he transferred them to the section of the city known as Muromachi. His power was established not without some difficulty, because he was forced to combat the supporters of Emperor Go-Daigo. Go-Daigo had succeeded in escaping from the control of the new *Bakufu*, and, rallying his allies, he installed himself at Yoshino, in the mountainous regions of southern Yamato. Having established his court there, Go-Daigo issued a decree in 1336 declaring that a new era, the Engen, had begun (although the legally existing era, the Kemmu, was that of the emperor of the Northern Court, established at Kyoto by Takauji). Thus began one of the darkest periods in the history of Japan, which has been called the Nambokuhō: from *Nanchō* (Southern Court) and *Hokuchō* (Northern Court).

Ashikaga Takauji's rise to power had by no means been supported by all the clans. Many nobles disapproved of the way Takauji had himself chosen the emperor, and there were those who—hoping for a restoration of the feudalism of Yoritomo—were dissatisfied with the policies of the new shōgun that tended to favor the clergy and the Kyoto aristocrats. The less important warrior-landowners, overwhelmed by debts and burdened with taxes, had also expected that, having overthrown the Hōjō, Takauji would introduce agrarian reforms that would give them some relief. The new shōgun, however, made no mention of reform in the additions he appended (known as the *Kemmu Shikimoku*) to the *Jōei Shikimoku* of the Minamoto.

For these reasons Go-Daigo, the Emperor of the Southern Court, was able to retain many powerful allies. As soon as Takauji had himself appointed shōgun by the emperor he installed in Kyoto, civil war broke out in all its fury. Many of the feudal lords took advantage of the weakness of the *Bakufu* in Kyoto and, preferring to act independently, took no sides in the struggle; others threw their support to either the *Bakufu* or Go-Daigo in the hope of ultimate gain.

From 1336 to 1392 the war raged bitterly but episodically. The city of Kyoto was captured four times by the loyalist troops, but it was retaken on each occasion by those of the *Bakufu*. The civil war affected every part of the country. When Prince Kanenaga, Go-Daigo's son, succeeded in rallying the support of Kyushu, it looked as if the cause of the Southern Court might be victorious.

Loyalty, which had been the fundamental principle of the samurai of the Kamakura *Bakufu*, no longer seemed to motivate the warriors. The clan chiefs, together with the military leaders, were apparently interested in the dispute only inasmuch as it directly involved their own interests. They allied themselves momentarily with the stronger side, but quickly changed sides when the fortunes of war turned against them. The clans themselves were divided. Families

fought among themselves, one branch attempting to increase its own holdings and to obtain special privileges.

No period in all Japanese history was more confused and more sharply characterized by political assassinations and acts of treachery. In the Japan of this period treachery was regarded as such only when it was directed against a superior; the fact that one fought against an equal who had previously been an ally was not considered to be treachery. From the Japanese point of view, a sudden change of sides indicated only a sense of the opportune and political acumen. Treason was punishable only when it involved the betrayal of a chief, a previously accepted superior, or the emperor. Any military commander who fought against the emperor was always legally branded a traitor and a rebel, and it is for that reason that the imperial cause, sacred in the eyes of the Japanese, always triumphed in the end.

The loyalists allied themselves with the pirates in control of the Inland Sea and were thus able to move troops more easily from one part of their territory to another. Land communications were in the hands of their adversaries. The Southern Court also had two powerful allies in the persons of the counselor Kitabatake Chikafusa, and the incomparable war chief Kusunoki Masashige. Go-Daigo died in 1339 and left as his successor one of his sons, the twelve-year-old Go-Murakami. Masashige had been killed in the Battle of Minatogawa in 1336, and thus only Chikafusa remained to lead the imperial armies. His son, Akiie, had also been killed in battle in 1338.

The struggle continued with about equal fortune for the two sides; both suffered reverses and won battles, but neither was able to destroy its adversary because the forces available on each occasion were too weak to achieve total victory. (The *Entairyaku*, the diary of Tōin Kinkata, a noble of the period, and the *Taiheiki*, a fictionalized chronicle by unknown authors, relate the events of the period until 1359 and 1357 respectively.)

The *Bakufu* was prey to serious inner conflicts created both by the jealousy of warriors such as Kō-no-Moronao and his brother Moroyasu, and by differences of opinion among such men as Tadayoshi, brother of Takauji, who supported one of Takauji's sons, Tadafuyu. Tadayoshi had Moronao assassinated; Takauji had his brother poisoned in 1352. The clans were thus divided not only between the two courts but also between those who supported Tadayoshi and those who sided with Moronao.

The situation fell into extreme confusion on the death of Takauji in 1358. Four years earlier the loyalists had lost their most able man, Chikafusa, and hostilities had abated to a certain extent. They were resumed in all their fury, however, when Ashikaga Yoshiakira succeeded his father, Takauji, as shōgun, and victory seemed to favor the loyalists when Prince Kanenaga was able to gain complete control of the island of Kyushu in 1365. Three years later both Emperor Go-Murakami and Ashikaga Yoshiakira died. Ashikaga Yoshimitsu became shōgun and was supported by an able general, Imagawa Sadayo, who regained control of the situation.

In 1383, at the death of Prince Kanenaga, Go-Kameyama was Emperor of the *Nanchō* (the Southern Court) and Go-Komatsu succeeded to the throne of the *Hokuchō* (the Northern Court). At that point both sides seemed to weary of this useless and destructive war. The city of Kyoto had been partially destroyed by many street battles and brought to its knees by the plundering and pillaging of the infantry soldiers *(ashigaru)*, mercenary troops organized by the *Bakufu* who were far more interested in looting than in fighting for a cause.

Yoshimitsu, supported by Sadayo and Hosokawa Yoriyuki, gradually pushed back the troops that had remained loyal to the *Nanchō*. The setback, together with the treachery of Kusunoki Masanori, son of Masashige, left only the island of Kyushu in the hands of the loyalists. In the north the great feudal lords such as Yamana declared their neutrality after having been allies of the loyalists, and Yoshimitsu was thus obliged to turn against them.

Peace finally returned in 1392 when Kyushu was conquered, the *Nanchō*'s cause was lost, and Emperor Go-Kameyama was forced to abdicate. The treaty signed by the two courts stipulated that from then on the emperors would alternate on the throne: first one from the Southern Court

and then one from the Northern Court (not considered legitimate by the Japanese). Once Go-Kameyama had abdicated, however, Yoshimitsu no longer felt obliged to keep his word, and only the line of the Northern emperors continued the succession and thus became officially recognized as legitimate. The more than fifty years of civil war had cost the country thousands of lives, destroyed many of the great families, devastated the city of Kyoto and most of the surrounding countryside, and ruined the nation economically.

The Supremacy of the Ashikaga

The appearance on the scene of Yoshimitsu marked the beginning of a new era despite the civil war which had bathed the country in blood. His predecessors, Takauji and his son, had been warriors with little interest in the administration of the nation. Beginning in 1368, Yoshimitsu, although still quite young, undertook the task of reconstructing the government and of reducing both the imperial power and the influence of the great nobles. He was counseled by Hosokawa Yoriyuki and the Zen priests Musō Kokushi and Gidō, of whom the most influential was Gidō. Yoriyuki was also assisted by two chiefs of great families who, after him, were to assume the office and title of *Shitsuji* (Chief Deputy). Prior to receiving that office they were called *Kanrei* (Governor General) and administered in the name of the shōgun the provinces of the Kantō (capital, Kamakura) and Kyoto. Inspector generals *(Tandai)* were also appointed for Kyushu and Oshu (north Honshu). Each *Kanrei's* government was composed of five ministries, organized on the same lines as the Kamakura *Bakufu*, divided into special offices responsible for public works, monasteries and shrines, titles, indemnities. Each province was governed by a constable *(Shugo)* who was responsible directly to the shōgun. The *Kanrei* of the Kantō, however, had as its head a *Kantō-Kubō*, who was practically a vice-shōgun, while Kyoto was directly under the authority of the shōgun himself.

This system of government divided the country into three large, almost independent regions which recognized, nevertheless, the authority of the shōgun in Kyoto: the central provinces (the *Kanrei* of Kyoto and adjacent provinces), the provinces of the Kantō (east and north), and the provinces of Kyushu. The post of *Kantō-Kanrei* was held by the chief of the Uesugi family, which was related to the Ashikaga clan. Even with the supposed coming of peace, however, there were still a few disturbances. A constable of several western provinces, Ōuchi Yoshihiro, turned against the government, and was supported in his revolt by the pirates of the Inland Sea and the rich merchants of the port of Sakai—which because of renewed commercial relations with China (now under Ming dynasty) was then a flourishing center. Yoshimitsu attempted to negotiate, but without success. In 1400 he attacked and, because of a fire which destroyed a large part of Sakai, was able to crush the rebellion.

The authority of Yoshimitsu thus became indisputable. He renewed official relations with China and reestablished legal commerce with the mainland after having ventured, at the request of the Ming emperor, to suppress piracy on the Sea of Japan. Yoshimitsu died in 1408, and his power was inherited by his son, Yoshimochi. Peace—interrupted only by a few easily overcome local uprisings—lasted until 1438, when the *Kantō-Kubo* Mochiuji rebelled.

The Peasant Rebellions

During Yoshimochi's leadership the Koreans attacked the island of Tsushima in 1419—which was a base for Japanese pirates—and in 1420 and 1425 there were famines followed by epidemics that left the country depleted. In 1428, the year of Yoshimochi's death, the peasants in the prov-

ince of Omi rose in protest against the financial measures imposed at the time, and they were soon joined in their revolt by the farmers of other provinces who demanded the cancellation of their debts. It was the peasants' first major rebellion. During the wars between the Northern and Southern Courts, and practically since the demise of the Kamakura *Bakufu*, troubles in the countryside had been latent and sporadic, and the peasants, who had suffered from the course of events, united and took up arms in order to defend themselves from the depredations of which they were the victims. From the death of Yoshimochi up to 1466—the thirty-eight years of the shōgunates of Yoshinori, Yoshikatsu, and Yoshimasa—the countryside witnessed various agrarian rebellions. The only political rebellions were the 1438 revolt of Mochiuji—repressed in 1439— and that of Akamatsu, which ended in the assassination of Shōgun Yoshinori.

The agrarian uprisings during the period comprised perhaps the most important sociological event in the history of Japan, because they indicated that the Japanese laborers had become conscious of the rights due to their class, and no longer intended to be treated as subhumans to whom all rights had been systematically denied. Ashikaga Takauji had rewarded his military leaders with appointments as commissioners in the provinces. These warriors practically replaced the *go-kenin*, the feudal aristocracy of the Kamakura period; they assumed the rights of landowners and the position of independent feudal lords. Known as *daimyō* (great landowners), these individuals were far more interested in increasing their personal fortunes than in supporting the regime set up by the Ashikaga clan to which they had sworn fidelity only as lip service. Along with these powerful landowners there were innumerable small landowners or farmers *(shōmyō)* who were descendants of the warriors *(kokujin)*; there were also the freeman peasants *(ryōmin)* who, although their tracts of land were small, were not thralls. These latter, together with the other peasants who worked on their lands, formed leagues *(ikki)*, both to protect themselves against the excess taxation imposed by the *daimyō* and—since the government, totally occupied by the civil war, was incapable of defending them—against the attacks of the brigands and the rapacity of the warriors. Many of the uprisings occurred primarily because the Ashikaga government had appointed constables for each one of the provinces, and these officials attempted to impose their authority over the peasants.

From the middle of the fourteenth century the peasant leagues continued to rebel, and at times even succeeded in driving out the constables appointed by the Kyoto *Bakufu*. The government managed to appease the peasants on some occasions with concessions, but when these proved impractical they repressed the rebellion by armed force.

During the fifteenth century the peasant leagues even managed to penetrate the city of Kyoto several times, and joined forces with the urban workers in order to assert their claims. After the disastrous famines of 1420 and 1425 many peasants were forced to borrow seed grain at outrageous rates of interest. The majority of the peasants were unable to repay these loans, on which the prohibitive interest mounted constantly. The creditors appealed to the constables to help recover the sums owed to them. Since the government made no attempt to remedy the peasants' situation, the peasants had no choice but rebellion in order to make their condition known to the authorities. As a result, with each uprising the property of the creditors was pillaged and all evidence of the peasants' debts was destroyed.

Peasants in the provinces of Yamashiro (Kyoto) and Nara—perhaps the most sociologically advanced in the country—were the best organized, and because they went to the great markets in the urban centers they had contact with the working classes in the cities. The agitation they set in motion soon extended rapidly to other parts of the country, with the principal aims of shaking off the yoke of the constables, eliminating the burden of the heavy taxes, and preventing the magistrates from seizing their land.

Instead of enacting efficacious reforms to relieve the plight of the peasant class—like the previous Kamakura *Bakufu*—the government took recourse to "acts of grace" *(tokusei)* which canceled the contracted debts. The result was not the alleviation of the misery of the peasants but the paralysis of all trade within the country. The peasants insisted that the *tokusei* should

apply to everyone and not solely to the soldier-farmers. Riots broke out in Kyoto itself, and even the monasteries, overflowing with provisions, were not spared. The magistrates, moreover, took refuge at times with the monks.

In 1456 Shōgun Yoshimasa was forced to recognize the peasants' rights of property and reduced their debts to 10 percent of the initial sum borrowed. But these measures did not suffice, and the riots continued with ever-increasing violence. In 1457 a new famine due to bad weather resulted in an epidemic that killed hundred of thousands of peasants. It does not appear that the government did anything whatever on this occasion. Yoshimasa improvidently spent countless sums for his own pleasures and emptied the state treasury. Also discontented, the great *daimyō* erected barriers at the entrances to their estates in order to keep out spies (known as *ninja*, these spies formed a sort of guild created in the Kamakura period, and their exploits gave rise to innumerable legends at a later date) and to control the comings and goings of their people as well as the circulation of merchandise. The tolls levied at each barrier weighed heavily on all commerical activity, but they provided such an important source of revenue for the *daimyō* that the Muromachi *Bakufu* tried to prohibit them and to replace them with others for its own benefit.

Such injunctions had no effect, however. Prices increased in proportion to the distance over which goods moved, and it was only at prohibitive prices that a starving region could obtain food from those provinces unaffected by disasters. Therefore, one of the principal goals of the rebellions became the complete destruction of these barriers. Yet the inefficiency of the central government only aggravated the general situation. Vast numbers of the discontented peasants enlisted in the private armies organized by some of the *daimyō* in order to resist the *Bakufu*. Unrest was widespread, and an insignificant event was all that was needed to light the fuse to ignite another civil war.

The Ōnin Civil War

In 1464 Yoshimasa was still childless, and the succession to the title of shōgun had to be decided. The *Kanrei* Hosokawa Katsumoto proposed that Yoshimi, the young brother of Yoshimasa, be nominated as heir. After the nomination, however, Yoshimasa's wife, Tomiko, gave birth to a son who was called Yoshihisa. The status of Yoshimi was thus imperiled, but Hosokawa did not want to acknowledge the right of Yoshimasa's son and continued to support his original choice. Tomiko, an ambitious woman with few scruples, wanted the title for her son. She appealed to Hosokawa's great rival, his sworn enemy (as well as his father-in-law) Yamana Sōzei, who for some time had been looking for an opportunity to destroy his son-in-law's ever-increasing power.

Despite Yoshimasa's attempt at conciliation, the two rivals rallied troops and effected alliances with other clans. In 1466 each side had 80,000 soldiers available: Hosokawa's were massed to the northeast of Kyoto, Yamana's on the southwest limits of the city. In a unique effort to quell the hostilities, Yoshimasa announced that whoever opened battle whithin the city would be declared a rebel. At the beginning of 1467 Hosokawa attacked, but he knew so well how to manipulate the shōgun that the shōgun declared Yamana and his allies to be the rebels—including the powerful western *daimyō* Ōuchi Masahiro.

The battle raged in the city. Soldiers of both factions pillaged, set fires, dug trenches in the streets, erected barricades. Outside of Kyoto the enemy clans fought one another, took sides with one or the other of the generals, and spread fire and destruction throughout the countryside.

By the end of the year the devastation was so great that most of Kyoto was reduced to ashes. All that remained standing was the imperial palace, the residence of the shōgun, and the general headquarters of the adversaries. The shōgun, however, seemed to be indifferent as to which side would be victorious in the war. In any case, he found himself completely powerless to control his vassals, who continued the struggle not only in battle but also in political intrigues.

In one of the reversals of position that seem to have been customary with the Japanese of that era, in 1468 Yoshimi unexpectedly found himself in the position of being a leading general of Yamana's army, fighting on the side of the man who had favored his nephew, Yoshihisa, the son of the present shōgun, as his successor to the shogunate, and against his brother (Shōgun Yoshimasa) and Hosokawa who had supported him up until that moment. Yoshimasa took advantage of the situation to nominate his son, Yoshihisa, as his heir, to declare Yoshimi a rebel, and to entrust Hosokawa with the task of punishing him.

As both sides were of equal strength, battle provided no solution, but fighting continued nonetheless, due to the implacable hatred that divided the Hosokawa and Yamana families. Skirmishes and deadly encounters continued spasmodically until 1473, with each side managing to hold its own position.

In that same year Yoshimasa, worn out by the exercise of a power for which he was not suited, retired in order to devote himself to his own pleasures. Subsequently both Hosokawa and Yamana died. Since the two protagonists of the fratricidal struggle were no longer on the scene, the war should have ended. Yet it continued for four more years and was constantly rekindled by the ambitions of the young warlords.

In 1477, ten years after its beginning, the Ōnin Civil War (so named after the era in which it took place) came to an end in Kyoto, but continued in the provinces. In the Kantō, the Ashikaga and Uesugi clans kept on fighting bitterly for the rights of succession to the position of *Kantō-Kanrei*; on the island of Kyushu rival families were involved in a struggle for supremacy. The starving peasants of Yamashiro rebelled in 1485, oppressed by taxation and driven to a fury by the war's rapine and destruction. Their crops destroyed, and despairing of their lives, they fearlessly took arms to defend themselves against the troops fighting on their land. They united *en masse* against the armies of the feudal factions and demanded not only their immediate withdrawal but restitution of property illegally seized by the soldiers, as well as the abolition of the toll-barriers. The leaders of the rebellion then organized a provincial government with headquarters in the temple of Byōdō-in at Uji. The soldiers, who were not particularly anxious to confront this new and very determined force, withdrew from the province.

The War of the Feudal Lords

Kyoto was devastated, overrun by marauders and thieves against which the police force was powerless. However, it was in that war-torn city that the Hosokawa family again took the political reins into its own hands. Yoshihisa was killed in a battle against rebellious feudal lords in 1489, and one of Yoshimi's sons, Yoshitane, assumed the title of shōgun on the death of Yoshimasa in 1490. However, Hosokawa Katsumoto and his son Masamoto were desirous of replacing Yoshitane with one of Yoshimasa's nephews, Yoshizumi, and in 1493 succeeded in expelling Yoshitane. Katsumoto died the following year, but Yoshitane was not restored to office until 1507, after the assassination of Masamoto. It was then Yoshizumi's turn to flee.

The situation became increasingly confused, because the successors of the Hosokawa *Kanrei* were practically puppets in the hands of Miyoshi, one of their own vassals. Ōuchi Masahiro (the *daimyō* who had been Yamana's ally against Shōgun Yoshimasa in 1467), for his part, "protected" the shōgun against the plans and plots of Miyoshi and made him act according to his wishes; nevertheless, Ōuchi's military strength prevented more disorder in the capital. Yet once he had returned to his estates in 1518, the shōguns again fell into the clutches of the Hosokawa family. Shōgun succeeded shōgun, but none was powerful enough to assert his control over the state and the great feudal lords who continued to indulge in merciless wars in the provinces in attempts to conquer new fiefs or to reinforce their political positions. The Hosokawa were finally defeated in 1558 by Miyoshi, who had never laid down his arms.

Conflicts raged throughout all of the provinces; fiefs and estates constantly changed hands, often to the detriment of the great landlords who were expelled by their own vassals. The peasant revolts, which were exploited by the petty landlords envious of the great landowners and anxious to increase their own holdings, brought no benefits to those who had fomented them. It is hard to find a political reason behind all these struggles. One finds only a continuous shift of power and a progressive appearance of new classes rising from the ranks of the plebeians. In Kyoto, as well as in other cities, the merchants and workers, faced with the impotence of the legal authorities, banded together and organized local governments. The imperial court continued its pretense of governing and did not try to change its mode of living, even though its circumstances were somewhat reduced. It became increasingly alienated from the country and showed distinct lack of interest in the outcome of feudal wars that had continued without let-up and had devastated the nation for so long.

These conflicts among the independent feudal lords, *daimyō*, were extremely bloody; no code regulated the actions of the belligerents. The *daimyō*, having established their strength, attempted to make laws with the sole purpose of reinforcing the power and position of their clan. Despite their stringency, these laws did nothing to protect the peasants or to establish order within the domains of the *daimyō*. The *daimyō* also began to build fortified castles around which settled their vassals and soldiers, thus creating a type of castled town. Edo was founded in this manner in 1457 by Ōta Dōkan, acting on orders of the Uesugi family; the site chosen was that of a fort built in 1185 by a governor of Musashi who was a descendant of the Taira clan.

Toward Unification

The *daimyō* were hoping for something more than sovereignty over their own territories; they engaged in court intrigue, hoping to obtain the imperial support that would permit them to subdue their neighbors and to achieve a form of unity under their own domination. They could not abandon their fiefs for long periods of time in order to impress their own strength in the capital; their rivals might take advantage of their absence. Only one of the *daimyō*, Imagawa, was in a position to attempt such a risk; he had only one person to fear: a young man named Oda Nobunaga, a minor noble and lord of Owari, a province through which Imagawa had to pass on his way to Kyoto. With an army of 20,000 men Imagawa advanced on the capital. Nobunaga, who had a much smaller army but the enormous advantage of thorough acquaintance with the terrain, ambushed Imagawa in a valley and defeated him completely. Imagawa was killed in action. This rapid skirmish, called the Battle of Okehazama, would have passed unnoticed among the innumerable engagements of the period between *daimyō* and *shōmyō* if it had not given an unimportant provincial lord of relatively modest origins the advantage of taking a step that was to have a decisive influence on the destiny of Japan.

After the death of Imagawa one of his generals, Matsudaira (better known as Tokugawa Ieyasu), made an alliance with Oda Nobunaga. Due to a shrewd matrimonial alliance, Nobunaga also gained the support of a northern chief of the province of Omi. As a result, between Nobunaga's state and Kyoto there remained only the small state of Mino, administered by the descendant of a rich merchant. One of Nobunaga's generals, Kinoshita Tōkichiro (who subsequently became famous under the name of Hideyoshi), succeeded in defeating the troops sent out against him.

One of the peculiarities of Oda Nobunaga's army was that it was made up not of conventional soldiers but of mercenaries *(ashigaru)* recruited for the most part from among the bands of brigands. These mercenaries had the double advantage of being more skilled in the tactics of ambush and surprise attack and more mobile than other armies, which partly explains their successes over troops that were superior in number.

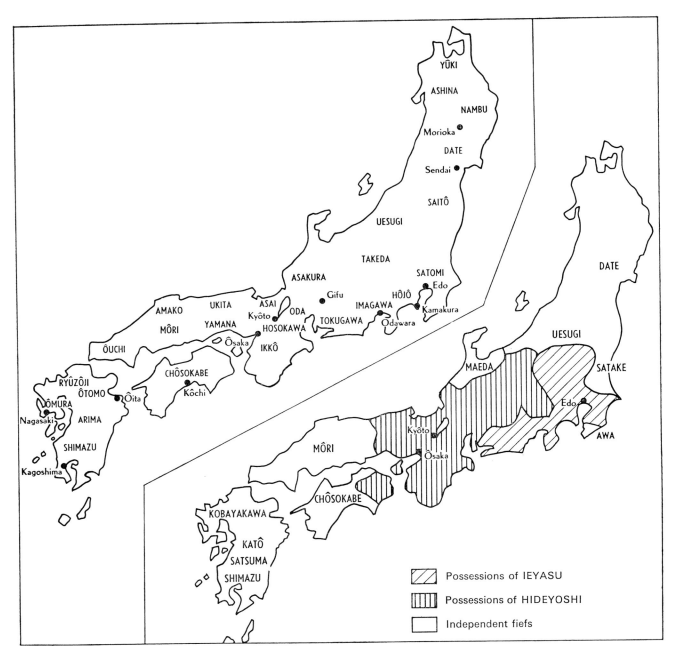

41. UPPER: APPROXIMATE LOCATION OF THE GREAT LORDS IN THE SIXTEENTH CENTURY
LOWER: JAPAN ON THE DEATH OF HIDEYOSHI (1598)

In 1567 the fame of Nobunaga's exploits reached Kyoto, and Emperor Ōgimachi believed that it would be good policy to send his congratulations to the young warrior. Yoshiaki (the grandson of Shōgun Yoshizumi), then in flight and opposed to Hosokawa, asked for his help. From his castle of Inabayama (renamed Gifu) Oda Nobunaga conducted his campaign against the last opponents remaining to block his path to Kyoto. He entered the capital as a conqueror in 1568 and gave Yoshiaki the title of shōgun. Hosokawa and Miyoshi had fled at his approach.

Aided by Ieyasu, who protected him from possible attack by the eastern provinces, Nobunaga tried to strengthen his position by conciliating the nobles and gaining the support of the farmer-warriors of the Kansai. He then attacked the *daimyō* of the adjacent provinces and compelled the shōgun to support his measures.

From the time of his arrival in Kyoto, Nobunaga, even though constantly involved in military exploits, tried to improve general conditions and to organize the government of the central

provinces. One of his first decrees placed a control on currency and fixed the rate of exchange. Later, in order to increase internal trade, he banned the toll-barriers and had the roads repaired.

In 1576 he had a large castle built at Azuchi to guard the approaches to Kyoto and bar possible invaders from the north or east. At the base of this imposing citadel—the apartments of which were decorated by the best artists of the period—he had fortified houses constructed for his generals, and he created on the shore of Lake Biwa a small town which, at the time of his death in 1582, boasted 5,000 inhabitants. Nobunaga regulated the rights of the citizens of his town in such a way as to attract as many people as possible, and he organized a free market within its limits. His policy had two basic objectives: to permit him to increase his own war booty, and, through trade, to create a climate favorable to the unification of the territory under his control.

In the meantime, however, beginning in 1570, he had attacked the *daimyō* of the Echizen and Asakura, and with the help of Ieyasu he had totally defeated them. The only serious form of opposition that remained was that of the Ikkō sect, an exclusivist and aggressive form of Amidism, whose doctrine advocated the suppression of all other Buddhist sects. It was firmly established in the monastery of Ishiyama Hongan-ji on the eastern shore of Osaka Bay. This sect also had numerous supporters in the other provinces and among the *daimyō* defeated by Nobunaga. The warlike monks of Mount Hiei were also hostile to him.

In 1571 Nobunaga did not hesitate to give the order to raze the monastery of Enryaku-ji on Mount Hiei and to kill all monks and priests found there. The Ikkō sect fulminated against him after he had made an alliance with the powerful *daimyō* Takeda, in which he had the secret support of Shōgun Yoshiaki. In 1573, after several reverses, Oda Nobunaga moved against the shōgun, who fled from his onslaught. Nobunaga then attacked the troops of Takeda and Asakura, completely defeating them. Their lands were given to Hideyoshi as a reward.

There still remained, however, the stronghold of the monastery of Ishiyama Hongan-ji. With the aid of pirates and backed by artillery—heavy muskets had been manufactured in Japan since 1543, when they were introduced by the newly arrived Portuguese—Nobunaga undertook several campaigns and sieges, which in the beginning were directed against Takeda, who had rebelled once again. Takeda was finally defeated at Nagashino, due to the perfect discipline of Nobunaga's troops and to his genius as a strategist. However, he suffered reverses on land and sea in his campaign against the monastery of Ishiyama Hongan-ji.

In 1577, when he had completed the construction of his castle at Azuchi, he fell upon the monasteries of the Ikkō sect, thereby severing the supply lines of the monastery of Ishiyama Hongan-ji. Three years later, totally defeated, the monastery surrendered on orders from the emperor. The Takeda family, in a state of continuous rebellion, was finally annihilated in 1582, due to the combined efforts of Nobunaga, Ieyasu, and members of the Hōjō family who had rallied to their support. But during a visit to Kyoto, Nobunaga was treacherously attacked in his own residence by a detachment of troops belonging to one of his generals, Akechi Mitsuhide. On the point of being taken prisoner, he committed suicide. Akechi Mitsuhide then believed himself to be the real master and slaughtered Nobutada, Oda Nobunaga's eldest son, and seized Azuchi Castle. However, Hideyoshi immediately marched against him and defeated him at Yamazaki, where he put him to the sword.

Oda Nobunaga, aided by his loyal and able generals, Hideyoshi and Ieyasu, had finally overthrown the power of the Muromachi shogunate (which had proved its ineffectiveness), and had thus prepared for the advent of a new order. Hideyoshi continued Nobunaga's work. With his cruel and pitiless character, Nobunaga believed that only force could establish peace. In a period in which no moral order or rule of life was respected by those very people whose duty it was to maintain law and order, force was the only means available to make the *daimyō* see reason. Oda Nobunaga had known how to utilize the newly introduced firearms to their best advantage by placing them in the hands of the infantry in battles against the traditional cavalry. He thus revolutionized Japanese warfare. Yet the useless massacres he had ordered and the harshness of the discipline he had imposed on his troops had made him a hated man.

SOCIOLOGICAL AND CULTURAL ASPECTS
OF THE MUROMACHI PERIOD

This blackest period in the entire history of Japan, which witnessed the most murderous civil wars of all time, had a decisive effect on both the evolution of society and Japanese culture. In fact, this period may be considered the transition point between the old and the new Japan. Just as the framework of the imperial society of the Heian period tottered with the advent of the system of military government during the Kamakura period, now the awakening of a social group far larger than the limited society composed of imperial aristocrats whose power struggles—which could not be controlled by either the emperors or the shōguns—permitted new classes to arise and make their influence felt. The introduction of firearms, along with the formation of the *ashigaru*, or infantry, not only revolutionized the methods of warfare but placed weapons in the hands of the common people, and thereby gave them the opportunity to protest or rebel with active strength, and even the peasant classes began to take part in rebellions. On the other hand, increasing demands for war matériel stimulated industry and commerce, favoring not only enterprising merchants but also the resumption of official relations with China. The arts benefited from their adaptation to the character of the new classes and to the aesthetic tenets of the Zen priesthood, whose influence at the court of the shōguns was ever-present.

Relations with Foreign Powers

Once the danger of the Mongol invasions had passed, private trade between China and the great lords of Kyushu resumed, to the great advantage of the lords and even at times of the imperial court. And when the Mongols were expelled by the newly established Ming dynasty, lines of communication seemed safer. The Emperor Hung-wu made open diplomatic overtures to Japan in the hope that steps would be taken to end the raids of Japanese pirates on the Chinese and Korean coasts. Numerous embassies were exchanged and after an interruption of another period of some fifteen years friendly relations were reestablished in 1400 by Shōgun Yoshimitsu who, in order to prove his conciliatory intentions, decreed sanctions against the pirates.

In 1405 a Chinese mission brought gifts and a seal to Yoshimitsu, and a commercial treaty regulating trade between the two countries was signed. The shōgun then took severe measures against the pirates, most of whom were based on the islands of Iki and Tsushima. Japan's chief exports were armor, swords, lacquered objects, mercury, and sulfur. In turn, imports from the mainland comprised coins, bolts of silk, silver ingots, jade jewelry and other precious objects, books, porcelain, perfumes, and medicaments.

After the death of Yoshimitsu official trade was suspended by his son and successor, Yoshimochi, despite repeated protests on the part of the Ming emperors. The shōgun, however, preferred strong drink to matters of government. His brother, Yoshinori, who succeeded him (after the intervening brief shogunate of Yoshimochi's son), resumed maritime relations in 1432. Trade was most active between China and the great monasteries, such as Tenryū-ji, or the more powerful lords of the manors, and it was carried on principally by merchants based in the ports of Hyōgo, Sakai, and Hakata, thereby contributing considerably to the wealth of those cities. A century later, however, when the quarrels between the Japanese feudal lords spread even to Chinese ports, the Ming authorities in 1548 prohibited the entry of Japanese vessels into Chinese waters.

There was also active trade between Japan and Korea, which was an important source of

supply for cotton cloth and ceramics. Through the fleet of the kingdom of the Ryukyu Islands, Japan also had access to the tropical products of Indonesia and Southeast Asia. From 1550 onward, maritime trade was carried on principally by the *wakō* (pirates) who acted on commissions from private interests. These *wakō* employed numerous Chinese fishermen, who had been deprived of work by the decrees of the Ming emperors (in their attempt to isolate the country the Ming emperors had ordered the destruction of all vessels capable of navigating the high seas).

At the same time, some Portuguese whose vessel ran aground on the small island of Tanegashima near Kyushu, introduced firearms in the shape of simple muskets to the Japanese. On their return to Macao they informed the Portuguese merchants of the trade opportunities existing at Japanese ports. The merchants wasted no time in arriving in Kyushum, where they were welcomed by the local lords, who were more than anxious to increase the wealth they garnered as war booty through profitable trade with foreigners. From then on, the *wakō* "reformed" and became honest merchants; following the routes of the Portuguese sailors, they penetrated ever farther into southern Asian waters, and in their dealings with the Chinese merchants they behaved henceforth more as smugglers than as pirates.

Finally, about 1560, the Ming government reopened foreign trade and piracy disappeared completely. Chinese captured by the pirates and sold as slaves in Japan were for a long time the subject of discussion between the two empires but were finally released and sent home. The ports of Hirado, Hakata, Hyōgo, and Sakai enjoyed a period of great prosperity, and the merchants rapidly gained in wealth.

Concurrently, there arose a new class of urban workers who, by virtue of their maritime pursuits, enjoyed a greater freedom of action. The port of Sakai benefited particularly from the talents of craftsmen from Kyoto who had fled the capital during the Ōnin Civil War. The mariners of Sakai had insured themselves against raids of the Inland Sea pirates by paying them tribute monies: thus, this port soon became the richest city in Japan.

In 1549 Francis-Xavier wrote about Sakai: "It is a very large port city in which live numerous merchants rich in silver and gold; and wealthier than any others of their class in all Japan."

In 1562 Father Vilela stated: "There is no city in Japan as safe as Sakai; whatever troubles may afflict the other provinces, they do not penetrate here.... The city is well fortified; to the west is the sea, and in other directions there are canals always filled with water which keep it safe from attack."

Missionaries had arrived with the first Portuguese ships, and they were welcomed at the courts of the western *daimyō*, in particular by Ōuchi and the lord of Satsuma, who received Francis-Xavier in 1549. In Kyoto, however, this missionary found only closed doors. On his return to Goa in 1552, Francis-Xavier sent other Jesuits to Japan to begin the work of conversion. They had little success except among the merchants and the poor peasants of western Japan. Christianity was vigorously opposed by the imperial court, by adherents of the Hokke sect, and by the Zen priesthood.

Japan's economic production continued to increase steadily. During the civil wars at the beginning of the Muromachi period the peasants had been treated with more respect by the warring factions because they needed the crops in order to feed their armies. During the entire period the maintenance of the armies required ever-increasing production of armor, weapons, carts, saddles, harnesses, and other equipment needed for military campaigns. Ruined or destroyed buildings had to be reconstructed, and carpenters, other artisans, and even artists were required for this task. The great quantities of goods transported by the armies created the need for depots and relay stations.

At the same time the steady increase of the rural population together with the division of patrimonies resulted in the reduction of the properties of the larger estates, which necessitated a more intensive cultivation of the land for greater yield. Crops soon exceeded family requirements, and trade in agricultural produce expanded. The produce was sent to the cities, as well

as to the various armies which were in constant need of provisions. Goods were transported either by way of the coastal sealanes or overland, and were handled by merchants who served as intermediaries between the peasant and the consumer.

Commerce was facilitated by the use of the coins imported from China. The peasant-producers as well as the merchants gained in prosperity, and as their buying power increased, numerous small shops were opened in villages, at crossroads, and in all locales where the armies camped.

The introduction from Indochina of new varieties of rice, more resistant to cold and to plant diseases, made it possible in some regions to harvest two crops annually. The rotation of crops—rice and barley or rice and buckwheat—in other provinces increased production still further. The demand for silk (which necessitated the cultivation of the mulberry tree, the leaves of which fed the silkworms), hemp, sesame oil, tea, fruit, and other agricultural products became greater and greater. The exploitation of mineral resources such as mercury, sulphur, silver, and iron was undertaken on a large scale. The production of lacquer and paper on a craft basis and the dyeing of cloth were developed in response to the augmented demand for both domestic and foreign trade.

These products made it possible to obtain from China the quantities of coins and art objects that entered into the luxury trade of Japan. When the use of money became both legal and common the barter system disappeared; markets were established, and cities of craftsmen and merchants grew up around them. Crafts became more and more specialized and craftsmen were often obliged to import their raw materials from remote areas. The products they created which they sold to the traveling merchants included ceramics, tools, paper, cloth, iron weapons, basketwork, bows and arrows, and dyes. Since these craftsmen were independent of any land-owner, they led a relatively free life.

Market cities grew up along the main routes of communication and at the crossroads. Markets were also set up at the gateways of monasteries and major shrines; most of them still exist. Inns as well as teahouses and other places for relaxation and diversion were established for the pilgrims. Inns were also built at the relay stations on the main roads. As the population of the cities increased constantly, local markets were unable to supply sufficient food for the inhabitants, and therefore large warehouses were built and placed under the management of wholesalers who were responsible for the distribution of the supplies, principally rice, throughout the various areas where they were needed. These wholesalers, however, could vary prices at their own pleasure and even starve a city if they so desired. The lords of the Muromachi *Bakufu* amassed incredible fortunes dealing with these wholesalers, at the expense, naturally, of the population. As they were also moneylenders, the wholesalers could even fix the prices paid to the farmers.

Like the members of most of the other professions (such as artists and craftsmen), the whole-salers and rich merchants were organized into types of guilds called *za*. A *za* was linked with a particular monastery, shrine, or noble family, which acted as its patron and protector, and which made certain, of course, that it reaped some profit from their connection. A *za* could control the production of the articles in which its members specialized and, consequently, the prices of said articles. The *za* were also able to resist any extortion or pressure on the part of government officials. On the other hand, the fact that they were specialized gave a great stimulus to trade and increased profits for their members. The guild members soon formed a new class that was later to become the basis of a Japanese middle class.

Courtiers of the highest rank, who had practically abandoned political activity, continued their traditional way of life, immersed in studies and complicated rituals and ceremonies. The lesser nobles devoted their time to leading a life of pleasure and cultivated the friendship of the *za* or the merchants, with an eye to increasing their private fortunes or at least compensating through dishonest business transactions (at the expense of the people) for the loss of revenues no longer forthcoming from the land.

During the Ōnin Civil War many of the courtiers and nobles had fled from the capital. On

their return, after 1477, they found the city in a deplorable state, a prey to looters and thieves. However, the inhabitants courageously began to rebuild the city and brought back the craftsmen who had emigrated to Osaka and Sakai, and the normal way of life quickly returned to Kyoto. The nobles were considerably impoverished, and the ceremonies at court had to be curtailed. On many occasions the *Bakufu* was obliged to levy special taxes in order to meet the expenses incurred by the most important ceremonies. However, with the revival of trade with China, the situation soon improved.

The extravagant tastes of Yoshimitsu and his successors, up until Yoshimasa, which rapidly depleted the state treasury, proved advantageous to the craftsmen and artists. Yoshimitsu maintained close relations with the emperor of China and imported vast quantities of art objects and furniture from the mainland. It was his pleasure to dress in the Chinese fashion, to be borne in a Chinese palanquin, and to burn incense (as a mark of extraordinary respect) in front of the letters received from his imperial correspondent.

Religion

The numerous sects continued to develop and grow in influence, particularly Zen. Some of the Zen leaders exerted a profound influence on the cultural evolution of the upper classes. Ashikaga Takauji had been the pupil of the priest Musō Kokushi (1275–1351), who ordered him to erect a Zen monastery in every province so that prayers might be said in each monastery for the repose of the souls of warriors killed during his campaigns. This program illustrates the Japanese inclination to repent and to recognize their own errors—in this instance, a type of self-criticism on a religious plane which obliges a person to pray for the souls of those he has slain in battle. Another custom (still observed) is to have prayers said by the silkworm breeders for the chrysalids killed during the year (the unwinding of the cocoons to make the thread destroys the occupant). In this pattern of thought more emphasis is placed on the religious ceremony itself than on the regenerating action of karma, even though the idea of karma is deeply embedded in the Japanese soul.

With the same propitiatory aims, Takauji commissioned the copying of sutras by Zen monks. The influence of the Zen clergy became preponderant even at the emperor's court, which caused violent reactions from other sects, such as the Tendai, Hokke, and Shingon. Above all, the bellicose priesthood of Enryaku-ji on Mount Hiei were among the most insistent in their attempts to intimidate the court and the military leaders with processions, threats, and even armed action.

The Zen priesthood, however, had the advantage in their close relation with imperial circles. They directed the most important schools and centers of Chinese studies, of which the most influential was the Ashikaga school. The Five Great Zen Monasteries *(Gozan)* of Kyoto were renowned for their learned clergy, who above all cultivated poetry and religious philosophy. The work of the Zen clergy which made perhaps the greatest impression on the citizenry was the foundation of monastic schools in which children of the lower and middle classes were taught to read and write. In the other monasteries, to which it was customary for the nobles and the warriors to send their sons at the age of ten, poetry and music were taught, in addition to instruction in the Chinese classics.

Numerous manuals written by the Zen clergy, such as the *Teikin-ōrai* (a kind of correspondence manual for self-teaching, containing moral instructions) and the *Jitsugo-kyō* (embodying maxims of truth), introduced the principles of Buddhist morality to the citizenry—something which no other school had done previously—and spread among the people ideas of equality and the right to an education. Popular literature was encouraged as well as the art of an essentially popular theater, out of which developed the *kyōgen*, or satirical farce. Poetry itself, which up

until then had been reserved for the aristocracy, began to be democratized with the development of *renga* or "linked *waka*." The teachings of the clergy also had their practical side, and during the entire period of internecine disorders the monasteries provided a refuge for artists and writers. Undoubtedly these artists and writers were influenced by Zen thought, which also had the attraction of novelty.

The other sects, however, did not remain inactive. The supporters of Nichiren and the followers of Shinran (the Ikkō sect) engaged in bitter struggles to obtain the favor of powerful officials in the capital for their orders. In the provinces other sects appeared or disappeared according to the fortunes of the *daimyō* who protected them. The Muromachi period was an era of political turmoil, but it was also a time of religious struggles in which the exclusivism preached by Nichiren and Shinran caused many fierce conflicts. Nichiren's followers became all the more intractable in proportion to the persecutions they suffered at the hands of the authorities at whom they scoffed. In 1536 the monks of Mount Hiei, religious allies of the Ikkō sect, fought a bloody battle with the followers of Nichiren and burned most of their temples in Kyoto. This act was approved by the military class, who considered these fanatics a danger to their own security.

The defeat of the Nichiren faction reinforced the prestige of the followers of Shinran, who had organized themselves into a feudal theocratic state under the leadership of their "bishop," Rennyo (1415–1499). Rennyo built numerous fortified religious institutions, particularly in and around Osaka, and instilled in the faithful of the Ikkō sect a warlike, militant zeal against the other sects.

Splinter groups were formed within the sects themselves, often secret associations (such as the *yamabushi*, or mountain ascetics) transforming the esoteric doctrines of Shingon into erotic or even stranger cults in which magic and sorcery played an important part. These sects or subsects—which for the most part professed doctrines that were a mixture of shamanist practices, Shintō ritual, Buddhist philosophy, and Chinese pragmatism—were so numerous and their influence was so great that they conditioned to a large extent the beliefs of the common people of Japan: beliefs of the most diverse sort, which are still widespread in Japan today.

Despite the civil wars, Shintō continued to exist as the very essence of the Japanese spirit. It may even be due to Shintō, as the state religion and the justification for the existence of the Japanese emperor, that strong nationalist sentiment survived after many years of disorder and strife. In fact, although some of the military were inclined to dispute the usefulness of the emperor, the principle of sovereignty was never questioned by the upper classes, by the most independent of the *daimyō*, or by the most intransigent of the religious bodies. During this period Shintō theology was organized systematically, and Ichijō Kanera (1402–1481) attempted to bring it into theological concord with Buddhism and Confucianism so as to endow it with a nationalist spirit. It was a doctrine founded on a triple moral base: materialist, philosophic, cosmic.

Another Shintō sect was created by Urabe Kanetomo (1435–1511) and was defined as "fundamental." It was based on revelations transmitted by the scriptures, but actually borrowed its tenets from the Buddhist sects of Shingon and Tendai, and its methods of divination from Chinese philosophies. While Ichijō Kanera's nationalist Shintoism had a great influence on the upper classes, because it supported the forces of unification, Urabe Kanetomo's new doctrine was welcomed by the common people who were always drawn to shamanist practices of divination, purification, and exorcism. The numerous sects that arose during this time formed a type of popular Shintoism, inextricably blended with religious beliefs and practices that had existed in Japan since prehistoric times: it is the Shintoism still extant in twentieth-century Japan.

The Writers and the Aesthetes

The religious turbulence naturally affected the spirit of the times, and literature reflected it. The relations with China and the return from that country of such Zen priests as Sesson Yūbai (who had lived there for twenty years) in 1329, and Musō Kokushi and his disciples, Zekkai and Gidō, gave renewed vigor to Chinese literature and poetry. The school of poetry inspired by Sesson's work imitated the Chinese masters as faithfully as possible. Secular subjects were more popular than religious ones at that time, even though most of the poets belonging to this school were members of the clergy.

From 1400 onward, however, Chinese poetry was gradually replaced by literary works of a historical or philosophical nature, and the clergy of the Five Great Zen Monasteries of Kyoto were the principal exponents of these works. The past was no longer regarded as barbarous, but as an initial phase in the development of Japan, and ancient literature, therefore, was studied and commented upon.

The nobles and rich merchants of the provinces invited poets and artists to their estates, and thus the culture of Kyoto permeated the rest of the country. The *renga*, or "linked" verse written in Japanese, became the subject of competitions and a form of diversion in which all classes participated. Anthologies of *renga*, such as the *Tsukuba Shū* (20 volumes, including works by 530 poets), were compiled, and such poets as the priest Sōgi (1421–1502) became extremely well known and traveled about the country from one castle to another. In 1470 Sōgi wrote a commentary on the rules of *renga*, the *Azuma Mondō*, and in 1495 compiled an anthology of poems, the *Shinsen Tsukuba Shū*.

At the same time *nō* plays were being written. The development of this theatrical form was rather complex: it probably evolved from *bugaku* and *kagura*—the ceremonial and ritual dances of the court and the Shintō shrines—and *sangaku*, a popular type of theatrical entertainment, also known as the *sarugaku* or "monkey dance." Typically Japanese, the *sarugaku* comprised various types of acrobatics, puppet shows, and exorcism dances. From the beginning of the fourteenth century *dengaku-nō*, traditional peasant folk dances, were added to these elements.

Under the patronage of Shōgun Yoshimitsu, Kanami (1333–1384) and his son, Zeami (1363–1443), are credited with having created and codified a new theatrical form that became a sort of aesthetic guide to the aristocratic milieu during the following periods. Once it had been systematized by Zeami—who wrote more than one hundred texts (twenty-six are still extant in his own handwriting), or libretti *(yōkyoku)*—this type of spectacle has not really varied up to the present day. After the death of Zeami's son, Motomasa, in 1432, his son-in-law, Zenchiku (1405–1468), his nephew, Onami (1398–1467), and Onami's descendants, Kanze Kojirō Nobumitsu (1435–1516) and Kanze Yajirō Nobutomo (1490–1541), continued to write *yōkyoku* and to fix the requirements regulating the essential rules for music and scenery, which thereby gave *nō* drama its unique spirit, as well as setting down stage directions for the actors. The present repertory consists of more than three thousand plays.

In the beginning, before *nō* was rigidly regulated by immutable rules, this type of spectacle was extremely popular. The *Taiheiki* contains a description of a *dengaku-nō* which was performed in 1349 before thousands of spectators from every social stratum, in an atmosphere and setting that was as solemnly religious as it was sumptuously magnificent. Originally these performances were given as a sort of competition between two or more troupes of actors. The first true *nō* performance took place in 1408 in the palace of Kitayama and was organized by Shōgun Yoshimitsu in honor of Emperor Go-Komatsu. Yoshimitsu's refined tastes permitted Kanami and his descendants to create an aesthetic synthesis of the popular theatrical spectacles *(dengaku, sarugaku, kyōgen)* in which both Shintō and Zen concepts played an important part, and the intentionally restricted form endowed the performance with great evocative power.

This aesthetic form influenced all the arts of Japan and intensified the innate attitude of the

Japanese that deep emotions and personal characteristics must never be clearly revealed, but merely suggested or symbolized. This demands great concentration of both actor and spectator; that which is visible, evident, and expressive is considered trivial, coarse, and vulgar; and that which is concealed and is realized only through sensitivity and intuitive observation is considered noble and admirable.

This spiritual attitude, derived directly from Zen teachings—the apparent simplicity of the form is essentially Shintoist—favors all forms of art in which true significance lies hidden within a form apparently simplified to an extreme degree, and it was perhaps responsible for the almost complete abandonment of sculpture at this time. During this period, painting was considered more suitable for the communication of emotions and sensations. Another reason for the lack of interest in sculpture was the influence of Zen, which could furnish artists with no iconography other than the portraits of important spiritual leaders.

The shōguns spent extravagant sums on *nō* performances. Oda Nobunaga, disgusted by a spectacle of extraordinary sumptuousness offered in his honor by Yoshiaki while the country was still at war and the peasants were dying of hunger, left his seat in the middle of the performance—but this gesture was also made to please the emperor.

Other recreational ceremonies were created for the pleasure of the aesthetes. The tea ceremony, for example, assumed great importance and almost completely eclipsed the incense ceremony. The origin of the aesthetic gatherings concerned with tea drinking can be traced to Shōgun Yoshimasa, who had a teahouse built by Shukō (1422–1502) on his estate at Higashiyama. The rules of the ceremony and the elaboration of its ritual can be attributed to Jōō (1503–1551) and to Sen-No-Rikyū (1521–1591), although they were fully developed under the generous patronage of Hideyoshi and the Tokugawa clan.

At the beginning of the sixteenth century emphasis was placed primarily on simplicity, and the ceremonies, directed for the most part by the Zen clergy, were merely meetings of aesthetes who sought to escape wordly preoccupations to attain a spiritual freedom impossible to find in the course of daily life. Having become a widely accepted beverage, especially among Zen adepts, tea drinking allowed persons of different classes to meet on a basis of social equality, because one of the principles of the tea ceremony was the denial of social differences (provided they were not too great!). The nobles and rich merchants purchased art objects, particularly porcelains imported from China, for their guests to admire at these gatherings. Splendid family collections were thus formed, which have been transmitted from generation to generation up to the present day. If the Ashikaga shōguns proved inefficient governors, at least their aesthetic sense, in sharp contrast to the harshness of the period, permitted the arts to take a new direction and to develop through the contribution of new elements.

Architecture and Sculpture

In the field of architecture, civic building set the pace. There were few architectural innovations in the great monasteries, and whatever construction was done employed a combination of the three traditional structural styles, as exemplified, for instance, in the Hondō of Kanshin-ji (1375) and the Sammon of Tōfuku-ji (1394–1427).

The taste of the great nobles was reflected primarily in the two great "retreat residences" built by the shōguns Yoshimitsu and Yoshimasa on their estates near Kyoto. The Golden Pavilion, or Kinkaku-ji (c. 1400), now part of the temple of Rokuon-ji, has a luxurious appearance and its design followed the architectural principles of the *shinden* style and the structural techniques employed in Zen architecture. The Silver Pavilion (Ginkaku-ji), built for Yoshimasa in 1479, was characterized by greater simplicity. Sliding doors made their appearance in this building, and endowed it with a remarkable sense of lightness; also its dimensions were con-

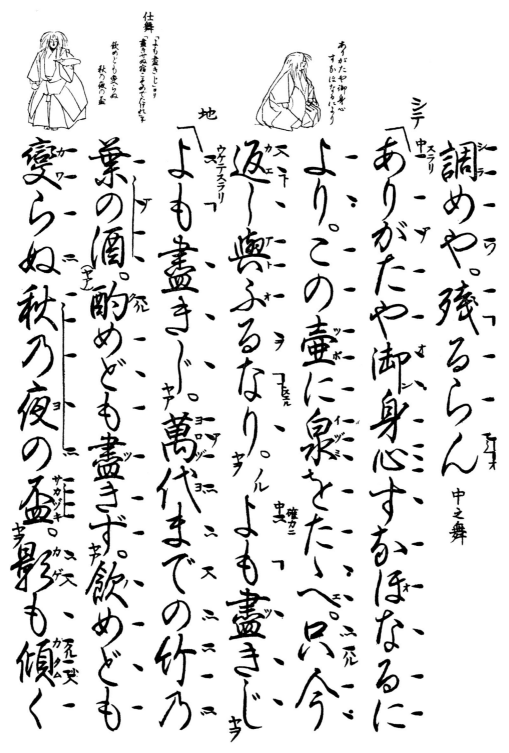

42. TEXT FROM THE YŌKYOKU OF THE NŌ PLAY SHŌJŌ—ATTRIBUTED TO ZEAMI

siderably smaller than the Kinkaku-ji (it is believed that the Ginkaku-ji was modeled after a pavilion at the Saihō-ji, and *not*, as is commonly believed, on the Kinkaku-ji). Another important element was the introduction of the *tokonoma*, an alcove or niche designed for displaying works of art (in general dominated by a vertical scroll painting, or *kakemono*), and the *tokowaki*, another type of alcove fitted with shelves for the display of porcelains and other art objects.

329

The Golden Pavilion and the Silver Pavilion were set in the middle of gardens designed in a new style influenced by the Zen spirit. One garden of this type was the work of the priest Musō Kokushi, a famed garden designer who attempted to reproduce the ideal Zen site as described in a Chinese book entitled *Pi Yen-lu*; it is the garden of Saihō-ji (Kyoto), which is popularly called the Kokedera, or Moss Temple.

Two new architectonic types also appeared during this period: the *nō* scenery, which united the simplicity of Shintō architecture with Zen functionalism; and the *chashitsu* (tearoom), a chamber or small building in the rustic style incorporating natural elements chosen at random. The *chashitsu* was the place where aesthetes desirous of following the "way of tea" gathered for tea ceremonies. The earliest *chashitsu* from this period seems to be the one constructed by Shukō. Situated in the Tōgudō (Eastern Request Hall), a building in the garden of the Ginkaku-ji, it consists of a single room with a floor space of only four-and-one-half mats (this is believed to have set the pattern for the standard four-and-a-half *tatami* tearoom).

Another important architectural development of the era was the construction of the first fortified castles. As early as the fifteenth century the independent lords of the provinces (the *daimyō*) had felt it prudent to erect citadels to protect their fiefs against marauding neighbors. After 1550, the introduction of firearms made it necessary to erect high defensive stone walls and to dig wide, deep moats that were filled with water.

The plans of these castles varied according to their location: the *yamajiro* or mountain citadels, and the *hirajō* or castles of the plains, which had the function of observation posts checking movement along the major arteries. The castles' defenses were additionally protected by towers surmounting the walls *(yagura)*, and within these walls were the soldiers' quarters, space for refugees, the residential palace and the temples, all surrounding the donjon or keep *(tenshu)* in which the lord of the castle kept his treasury, supplies, and weapons. The *tenshu* was usually quite high—from five to seven stories—and also served as an observation tower.

The first fortified castles of this type were those of Ōta Dōkan at Edo, Hōjō Sōun at Odawara, Rakuta Castle at Owari, and Shigisan Castle in Yamato, all of which were generally erected on older defensive sites. The *daimyō* built such citadels throughout the sixteenth century, but the first that can be considered to have been an authentic castle (combining a system of defense with a luxurious residence) was Azuchi Castle, constructed by Oda Nobunaga in 1576. This was copied by the other great nobles, such as Hideyoshi and the members of the Tokugawa clan. These *hirajō* often formed the nuclei of towns or cities that attained great importance in the following century, such as Osaka and, especially, Edo, the future Tokyo.

As we have stated, the art of sculpture could hardly be said to have flourished during the Muromachi period. At best, only badly executed copies of works from preceding periods were produced. There were neither innovations nor, it seems, any impetus toward giving old forms new life. Mention must be made, however, of the masks created for *nō* dramas by an excellent artist of the period, Hisatsugu Zōami, who was not only a friend of Zeami's but who also worked for him. His masks served as models for all subsequent craftsmen.

Painting

Although sculpture remained at a standstill during the Muromachi period, the same cannot be said for painting. Painting developed through several schools which drew their inspiration from various sources. These sources endowed the pictorial art of Japan with its definitive character and inspired its most classical works. Certain paintings executed at the start of the Zen movement were so strongly influenced by the Chinese art of the Sung and Yuan dynasties that it would be difficult to classify them as Japanese, even though they were created by Japanese painters.

Chinese art had such an attraction for the Japanese that many artists went to China and settled there permanently: Mokuan Reien (c. 1350), for example, ended his days on the mainland where he was known as the second Mu-Ch'i; Kaō (d. 1345) was more authentically Japanese; the same applies for Ryōzen, Gyokuen Bompō, and Tesshū Tokusai. These Zen monks and priests introduced into Japan a style of painting with India ink known as *suiboku*, in which supple, vibrant lines no longer served merely to emphasize an outline but at times replaced the surfaces and suggested volume. The lines, which are more or less black and more or less accentuated, transmit to the viewer the living spirit of the things they represent and are a faithful imitation of nature—not in form, but in essence.

These artist-monks were more or less specialized: some depicted flowers, some bamboo trees, others devoted themselves to portraits of the Great Zen Masters *(chinsō)*, and still others to subjects *(Doshaku-ga)* that aimed at arousing a spiritual awakening in the observer.

Paintings depicting traditional Buddhist subjects, although not completely abandoned, were rarely done, because the Zen clergy refused to accept the authority of the scriptures. The works were executed primarily by artists who were members of the imperial *Edokoro* (Bureau of Painters) and who followed more or less the *yamato-e* style. Beginning about 1400 the *suiboku* style, which up until then had been limited to reproducing specific subjects, widened in scope, and landscapes began to be painted. The era of the *shijiku*, or *kakemono* (vertically hung scroll paintings, often bearing poetry in fine calligraphy), had arrived. The art of painting in black-and-white no longer concentrated solely on the visual aesthetic, but also on the spirit of the work, and thus it became difficult to make a distinction between poetry and painting, because the one complemented the other.

The most representative painters of this new style—which has been called *Ōei*, from the name of the era (1394–1427) in which it was developed—were two men: Minchō (also known as Chō Densu), a Zen monk (1352–1431), who primarily depicted the *chinsō* and the Chinese divinities; and Tenshō Shūbun, the abbot of the Zen monastery of Shōkoku-ji, who worked for the Ashikaga shogunate and was the first director of its *Edokoro*. The work of Tenshō Shūbun followed the Sung and Yuan styles and he often depicted airy landscapes in which one discovers a Zen monk in meditation near a hermitage: a type of studio painting called *shosai-zu*. Shūbun also executed secular commissions and decorated screens with landscapes devoid of religious allusions. Sōtan and his son, Sōkei, succeeded Shūbun as directors of the shogunate's *Edokoro* and followed in his footsteps. Members of the same school were the "three Ami": Nō-ami (1397–1471), Gei-ami (1431–1485), and Sō-ami (1472–1525). Kenkō Shōkei also followed this school.

The fame of these more or less official painters was eclipsed by that of one of Shūbun's pupils, Sesshū Tōyō (1420–1506), whose style characterized the art of the Bummei era (1469–1486). After a trip to China lasting two years (1468 and 1469), this painter attempted to re-create the essence of the Chinese and Japanese landscapes from the impressions he had received. As a result of his efforts the Chinese *suiboku* style became typically Japanese, because it employed the *haboku* technique (literally "flung ink," employing a freely handled wash) with the greatest effect. The painting of the Ming period, which he had admired in China, supplied him with new subjects—principally flowers and birds—which later were imitated in a different style by the Kanō school.

Sesshū's art was faithfully followed by his successors: Josui Sō-en, Shūgetsu Tōkan, Sesson Shūkei, Umpō Tōetsu, and others. Another style of *suiboku* painting, the Soga school, was characterized by powerful brushstrokes. Its most typical representatives were the priests Soga Dasoku and Bunsei, truly original painters whose works were in essence far removed from those of their famous contemporary, Sesshū.

The painters of the *yamato-e* style—the only authentically Japanese artists until that time—continued to work for non-Zen monasteries and also on either portraits or illustrations for scrolls *(emakimono)* recounting the histories of the temples. (The most remarkable *emakimono* of this period were the *Kasuga-Gongen Genki Emaki* and the *Hossō Hiji Ekotoba* by Takashina Takakane). The *yamato-e* schools finally fused into a single style elaborated by Tosa Mitsunobu

331

(1434–1525), third in line of a family of well-known painters and a director of the imperial *Edokoro*. The illustrated scrolls by this artist—the *Seisui-ji Engi Emaki*, the *Seikō-ji Engi*, and others—and those of his sons, Mitsumochi and Mitsumoto, were among the finest contributions of this school.

Kanō Masanobu (1434–1530), an adherent of both the then-new *sumi-e* style employed by the Zen monks and the traditional *yamato-e* style, developed a new, typically Japanese idiom employing Chinese *kanga-e* techniques. His was not an art for monks and priests, but one for the feudal lords and warriors; and even though the subject matter was often borrowed from Buddhist or Chinese sources, the style had an undeniably national character. This character was exemplified by the artist's son, Motonobu (1476–1559), who also introduced color into the monochromatic *suiboku-ga* style. In the following period other painters of the Kanō group were further to refine and improve the unique style created by Motonobu.

Always highly admired, calligraphy offered no new styles. During this period it tended to become conventionalized and to imitate Chinese counterparts of the Sung and Yuan dynasties. However, the calligraphic style of Ikkyū Sōjun (1394–1481), a painter of the *suiboku* style, remained unique in this period.

279. KYOTO. NINNA-JI. WOODEN RAILING.

280. NARA. DANZAN JINJA. THIRTEEN-ROOFED PAGODA. This unique type of pagoda is remarkably well-proportioned. It was probably first erected in 679. However, the present structure was rebuilt in 1532. The interior is unstoried, and the structure is unfenestrated. The roofs are shingled with cypress bark, and the pagoda is set on a stepped base reached by three stairs. The structure belongs to a syncretic Shintō cult. Height 42½′.

281. NARA. KŌFUKU-JI. GOJŪ-NO-TŌ. A typical structure of the Muromachi period, this pagoda has five functional stories, and its roofs are tiled. It was built in 1426. Height 180′.

282. KYOTO. KINKAKU-JI. Originally the residence of a noble, Saionji Kintsune, this pavilion was rebuilt in a luxurious style about 1400 by Shōgun Ashikaga Yoshimitsu as but one of a complex of palaces (no longer extant) set within a immense parklike garden. Yoshimitsu also ordered the beautiful pool dug. The shōgun died in this pavilion. It has been called the Golden Pavilion (Kinkaku-ji) because of the extensive use throughout of gilding (*kin* means gold in Japanese). The roof is bark-shingled and is crowned by a golden *hō-ō* (a phoenix). The property was converted into the temple of Rokuon-ji by Yoshimitsu's son, Yoshimochi, in obedience to a vow made to his father. The magnificent building was totally destroyed in a fire set by a psychopathic neophyte monk in 1950, but was rebuilt in 1955 in an exact reconstruction of the original. The garden is an excellent example of Muromachi landscape art.

283–84. KYOTO. GINKAKU-JI. THE GARDENS AND THE PAVILION WITH THE "MOON-FACING MOUND" AND "SILVER SAND PLATFORM." Built in 1479 by Shōgun Ashi-

kaga Yoshimasa, this pavilion was never covered in silver even though it is called the Silver Pavilion. It is sometimes called the Jishō-ji. Of a more austere style than the Kinkaku-ji, the pavilion, the garden, and the Tōgudō, or Eastern Request Hall (plate 283), are perfect embodiments of the Zen aesthetic formulated by the priesthood attendant on the shōguns during that period. The garden has been attributed to Sō-ami. It consists of two parts: the first is classical, with a pond; the other is a dry-landscape garden composed of sand, gravel, and stones arranged to symbolize the sea and the mountains.

285. KYOTO. DAITOKU-JI. DAISEN-IN. SOUTH GARDEN OF THE ABBOT'S RESIDENCE. A Zen sand garden of utter simplicity—an ocean of space with two mysterious mounds. The Daisen-in is a sub-temple of Daitoku-ji. The gardens (see also plate 291) are superb examples of Zen landscape art of the Muromachi period (c. 1509).

286. KYOTO. CHION-IN. SEISHI-DŌ. Chion-in houses the Kyoto headquarters of the Jōdo sect. With a square ground plan, this building is one of the oldest structures of the complex. Originally built in 1530, it was almost completely reconstructed in 1633.

287. KYOTO. TŌFUKU-JI. SAMMON. This large two-story gateway dates from the Muromachi period and was built in the fourteenth century. The upper hall is decorated with paintings, including several by Minchō. It is the only extant Sammon from the early period of Zen architecture. Height c. 108′.

288. KYOTO. NINNA-JI. ENTRANCE STAIRS OF THE MIEI-DŌ. End of the Muromachi era.

289. KYOTO. NINNA-JI. MIEI-DŌ. DETAIL OF BRACKETING. End of the Muromachi era.

290. KYOTO. CHISHAKU-IN. Garden attributed to the "tea master" and aesthete, Sen-No-Rikyū, who was forced by Toyotomi Hideyoshi to commit suicide in 1591.

291. KYOTO. DAITOKU-JI. DAISEN-IN. DRY-LANDSCAPE GARDEN NORTH OF THE ABBOT'S RESIDENCE. This famous stone garden has been ascribed to Kogaku Sōkō, the founder of this part of the temple, and was inspired by Zen aesthetic. In this garden pebbles symbolize water, foliage, and the distant mountains. Large boulders suggest the world of humans. The large stone on the left is called *Fudōseki* (Immutable Rock); the one in the middle is known as *Kannonishi* (the Stone of Avalokiteshvara). The stones in back of these two symbolize a waterfall and the severely clipped foliage above is meant to suggest Mount Hōrai, the fabled treasure mountain of Chinese mythology.

43. INTERIOR OF THE TEAHOUSE (CHASHITSU), KŌ-AN, SANGEN-IN, DAITOKU-JU TEMPLE IN KYOTO

292. KYOTO. TŌFUKU-JI. TILE ROOF. Of these ornamental

terminal tiles, one is decorated with the three characters of the name of the monastery, *Tō-Fuku-ji*, and the other with the monastery's sacred name, *E-Nichi-Zan*.

293. KYOTO. HŌKAN-JI. DOOR. This fifteenth-century door made of beautifully grained planks belongs to a temple first built in 1179 and later reconstructed by Shōgun Ashikaga Yoshinori. The monastery has been destroyed.

294. KYOTO. NISHI HONGAN-JI. GARDEN. This monolith bridge spans a sand river. Cycads and pines create extraordinary textural contrasts with the rocks.

295. KYOTO. TŌFUKU-JI. SAND GARDEN. Another example of the subtle impact provided by sand raked into patterns symbolic of water. (See also plate 343.)

296. KYOTO. NANZEN-JI. SAMMON. Corner baluster of the railing on the second-story gallery.

297. TSURUGAOKA HACHIMAN-GŪ. MINAMOTO-NO-YORI-YOSHI. This work portrays the founder of the Tsurugaoka Hachiman Shrine (1063), and is carved from wood which was then painted. It dates from the Muromachi period. The subject is portrayed as the Shintō divinity Hachiman holding a ceremonial scepter in his hands. Kamakura Museum.

298. KYOTO. SHINJU-AN. CALLIGRAPHIC SCROLL. The work of Ikkyū Sōjun (1394–1481), it exemplifies the *sumi-e* style. Ink on paper. Height 52⅜".

299. OSAKA CASTLE. CALLIGRAPHY. This is a letter from Ieyasu addressed to Oda Nobunaga.

300. CHARACTERS FROM THE NŌ PLAYS. These drawings by Morikawa Sōbun are from a notebook devoted to the *nō* theater. The work dates from the Meiji era. Hauchecorne Collection.

301. DARUMA. This *sumi-e* painting on paper dates from the Muromachi period and bears an inscription by Shigen. The subject was a popular one and is only one of many depicting an imaginary portrait of Bodhidharma (Daruma), the Chinese priest who was the first Zen (Ch'an) patriarch. Nara National Museum.

302. SELF-PORTRAIT OF SESSON. This shows the painter as a monk seated on a chair. *Sumi-e* style, in colors, on paper. Height 25⅝". Museum Yamato Bunkakan, Nara.

303. BUKKI-GUN EMAKI. Illustration from a fifteenth-century *emakimono* depicting the tortures of Hell; here, a multi-eyed demon pursues one of the damned. *Sumi-e* style, on paper. Kyoto National Museum.

304. THE FIVE HUNDRED RAKAN. Detail of a hanging scroll painting which depicts the disciples of the Buddha. Also known as Arhats, they are individuals who have reached the uttermost state of Perfection. Arhats or Rakan are often depicted as grotesque or emaciated old men. This scroll is attributed to Chō Denso (Minchō). Kyoto National Museum.

305. CHION-IN. HŌNEN SHŌNIN EDEN. This *emakimono* in forty-eight scrolls recounts the life of Hōnen and contains a series of illustrations in color on paper. It was executed by eight artists between 1307 and 1317 and consists of 234 texts and 230 illustrations. Height 13".

306. A NOBLEMAN AND A COURT LADY. This is a detail from an *emakimono* (identified as the *Heike Monogatari*) executed in the *yamato-e* style, and dating from the Muromachi period. The two figures are Takiguchi Tokiyori and the Lady Yokobue. Kyoto National Museum.

307. LANDSCAPE. Detail of a *kakemono* painted in ink on paper executed by the famous Sesshū for Sō-en, his pupil and disciple. It is one of the finest examples of the *haboku* (flung-ink) style. Height 58¼". Tokyo National Museum.

308. KYOTO. DAITOKU-JI. DAISEN-IN. BIRDS AND FLOWERS BY A WATERFALL. This is a portion of a sliding screen *(fusuma)*, painted in 1509 by Kano Motonobu, depicting magpies on the trunk of a pine tree. Painted in color on paper. (See also plates 313–314.)

309. RYODŌHIN. This portrayal of the Chinese sage Ryodōhin (in Chinese, Lu Tung-pin), a Taoist Immortal, was executed by Sesson. It is a detail from a *kakemono* painted in ink on paper. Sixteenth century. Height 45¼". Museum Yamato Bunkakan, Nara.

310. WATERFALL. Detail of a scroll attributed to Kano Motonobu, and painted in the *sumi-e* style. Ink and color washes on paper. Beginning of the sixteenth century. Museum Yamato Bunkakan, Nara.

311. KASUGA SHIKA MANDARA. This is a work of syncretic iconography showing the descent of Buddhist divinities into the Shintō Kasuga Shrine (symbolized by a deer) in Nara. This type of mandala was greatly admired in the shrines administered by followers of the Suijaku doctrine. Painted on silk and dating from the sixteenth century, it was originally in the monastery of Hongan-ji. Nara National Museum.

312. WILD GEESE. This is a detail from a painting by Sō-ami in the *sumi-e* style. Beginning of the sixteenth century. Kyoto National Museum.

313–14. KYOTO. DAITOKU-JI. DAISEN-IN. SHIKI KŌSAKU-ZU. These are details from a work depicting the four seasons attributed to Kano Yukinobu, and executed in the *sumi-e* style on paper. Plate 313: buffalo pulling

a plow in a rice paddy. Plate 314: storing the rice harvest.

315. SANSUI-ZU. A detail of a painting executed by Sō-ami in *sumi-e* style on paper, depicting scenes of country life. Kyoto National Museum.

316. KYOTO. DAITOKU-JI. ŌBAI-IN. LANDSCAPE. This is a portion of a *fusuma* (sliding screen) from a *chashitsu* (room or small house for the tea ceremony). Executed by Tōetsu in the *sumi-e* style at the end of the sixteenth century.

317. LANDSCAPE. This is a portion of a six-panel screen attributed to Shūbun. Dating from the fifteenth century, it is executed in the *sumi-e* style on paper. Museum Yamato Bunkakan, Nara.

318. KYOTO. GINKAKU-JI. PAINTED SCREENS. This shows the appearance of *fusuma* in an actual room setting.

319. KYOTO. DAITOKU-JI. SANGEN-IN. MONKEYS. This detail from a late-eighteenth-century *fusuma* is by Hara Zaichu (1750–1837). After a visit to China, he created many works imitating the style of Mu Ch'i, a Chinese artist of the Sung dynasty. However, in the work shown here he copied the style of Hasegawa Tōhaku (1539–1610).

320. KYOTO. DAITOKU-JI. ŌBAI-IN. A FAN. This painted paper fan dates from the Muromachi period.

321. HOSOKAWA KATSUMOTO. This is a portrait of the precipitator of the Ōnin Civil War. Originally in the temple of Ryōan-ji, it is painted in colors on silk. Sixteenth century. Kyoto National Museum.

322. ODA NOBUNAGA. This portrait of the famous Muromachi period warrior, painted on silk, dates from the end of the sixteenth century. Kyoto National Museum.

323. MŌRYŌ KIJIN. This fifteenth-century statue of a demon in painted wood with inset glass eyes *(gyokugan)* was originally in the monastery of Saimyō-ji. Nara National Museum.

324. KYOTO. TŌFUKU-JI. SAMMON. MISSHAKU KONGŌ. This is a painted clay and wood effigy of a guardian divinity (see also plates 257 and 258) dating from the sixteenth century.

325. NARA. HOKKE-JI. JŪICHI-MEN KANNON. Of painted wood, this work dates from the Muromachi period.

326. KYOTO. TŌFUKU-JI. KADEN SHAKA. This painted wood effigy was executed by Kō-ei in the sixteenth century. It stands in the upper hall of the Sammon (gateway).

327. ASCETIC SHAKA. Also known as Shaka Descending from the Mountain, this represents the Buddha as an emaciated ascetic after his years of fasting, at the moment he resolved to terminate his withdrawal from the world to seek the Way of Truth. Dating from the fifteenth century, the work is made of painted wood. Nara National Museum.

CULTURAL CHART

1339	L–H	*Jinnō Shōtōki*: biographies of the emperors by Kitabatake Chikafusa.
1340	A	Garden of the monastery of Tenryū-ji, Kyoto.
1346	Po	*Fuga Waka Shū*: an anthology of *waka*.
c. 1350	A	Garden of the monastery of Saihō-ji, Kyoto.
1356	Po	*Tsukuba Shū*: *renga* poems by Njiō Yoshimoto and Gusai.
1358	L	*Yoshino Shūi*: a collection of legends.
1368	L	*Soga Monogatari*: a battle tale.
c. 1370	L	*Taiheiki*: a romantic historical chronicle.
1372	Po	*Renga Shinshiki*: anthology of *renga*.
1375	A	Construction of the Hondō (main hall) of the monastery of Kanshin-ji, Osaka.
1376	L–H	*Masu Kagami*: an anecdotal chronicle.
1381	Po	*Shin-yō Waka Shū*: anthology of *waka*.
1384	Th	Death of Kanami, early master of *nō* drama.
c. 1394–1427	A	Construction of the monastery of Kinkaku-ji, Kyoto.
	A	Construction of the Sammon (gateway) of the monastery of Tōfuku-ji, Kyoto.
c. 1400	L	Period of popularity of *otogi zōshi*: short stories.
1400	Th	*Kadensho*: a commentary on the *nō* theater written by Zeami.
1408	L	Period of formation of the *Gikeiki*: the chronicle of Minamoto Yoshitsune.
1423	Th	*Nōsakusho*: a commentary on the *nō* theater written by Zeami.
1430	Th	*Sarugaku Dangi*: a commentary on the *nō* theater written by Zeami.
1438	Po	*Shin-shoku Kokin Waka Shū*: an anthology of poetry.
1443	P	Last documentary reference to the priest-painter Shūbun. It is generally assumed that he died in the Bun-an era (1444–48).
	Th	Zeami completes his *yōkyoku* (scripts for the *nō* theater). Death of Zeami.
1450	Th	Introduction of the *kōwaka-mai* dance and the beginnings of popular theater.
1455	Po	Death of Sōzei, *renga* poet.
1459	Po	Death of Shōtetsu, author of the *Sōkon Waka Shū*, an anthology of *waka*.
1468	P	Visit of Sesshū to China.
1470	Po	*Azuma Mondō*: a commentary on the rules of *renga* written by Sōgi.
1475	Po	Death of Shinkei, *renga* poet.
1479	A	Construction of the Ginkaku-ji Pavilion, Kyoto.
1486	P	*Sansui Chōkai*: the long landscape scroll by Sesshū in the collection of the Mōri family.
1488	Po	*Minase Sangin hyaku-in*: an anthology of the three *renga* poets Sōgi, Sōchō, and Shōhaku.
1495	Po	*Shinsen Tsukuba Shū*: a collection of *renga* by Sōgi.
c. 1500	A	The dry landscape garden of the monastery of Ryōan-ji, Kyoto.
1502	Po	Death of Sōgi, *renga* poet (b. 1421).
1506	P	Death of Sesshū (b. 1420).
1510	A	The garden of the Daisen-in in Daitoku-ji, Kyoto.
1518	Po	*Kanginshū*: an anthology of poetry.
1540	Po	*Haikai-no-Renga, Moritake Senku*: the first *haiku* poems.
1542	H	Introduction of firearms.
1549	C	Arrival of Francis-Xavier in Nagasaki.
c. 1550	Sc	Zoami sculpts masks for the *nō* theater.
1559	P	Death of Kanō Motonobu.
1565	H	Assassination of Shōgun Yoshiteru.
1571	A	Reconstruction of the Honden of Itsukushima Jinja.
1574	P	*Rakuchū-Rakugai Zu Byōbu*: a pair of folding screens painted by Kanō Eitoku.
1576	A	Construction of Azuchi Castle by Oda Nobunaga.

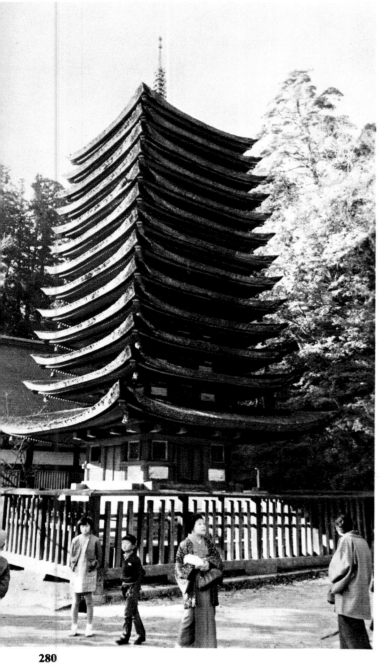

280

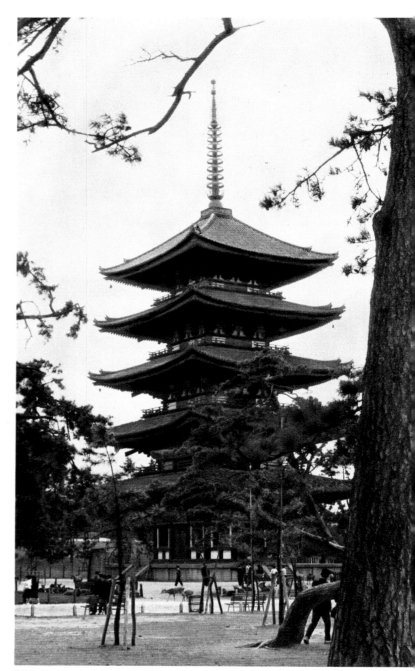

281

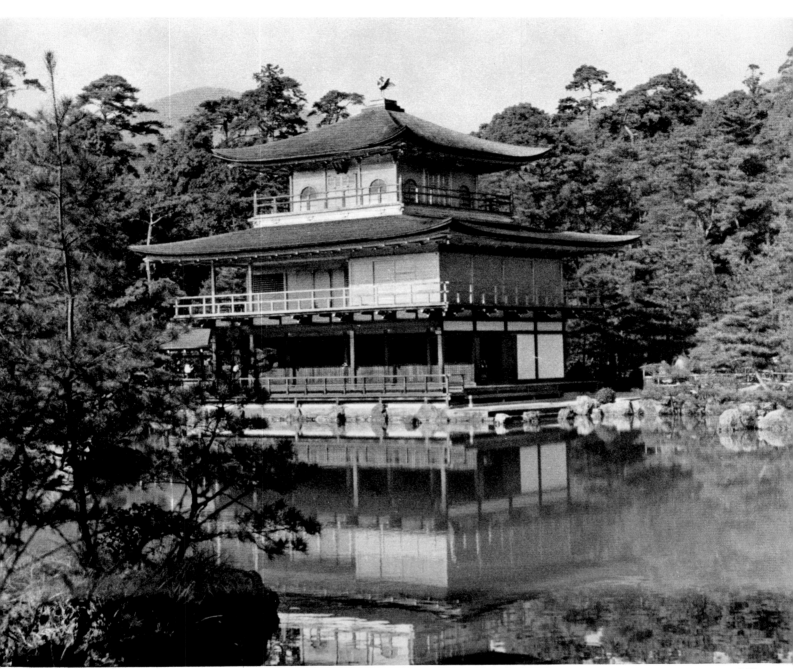

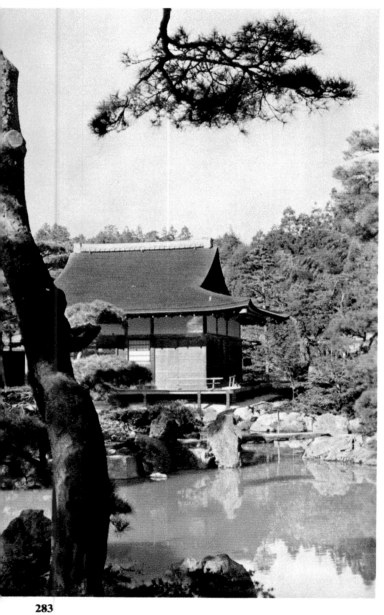

283

284

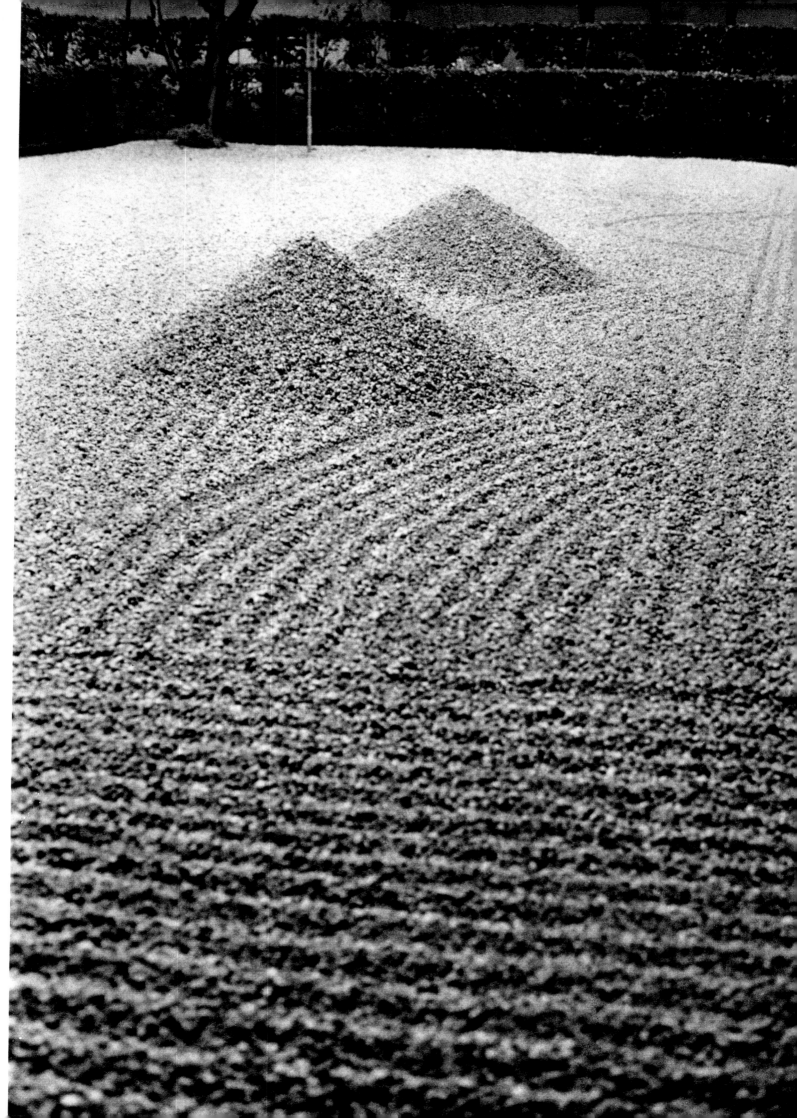

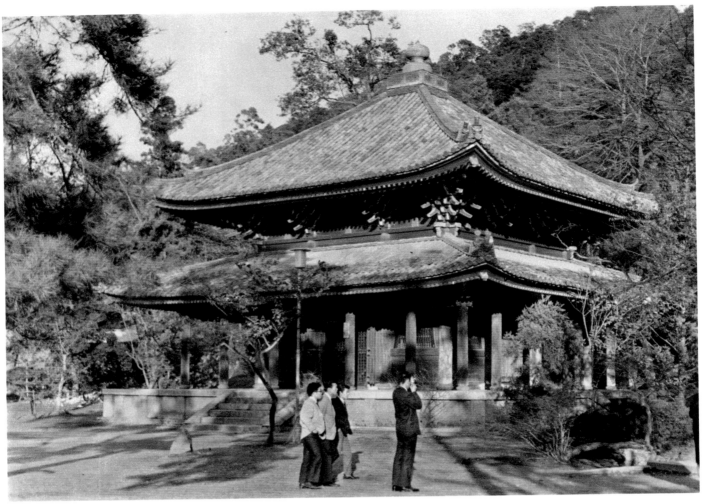

286

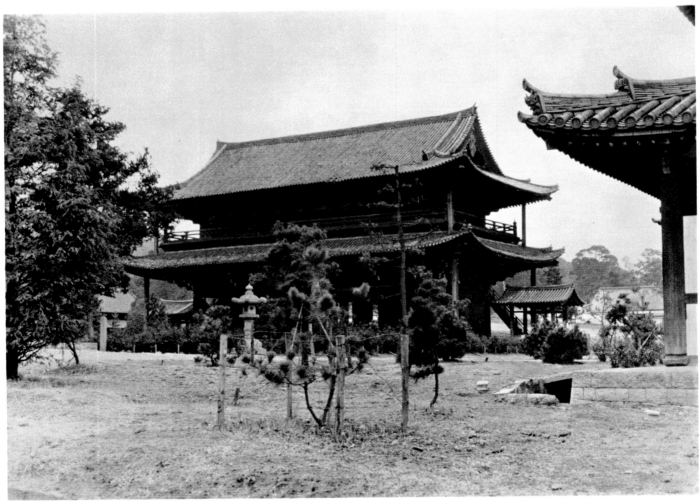

287

288

289

290

291

292

293

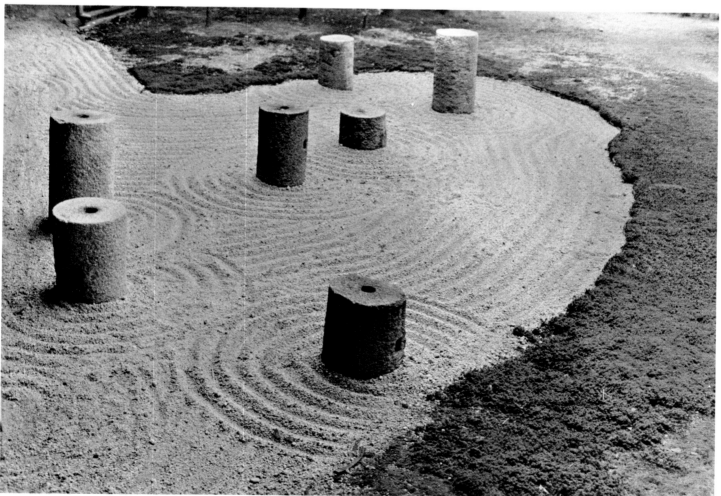

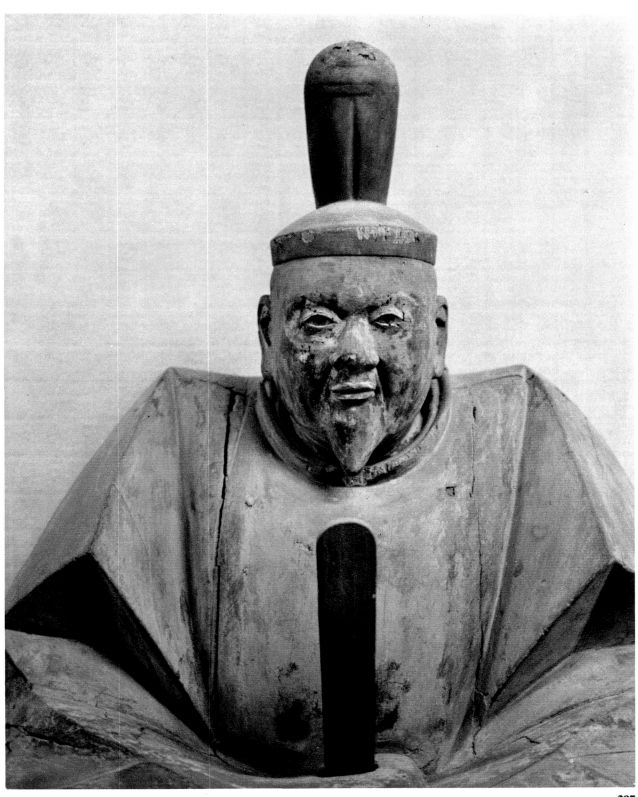

298

299

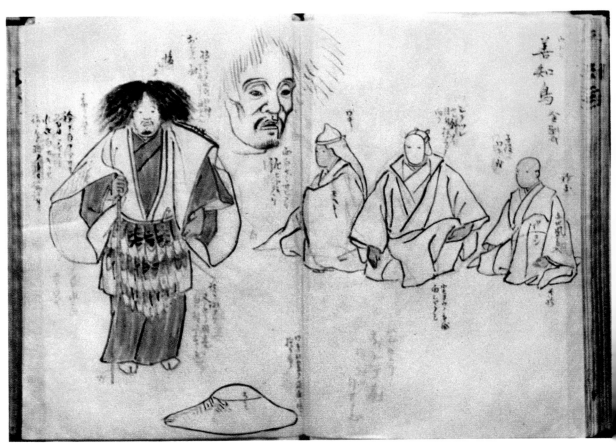

300

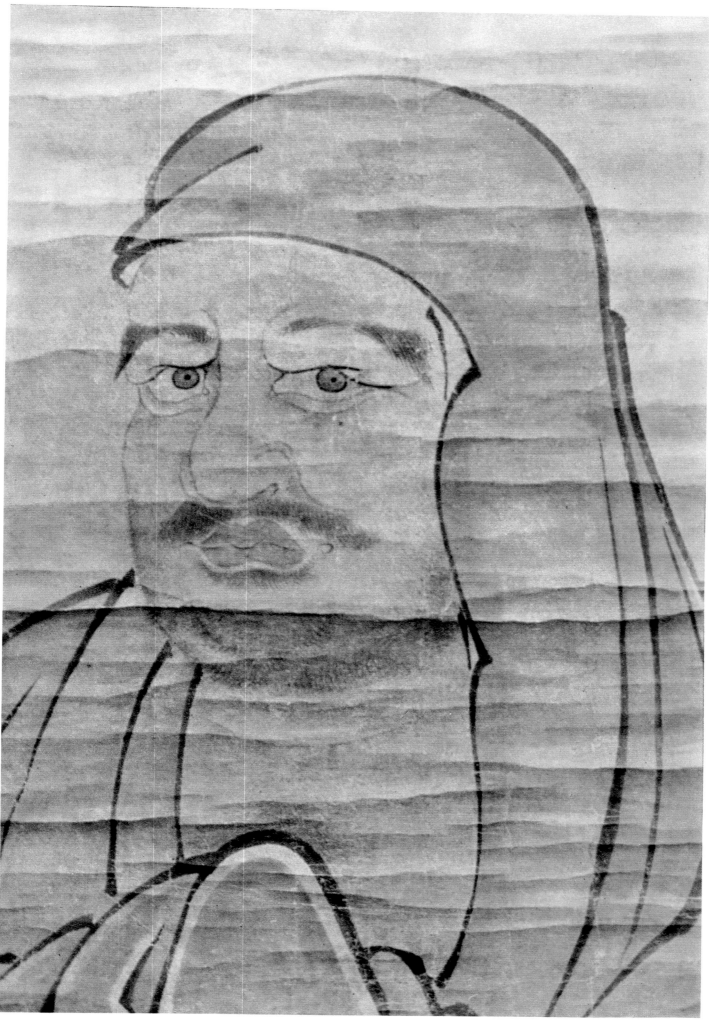

302

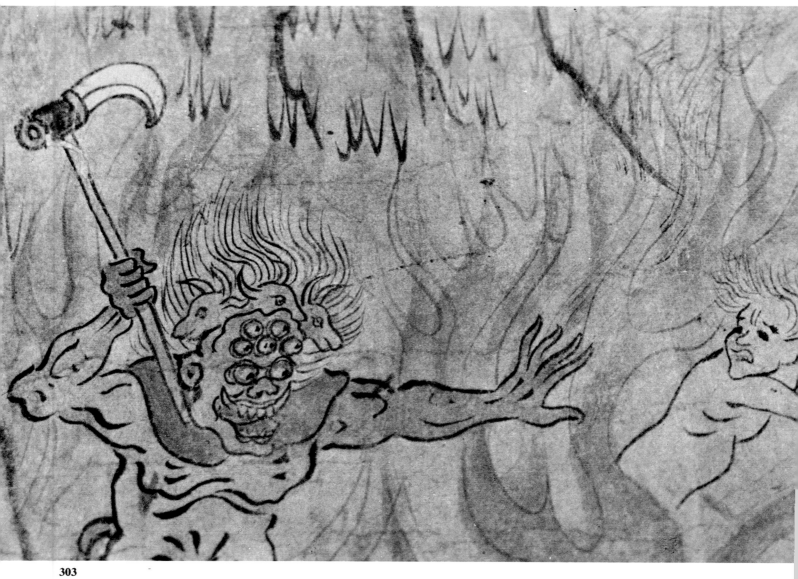

303

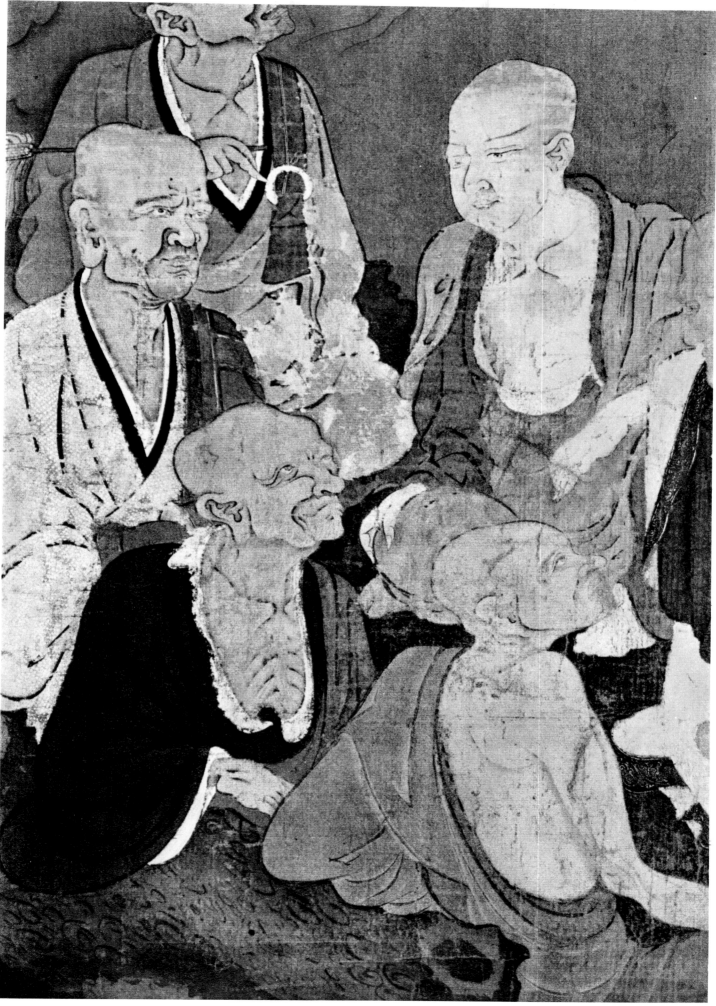

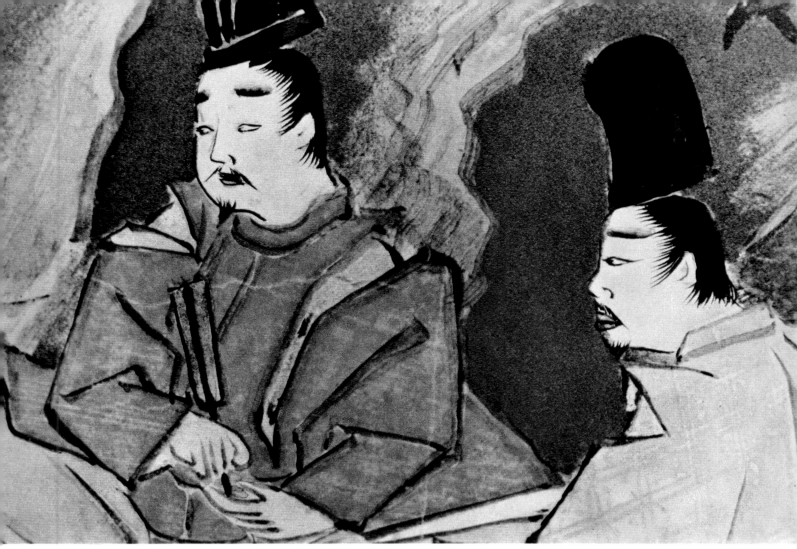

305 306

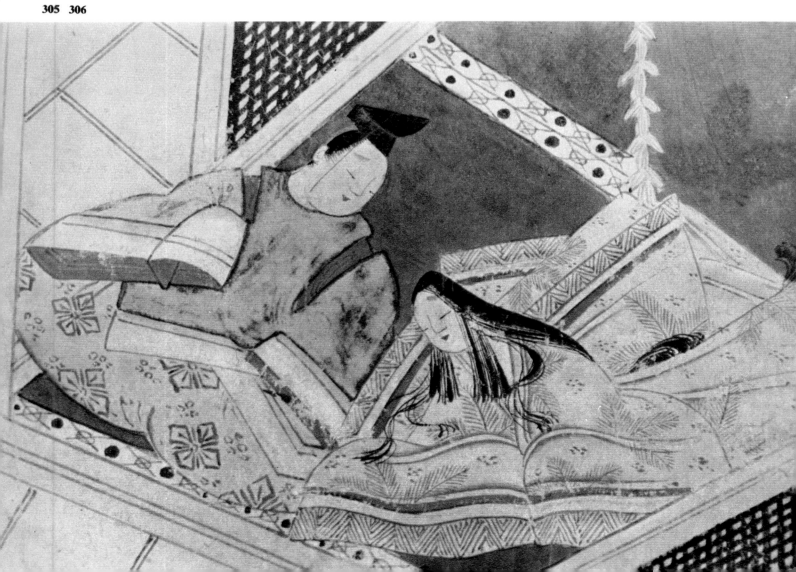

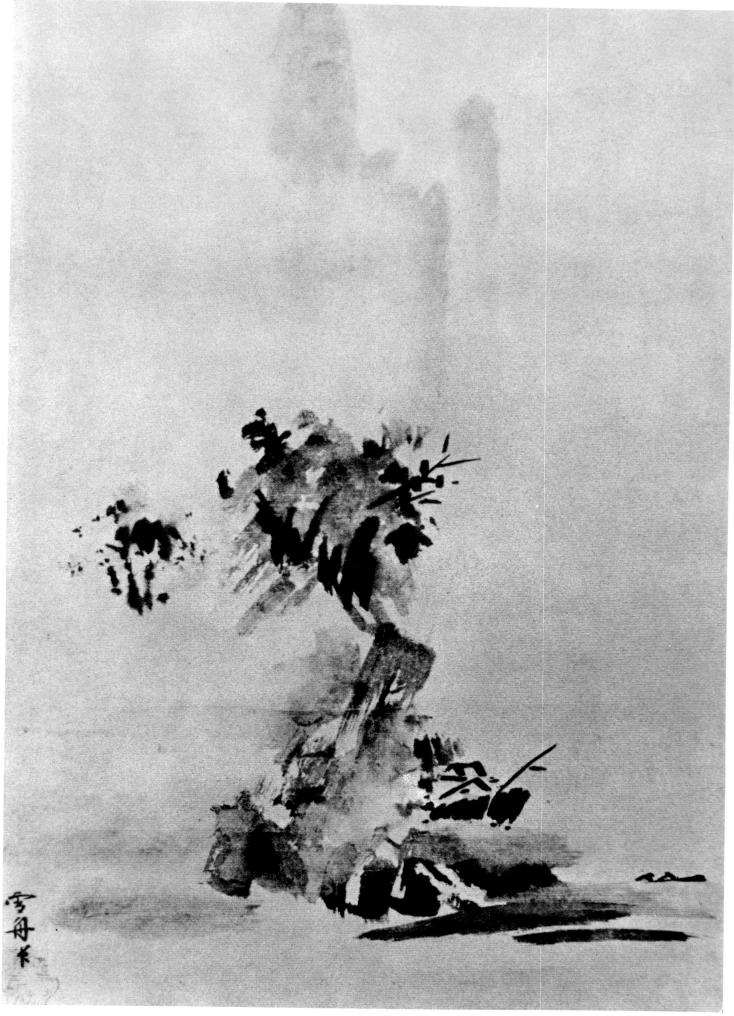

308

309

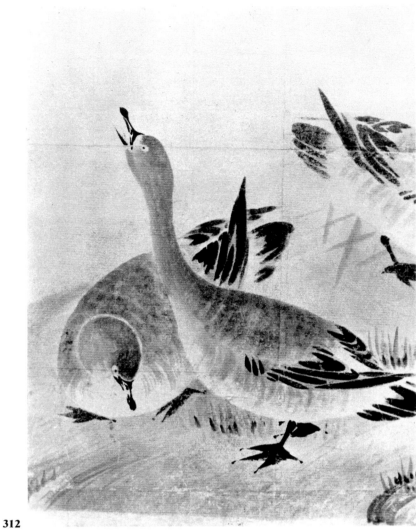

311 312

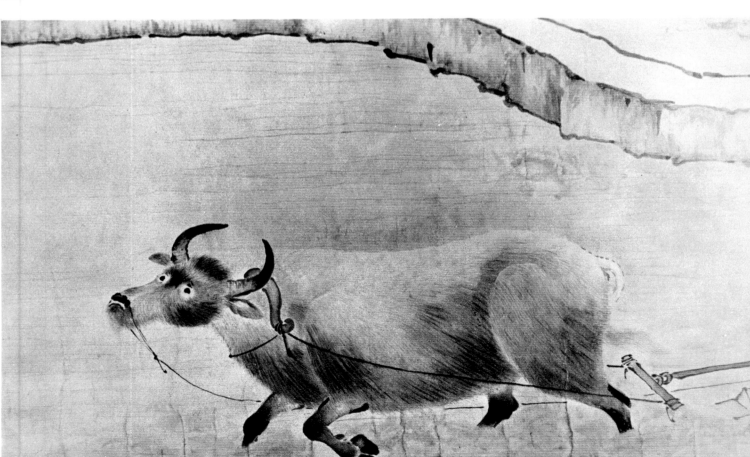

313

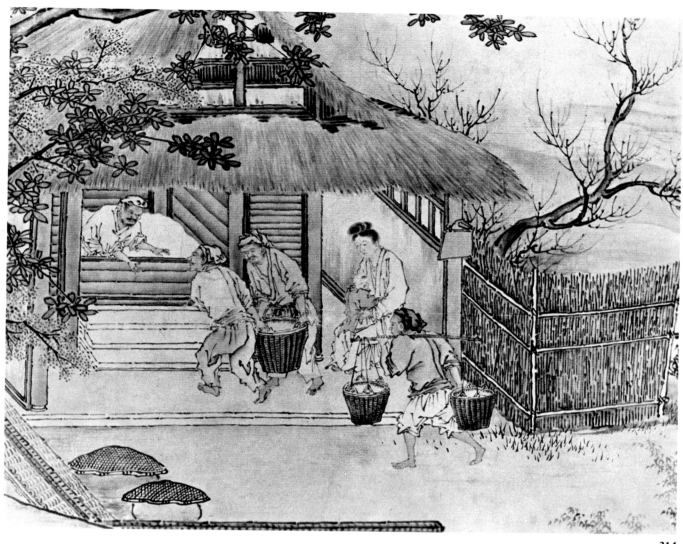

314

315

316

317

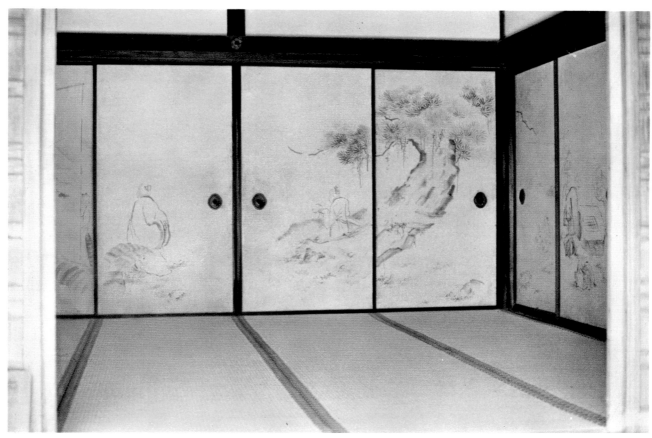

318

319

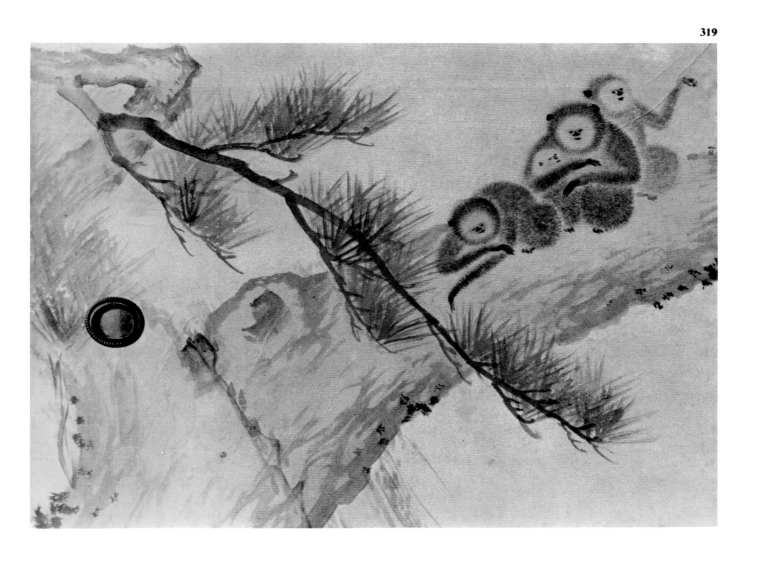

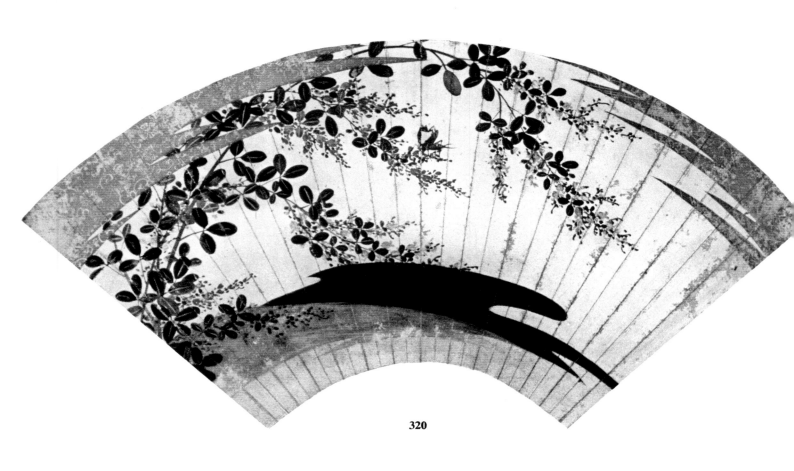

320

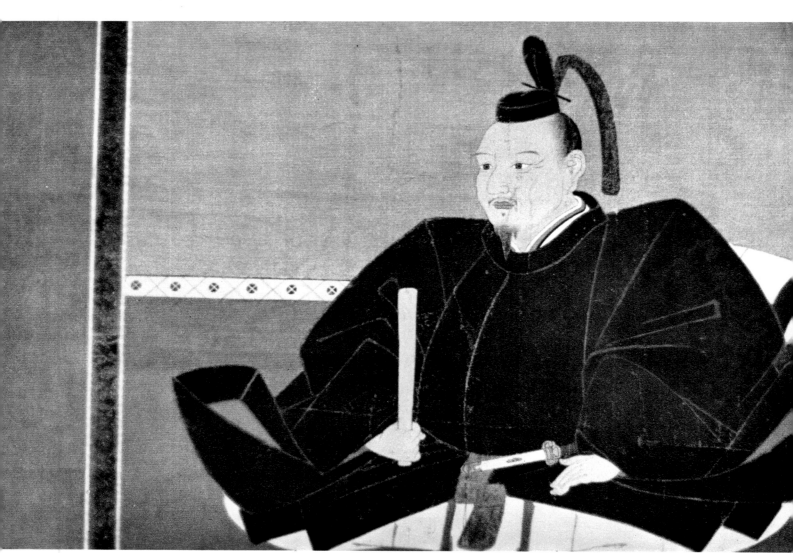

321

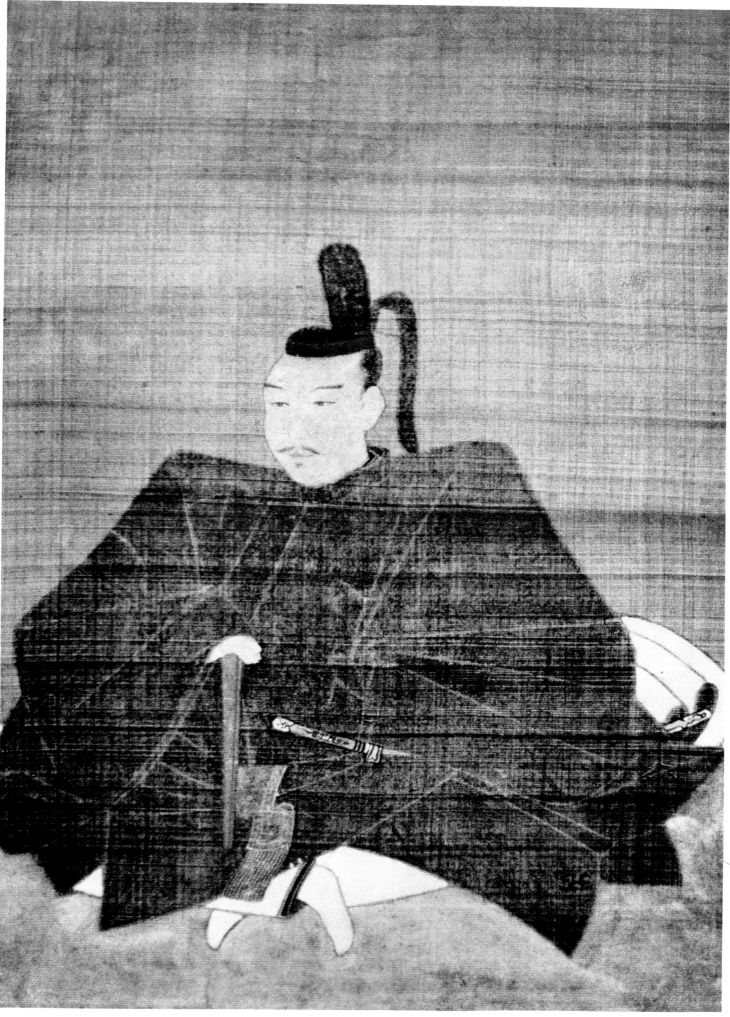

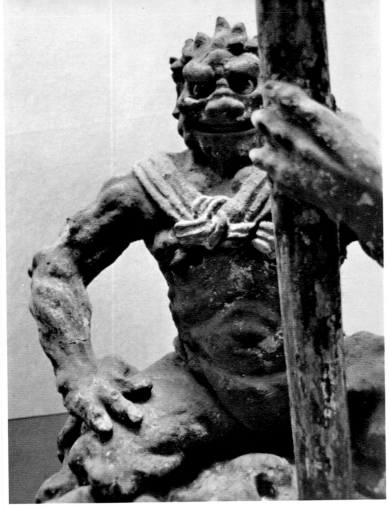

323

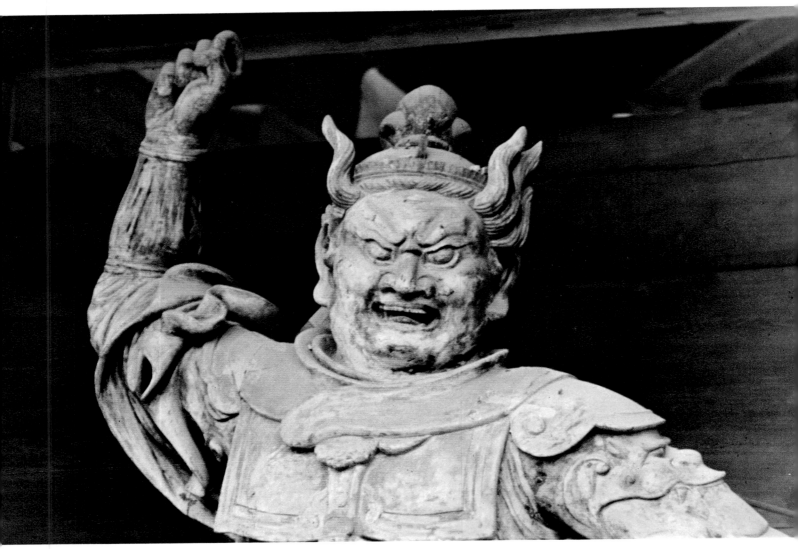

324

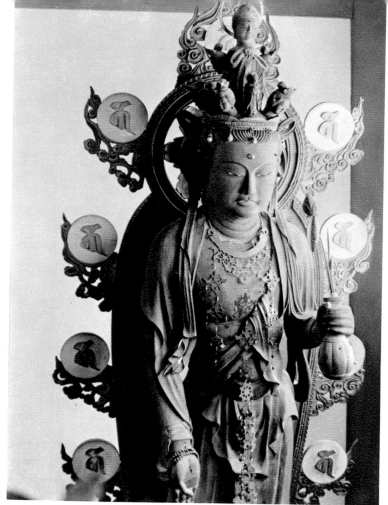

325

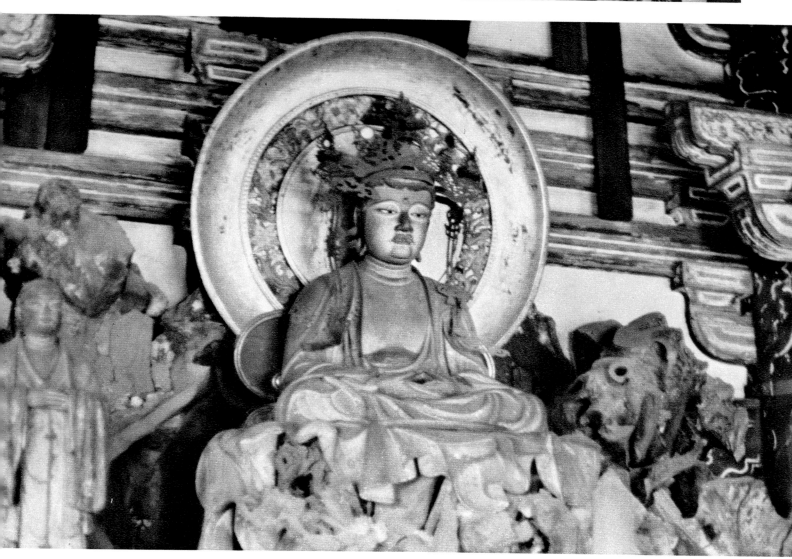

326

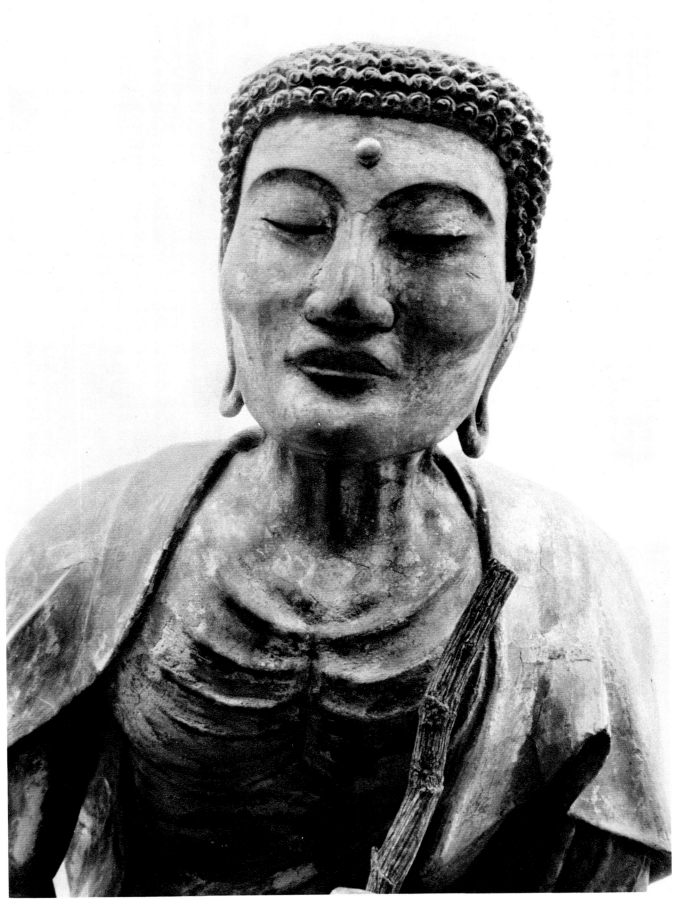

327

VIII. THE DICTATORS
(1582–1616)

HIDEYOSHI (1582–1598)

The Castles

O N THE DEATH of Oda Nobunaga, Hideyoshi became the most powerful general of his time. He assembled Nobunaga's most important vassals and had them elect a child as his successor: Sambōshi, Oda Nobunaga's grandson. Hideyoshi then distributed among his commanders the various provinces Oda Nobunaga had conquered. Four of these commanders formed a type of regency council which acted in the name of Sambōshi.

However, numerous *daimyō* still had to be subdued before all of Nobunaga's vassal provinces could be controlled. Hideyoshi defeated Shibata Katsure at Shizugatake and thus became, practically speaking, the master of the central provinces. Ieyasu, who had been one of Nobunaga's best generals and who controlled the provinces of the Kantō, also took up arms against Hideyoshi, but after a few skirmishes the two men made peace. This left Hideyoshi free to conquer the western provinces—under the control of the Mōri family and other independent clans—and the island of Kyushu.

In order to guard against further rebellions Hideyoshi destroyed many of the small castles in the provinces he controlled and placed the most important fortresses in the hands of his loyal followers. Then, having transferred the seat of his government to Osaka, in 1584 he began the construction of an enormous castle-fortress on the site of the citadel belonging to Ikeda Nobu-teru, to whom he gave in exchange the castle of Gifu.

It took several years to build his fortress. The immense stone blocks used for the base were brought from the island of Shikoku by Sakai boatmen who were obliged to supply two hundred boats a day for this task.

Father Luis Frois, a Jesuit missionary in Japan, described the castle as follows:

Chikugendono [a title given to Hideyoshi] has a huge and very spacious fortress with a high central tower and living quarters, surrounded by walls built in the same way as the tower and provided with iron-clad doors and posterns. This is the residence where he lives with his closest officers and servants. He keeps his treasury there, together with a large supply of arms, munitions, and provisions. The fortress has been built within the walls and moats of the ancient fortress, but with a plan whose grandeur, splendid design, and beauty equals any newly built edifice. The central tower has been deliberately decorated in blue and gold so that it may be seen from a distance, and it has an effect of superb arrogance. In an unfortified area of this great castle a *niwa* has been laid out, which among us would correspond to a marvelous garden; it is decorated with rusticated stones, trees, ponds, and groves, which change with the seasons of the year, and it also contains many natural objects.

When distributing lands among his military commanders, Hideyoshi shrewdly took care to appoint them masters of provinces far from those of their families. In this way he exerted a more rigid control over them. His next step was to order a general registration of land and to establish the tax rate that each owner had to pay. This did not sit well with the peasant landowners, who during the recent wars had taken care to conceal the actual size of their property so as to avoid taxes. Hideyoshi enforced his measures and repressed with severity any attempts at rebellion. He thus succeeded in obtaining an accurate listing of all cultivated land, whether it belonged to the peasants, the great landowners, or the monasteries.

These measures also gave him effective control over the peasants. Under this new system they were left practically independent, but in return they were obliged to remain on their land and to cultivate it in order to pay their taxes, which had been calculated according to the area and type of soil of each individual's property.

The land census took a long time to complete, and Hideyoshi was forced more than once to use strong measures to make the peasants comply with the law. In 1588 he prohibited their possessing arms and ordered them to convert whatever weapons they had into tools or to surrender them to government agents. "If the people possess only tools and dedicate themselves completely to agriculture, they and their descendants will prosper. The welfare of the people is the justification of this order, which is fundamental for the peace and security of the country and for the well-being of the people" (Kuroita: *Kokushi Gaikan*. Extract of the order dated *Tenshō* 16, 7th month, 8th day).

In 1591 Hideyoshi issued strict orders that the peasants were to remain on their land. With this edict he established a rigid social system which, under the Tokugawa, preserved peace at the price of the almost total serfdom of the rural population. Yet the principle of collective responsibility was also established.

If a peasant abandons his fields in order to enter a trade or to become a shopkeeper or workman, he must be punished, and all the members of his village shall be prosecuted with him. All men not serving in the armed forces or cultivating the land must be questioned by the authorities and expelled from the community... In cases of dissimulation, where peasants have abandoned their land to engage in commerce, the entire village or town will be held responsible... No soldier who was left his commander without permission can enter the service of another commander. If this rule is broken and the soldier has gone free, three other men must be offered in compensation to the original commander (*Kokushi Shiryō Shū* III. Extract of order dated *Tenshō* 19, 8th month, 21st day).

In other cases Hideyoshi threatened to mete out the death penalty to all members of peasant families who resisted the government investigators, and the total destruction of villages that showed signs of insubordination. The peasants had to pay a 40 to 50 percent tax on their annual crops. This left them with barely enough to keep them from starving.

Once the land census had been completed in all the provinces, Hideyoshi was able to classify the lands allotted to his vassals according to their yield in *koku* (about 320 pounds) of rice.

In 1598, the yield of all fiefs throughout Japan was estimated to be approximately 20,000,000 *koku* of rice. Aside from Hideyoshi himself, the most important *daimyō* were: Tokugawa Ieyasu (2,500,000 *koku*); Mōri Terumoto (1,200,000 *koku*); Uesugi Kagekatsu (1,200,000 *koku*); Maeda Toshiie (more than 800,000 *koku*). Revenues of the other *daimyō* ranged from a maximum yield of 600,000 to a minimum of 10,000 *koku* or even less. This system of calculating taxes and wealth was subsequently to become the norm in feudal Japan.

As far as administration was concerned, Hideyoshi continued the work begun by Oda Nobunaga, who had not really modified the governmental structure of the Muromachi *Bakufu*. A five-member commission was set up in Kyoto under the direction of Asano Nagamasa, which was responsible for land registration, finances, the police, and judicial matters. Political control

was entrusted to a council, the Five Elders—*Go-Tairō*—composed of the most powerful *daimyō*: Tokugawa, Mōri, Ukita, Maeda, and Kobayakawa. They were assisted by a group of advisers *(Chūrō)*. Under this council were the *Daikan* or territorial governors, who were under the personal jurisdiction of Hideyoshi.

Samurai were organized into groups of five *(gonin-gumi)*, and the peasants into groups of ten *(jūnin-gumi)* persons collectively responsible for any infraction of the law on the part of any member. Those who were excluded from these groups for any reason had to have their little finger cut off. One of the distinctions of Hideyoshi's government was that he always entrusted important positions to capable men. Being of modest origin himself, Hideyoshi placed no importance on social status. He interested himself in mining, especially the development of gold, copper, and silver mines (he himself owned a good many), and beginning in 1585, he minted his own coins, called *tenshō*. He also authorized the production of ingots, which had to bear the seal of legally appointed smelters.

His own wealth became proverbial. He was even able to permit himself the luxury—although it was also a shrewd political move—of offering financial assistance to the impoverished imperial court, so that it might rebuild the emperor's palace. In return for their complete obedience, he also feted the emperors magnificently in his own palace, the Jurakudai, a superb residence decorated with paintings by the finest artists of the period. Although the emperor himself continued to be virtually powerless, he retained all his prestige. He was always considered the symbol of the nation, and Hideyoshi needed his presence in order to achieve the unification of the country.

The Conquests

Among the most powerful *daimyō* were the Mōri family, who controlled nine provinces in western Honshu, and the great families of Kyushu, including the Shimazu of Satsuma. Having become *Kampaku* in 1585, Hideyoshi subdued the island of Shikoku and the provinces of northern Japan. The following year the emperor appointed him *Dajo Daijin* and granted him the family name of Toyotomi. (Hideyoshi, the son of a poor foot soldier *[ashigaru]*, in childhood had been called Kinoshita—"under the tree." He grew up without a family, and his rise to power was due to his own military talent and vaulting ambition.)

In 1586 he mobilized an army of considerable size and began a campaign against the Mōri family and the Kyushu nobles, whom he vanquished in 1587. Three years later the castle of Odawara, the last fief of the Hōjō, had fallen, Osaka Castle had been completed, and Hideyoshi became the undisputed master of all Japan.

Ieyasu, his most powerful rival, was considered an ally. Hideyoshi, however, already nurtured greater ambitions. In several of his letters he spoke of his intention to conquer not only Korea but the "great Ming"—the Chinese empire.

In order to attain these ends he appointed his nephew, Hidetsugu, to the post of *Kampaku* in his place, and commanding an army of more than 200,000 men, he invaded Korea in 1592, which at first offered little resistance. In May of the same year he wrote to Hidetsugu (whom he gave in advance the title of Civil Dictator of China, as well as a fief of one hundred provinces around Peking) proclaiming the capture of Seoul and requesting him to prepare for the journey of the Japanese emperor to China in the near future, since he was completely confident of his final victory (*Akiyama, Nisshi Kōshō-Shi Kenkyū*: letter dated *Tenshō* 20, 5th month, 18th day).

However, the Koreans soon took the offensive and, with the help of Chinese troops, recaptured Seoul in 1593, thus preventing further progress on the part of the Japanese armies. But one of Hideyoshi's generals, Konishi (who, incidentally, was a Christian convert) succeeded in expelling the Chinese, who had sent an ineffective embassy to the imperial court in Kyoto to try to nego-

tiate terms. Hideyoshi continued to dream of invading China, although many of his generals were anxious to conclude a peace.

In 1595 Hideyoshi, who up until then had been shrewd and prudent, became ill and seemed to be afflicted with spells of madness. He was alarmed by the news from Korea. When he learned that his nephew Hidetsugu (a debauchee with criminal instincts, who was known as the "murderous Regent," *Sasshō Kampaku*) had plotted to capture Osaka Castle, he banished him, and Hidetsugu committed suicide. Hideyoshi then exterminated his nephew's family. This last act, instead of being one of revenge, was probably an attempt to guarantee his own succession. In 1593 Hideyoshi had fathered a son, Hideyori, by his favorite mistress (his own wife was barren). Immediately after the massacre of his nephew's family, Hideyoshi made the *daimyō* swear eternal loyalty to his own son. In 1596 he appointed the three-year-old Hideyori to the post of *Kampaku*. Then, in retort to the ridicule leveled at him by the Chinese court, he decided to attack the Ming emperor.

But the Japanese naval forces were weak and poorly armed, whereas the Korean fleet was superior both in tactics and armament. Hideyoshi then concentrated on reorganizing his navy, and in 1597 finally succeeded in defeating a Korean squadron which had attempted to prevent the landing of Japanese reinforcements requested by General Konishi. At that point Hideyoshi sent 100,000 men to the Korean peninsula. At the beginning of 1598 the Japanese troops, outnumbered by the Chinese army, were forced to retreat, despite the fact that Konishi had inflicted extremely heavy losses on the enemy before the gates of Pusan.

However, Hideyoshi died unexpectedly in September, 1598 (not on the field of battle, but in his house at Fushimi, south of Kyoto on the hill now called Momoyama), and this turn of events brought hostilities to an end. Konishi negotiated with the Chinese, and the Japanese troops were withdrawn from the mainland.

IEYASU (1598–1616)

Legislation

Matsudaira Ieyasu was the son of a minor *daimyō*, but was also of the house of Minamoto, a direct descendant of Minamoto Yoshiie. After a childhood passed as a hostage with the clans whose lands bordered on those of his father, Ieyasu entered the service of Oda Nobunaga. As a token of gratitude for his support, Nobunaga married his daughter, Tokuhime, to Ieyasu's son. In 1567, after Ieyasu had subdued the clans that had once held him hostage in the province of Mikawa, the emperor granted him the family name of Tokugawa.

From this point onward, Ieyasu steadily increased his possessions at the expense of the *daimyō* of eastern Japan, whom he was constantly fighting for control of the coastal provinces. After the death of Nobunaga and a few skirmishes with Hideyoshi, he judged that it would be more prudent to continue as Hideyoshi's ally, at the same time maintaining his independence. However, he refused to participate in the Korean invasion.

After the conquest of Kyushu, Hideyoshi had given him some lands which made Tokugawa the most powerful of all the *daimyō* after Hideyoshi's death. Yet Ieyasu had enemies, especially certain generals who, after their return from Korea, rallied support and opposed him. They claimed to be protecting the child Hideyori from Ieyasu's scheming; according to them, Ieyasu had not kept the promises he had made to Hideyoshi. For the most part, the intrigues were instigated by Ishida Mitsunari, a favorite of Hideyoshi's, who attempted to seize power by stirring up Ieyasu's enemies.

Finally, after two years of political struggles, civil war became inevitable. On the one side were Ieyasu and his allies, on the other the supporters of Hideyori, including such powerful *daimyō* as Uesugi, Mōri, Chōsokabe, Shimazu, Kobayakawa, and General Konishi. Each of the contending sides had a force of about 100,000 men. Due to acute tactical strategy, as well as to the defection and treachery of many of the *daimyō*—more than half the forces recruited by Mitsunari would not fight, or changed sides at the last moment—Ieyasu obtained a great victory at Sekigahara.

As soon as Mitsunari and Konishi had been executed, Ieyasu became the master of the country. Another general redistribution of the fiefs was then carried out, from which Ieyasu's generals naturally benefited. Ieyasu had Edo Castle rebuilt and thought of making it the seat of his government. He decided to fortify Kyoto by encircling it with fortresses. As he was now the most powerful of the *daimyō*, he felt secure in his power, since he had little to fear from a possible coalition of the others. And throughout the seventeenth century his successors were to continue his policy of enriching their own *Bakufu*.

Having confiscated all the gold and silver mines for his own benefit, Ieyasu began to coin money *(koban)* as early as 1601. The cities were forced to surrender their privileges to Ieyasu's *Bakufu*, which then controlled the appointment of local governors *(shoshi-dai)*, who were drawn from the most important members of Ieyasu's government. In 1603 he established his government in Edo and in 1604 created a trade monopoly in raw silk which was exported in large quantities to China.

Although Ieyasu was not a legislator, his statutes continued the policies of Nobunaga and Hideyoshi and laid the foundations of Tokugawa society. Once the peasants had been brought under control, he defined in his *Buke-Sho-Hatto* ("Rules Governing the Military Households") of 1615 the principles that were to assure the permanence of his regime and to guarantee that both the warriors and the peasants would be kept in a state of rigid subjugation.

These principles were:

1. The study of literature and the practice of the military arts must be pursued together.
2. Drunkenness and licentious behavior must be eschewed.
3. Those who break the law cannot be given refuge in any fief.
4. The *daimyō* and the *shōmyō*, as well as the landowners and their people, must immediately expel from their lands any soldiers in their service guilty of treason or murder.
5. No refuge must be granted men who plot rebellion or incite an uprising. Residence in the fief must be limited to men born in said fief.
6. All work undertaken in a castle, even if it consist only of repairs, must be reported at once to the authorities, and all new building is strictly forbidden.
7. If one learns that in a neighboring fief men are plotting a change or organizing partisans or factions with this aim, they must be immediately denounced.
8. Marriages must not take place in private.
9. All the *daimyō* of the shōgun's court must strictly observe all rules governing conduct. They must not enter the city with an escort larger than the one permitted those of their rank.
10. Dress and jewels must be appropriate to the rank of those wearing them. There must be no extravagance in either color or design.
11. The common people must not be carried about in a palanquin without permission. Exceptions are to be made only for doctors, astrologers, old people, and invalids.
12. All samurai of all the fiefs must live frugally.
13. The *daimyō* must choose capable persons as officials in the government of their fiefs.

In order to ensure the success and stability of his own government, Ieyasu surrounded himself with able people, among whom were his "gray eminence," Hayashi Razan, a scholar well versed in the neo-Confucian doctrines of Chu Hsi; the navigator, Will Adams (the first English-

369

man to have come to Japan, Adams became a valued friend and adviser of Ieyasu, married a Japanese woman, was accorded an estate as a vassal of Ieyasu's, and ended his days as a respected man of substance), and the merchant, Chaya Shirōjirō. Ieyasu did not have time to organize and to put his personal opinions in writing, but they are expounded clearly in the *Honsa Roku*, possibly written by Honda Masanobu, his falconer and intimate adviser.

In the same way that he had defined the respective positions of the samurai and the peasants, Ieyasu felt it his duty to set down regulations for the nobles and to limit the powers and prerogatives of the sovereigns:

"...The emperor must devote himself to study. He must follow the teachings of the classics and support the tradition of poetry...."

Ieasu divided the vassals into three classes with strictly regulated rights and duties:

1. The *Fudai*, or hereditary vassals directly answerable to Ieyasu, owning small domains yielding a revenue of approximately 50,000 *koku*.

2. The *Tozama*, or *daimyō* of the outer provinces—Maeda, Shimazu, Date, Hosokawa, Kuroda, Asano, and others—whose domains produced from 500,000 to 1,000,000 *koku* annually. They were obliged to leave hostages at Edo and live in that city at least four months out of every year.

3. The *Hatamoto*, or minor vassals with a revenue of less than 10,000 *koku*.

While Ieyasu was busy organizing his territories, Hideyori and the Toyotomi family—as descendants of Hideyoshi—continued to threaten the stability of the government. Thousands of masterless and landless samurai (the *rōnin*) were discontented after the redistribution of the land from which they had received nothing, and they offered their services to Hideyori. In this way Hideyori was able to recruit an army of almost 100,000 men.

In 1614 Ieyasu, having decided to eliminate him, attacked Osaka Castle in which Hideyori, his family, and his troops had gathered. After a bitter struggle, and weakened by inner dissensions, the beleaguered forces were obliged to surrender after the famous summer siege *(natsu-no-jin)*, during which Ieyasu's army of more than 200,000 men had battered the ramparts and had filled in the moats during the preceding winter. In June, 1615, Hideyori committed suicide, and Osaka Castle finally fell into the hands of Ieyasu, who exterminated the Toyotomi family and put the castle to the torch. It was a victory, however, from which Ieyasu gained no personal advantage: in 1616 he died at the age of seventy-five, leaving the shogunate to his son, Tokugawa Hidetada.

Ieyasu's success, fame, and power were so great that the people subsequently deified him with the name of Gongen-Sama. His renown extended even beyond the frontiers of Japan. As early as 1592 Hideyoshi had given his "red seal" to nine ships so that they might establish trading relations with Annam, Tonkin, Cambodia, Malacca, Formosa, Manila, and Macao, and to settle colonies in these areas. Ieyasu developed this policy of his predecessor, corresponded with foreign courts, sent trading missions abroad, and opened Japanese ports to foreign ships. He also regulated the movements of those Japanese traveling abroad, so that they would not cause trouble in foreign countries (as they had done in Siam and elsewhere), and he granted his red seal only to those merchants of whose conduct he was certain.

At the same time Ieyasu encouraged maritime activity in every way. Japanese vessels ventured as far as Mexico by way of Hawaii, and Date Masamune, the *daimyō* of Sendai, sent a commercial mission to Madrid and Rome in 1613 by way of Manila, Hawaii, Acapulco, and around Cape Horn to Cuba and the Atlantic Ocean. Such a journey attests to the daring and enterprising spirit of the Japanese sailors and merchants of the period.

Yet it was the Chinese and Dutch vessels that Ieyasu welcomed most enthusiastically, because he had nothing to fear from merchant ships (in addition to trading, these merchants helped drive the Portuguese from Oriental waters). Ieyasu was exasperated by the disputes of the

European priests (Spanish Franciscans and Portuguese Jesuits), and he feared the Spanish navy anchored at Manila. Foreigners who were not missionaries were welcomed in Japan; they could settle in the city of their choice and trade freely. Some English of the East India Company and some Dutch even created flourishing banks and trading offices in Nagasaki, Hirado, and especially Sakai.

The Foreign Priests

On their arrival in Japan the first Portuguese Jesuit missionaries had been cordially received. As early as 1560 Father Vilela had succeeded in meeting Shōgun Ashikaga Yoshiteru. Despite the opposition of the Buddhist clergy, he obtained permission for himself and five companions to preach their religion. Four years later twelve Jesuit fathers—among them Father Frois, who has left some interesting letters describing that tumultuous period—proselytized throughout the country. A converted *daimyō* presented Father Frois to Oda Nobunaga and to Shōgun Yoshiaki, who gave the Jesuits complete freedom to preach the Gospel of Christ. From then on, missionaries began to arrive in great numbers, and conversions of the Japanese increased.

After the death of Yoshiteru (who was assassinated in 1565), the emperor yielded to the pressure of Buddhist leaders and ordered the Jesuits to leave the country. Frois and Vilela took refuge in Sakai and continued to convert both peasants and warriors. In 1582 the Inspector General of the Jesuits, Valignano, estimated that there had been approximately 150,000 conversions. He sent four young Japanese to Goa as special envoys of the Christian *daimyō*, and they continued their journey to Portugal, Madrid (where King Philip II received them), and Rome. Pope Gregory XIII welcomed these first Japanese to arrive in Europe and granted to the Company of Jesus a monopoly for the evangelization of Japan. Wishing to encourage trade with foreigners, Nobunaga protected the Christians. In the beginning, Hideyoshi himself permitted European priests to carry out their missionary work and even allowed them to build churches in Osaka. Numerous members of his circle, such as General Konishi, were converted, and seminaries and convents were established.

In 1587, however, Hideyoshi abruptly ordered the Jesuits to leave Japan, perhaps because he feared their increasing influence in Kyushu and Nagasaki. The missionaries had no intention of departing and went into hiding among their converts. Hideyoshi, absorbed in other problems, did not press his ban, and in 1590 even received a mission from the Viceroy of the Indies, led by Valignano, who was accompanied by the four Japanese who had left the country eight years previously, and by some Portuguese from Nagasaki.

This mission remained in Japan for two years. The number of conversions continued to increase, and by 1595 there were about one hundred Jesuit priests in Japan ministering to nearly 300,000 Chistians, among whom were even members of Hideyoshi's family.

The Spanish merchants and the Franciscan missionaries based at Manila became jealous of the monopoly that had been granted to the Portuguese merchants and the Jesuits. A Spanish galleon that had arrived in Hirado in 1584 had been well received. In 1593, deliberately ignoring the Jesuit monopoly, four Franciscan missionaries disguised as diplomats entered Japan and began to preach, to the great fury of the Jesuits, who were then constrained to live in Nagasaki. As the result of an incident that occurred during the visit of a Spanish galleon and the reciprocally calumnious denunciations of the two groups of missionaries, Hideyoshi ordered the execution of seven Franciscans and nineteen Japanese converts.

One of Hideyoshi's advisers was Seiyaku-in Zensō (called "Jacuin" in the reports of the Jesuits), an aged monk of Mount Hiei who hated Christians and inflamed Hideyoshi against them. Hideyoshi again ordered the Jesuits expelled, but they again went into hiding. After the death of Hideyoshi the Christians breathed a sigh of relief.

Ieyasu, who was anxious to maintain trade with European countries and especially to improve his navy, encouraged foreign vessels to visit Japanese ports. Numerous Japanese merchants set up colonial trading offices and banks as far afield as the Philippines, Cambodia, and Siam. In 1600 a Dutch ship ran aground on the island of Kyushu. Aboard was the marine engineer and naval architect, Will Adams, who was well treated by Ieyasu and who reciprocated by helping the Japanese to build some ships along European lines. In 1605 Ieyasu invited the Dutch to trade with Japan in competition with the Portuguese. He needed foreign products such as cannon and technical experts to advise him on their use, and he requested this from anyone who might be able to procure them for him.

In 1614, in one of those sudden changes of policy customary among the Japanese—due in this instance perhaps to political activity undertaken by the foreign missionaries—Ieyasu decided that the Christian faith was contrary to the "Way of the Warrior," which insisted on absolute obedience to the authority of the *daimyō* (in accordance with the neo-Confucian precepts preached at the court of the shōgun and in Kyushu by Hayashi Razan). Therefore, accusing the Christians of having tried to destroy Shintō beliefs, Ieyasu prohibited any further missionary activity and razed the churches. During his lifetime, however, there was no persecution or corporal punishment of the Japanese Christians. In fact, Ieyasu did not disapprove of the conversion of the peasants. What he feared was the collusion of the warriors and *daimyō* with belligerent foreign powers (Spain and Portugal specifically) through their Catholic agents and spies. Many of the priests and friars departed, but a few Jesuits remained in Japan and from their hiding places continued their missionary work. They were protected by their converts and several *daimyō* of Kyushu whose loyalty to the shōgun was at best doubtful.

SOCIOLOGICAL AND CULTURAL ASPECTS OF THE MOMOYAMA PERIOD

Progress

At the time when Hideyoshi began his land registration, the peasants lived in villages that were rather widely separated but relatively close to the fields. These villages were composed of one or more manors of the most important families who had lived in the area for a very long time. Quite often the village chief was a *ji-samurai* (peasant-soldier) or even a *kokujin* (simple peasant). The larger individual properties *(yashiki)* were in some instances extensive enough to yield up to one hundred *koku* of rice annually. The poorer peasants, whose land had an annual yield of one *koku* (about 320 pounds) or less, were obliged to hire out their services to the *dōgo* or head of the great family of their village. At least one *koku* of rice was needed (as a basic foodstuff) for the subsistence of each average family during the year. Therefore, after having paid his tax, a farmer could not feed his family on what he produced if his plot yielded less than two *koku*. On the other hand, the larger peasant landowners paying taxes amounting to fifty or more *koku* annually did not always have enough workers in their family to assure maximum production of their rice paddies. Each farm laborer could cultivate only an area yielding a maximum of six or seven *koku* of rice. It was therefore usual for wealthier families to employ only the poorer peasant landowners.

The homes of the *dōgo* were relatively comfortable—probably similar to the farms one sees today in the Japanese countryside—but the houses of the agricultural workers, who were usually petty landowners (the *hikan* or *nago*, who were the most numerous, the worst nourished, and the

hardest worked), were for the most part nothing more than wretched huts. The economic condition of these poor peasants depended on the goodwill of the large landowners who employed them.

Hideyoshi's agrarian reforms brought no relief to their misery. True, it gave them independence, which was of little importance to them, but it also made them personally responsible for the very heavy annual tax. Once that tax was paid, they had barely enough to survive, and they had to work on the estates of the *dōgo* in order to earn what they still needed. The *dōgo* themselves were equally dissatisfied, because it had become impossible to conceal their assets from the government assessors and they, too, had to shoulder the heavy tax burden. The petty landowners, whose land had been confiscated during the various distributions of the fiefs, and the numerous samurai who had become *rōnin* (landless and masterless) wandered starving throughout the countryside.

The situation in the cities was different. The craftsmen and merchants led an easier life, due to the restored freedom of trade, the yield from the gold and silver mines, and the exports, which latter created an increasing demand for manufactured goods. The ports flourished, supplying salt and fish to the interior and linking the provinces through the coastal sealanes. Through their imports from abroad these ports became increasingly prosperous. Sakai became the most important trading center for rice, and the firearms, based on European models, manufactured there were in ever-increasing demand.

It was during this period that numerous foreign products first appeared in Japan: the telescope, waterproof oilcloth (imported from China), buttons for clothing, woolens and velvets, playing cards, bread, various types of cake, soap, tobacco, potatoes, and pumpkins (from Cambodia).

When Hideyoshi built Osaka Castle, he ordered various merchants and his nobles to build homes not far from this magnificent residence. The city of Osaka thus grew apace; modeled on Sakai, which it tended to replace as the center of trade.

At the court in Kyoto life had become more comfortable than in the preceding period. The aristocrats lived a calm, refined, somewhat old-fashioned existence. Some of the nobles and merchants, however, wishing to prove that they were up-to-date, wore Portuguese-style clothes and, typical of snobs of all epochs, included a few Dutch and Portuguese words in their daily conversation.

The missionaries and merchants had brought in a few Western books, of which some were translated into Japanese and printed in roman typeface *(rōmaji)*, using presses and movable metal type—a Korean invention of the beginning of the fifteenth century. The first European book to be translated was *Aesop's Fables (Esopo Monogatari)* in 1593. The most vital imports for Japan, however, were the maps and marine charts. With these, the Japanese finally became acquainted with their own geographical position in relation to the rest of the world, with the fundamentals of astronomy, and with other basic scientific facts.

As a result of Hideyoshi's military campaigns, some of the *daimyō* brought some Korean potters to Japan. They established ceramic workshops, notably those of Satsuma and Yatsushiro. Basing their work on Chinese prototypes imported at the beginning of the century, such ceramists as Shonzui, Chōyu, and Rokubei created new styles.

All of the minor arts—lacquer, textiles, metals, decoration—of the Momoyama period were characterized by opulence and excellent craftsmanship. The buildings erected by Nobunaga, Hideyoshi, and Ieyasu required the work of thousands of specialized artisans and craftsmen. The warlords spent their accumulated wealth on displays of luxury that often bordered on bad taste: Osaka Castle had ceilings and pillars covered in gold; the tableware was solid gold; the *fusuma* (sliding screens) had gold-leaf backgrounds. Even the roofs of the palaces were gilded. One can still see the luxury typical of this period in the great hall of the monastery of Nishi Hongan-ji in Kyoto, which is said to have been transferred to its present site from Hideyoshi's pleasure palace, Jurakudai, when it was destroyed prior to the construction of his residence at Fushimi on Momoyama Hill near Kyoto.

Religion

Although Hideyoshi, like Nobunaga, became incensed with those members of the clergy who dared oppose him, he showed considerable magnanimity to those who submitted to his power. He restored their monasteries and lands to them and even gave them subsidies so that they could rebuild some of the temples on Mount Hiei. Kōsa, the head of the Ikkō sect, who became his ally, received permission to build the sect's monasteries and, on receiving a gift of land in the Ōtani district of Kyoto, was even able to rebuild Hongan-ji. Hideyoshi decided to erect an enormous image of Buddha in Kyoto and sent for experts from China to work on it. The statue was never completed, however, because earthquakes destroyed it on several occasions.

Once Ieyasu gained power, he decided to pass new laws governing religion. He was assisted by Hayashi Razan, who was in favor of the secularization of teaching and its withdrawal from the control of the Buddhist priesthood. The state religion at the beginning of the seventeenth century was a type of Buddhist-Shintō syncretism onto which were added the materialist neo-Confucian doctrines of Chu Hsi. In the face of these philosophical and religious beliefs, Christianity had little chance to become entrenched with the majority of the Japanese. Its prestige was tarnished, too, by various squabbles among priests and missionaries and the sometimes shameful conduct of the Spanish and Portuguese, who were even involved in the slave trade.

The tea cult was adopted on an ever-widening scale by the wealthy and the nobility. Sen-No-Rikyū (1521–1591), friend and confidant of Hideyoshi, laid down its precise rules, which still serve today as the basis of etiquette adopted by the various schools that developed later. Rikyū also established the shape of the utensils to be used in preparing the tea. He also outlined the principles to be followed in laying out the gardens surrounding the teahouses (chashitsu). The art of flower arrangement—established perhaps during Yoshimasa's lifetime by Sō-ami—was also regulated by precise rules during the Momoyama period. At the beginning of the seventeenth century the priest Ikenobō Senkō created the rikka and nageire styles of flower arrangement that were to become famous as classics of ikebana. Rikyū preferred the nageire style, which was simpler and more natural than the rikka style, and declared that it conformed perfectly with the cha-no-yu (tea ceremony). He, too, was considered a master of ikebana.

Architecture

The architecture of the Momoyama period (which included the final years of the sixteenth century) was characterized by the splendor of the buildings. Having become veritable palaces, castles and fortresses rivaled one another in both size and luxury. Azuchi Castle, for instance, had seven stories, and each room had fusuma (sliding screens) decorated with subjects that varied from one floor to another—landscapes, animals, flowers—painted by the most famous artists of the day.

The period saw the development of curved, ornamental gables, a so-called Chinese form (kara-hafu) that became a definite characteristic of ensuing styles. In imitation of Ming architecture, color was employed to accent the carving of the columns, the decorated beam ends, and the ramma (the carved transom freize) of the walls or partitions. Most of the older Buddhist monasteries and Shintō shrines of major importance were restored. The new shrines were built in the elaborate and grandiose gongen-zukuri style, a tripartite structure with the main sanctuary and worship hall linked by a covered corridor, imitating—after a fashion—the Buddhist style (for example, the Kitano shrine in Kyoto). The architecture of the palaces followed the traditional shinden style. Sliding screens (fusuma) decorated with paintings were used extensively for room partitions. Fenestration (as well as access) was provided by shōji screens covered with translucent paper. Objects or flower arrangements were displayed in tokonoma and tokowaki

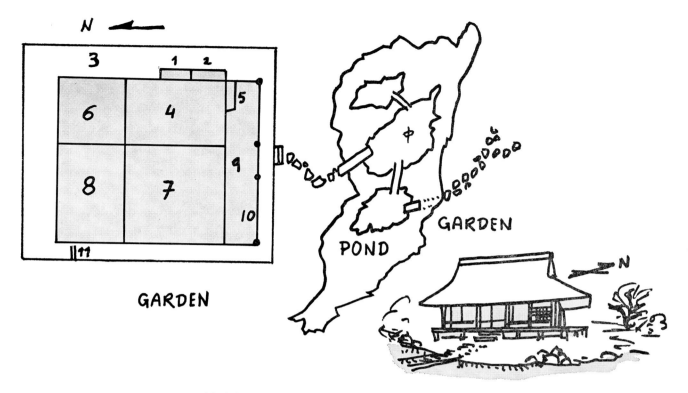

GARDEN

POND

GARDEN

44. SHOIN-ZUKURI RESIDENCE OF THE SQUARE TYPE

1. TOKONOMA
2. TOKOWAKI
3. REAR VERANDA
4. ICHI-NO-MA (LIVING ROOM)
5. TSUKE-SHOIN

6, 8. BEDROOMS
7. NI-NO-MA (SECOND LIVING ROOM)
9. MAIN VERANDA
10. RAILING
11. DOOR

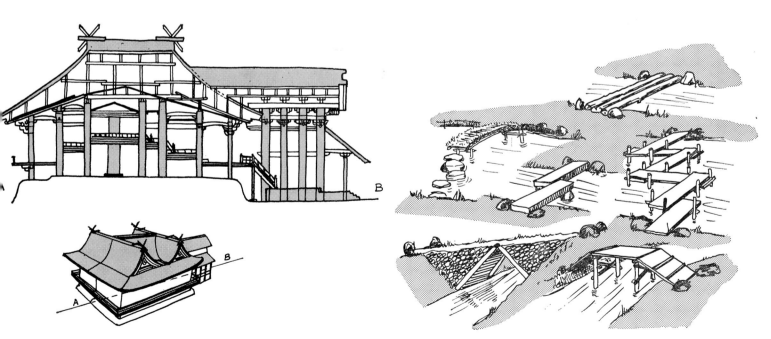

45. CROSS SECTION AND VIEW OF THE KIBITSU-JINJA OF OKAYAMA (FIFTEENTH CENTURY)

46. GARDEN BRIDGES

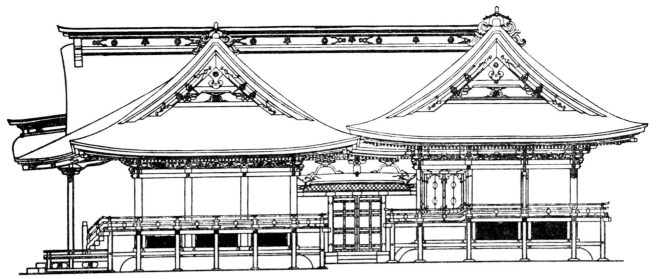

47. VIEW OF ŌSAKI HACHIMAN-JINGŪ; GONGEN STYLE (1604–1607)

(alcoves) with *chigaidana* (sets of shelves and cabinets). Known as the *shoin* "style" (taking its name from the reading room or library of the larger houses), it was overloaded with carved and painted decorations and metal fittings and contrasted sharply with the simplicity of the Muromachi period, even though the basic architectural principles were the same. This "style" is best exemplified in many of the rooms in Nijō Castle in Kyoto, which was built during the first years of Ieyasu's rule.

Because of the vogue for the tea ceremony, the *chashitsu* (teahouses) became expensive structures in which apparent simplicity was obtained only through use of rare and choice materials. This "hypocritical" style led to a new style in domestic architecture known as *sukiya* ("artless structures"): residences—or even rooms—of vast dimensions that combined the seeming simplicity of the *chashitsu* with the ostentatious luxury of the *shoin* style.

These residences almost always faced onto a small garden representing a solitary mountainous site, with waterfalls, paved paths, rustic troughs for ablutions, and mosses. The *shinden* style of garden continued to be employed, although usually on a larger scale and furnished with stone or metal lanterns and bridges. These gardens were not meant to be merely contemplated from the veranda of the house; their full impact was obtained only by walking along paths laid out to achieve certain carefully planned effects. The Zen gardens of sand and stones were still greatly admired and now contained elements symbolically expressing not only nature but personages or events. For example, according to the number and arrangement of the elements in the garden, one saw the sixteen Arhats, or the twenty-five Bodhisattvas.

Painting

During this period, which was both ostentatious and heroic, painting tended to follow the trends in architecture. The destruction of the great monasteries by Nobunaga and Hideyoshi had delivered a fatal blow to the traditions of the priest-painters. The devastated monasteries could no longer commission works from artists. Patrons of the arts were primarily the great warriors and the merchants. The arts were thus freed from religious influence, and artists began to draw their inspiration from secular subjects. During this period one can distinguish at least four important styles of painting: the European style, the Kanō school, the *sumi-e* schools, and the Tosa school.

376

The European style (sometimes called the *yōga*) dealt with non-Japanese subjects and depicted them in a more or less Western manner that derived from paintings brought from Europe by the Portuguese missionaries and the Dutch merchants. There were the *namban* screens ("foreigner screens," of which about fifty are still in existence) on which were painted European personages or scenes depicting encounters between Japanese and Europeans, or even religious subjects of Christian inspiration. The artists were probably converts who worked in the Jesuit missions or schools, but their names have not come down to us.

The followers of Kanō Motonobu (1476–1559) developed his style and adopted a more energetic brushstroke better adapted to decorating the large panels commissioned for the ostentatious rooms of the mansions in the *shoin* and *sukiya* styles, or for the castles. Motonobu's grandson, Kanō Eitoku (1543–1590), while working at Azuchi Castle, gave the so-called Momoyama art its true direction by combining the two types of *shōhekiga* (paintings mounted on a wall, a sliding door, or a folding screen): the monochrome Chinese and the *yamato-e* styles. The few authenticated *sumi-e* paintings executed on gold-leaf backgrounds (the first use of *kirikane* or patterning in cut gold leaf) that have survived the destruction of the castles in which Eitoku worked, reveal a powerful style and a remarkable sense of proportion, despite the fact that they are grandiose compositions in which subject matter is reduced to the essentials and all superfluous details are eliminated.

The pupils and successors of Kanō Eitoku—his son Takanobu (1571–1618), his brother Hidenobu, Hidenobu's son Motohide, another son, Mitsunobu (1568–1608)—executed numerous paintings for the monasteries of Kyoto as well as for the residences of the nobility or military leaders. These painters also decorated fans, illustrated *emakimono*, and painted *kakemono*. Others of this flourishing school included Naganobu (1577–1654), Sanraku (1559–1635), and Yoshinobu (beginning of the seventeenth century).

Other artists took their inspiration from the *suiboku* style of the Muromachi period, and formed schools the styles of which were followed throughout most of the seventeenth century. Prominent painters working in this style included Kaihō Yūshō (1535–1615), a former pupil of Eitoku; Unkoku Tōgan (1547–1618); Hasegawa Tōhaku (1539–1610); Soga Chokuan (died c. 1610). These artists worked principally in the *suiboku* technique and derived their personal styles from the works of the Chinese painters of the Sung and Yuan dynasties—in particular the works of Mu Ch'i—and they spoke of themselves as the continuers of Sesshū's art.

Aside from these painters, who mostly worked in monochrome, there was one who belonged to a new *yamato-e* school: Sōtatsu (beginning of the seventeenth century), whose style of composition and treatment of color differed considerably from those of the *yamato-e* artists of the Tosa school. Sōtatsu drew inspiration from literary works and depicted his subjects in a very personal and decorative fashion. His style foreshadowed that of the Kōrin school, which developed during the Edo period.

Together with these artists working in the *yamato-e* styles, there were those painters belonging to Tosa Mitsunobu's school. Working almost exclusively at Sakai and Osaka, they illustrated literary works *(Heiji Monogatari, Genji Monogatari)* on scrolls *(emakimono)* or decorated fans and *shikishi* (almost square pieces of paper used for calligraphy). Lacking definite character, their work reveals the decadence of this school.

Toward the end of the Momoyama period there developed, along with secular painting (flowers, animals, landscapes), a genre style with subjects drawn from scenes of daily life, from various occupations, and from the theatrical world. It was intended to satisfy the taste of the rich merchants and the warriors. Out of it subsequently grew the type of colored woodblock prints known as *ukiyo-e*, "pictures of the floating [ephemeral] world."

During this period sculpture underwent absolutely no process of renewal or development. The sculptors were satisfied, as during the preceding period, to copy the ancient models more or less faithfully. There is not a single sculptor worthy of mention.

328. KYOTO. TŌ-JI. CORNER GABLE OF THE KONDŌ.

329. KYOTO. KITANO TEMMANGŪ. HONDEN. With the new style of Shintō architecture, formerly separated structures were now linked under one roof. In the Kitano shrine, known as the Kitano Temmangū, built in 1607, the prayer hall was joined to the Honden, or main hall. This shrine later served as the model for the Tōshōgū in Nikko (see plate 381). The roof over the entrance embodies a rather sober *kara-hafu* style.

330. OSAKA. ISHIYAMA. HONGAN-JI. On the site of this monastery Hideyoshi built Osaka Castle. Hongan-ji was famous for the stubborn resistance offered by the Ikkō sect during the siege of Oda Nobunaga. The monastery surrendered only at the request of Emperor Ōgimachi. This woodblock print by Sadanobu (1807–1879) is a reproduction of a contemporaneous view (no longer extant) of the famous temple. Hauchecorne Collection.

331. KYOTO. DAITOKU-JI. HŌSHUN-IN. DONKOKAKU. This famous square pavilion is linked to the main temple structure by a covered bridge built on piles sunk into the lake (see also plate 333). The pavilion dates from the beginning of the seventeenth century.

332. KYOTO. NINNA-JI. KARAMON. Founded in the Ninna era in 888, all the original buildings of this monastery were destroyed during the Ōnin Civil War, and were later reconstructed in the Momoyama style. This *shikyaku*, or four-legged gate, has a splendid *kara-hafu* gable over the main entrance. The structure is a typical example of late-sixteenth-century architecture.

333. KYOTO. DAITOKU-JI. HŌSHUN-IN. COVERED BRIDGE. (See also plate 331.) This lovely roofed and galleried bridge was built in 1617 by Toi Yokoi (1550–1630).

334. KYOTO. DAITOKU-JI. SHŌRO. This exceptionally handsome bell tower is topped by an *irimoya* roof, and the upper portion of the building is girdled by an outhanging porch. The building dates from the end of the sixteenth century.

335. KYOTO. NIJŌ CASTLE. NINOMARU. SHOIN. This unit is part of the Ninomaru (the Inner Citadel), a complex of buildings that is part of Nijō Castle. It was erected by Ieyasu between 1601 and 1603. It is the most nearly perfect example of the *shoin* type still in existence. The interior is sumptuously decorated with paintings and carved woodwork, and the rooms are spacious. (See also plate 339.)

336. KYOTO. NANZEN-JI. SAMMON. BRACKETING. This type of bracketing exemplifies a style employed during the beginning of the eighteenth century. The *to* and *hijiki* are short and flat. The general impression is heavy, although quite decorative.

337. KYOTO. KŌDAI-JI. DOORWAY. This beautiful interbeam support (called *kaerumata*, because of the resemblance of the shape to frogs' legs) is typical of Momoyama period decorative detailing. The monastery of Kōdai-ji was constructed in 1606 by order of Hideyoshi's widow.

338. KAMAKURA. TSURUGAOKA HACHIMAN-GŪ. SUMIYOSHI MYŌJIN. This wooden image, originally painted, represents a Shintō divinity. It is rather poorly executed, as was typical of the sculpture during this period. It probably dates from the end of the sixteenth or beginning of the seventeenth century.

339. KYOTO. NIJŌ CASTLE. NINOMARU. WALL. A portion of wood and white plaster walls that screen the private gardens.

340. KYOTO. TENRYŪ-JI. GREAT HALL. The sliding *shoji* screens have been opened, thereby placing the interior in direct relationship with the garden. It is an arrangement typical of the *shoin* style. The garden has been attributed to the priest Musō Kokushi.

341. KYOTO. DAITOKU-JI. HŌSHUN-IN. GARDEN. The especially beautifully planted garden was designed by Kobori Enshū (1579–1647). (See also plates 331 and 333.)

342. KYOTO. KENNIN-JI. RYŌSOKU-IN. GARDEN. A detail from the rock garden showing a low mound of pebbles resembling an island projecting above the surface of an ocean of pebbles around it. These surrounding pebbles are raked into a spiral pattern suggesting the ocean's waves which break continually on an island's shore.

343. KYOTO. TŌFUKU-JI. REIUN-IN. GARDEN. The Reiun-in is part of the Tōfuku-ji complex. The detail of the garden shown here displays an exceptionally fine sense of design, as well as the unusual textural contrast of the square paving stones sunk into the surrounding ground cover. (See also plate 295.)

344. RYŌAN-JI. STONE GARDEN. Possibly the most famous garden reflecting the Zen ideal (there is a full-scale replica in the New York City Botanical Garden), this unique example of landscape design comprises fifteen stones disposed in five isolated groupings (the fifth is at lower left, just outside camera range). The almost mathematical arrangement of these beautifully formed and textured rocks and the sheer emptiness of the surrounding raked sand are both tranquil and surprising in their utter simplicity. This photograph shows a view that could never be obtained by a visitor, because the veranda of the Hōjō (the Abbot's Residence) is the only place from which one is intended to see this garden. (Not shown, the Hōjō is at left.)

345. NAGANO. MATSUMOTO CASTLE. Begun in 1504, the

castle was rebuilt in the late sixteenth century by the Ishikawa clan. The present donjon was constructed between 1594 and 1596 and is considered to be so fine an example of this type of structure that it has been designated a National Treasure.

346. MODEL OF OSAKA CASTLE. This reconstruction shows the vastness of the castle in its heyday. Surrounding the central keep was the Hommaru, the innermost enclosure reserved for the lord of the castle. This was surrounded by a defensive wall with towers, and was additionally protected by large moats. Outside this complex was the Ninomaru which consisted of buildings reserved for the soldiers and for people seeking refuge in the castle during times of strife; this, too, was enclosed by a defensive wall. Entry into the castle was made more difficult by a series of false gates and extensive flights of stairs. The fortress was begun in 1583 by Hideyoshi and was destroyed by Ieyasu in 1615. Reconstructed after World War II, it is now a museum. (See also plate 349.)

347. HYŌGO. HIMEJI CASTLE. This magnificent castle is known as Shirasagijō, or White Heron Castle. The original building on the site dating back to the fourteenth century was enlarged by Hideyoshi and given its present majestic appearance around 1600 by Ikeda Terumasa, one of Ieyasu's generals.

348. AICHI. INUYAMA CASTLE. This structure was built at the end of the sixteenth century. Typical of the oldest style of donjon construction is the porch encircling the keep which served as an observation post.

349. OSAKA CASTLE. OUTER DEFENSIVE WALLS. This fortress-castle, begun in 1583 by Hideyoshi, took seven years to build. The enormous stone blocks were

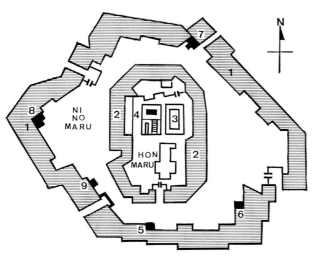

48. PLAN OF OSAKA CASTLE

1. EXTERIOR MOATS 4. KEEP (TENSHU)
2. INTERIOR MOATS 5-9. TURRETS (YAGURA)
3. RESERVOIR ON THE WALLS

brought from the island of Shikoku by Sakai boatmen. It was the largest and most luxurious castle in Japan.

350. OSAKA CASTLE. HIDEYOSHI. This polychromed wood sculpture portrays the famous sixteenth-century military leader. Height of entire work 28¾".

351. OSAKA CASTLE. HIDEYOSHI. This portrait painted on silk bears a dedication to *Hōkoku Daimyōjin*, a title bestowed on Hideyoshi by the emperor.

352. OSAKA CASTLE. PRAYER WRITTEN BY IEYASU. This was inscribed by Hideyoshi's fierce adversary and successor, Shōgun Tokugawa Ieyasu.

353. PORTRAIT OF CHŪMU. This portrait of one of the Thirty-six Immortal Poets is attributed to Matabe Iwasa (1578–1650), a painter who came to prominence in the early Edo period, and who is sometimes described as the father of *ukyio-e*. In colors, on paper. Height 17¾".

354. KYOTO. NINNA-JI. GIGAKU DANCER. Painted on a wooden door panel, this shows a *gigaku* dancer wearing the mask of Ran-Ryū-ō. It dates from the end of the sixteenth century.

355. TOKYO. KARA-SHISHI. This is a portion of a six-panel paper screen by Kanō Eitoku (1543–1590). *Kara-shishi* are fabulous Chinese lions. This is one of the finest works of the *shōhekiga* style of the Momoyama period. Height 88⅝". Imperial Collection.

356. CHISHAKU-IN. PINE TREE AND GRASS. Originally installed as *fusuma* (sliding screens), the paintings on this two-panel folding screen were executed by Hasegawa Tōhaku (1539–1610). In colors, on paper. Height 38".

357. KYOTO. CHIKURIN-NO-SHICHIKEN-ZU. Detail of a *fusuma* executed in the *sumi-e* style by Kaihō Yūshō (1533–1615) on which are portrayed the "Seven Sages of the Bamboo Grove." This detail depicts one of these Chinese immortals. Kyoto National Museum.

358. KYOTO. DAITOKU-JI. ŌBAI-IN. DETAIL OF A FUSUMA. This *fusuma* depicting the "Seven Sages of the Bamboo Grove" was executed in the *sumi-e* style by Unkoku Tōgan (1547–1618).

359. KYOTO. BIRDS AND FLOWERS. A portion of *Pictures of Flowers and Birds* by Unkoku Tōeki (1591–1644). It was executed in the *sumi-e* style on paper and is on a *fusuma*. Kyoto National Museum.

360. KYOTO. DAIGO-JI. PORTION OF A SIX-FOLD SCREEN. Executed by an unknown artist of the Kanō school, this painting depicts scenes of horse-training and was done in colors on a gold-leaf background. Height 59".

361. KYOTO. MAEDA GEN-I. This is a portrait of the Zen

priest Maeda Gen-i (1539–1602), who was adviser to both Nobunaga and Hideyoshi. Painted in colors on paper. Kyoto National Museum.

362. NARA. PORTRAIT OF A LADY. By an unknown artist, this depicts a woman of the aristocracy, perhaps the wife of a high-ranking warrior. It is a *kakemono*, dating from the end of the sixteenth century, in colors on paper. Height 19⅝". Museum Yamato Bunkakan, Nara.

363. NARA. MATSU-URA BYOBU. This is a portion of the first of two screens, each composed of six panels and decorated with domestic scenes. It was executed by an unknown artist. Here, a young girl is combing a woman's hair. The screens are painted in exceptionally bright colors on a gold-leaf background. Height of screen 60¼". Museum Yamato Bunkakan, Nara.

364. KYOTO. KIKU-JIDŌ-ZU. Portrait of a woman with chrysanthemums. It was painted in colors on a gold-leaf background by an unknown artist. Kyoto National Museum.

365. OSAKA CASTLE. THE SIEGE OF 1615. The *natsu-no-sjin* (the summer siege) is famous in the military history of Japan. It ended with victory for Ieyasu and the suicide of Hideyoshi's son, Hideyori, and the extermination of the Toyotomi family. This detail from a painted screen was commissioned (from an unknown artist) by Kuroda Nagamasa (1568–1623), a general who served under both Hideyoshi and Ieyasu and participated in the siege. The entire screen contains 348 horses, 5,071 persons, 1,387 flags or standards, 974 halberds, 119 bows, 158 muskets, and 368 swords. The scene shown here depicts Ieyasu's troops crossing one of the moats of Osaka Castle.

366. EUROPEANS. These painted clay figurines were made in Nagasaki. They give a Japanese-eye view of the Europeans who were confined to a sector provided for them: the artificially made island of Deshima in Nagasaki Harbor, which was especially set aside as a restricted compound for members of the Dutch East India Company. Height 3½". De Berval Collection.

CULTURAL CHART

Indications: A = architecture; P = painting; L = literature; H = history; C = cultural influence.

1584	A	Construction of Osaka Castle begun by Toyotomi Hideyoshi.
1587	C	First persecution of Christians.
1588	C	Establishment by the Jesuits of a college and printing press on the island of Amakusa.
1589	P	Death of the artist Sesson (b. 1504).
1590	P	Death of the artist Kanō Eitoku (b. 1543).
1591	H	The *Kokushi Shiryō Shū*: the laws of Hideyoshi.
	C	Suicide of Sen-No-Rikyū, master of the tea cult and aesthete.
1593	L	*Esopo Monogatari*: a translation into Japanese of *Aesop's Fables*.
c. 1596	L	Appearance of the *kana zōshi*, novels written in *hiragana* for the common people. Authors were monks, warriors, and intellectuals. The novels were printed and widely distributed.
1598	A	Completion of the reconstruction of the gardens and temple of the Sambō-in in the *shoin* style at the monastery of Daigo-ji outside of Kyoto.
1598	H	Death of Toyotomi Hideyoshi.
1601	A	Construction of the Kyakuden in the Kojo-in precinct within the monastery of Onjō-ji, Shiga.
1602	A	Construction of Nijō Castle in Kyoto.
1603	H	Establishment of the Edo *Bakufu* by Ieyasu.
1604–7	A	Construction of the Honden of Osaki Hachiman Jinja in Sendai.
1608	A	Enlargement of Himeji Castle to its final form.
1610	P	Death of Hasegawa Tōhaku (b. 1539).
1613	C	Journey to Rome of the envoys of Date Masamune.
1614	C	Proscription of Christianity by Ieyasu.
1615	H	Appearance of the *Buke-Sho-Hatto*, "Rules Governing the Military Households."
	H	Surrender of Osaka Castle.
1616	H	Death of Tokugawa Ieyasu.

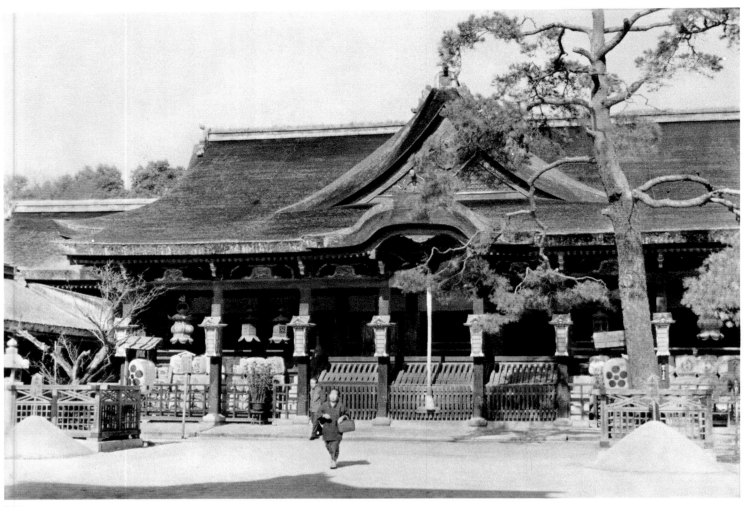

329

330

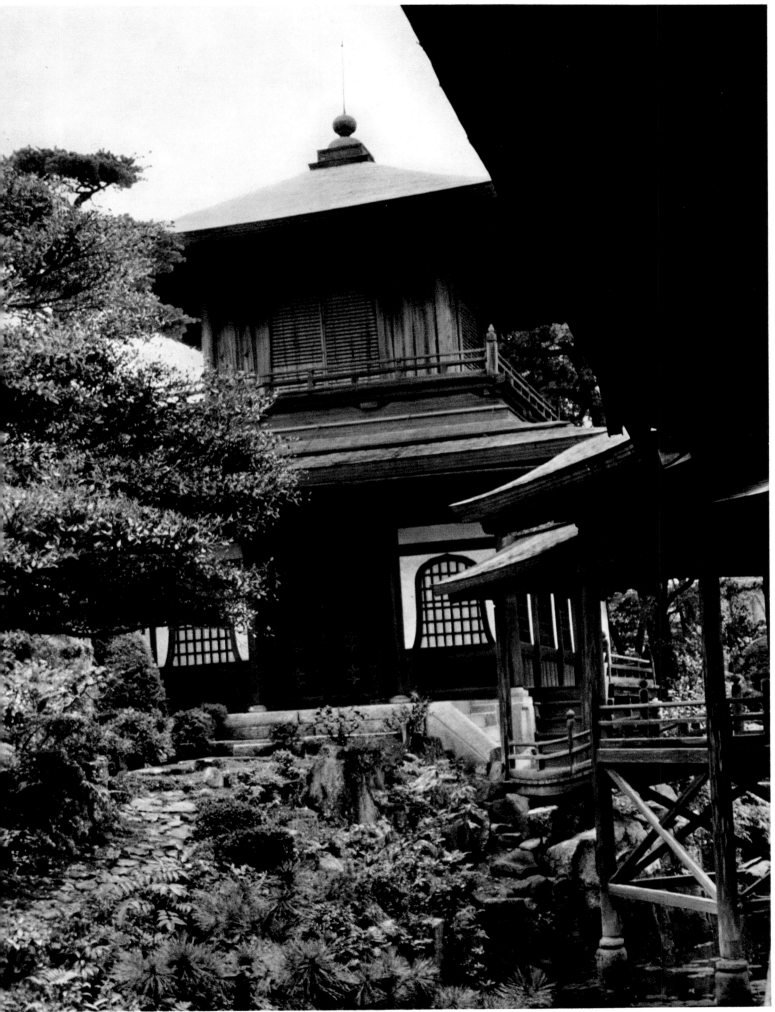

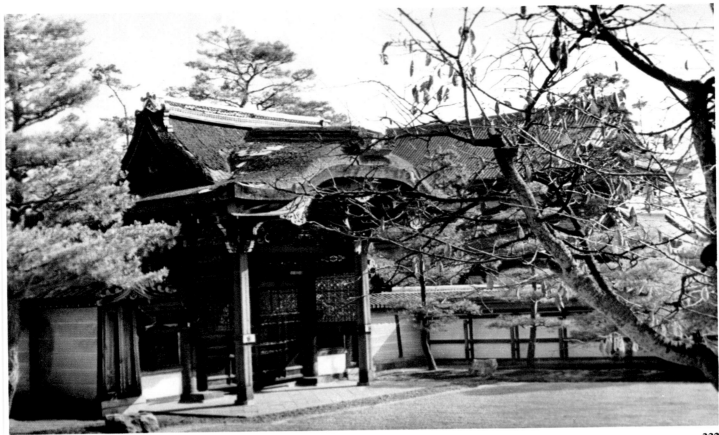

332

333

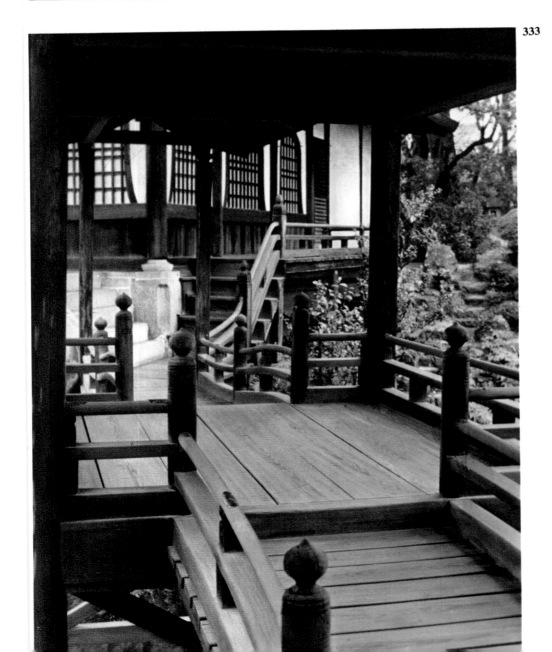

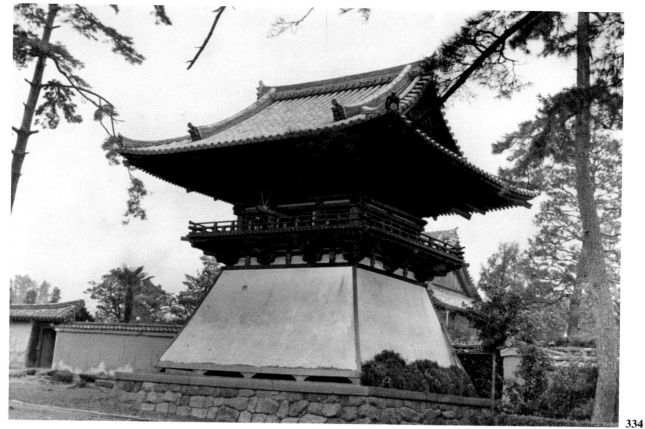

334

335

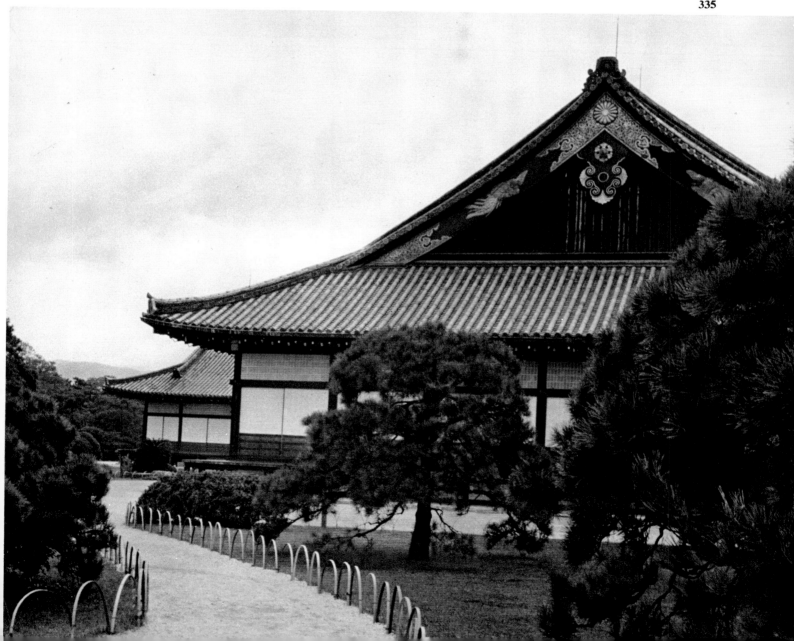

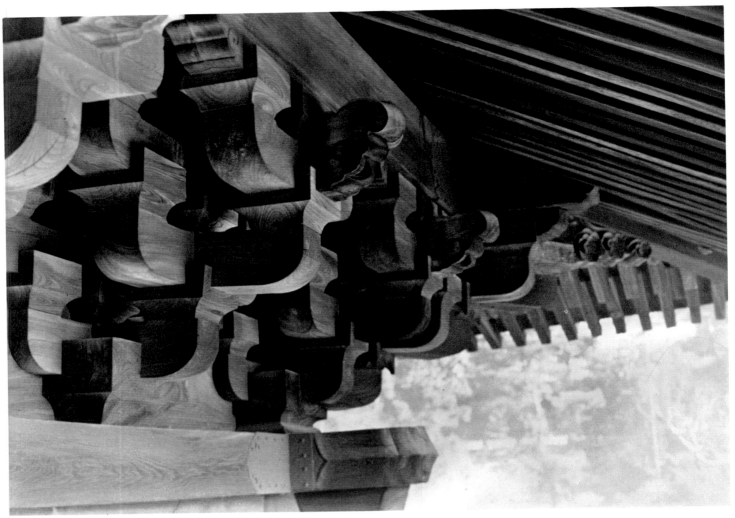

336

337

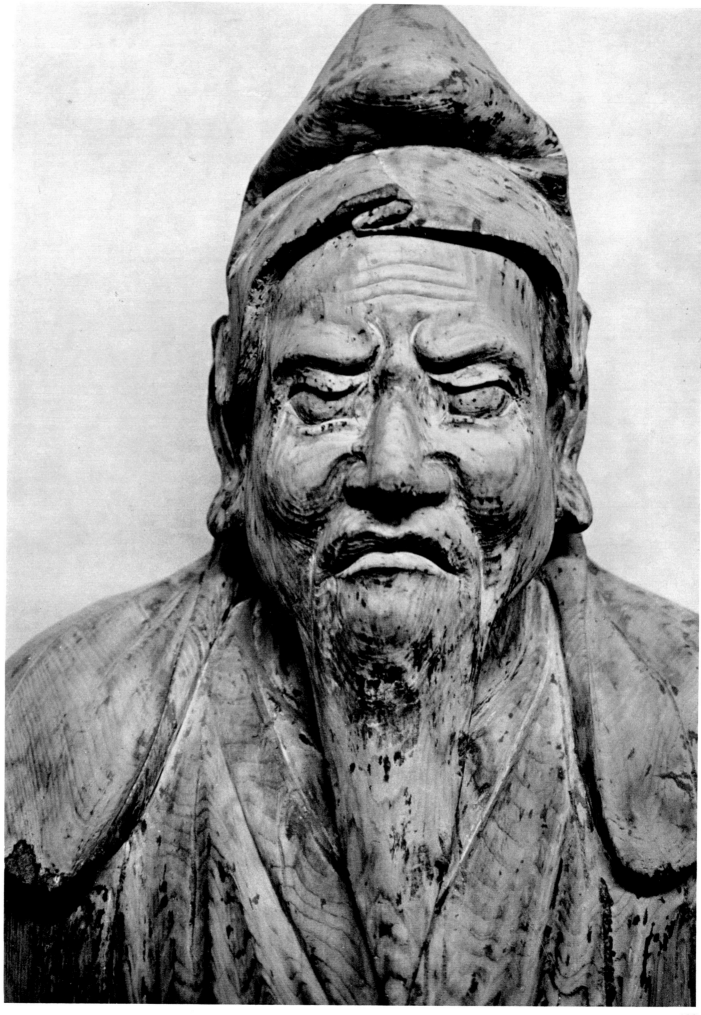

338

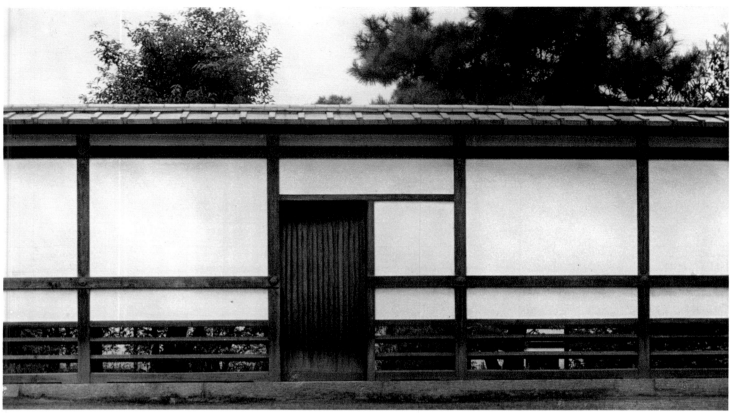

339

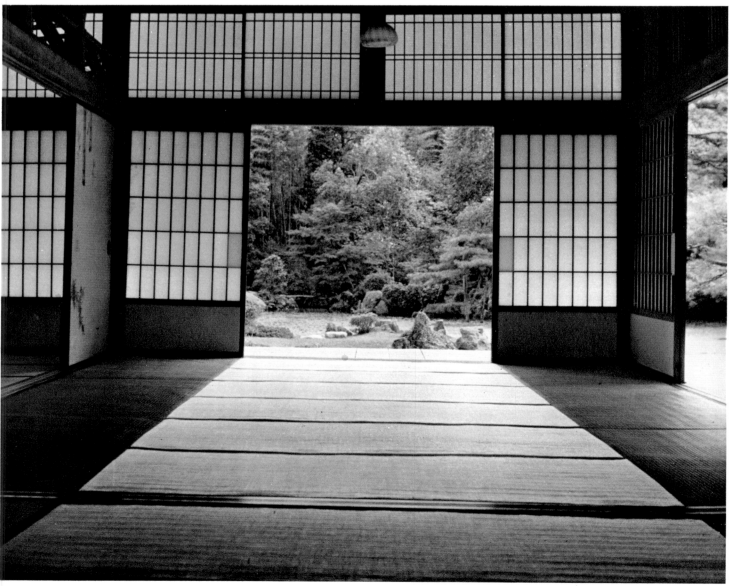

340

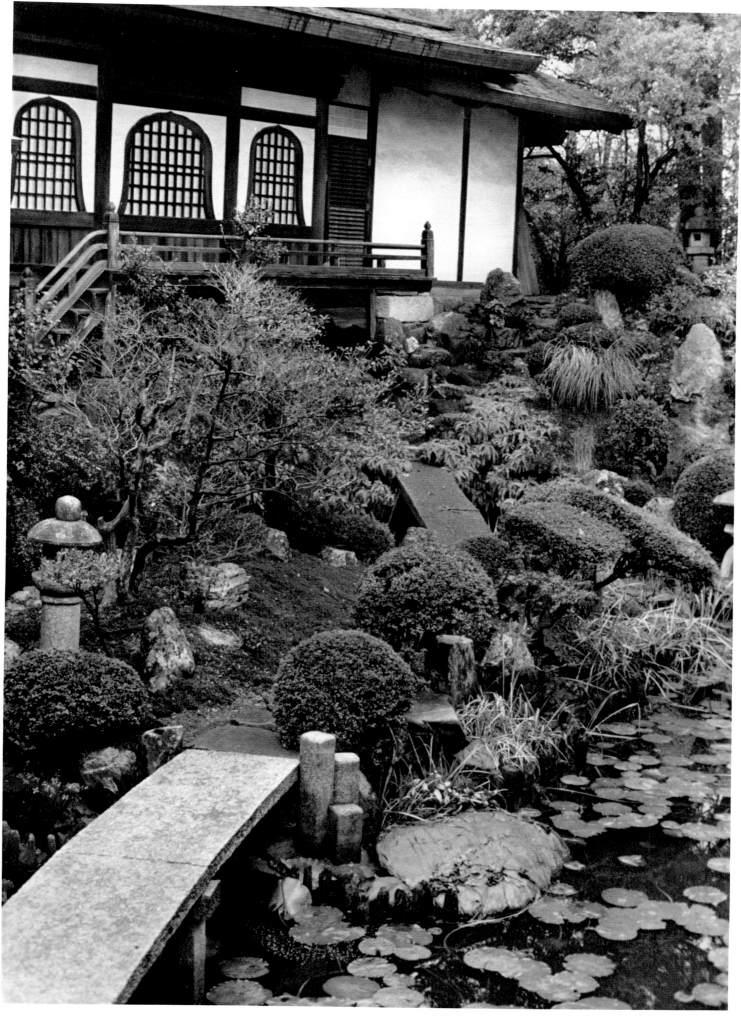

342

343

345

346

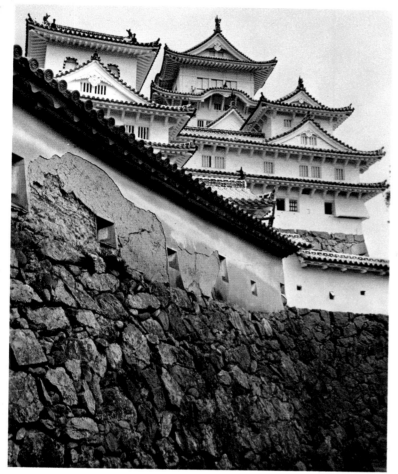

347

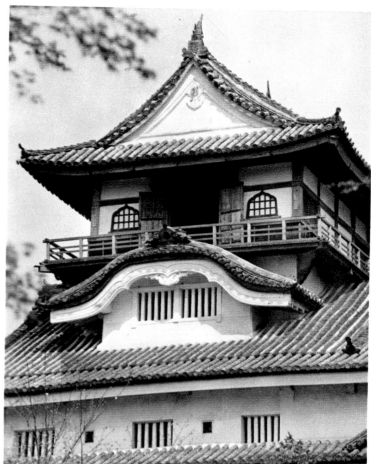

348

349

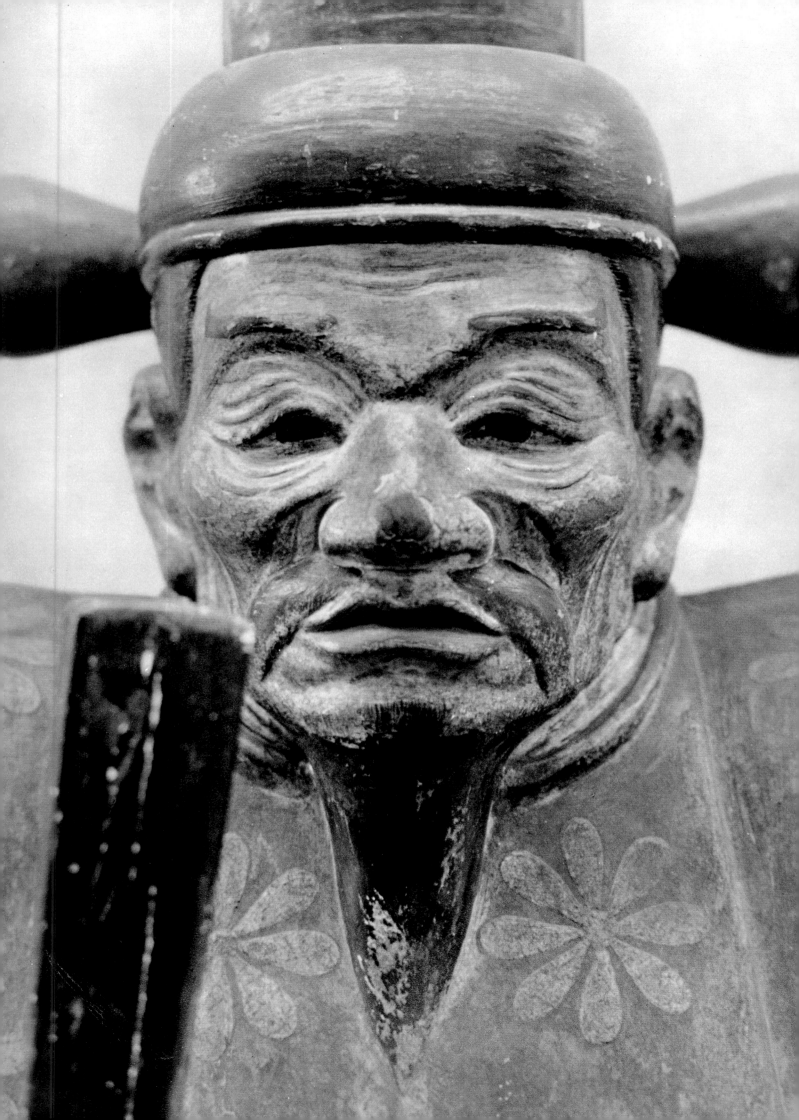

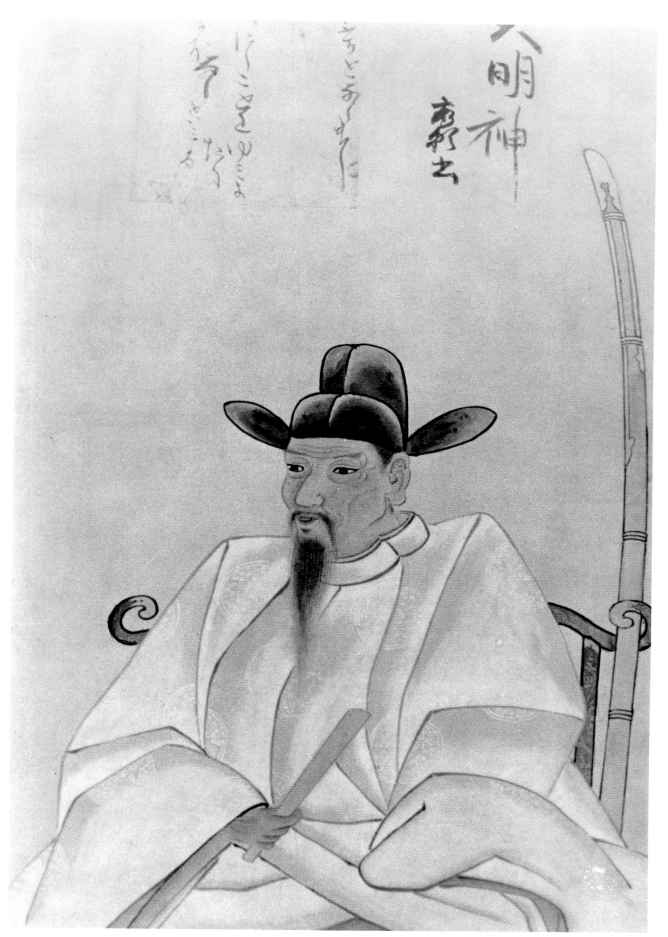

352

353

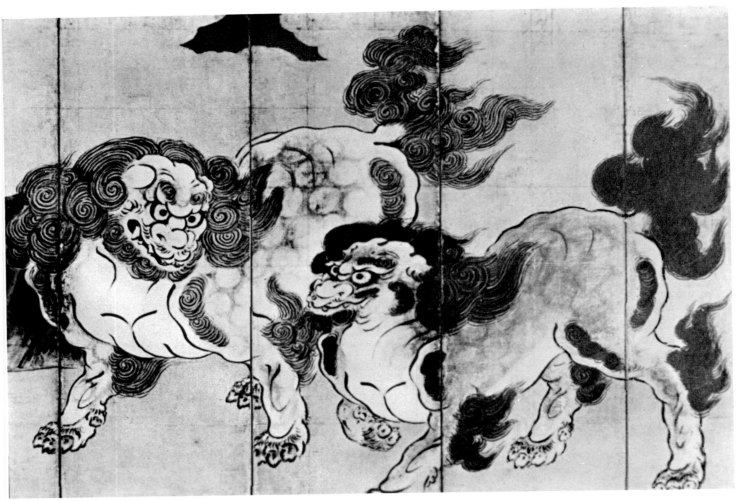

355

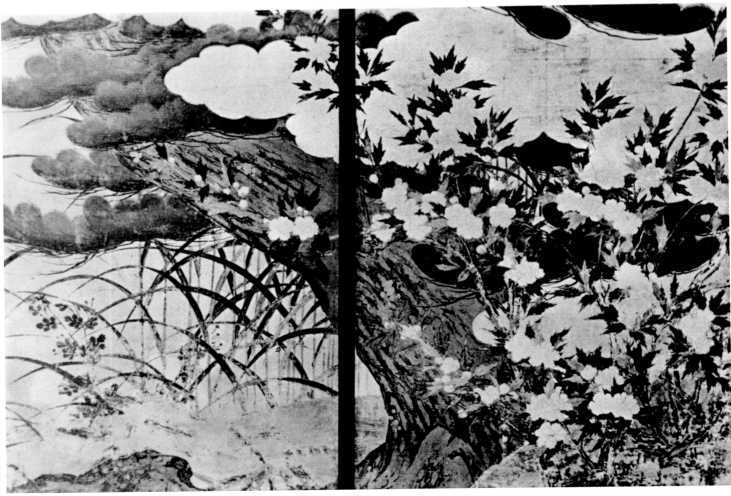

356

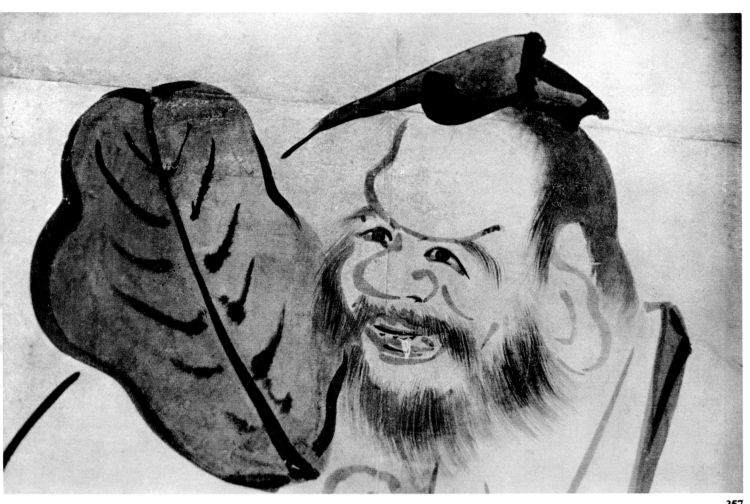

357

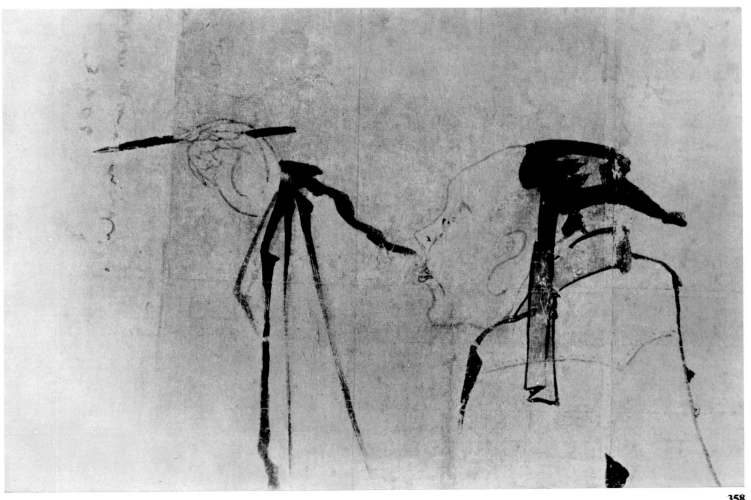

358

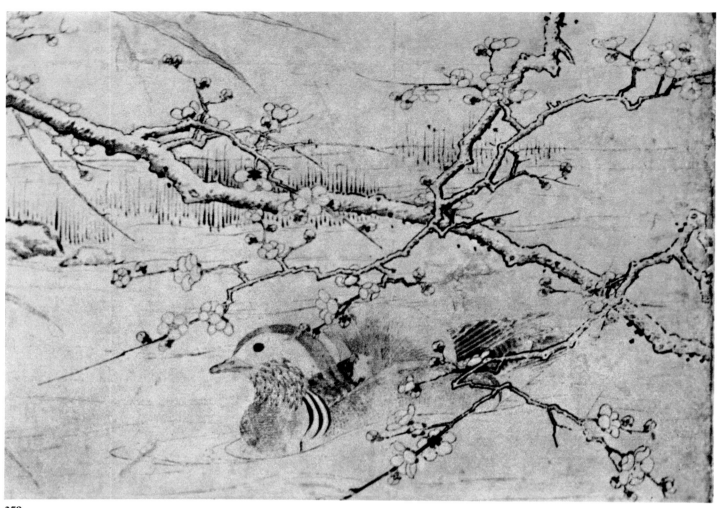

359

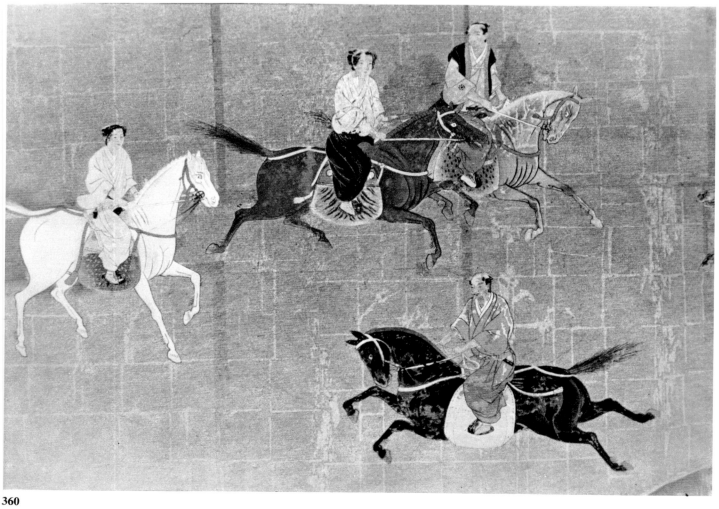

360

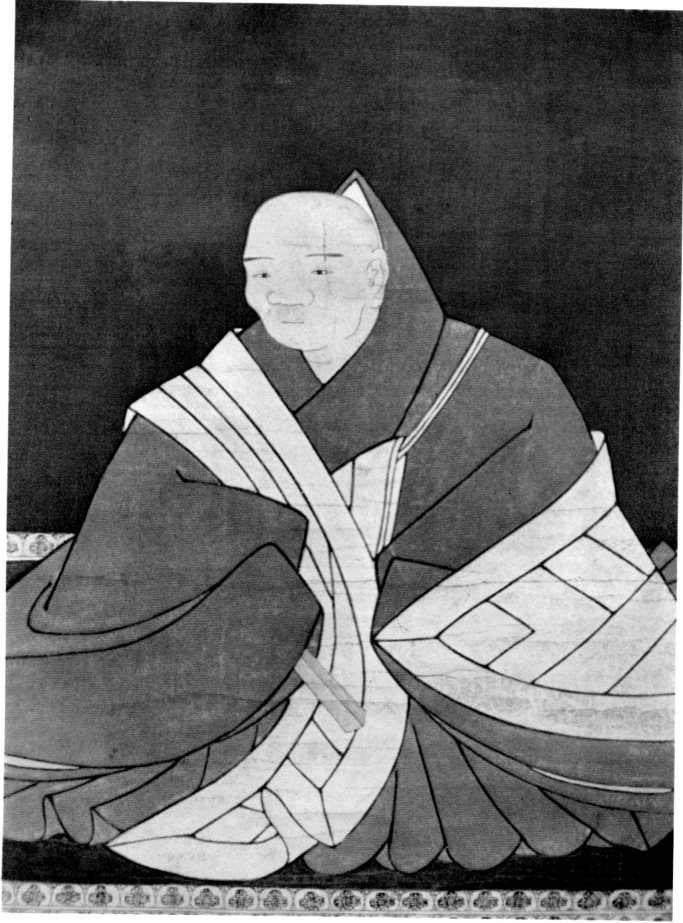

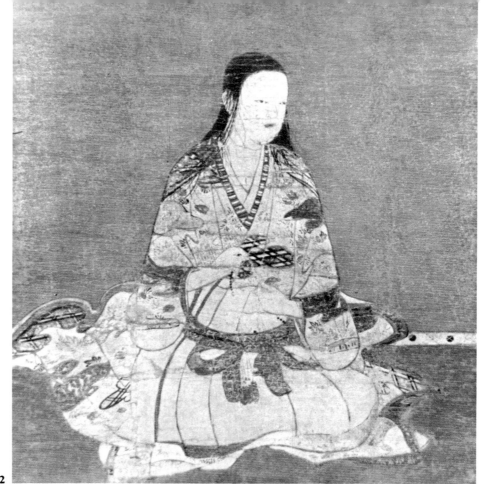

362

363

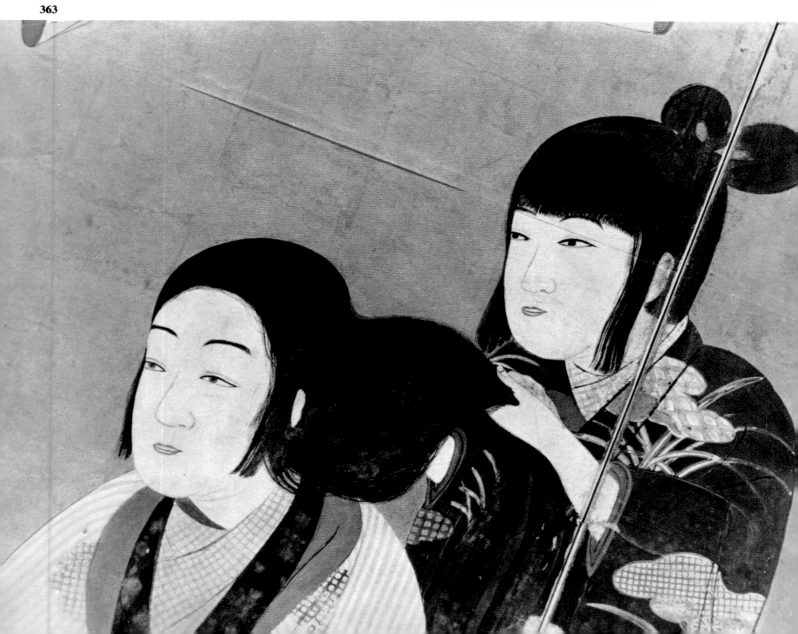

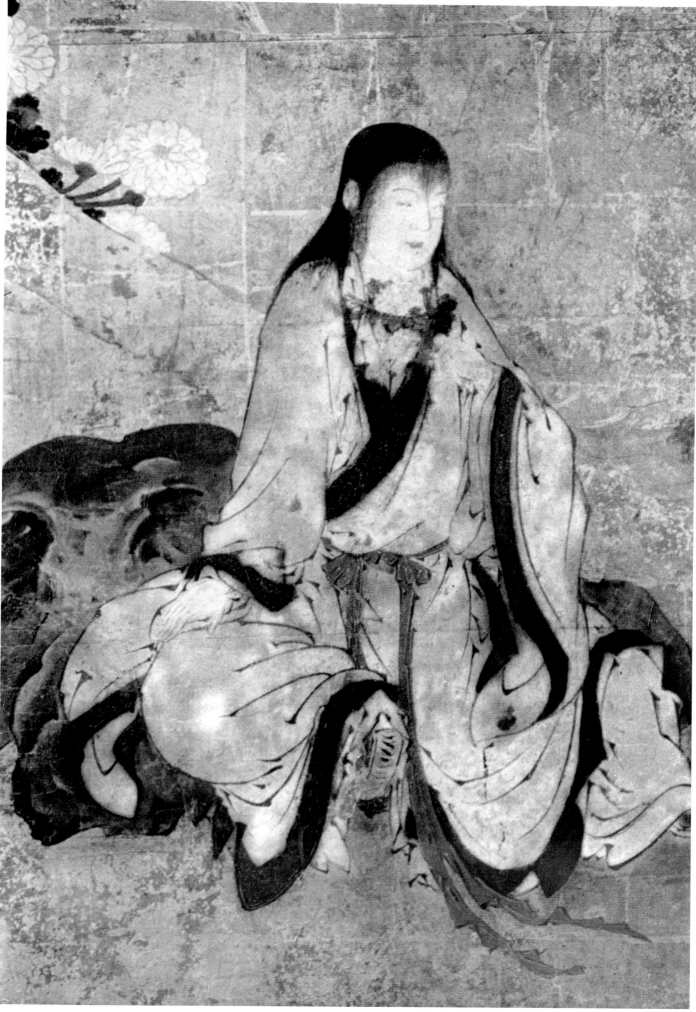

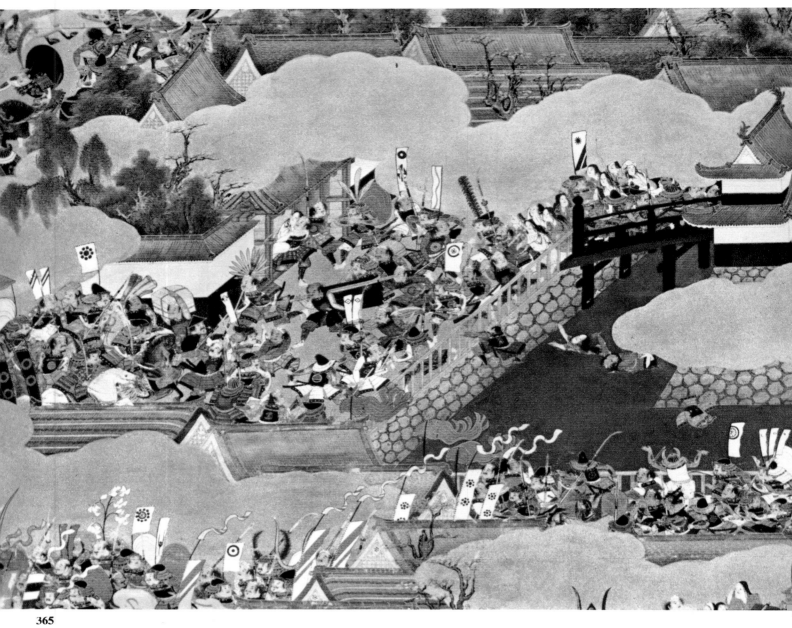

365

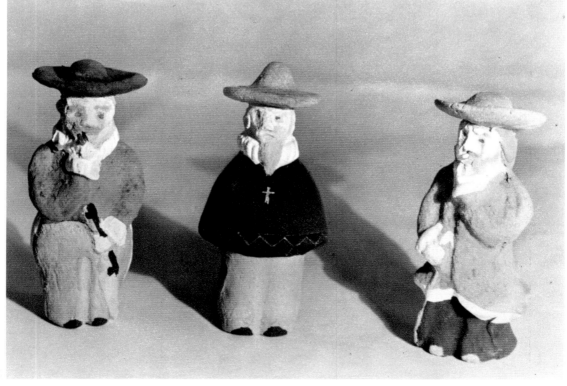

366

IX. THE TOKUGAWA REGIME
(1615–1868)

THE NEW ORDER

The Organization of the Tokugawa *Bakufu* and the Policy of Isolation

A FTER THE DEATH of Ieyasu, peace was assured and the authority of the Tokugawa family was indisputable. The government of the shogunate was firmly established at Edo and set about organizing an administrative system, while Ieyasu's son, Hidetada, made every effort to continue the work of the consolidation of the *daimyō* begun by his father. In 1623 Hidetada retired and transferred his responsibilities to his son, Iemitsu, who subsequently put the Tokugawa *Bakufu* on a solid basis. The administrative system of government, created progressively by the first three shōguns and given its final form by Iemitsu, consisted of several departments or ministries with well-defined functions:

The *Tairō*, or Great Elders, was formed to advise the shōgun and to act as a type of regency in those cases in which the shōgun was still a minor. In 1633 there were three members.

The *Rōjū*, or Council of the Elders, which was responsible for purely administrative affairs. Its activities were divided among numerous offices whose functions included: relations between the *Bakufu* with the imperial court and the *daimyō*; the supervision of provinces that were the personal property of the shōgun; and public works, finance, and the control of the monasteries.

The *Hyōjōsho* was a sort of judicial council. It consisted of the *Rōjū* and some commissioners *(bugyō)* who were responsible for the maintenance of law and order and for the administration of justice. The *bugyō* were assisted by numerous officials whose function it was to supervise the vassals, the *daimyō*, and others, the religious establishments, government land agents, and the police. The provinces were governed by deputies *(Daikan)* who acted in the name of the shōgun. Finally, there were the military governors *(Jōdai)* responsible for the administration of the great castle-fortresses. These key posts were generally given only to *Fudai-daimyō* (hereditary *daimyō*) or *hatamoto* vassals (who were under liege to the shōgun).

In the provinces under the control of the *tozama* (independent lords) the administration was the responsibility of the *daimyō*, but they were obliged to observe the laws issued by the shogunate. The great *daimyō* were kept under tight control by the heavy taxes imposed on them and by the obligation to live four months of the year in Edo (and of having to leave their families as hostages in that city). They enjoyed considerable autonomy, however, in their own territories; there they had complete power over the people.

The warriors were divided into a large number of classes of varying importance, depending on the amount of land allotted them or the size of their incomes. Each samurai who owned land was free to administer it as he saw fit, but in most cases the taxes were collected by the *daimyō*, who then paid a stipend to the samurai. As a result the samurai were considered a type of steward. The assignment of land to a warrior thus became more and more an honorary office

accompanied by a salary. The samurai were therefore obliged to live in the city and had little contact with the people of their own estates, and thus the land virtually became the property of the *daimyō*. This system both satisfied the samurai and did not weaken the power of the *daimyō*. Yet it also brought about the existence of a discontented social class: the *rōnin*, or masterless samurai. The displaced *daimyō*, who had been given provinces far from their family domains or whose land had been confiscated or reduced, were unable to keep all their warriors once peace had returned to the country. The warriors who, under the laws of Hideyoshi, could not become peasants or settle in the villages, became a type of wandering displaced person. At the time of Ieyasu's death there were more than 500,000 of these *rōnin* who were a constant source of trouble, particularly on the island of Kyushu (where for the most part they were Christians).

The social structure imposed by the *Bakufu* was organized into a rigid hierarchy and divided into classes from which it was not easy to escape. In principle no one could move from one class to another. There were four echelons within this structure that were officially recognized according to their social prerogatives: the samurai, or *shi*: the peasants, or *nō* (ninety percent of the population); the artisans, or *kō*; the merchants, or *shō* (the wealthiest). Each of these classes was subdivided into numerous categories, which did permit a certain mobility within the particular class. In fact, a poverty-stricken warrior could rise to the position of a *daimyō*; a farm laborer could become an important landowner; a peddler could amass a fortune as a wholesale merchant.

There were also exceptions to the system: in order to evade taxes and excessive work, numerous peasants moved to the cities and became domestic servants, thus voluntarily placing themselves in an inferior class; some of them lowered their social position even further by becoming craftsmen or traders. Therefore, the artisan or mercantile classes had a tendency to increase in number. It was quite common for skilled craftsmen and successful merchants to live much better than peasants and to be considered superior to them, although officially they belonged to a lower class on the recognized social scale. An extremely complicated and scrupulously observed system of etiquette—which even conditions the social attitudes of the present-day Japanese—regulated the life and relationships of persons belonging to the same class.

Outside of these four classes there were two categories of people whose ambiguous social status was considered inferior even to that of the merchants: the first group was made up of domestic servants, sailors, and day laborers; the second consisted of persons who had been excluded from a class for one reason or another and condemned to the position of an "un-person" *(hinin)*. The *hinin* were forced to beg or accept the most repugnant work. The *rōnin* (masterless samurai) did not form a social class that was different from that of the regular samurai, but they were considered rebels whose elimination was vital. Some of them, however, set up military schools or became tutors in the service of families of the wealthier samurai. The members of the Buddhist clergy were not included in the class system. However, their social rank was the equivalent of that of the samurai.

Also, having been deprived of their domains, many of the noble families had become extremely poor, and their members were obliged to earn their living as teachers of etiquette, music, poetry, or painting. The emperor himself required subsidies from the shōgun in order to maintain his court. Iemitsu's administration concentrated on extending and consolidating the power of the *Bakufu*. The vassals were strictly controlled; the imperial court was deprived of most of its prerogatives, including that of appointing ecclesiastics to the highest clerical rank. Even the crown princes were chosen by the shōguns. In 1634, in order to impress the people and the court, as well as the *daimyō*, the shōgun led an army of 300,000 men from Edo to Kyoto.

Iemitsu outlawed Christianity—which had drawn converts primarily among the *rōnin*, who thus became dangerous adversaries of the *Bakufu*—and he banned the importation of Western religious books. The anti-Christian laws issued during Ieyasu's administration were now strictly enforced, and numerous Japanese Christians were condemned to death in Kyoto and Nagasaki for having violated these proscriptions. Most of the Jesuits who had gone into hiding at the

time of Ieyasu's order of expulsion in 1641 were arrested and put to death from 1622 onward.

In some parts of Kyushu the Christian peasants, augmented by the converted *rōnin* and supported by the less important *daimyō*, organized resistance to the *Bakufu*'s anti-Christian measures. In the Shimabara Revolt in 1637 they were mercilessly crushed, and most survivors of the massacre went into hiding. In 1624 all Spaniards had been expelled. In 1636 all foreigners were forced to reside on the small man-made island of Deshima in Nagasaki Harbor. In 1639, as a last measure, Iemitsu prohibited the entry of all Portuguese vessels into Japanese ports, and in 1640, when the members of an embassy from Macao had disembarked in violation of his orders, he had all but thirteen beheaded and burned the ships. "Inquisitors" were appointed, and each year all the inhabitants of regions suspected to be centers of Christianity (primarily Nagasaki) were obliged to prove that they did not belong to this "anti-social" faith, after which they were forced to walk on a sacred Christian image—a Cross or effigy of the Virgin called *fumi-e* (icons to be trampled underfoot). Buddhist statues of the divinity Kishimojin (somewhat similar to representations of the Virgin and Child) and some crucifixes with Buddha as the *corpus* began to appear. They were created by Christians who wished to perpetuate the symbols of their faith without seeming to do so.

Eventually, the only foreigners allowed to live on Deshima were members of the Dutch East India Company, who were not suspected of proselytism. The Christians were persecuted mainly because the shōguns were afraid that Japan would be invaded by a foreign power. In studying Western maps, they had come to realize how small Japan was in comparison with the rest of the world with its numerous powers then engaged in wars of conquest.

This fear of the outer world led Iemitsu to prohibit vessels from leaving Japan for a foreign country without first obtaining special authorization. The death sentence was ordered for all Japanese who attempted to return home after they had resided abroad for more than five years. It was intended to discourage Japanese citizens from leaving their native soil.

Such draconian measures practically closed Japan to foreigners. Foreign trade continued to flourish nevertheless: although communications with European countries were almost entirely severed, those with Asian nations continued. Chinese ships were still able to trade in Japanese ports, and a few Japanese vessels furnished with the "red seal" received permission to carry on commerce with the Japanese colonies in Southeast Asia, which supplied raw silk, cotton, tin, and sugar. Also, the Dutch and a few English merchants were allowed to engage in commercial trade within the Deshima compound.

Thus Japan was not completely deprived of products essential to the economy. The isolation of the country had only a relative importance.

Shōgun Ietsuna (1651–1680)

Iemitsu died in 1651, and according to the custom of *junshi* his death was followed by the collective suicide of his most faithful vassals. His successor was his son, Ietsuna, then only ten years old. The Regency was therefore assumed by the *Tairō* (the Council of Great Elders). A few weeks after the accession of the new shōgun, a group of *rōnin*, led by Yui Shōsetsu and Marubashi Chūya (who sought revenge for the death of his father, who had been executed at the time of the surrender of Osaka Castle), stirred up a revolt that aimed at the overthrow of the shogunate. But the plot was discovered and the leaders, together with their families, were executed.

The threat posed by the *rōnin* was not eliminated by that action, and it became the prudent policy of the *Bakufu* to find some employment for these warriors without land or master. The government also put limits on the confiscation of land, since this had the effect of constantly increasing the number of *rōnin*. As the years passed, the *rōnin* began to disappear, vanquished by old age. Their sons, due to an education the fathers had been unable to obtain, were usually

reclassified into administrative positions. Some of the "reformed" *rōnin* or their sons became famous: Arai Hakuseki (scholar and encyclopedist); Ogyū Sorai (intellectual and man of letters); the poet Bashō. The *Bakufu* was also faced with the problem of groups of young unemployed workers who had organized in gangs and terrorized the inhabitants of the cities. Because of their strange clothes and bizarre hairdos and their assiduous attendance at the *kabuki* theater, they were dubbed *kabukimono*. They indulged in murder, armed robbery, and assassination. Many of the shōgun's vassals, as well as gamblers and other unsavory types, also joined these gangs.

In 1657 a fire destroyed more than half of the city of Edo and caused the death of more than 100,000 people. The capital was soon rebuilt according to an improved plan which included sites for marketplaces and large vacant areas that would prevent the spread of future fires.

Although political equilibrium seemed to have been achieved in the government, numerous quarrels over the rights of succession caused disturbances in the fiefs of such clans as the Date, Kaga, and Kuroda. The *Bakufu* was obliged to intervene in these squabbles in order to pacify these incidents that posed potential threats to the stability of the government.

In the field of foreign affairs the *Bakufu*, having no navy, had no desire to renew diplomatic or military relations with other countries. They also refused to aid Chinese rebels who appealed to Japan for support. Ietsuna died in 1680, and the succession passed to his brother, Tsunayoshi, who became the fifth Tokugawa shōgun.

The Shōguns Tsunayoshi (1690–1709), Ienobu (1709–1713), and Ietsugu (1713–1716)

Tsunayoshi revived the policy of his father, Iemitsu, of confiscating the lands of the undisciplined vassals. Intending to govern as absolute master, he made every effort to reduce the authority of the *Tairō*, and in order to increase the money supply—the treasury had been seriously depleted by numerous donations to the Buddhist monasteries—he imposed a gradual devaluation on gold and silver currency. His reign, however, was destitute of any real political activity. Somewhat troubled mentally, Tsunayoshi became noted for the extravagance of his laws promulgated to uphold morals as well as for those issued for the protection of dogs! (The dogs, thus protected, multiplied so rapidly that it became necessary to build a special enclosure for them on the outskirts of Edo where more than 50,000 canines were cared for and fed at the expense of the citizenry.) Tsunayoshi, who was also a fanatical adherent of neo-Confucianism, concentrated his efforts on spreading the doctrines of Chu Hsi, and he retired in 1708 in order to devote all his time to his studies, but died the following year.

Tsunayoshi firmly asserted the totalitarian power of the shōguns. His reign is famous for the incident known as the "Vengeance of the Forty-seven *Rōnin*," which was immortalized in a celebrated play. Tsunayoshi gave to his luxurious era the appellation Genroku, the most glorious of epochs. During the last years of the "glorious epoch," however, the country was afflicted with numerous catastrophes. In 1703 an earthquake ravaged the Kantō region and destroyed a large part of Edo, and a tidal wave devastated the coasts. In 1707 an eruption of Mount Fuji (the last of modern times) buried the surrounding countryside under cinders and ash that destroyed all vegetation. And the following year the land was plagued by a series of floods.

Ienobu, a grandson of Iemitsu, assumed the title of shōgun in 1709. Advised by an old *rōnin*, Arai Hakuseki—a scholar well versed in the Chinese classics and a brilliant historian—Ienobu introduced reforms that suppressed the extravagant edicts of his predecessor. He revised the *Buke Sho-Hatto* ("Rules Governing the Military Households") by adding to its articles concerning the administration of justice (and thereby considerably alleviating its harshness) and the control of corruption. He stabilized the currency which had been dangerously devalued by Tsunayoshi,

and he minted new gold coins, thus bringing to a halt an inflationary trend that had threatened the economy and given rise to widespread discontent.

After the death of Ienobu in 1713 and during the short period in which the infant Ietsugu was shōgun (born in 1712, he died in 1716), Arai Hakuseki continued as counselor to the *Bakufu*. Since the monetary situation was again precarious, it was decided to return to the use of the monies issued prior to 1695. Confidence returned, and prices began to fall with the restored fiscal stability. Yet it was difficult to maintain a balanced budget in view of the continuing diminution of exchanges with foreign countries.

Rural and Urban Life

The peasants were (as usual) crushed by heavy taxes, often ill-treated, and punished severely for the slightest infringement of the law. In addition to their own fatiguing labor in the fields, they were often forced to work without pay on public projects. Although the peasants had been placed on a higher social level than the craftsmen and merchants, their material situation was far inferior. The laws were rigorous:

> Peasants and their wives may drink neither tea nor *sake* and are forbidden smoke.... The peasants are people without spirit. They must not feed rice to their wives or children during the harvest season, but must put it aside as seed grain. They must eat millet, vegetables, and other coarse foods in place of rice.... They must store the foliage of plants as insurance against famine.... The husband must work in the fields, and the wife must weave. Both must work at night making straw ropes or baskets with great care.... In order to economize they must use dead leaves as fuel.... They must wear only garments of cotton or hemp, never silk.... They are forbidden to play games.

And in addition to these proscriptions, the law ordered the peasants "to keep highways, drainage ditches, and wells clean, to maintain roads and bridges in good condition, and to apply for permission to the authorities before cutting down trees or bamboo groves."

Toward the end of the seventeenth century these laws were still applied, though in as lightly less severe fashion. The peasants began to improve and increase the yield of their fields by cultivating (in addition to rice) vegetables and fruits and such commercial products as mulberry trees (the leaves of which fed the silkworms), tobacco, and oil-producing grains. Some peasants also developed cottage industries for the manufacture of paper or other salable products which, though taxed, permitted them to live a little more comfortably. However, since the population increased at least as rapidly as overall production, the general living standard of the peasantry remained at a very low level. The peasants were grouped in villages, which were administrative units made up of several farmers under the authority of a village leader. The peasants were also grouped in units of five *(gonin-gumi)* in which they were collectively responsible for one another, but they also helped one another to the best of their abilities.

The structural hierarchy of the peasant class was rigid and was based more on the family one was born into than on wealth. The most unfortunate farmers were, naturally, the ones with small plots of land, since they were obliged to work for the large landowners and to cultivate their own fields as well, and sometimes their small plots were also taken over by wealthier farmers in lieu of a certain number of working days.

In principle, a land census was to be taken every ten years. The inspectors, often not very honest, oppressed the peasants or could be bribed into "not seeing" fallow land brought into cultivation or crops not declared. Obviously, the poorest peasants could not afford to pay off the inspectors. At times the more put-upon peasants even rebelled and abandoned their land.

409

The other peasants in the village commune were then forced to cultivate these deserted fields and to pay the taxes due on them. Quite often in such cases of land desertion the village leader was punished either by torture or execution.

During these years vast irrigation projects were undertaken in the Kantō which permitted the cultivation of large areas of reclaimed land. The demand for agricultural products was always great, especially in the cities, and it was always necessary to improve agrarian methods and techniques. Harassed by the incessant work imposed on them, the Japanese peasants developed remarkable ingenuity in inventing means of alleviating their wretched drudgery by making new tools. This ingenuity, together with diligence and prodigious manual dexterity, is still one of the characteristics of the Japanese people.

At this time fishing was limited to the coasts and rivers, because the lack of seaworthy craft made it impossible to venture far from shore. The fishermen were heavily taxed on the portion of the catch they sold, but their standard of living was better than that of the peasants, who were tied to their plots of land and could not count on supplementing their diet from other sources. Most of the traders and craftsmen lived in the cities, or in whatever district they worked. They paid regular visits to the local markets, either to sell their products or to buy raw materials, such as wood, iron, dyes, silk, and leather.

Life in the cities at this time offered a far more attractive prospect. Since peace had been restored, the traders had settled down at the major junctions along the great highways, and many of the seasonal markets had become permanent. Whenever the castles or administrative and military headquarters were built in an area propitious for commercial activity, important cities grew up around them and attracted merchants, craftsmen, *hatamoto* (the shōgun's own vassals), and minor nobility or gentlefolk. It was a movement that developed to the advantage of the commercial centers and at the expense of the military strongholds that were less favorably situated for trade.

There was a rapid growth of cities like Osaka, Kyoto, and especially Edo, where the regular four-month periods of enforced residence of the *daimyō* and their retinues brought a group of wealthy customers to the local craftsmen and merchants. By 1700 Edo had become the most important city in Japan and boasted about 500,000 inhabitants, whereas Kyoto and Osaka had risen to 400,000 and 350,000 respectively. These three cities were the centers of trade and handicrafts and were the principal sources of revenue for the merchants and the craftsmen. The urban population, however, produced relatively little but consumed a great deal. Agricultural produce and the raw materials required by builders and artisans, as well as laborers of all types, flowed in from the countryside. Overland transportation was slow and difficult, and therefore the cities were supplied principally by sea.

Osaka, being the port best situated to assume the role of a trade center, developed rapidly. The leading merchant families of Osaka and Edo founded the powerful dynasties of financiers (including the Kinokuniya and Mitsui families, for instance) whose influence still dominates the economic life of Japan. These merchants often amassed enormous fortunes by profiting from various natural disasters—earthquakes and fires—which periodically devastated the cities.

Rōnin, landless peasants, and farm laborers also came in increasing numbers to the cities, where servants and unskilled laborers were needed. The younger sons of the nobility and the samurai also came, in the hope of finding some sort of lucrative employment. Many inns, eating places, and establishments catering to other appetites came into being and attracted ever-increasing numbers of people to the cities. In Edo particularly—which as far as power and importance were concerned had become the capital of Japan, although officially the capital was still Kyoto where the emperor resided—the citizenry, who were made up of peaceful merchants, quarrelsome samurai, and public officials, had a far better living standard than those who remained in the country. They also enjoyed a certain degree of freedom, and although their taxes were heavy, they were not obligated to contribute their labor on public works, and they had leisure time.

Within a relatively short period Edo replaced Kyoto as the center of artistic and literary movements. The *chōnin*, or citizenry (the inhabitants of Edo were called *Edokko*), who were mostly followers of neo-Confucian doctrines, favored the arts, and were deeply interested in Chinese and Japanese literature. Kyoto, the guardian of tradition, was a calmer city where existence was characterized by a more rural way of life. Osaka, the great commercial city, witnessed the constant arrival of men from the countryside who were doggedly determined to make their fortunes.

A new class whose origins were the common people gradually tended to replace the samurai, and the military government of the *Bakufu* surrendered more and more of its authority to a civil administration. Actually, a military type of government could rule only with difficulty a country that was becoming increasingly dominated by the merchant class. Numerous problems had to be taken into consideration: in particular the question of transportation, especially vital in a country with a terrain so irregular as Japan's. The very existence of the *Bakufu* depended at this point more on the prosperity of the country than on its military strength, and any difficulties that threatened the stability of the government were primarily economic. This did not imply, however, the decline of the samurai class, which guarded both its honor and way of life. This class was nevertheless forced to reconsider its social position and to admit the existence of new classes that had arisen among the people and whose different aspirations affected the tenor of life.

Yoshimune (1716–1745) and His Successors

The new shōguns had to face a financial problem that was all the more difficult inasmuch as the Japanese economy was based on the production of a single basic crop: rice. In the years of a good harvest, when the peasants had a salable surplus, the officials and the vassals found themselves at a disadvantage, because the price of the crop fell. Only the residents of the cities and the consumers received any benefit from this. On the other hand, when the harvest was poor, the price rose, to the great satisfaction of the officials who were paid in rice. But the people suffered, and there was disorder among farmers who did not have enough rice to sell. For this reason, alternating periods of good and bad harvests were detrimental to the majority: an economy based on rice was too unstable.

To solve this problem, Yoshimune proposed certain reforms: a reduction in the number of vassals and officials who were paid in rice, an end to the hereditary official posts, a policy of economy in all spheres of administration, and finally, an annual tax on the revenues of the *daimyō* in return for a reduction of the period they were obligated to reside in Edo. These measures were only provisional and did not avert a few local rebellions. After disastrous harvests of 1720 and 1721, Yoshimune therefore attempted to increase overall production by opening new land to irrigation, particularly in the Kantō region in the Tamagawa and Arakawa valleys. It was difficult to collect taxes, because officials were easily corrupted and the land census was made in a hit-or-miss fashion. Many wealthy farmers concealed the actual production figures of their land from the officials, while the poorer peasants, proportionately more heavily taxed, saw their reduced harvests crushed under a general 10 percent increase of all taxes. The economy measures of Yoshimune—sumptuary laws for women, and structures regulating the decoration of lacquered objects and the expenses allowed for marriage ceremonies—proved futile; for the most part they were not even observed.

At that point a type of ministry of finance was created to control the state revenues. In 1730 the state budget finally seemed to have been balanced, but this solvency could be maintained only with the greatest difficulty, because the harvest obviously varied from year to year and could not be predicted in a country so often devastated by natural disasters. The price of a *koku*

of rice oscillated widely from one year to the next: for instance, the 1731 price had quadrupled in 1734. In 1735 Yoshimune fixed both the buying and the selling price of rice, but even this reform proved unsuccessful, and on his retirement, despite all his efforts, the "rice shōgun" *(kome-shōgun)*, as he was called, left the finances of the state in a deplorable condition.

The situation could mostly be blamed on the officials, who were both incompetent and corrupt. The rural areas began to show symptoms of unrest. The methods employed by Prime Minister Kamio Haruhide in collecting taxes from the peasants was described as "pressing sesame seeds to extract their oil."

Yoshimune, who was interested in the scientific development of the country, abolished the ban prohibiting the importation of books from China and even ordered some of the eminent intellectuals of the period to learn Dutch so that some access to Western culture might be gained. In an attempt to control the famines in the years of poor rice harvests, he encouraged the cultivation of other crops; sweet potatoes, for example, were introduced from the Ryukyu Islands in 1734. As early as 1719 Yoshimune abolished the law prohibiting the presentation of petitions directly to the shōgun. Having set up his system of government, he then occupied himself with all the important matters pertaining thereto. In 1745 he retired in favor of his son, Ieshige, and he died six years later.

The succeeding forty years saw two shōguns—Ieshige (1745–1760) and Ieharu (1760–1786)—who were men of weak character and who left the administration of the government in the hands of greedy and dishonest officials. Ieshige stuttered, and because no one could understand him he employed as his interpreter a samurai who was a childhood friend, Ōoka Tadamitsu, who took advantage of his position to amass a fortune. As in the past, however, the Council of the Elders continued to govern the country; nothing was changed.

After the death of Ieshige his son, Ieharu, an unstable individual, practically surrendered his powers to a skilled but unscrupulous man, Tanuma Okitsugu. The latter assumed the post of chamberlain after Ōoka's death and profited as scandalously as his predecessor, taking advantage of his official powers to create a personal fortune. Okitsugu began the unfortunate policy of almost literally legalizing official corruption. However, he was the first person to consider the possibility of exploiting new land areas on the island of Hokkaido (then called Ezo), and he sent officials there to report on the available arable land.

Having learned of the presence of *Aka-Ezo* (Russians) on Hokkaido, and of the illegal trade they were carrying on with the people of the fief of Matsumae, he decided to legalize this commerce and to reap the benefits it would bring to Hokkaido in developing agriculture on the island. In 1785 he opened negotiations with Russia with a view to increasing trade. Having also created a series of monopolies that he taxed heavily, he was thereby able to improve somewhat the financial situation of the state—and his own as well.

However, the instability of the economy, the inability of the government to regulate commerce, and the corruption of the officials, aroused new movements throughout the land which were of the opinion that it was high time for a change of regime. Such a movement was discovered in Kyoto, and its leaders were accused of plotting against the state and were severely punished. The heavily taxed peasants organized an uprising in Nikkō during the annual procession of the shōgun in 1764 and plundered the government granaries. Following this example, peasants rebelled in other parts of the country and deserted their fields in droves. Powerless to control these rebellions, the *Bakufu* encouraged informers and spies and promised large rewards for any reports regarding planned uprisings. Each revolt was mercilessly repressed—such as those of 1765 and 1773—but they reflected the general discontent of the people, who felt that they were governed by incapable shōguns and exploited by the rapacity of the merchants and the avarice of the officials.

From 1770 onward, the peasantry was additionally plagued by a series of natural disasters: repeated periods of drought, fires in Edo in 1772, epidemics in 1773, volcanic eruptions in 1773 and 1783, floods in 1778, and famine from 1783 to 1786. The *daimyō* of the unaffected provinces

refused to aid the devastated regions, and the *Bakufu* could do nothing to alleviate the country's ever-increasing misery. The famine of 1783–86 was so terrible that peasants in the northern part of the country were forced into cannibalism. Riots broke out even in Edo, where mobs stormed the houses of the rich merchants and speculators.

The Foreign Threat

Ieharu died in 1786, and a member of the Hitotsubashi branch of the Tokugawa clan succeeded him, supported by the efforts of a member of the Tayasu branch, Matsudaira Sadanobu, who was the chief of the Shirakawa clan. As the new shōgun, Ienari, was a minor, Matsudaira dismissed the chamberlain, Tanuma Okitsugu, and placed himself in the midst of the *Rōjū* (Council of the Elders). Shortly afterward he was appointed Regent. He soon introduced reforms that aimed at eliminating the causes of the government's difficulties: the indiscreet officials and those who had engaged in corruption with Tanuma Okitsugu. The treasury was empty, the condition of the peasants desperate. Matsudaira cut public expenses, levied further taxes on the *daimyō*, and reduced the interest on loans made by the moneylenders. As the harvest began to yield normally again, the agrarian rebellions ceased, and trade gradually regained its equilibrium.

Fearing new famines, Matsudaira ordered the *daimyō* to build up stocks of rice. In order to relieve the peasants—his Confucian education had given him humanitarian viewpoints—he reduced the number of days they were forced to work on public projects. In 1790 he attempted to repopulate the countryside decimated by the famines in which more than a million peasants had starved to death. He ordered those farmers who had moved to the cities to return to the land.

All these reforms had little effect, however. Once prosperity had returned, the people had little interest in the boring philosophical theories of Matsudaira Sadanobu. Alarmed by the arrival of Russian ships in the waters around Hokkaido and by the arrival of a mission from Catherine the Great to which he refused permission to visit Edo, Matsudaira decided in 1794 to retire.

Having come of age, Shōgun Ienari took up the reins of power; but he was so incompetent that Matsudaira was forced officially to reassume the direction of state affairs; the laws that he imposed at that point were so unimportant and so ridiculed that in order to enforce them he resorted, like his predecessors, to using informers. In fact, he organized a regular army of "stool pigeons" to expose anyone who expressed subversive or even critical opinions regarding the government. Matsudaira also arrested a number of writers and artists whom he considered licentious—Utamaro, for example—and he imposed strict censorship on all publications. After the death of his associate, Nobuaki (to whom the inspiration of some of the so-called reforms has been attributed), his unfortunate laws were quickly forgotten.

Ienari and his favorite, Mizuno Tadanari—the adopted son of a partisan of Tanuma—were corrupt and degenerate. The *daimyō* and even the people living in the larger cities soon followed their deplorable example. Prosperity had returned and so had the zest for living. In order to compensate for the enormous expenses of the shogunate, currency had to be devalued once again. All this could be borne by the country only so long as the harvests were abundant, and fortunately they were until 1832.

The Russians had not given up hope of establishing friendly relations with Japan. In 1804 Admiral Rezanov anchored in Nagasaki Harbor, but he remained there for six months without ever receiving permission to visit Edo.

As the result of several Russian expeditions to the coast of Hokkaido, the alarmed *Bakufu* prepared its defenses. In 1808 the arrival at Nagasaki of an English vessel, which threatened to open fire on the port if supplies and water were refused, resulted in the reinforcement of the city's fortifications. In 1811 the Japanese captured some Russian officers who had landed on the

coast of Hokkaido for purposes of scientific study and did not release them until two years later.

Japan began to interest the Europeans, and English and American vessels appeared more frequently in Japanese waters (1797, 1817, 1818, 1824). Ienari was alarmed, and in 1825 promulgated a second series of regulations ordering the instant destruction of all foreign ships that approached the coast and the execution of their crews.

Even though there was peace of a carefree type in the large cities—owing to a curious sense of premonition, it seems that people everywhere are always ready to make merry and give free rein to their instincts when a catastrophe is imminent—the situation in the fiefs was evolving in quite a different fashion. Whereas the estates with limited revenue (the most numerous) were crippled with debts and had been the scene of disorders in the years of poor harvests or of inflation, the great fiefs that lay outside of the *Bakufu's* control (the *tozama*—or "outer" *daimyō*), although in general incompetently administered, had flourished through precarious economies. The majority of the *daimyō*, who were obliged to sell their rice at the prices fixed by the merchants in Osaka in order to finance their enforced period of residence in Edo, were so deeply in debt that it would have been impossible for them ever to repay their loans. Practically all their revenues were pledged to the merchants and moneylenders of Osaka, in some cases for almost a century.

The *daimyō*, therefore, tended to bear down even more heavily on the peasants in order to relieve the burden of their debts. Some *daimyō* even resorted to illegally expropriating possessions of the richest merchants (or murdering them for their money), selling their titles to wealthy bourgeois, and—in desperate cases—declaring themselves bankrupt. Since the unfortunate merchants were considered by the samurai to be nonentities because they were members of the lowest class, there was little they could do to defend themselves against this rapaciousness.

The reforms introduced by some of the *daimyō* were not particularly efficacious. Those of certain provinces, however, did discover more or less realistic (and honest) solutions to alleviate their problems, which permitted them—at least temporarily—to bolster their tottering economies. This held true for the provinces under the Satsuma and Chōshū clans, but they were additionally aided by the fact that they were relatively independent as well as militarily powerful.

The *Bakufu* did nothing to aid the provinces. Not only was it too preoccupied with the arrival of foreign vessels, but it was also saddled with a perilous financial situation, which had deteriorated still further after the famine of 1832–36. The more intelligent members of the government soon realized that the *Bakufu's* policy of isolation was leading the country to ruin. In 1837 Ienari was replaced as shōgun by Ieyoshi, with Mizuno Tadakuni as his prime minister. The peasant rebellions increased each year, and the cities were the scene of continuous riots. Mizuno Tadakuni attempted to legislate a few reforms that were as ridiculous as they were petty, and having created a general sense of discontent, he was forced to step down in 1844.

The same year, the Dutch government sent a memorandum to the *Bakufu* in which the international situation was described in detail and a request was made for the termination of the policy of Japanese isolation. The *Bakufu* refused, but did permit a British warship to visit Nagasaki in 1845, and three years later allowed a French vessel to drop anchor in the same port.

The Japanese intelligentsia were becoming increasingly curious about Western culture, and several of them were executed for having dared to express their opinions in public; yet even the death sentence could not prevent the progress of ideas. However, the *Bakufu* turned a deaf ear to all appeals and redoubled police surveillance.

In 1845 two American warships anchored in Edo Bay and brought a request from the United States Government for the establishment of commercial relations between the two countries. It was rejected. In the summer of 1853 Commodore Matthew Perry sailed into Uraga Harbor with a squadron of four warships. He delivered a letter from the President of the United States, Millard Fillmore, and announced that he would return the following year for an answer. The Japanese were amazed (and terrified) by Perry's ships, two of which were steam-driven, as they had never seen anything like them. Even the *Bakufu* was intimidated by the powerful impression created by these "Black Ships of evil mien," as the Japanese called them.

In February, 1854, Perry returned with seven ships, and a treaty was signed on the last day of March. Known as the Treaty of Kanagawa, the agreement opened the ports of Shimoda and Hakodate to American ships. Additionally, it stated that shipwrecked sailors were to receive aid and protection, and it was also agreed that an American consul was to be allowed to reside in Shimoda.

Later the same year the *Bakufu* signed a similar agreement with Great Britain and the following year with Russia and the Netherlands. At the same time it ordered the coastal defenses reinforced and created an Office of Foreign Studies. In a curious but easily understood *volte-face*, the Shintō factions (who always favored the emperor, and who seized every possible opportunity to attempt to overthrow the *Bakufu* so as to create an imperial restoration) set themselves up as champions of the antiforeign sentiment and opposed the agreements signed by the shogunate.

The arrival of the American consul, Townsend Harris, in Shimoda in 1856 was accepted with difficulty. Finally, in December, 1857, at the insistence of one of the shōgun's most important counselors, Ii Naosuke, *daimyō* of Hikone, and as a result of the warnings of the Dutch of Nagasaki, Townsend Harris was received by Shōgun Iesada, who had succeeded Ienari. The following year a treaty signed with the United States, Great Britain, Russia, and France aroused a wave of indignation among those who disapproved of the timorous and weak policy of the *Bakufu*, the most important of whom were the powerful *daimyō* led by the lord of Mito. Ii Naosuke became the most hated man in the empire, both because of the harshness with which he dealt with his adversaries and his concessions to the "barbarians." He was assassinated in 1860 by nationalist fanatics. The shōgun at that point requested the advice of the emperor; it was a step that had never been taken during the entire existence of the Tokugawa shogunate.

Extremist opinion was in favor of the expulsion of the foreigners, and in 1862 Emperor Komei issued an edict to the shōgun ordering him to commence the expulsion in June, 1863, but it was a step that the *Bakufu* correctly considered to be dangerous. In September, 1862, an Englishman was murdered on the Tokaido Road by retainers of the chief of the Satsuma clan, and the following June the British fleet retaliated by shelling the city of Kagoshima, the headquarters of the Satsuma clan. Previously that same June, on the very day the emperor had demanded that all foreigners be banished from Japan, Choshū coastal batteries on the Shimonoseki Straits opened fire on American, Dutch, and French vessels. There was immediate retaliation by the Americans and French, and the British destroyed Kagoshima in the above-mentioned incident. In 1864 the combined American, British, Dutch, and French fleets demolished the Choshū batteries, and extracted a pledge that the straits would never again be barred to shipping. The Choshū clan was forced to pay a heavy indemnity. In 1866 a rebellion exploded in Kyoto, and the *Bakufu* sent troops to overcome the Satsuma and Choshū clans, who had formed an alliance. The *Bakufu* army was defeated and forced to withdraw.

In the same year Shōgun Iemochi died. His successor, Hitotsubashi Keiki (Yoshinobu), attempted to restore law and order, but in 1867 he was obliged to resign. A provisional government, from which the Tokugawa clan was excluded, was set up and, after a few brief skirmishes between the supporters of the emperor and those of the shōgun, Emperor Mutsuhito (known to history as Emperor Meiji), the 122nd sovereign of Japan, ascended the throne.

A new era, the Meiji, was inaugurated in 1868. It was to witness the transformation of Japan under Western influence and the end of a feudal and military regime that had lasted seven hundred years. The new emperor left Kyoto and established his capital in Edo, which was renamed Tokyo ("Eastern Capital").

Japan was soon to become an international power.

Philosophies

From the time of their rise to power, Ieyasu's successors made it a point to suppress everything that might in one way or another undermine their authority. Having attained their position, they intended to defend it at all costs. Because of its various philosophies, religion often ran contrary to the ideas of the state. Christianity had been extirpated with violence, not because it was a religious doctrine that differed from those already extant in Japan, but because its tenets were considered dangerous by a militaristic government aiming to exert absolute power. Ever since the severe measures taken against them by Nobunaga and Hideyoshi, the Buddhist sects and clergy had been satisfied to carry on their functions without attracting undue attention. The obligation of every Japanese to belong to a Buddhist sect—which to all intents made Buddhism the state religion—was primarily an anti-Christian measure. In point of fact, Buddhism survived only because it knuckled under the authority of the Ministry of Religious Affairs (*Jisha Bugyō*); the monasteries and the temples were assured of receiving generous donations in return for their submission.

The Tokugawa were official patrons of numerous temples. They built two of them in their capital—Kan Ei-ji in Ueno and Zōjō-ji in Shiba—which they richly endowed. Like the majority of the people at the beginning of the seventeenth century who did not pretend to be fervent Buddhists, the Tokugawa considered the observance of the rites and the respect due the clergy an important aspect of correct social conduct. The Jōdo sect, which was the most contemplative, found its largest following among the samurai and the common people, and certainly posed no threat to the plans of the shogunate. Therefore, it was deemed a wise policy to adopt and support it.

Yet, not wishing to favor one sect over another, the shōguns showered benefits impartially on all the sects. As in the past, the people were Buddhist by adoption and Shintoist at heart. Religious syncretism permitted the individual to reconcile his faith and beliefs by observing simultaneously the rites of the Shintō shrines and the ceremonies of the Buddhist monasteries.

Yet neither religion lent real support to the government of the shōguns: Buddhism preached gentleness and equality; Shintō had neither teachings nor a moral code to offer. Only Confucianism, little known prior to Ieyasu's rise to power, could bolster the foundations of a military state, since its philosophies extolled the virtues of obedience, loyalty, and filial piety. Confucianism was expounded primarily in the Zen monasteries, not because it was a part of Zen doctrines, but because it was included in the classical studies taught in the monasteries.

The Tokugawa shōguns found in Confucianism's Doctrine of the Mean—obedience to the state, to parents, of wife to husband, of children to their elders, and mutual respect among equals—as well as in the five Cardinal Virtues—benevolence, duty, manners (and a sense of propriety), wisdom (and justice), and trustworthiness—an ethical doctrine suited to the social system they were anxious to impose, especially on the samurai. The principles expounded to Ieyasu by Hayashi Razan (1583–1657) and before him by the Zen priest Fujiwara Seika (1561–1617) were accepted by the majority of the samurai. This does not mean that those principles were faithfully followed by the government or that the government based its policies on them (no state has ever strictly observed a moral code). However, the government did encourage the propagation of this philosophy among the samurai and the people, because it drew from its adherents a behavioral pattern that in the majority of cases could be predicted in advance. And once society was thus stratified and crystallized it was easier to govern.

Each individual had to conform to his social status and act according to the laws that had been made for his social group. Each act was regulated, regardless of whether it was a question of

conversation or of work, and the relationship between individuals was governed by strict rules of etiquette. The samurai's code of honor—which was soon taken by the other classes—insisted that one commit *seppuku* (the word *hara-kiri* was rarely used as it was considered vulgar) if he in any way failed in following *bushidō*, "The Way of the Warrior."

The code of *bushidō*, which was extremely severe and demanded perfect self-control of the samurai, was also applied to other classes according to their duties and capacities. Thus, a type of society came into being in which the individual had no rights, only duties, and it was important only that these duties be correctly carried out so that Heaven and Earth might exist in harmony. The individual *per se* did not count; his only value or function was as a member of a clearly defined unit which contributed to the formation of a type of society demanded by the shogunate. All educational principles and all laws aimed at the negation of any sense of the usefulness of an individual's personal existence and the reality of his own presence, and with this objective they forbade every act of human volition and every tendency toward initiative. An individual was merely a cog in the wheel of the shogunate's governmental machine.

Weighing heavily for three centuries on each individual Japanese, those obligations deprived almost everyone of almost all personal emotions and initiative, and what remained was a sense of responsibility toward the whole of society itself. Each person was forced to become an obedient, unthinking mechanism whose sole duty was to transmit to its subordinates orders received from the superior power. A Japanese individual had no real existence; he could live only in a context in which there was inevitably a superior level and one or more inferior levels. This situation nurtured a state of mind that rapidly became a state of existence from which the Japanese have never been able to free themselves completely and which still prevails—albeit under the surface—in their attitude toward others.

The wife's position within this order was also clearly defined. Kaibara Ekken (1630–1714) wrote on the subject:

....The five greatest maladies afflicting the female spirit are intractability, bad temper, backbiting, jealousy, and stupidity.... It is because of these qualities that woman is inferior to man.... Woman is like a shadow; she is a passive being. This passivity is vague.... A wife must regard her husband as her lord and serve him with all the reverence and all the adoration of which she is capable. The chief duty of woman, her duty throughout life, is to obey. A wife must consider her husband as Heaven itself; she must never grow weary of thinking how she can better submit to him in order to escape from Celestial wrath....

These ideas were certainly quite contradictory to ancient Japanese tradition, which had always accepted the idea that the woman was equal to man. The Tokugawa, however, wanted to change society; and they partly succeeded.

A little book, the *Budō Shoshin Shū*—written in the seventeenth century by an erudite samurai, Daidōji Yūzan (1639–1730), for his son—expresses the spirit motivating the upper classes of the time. A few selected quotations give a better understanding of the samurai mind during that period:

It is only by thinking ceaselessly of death that one can cherish within oneself the two fundamental virtues: loyalty to the sovereign and filial piety. The samurai is accorded tasks that are of a superior nature to those allotted to the three other classes. He must educate himself and know the reasons underlying all things.... At seven years of age the son of a samurai must begin to read the four books of Confucius, the five books of sacred words, and the seven books of war [all of these are of Chinese origin].... Obedience to the two moral laws, loyalty and filial piety, is not limited to the samurai. The farmers, craftsmen, and merchants are also called upon to practice them. A modern samurai, although he cannot be the equal to those of bygone days, must at least respect the attitudes of those samurai and aspire to imitate them....

The doctrines of Chu Hsi were strongly supported by the Hayashi family and numerous intellectual and well-read officials, such as Arai Hakuseki, Yamazaki Ansai (1618–1682), Kaibara Ekken, and Muro Kyūsō (1658–1734). These philosophical ideas were not exempt from attack, however, and seventeenth-century Japan was, in a certain sense, the scene of ideological struggles. Nakae Tōju (1608–1648), Kumazawa Banzan (1619–1691), Yamaga Sokō (1622–1685), and Itō Jinsai (1627–1705) were the philosophers most famous for their opposition to the official doctrines. This opposition was sometimes punished by exile or imprisonment, and occasionally by the obligation to commit *seppuku*. Those Confucians who opposed the viewpoints adopted by the Hayashi family belonged to divergent schools (Wang or Yang-Ming, for instance) and were exponents of the ancient doctrines of Confucius. Or, to put it more simply, they were isolated thinkers.

Among these isolated thinkers were some who attempted to create new Shintō sects by revising Confucianism in such a way as to give it a deeply nationalist significance. Others merely rejected Confucianism as a doctrine inadequate to expressing the Shintō spirit. Many of these stern doctrines were often reactionary (the absolute authority of the elders, the inferiority of women, the separation of the sexes, the watertight division of the classes), and it is evident that they were ill-adapted to the Japanese civilization of the beginning of the seventeenth century. The only elements that could be shared by such different ethical systems as Confucianism and syncretic Shintō-Buddhism were nationalism and a spirit of loyalty.

The influence of Confucianism on the Japanese spirit affected primarily the upper classes and the city dwellers. Yet, except for the samurai (and at times not even them), Confucianism was principally a form of external behavior and a science governing outward relations which good manners and breeding required one to respect. It is certain, moreover, that Shintō remained the fundamental essence of Japanese thought, which is why Confucian philosophers attempted (but without success) to associate their principles with it. The large majority of the people, although they were forced to behave according to the official rules, never approved of the spirit of these rules. Moreover, these rules were the origin of numerous conflicts between *giri* (behavior or social duty) and *ninjō* (human feelings), which often resulted in the individual either running away from it all or committing suicide. Accounts of both reactions filled the chronicles and supplied most of the themes for the plays of the Edo period.

The only philosophers able to offer effective resistance to governmental Confucianism were the Buddhists. Yet even the beliefs in Buddhist doctrines and philosophy held by the ordinary Japanese were rather superficial. The monasteries had to be cautious in taking a stand against those in power, who could crush them in an instant, and the contemplative quietism of Jōdo was far removed from the energetic activism of the clergy of the preceding periods.

A reaction began to set in toward the end of the seventeenth century, and it gained in power throughout the eighteenth century with the advent of scientific progress and the economic domination of the lowest class on the social scale: the merchants. The city dwellers acted against the social oppression of the samurai by an open defiance of the rules concerning manners, dress, and duties.

During the Genroku era (1688–1703) city dwellers attempted to escape from the confining tenets of Confucianism by hurling headlong into *ukiyo*, or "the floating [transitory] world" of licentiousness and pleasure. Pleasure quarters—the Yoshiwara district in Tokyo, Shimabara in Kyoto, and Shinmachi in Osaka—were the gathering places for all who were suffocating under official regulations. The puppet and the *kabuki* theaters were always full, and celebrated actors became the arbiters of fashion. Licentiousness had free rein, and the courtesans lived and dressed with a luxuriousness quite out of keeping with their humble origins. Most of them were country girls who had fled to the city to escape too-strict parents or a mother-in-law who was all the more shrewish because the Confucian code gave her complete control over her son's spouse.

If the individual was profoundly anarchistic, however, society preserved the *status quo* because of the obligatory Confucian idea of collective responsibility. During the Genroku era this resulted

in a country composed for the most part of persons whose thoughts were almost anarchistic, or at least strongly individualistic. It was an attitude that could be expressed only in literature or the arts, with the result that the artists were inclined to deviate from the official ideals admired by the Tokugawa aristocracy. And whereas these aristocrats encouraged an unyielding and almost sterile aesthetic in painting and literature, the people preferred illustrative paintings, the decorative arts, and *haiku* (poems of seventeen syllables): forms of artistic expression that were scorned by the samurai.

Thus were born the graphic masterworks of *ukiyo-e* (the aesthetic value of these woodblock prints was discovered by the West a good many years prior to its recognition by the aesthetes of the Japanese aristocracy) which developed as a popular artistic expression in opposition to the classicism of the Kanō school of painting. The *haiku* of Bashō (1644–1694) arose from the depths of the spirit of the people in the same way as the almost Shakesperian tragedies of Chikamatsu Monzaemon (1653–1724), in which the spiritual clashes aroused by the daily conflict between *giri* and *ninjō* were clothed with an official morality that was actually a disguised criticism of the mores imposed on the people. The eighteenth century saw the continuation and flowering of this peoples' culture. It was a growth that kept pace with the ever-increasing wealth of the mercantile class, the progressive impoverishment of the samurai, and the penetration of Western science through the medium of Chinese and Dutch books.

Toward the end of the eighteenth century the shōgun's edicts were obeyed only by those whose social position or fortune was at the mercy of the samurai. The banning of books and, in 1790, of all "heretical" forms of Confucianism, together with various decrees ordering the people to live according to the principles of Chu Hsi, forced the Japanese into the semblance of passive submission. But it was only a sham, for their true gay, epicurean spirit survived.

Cynicism replaced licentiousness, and repressed revolt was hidden under the cloak of submission. The debauchery and excesses of the last shōguns, as well as their notorious incompetence, nourished disobedience in the hearts of the people. Even the samurai themselves no longer believed in their own principles, and many of them abandoned their social class or assumed a disguise in order to partake of the pleasures enjoyed by the common people. From the people there arose independent thinkers who tried to implement moral or agrarian reforms. Their ideas exercised a strong influence with the merchants and the peasants, even though these thinkers expounded what was apparently only a continuation of Confucian thought.

Not proscribed by the government, despite the protests of some of the Confucian officials, the Buddhist clergy devoted themselves to the publishing and clarifying of their doctrines and to the disputation of the more doubtful points. They continued to preach outside the monasteries, but those who listened did so more in appreciation of the theatricality of the preachers than through an inclination to meditate on the content of the discourses. There was also an aspect of Confucian philosophy—still apparent today—which holds that the behavior of an individual must necessarily be more important than his thinking. "Without Confucian virtue a samurai will only be a good-for-nothing, even if he is famous, intelligent, talented, and a good orator," Daidōji Yūzan wrote. Above all, one had to display these virtues.

Several movements associated with Shintō also arose at the beginning of the eighteenth century. Paradoxically, they were the creation of two women who displayed a typically Japanese reaction to the denigration of the female sex proclaimed by the Confucians: Kino (1756–1826), a peasant woman of Owari who claimed to be the savior of humanity; and Miki (1798–1897), a peasant woman of Yamato, who was a sort of prophetess-cum-shaman. Other preachers founded various Shintō movements that principally influenced the country people, and which were perhaps the cause of numerous uprisings. The most famous founder of one of these Shintō movements was a peasant, Kurozumi Munetada (1779–1849). Shintō and Confucian apostates led the final struggle that ended in the collapse of the Tokugawa shogunate and the restoration of imperial power in 1868. The head of the Mito clan (a descendant of Tokugawa Mitsukuni, and a noted historian) was an ardent partisan of the emperor's cause, even though he was a

member of the shōgun's family. This lord founded an apostate Confucian sect known as "The School of Mito," and played a very important role in restoring the emperor to power. The Confucianism imposed by the Tokugawa thus became one of the principal instruments of their fall.

Advances in Education and the Expansion of Intellectual Horizons

During the Tokugawa regime education followed two distinct lines. The first was official and was reserved for the samurai; it was best typified by the Confucian schools directed by the Hayashi family, which served as models for the provincial schools. The second was represented by the independent schools *(terakoya)* founded by the Buddhist clergy. Whereas the teaching of the Confucian schools was concerned chiefly with the Chinese classics and the arts of warfare and military skills, the *terakoya* emphasized the reading and writing of the Japanese language, the art of life, mathematics, accounting, and other subjects or sciences that would prove useful to the mercantile class.

About 1720 there were approximately eight hundred *terakoya* in Edo alone. The teachers came from all backgrounds and professions and were not recruited solely from among the clergy. The appearance of the *soroban* (a type of abacus originally imported from China) made it possible to master calculation in a swift, practical manner. Having completed their schooling, which was in no way obligatory, boys were usually apprenticed to an established merchant for a period of from ten to fifteen years, at the end of which time they had become familiar with every aspect of commercial practice and could take over their fathers' firms or set up their own business.

The *terakoya* played an important role in the formation of Edo society, because they permitted the merchants to obtain an education and expand their commercial activities. Chikamatsu noted this fact in one of his works entitled *Nebiki no Kadomatsu* ("The End of the New Year of Good Fortune"):

> The samurai becomes a warrior because his parents raise him as a warrior; the merchants become merchants because their parents teach them business. The warriors reject profit and seek glory; the merchant repudiates glory and seeks profit. To amass wealth is "The Way of the Merchant."

It should be quite evident that girls did not attend school. Only the daughters of the most important samurai were given a rudimentary education, always based on the study of the Chinese classics. It was a strange paradox that a country devoted to isolation and the most exclusivist chauvinism nourished an upper class that adopted and tried to force on their inferiors a foreign philosophy that had no roots in their native soil and no affinity with the feelings of the majority.

Still other schools existed, but they were primarily concerned with giving courses in morals. Institutions of this type were the Confucian temple of Yushima Seidō and schools in Edo and Kyoto which taught "Heart Learning," or *Shingaku*. These institutions were reserved for the merchants *(chōnin)* and taught only officially acceptable subjects, however. Both the Confucian and Buddhist instruction received by the merchant class was often equal to that of the samurai as far as overall knowledge was concerned. Their wealth gave them confidence, and the realization that they were so numerous helped the craftsmen and tradesmen to become the real masters of the country, even though they appeared to be dominated by the samurai. The cultural aspects of the Edo period reveal a transition from a militaristic civilization to one dominated by the mercantile class.

The development of schools and teaching was accompanied by a natural curiosity brought

about by the "mystery" that foreign civilizations posed for the more educated Japanese. Because of access in certain quarters to books brought in by the Dutch, the eighteenth century saw enormous advances made in science. The Japanese already possessed a knowledge of metallurgy, due to having produced firearms, and remarkable strides had been made in the processing of mineral ores as well as the assaying of silver and the refining of copper. Many of these techniques had come from China and had been considerably improved by the Japanese. The need to protect low-lying land against floods had led scientists to a more rational observation of natural phenomena, as well as the rejection of many superstitions.

The eighteenth century was an age of reason that witnessed the establishment of the basis of present-day Japanese society. This was partly brought about by the progressive disappearance of *hiden*, or concealed knowledge (of which some elements unfortunately still exist among many Japanese pedagogues). *Hiden* was a practice of professors to divulge information (of which they considered themselves the sole trustees) only in small doses to a limited number of their students.

In revoking in 1720 the decree banning foreign books, Shōgun Yoshimune became the first Japanese to turn to Western science in an attempt to produce an exact calendar. For this purpose he built an observatory, equipped with European instruments, that was placed under the supervision of Takebe Katahiro, a disciple of the famous mathematician Seki Takakazu (1642–1708). Translations of Dutch and English books revealed Copernican theories to the Japanese. Asado Gōryū (1734–1799) was the first native scientist to study the stars and other natural phenomena in a rational, analytical manner, and he was also one of the first Japanese to study anatomy through dissection. Through the diffusion of *rangaku*, the study of Dutch—or Western—subjects, knowledge of astronomy and mathematics developed in a remarkable fashion. Ajima Naonobu (1733–1798), one of the most advanced mathematicians of his time, introduced the Japanese to integral and differential calculus and the use of logarithms. Numerous other scholars, such as Fujita Sadasuke (1734–1807) and Aida Yasuaki (1747–1817), were responsible for great scientific progress. Medicine, which had been almost exclusively Chinese, began to adopt European experimental methods, and the study of botanical pharmacology was henceforth carried on in a more scientific fashion. This advance was due primarily to the interpreters in Nagasaki who translated into Japanese the basic Dutch and English texts which arrived in that port.

The Motoki and Yoshio families produced the largest number of scholars and scientists, particularly doctors and surgeons. As early as 1805 Hanaoka Seishū (1760–1836) performed an operation under a general anesthetic. When Philippe Franz Von Siebold (1786–1866) arrived in Nagasaki, Japanese medicine had already made such great advances that the local doctors had no difficulty in following his instructions.

Geography, physics, and chemistry also evolved in a parallel manner. Hiraga Gennai (1729–1780), an all-around genius, devoted his studies to mineralogy, sugar refining, and electricity, and he constructed Japan's first electrical generator, which he called the *Erekiteru* (by substituting "l" for "r," one can see that the word is a Japanization of "electrical"). Hashimoto Sokichi and, later, Aoji Rinsō and Kawamoto Kōmin developed his discoveries.

During the entire eighteenth century and from the beginning of the nineteenth century until the Meiji era, science, despite its rapid progress, was considered to be a type of fine art or a pastime. Except for those fields that provided practical and functional results—such as medicine—or were important to the state—such as astronomy—no official encouragement was given to research or experimentation.

The peace of an isolated world that was Japan's under the Tokugawa regime (in which men were divided theoretically into four classes but actually into two—the oppressors and the oppressed) allowed literature to develop along separate lines. This proved to be advantageous to the most progressive element of society—the oppressed—which was able to proceed in its own way within the relative freedom accorded to Chinese literature by the aristocrats. This period witnessed the birth of a people's literature, which, although scorned by the rulers, was nevertheless the most representative element of Japanese culture of the time.

While the officially recognized writers spent their time in exhaustive examinations of the Chinese classics or delighted in editing moralizing essays (Hayashi Razan, 1583–1657, or Kaibara Ekken) or historical treatises (Arai Hakuseki, 1656–1725), and the philosophers attempted to extract doubtful or biased meanings from ancient texts (Shaku Keishū, end of the seventeenth century, or Kada-no-Azumamaro, 1669–1736, or Kamo-no-Mabuchi, 1697–1769), the literary figures of the lower classes devoted their energies to the writing of plays, novels, and popular poetry. Ihara Saikaku (1642–1693), a talented writer of humorous prose wrote many *kana-zōshi* (novels in *kana*, or syllabic characters). At times these novels were licentious, dealing with the "flower districts" of the large cities. In a style that on some occasions became poetic, he left us descriptions—somewhat hypocritical, it is true, but the authorities were always on the watch—of the life of the city dwellers: the *ukiyo* or floating, transitory world of passion, pleasure, and human desires. His *ukiyo-zōshi* enjoyed great success and were widely imitated, particularly by Ejimaya Kiseki (1667–1736). However, it was a rather limited type of literature and was rapidly exhausted as a vein of inspiration, to be replaced in the public's favor by plays.

Jōruri, scripts for the puppet plays accompanied by sung recitation, was best exemplified in the work of Chikamatsu Monzaemon, an author of great talent. Working for the Takemoto-za theater in Osaka, he wrote more than one hundred and twenty *jōruri* libretti for the *bunraku* (puppet plays). He drew his inspiration from both classical *monogatari* and historical events (which he romanticized to the point of pure fiction), and brought them up to date (his *Double Suicide in Sonezaki*, for example). This author, who has been called the Japanese Shakespeare, founded a school that had great influence on the *kabuki* theater as well as on the puppet plays. Two of his most talented followers were Takeda Izumo (1691–1756) and Chikamatsu Hanji (1725–1783). The puppet plays were soon supplanted in popularity by the *kabuki* theater, which made use of live actors, and the authors gradually abandoned *jōruri* in order to devote themselves completely to this new theatrical form.

Poetry, which had been mainly a pastime for the cultivated aristocracy, assumed a truly popular form in the works of Matsuo Bashō (1644–1694) whose travel diaries *(Kikōnikki*, which contained many poems, or *uta)*, demonstrated his ability to condense with unique charm his impressions and thoughts into the *haiku* form. Although always expressed in pure, elevated terms, these nevertheless reflected the tenuous and changing aspects of the Floating World *(ukiyo)* with a typically Buddhist attitude toward life.

> *Vainly, the heavy dragonfly*
> *Tried to keep its perch*
> *On a blade of grass.*

Bashō's poetry was tremendously successful and was immediately imitated by such poets as Enomoto Kikaku (1661–1707) and the poetess Kaga-no-Chiyo (1703–1775). (Present-day Japanese still write *haiku*, and almost every author boasts *he* is the "only true" disciple of Bashō). Bashō's most famous successors were Yosa Buson (1716–1783) and Kobayashi Issa (1762–1826).

About the middle of the eighteenth century, even though the official authors continued to write historical and philological works—as exemplified by the commentaries of Motoori Norinaga (1730–1801)—the popular authors, especially those of Edo, gave new life to the novel with the *yomihon*, anthologies of fantastic tales, such as those of Ueda Akinari (1734–1809). There were also the allegorical narratives of Takizawa Bakin (1767–1848) and the picaresque novels known as *kokkeibon*, skillfully and brilliantly written by such literary lights as Jippensha Ikku (1765–1831)—one of the very rare true humorists in generally sober and serious Japan—Shikitei Sanba (1776–1822), and Tamenaga Shunsui (1790–1843). The latter's work was so extraordinarily licentious that he ended his life in prison.

Up until this time theatrical forms using live actors had been scorned as vulgar (this approbation, however, proved favorable to the development of the puppet plays). But about 1740

plays performed by actors returned to favor and plays dealing with violence *(aragoto)* began to replace the *jōruri* recitations of the puppet plays.

The origin of *kabuki* is obscure, but—like the *nō* theater—it may have had a link with the *sarugaku* dances, a type of spectacle reserved exclusively for the nobility and the samurai. From the end of the eighteenth century in both Osaka and Edo *kabuki* enjoyed a resounding success, chiefly due to the plays written by Tsuruya Nanboku (1755–1829) and Kawatake Mokuami (1816–1893).

Since almost all of the literature (as well as the visual arts) of the eighteenth and the beginning of the nineteenth century dealt realistically with aspects of everyday life, one might be tempted to judge Japan of that period by the descriptions of the pleasure quarters or of the life of the lower-class city dwellers. The fact is, however, that art and literature of this period reflected only a very small segment of Japanese life, that of the wealthy Merchants, the *nouveaux riches*, the courtesans, and the riffraff. Even if it can be defined as popular (in the sense of dealing with the people, *per se*), this literature did not really depict the life of the Japanese peasant or laborer, or any member of other oppressed classes, only that of the more decadent elements of Japanese society. Yet this in no way diminishes the literary or artistic merit of these works. Therefore, the Japanese of the Edo period cannot be judged on the basis of works which dealt with only a fraction of the population.

Architecture

There is no architectural style that can be considered characteristic of the Edo period. The monasteries and shrines continued to be built in past styles and varied only in dimensions and ornamentation. Whether carved or painted, ornamentation for the most part followed the Chinese styles of the Ming dynasty. The most representative shrine of the Edo period was probably the Tōshōgū at Nikkō, built in the middle of the seventeenth century. Its carved and painted decorations were characterized by such baroque virtuosity that they bordered on outright bad taste. The gateways with *kara-hafu* (curving, "Chinese" gables), called *karamon*, the carved, fretwork transom friezes *(ramma)*, and the interbeam supports *(kaerumata)* were completely covered with carved and painted details abounding in flowers, foliage, fruit, and animals. Although the colors were pure and brilliant, they were rather harsh and often clashed with one another.

Many other buildings, however, were simple and devoid of ostentatious luxury. The sculptures of unpainted wood decorating entrances and beam ends were usually quite intricately carved, even tortuous, and contrasted violently with the nobly austere styles of the preceding periods. The Ming style was first brought to Nagasaki in 1654 by thirteen Zen monks of the Ōbaku sect, and it was later adopted for the Manpuku-ji temple in Kyoto, where it was combined with the *Kara-yō* style. Numerous structures within the temple and monastery complexes were reconstructed and, although they generally followed the original style, many additions were made with elements characteristic of the Edo period. The new Shintō shrines were mostly in the *gongen* (tripartite) style.

The style of the houses followed the traditional lines of the dwellings in Edo and Kyoto. In order to guard against the ever-recurring fires, however, the shōgunate encouraged city dwellers to make use of nonflammable building materials: plaster, brick, and tile. One notes the appearance of two-story houses, which were mainly built for the merchants and craftsmen who used the ground floor for commercial purposes. The streets were widened and, because of the ever-increasing population, each tenanted dwelling tended to occupy a smaller area of land. (This was another reason why many builders increased the number of stories.)

The palaces erected during the Edo period always imitated the great *shoin* style that had been

inaugurated with the Nijō Palace in Kyoto. The gardens and teahouses followed those of the Momoyama period.

Sculpture

Aside from the decorative carving on the paneling interbeam supports and transom friezes of temples and shrines, the sculpture of the Edo period was devoid of any new styles in statuary. Sculpture during this long period displayed only a degeneration into sterile decadence when compared with previous centuries, and it possessed no originality: it was generally baroque, overdecorated, and painted in vivid hues. The only exceptions were the extremely rough-hewn works produced by the clergy, such as the smiling images made of pine by Enkū (d. 1695), and those of Tanaki (1629–1716) and Makujiki Shōnin (1718–1810).

Since the art of puppetry enjoyed popular favor, life-size puppets of extreme mechanical complexity were produced in ever-increasing numbers for the *bunraku* theater, but with few exceptions they embody little true artistic value.

Toward the end of the seventeenth century a special type of carving began to develop: that of the *netsuke*—small ivory, bone, or wooden ornaments that were employed as a counterweight (or fob) to hold a cord to the kimono sash on the other end of which was attached a little box *(inro)* holding medicine or tobacco. This art in miniature, though often scorned, proved that Japanese artists had retained a prodigious ability in working with tiny objects, a sharpness of observation, and a sense of humor that apparently had never been manifested in other art forms. The creation of carved masks for the *nō* theater continued without noticeable modification of the style of the preceding periods.

Painting and Prints

Unlike sculpture, which fell into relative neglect under the Tokugawa shogunate, painting was highly esteemed and found patrons among both the shōguns (the traditional Kanō, Tosa, and Nanga schools) and the merchants and other wealthy members of the rising middle classes (Sōtatsu-Kōrin, Shijō-Maruyama, and *ukiyo-e* schools), Whereas the traditional (and by now sterile) schools added nothing new to the developments created in the past, the so-called popular movements which followed the taste and the fashions (essentially transitory and fleeting: *ukiyo-e* "Pictures of the Floating World") of the townspeople, resulted in ever-new and original pictorial styles.

THE KANŌ SCHOOL
Tan-yū and his disciples settled in Edo at the command of Ieyasu and founded a branch of the Kanō school known as Kajibashi (because he lived near the Kajibashi Gate of Edo Castle). Sanraku continued to live in Kyoto, where he established a school that was subsequently called Kyo-Kanō. In Edo other adherents of the Kanō school founded distinctive families of painters: the family of Naonobu created one called Kobikichō; the family of Yusonobo established one named Nakabashi; and a grandson of Naonobu, Minenobu, created still another called Hama-chō. (The names were taken from the zones of the city where they worked.)

Aside from the four great families of painters, who were united in a group known as the *oku-eshi*, or painters of the inner palace or the shogunate, there were other artists who were descendants or students of the Kanō family, and who, although not officially patronized by the shogunate, worked on commissions from it or its officials. These artists were given the title of *Omote-*

eshi (painters of the outer palace in semi-official service to the shogunate), or *Machi-Kanō* (Kanō painters of the city). Among them were a few men worthy of renown, although they did not surpass their masters: Tan-yū, Tsunenobu, Naonobu, and Yasunobu. However, their work was mostly representative Momoyama period painting. Other names of a certain importance were those of Kusumi Morikage (c. 1706), Momota Ryū-ei (1647–1698), and Tsugusawa Tanzan (1655–1729). These painters had no originality, however, and were satisfied with imitating the styles of their predecessors (primarily of Tan-yū and Chinese artists).

THE TOSA SCHOOL

The shogunate had placed the schools of art and music under the supervision of unemployed nobles. These schools were chiefly under the patronage of the Tosa family because of its hereditary post as head of the imperial *Edokoro* (Bureau of Painters). Painters of the Tosa school showed a tendency to hesitate over imitating Chinese artists, but two of them—Mitsuoki (1617–1691) and Hiromichi (1599–1670), who founded the Sumiyoshi family in Edo—finally adopted with a certain brilliance the *kanga-e* style, which was characterized by vigorous brushstrokes. Jokei's son, Gukei (1631–1705), achieved some fame with his refined and delicate works. Still later one notes a survival of the *yamato-e* (or *fukko-yamato-e*) style, which attempted a renaissance through a return to the traditional art of the Heian period. These minor painters had some success, although it was quite brief. Among them were Tanaka Totsugen (1768–1823), Watanabe Kiyoshi (1778–1861), and Ukita Ikkei (1795–1859).

THE KŌRIN SCHOOL

The style first created by Sōtatsu was followed by Kitagawa Sōsetsu in the seventeenth century and then by Ogata Kōrin (1658–1716), who contributed works of great decorative quality to Edo art. They were works which the merchants found most attractive. Kōrin painted screens and sliding partitions, decorated lacquered objects, and designed fabrics (he was the son of a family of wealthy drapers). His brilliantly colored compositions are chiefly drawn from natural subjects. His brother Kenzan (1663–1743), and his disciples, particularly Sakai Hōitsu (1761–1828), gave a new freshness to classical Japanese painting, derived from a realistic inspiration and an astonishingly modern decorative spirit.

THE SHIJŌ-MARUYAMA SCHOOL

Maruyama Ōkyo (1733–1795) was born in Kyoto. He was essentially a realistic painter who had studied European styles from prints and drawings imported into Nagasaki by the Dutch and who later fell under the influence of Chinese painter Shên Nan-p'in. Ōkyo was imitated by a group of painters in Kyoto, who formed the Shijō-Maruyama school. Outstanding members of this school included Matsumura Goshun (1752–1811), who knew how to unite the realism of Ōkyo with the poetic qualities of Yosa Buson; Nagasawa Rosetsu (1755–1799); Komai Genki (1747–1797); Okamoto Toyohiko (1773–1845); Mori Sosen (1749–1821).

THE NANGA SCHOOL

Over the centuries, Chinese painters had brought their own styles to Japan: *hokuga* (the northern style, which dominated the Muromachi period) and *nanga* (the southern style of the literati-painters). The latter was taken up by the Japanese in the Edo period, through the study of Chinese texts. The fervor of the followers of Confucianism gave impetus to this continental school among those men of letters who were amateur painters. The most important figures were Yosa Buson (1716–1783) and Ikeno Taiga (1723–1776), who, on the basis of Chinese paintings, imitated by their predecessors—including Gron Nankai and Hattori Nankaku, among others—created a completely personal style strongly influenced by Zen, which had survived due to the efforts of the priest Haku-in (1685–1768). It was primarily in Osaka that the painter-disciples of Yosa Buson and Ikeno Taiga prospered, and the art of such men as Aoki Mokubei (1767–

1833) and Uragami Gyokudō (1745–1820) was extremely original in style. There were also many followers of this school in Kyoto, of which the most notable was Tanomura Chikuden (1777–1835), as well as in Edo, such as Tani Bunchō (1763–1840), and also in the provinces. The *nanga* school was remarkable because it encouraged the individualism of each painter and scorned classical canons. This allowed the artist to express his own feelings, which were considered to be more important than form. Such a concept was truly revolutionary in this period.

UKIYO-E HANGA

The art of engraving on wood and printing the engraved design in colors on paper (each color requiring a separate woodblock) belongs more to the field of illustration than to true painting. Some Edo period artists, however, showed genuine talent in the execution and printing of their works. Their fame was so great that they were accorded the same rank as painters. In order to satisfy the desires of the townsmen who could not afford original paintings, some artists—the first was Hishikawa Moronobu (1618–1694)—began to produce colored woodblock prints. The subjects were chiefly the courtesans of the Yoshiwara district or famous *kabuki* actors. These prints were called *ukiyo-e hanga* (woodblock prints of the Floating World).

In the beginning, subject matter was limited to pretty women and harlots or well-known actors and a great number of artists were needed to satisfy customers with not-too-refined tastes. (The Europeans rediscovered these works in the nineteenth century and declared them to be masterpieces.) They often reveal able drawing, yet as the medium produced a somewhat coarse art, the style soon became stereotyped: mechanical expressions, exaggerated dress, movements emphasized to the point of grotesqueness. The *ukiyo-e hanga* were created not for artistic reasons but for their salability.

The styles of most of these prints are so similar that it is difficult to distinguish the artists. Torii Kiyonobu (1664–1729), Okumura Masanobu (1686–1764), and Ishikawa Toyonobu (1711–1785) were the most famous among scores of others who issued their prints by the hundreds.

With the works of Suzuki Harunobu (1725–1770), who had a most individual style and invented the technique of printing in several colors, *ukiyo-e hanga* began to attain real artistic merit. The *bijin* (beautiful women) of Harunobu were soon replaced by the more individual women of Torii Kiyonaga (1752–1815) and Kitagawa Utamaro (1753–1806). In the works of Katsukawa Shunshō (1726–1792) and Ippitsusai Bunchō (1725–1794) the portraits of the actors reveal greater realism, although the faces are still set into a grimace and are rather forced.

Tōshūsai Sharaku, who worked only during 1794 and 1795, accentuated the style of portraying *kabuki* actors and endowed his work with characteristics which were subsequently imitated by most *ukiyo-e* artists: the small eyes, large nose, distorted mouth, and characteristic wild pose. Innumerable printmakers were commissioned by actors or publishers, and the market was soon flooded with caricatures created for mere publicity purposes. However, Katsushika Hokusai (1760–1849) and Andō Hiroshige (1797–1858) gave greatness to the art of the Japanese woodblock print. The landscapes depicted in Hokusai's *The Thirty-six Views of Mount Fuji* and Hiroshige's *The Fifty-three Stages of the Tōkaidō* will always remain classics. Their harmony, feeling, and sense of composition make them artworks truly worthy of admiration. Utagawa Kuniyoshi (1797–1861) with his renowned *Famous Places of Edo* was also one of the finest artists of the end of this era.

Beginning as simple broadsheet pictures for popular consumption, the *ukiyo-e hanga* had finally become the most typical form of Japanese art. Yet 150 years were needed for it to attain this distinction.

The arrival of the Europeans and the introduction of Western styles eclipsed to a large degree Japan's artistic production from 1868 onward. Art was to follow Occidental fashions and lose something of its original flavor. Ancient Japan was gradually to disappear in order to make way for a new nation.

367. KYOTO. KIYOMIZU-DERA. HONDŌ. ORNAMENTAL FERRULES ON THE RAILING. According to tradition, this temple—also known as Seisui-ji—was founded by Sakanoue-no-Tamuramaro, a famous military leader at the end of the eighth century. The Hondō is uniquely built on a steep slope of the Higashimaya mountains, the eastern hills of Kyoto. It is fronted by a wide wooden platform or terrace built out over the hillside. The platform is supported by an elaborate structure whose braced columns are sunk into the bottom of a ravine and is situated on the south side of this large (nine bays by five) structure. The Hondō (main hall) burned down several times; the present structure was probably erected by order of Shōgun Iemitsu in 1633. Its huge, hipped main roof is shingled with cedar and cypress bark; the subsidiary projecting roofs *(hisashi)* are reminiscent of the style of construction during the Heian period. The *gibōshu-bashira* (posts or pillars with jewel-shaped terminals) illustrated here are in the *Wa-yō* style and are capped by decorative bronze ferrules, which preserve the wood from the effects of weathering. Their shape is suggestive of the *dōtaku* of the Yayoi period (see plates 22–24). Perhaps they symbolize the precious jewel *(hōshu, or bōshu)* that grants all wishes.

368. KAMAKURA. DETAIL OF A KARA-HAFU ROOF. This photograph clearly shows the construction of this type of roof, which was first used around the end of the Fujiwara era and became very popular during the Edo period (this example dates from the seventeenth

century). The manner in which the thin cypress-bark shingles are overlapped created the harmonious curve typical of this type of roof. The tile-covered ridgepole terminates in a decorative motif called the *shishiguchi* (lion's mouth), which is rather like the stylized animals' or demons' heads *(shibi)* that decorate the gable ends of earlier structures (see plates 109 and 110).

369. KYOTO. DAITOKU-JI. AN OUTER WALL. Built on a foundation of hand-dressed stones, this eighteenth-century wall has slightly inward-sloping sides covered with plaster that has been applied over a wooden framework. It is surmounted by a sharply pitched tiled roof that extends to protect the plastered wall surface from the rain. This roof is of the same type used for the temples and consists of alternating layers of convex "positive" tiles *(hon-gawara)* terminating in round bosses *(maru-gawara)* and concave "negative" tiles *(hira-gawara)* decorated either with traditional motifs or with the name of the monastery in Japanese characters. Of particular interest is the octagonal wooden pole that supports the rafters under the eaves. The terminal gable is typical of the Edo style from the seventeenth century onward. At the base of the wall is a small drainage ditch to carry off rainwater.

370. TOKYO. UENO PARK. DAIMYŌ IKEDA'S GATE. This detail shows a portion of the roof at one of the corners and the top of a *kara-hafu* archway over the entrance. It dates from the eighteenth century.

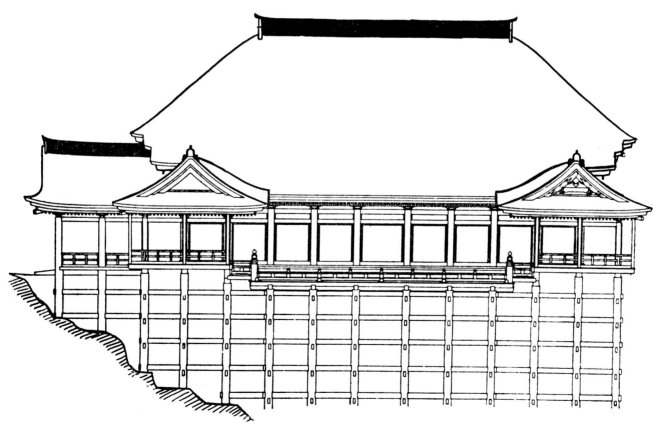

49. CROSS SECTION OF THE TEMPLE OF KIYOMIZU-DERA IN KYOTO

371. KYOTO. TO-JI. GOJŪ-NO-TO. This five-story structure is the highest pagoda in Japan (height 180'). It was built in 1644 to replace an older pagoda. It was erected on a high stone base, and its construction reflects the traditional style of Kyoto carpenters. The roofs are tile-covered, and each story is encircled by a railed gallery or porch.

372. FUJI-YOSHIDA. FUJI-SENGEN-JINJA. THE GREAT TORII. This double *torii* represents the *Ryōbu* type of gateway, suggesting the doctrine of Ryōbu Shintō, in which Shintō deities were viewed as manifestations of Buddhist divinities. It is an unusual adaptation of a Buddhist concept to Shintō architecture (see A. Akiyama: *Shintō and Its Architecture*, Tokyo, 1955), a concept elaborated at the time of the development of Shintō-Buddhist syncretism. The most complex as well as the most stable type of *torii*, a gateway in this style is characterized by four short subsidiary columns which act as braces reinforcing the two main columns. The main columns are of the *inari* type, first used in the Fushimi shrine near Kyoto, built during the Fujiwara period. The columns are made of the trunks of the hinoki tree *(Chamaecyparus obtusa)*, driven deeply into the ground, and the bases have been reinforced with concrete. The Fuji-Sengen shrine is the first of a series that lead up to the summit of Mount Fuji.

373. KYOTO. HIGASHIYAMA. SHISEN-DŌ. A rural retreat in *sukiya* style built by the poet Ishikawa Jōzan in 1641, not far from the Ginkaku-ji. Consisting of several rooms, the house is roofed with thatch, but the porches are tile-roofed. A projecting dormer on the side of the roof looks out onto the garden, which slopes gently down a hillside. This "rustic" style of residence was considered quite fashionable in the seventeenth century.

374. KYOTO. KENNIN-JI. This temple, one of the Five Great Zen Temples in Kyoto, was founded in 1202 by the Zen priest Eisai, and it is the site of his tomb. Most of the buildings (fifteen subsidiary temples) were reconstructed during the eighteenth century. The one shown is typical of a Zen monastery of the Edo period.

375. KYOTO. CHION-IN. MIEI-DŌ. This very large temple is the headquarters of the Jōdo sect. The temple was completely rebuilt between 1633 and 1639 with the wood that remained after construction of Kofu Castle. The architecture is typical of the early Edo period.

376. NARA. SAIDAI-JI. AIZEN-DŌ. This hall was moved from Kyoto—where it had served as a government office—during the reconstruction of the monastery about 1750. It is built in a "revival" style reminiscent of the years prior to the Edo period.

377. NARA. HŌRIN-JI. KONDŌ. In 1645 a violent storm destroyed all the buildings (except the pagoda) of this temple of the Hossō sect. The buildings were reconstructed in 1737, and the complex was taken over by the Shingon sect. This small Kondō, measuring only five bays by four, is unusual because it is tile-paved in the ancient style. (It was probably erected on the foundation of a previous structure.) Although the building conforms generally to the architectural style of the Kamakura period, the roofs are typical of the Edo period. Many sculptures are housed in it. Hōrin-ji, a small dependency of nearby Hōryū-ji, is also called Mii-dera, or Mii-no-Myōken, in honor of the divinity of the North Star, Myōken.

378. KYOTO. KIYOMIZU-DERA. THE SAMMON. The Sammon, or west gate, is situated on the west side of this temple. It was rebuilt in 1633 by order of Iemitsu. The entrance of this two-story structure is flanked by statues of the guardian Ni-ō: Kongō-Rikishi and Misshaku-Kongō. To the right of the cypress-bark-shingled Sammon is the temple's three-story pagoda (Sanjū-no-tō). Both buildings date from the same period.

379. KYOTO. KENNIN-JI. RYŌSOKU-IN. This attached teahouse is but one of the buildings of the temple of Kennin-ji. It is notable for the *tsuki-mado* (round moon window) that overlooks the moss-covered garden.

380. KYOTO. SAIHŌ-JI. KOKEDERA. COVERED CORRIDOR. A portion of the building within the famous Moss Temple (as the Kokedera is popularly called) reveals that even the roofs here are sometimes moss-covered. The gardens of this temple are famed for the innumerable mosses of many species.

381. NIKKŌ. TŌSHŌGŪ SHRINE. DETAILS OF THE YŌMEI-MON. This Shintō shrine was built between 1634 and 1636 by Ieyasu's grandson, Iemitsu, in memory of his illustrious grandsire. The architects adopted both the Momoyama and Edo styles, and most of the carpenters who worked on the project came from Kyoto and Nara. Although some of this shrine's buildings are relatively austere, others, such as the two-story Yōmei-mon (Gate of Sunlight), are decorated in an excessively baroque Ming-influenced style. The gateway is completely encrusted with brightly painted carvings, and many of the details have been highlighted by gilding. The columns are elaborately carved with numerous decorative motifs, such as birds, flowers, animals, and various geometric designs. The arched and gabled *kara-hafu* roof projects far out over the second-story gallery. This detail shows the left corner of this gallery; the ornamentation is aggressively Chinese in style.

382 and **384.** TOKYO CASTLE. OUTER WALLS AND ENTRANCE GATE. The gate in plate 382, the Sakuradamon, was formerly the main entrance to the shōgun's palace. This castle was rebuilt under the Tokugawa shogunate on the site of a fortress erected in 1457 by Ōta Dōkan, a samurai of the Uesugi clan. Surrounded by wide, deep, water-filled moats, the outer walls of this huge stronghold were constructed of enormous stone blocks either piled one on top of another or, as shown here,

perfectly cut and fitted together, with no cement to hold them in place. The irregular shape and arrangement of these stones keep them firmly in place during earthquakes. Wider at the base, the outer walls slope inward and are generally buttressed on the inner side by mounds of earth and stone on which the turrets and the ramps were constructed. The area within these walls was capable of sheltering 80,000 soldiers. The castle itself was destroyed by fire on many occasions, and the present reconstruction was not undertaken until after World War II. Today, entrance is gained by a double-arched European-style stone bridge which was built at the beginning of this century (plate 384). The structures flanking the new entrance are faithful copies of those of the Tokugawa period.

383. DAIMATSU CASTLE. This 1639 French engraving depicts a feudal castle somewhere near Hizen on Kyushu (modern Nagasaki and vicinity). As it is no longer standing, it is rather difficult to pinpoint its exact location today. This view provides an excellent and detailed illustration of the various elements of a seventeenth-century fortress-castle. In times of peace the citizenry lived in the city that can be seen in the background on the left. During wartime, however, they took shelter in the area between the outer walls and the castle proper. Note the steeply raked entrance ramps and the turrets *(yagura)* on the rusticated stone walls, and the wide moat which was fed with water from the river. On the hill beyond the walls rise the towers of the castle itself, in the middle of which is the keep *(tenshu)*. The *daimyō's* pleasure house was situated outside the castle's walls, on the riverbank. (See also plate 399.) De Berval Collection.

385. NISHI-IWAKUNI. KINTAI BRIDGE. This superb three-arched bridge is the only one of its type surviving from the Edo period. It was built in 1673 and was repaired or rebuilt in the same style on several occasions. Four enormous stone piers support the graceful wooden arches. At each end of the bridge is a ramp built on wooden piles sunk into the bed of the Nishiki River. The bridge is approximately 820' long, and was probably built along the lines of a Chinese prototype.

386. KYOTO. NISHI ŌTANI. This nineteenth-century woodcut shows a stone barrel bridge, built in the Chinese style, leading to a temple. No longer extant, it was probably built at the end of the Edo period.

387. THREE TYPES OF GARDEN WATERFALLS. These woodcut illustrations from an old manual on garden landscaping show how to arrange waterfalls in relationship to ponds.

388. KYOTO. MANPUKU-JI. STONE PATH. An unusual arrangement of paving stones set into the ground, this pathway is also functional, since it keeps one's feet from becoming muddy. The shallow ditches flanking the stone curbing serve to carry off excess water.

389. KYOTO. GOKŌGŪ-JINJA. GARDEN. This Shintō garden was laid out by Kobori Enshū (1579–1647), one of the masters of the tea ceremony. He also worked on the gardens of the Katsura imperial villa, and the temples of Nanzen-ji and Chion-in. This garden is a combination of the austere Zen stone and sand garden and the traditional, flat, single-plane *hira-niwi* garden.

390. KYOTO. MANPUKU-JI. HOTEI. This depicts a Japanese god of good luck, held to be the deified Chinese hermit Fu T'ai-shih, who died in 917. This statue possibly embodies an aspect of the deity as Miroku Bosatsu (Maitreya), the future Buddha. There were seven divinities of good luck (Shichi-fukujin), and the power of generosity was attributed to this one during the Edo period. A ponderous work derived from Chinese prototypes, it cannot be dated with certainty, although it was definitely created in the Edo period.

391. NARA. MURŌ-JI. PRIEST. Located in the gardens of Murō-ji, this stone image possibly portrays Kenkai (active in the late eighth century), one of the temple's founders. Kenkai was a priest of the Hossō sect at Kōfuku-ji, and the *vajra* in his right hand symbolizes the esoteric doctrines he preached. After 1701 Murō-ji was administered by the Shingon sect, and this work can probably be dated after this time.

392. NIKKŌ. TŌSHŌGŪ. PORTION OF A CARVED TRANSOM FRIEZE. The eagles decorating this transom frieze *(ramma)* were carved about 1636, and were adapted from a drawing by an artist of the Kanō school.

393. KYOTO. KŌRYŪ-JI. SENTAI JIZŌ. This gilded-wood image of Jizō Bosatsu is surrounded by innumerable Bodhisattvas (the specified number for this should be a thousand: *sentai*), symbolizing the multiplicity of his good deeds and the universality of his salvation.

394. NARA. MURŌ-JI. MARUYAMA KANCHŌ. This superbly stylized work is a self-portrait of the sculptor-priest Maruyama Kanchō. Made of clay and *papier maché*, it is life size. It dates from the end of the Edo period.

395, 396, 398. OSAKA CASTLE. PORTIONS OF A NANBAN BYŌBU. Screens depicting "the barbarians from the south" *(nanban-byōbu)* were probably made in Nagasaki at the end of the Momoyama or the beginning of the Edo period. The detail in plate 395 depicts a rich Portuguese and his companions walking down a city street. That shown in plate 396 shows an encounter between a European woman and a Japanese youth (perhaps a Christian convert), who is kissing her hand as a mark of respect. In the last detail (plate 398), two European gentlemen greet three Jesuits. There are also two groups of Japanese, one of whom (center foreground) must be a convert, since he is wearing a cross around his neck. The treatment of the scenes is fresh and artless. The style is a cross between seventeenth-century European and Japanese painting.

397. TOKYO. CRUCIFIX. Dating from the end of the Edo period, this cast-iron cross bears the Buddha as the *corpus*. It may have been either a *fumi-e* (an icon to be trampled upon as proof that one was not a Christian) or a sacred object belonging to a convert.

399. A SAMURAI COMMITTING SEPPUKU. This engraving is from a French work published in 1639, entitled *De l'Asie*, based on reports brought by Dutch and Portuguese travelers. This illustration clearly shows how Europeans of the period visualized the Japanese: nothing could be more "exotic." However, it must be realized that this artist worked from a description provided by the author, who, in turn, had received his information from travelers. (See also plate 383.)

400. SILVER MONEY. This rectangular coin bears the inscription: *Ichi-bu-gin*. Its purchasing power is equal to about 0.388 grams of fine gold. It represents a type of money minted during the eighteenth and the beginning of the nineteenth century. Height ⅝″.

401. OSAKA CASTLE. PORTION OF A SCREEN. This folding screen is called the *Shuin Bōeki-sen*, and the detail here shows a rich merchant on board one of the ships that received permission (with the "red seal" granted by the shōgun) to trade with foreigners at the beginning of the Edo period. Seated on a chair beneath a canopy of woven bamboo, the merchant fans himself while his son (or a page) rests his arm on the ship's rail and looks out to sea. End of the seventeenth century.

402. KYOTO. DAIGO-JI. BUGAKU DANCERS. This is a detail from a two-panel screen by Nonomura Sōtatsu. Painted in brilliant colors on a gold-leaf background, it shows costumed and masked dancers performing a classical *bugaku* dance in a temple courtyard. Sōtatsu began his career as master of a commercial fan-painting shop, but went on to become one of the most important artists of the early seventeenth century, receiving the rank of *Hokyō* for his work for the Tokugawa shōguns. He injected new life into the old *yamato-e* style. Measurement of each panel 5 × 5′.

403. SCENE FROM A NŌ PLAY. This colored woodblock by Hishikawa Moronobu (1618–1694) depicts a scene from the *nō* play, *Sumidagawa (The Sumida River)*. In the background are the musicians; on the forestage a bamboo framework represents a boat. The audience includes a samurai, a woman, and others, and the performance seems to be taking place in the open. *Nō* plays in this period were part of the popular theater and quite different from the forms specified by Zeami. Dated 1680. Height 24″. Hauchecorne Collection.

404. DANCERS. This seventeenth-century work is a typical example of genre painting of the time. It depicts the common people, men and women, dancing. Their movements are lively within the rather formal composition. Height 40″. Hauchecorne Collection.

405. KYOTO. INSCRIPTION OF TOSA MITSUOKI. A famous painter of the Tosa school, Tosa Mitsuoki lived in Sakai and also in Kyoto, where he was the director of the imperial *Edokoro*. When he became a priest, he took the name of Jōshō. The inscription reads: "*Sakon-e-no-Shōgen* [a title of fifth rank at the court] Tosa Mitsuoki painted this picture." Kyoto National Museum.

406. NARA. BOX. The interior of this gilded wooden box was decorated with a fan face painted by Ogata Kōrin (1658–1716). The painting depicts Mount Fuji and was executed on paper glued to the bottom of the box. 10 × 14″. Museum Yamato Bunkakan, Nara.

407. HIKONE BYŌBU. This is a portion of a six-panel screen painted in brilliant colors on paper on a background of gold leaf. It belonged to the Ii clan of Hikone and was perhaps executed between 1624 and 1643 by an artist of the Kanō school. Without doubt it is contemporaneous to the *Women of the Yuna Bathhouse* in the Atami Museum. This type of art foreshadowed the *ukiyo-e* school. Here we see a woman playing a *samisen*, while two women and a man are playing *sugoroku* (a type of backgammon). In the background there is a screen painted with a landscape in the *sumi-e* style. Entire work 102⅜ × 37″.

408. KYOTO. DAITOKU-JI. SANGEN-IN. TIGER. This is a portion of a *fusuma* painted by Hara Zaichū (1750–1837) after the style of the Chinese artist Mu Ch'i.

409. KYOTO. HERON. This comes from a screen painted with birds and flowers *(kachō-zu)*. The artist was Unkoku Tōeki (1591–1644), whose style here follows the traditions of the Kanō school. Unkoku, however, also created his own school of painting, and he specialized in subjects derived from nature: animals, trees, and flowers. Kyoto National Museum.

410. PEACOCK SCREEN. Painted on gold-leafed paper, this screen is by Ogata Kōrin (1658–1716), an artist who founded the school bearing his name. He painted in a decorative style that contrasted with the works of the Kanō school. Later, however, he turned to subjects like these peacocks, in a style which follows that of Sōtatsu and Kōetsu. Height of entire work 58″. Hinohara Mariko Collection.

411. KYOTO. PORTION OF A PAINTING DEPICTING KANZAN AND JITTOKU. As a disciple of Maruyama Ōkyo, Nagasawa Rosetsu (1755–1799), a noble of Yamashiro, painted numerous subjects in the *sumi-e* style. His technique is free, his style extraordinarily lively. The head here is a detail from a large painting depicting Han-Shan and Shin-te (Kanzan and Jittoku), two Chinese sages of the T'ang dynasty. It was said that they were reincarnations of Monju Bosatsu (Manjusri) and Fugen Bosatsu (Samantabhadra), two of the great Bodhisattvas. Kyoto National Museum.

412. NARA. BEAUTIFUL WOMAN. Executed at the beginning of the development of *ukiyo-e* style by Miyagawa Chōshun (1682–1752), this work reveals the influence of the Tosa school. Most of the artist's works depicted women. This painting of a beautifully robed woman also contains a poetical text by the Zen priest Takuan (not shown in this detail) whose calligraphy was executed by Kawakami Fuhaku. The painting typifies the style of the followers of Kaigetsudō Andō, an artist who flourished at the beginning of the eighteenth century in Edo. Entire work 53 × 35⅜". Museum Yamato Bunkakan, Nara.

413–16. SHOKUNIN-ZUKUSHI-ZU. Dating from the Edo period, these four scenes are selected from a series dealing with various craftsmen *(shokunin)* at work in their establishments. The scenes chosen here depict a blacksmith (plate 413), a parasol maker (plate 414), a weaver (plate 415), and a fletcher (plate 416). The gestures have been carefully observed, and great attention has been given to innumerable details. The series was painted by Kanō Yoshinobu at the beginning of the eighteenth century. Each scene is 23 × 16½".

417. DAISHŌMAI-ZU. Painted on wood, this shows a scene from a dance drama. The work of Torii Kiyomitsu II, it was executed during his youth, when he painted under the name of Kiyomine. This artist, a disciple of his father, Kiyomitsu I, was a third-generation artist of the Torii family. He was a follower of the "classical" *ukiyo-e* style. Height of panel 76¾". Hauchecorne Collection.

418. YOSHITSUNE. This woodblock printed in the *ukiyo-e* style was executed by Kuniyoshi (1797–1861), a pupil of Toyokuni. It illustrates an episode from the tale of Ushiwaka-maru (Yoshitsune), the youngest brother of Shōgun Yoritomo, showing him in the forest near the temple of Kuramadera practicing swordsmanship under the supervision of the *tengu* (fabulous beasts: those depicted here are the winged variety, the *karasu tengu*). Kuniyoshi developed an individual style of *ukiyo-e* and was also a talented tattooist. Hauchecorne Collection.

419. RŌNIN. This is a portion of a three-part color woodblock print by Andō Hiroshige illustrating the popular tale *The Forty-seven Rōnin*, an actual incident that took place in 1702 during the reign of Shōgun Tsunayoshi. Hauchecorne Collection.

420. KABUKI ACTOR. A color woodblock print by Toyokuni Kunisada III. Hauchecorne Collection.

421. THE VILLAGE INN IN MARIKO. A color woodblock print by Andō Hiroshige, this characteristic landscape study is one of the famous *Fifty-three Stages of the Tōkaidō* series. This scene shows a small inn in the village with two travelers drinking the yam soup for which Mariko is famous. 8¼ × 13". Hauchecorne Collection.

422. TOKYO. KABUKI ACTOR. A color woodblock print by Tōshūsai Sharaku (active 1794–1795). Dated 1794, this print portrays the actor Ichikawa Ebizō (also known as Danjūrō) in the role of Takemura Sadanoshin. The artist himself was probably also an actor, but little is known of his life, and all his works were executed within a period of only ten months. His work is marked by a very personal style that seems to have developed from that of the *ukiyo-e hanga* artists of Osaka. Ōban shape, printed on paper with a mica ground. 17¾ × 9⅞". Tokyo National Museum.

423. TOKYO. THE GREAT WAVE. This famous color woodblock print was executed between 1827 and 1830 by Katsushika Hokusai. It was part of the series entitled *Thirty-six Views of Mount Fuji*. The fact that *The Great Wave* was reproduced on the cover of the first edition of the score of Debussy's *La Mer* is but one example out of many that attests to the Impressionists' fascination with the art of the Japanese print. 8¼ × 13". Tokyo National Museum.

424–26. A PADDLE-WHEEL STEAMSHIP. This color woodblock print in three parts by Ōkō (Yōsai) Kuniteru shows one of the first Japanese steamships, which were constructed about 1870, at the beginning of the Meiji era. Employing completely anachronistic elements and style, the artist depicted in this triptych the conquest of the Takadate Castle, an incident that took place during Yoritomo's war against his brother, Yoshitsune, in 1185. However, the artist provided a beautiful panoramic view of the Bay of Matsushima, a renowned Japanese scenic spot. Hauchecorne Collection.

427. EUROPEAN EQUESTRIENNE. This color woodblock print by Utagawa Iadahide (1820–1883) shows a French merchant of Yokohama speaking with a Frenchwoman on horseback. c. 1875. Hauchecorne Collection.

428. THE INCONVENIENCES OF TOKYO. This color woodblock print by Ukita Ikkei (1795–1859), depicting an accident that took place on Tokyo's Kyōbashi Bridge in 1858, shows the decadent style of *ukiyo-e hanga* that approaches caricature. Hauchecorne Collection.

429. KAIKA INJUN. A caricature type of woodblock print depicting the struggle of traditional native objects with Western novelties: the parasol versus the umbrella, the kimono versus European clothing, a Japanese dog versus a lapdog, the *eboshi* versus the hat. It illustrates the reaction of traditional Japan to the importation of Western customs. This delightful work was executed by Ukita Ikkei. Hauchecorne Collection.

430. YOUNG WOMAN IN THE SNOW. This color woodblock print is by Kitagawa Fujimaro, a disciple of Kitagawa Utamaro. Executed during the first years of the nineteenth century, it embodies the characteristic style of Utamaro and his followers. Full of grace and lightness, this work contrasts sharply with the general decadence of *ukiyo-e* art. Height 37⅜". Hauchecorne Collection.

CULTURAL CHART

1615–23 A Construction of the Hiunkaku of the monastery of Nishi Hongan-ji in Kyoto.

1620–24 A Construction of the teahouse and garden of Katsura Palace in Kyoto.

1621 P Kanō Tan-yū appointed head of official shogunate painters, granted a house near the Kajibashi Gate of the shogunate Edo Castle, and founded the Kajibashi branch of the Kanō school.

P Sōtatsu given his first important shogunate commission, the wall paintings of the Yōgen-in, Kyoto.

1624–43 A Construction of the Ōhiroma in the Shoin of Nishi Hongan-ji in Kyoto.

1633 A Restoration of the Hondō of Kiyomizu-dera temple in Kyoto.

1634 P The *Kin Ki Sho Ga* wall paintings in the Jōrakuden of Nagoya Castle by Kanō Tan-yū.

1634–36 A Construction of the Tōshōgū in Nikko.

1639 C Suspension of relations with foreigners.

1649 Po Appearance of the *Kyohakushū*: anthology of poetry.

1654 P Death of Kanō Naganobu (Kyūhaku) (b. 1577).

1655–59 A Construction of the imperial retreat called the Shūgakuin, Kyoto.

1674 P Death of Kanō Tan-yū (b. 1602).

c. 1675 L Appearance of the "Red Books," books with red covers containing fairy tales like *Momotarō* and the *ukiyo-zōshi*, "Notebooks of the Floating World," describing everyday life.

1684 Th First plays of Chikamatsu Monzaemon.

1686 L *Kōshoku Gonin Onna*: "Five Women Who Loved Love" by Ihara Saikaku.

1689 Po Matsuo Bashō's trip to northern Japan published with his *haiku* poems in *Oku No Hoso Michi*, "The Narrow Road of Oku."

1693 L Death of the novelist Saikaku (b. 1642).

1694 Po Death of the poet Bashō (b. 1644).

1703 C Vengeance of the forty-seven *rōnin*.

1716 Po The *Hitorigoto*: anthology of *haiku* by Kamijima Onitsura.

1716 P Death of Ogata Kōrin (b. 1658).

1724 Th Death of Chikamatsu Monzaemon (b. 1653).

c. 1738 L Appearance of the "Black and Blue Books" for children, and the *kokkeibon*: picaresque novels.

c. 1744 L Appearance of *yomihon*: edifying novels and tales of fantasy.

c. 1764 L The *sharebon* became fashionable: elegant and licentious books written in a conversational style.

1766–1838 Po Publication of the *Haifū Yanagidaru*: an early collection of satirical *haiku*, also called *senryū*.

1770 P Death of Suzuki Harunobu (b. 1725).

1771 P The *Jūben Jūgi*: *The Ten Conveniences and Ten Pleasures*, the conveniences illustrated by Ikeno Taiga, and the pleasures by Yosa Buson.

c. 1775 L Appearance of the *kibyōshi*: illustrated satirical books in yellow covers. Banned by the authorities.

1776 P Death of Ikeno Taiga (b. 1723).

c. 1781 Po *Kyōka*, a type of frivolous poetry, appeared.

1783 Po Death of Yosa Buson (b. 1716).

1791 P Kitagawa Utamaro introduced his rejuvenated style of *ukiyo-e* woodblock prints.

1794–95 P Tōshūsai Sharaku, an artist of the *ukiyo-e* school, produced his woodblock prints.

1795 P Death of Maruyama Ōkyo (b. 1733).

c. 1799 L Publication of the *Kanden Kōhitsu*, a literary essay by Ban Kōkei.

1805 L Appearance of the *gōkan*, collections of books.

1806 P Death of Utamaro (b. 1753).

c. 1818 L The *Ninjōbon*: essays dealing with sentiments and social proprieties.

1820 P Death of the Nanga painter Uragami Gyokudō (b. 1795).

c. 1830 P Execution of the series of color woodblock prints entitled *Thirty-six Views of Mount Fuji* by Katsushika Hokusai.

1832 P Execution of the series of color woodblock prints entitled *Fifty-three Stages of the Tōkaidō* by Andō Hiroshige.

1837 P Creation of the *Chūgyojō* by Watanabe Kazan, a painter of Kyoto.

1849 P Death of Hokusai (b. 1760).

1854 H Treaty of Kanagawa negotiated between the Japanese government and Commodore Matthew Perry.

1858 P Death of Hiroshige (b. 1797).

1861 P Death of Utagawa Kuniyoshi (b. 1797).

1868 H Accession of the Emperor Mutsuhito and the advent of the Meiji era.

368

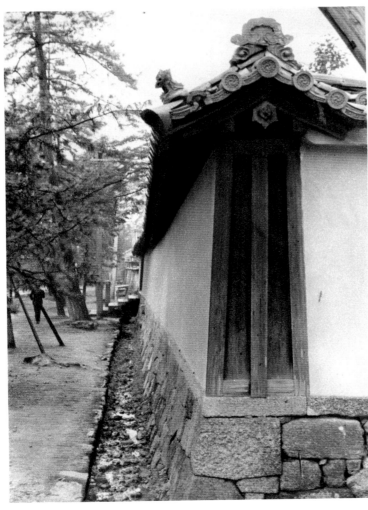

369

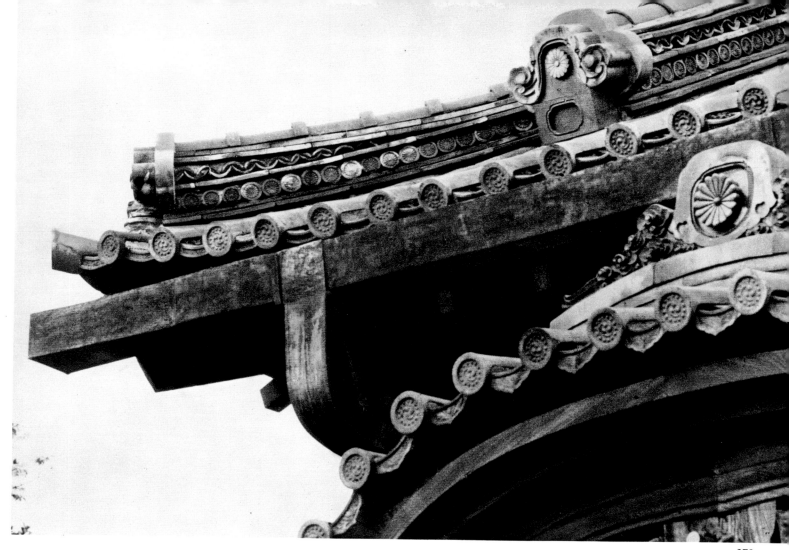

370

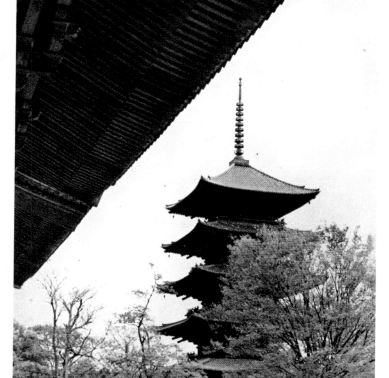

371

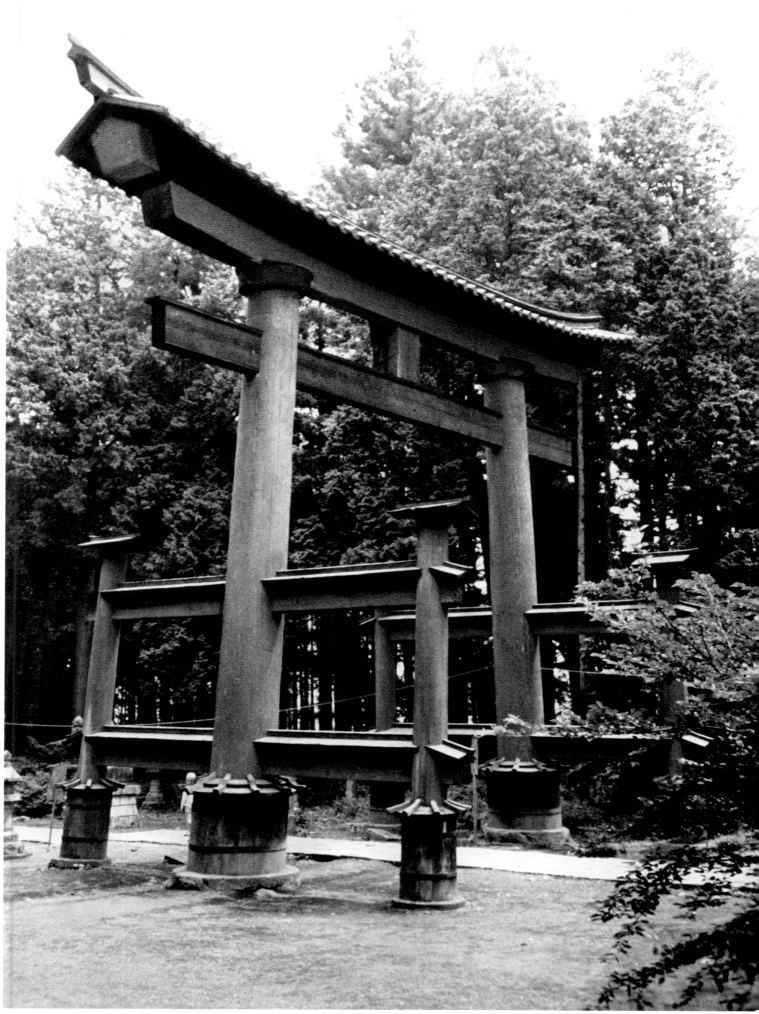

373

374

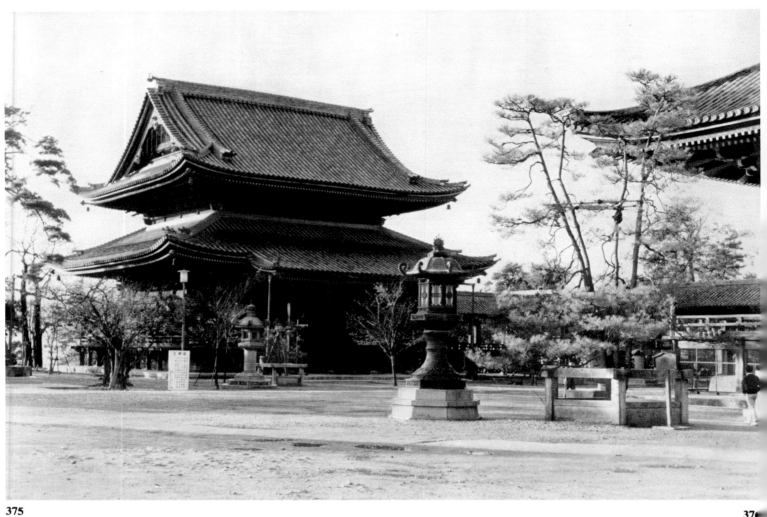

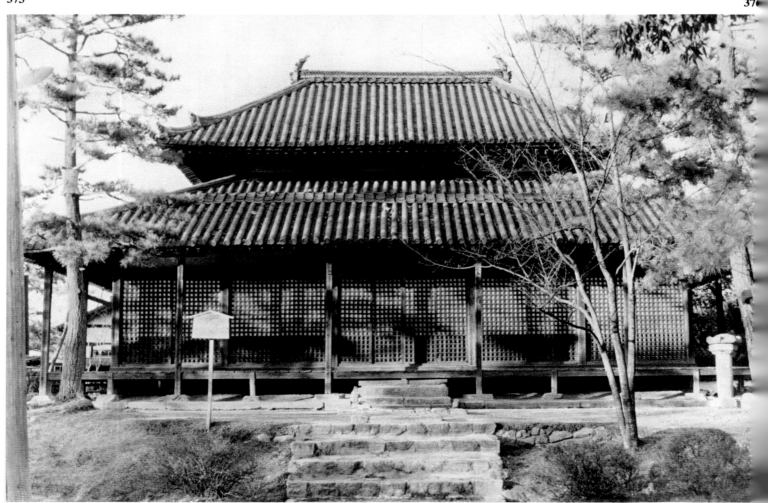

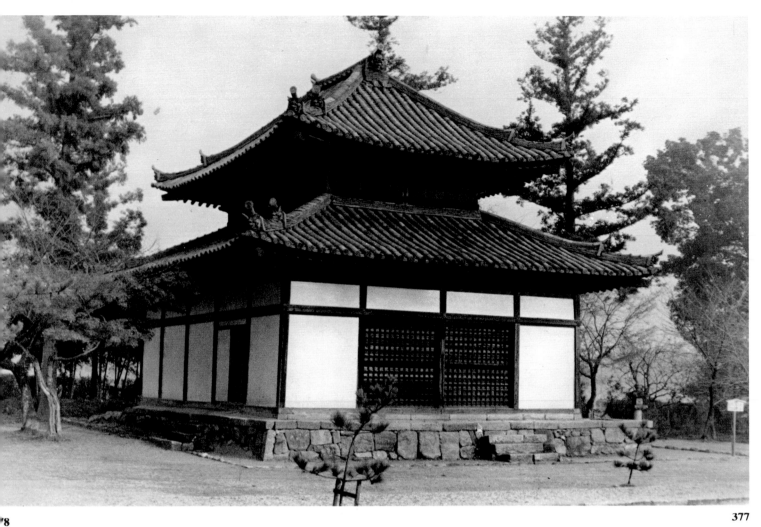

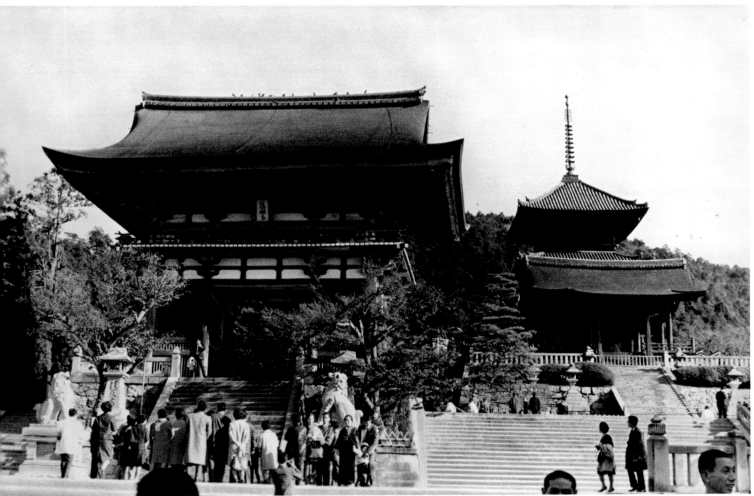

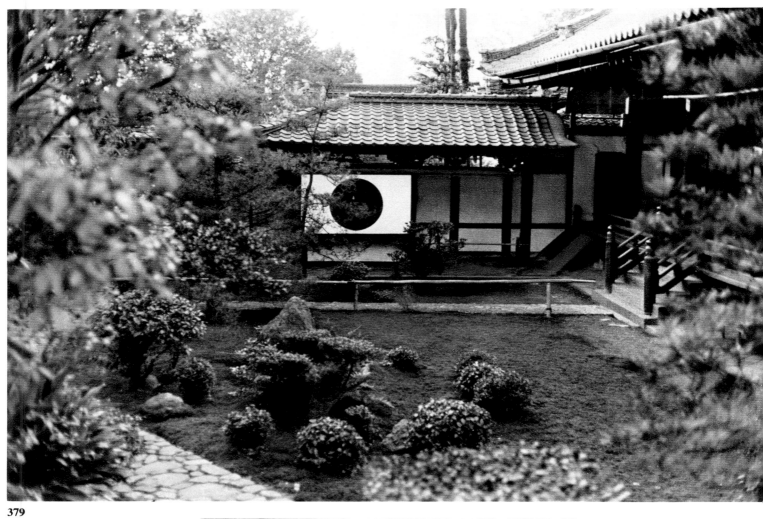

379

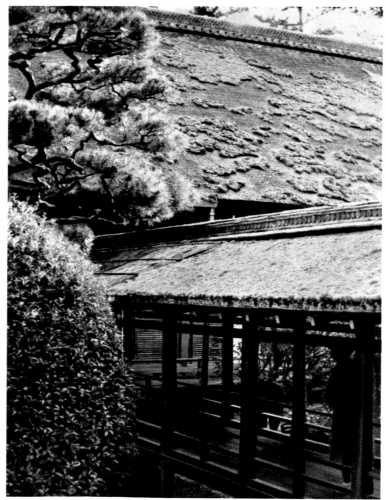

380

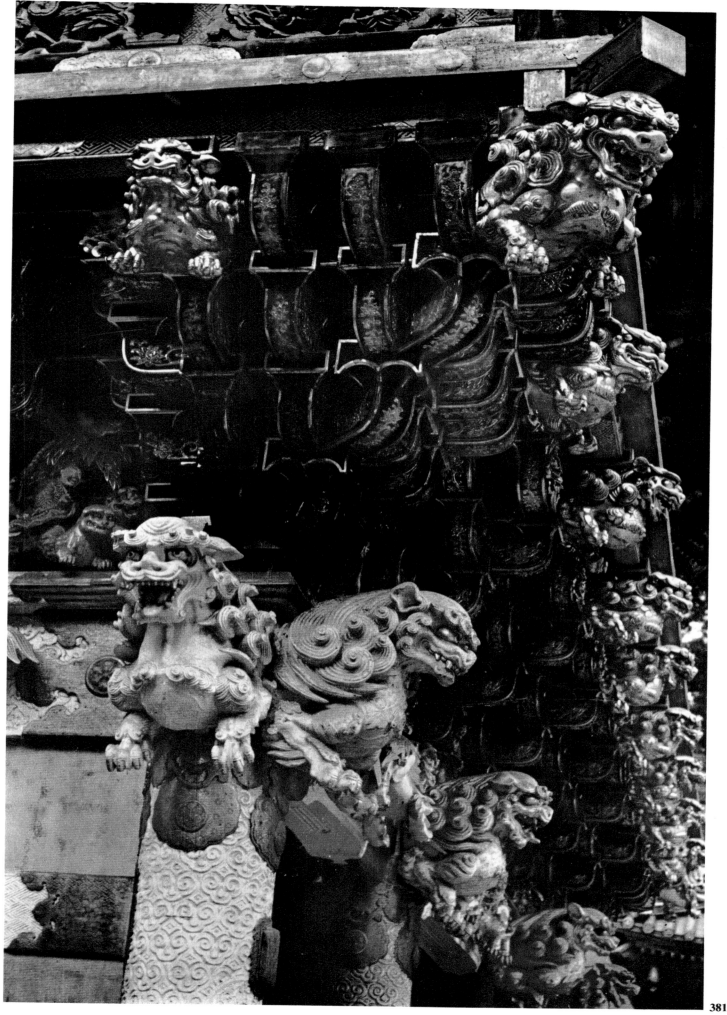

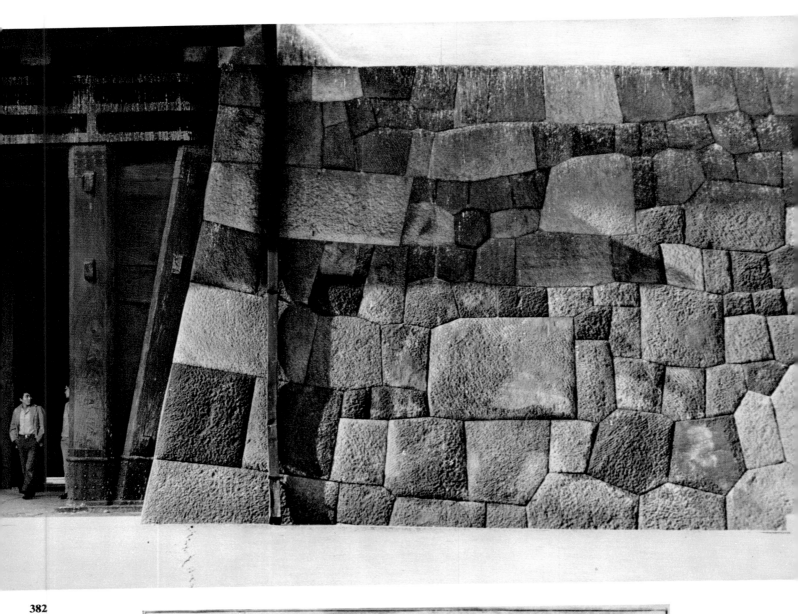

382

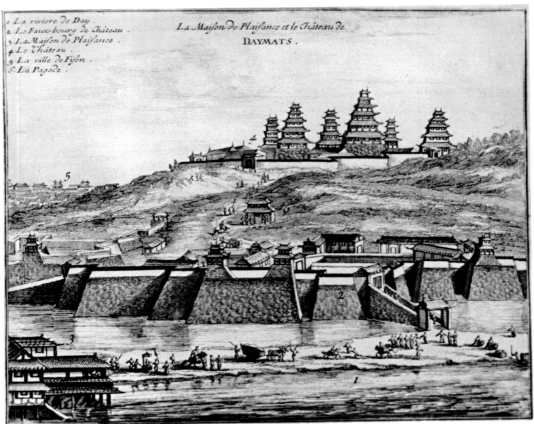

1 La riviere de Day
2 Le Faux-bourg de Château.
3 La Maison de Plaisance.
4 Le Château.
5 La ville de Fisen.
6 La Pagode.

La Maison de Plaisance et le Château de
DAYMATS.

383

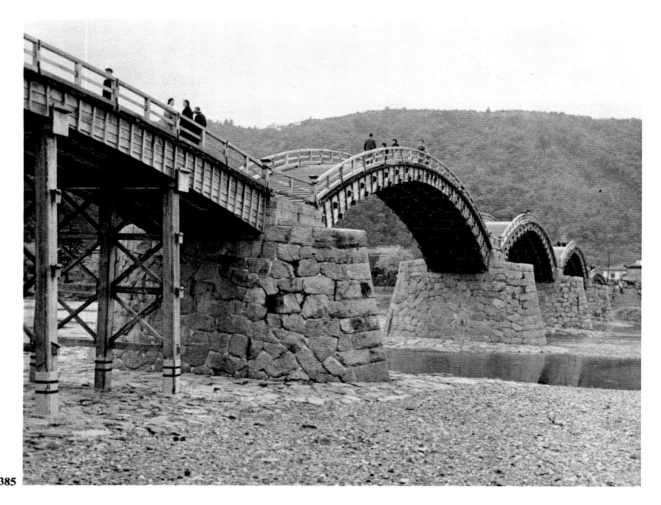

385

西大谷

386

正面瀧
の図

吐水

左瀧の図

左瀧の図

吐水

右瀧の図

吐水

387

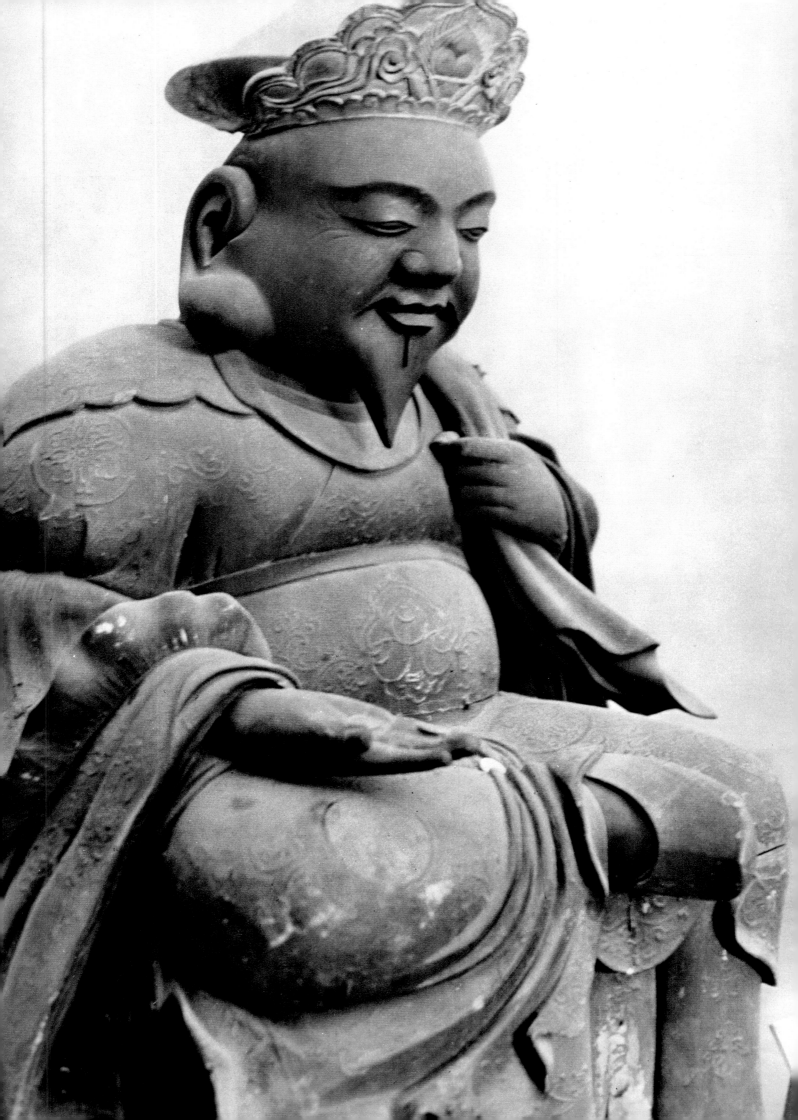

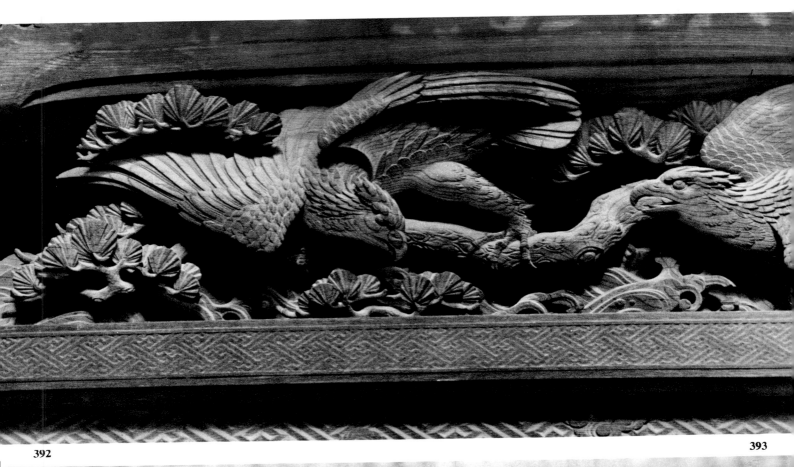

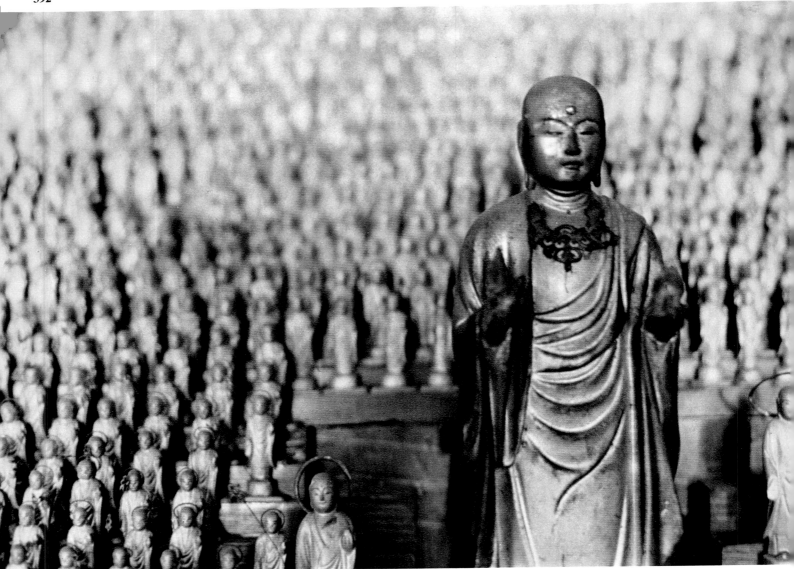

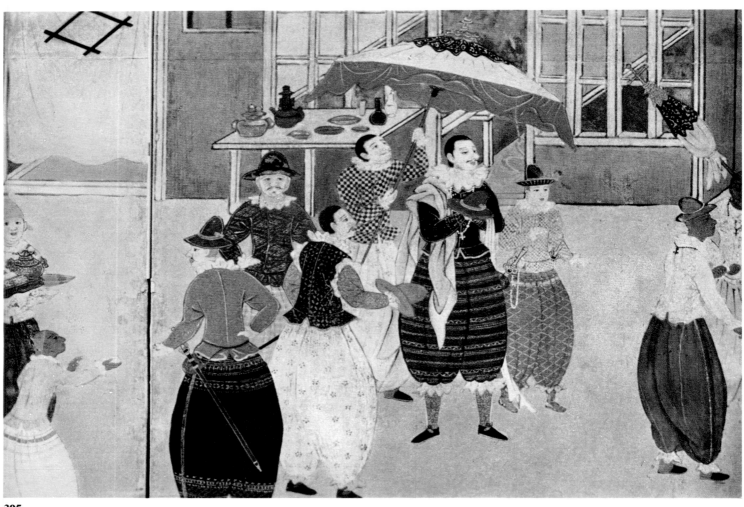

395

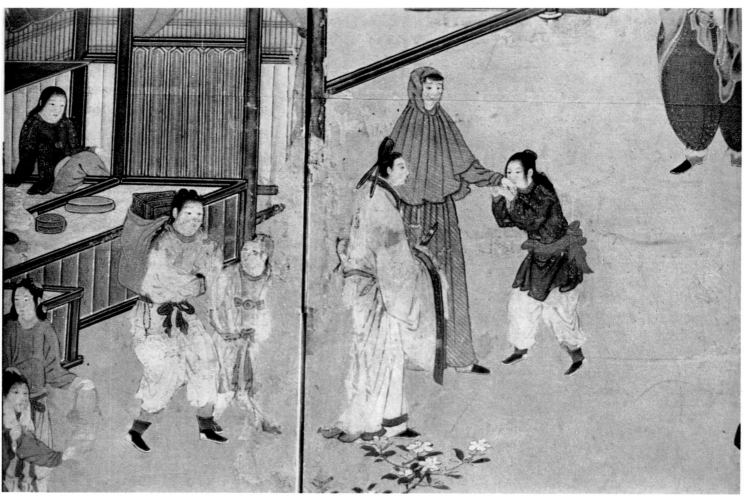

396

397

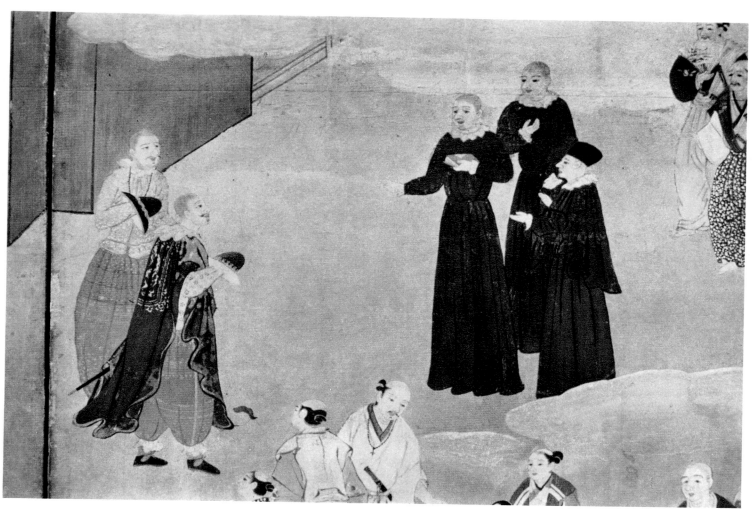

398

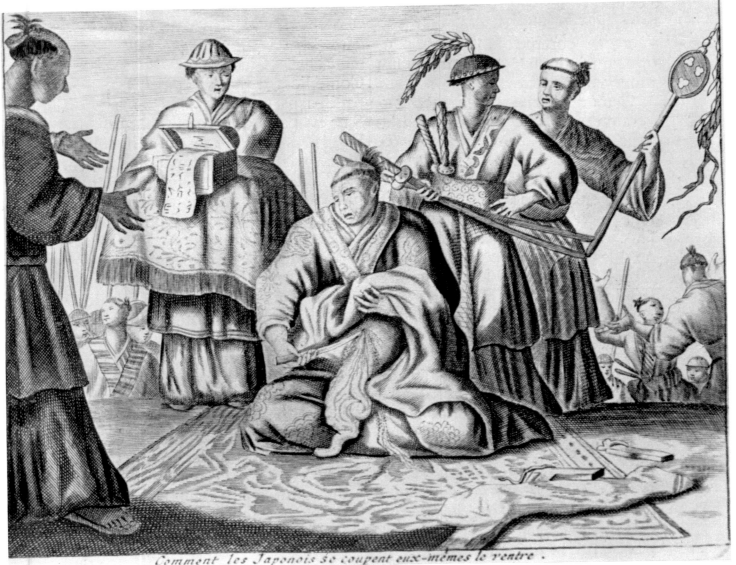

Comment les Japonois se coupent eux-mêmes le ventre.

399

400

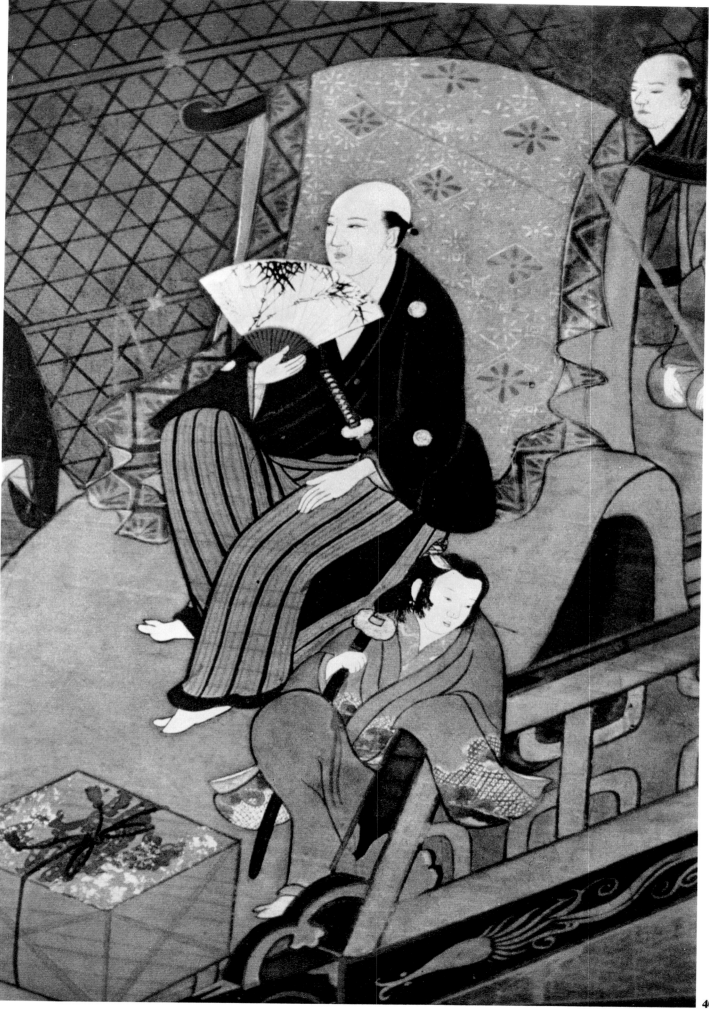

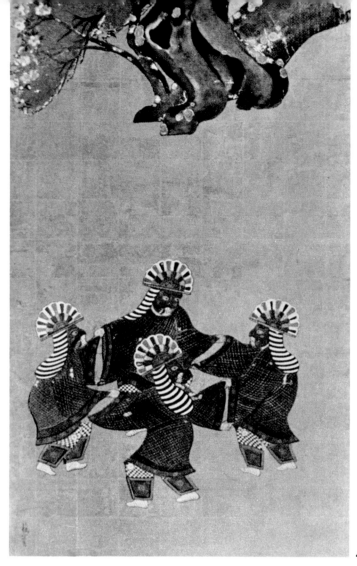

402

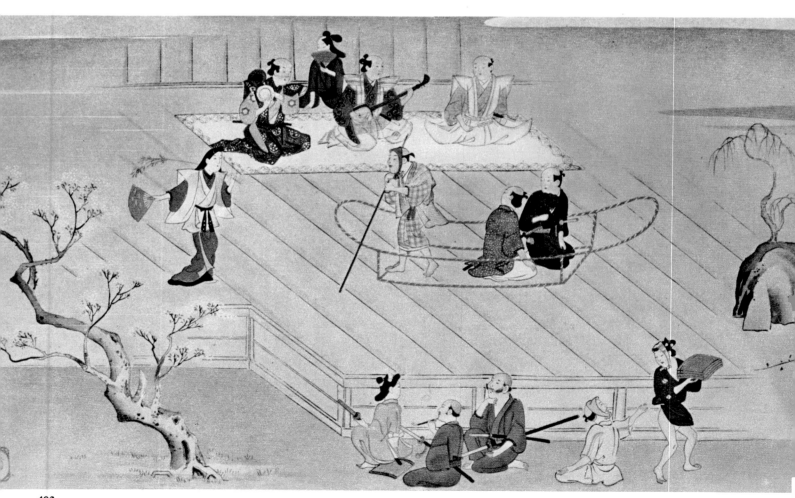

403

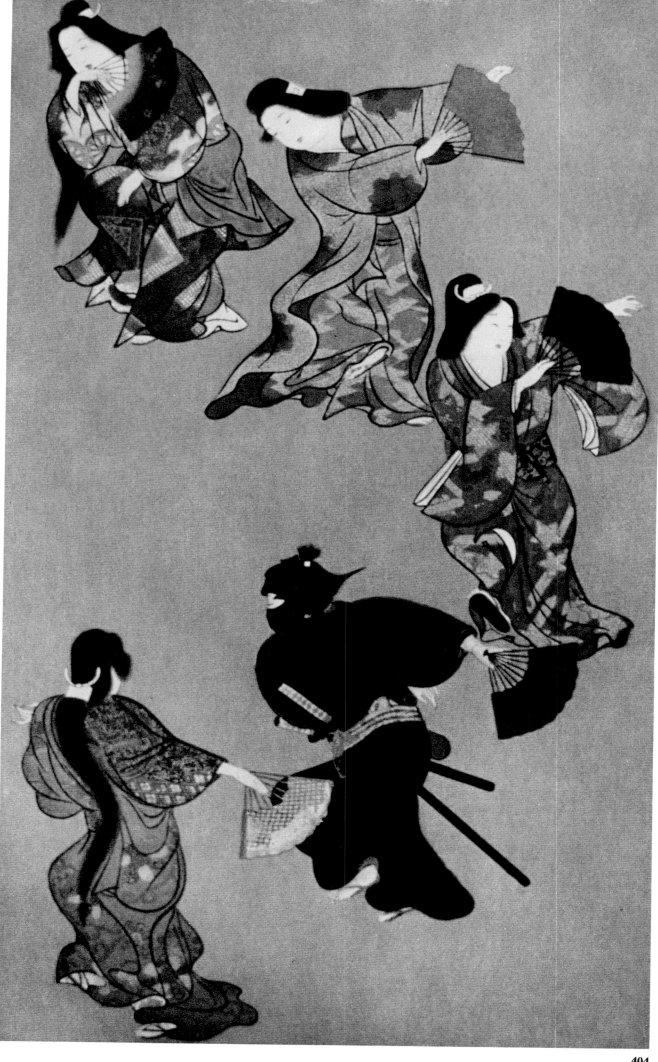

405

406

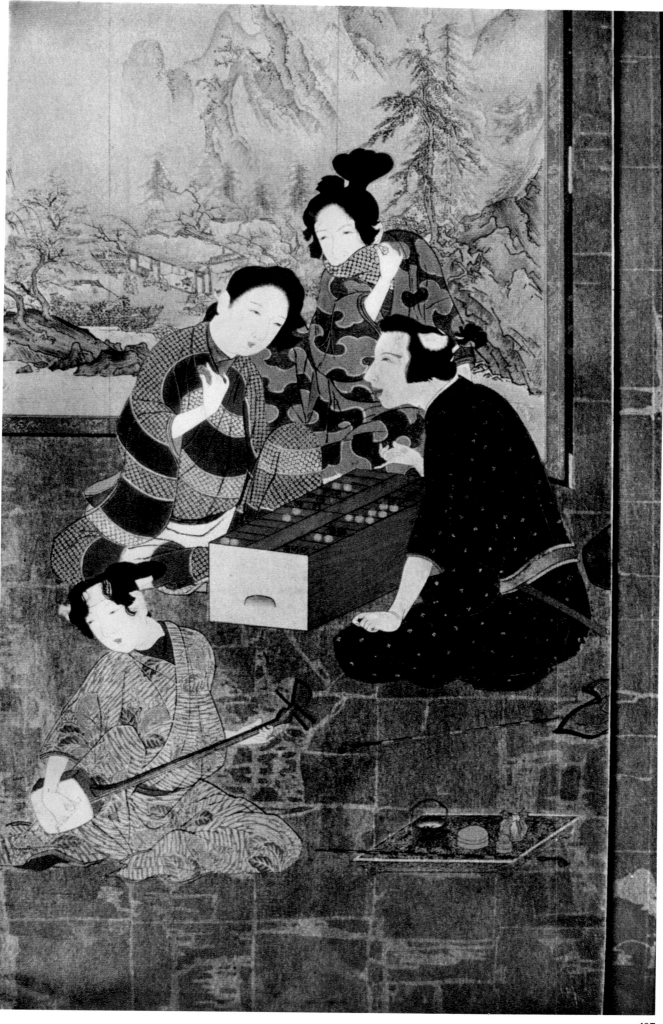

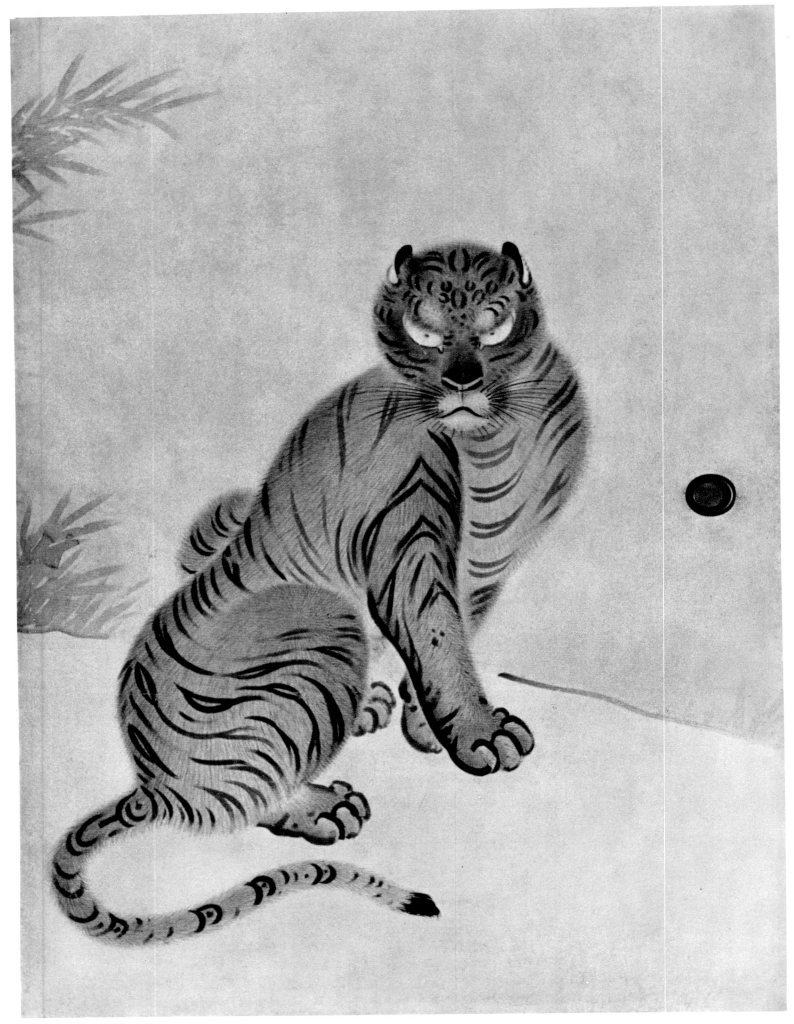

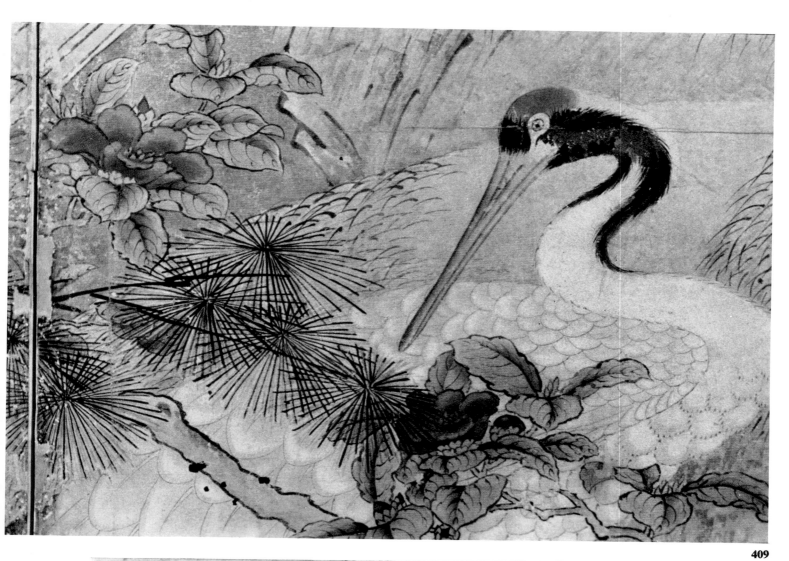

409

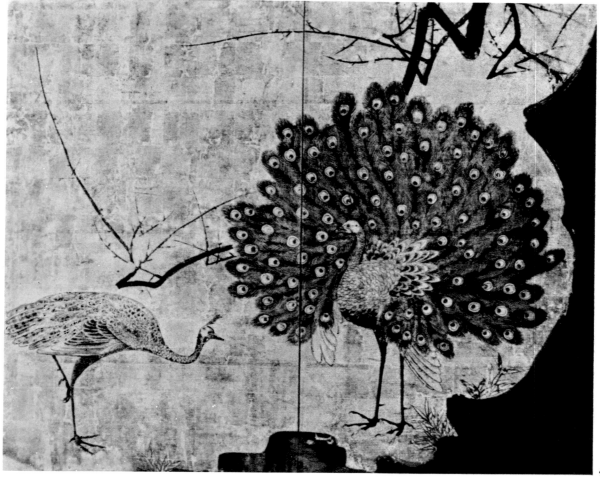

410

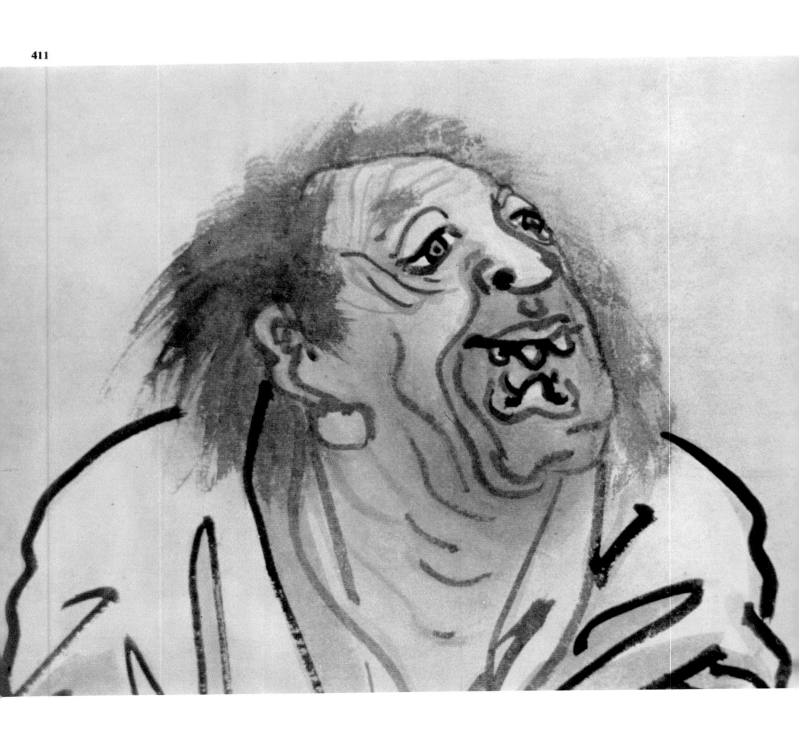

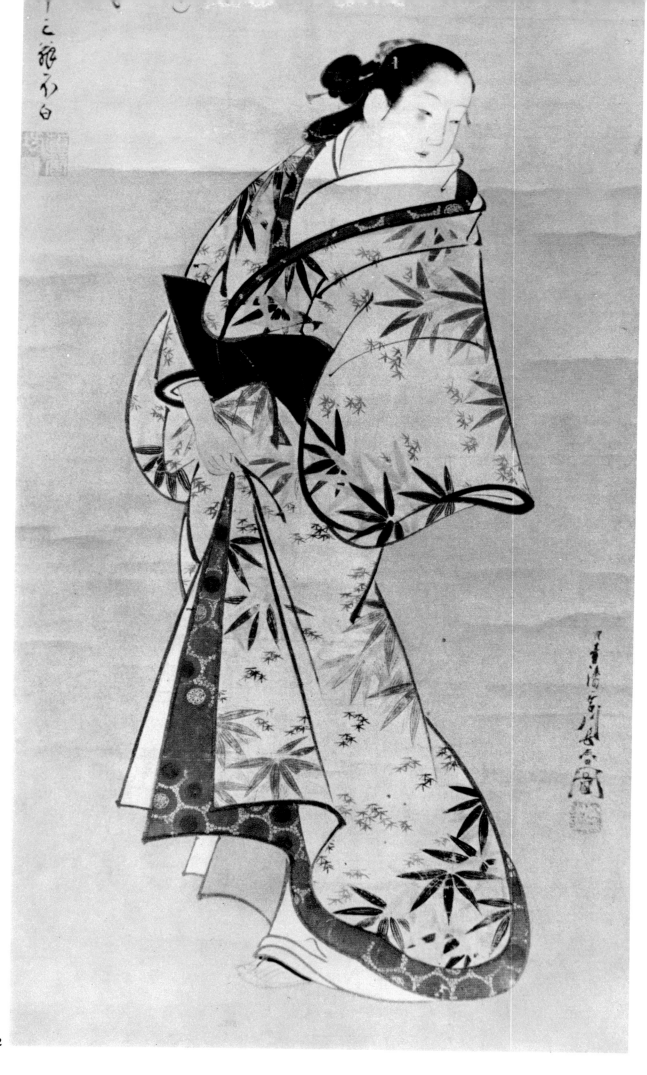

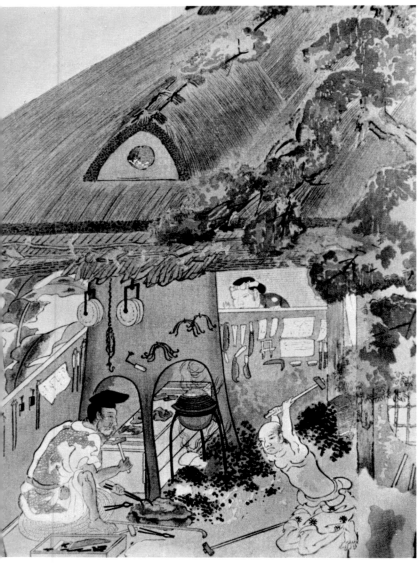

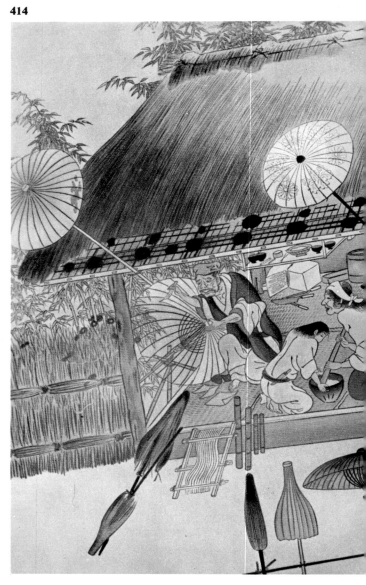

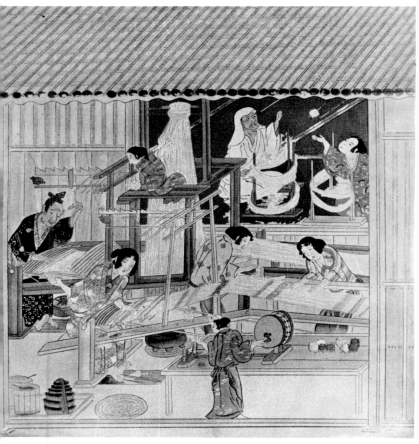

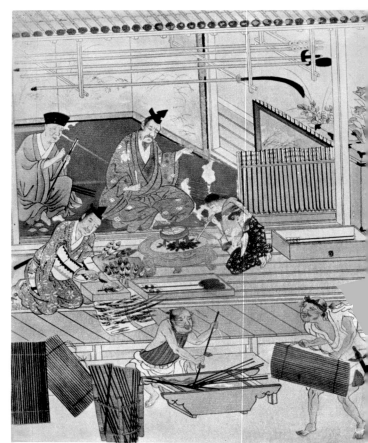

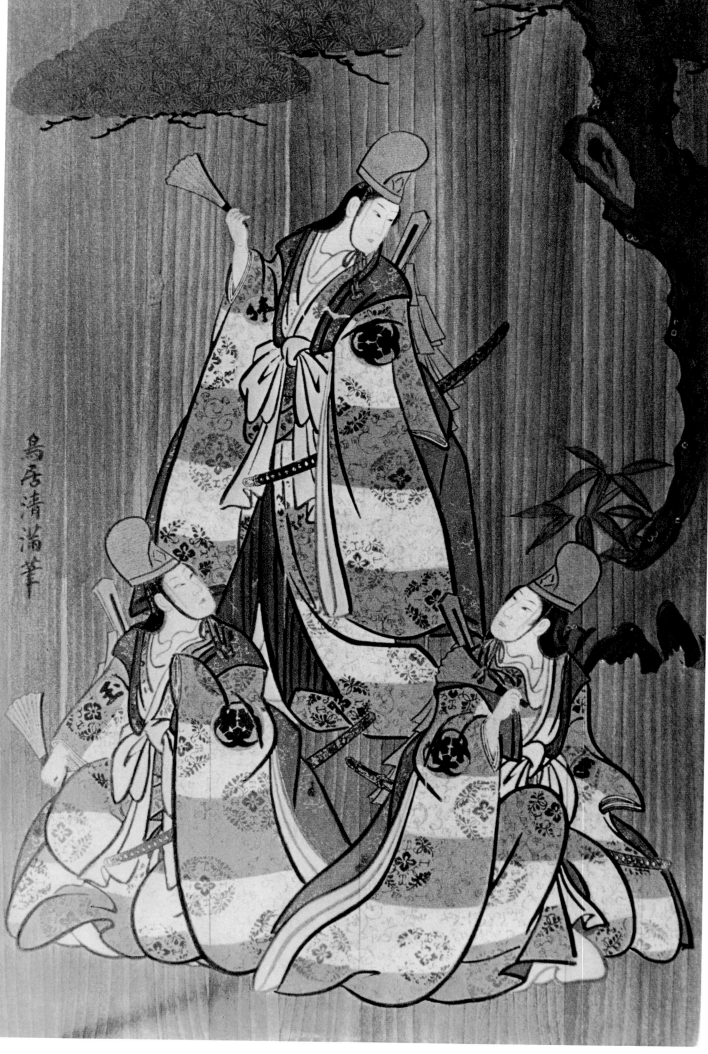

鳥居清満筆

417

420

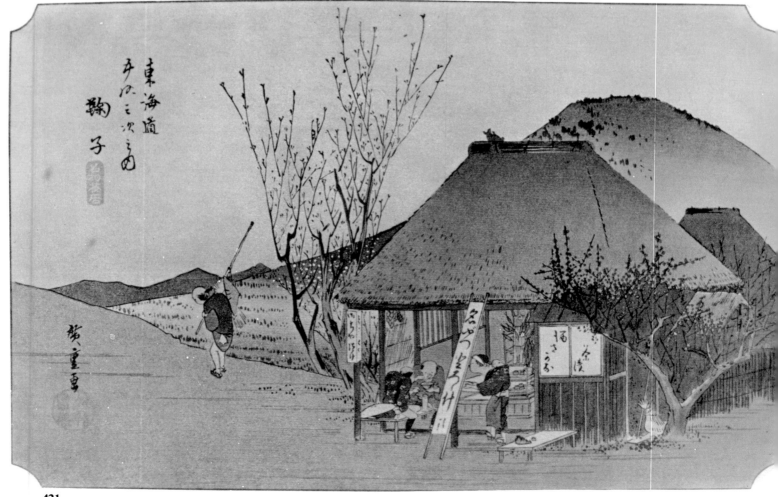

421

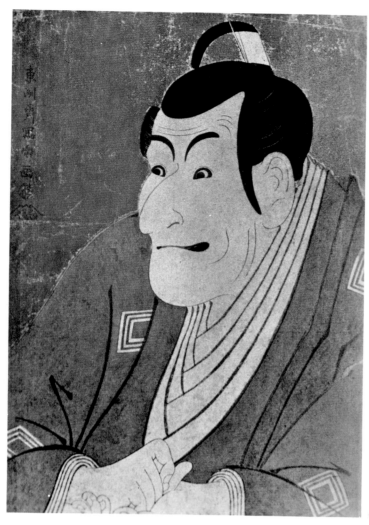

422

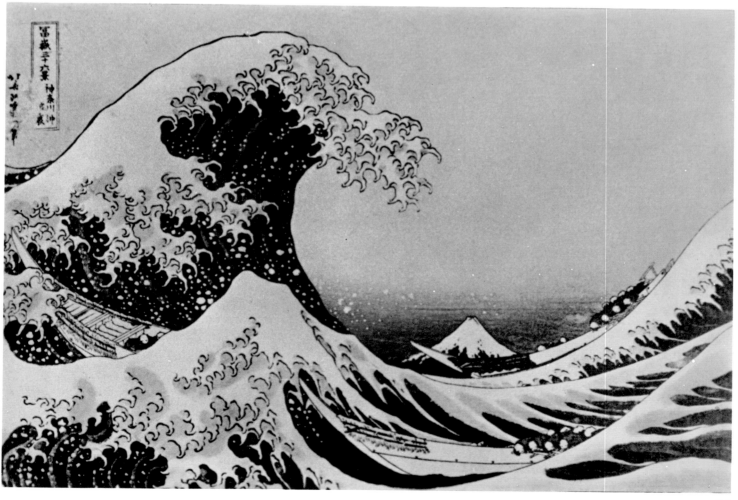

423

424 425 426

427 428 429

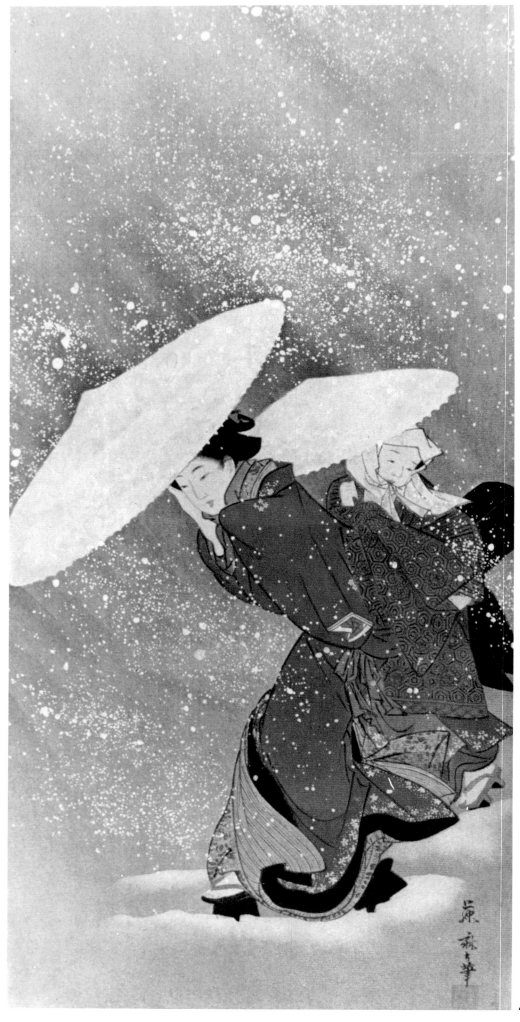

APPENDICES

The Ancient Japanese Calendar

At the time of the Meiji restoration in 1868 the Japanese had three different methods for reckoning years.

1. Year by year, beginning with the traditional date of the foundation of the Japanese empire by the mythical Emperor Jimmu in 660 B.C. The year A.D. 645, in which the era system *(nengō)* was adopted, corresponds to the year 1305 in the traditional chronology. There is, therefore, a time lag of approximately 660 years between the traditional Japanese dates and those of the Gregorian calendar.

Gregorian Calendar		*Traditional Japanese Date*
A.D. 645	corresponds to	1305
A.D. 1000	corresponds to	1660
A.D. 1192	corresponds to	1852
A.D. 1603	corresponds to	2263
A.D. 1868	corresponds to	2528
A.D. 1940	corresponds to	2600
A.D. 1968	corresponds to	2628

2. Beginning in 1305 (Japanese date), or A.D. 645, the Emperor Kōtoku adopted a Chinese system in which eras were given names that varied according to the whims of the sovereigns: eras were abruptly terminated if they were felt to be unpropitious or bearers of bad luck; others were inaugurated to mark the beginning of a new reign or an important event. The first era—the Taika—began in A.D. 645 and ended in A.D. 649. There were years, however, in which there were several changes of eras. In order to regulate this chaotic system, Emperor Meiji established the rule of a single era for each sovereign that would begin on January 1 of the year following his accession to the throne. With this new system the Meiji era lasted from 1868 to 1912, the Taishō era from 1913 to 1926, and the current era—the Shōwa—from 1927 to the present.

3. Another chronological method of reckoning the years, also of Chinese origin and widely utilized in Japan, consisted of sixty-year cycles subdivided into twelve "branches" *(shi)* symbolized by animals, and into five major (positive) and five minor (negative) "trunks" *(kan)*. With this system a date would be expressed as follows: 8th day of the 3rd month of the *Tsuchinoe-Tora* (Tiger-Positive Earth) year. The year 1966, for example, is the *Hinoe-Uma* (Horse-Positive Fire) year. The inconvenience of this system lies in the fact that there is no indication of *which* sixty-year cycle a particular date comes from, since a *Hinoe-Uma* year will occur every sixty years, but no clue is provided as to the specific cycle to which it appertains. The following table, however, offers a simple system of determining a date once the last year of each cycle is known:

TABLE I: THE LAST YEAR OF EACH CYCLE

604 (first year of the adoption of this system)

663	903	1143	1383	1623	1863
723	963	1203	1443	1683	1923
783	1023	1263	1503	1743	1983
843	1083	1323	1563	1803	2043

FIRST PROBLEM: To what cyclical year does the Gregorian 1927 correspond?

We look in Table I for the last year that is immediately lower than the Gregorian number: this is 1923. We then subtract 1923 from 1927 and the answer is 4. We then look up the number 4 in Table II: it will be found at the intersection of the lines of the Hare and Negative Fire, so it becomes the Hare-Negative Fire year *(Hinoto-U)*.

SECOND PROBLEM: To what Gregorian year does *Mizunoe-Inu* correspond? In Table II we shall find that at the intersection of the lines *Inu* (Dog) and *Mizunoe* (Positive Water) there is the figure 59. The *Mizunoe-Inu* year corresponds, therefore, to all the fifty-ninth years of all the cycles: in other words, to 662, 722, 782, 842, 1022, 1922, and so on at regular intervals of sixty years.

NOTE: 1. The last year of each cycle is always *Mizunoto-I* (Boar-Negative Water). 2. The first year of each sixty-year cycle is always *Kinoe-Ne* (Rat-Positive Wood).

THE HOURS

In ancient Japan each hour was given the approximate equivalent of 2 of our hours. The complete day, therefore, consisted of six night hours and six daylight hours. A Japanese "hour" was called a *koku*.

The night was subdivided as follows:
Midnight: hour of the Rat; 9 strokes of the bell.
 2 A.M.: hour of the Ox; 8 strokes of the bell.
 4 A.M.: hour of the Tiger; 7 strokes of the bell.
 6 A.M.: hour of the Hare; 6 strokes of the bell.
 8 A.M.: hour of the Dragon; 5 strokes of the bell.
 10 A.M.: hour of the Serpent; 4 strokes of the bell.

The day was subdivided as follows:
 Noon: hour of the Horse; 9 strokes of the bell.
 2 P.M.: hour of the Ram; 8 strokes of the bell.
 4 P.M.: hour of the Monkey; 7 strokes of the bell.
 6 P.M.: hour of the Cock; 6 strokes of the bell.
 8 P.M.: hour of the Dog; 5 strokes of the bell.
 10 P.M.: hour of the Boar; 4 strokes of the bell.

The names of the hours correspond to the number of blows that the monks struck on the bell to announce them. These "hours" or *koku* varied in duration, however, during both the day and the night and also according to the season. Thus at the winter solstice the duration of a *koku* was 1 hour and 48 minutes during the day and 2 hours and 12 minutes during the night; at the summer solstice, 2 hours and 36 minutes during the day and 1 hour and 21 minutes during the night.

Although these various chronological systems are still being utilized in Japan—primarily in the rural districts—the government adopted on January 1, 1873, the Gregorian calendar for all international relations.

TABLE II: THE CYCLICAL CHARACTERS

KAN / SHI	*Kō* WOOD + Kinoe	*Otsu* WOOD − Kinoto	*Hei* FIRE + Hinoe	*Tei* FIRE − Hinoto	*Bo* EARTH + Tsuchinoe	*Ki* EARTH − Tsuchinoto	*Ko* METAL + Kanoe	*Shin* METAL − Kanoto	*Jin* WATER + Mizunoe	*Ki* WATER − Mizunoto
RAT *Shi* Ne	1		13		25		37		49	
OX *Chū* Ushi		2		14		26		38		50
TIGER *In* Tora	51		3		15		27		39	
HARE *Bō* U		52		4		16		28		40
DRAGON *Shin* Tatsu	41		53		5		17		29	
SERPENT *Shi* Mi		42		54		6		18		30
HORSE *Go* Uma	31		43		55		7		19	
GOAT *Bi* Hitsuji		32		44		56		8		20
MONKEY *Shin* Saru	21		33		45		57		9	
BIRD *Yū* Tori		22		34		46		58		10
DOG *Jutsu* Inu	11		23		35		47		59	
BOAR *Gai* I		12		24		36		48		60

NOTE: The words in italics correspond to the Sino-Japanese pronunciation.

Table of Emperors, Empresses, Cloistered Emperors, Regents, Shōguns, Administrators, and Corresponding Eras

EMPERORS	TRADITIONAL DATES	CONJECTURAL DATES	DATES ACCORDING TO THE NIHON-SHOKI	DATES ACCORDING TO THE KOJIKI	PROBABLE DATES
1 Jimmu	660 B.C.	1?			
2 Suisei	581	25?			
3 Annei	548	50?			
4 Itoku	510	75?			
5 Kōshō	475	100?			
6 Kōan	392	125?			
7 Kōrei	290	150?			
8 Kōgen	214	175?			
9 Kaika	157	200?			
10 Sujin		229?	97 B.C.		200
11 Suinin		259?	29 B.C.		520
12 Keikō		291	A.D. 71		280
13 Seimu		323	131		316
14 Chūai (nephew of 13)		356	190		343
– Regency of Jingū					
15 Ōjin		380	270		346
16 Nintoku		395	313		395
17 Richū		428	400		427
18 Hanshō (brother of 17)		433	406		433
19 Inkyō (brother of 17 and 18)		438	412		438
20 Ankō		455	454		
21 Yūryaku (brother of 20)		457	457		
22 Seinei		490	480		
23 Kensō (grandson of 17)		495	485		
24 Ninken (brother of 23)		498	488		
25 Buretsu		504	499		
26 Keitai (descendant of the 4th generation of a brother or sister of 16)		510	507		
27 Ankan		527	534		
28 Senka (brother of 27)		536	536		
29 Kimmei (brother of 27 and 28)		539	540		
30 Bidatsu		572	572		
31 Yōmei (brother of 30)		585	586		
32 Sunjun (brother of 30 and 31)		587	588		
33 Suiko (empress, widow of 30)		592	593		
34 Jomei (grandson of 30)		628	629		
35 Kōgyoku (empress, granddaughter of 30)		641	642		

NOTES:

1 The first number indicates the position of the emperors in the official list.

2 The succession is from father to son unless otherwise indicated.

3 The names of the cloistered emperors are in italics.

4 The first emperors were mythical or chiefs of various clans; the duration of their reigns is purely conjectural.

. .

BEGINNING OF THE ERAS

EMPERORS	BEGINNING OF REIGN	ERAS	
36 Kōtoku (grandson of 30)	645	Taika	645–649
		Hakuchi	649–654
37 Saimei (empress)	654		
38 Tenchi (son of 34)	661		
39 Kōbun (son of 38)	672	Hakuhō	672–685
40 Temmu (brother of 38)	672		
41 Jitō (empress, daughter of 38)	686	Shuchō	686–690
42 Mommu (grandson of 40)	697	Taihō	701–703
		Keiun	704–707
43 Gemmei (empress, sister of 39 and 41)	707	Wadō	708–714
44 Genshō (empress, sister of 42)	715	Reiki	715–716
		Yōrō	717–723

45 Shōmu (son of 42)	724	Jinki	724–728
		Tempyō	729–748
46 Kōken (empress)	749	Tempyō-Kampo	749
		Tempyō-Shōhō	749–756
47 Junnin (grandson of 40)	759	Tempyō-Hōji	757–764
48 Shōtoku (empress, the same as 46)	765	Tempyō-Jingo	765–766
		Jingo-Keiun	767–769
49 Kōnin (grandson of 38)	770	Hōki	770–780
		Ten-ō	781
50 Kammu	782	Enryaku	782–805
51 Heijō (Heizei)	806	Daidō	806–809
52 Saga (brother of 51)	809	Kōnin	810–823
53 Junna (brother of 51 and 52)	823	Tenchō	824–833
54 Nimmyō (son of 52)	833	Shōwa	834–847
		Kashō	848–850
55 Montoku	850	Ninju	851–853
		Saikō	854–856
56 Seiwa	858	Jōgan	859–876
57 Yōzei	877	Gangyō	877–884
58 Kōkō (brother of 55)	884	Ninna	885–888
59 Uda	887	Kampyō	889–897
60 Daigo	897	Shōtai	898–900
		Engi	901–922
		Enchō	923–930
61 Sūjaku	930	Shōhei	931–937
		Tenkei	938–946
62 Murakami (brother of 61)	946	Tenryaku	947–956
		Tentoku	957–960
		Ōwa	961–963
		Kōhō	964–967
63 Reizei	967	Anna	968–969
64 En-yū (brother of 63)	969	Tenroku	970–972
		Ten-en	972–975
		Jōgen	976–977
		Tengen	978–982
		Eikan	983–984
65 Kazan (son of 63)	984	Kanwa	985–986
66 Ichijō (son of 64)	986	Eien	987–988
		Eiso	989
		Shōryaku	990–994
		Chōtoku	995–998
		Chōhō	999–1003
		Kankō	1004–1011
67 Sanjō (brother of 65)	1011	Chōwa	1012–1016
68 Go-Ichijō (son of 66)	1016	Kannin	1017–1020
		Jian	1021–1023
		Manju	1024–1027
		Chōgen	1028–1036
69 Go-Sūjaku (brother of 68)	1036	Chōryaku	1037–1039
		Chōkyū	1040–1043
		Kantoku	1044–1045
70 Go-Reizei (no male descendants)	1045	Eishō	1046–1052
		Tenki	1053–1057
		Kōhei	1058–1064
		Jiryaku	1065–1068
71 Go-Sanjō (half-brother of 70)	1068	Enkyū	1069–1073
72 Shirakawa	1072	Shōhō	1074–1076
71 – Go-Sanjō (1073–1074)		Shōryaku	1077–1080
		Eihō	1081–1083
		Ōtoku	1084–1086

73 Horikawa 1086 Kanji 1087–1093
 72 – *Shirakawa* Kahō 1094–1095
 Eichō 1096
 Shōtoku 1097–1098
 Kōwa 1099–1103
 Chōji 1104–1105
 Kashō 1106–1107

74 Toba 1107 Tennin 1108–1109
 72 – *Shirakawa* Ten-ei 1110–1112
 Eikyū 1113–1117
 Gen-ei 1118–1119
 Hōan 1120–1123

75 Sutoku 1123 Tenji 1124–1125
 72 – *Shirakawa* (d. 1129) Taiji 1126–1130
 74 – *Toba* Tenshō 1131
 Chōshō 1132–1134
 Hōen 1135–1140
 Eiji 1141

76 Konoe (brother of 75) 1141 Kōji 1142–1143
 74 – *Toba* Ten-yō 1144
 75 – *Sutoku* Kyūan 1145–1150
 Nimpei 1151–1153
 Kyūju 1154–1155

77 Go-Shirakawa (brother of 75
 and 76) 1155 Hōgen 1156–1158
 74 – *Toba* (d. 1156)
 75 – *Sutoku*

78 Nijō 1158 Heiji 1159
 77 – *Go-Shirakawa* Eiryaku 1160
 Ōhō 1161–1162
 Chōkan 1163–1164
 Eiman 1165

79 Rokujō 1165 Nin-an 1166–1169
 77 – *Go-Shirakawa*

80 Takakura (brother of 78) 1168 Kaō 1169–1170
 77 – *Go-Shirakawa* Shō-an 1171–1174
 79 – *Rokujō* (d. 1176) Angen 1175–1176
 Jishō 1177–1180

81 Antoku 1180 Yōwa 1181
 77 – *Go-Shirakawa* Juei 1182–1183
 80 – *Takakura* (d. 1181) Genryaku 1184

SHŌGUNS **REGENTS (HŌJŌ)**
(MINAMOTO CLAN)

82 Go-Toba (brother of 81) 1184 Bunji 1185–1189 (1) Yoritomo 1192
 77 – *Go-Shirakawa* (d. 1192) Kenkyū 1190–1198 (2) Yoriye 1202

83 Tsuchimikado 1198 Shōji 1199–1200 (son of 1)
 82 – *Go-Toba* Kennin 1201–1203
 Genkyū 1204–1205 (3) Sanetomo 1203 Tokimasa 1203
 Ken-ei 1206 (brother of 2) Yoshitoki 1205
 Shōgen 1207–1210 (son of Tokimasa)

84 Juntoku (brother of 83) 1210 Kenryaku 1211–1212
 82 – *Go-Toba* Kempō 1213–1218
 Jōkyū 1219–1221

85 Chūkyō (Kanenari)
 (reigned only 70 days) 1221
 82 – *Go-Toba*
 Go-Takakura (Prince Morisada,
 son of 80, never reigned,
 1221–1223)

86 Go-Horikawa (grandson of
 80 and son of Go-Takakura) 1221 Jōō 1222–1223 **(FUJIWARA CLAN)**
 Go-Takakura (see above) Gennin 1224 (4) Yoritsune 1226 Yasutoki 1224
 Karoku 1225–1226 (son of Yoshitoki)
 Antei 1227–1228
 Kanki 1229–1231
 Jōei 1232

87 Shijō 1232 Tempuku 1233
 86 – *Go-Horikawa* (d. 1234) Bunryaku 1234

Emperor	Acc.	Era names	Shogun	Regent
		Katei 1235–1237		
		Ryakunin 1238		
		En-ō 1239		Tsunetoki 1242 (grandson of Yasutoki)
		Nin-ji 1240–1242		
88 Go-Saga (son of 83)	1242	Kangen 1243–1246	(5) Yoritsugu 1244 (son of 4)	Tokiyori 1246 (brother of Tsunetoki)
89 Go-Fukakusa (son of 88) 88 – Go-Saga	1246	Hōji 1247–1248	(IMPERIAL PRINCES)	
		Kenchō 1249–1255	(6) Munetaka 1252 (son of 88)	
		Kōgen 1256		Nagatoki 1256 (nephew of Yasutoki)
		Shōka 1257–1258		
		Shōgen 1259		
90 Kameyama (brother of 89) 88 – Go-Saga (d. 1272)	1259	Bun-ō 1260		
		Kōchō 1261–1263		
		Bun-ei 1264–1274	(7) Koreyasu 1266 (son of Munetaka)	Masamura 1264 (brother of Yasutoki)
91 Go-Uda 90 – Kameyama	1274	Kenji 1275–1277		Tokimune 1268 (son of Tokiyori)
		Kōan 1278–1287		Sadatoki 1284 (son of Tokimune)
92 Fushimi (son of 89) 89 – Go-Fukakusa	1288	Shōō 1288–1292	(8) Hisa-Akira 1289 (brother of 92, son of 89)	
		Einin 1293–1298		
93 Go-Fushimi 92 – Fushimi	1298	Shōan 1299–1301		Morotoki 1301 (nephew of Tokimune)
94 Go-Nijō (son of 91) 91 – Go-Uda	1301	Kengen 1302		
		Kagen 1303–1305		
		Tokuji 1306–1307		
95 Hanazono (son of 92) 93 – Go-Fushimi	1308	Enkyō 1308–1310	(9) Morikuni 1308 (son of Hisa-Akira)	
		Ōchō 1311		
		Shōwa 1312–1316		Takatoki 1316 (grandson of the 7th generation of Tokimasa)
		Bumpō 1317–1318		
96 Go-Daigo (son of 91) 91 – Go-Uda (d. 1321)	1318	Gen-ō 1319–1320		
		Genkyō 1321–1323		
		Shōchū 1324–1325		
		Karyaku 1326–1328		
		Gentoku 1329–1331		
		Genkō 1331–1333		
		Kemmu 1334–1335	(10) Morinaga 1334 (son of 96)	
		Engen 1336–1339		

. .

EMPERORS OF THE NORTHERN COURT (NOT RECOGNIZED OFFICIALLY)

Emperor	Acc.	Era names	Clan
		Gentoku 1329–1331	
1 Kōgon (son of 93)	1331	Shōkyō 1332–1333	
		Kemmu 1334–1337	(ASHIKAGA CLAN)
2 Kōmyō (son of 1)	1337	Ryakuō 1338–1341	(11) Takauji 1338
		Kōei 1342–1344	
		Jōwa 1345–1349	
3 Sukō (son of 1)	1349	Kan-ō 1350–1351	
4 Go-Kōgon (brother of 3)	1353	Bunna 1352–1355	
		Embun 1356–1360	(12) Yoshiakira 1358 (son of 11)
		Kōan 1361	
		Jōji 1362–1367	(13) Yoshimitsu 1368 (son of 12)
5 Go-En-yū	1374	Ōan 1368–1374	
		Eiwa 1375–1378	
		Kōryaku 1379–1380	
		Eitoku 1381–1383	
6 Go-Komatsu	1382	Shitoku 1384–1386	
		Kakei 1387–1388	
		Kō-ō 1389	
		Meitoku 1390–1392	

. .

Emperor	Accession	Era	Era years	Shogun / Administrator
97 Go-Murakami	1339	Kōkoku	1340–1345	(ASHIKAGA CLAN)
		Shōhei	1346–1369	(11) Takauji 1338
				(12) Yoshiakira 1358
				(son of 11)
				(13) Yoshimitsu 1368
				(son of 12)
98 Chōkei	1368	Kentoku	1370–1371	
		Bunchū	1372–1374	
99 Go-Kameyama	1383	Tenju	1375–1380	
(brother of 98)		Kōwa	1381–1383	
		Genchū	1384–1392	
100 Go-Komatsu	1392	Meitoku	1393	
(great-great-grandson of 93)				
101 Shōkō	1412	Ōei	1394–1427	(14) Yoshimochi 1395
		Shōchō	1428	(15) Yoshikazu 1423
				(son of 14)
				(16) Yoshinori 1428
				(son of 13, brother of 14)
102 Go-Hanazono	1429	Eikyō	1429–1440	
(great-great-great-grandson of 93)		Kakitsu	1441–1443	(17) Yoshikatsu 1441
				(son of 16)
		Bun-an	1444–1448	(18) Yoshimasa 1443
		Hōtoku	1449–1451	(son of 16, brother of 17)
		Kyōtoku	1452–1454	
		Kōshō	1455–1456	
		Chōroku	1457–1459	
103 Go-Tsuchimikado	1465	Kanshō	1460–1465	
		Bunshō	1466	
		Onin	1467–1468	
		Bummei	1469–1486	(19) Yoshihisa 1474
		Chōkyō	1486–1488	(son of 18)
		Entoku	1489–1491	(20) Yoshitane 1490
				(nephew of 18)
		Meiō	1492–1500	(21) Yoshizumi 1493
				(nephew of 18)
104 Go-Kashiwabara	1500	Bunki	1501–1503	
		Eishō	1504–1520	(22) Yoshitane 1508
				(same person as 20)
		Taiei	1521–1527	(23) Yoshiharu 1521
				(son of 21)
105 Go-Nara	1526	Kyōroku	1528–1531	
		Tembun	1532–1554	(24) Yoshiteru 1545
				(son of 23)
106 Ogimachi	1557	Kōji	1555–1557	
		Eiroku	1558–1569	(25) Yoshihide 1565
				(nephew of 23)
				(26) Yoshiaki 1568
				(son of 23)
		Genki	1570–1572	(ADMINISTRATORS)
107 Go-Yōzei	1586	Tenshō	1573–1591	Oda Nobunaga 1573
(grandson of 106)				Hideyoshi 1582
		Bunroku	1592–1595	Hideyori 1598
				(TOKUGAWA CLAN)
108 Go-Mizuno-o	1611	Keichō	1596–1614	(1) Ieyasu 1603
				(2) Hidetada 1616
				(son of 1)
		Genna	1615–1623	(3) Iemitsu 1623
				(son of 2)
109 Myōshō (Empress Meishō)	1630	Kan-ei	1624–1643	
110 Go-Kōmyō (brother of 109)	1643	Shōhō	1644–1647	
		Keian	1648–1651	(4) Ietsuna 1651
		Shōō	1652–1654	(son of 3)
111 Go-Sai (brother of 109 and 110)	1656	Meireki	1655–1657	
		Manji	1658–1660	
112 Reigen (brother of 109, 110, and 111)	1663	Kambun	1661–1672	
		Empō	1673–1680	(5) Tsunayoshi 1680
		Tenna	1681–1683	(son of 4)

113	Higashiyama	1687	Jōkyō	1684–1687			
			Genroku	1688–1703			
114	Nakamikado	1710	Hōei	1704–1710	(6)	Ienobu	1709
			Shōtoku	1711–1715	(7)	Ietsugu	1713
			Kyōhō	1716–1735	(8)	Yoshimune	1716
115	Sakuramachi	1735	Gembun	1736–1740			
			Kampō	1741–1743			
			Enkyō	1744–1747	(9)	Ieshige	1745
116	Momozono	1747	Kan-en	1748–1750			
117	Go-Sakuramachi		Hōreki	1751–1763	(10)	Ieharu	1760
	(empress, sister of 116)						
118	Go-Momozono (son of 116)	1762	Meiwa	1764–1771			
		1771	An-ei	1772–1780			
119	Kōkaku	1780	Temmei	1781–1788	(11)	Ienari	1787
	(great grandson of 113)		Kansei	1789–1800			
			Kyōwa	1801–1803			
120	Ninkō (brother of 119)	1817	Bunka	1804–1817			
			Bunsei	1818–1829			
			Tempō	1830–1843	(12)	Ieyoshi	1837
121	Kōmei	1847	Kōka	1844–1847			
			Kaei	1848–1853	(13)	Iesada	1853
			Ansei	1854–1859	(14)	Iemochi	1858
			Man-en	1860			
			Bunkyū	1861–1863			
			Genji	1864			
			Keiō	1865–1867	(15)	Yoshinobu	
						(Keiki) 1866–1867	
122	Mutsuhito (Meiji)	1868	Meiji	1868–1912			
123	Yoshihito (Taishō)	1912	Taishō	1912–1926			
124	Hirohito (Kinjō)	1926	Shōwa	1926–			
125	Akihito (Crown Prince)						

Genealogy of the Tokugawa Shōguns

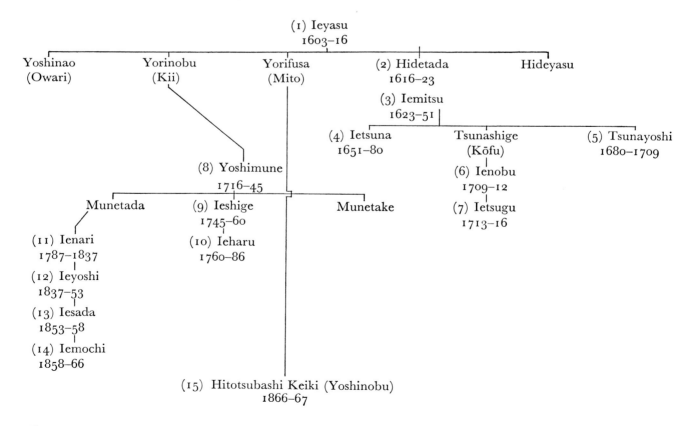

Genealogy of the Great Classical Sculptors

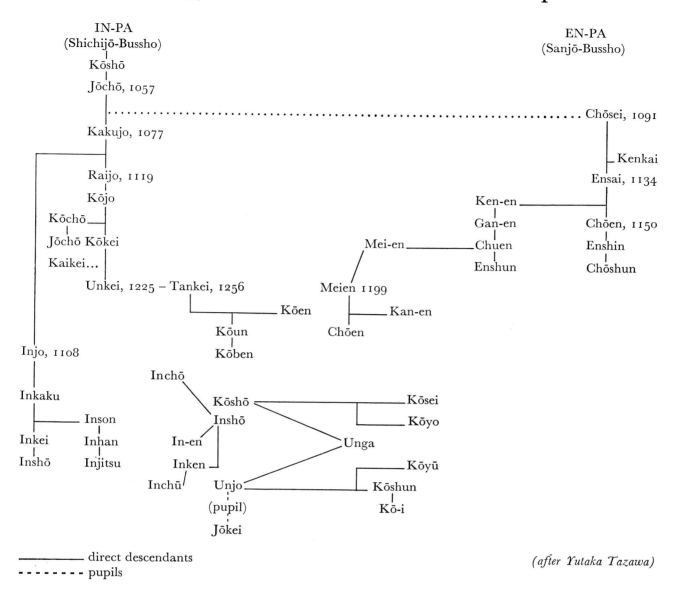

IN-PA
(Shichijō-Bussho)

Kōshō

Jōchō, 1057

Kakujo, 1077

Raijo, 1119

Kōjo

Kōchō

Jōchō Kōkei

Kaikei...

Unkei, 1225 – Tankei, 1256

Kōen

Kōun

Kōben

Injo, 1108

Inkaku

Inson

Inkei Inhan

Inshō Injitsu

Inchō

Kōshō

Inshō

In-en

Inken

Inchū

Unjo

(pupil)

Jōkei

Meien 1199

Kan-en

Chōen

Mei-en

Ken-en

Gan-en

Chuen

Enshun

Unga

Kōsei

Kōyo

Kōyū

Kōshun

Kō-i

EN-PA
(Sanjō-Bussho)

Chōsei, 1091

Kenkai

Ensai, 1134

Chōen, 1150

Enshin

Chōshun

————— direct descendants
- - - - - - - pupils

(after Yutaka Tazawa)

481

Genealogy of the Painters of the Kanō, Kang-e, and Yamato-e (Tosa) Schools

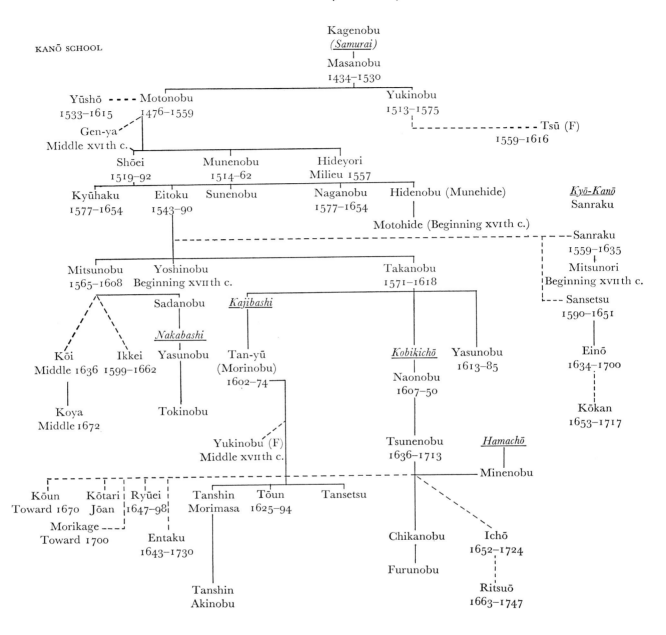

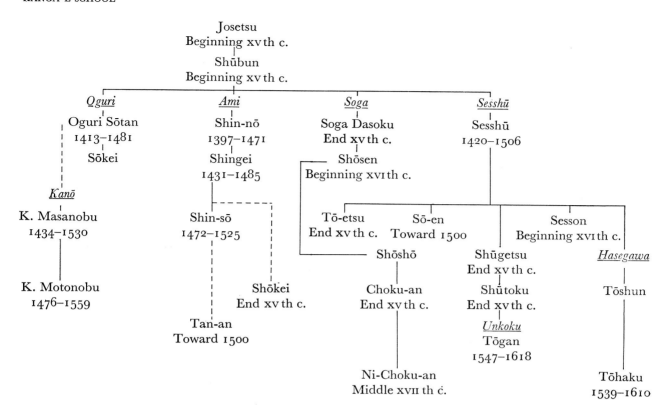

Josetsu
Beginning xvth c.

Shūbun
Beginning xvth c.

Oguri
Oguri Sōtan
1413–1481
Sōkei

Kanō
K. Masanobu
1434–1530

K. Motonobu
1476–1559

Ami
Shin-nō
1397–1471
Shingei
1431–1485

Shin-sō
1472–1525

Shōkei
End xvth c.

Tan-an
Toward 1500

Soga
Soga Dasoku
End xvth c.

Shōsen
Beginning xvith c.

Tō-etsu Sō-en
End xvth c. Toward 1500

Shōshō

Choku-an
End xvth c.

Ni-Choku-an
Middle xviith c.

Sesshū
Sesshū
1420–1506

Sesson
Beginning xvith c.

Shūgetsu
End xvth c.

Shūtoku
End xvth c.

Unkoku
Tōgan
1547–1618

Hasegawa
Tōshun

Tōhaku
1539–1610

YAMATO-E (TOSA) SCHOOL

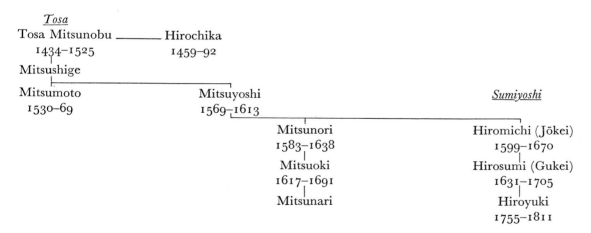

Tosa
Tosa Mitsunobu ———— Hirochika
1434–1525 1459–92
Mitsushige

Mitsumoto Mitsuyoshi
1530–69 1569–1613

Mitsunori *Sumiyoshi*
1583–1638 Hiromichi (Jōkei)
Mitsuoki 1599–1670
1617–1691 Hirosumi (Gukei)
Mitsunari 1631–1705
 Hiroyuki
 1755–1811

F = Women painters Not yet identified: Sōyū (Gyōkuraku?), sixteenth century (?)
The names underlined and in italics are the family names of the artists.
Black lines: direct descendants
Broken lines: pupils

The Great Schools of Japanese Painting

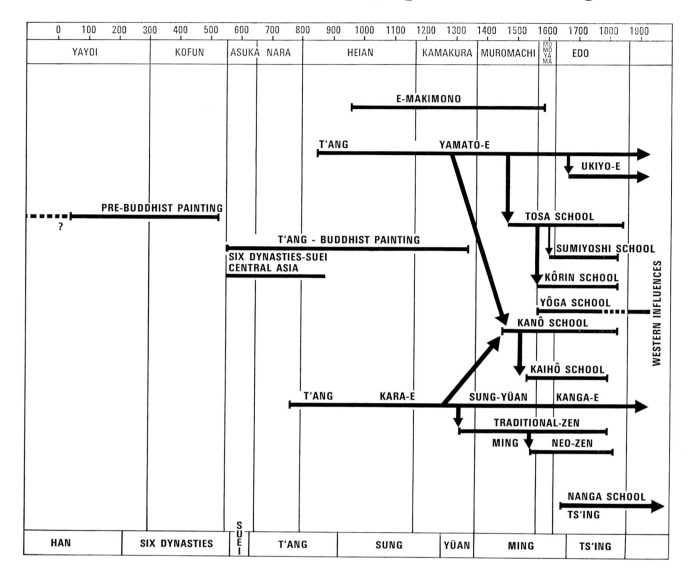

0	100	200	300	400	500	600	700	800	900	1000	1100	1200	1300	1400	1500	1600	1700	1800	1900

YAYOI · KOFUN · ASUKA · NARA · HEIAN · KAMAKURA · MUROMACHI · MOMOYAMA · EDO

E-MAKIMONO

T'ANG — YAMATO-E — UKIYO-E

PRE-BUDDHIST PAINTING ?

T'ANG - BUDDHIST PAINTING

SIX DYNASTIES-SUEI CENTRAL ASIA

TOSA SCHOOL

SUMIYOSHI SCHOOL

KÔRIN SCHOOL

YÔGA SCHOOL

KANÔ SCHOOL

KAIHÔ SCHOOL

T'ANG — KARA-E — SUNG-YÜAN — KANGA-E

TRADITIONAL-ZEN

MING — NEO-ZEN

NANGA SCHOOL

TS'ING

WESTERN INFLUENCES

HAN	SIX DYNASTIES	SUEI	T'ANG	SUNG	YÜAN	MING	TS'ING	

Glossary

AINU: People of the far north of Japan with a primitive culture. *Ezo. Ebisu. Emishi.*

AMIDADŌ: Hall reserved for the veneration of Amida Buddha.

AOI: Japanese plant resembling the hollyhock. *Asarum.*

ARAGOTO: Gesticulating, dynamic recital of the Kabuki theater.

ASHIGARU: Foot soldiers.

AZEKURA: Type of building used for warehouses and supplies.

BAKUFU: Military government.

BE: A guild or occupation group in ancient Japan.

BENI-E: A type of *ukiyo-e* woodblock print in two colors, the second of which was usually applied by hand and was a reddish pigment extracted from the safflower plant; other pigments were also used.

BENIZURI-E: A type of *ukiyo-e* woodblock print using *beni* (red), indigo, yellow, and green. The colors were printed using several blocks. These prints are the first true Japanese color prints.

BIWA: Type of four-stringed lute of Chinese origin.

BOSATSU: A Bodhisattva.

BU: Measure of length: approximately one-tenth of an inch.

BUGAKU: Court dance and music.

BUKE-ZUKURI: A style of dwelling used by samurai.

BUNJINGA: Literati painting. *Nanga-e.*

BUSHI: Warrior.

BUSHIDŌ: "The Way of the Warrior"; his code of conduct.

BUSSHI: A master painter or sculptor associated with a temple.

BUSSHO: Studio in which Buddhist art is produced, usually the atelier of a temple.

BUTSU: Buddha. *Nyorai.*

BUTSUDAN: Dais on which Buddhist images are installed and worshiped. Buddhist family altar.

BYŌBU: Painted folding or single screen.

CHA-NO-YA: Small house reserved for the tea ceremony. *Chashitsu.*

CHA-NO-YU: The tea ceremony.

CHASHITSU: Teahouse. *Cha-no-ya.*

CHAWAN: Tea bowl.

CHIGAI-DANA: Shelves for the display of art objects in a *tokowaki* (alcove).

CHIGI: Ornament in the form of a horn for the gable ends of Shintō shrines.

CHINSŌ: Portrait of a monk or priest.

CHŌ: Measure of length: approximately 160 feet. Land measure: approximately 2½ acres.

CHŌKA: A long poem in lines of five or seven syllables.

CHOKKOMON: Decorative motif typical of the Kofun era (third to seventh centuries).

CHŌNIN: A resident of a city. A townsman.

CHŪMON: Middle gate, a gateway in the roofed corridors enclosing the main buildings of a temple. It stands midway between the main front gate and the Hondō.

CHŪMONRŌ: Covered corridor or gallery of *shinden* style houses.

DAI: Great, large, big.

DAIDOKORO: Kitchen.

DAIMYŌ: Important feudal landowner; lord of the manor.

DAINAGON: Great counselor.

DAINICHI NYORAI: The great solar Buddha. Mahavairocana.

DAISHI: Religious title: grand master.

DAIZA: Pedestal of a statue.

DAJŌ DAIJIN: Prime minister.

DARUMA: Chinese priest (Sanskrit: Bodhidharma). Patron "saint" and founder of Zen (Ch'an) Buddhism.

DASHI: Portable shrine used in festival processions.

DERA: Buddhist temple. *Ji. Tera.*

DHARMA (Sanskrit): Law.

DŌ: Main Hall of a temple.

DŌGO: Important peasant landowner.

DOGŪ: Figurine from the Jōmon period.

DOMEN: Mask made in the Jōmon period.

DŌTAKU: Bronze object of the Yayoi period resembling a bell.

EBOSHI: Tall headdress of black fabric worn by men.

E-BUSSHI: Painting masters skilled in the production of Buddhist paintings.

EDOKORO: Bureau of Painters, serving either the imperial court or the shogunate.

EJI: The imperial guard.

E-MA: Votive painting of a horse.

E-MA-DŌ: Building erected to house the *e-ma.*

EMAKIMONO: Horizontal narrative scroll with a handwritten text and illustrations.

EMISHI: Aborigines of eastern and northern Japan. *Ezo. Ebisu. Ainu.*

ENGI: The account, sometimes historically accurate but more often based on folklore, of the founding of a temple.

EN-PA: A school of sculpture in the late Heian and Kamakura periods.

ESHI: A master painter.

EZO: See *Emishi, Ainu.*

FUDE: A brush used for writing or for painting pictures.

FŪDOKI: Records of the topography, natural resources, and local traditions of the various provinces.

FUJI: Wisteria.

FUKKO-YAMATO-E. School of *yamato-e* painting of the late Edo period.

FUSUMA: Sliding partition, often decorated.

GACHŌ: Album of paintings.

GAGAKU: Ceremonial music and dances of the imperial court.

GEGYO: Piece of decorated wood concealing the end of the ridge beam of a building.

GEMPITSU: Style of painting characterized by a very limited number o brushstrokes.

GENJI: See *Minamoto.*

GETA: Wooden clogs.

GIBŌSHU-BASHIRA: Column of a balustrade with a jewel-shaped metal cap.

GIGAKU: A dance form originally brought from Korea in the seventh century.

GIN: Silver.

GINKGO: See *Ichō.*

GIRI: Social behavior or duty.

GŌ: Pseudonym of a painter.

GO: Honorary prefix.

GO: Game of the aristocracy, imported from China. *Igo.*

GOFUN: Calcium carbonate powder produced by calcining shells and used as an undercoat for painting.

GOHAI: Small roof porch.

GOHEI: White or colored bands of cut paper attached to a piece of wood and used in Shintō festivals.

GOJŪ-NO-TŌ: A five-storied pagoda.

GONGEN: Reincarnation of a Buddhist divinity in the form of a Shintō deity.

GONGEN: Style of Shintō shrine architecture.

GŌSHI: System of land distribution during the feudal period.

GYOKUGAN: Obsidian or glass used for the eyes of statues during the Kamakura period.

HABOKU: A technique of *sumi* painting in which ink is flung on the surface of paper or silk to suggest natural forms.

HAIDEN: Worship hall in front of the main building of a Shintō shrine.

HAIGA: Illustration of a *haiku* poem.

HAIKU: A poem of seventeen syllables.

HAJIBE: Pottery of the Yayoi, Kofun, and Nara eras.

HANA: Flower.

HANASHI: Story. Narration.

HANIWA: Decorative tube or cylinder of terra cotta of the Kofun era.

HARAI: Purification.

HARA-KIRI: Suicide by thrusting a sword into the abdomen. *Seppuku.*

HATAMOTO: Vassal directly under a shōgun.

HEIKE: An alternate name for the Taira clan.

HIBACHI: Brazier.

HIBUTSU: Secret image of esoteric Buddhism.

HIDEN: Secret knowledge not transmitted in general teachings.

HIGASHI: The East. *Tō.*

HIJIKI: Intercolumnar brackets inserted through the top portions of supporting pillars.

HIKAN: Peasant. *Nago.*

HIKIME-KAGIHANA: Style of representing facial features in the Heian era. Literally: "line eye, hook nose."

HININ: Criminal.

HINOKI: Species of tree, commonly called a cypress. *Chamaecyparis obtusa.*

HIRAGANA: Cursive syllabic writing.

HIRAJŌ: A castle on a plain.

HISASHI: Roof over a gallery or corridor.

HITEN: Flying divinity used as a decorative motif.

HITO-BASHIRA: Person buried alive in the foundation of a building. Literally: "Human Pillar."

HŌGEN: An honorary title, "Eye of the Law," bestowed on an artist of great merit.

HŌGO: Religious phrase written by a Zen master on his portrait.

HŌIN: An honorary title, "Seal of the Law," like *Hōgen* granted to artists.

HŌJŌ: Residence of the abbot of a monastery.

HOKKYŌ: An honorary title, "Bridge of the Law," granted to artists.

HOKU: The North. *Kita.*

HOKUCHŌ: The Northern Court during the 14th century.

HOKUGA: Style of painting of North China imported into Japan.

HOMPA-SHIKI: The rolling-wave style of drapery associated with sculptures of Buddhist divinities in the ninth century.

HONDEN: Principal building in a Shintō shrine.

HONDŌ: Principal building of a Buddhist monastery.

HONJI-SUIJAKU: Syncretic Buddhist-Shintō doctrine.

HONZON: Principal sacred image of a temple.

HOŌ: Phoenix.

HOŌ: Cloistered emperor. *In.*

HŌSHU: Gem that grants all wishes. *Cintamani.*

HŌSŌGE: Floral decorative motif resembling a peony, originating in the East Indies.

ICHIBOKU: Method of sculpting a statue from a single block of wood.

ICHŌ: Species of tree. *Ginkgo biloba,* syn. *Salisburia Adamtifolia.*

IGARAKURI: Technique of casting a large bronze statue in several horizontal sections.

IHAI: Tablet bearing the names of one's ancestors. It is placed on the family altar.

IKEBANA: The art of flower arrangement.

IKKI: League, confederacy.

IN: Cloistered emperor. *Hoō.*

INABO: Small stick decorated with wood shavings; of Ainu origin and analogous to the Shintō *gohei.*

INGA: Law of retribution in a future existence for one's acts. *Karma.*

IN-PA: A school of sculpture in the late Heian and Kamakura periods.

INRŌ: Tiny medicine box attached to the belt with a *netsuke.*

INSEI: A practice which grew up in the Heian period whereby an emperor retired after the birth of a son and established himself as *de facto* ruler.

IN-ZŌ: Symbolic position of the hands. *Mudra.*

IRIMOYA: A hipped and gabled roof.

IROHA: Poem written to serve as an aid in memorizing the Japanese syllables.

IRORI: The square sunken hearth of a house.

ISHIDŌRŌ: Lantern made of stone.

IWAIBE: A name for the pottery of the *sue-ki* type.

JATAKA (Sanskrit): History of the previous incarnations of the historical Buddha, Sakyamuni.

JI: Buddhist monastery or temple. *Dera. Tera.*

JIGOKU: The Buddhist Hells.

JIMOTSU: Attributes of Buddhist divinities.

JINGŪ: Imperial Shintō shrine.

JINJA: Ordinary Shintō shrine.

JITŌ: Feudal administrator or military inspector.

JŌ: Castle. *Shiro.*

JŌ: Measure of length: 10 *shaku* or approximately 10 feet.

JŌDO: The Western Paradise of Amida. Also a sect of Buddhism founded by Hōnen.

JŌMON: Pottery with decorative motif obtained by pressing rope into the wet clay. Also prehistorical era of Japan.

JŌRI: Method of settling people on the land in the seventh century.

JŌROKU: Measurement of the height of Buddhist statues: approximately 16'6" for standing figures, 8'3" for seated figures.

JŌRURI: Epic puppet plays accompanied by music.

JUNSHI: Collective suicide by the servants of a chief at the time of his death.

JŪSHA: Follower, retainer.

KABUKI: Form of popular theater.

KACHŌ: Flower and bird painting. *Kachō-zu.*

KAERUMATA: Interbeam support resembling the shape of frogs' legs.

KAGAMI: The sacred mirror, part of the imperial regalia.

KAGO: Basket.

KAIDŌ: Coastal road.

KAIZUKA: Piles of empty shells; analogous to the *Kjökkenmödding.*

KAKEBOTOKE: Image of Buddha hung on a wall.

KAKEMONO: A painting intended to be hung and viewed as a totality in contrast to a *makimono* which was designed to be viewed one section at a time.

KAME: Tortoise.

KAMI: A Shintō divinity.

KAMI: Paper.

KAMIKAZE: Typhoon. Literally: "Divine Wind."

KAMMURI: Headdress of the highest ranking nobles at the imperial court.

KAMPAKU: Regent of an emperor.

KAMUI: Ainu divinity.

KANA: Syllabic writing.

KANGA-E: Chinese style of painting of the Sung and Yuan dynasties. Also *Kara-e.*

KANREI: A deputy of the shōgun governing the Kantō region in the Muromachi period.

KANSHITSU: The technique of sculpting in which cloth soaked in lacquer is used as the substance out of which the sculpture is modeled.

KANTŌ: The region in Japan including Tokyo east of Mount Fuji.

KAPPA: Mythical semi-aquatic being.

KARA-E: Chinese style of painting. *Kanga-e.*

KARAFUTO: The island of Sakhalin.

KARA-HAFU: Roof with an arched gable.

KARA-MON: Chinese gate decorated with a *kara-hafu* gable.

KARA-SHISHI: Mythical Chinese lions guarding the entrances of temples.

KARA-YŌ: "Chinese" style of architecture.

KARE-SANSUI: A garden of rocks and stones but no water, arranged to suggest a landscape of water, trees, and mountains.

KARMA (Sanskrit): Law of retribution. (See *Inga.*)

KASEN: Title given to a master of *waka* poetry.

KASEN-E: A portrait of a poetry master accompanied by a short biography and a sample of his poetry.

KASUGA: Type of Shintō shrine architecture named for the most famous example of it, the Kasuga Shrine at Nara.

KATAKANA: "Squared" syllabic writing.

KATANA: Battle sword.

KATATAGAE: Means of freeing oneself from a directional taboo, a direction of movement which would cause one to cross the path of a divine spirit.

KATŌ-MADO: A window associated with the *Kara-yō* style of architecture having unusual curves at both top and sides.

KATSUO-GI: Piece of wood placed transversely on the ridgepole of a Shintō shrine.

KATTCHŪ: A complete suit of armor including a helmet.

KAWARA: Tile.

KEBIISHI: The metropolitan police in Kyoto.

KEBUTSU: Small image of a Buddha in the crown of a Bodhisattva.

KEGON: Buddhist sect.

KEMAN: Buddhist banner or hanging ornament.

KEMARI: Ball game played with the feet.

KEN: Sword.

KEN: Prefecture.

KEN: Measure of space between two columns: approximately 6'3½".

KENIN: A vassal.

KENTŌSHI: An ambassador of the court of the T'ang emperors.

KESA: A monastic robe.

KIKU: Chrysanthemum.

KIMONO: A type of Japanese garment worn by both men and women.

KIN: Gold.

KINUTA-SEIJI: Celadon ware, a type of sea-green ceramic.

KIRI: Species of tree with very light wood. *Pawlownia imperialis.*

KIRIKANE: "Cut gold," a method of decorating paintings or sculpture with thin strips or flakes of gold or silver leaf.

KIRIN: Mythical animal; a type of flying horse.

KITA: The North. *Hoku.*

KŌBETSU: Name for those clans whose founders were offspring of the emperor but whose later stock were no longer considered to be members of the imperial clan.

KŌDŌ: The Lecture Hall in a Buddhist monastery.

KOFUN: Megalithic tomb. Tumulus.

KŌHAI: The halo of Buddhist statues.

KOKU: Measure used for rice: approximately 320 pounds.

KOKUBUN-JI: Official provincial temple.

KOKUSHI: Buddhist religious title.

KOKUSO: A substance made of potter's clay, sawdust, incense powder, which was mixed with lacquer and used for modeling the surface details of a wooden or dry-lacquer statue.

KOMA-INU: Mythical dog guarding the entrance of a Shintō shrine.

KONDEN: Reclaimed rice land.

KONDŌ: Golden hall; principal hall of a Buddhist monastery.

KORŌ: Building housing the drums of a temple.

KOTO: A type of zither with thirteen or twenty-five strings.

KOURGANE: Typical tomb of Scythian and Altaic civilizations.

KU: Ward of a city (*shi*).

KUBŌ: Head official of a province.

KUGE: Nobility.

KUMASO: Aboriginal population of eastern Japan and Kyushu.

KUNI: The ancient name for a province in Japan.

KURA: Granary. Warehouse.

KURA: Saddle for a horse.

KUROSHIO: Warm marine current on the east coast of Japan.

KYŌ: Sacred Buddhist writing. Sutra.

KYŌZŌ: Sutra repository, or library.

KYŌZUKA: Tumulus erected over a deposit of sacred Buddhist writings.

KYŪDŌ: Ancient highway or road.

MAGATAMA: Jewel in the shape of a comma or hook.

MAKI-E: Lacquer objects decorated with pictures and designs in gold and silver dust sprinkled on the surface.

MAKIMONO: A long scroll painting meant to be seen in sections as it is unrolled.

MAKURA: Pillow.

MANDARA: Graphic representation of the cosmic universe. (Sanskrit: *Mandala.*)

MAPPŌ: According to Buddhist thought a period when the law taught by the historical Buddha, Sakyamuni, would cease to exist and the world would fall into chaos.

MATSURI: A Shintō festival.

MEI: Stamp bearing the signature of an artist.

MEN: Mask.

MIKKYŌ: The doctrines of esoteric Buddhism.

MIKOSHI: Portable Shintō shrine carried in processions.

MIKOTO: An honorific title applied to great Shintō divinities of Japan.

MINAMI: The South. *Nan.*

MINAMOTO: A clan of warriors also known as the Genji.

MINATO: Harbor, port.

MINO: Straw rain cloak.

MISOGI: Ritual ablution with water.

MIYA: The imperial palace or a special Shintō shrine such as the Ise Jingu.

MIZU-E: A woodcut with faintly printed lines.

MOKOSHI. A roofed porch added onto a structure under the eaves of the main roof.

MOKUGYO: Buddhist gong in the shape of a fish.

MOKUSHIN KANSHITSU: Sculpture of dry lacquer over a wooden core.

MONOGATARI: Novel, narrative tale.

MONOIMI: Taboos.

MURA: Village.

MYŌ-Ō: The Enlightened Kings, a type of Buddhist divinity often portrayed as a demonic figure.

NAGARE: Type of Shintō shrine.

NAGINATA: Type of long-bladed halberd.

NAGO: Peasant. *Hikan.*

NAIRAN: Personal counselor and confidant of the emperors.

NAMBOKUCHŌ: The period of rivalry between the Northern and Southern Courts.

NAN: The South. *Minami.*

NANCHŌ: The Southern Court in the 14th century.

NANDAIMON: The great south gateway of a temple.

NANGA-E: Style of painting associated with South China.

NATABORI: A style of sculpture on which the chisel marks are visible.

NEHAN: The death of Buddha. *Parinirvana.*

NEMBUTSU: Repetition of the name of Amida Buddha.

NETSUKE: Small carved button used to attach an *inrō* box to the belt.

NIGITE: Folded paper offering dedicated to a Shintō divinity. *Nusa.*

NIHONGI: Historical chronicle (720). Also known as the *Nihon-shoki.*

NIHON-SHOKI: See *Nihongi.*

NIKKI: Diary, either a poetic diary written in Japanese or a systematically recorded chronicle of events written in Chinese.

NINGYŌ: Doll, puppet.

NINJA: A spy.

NINJŌ: Human feelings.

NIROTO: Shintō prayer.

NISE-E: The "likeness" style; a portrait.

NISHI: The West. *Sai.*

NISHIKI-E: Multicolored *ukiyo-e* woodblock prints resembling Nishiki brocades.

NŌ: A theatrical form created by Zeami in the fourteenth century.

NUSA: See *Nigite.*

NYORAI: The supreme Buddha. *Tathagata.*

OBAKE: Ghost.

ŌBAKU: Chinese sect of Zen Buddhism introduced into Japan in 1644.

ŌBAN: Paper of particular measurements used for woodcuts.

OBI: Belt or sash of a kimono.

ŌGI: Folding fan.

OKUGAKI: Signature, seal, or inscription at the inner end of a *makimono.*

ONI: A demon.

OYASHIO: Cold marine current on the west coast of Japan.

RAHOTSU: The snailshell-shaped curls covering the head of a Buddha image.

RAIGŌ: Descent of Amida Buddha accompanied by Bodhisattvas to receive the souls of the faithful into the Western Paradise.

RAKAN: A person who has achieved a high level of spiritual enlightenment, according to Hinayana Buddhism, the highest level short of Buddhahood. Also *Arhat, Arakan.*

RAMMA: Carved transom frieze.

RENGA: Linked verse.

RENGE: The lotus flower.

RENJI-MADO: Square or rectangular window with vertical wooden bars.

RENNIKU: Inverted cone-shaped portion of a pedestal from which project lotus petals.

RINZŌ: An eight-sided bookcase containing all the sacred Buddhist writings. Set up in the center of a Buddhist hall.

RITSU: Buddhist sect.

RITSU: The penal code.

RO: The brazier in a teahouse reserved for the tea ceremony.

RŌGATA: Method of casting bronze by the lost-wax process.

RŌMAJI: Japanese printed or written in the Roman alphabet.

RŌNIN: Warrior without land or master.

RYŌ: The civil code.

RYŌ: A gold coin.

RYŌBU-SHINTŌ: Syncretic Shintō-Buddhist doctrine of the Shingon sect.

RYŌMIN: A free peasant.

RYŪ: Dragon.

SADAIBEN: Controller of the Left.

SADAIJIN: Minister of the Left.

SAI: The West. *Nishi*.

SAKAKI: Species of evergreen shrub sacred to the Shintō faith. *Cleyera ochnacea*.

SAKE: Alcoholic beverage made from rice.

SAMMON: A two-storied gateway.

SAMPITSU: Title given to the three best calligraphers of Japan.

SAMURAI: Warrior. Literally: "He who is alongside."

SANDŌ: The three "beauty creases" (or "folds") on the throat of a Buddhist sculpted figure.

SANGHA (Sanskrit): Buddhist community.

SANGI: Small wooden sticks used for arithmetical calculation.

SANJO: Mountain castle. *Yamajiro*.

SANJŪ-NO-TŌ: Pagoda with three stories.

SANZON: A Buddhist trinity.

SEGURI: The hollow interior of a statue.

SEII TAISHŌGUN: The shōgun; the general in command of all the armies.

SEMMIN: The servant and slave class.

SENNIN: A hermit who follows the way of the Buddha.

SEPPUKU: Ritual suicide. See *Harakiri*.

SESSHŌ: The Regent for an emperor during his childhood.

SHAKA NYORAI: The Buddha Sakyamuni.

SHAKU: Ceremonial staff.

SHAKU: Measure of length: approximately 11½".

SHAMISEN: Musical instrument with three strings.

SHARITŌ: Buddhist reliquary in the shape of a pagoda.

SHI: City.

SHIGA-JIKU: A hanging scroll with poetry and a painting.

SHI-IN: A smaller monastery within the precincts of a large one.

SHIKA: Stag, deer.

SHIKISHI: A rectangular piece of paper used for painting or writing poetry.

SHIKKEN: The prime minister of a shōgun.

SHIKYAKUMON: A four-legged gate.

SHIMA: Island. *Tō*.

SHIMBETSU: A clan classification in ancient Japan.

SHIMENAWA: Shintō straw cord or rope

indicating the sacred character of a thing or place.

SHIMMEI: The most ancient type of Shintō shrine.

SHIN: New.

SHIN: Traditional and formal style of calligraphy and of gardens.

SHINDEN: The main house in a residential complex. Also a style of residential architecture.

SHINDŌ: New highway.

SHINGON: Esoteric Buddhist sect founded in Japan by Kūkai in 806.

SHINKAN: Calligraphy of an emperor.

SHINTŌ: The native religion of Japan.

SHISHI: Lion.

SHODŌ: The art of calligraphy.

SHŌEN: A feudal manor.

SHŌGUN: Commander-in-chief of all the armies. A military dictator.

SHŌHAN: Name applied to smaller clans.

SHOIN: Library or reading room.

SHOIN: Style of residential and palace architecture originating in the Momoyama period.

SHŌJI: A type of sliding door consisting of a wooden framework to which translucent paper has been pasted.

SHŌMYŌ: Small landowners; farmers owning land.

SHŌNAGON: Lesser counselor.

SHŌRŌ: Bell tower of a monastery.

SHOSAI-GA: Painting in *sumi-e* style *(suiboku)* of a landscape with a hermit in his study.

SO: Free style of calligraphy and of gardens.

SO: Tax on land.

SŌBAN: A column base used in *Kara-yō* style architecture.

SŌ-DŌ: Two halls or buildings joined to form a pair.

SŌRIN: Bronze ornament surmounting the roof of a Buddhist pagoda, often capped by a flame-shaped *sui-en*.

SOROBAN: An abacus for making calculations.

SOTOBA: A grave marker consisting of a column surmounted by a small pagoda of stone.

SUE-KI: A type of pottery.

SUGI: Japanese cypress. *Cryptomeria japonica*.

SUIBOKU-GA: Painting with watercolors. (See *sumi-e*.)

SUI-EN: Terminal ornament of a *sōrin* or pagoda steeple.

SUIJAKU: Syncretic Shintō-Buddhist doctrine.

SUIJAKU-GA: Syncretic painting.

SUKIYA: Austere country-like style of architecture.

SUMI-E: Monochrome painting in India ink.

SUMIZURI-E: An old style of *ukiyo-e* woodblock printed in black ink.

SUN: Measure of length: one-tenth of a *shaku*, approximately 1½".

SUZURI: Ink stone.

TABI: Japanese socks.

TACHI: General name for swords; used for ceremonial as well as battle swords.

TAHŌTŌ: A type of pagoda associated with the Shingon sect.

TAIHEIYŌ: The Pacific Ocean.

TAIHEI-ZUKA: An architectural support in bottle-like form.

TAIRA: Alternate name of the Heike clan.

TAISHA: Type of Shintō shrine.

TAMA: Jewel.

TAMAGAKI: Fence surrounding the central area of a Shintō shrine on which the main hall is situated.

TANDAI: Inspector, a deputy of the shōgun.

TAN-E: *Ukiyo-e* prints with contour lines printed in black and tones of orange applied with a brush.

TA-NO-KAMI: The Shintō divinities of the fields.

TATAMI: Floor mat of woven grass.

TEN: Minor Buddhist divinity. Deva.

TENDAI: Esoteric Buddhist sect founded in Japan by Saichō in 805.

TENGU: Mythical being with a long nose (and sometimes wings).

TENJIKU-YŌ: Indian style of architecture.

TENNIN: Celestial beings.

TENNŌ: Title of the emperors of Japan.

TENSHU: The keep of a castle.

TEPPŌ: Firearms.

TERAKOYA: A school founded by a monastery for the people.

TETSU: Iron.

TŌ: Pagoda.

TŌ: The East. *Higashi*.

TOKONOMA: An alcove along one wall of a room in which treasured objects are displayed.

TOKOWAKI: Alcove with shelves for art objects; located next to the *tokonoma*.

TOKUSEI-REI: Act of deferment or abrogation of debts.

TO-KYŌ: A bracketing system for supporting the roof of a building, usually a Buddhist temple.

TOMO: Arm guard to protect an archer as he shoots an arrow.

TONDEN-HEI: Type of military force established on the island of Hokkaido to encourage colonization.

TORII: The sacred entrance gate of a Shintō shrine.

TRIBHANGA (Sanskrit): Triple bending of the body.

TSUBA: Sword guard.

TSUBO: Measure of surface: equivalent to two *tatami*; approximately 36 square feet.

UCHIWA: A nonfolding fan.
UDAIBEN: Controller of the Right.
UDAIJIN: Minister of the Right.
UJI: Patriarchal unit; the clan.
UKI-E: Style of *ukiyo-e*, woodblock print utilizing the rules of perspective.
UKIYO-E: Woodcuts printed in several colors (from 1700 onward) depicting scenes from Kabuki plays and life in the pleasure districts of Tokyo, Kyoto, and Osaka.
UMA: Horse.
UMAYA: Stable, shed.
URABE: Shintō priest.
URUSHI: Lacquer.
USHNISHA (Sanskrit): Topknot on the head of a Buddha image. In Japanese: *Nikkei*.
UTA-E: Painting inspired by a poem.

WAKA: A type of poem, popular at imperial court during the Heian and Kamakura periods, consisting of thirty-one syllables. *Tanka*.
WAKŌ: Japanese pirates.
WARAJI: Straw sandals.
WASAN: Religious hymn.
WA-YŌ: Japanese style of building.
WAZA: Art, technique, skill.

YABUSAME: Shooting with bow and arrow while on horseback.
YAGURA: A castle tower.
YAMABUSHI: Monk ascetics who lived in the mountains; warrior monks.
YAMAJIRO: Mountain castle. Also *Sanjō*.
YAMA-NO-KAMI: Shintō divinities of the mountains.
YAMATO-E: Style of Japanese painting in contrast to *kara-e*, Chinese painting.
YANAGI: Willow tree.
YAYOI: Protohistorical period: c. 300 B.C.–A.D. 300.
YŌRAKU: Ornaments embellishing a Buddhist statue or temple building.
YOSEGI: Technique of sculpture in which a work is made up of many pieces separately carved.
YUKATA: Type of light cotton kimono worn in the summer.
YUMI: Bow, a weapon made of laminated wood.

ZA: Seat or pedestal of a statue.
ZA: Corporation or guild.
ZAZEN: "Non-mediation" in a seated position advocated by Zen.
ZEN: A sect of Buddhism imported from China into Japan in the twelfth century.
ZENKI: Meditative Zen poem or painting.
ZŌ: Sculpture, image.
ZŌGAN: A technique of incrustation used in the making of small utilitarian objects.
ZŌRI: Light sandals of straw or leather.
ZŌYŌ: Tax payable in the form of labor on public works—corvee.
ZU: Painting, image.
ZUKURI: Style. Also *tsukuri*.
ZUSHI: Small portable shrine.

Bibliography

GENERAL WORKS

CHALLAYE, FÉLICIEN. *Le Japon illustré*. Paris: Larousse, 1915.
CHAMBERLAIN, BASIL HALL. *Things Japanese*. 6th ed. London: Kegan Paul & Co., 1939.
GIUGLARIS, MARCEL. *Japon des réalités*. Paris: Gallimard, 1965.
GIUGLARIS, MARCEL. *Visa pour le Japon*. Paris: Gallimard, 1957.
JAPANESE NATIONAL COMMISSION FOR UNESCO. *Japan: Its Land, People and Culture*. Revised ed. Tokyo: Ministry of Finance Printing Bureau, 1964.
HEARN, LAFCADIO. *Writings*. 16 vols. Boston, New York: Houghton Mifflin Company, 1922.
MARAINI, FOSCO. *Meeting with Japan*. New York: The Viking Press, Inc.; London: Hutchinson, 1959.
MOKU JŌYA. *Mock Joya's Things Japanese*. 2nd ed. Tokyo: Tokyo News Service, 1960.

HISTORY

WORKS IN EUROPEAN LANGUAGES

BATCHELOR, JOHN. *The Ainu of Japan*. New York: F. H. Revell Co., 1892.
EIJI YOSHIKAWA. *The Heike Story*. New York: Alfred A. Knopf, Inc., 1956.
HAGUENAUER, CHARLES. *Origines de la civilisation japonaise*. Paris: Imprimerie nationale, 1956.
JOÜON DES LONGRAIS, FRÉDÉRIC. *Age de Kamakura, sources, archives*. Tokyo: Maison franco-japonaise, 1950.
JOÜON DES LONGRAIS, FRÉDÉRIC. *L'Est et l'Ouest*. Tokyo: Maison franco-japonaise, 1958.

KIDDER, JONATHAN EDWARD. *Japan before Buddhism*. New York: Praeger; London: Thames and Hudson, 1959.
LOUIS FRÉDÉRIC (pseud.). *La vie quotidienne à l'époque des Samurai (1185–1603)*. Paris: Hachette, 1968.
MONTANDON, GEORGES. *La civilisation aïnou et les cultures arctiques*. Paris: Payot, 1937.
MORRIS, IVAN I. *The World of the Shining Prince*. New York: Alfred A. Knopf, Inc.; London: Oxford University Press, 1964. Harmondsworth: Penguin Books, 1969.
REISCHAUER, EDWIN O., and YAMAGIWA, JOSEPH K. *Translations from Early Japanese Literature*. Cambridge, Mass.: Harvard University Press, 1951.
RYŪSAKU TSUNODA, DE BARY, WILLIAM T., and KEENE, DONALD. *Sources of the Japanese Tradition*. 2 vols. New York and London: Columbia University Press, 1964.
SANSOM, GEORGE B. *A History of Japan*. 3 vols. Stanford, Calif.: Stanford University Press, 1958–63; London: Cresset Press, 1959–64.
SANSOM, GEORGE B. *Japan. A Short Cultural History*. Revised ed. London: Cresset Press, 1946; New York: Appleton-Century Crofts, 1962.

WORKS IN JAPANESE

AKIYAMA KENZŌ. *Nihon Chūsei-shi*. Tokyo: 1940.
ENDŌ MOTOO and WATANABE TAMOTSU. *Nihon Chūsei-shi*. Tokyo: 1939.
ITŌ TASABURŌ. *Nihon Hōken Seido-shi*. Tokyo: 1951.
KIKUCHI TAKEYASU. *Zenken Kojitsu*. Tokyo: 1836 (reprint 1965).
NIHON NO REKISHI. *Chūō Kōron Sha*. 24 vols. Tokyo: 1965.
RYŌ SUSUMU. *Kamakura bakufu no Seiji*. Tokyo: 1934.
SAKAMOTO TARO. *Nihon-shi shōjiten*. Tokyo: 1965.

LITERATURE

WORKS IN EUROPEAN LANGUAGES

ASTON, WILLIAM G. *A History of Japanese Literature*. New York: Appleton; London: Heinemann, 1899 (U.S. reprint 1966).

KEENE, DONALD. *Anthology of Japanese Literature*. New York: Grove Press, 1955; London: Allen and Unwin, 1956; (revised ed.) Harmondsworth: Penguin Books, 1968.

PÉRI, NOËL. *Le Nô*. Tokyo: Maison franco-japonaise, 1944.

PETIT, KARL. *La poésie japonaise*. Paris: Editions Seghers, 1959.

RENONDEAU, GEORGES. *Le Nô*. Tokyo: Maison franco-japonaise, 1952.

REVON, MICHEL. *Anthologie de la littérature japonaise*. 5th ed. Paris: Delagrave, 1923.

SEIFFERT, RENÉ. *La littérature japonaise*. Paris: A. Colin, 1961.

TEXTS IN TRANSLATION

FUJIWARA MICHITSUNA NO HAHA. *The Gossamer Years [Kagerō nikki]*. English translation by Edward G. Seidensticker. Tokyo and Rutland, Vt.: C. E. Tuttle Co., 1964.

GIKEIKI. *Yoshitsune. A Fifteenth-Century Japanese Chronicle [Yoshitsune]*. English translation by Helen C. McCullough Stanford, Calif.: Stanford University Press, 1966.

IHARA SAIKAKU. *Five Women Who Loved Love [Koshōku gonin onna]*. English translation by William T. de Bary. Tokyo and Rutland, Vt.: C. E. Tuttle Co., 1956; London: New English Library, 1962.

KENKŌ YOSHIDA. *Essays in Idleness [Tsurezuregusa]*. English translation by Donald Keene. New York: Columbia University Press, 1967.

Kojiki [Kojiki]. English translation by Donald L. Philippi. Princeton: Princeton University Press; Tokyo: University of Tokyo Press, 1969.

Histoires qui sont maintenant du passé [Konjaku monogatari]. French translation by Bernard Frank. Paris: Gallimard, 1968.

MURASAKI SHIKIBU. *The Tale of Genji [Genji monogatari]*. English translation by Arthur Waley. Boston, New York: Houghton Mifflin Company, 1935.

The Tale of the Lady Ochikubo [Ochikubo monogatari]. English translation by Wilfred Whitehouse. Kobe: J. L. Thompson; London: Kegan Paul, 1934.

The Ōkagami. A Japanese Historical Tale [Okagami]. English translation by Joseph K. Yamagiwa. London: Allen and Unwin, 1967.

OMORI, ANNIE S. and KŌCHI DOI. *Diaries of Court Ladies of Old Japan*. Boston, New York: Houghton Mifflin Company, 1920; London: Constable, 1921. Reprint Tokyo: Kenkusha, 1961.

ZEAMI. *La tradition secrète du Nô*. French translation by René Seiffert. Paris: Gallimard, 1960.

SEI SHŌNAGON. *The Pillow Book of Sei Shonagon [Makura no sōshi]*. English translation by Ivan I. Morris. 2 vols. New York: Columbia University Press; London: Oxford University Press, 1967.

The Taiheiki. A Chronicle of Medieval Japan [Taiheiki]. English translation by Helen C. McCullough. New York: Columbia University Press, 1959.

Taketori monogatari. French translation by René Seiffert. Tokyo: Maison franco-japonaise, 1953.

UEDA AKINARI. *Ugetsu monogatari*. French translation by René Seiffert. 2nd ed. Paris: Gallimard, 1956.

WORKS IN JAPANESE

Nihon Bungaku Daijiten. 8 vols. Tokyo: 1952.
Nihon Bungaku Zenshū. 15 vols. Tokyo: 1959.
Nihon Bungaku Yōshi. Tokyo: 1955.
Nihon Koten Bungaku Taikei. 66 vols. Tokyo: 1957.

ARTS

WORKS IN EUROPEAN LANGUAGES

BLASER, WERNER. *Japanese Temples and Tea-Houses*. New York: F. W. Dodge Corp., 1957.

GORHAM, H. H. *Japanese and Oriental Pottery*. Yokohama: Yamagata Printing Co., n.d.

HARADA JIRO. *The Lesson of Japanese Architecture*. Revised ed. Boston: C. T. Branford; London: The Studio, 1954.

KIDDER, JONATHAN EDWARD. *Early Japanese Art*. Princeton: Van Nostrand; London: Thames and Hudson, 1964.

KIYOSHI SEIKE and TERRY, CHARLES S. *Contemporary Japanese Houses*. Tokyo: Kodansha International; London: Ward Lock, 1964.

LANE, RICHARD D. *Masters of the Japanese Print*. Garden City, N. Y.: Doubleday; London: Thames and Hudson, 1962.

MOSAKU ISHIDA. *Japanese Buddhist Prints*. New York: Harry N. Abrams, Inc., 1964.

NEWMAN, ALEXANDER R. and RYERSON, EGERTON. *Japanese Art, A Collector's Guide*. London: G. Bell, 1964.

OSAMU MORI. *Typical Japanese Gardens*. Tokyo: Shibata Publishing Co., 1963.

PAINE, ROBERT T. and SOPER, ALEXANDER. *The Art and Architecture of Japan*. Harmondsworth, Baltimore: Penguin Books, 1960.

SEIROKU NOMA. *The Arts of Japan*. 2 vols. Tokyo: Kodansha International; London: Ward Lock, 1966–67.

TAKEJI IWAMIYA and RICHIE, DONALD. *Design and Craftsmanship of Japan*. New York: Harry N. Abrams, Inc., 1965.

TOKYO NATIONAL MUSEUM. *Pageant of Japanese Art*. 6 vols. Tokyo: Tōto Shuppan Co.; Rutland, Vt.: C. E. Tuttle Co., 1957–58.

TŌYŌ BIJUTSU KOKUSAI KENKYŪSAI. *Index of Japanese Painters*. Tokyo and Rutland, Vt.: C. E. Tuttle Co., 1958.

WORKS IN JAPANESE

FUKUYAMA TOSHIO. *Nihon no Kenchiku*. Tokyo: 1965.

KUNO TAKESHI. *Nihon no Chōkoku*. Tokyo: 1965.

MASUYAMA SHIMPEI. *Nihon kenchiku jidai yōshiki kanshiki zushu*. Tokyo: 1926.

NAKAGAWA CHISAKI. *Nihon no Kōgei*. Tokyo: 1963.

NIHON BIJUTSU. *Kadokawa shoten*. Tokyo: 1965.

TAZAWA YUTAKA and ŌOKA MINORU. *Zusetsu Nihon Bijutsushi*. 2 vols. Tokyo: 1933.

RELIGION AND CUSTOMS

WORKS IN EUROPEAN LANGUAGES

ANESAKI MASAHARU. *History of Japanese Religion*. Tokyo and Rutland, Vt.: C. E. Tuttle Co.; London: Kegan Paul, Trench, Trubner, 1963.

ANESAKI MASAHARU. *Religious Life of the Japanese People*. Tokyo: Kokusai Bunka Shinkokai, 1961.

ASTON, WILLIAM G. *Shinto, the Way of the Gods*. London, New York: Longmans, Green & Co., 1905.

BLYTH, REGINALD H. *Zen and Zen Classics*. 7 vols. Tokyo: Hokuseido Press, 1964.

490

ELIOT, SIR CHARLES. *Japanese Buddhism*. London: E. Arnold, 1935.

FRANCE-ASIE. *Présence du Bouddhisme*. Saigon, 1959.

FRANK, BERNARD. *Kata-imi et Kata-Tagae*. Tokyo: Maison franco-japonaise, 1958.

FUJISHIMA RAYAUON. *Le Bouddhisme japonais*. Paris: Maisonneuve, 1889.

GENCHI KATŌ. *A Study of Shintō*. Tokyo: Meiji Japan Society 1926.

GETTY, ALICE. *The Gods of Northern Buddhism*. Tokyo and Rutland, Vt.: C. E. Tuttle Co., 1962.

HERBERT, JEAN. *Aux sources du Japon, le Shintō*. Paris: A. Michel, 1964.

MATSUDAIRA, N. *Les fêtes saisonnières au Japon*. Paris: G.-P. Maisonneuve, 1936.

MURAOKA TSUNETSUGU. *Studies in Shintō Thought*. Tokyo: Ministry of Education and Culture, 1964.

PONSONBY-FANE, RICHARD A. B. *Studies in Shintō and Shrines*. Kyoto: Ponsonby Memorial Society, 1953.

SAUNDERS, ERNEST D. *Buddhism in Japan*. Philadelphia: University of Pennsylvania Press, 1964.

SOKYO ONO and WOODARD, W. P. *Shintō, the Kami Way*. Tokyo and Rutland, Vt.: Bridgeway Press, 1962.

SUZUKI, DAISETZ T. *Zen and Japanese Culture*. Revised ed. New York: Pantheon Books; London: Routledge and Kegan Paul, 1959.

INDEX

Numbers in italics identify captions for figures and plates by page and number. Captions, text, and cultural charts are indexed selectively. In general, subjects or titles of works of art and names of buildings, artists, architects, patrons, and proveniences (but usually not attributions) are recorded.

In the index Japanese personal names are entered under the prename (e.g., Busshi), but when the text refers to persons by their surnames (e.g., Tori), cross references are given from the full names (surnames entered first): e.g., Tori Busshi. *See* Busshi

497

499

502

Photo Credits

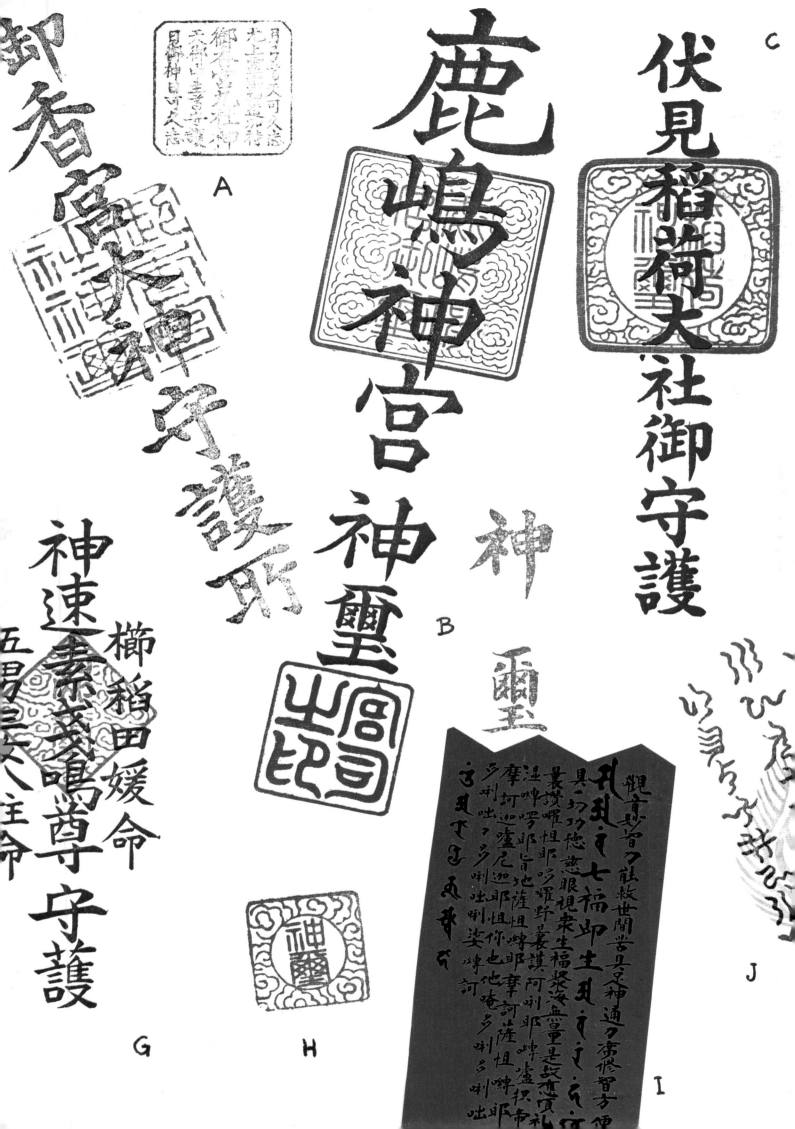